THE MONASTERY OF SAINT CATHERINE AT MOUNT SINAI

THE ILLUMINATED MANUSCRIPTS

VOLUME ONE:
FROM THE NINTH TO THE
TWELFTH CENTURY

THE UNIVERSITY OF ALEXANDRIA
THE UNIVERSITY OF MICHIGAN
PRINCETON UNIVERSITY

THE MONASTERY OF SAINT CATHERINE
AT
MOUNT SINAI

George H. Forsyth
Field Director
The University of Michigan

Kurt Weitzmann
Editor
Princeton University

Publication of this book has been aided by
the Publications Committee of the Department of Art
and Archaeology of Princeton University

THE MONASTERY OF SAINT CATHERINE

AT

MOUNT SINAI

THE ILLUMINATED
GREEK MANUSCRIPTS

VOLUME ONE:

FROM THE NINTH TO THE

TWELFTH CENTURY

KURT WEITZMANN

AND

GEORGE GALAVARIS

PRINCETON UNIVERSITY PRESS

PRINCETON, NEW JERSEY

Copyright © 1990 by Princeton University Press
Published by Princeton University Press, 41 William Street
Princeton, New Jersey 08540
In the United Kingdom: Princeton University Press, Oxford

Library of Congress Cataloging-in-Publication Data

Weitzmann, Kurt, 1904—
 The Monastery of Saint Catherine at Mount Sinai: the
illuminated Greek manuscripts / Kurt Weitzmann and
George Galavaris
 Includes index.
 CONTENTS: v. 1. From the ninth to the twelfth century.
 1. Illumination of books and manuscripts, Byzantine—
Egypt—Sinai, Mount—Catalogs. 2. Illumination of books
and manuscripts, Medieval—Egypt—Sinai, Mount—
Catalogs. 3. Illumination of books and manuscripts—
Egypt—Sinai, Mount—Catalog. 4. Saint Catherine
(Monastery: Mount Sinai)—Catalogs. I. Title.
REF ND2930.W425 1991 745.6' 7487—dc20 90-8594
 ISBN 0-691-03602-0 (alk. paper)
 70598

Princeton University Press books are printed on acid-free
paper, and meet the guidelines for permanence and durability
of the Committee on Production Guidelines for Book
Longevity of the Council on Library Resources

Printed in the United States of America by
Princeton University Press
Princeton, New Jersey

10 9 8 7 6 5 4 3 2 1

TO THE MEMORY OF OUR MOTHERS

Contents

List of Illustrations

Preface

MY INTEREST in the illustrated manuscripts of Sinai goes back to the year 1931, when I held a stipend from the German Archaeological Institute of Berlin to visit the most important libraries in Greece and some Near Eastern countries with the purpose of studying and photographing miniatures in Byzantine manuscripts. I had more or less focused at that time on codices of the ninth and tenth centuries. Having worked in the libraries of Athens, Meteora and Mount Athos, my travels came to an end when I contracted typhus at St. John's Monastery on Patmos, and thus failed to reach Sinai.

I made a second attempt in 1939. In 1935 I had moved to the United States. Princeton University had agreed to sponsor a trip to Sinai by Professor Albert Friend of the Princeton Department of Art and Archaeology and myself to photograph all its Old Testament miniatures as part of the Princeton project of publishing the illustrated manuscripts of the Septuagint, as well as the evangelist portraits for a personal project of Professor Friend. But the outbreak of World War II made the trip impossible.

A third attempt to reach Sinai, in 1951, took me as far as Cairo, which I reached on the very day civil war broke out. Understandably, the Egyptian Frontier Department withheld permission to enter Sinai.

In 1956, on my fourth attempt, I succeeded in reaching the goal I had sought for so long, St. Catherine's Monastery. Professor George Forsyth of the University of Michigan had invited me on that occasion to join him in an exploratory trip to Sinai. We subsequently undertook four extensive campaigns in 1958, 1960, 1963, and 1965, each time spending about three months in the monastery. While Forsyth concentrated on photographic coverage of the architecture, I began to photograph systematically not only the miniatures of the Old and New Testaments but of all the other Byzantine manuscripts and also the few manuscripts in languages other than Greek.

Many of the miniatures had already been photographed by Professor Kenneth Clark of the Divinity School of Duke University during an expedition to Sinai sponsored by the Library of Congress in 1950, which had concentrated on microfilming the manuscripts and photographing most of their miniatures. Many of these photographs, whose negatives are deposited in the Library of Congress, have been used in the present volume. Some photographs, however, had to be reshot for our purposes; additional ones were taken, especially of the ornamental decoration, and some examples had to be photographed in color. Our expedition's chief photographer was Fred Anderegg, the head of Photographic Services at the University of Michigan. Anderegg was in charge of all photographic operations of our campaigns, and while he photographed some miniatures himself, most of our photography was done by his assistants, the best of whom was John Galey, a Swiss from Basel. Although my main interest at Sinai soon shifted to the collection of icons and they then absorbed the main energies of the photographic staff, much attention was paid to the manuscripts; they were photographed, studied, and copious notes were taken.

Our most sincere gratitude goes to the late Archbishop Porphyrios III, who gave us permission to work freely in the library and open access to the shelves. This enabled me to take every codex into my hands and examine it. Equally great is our debt to Professor Aziz Atiya, who had participated in the Library of Congress expedition and catalogued all the Arabic manuscripts. His letter of recommendation to the Archbishop, who was his personal friend, no doubt had much to do with the Archbishop's decision to grant us free access to the library. The Archbishop's generosity was shared by his secretary, Father Gregorios, who later succeeded him as archbishop. Gregorios was an intelligent and learned man who took a lively interest in our work and supported it in many ways. Our last trip to Sinai was made in 1965, ten years before the findings made in 1975 which, therefore, have not been included in our study. However, it is known now that among the newly discovered fragments there are only a few scattered and flaked miniatures and no important examples of ornament that would essentially alter the picture presented in this volume. The new material does

not contribute as much to the history of book illumination as it does to textual matters.

It was only after this rare unlimited access to the library had been granted to us that we developed a plan to publish all the miniatures and ornamental decoration of the Greek manuscripts, which predominate in the polyglot library of St. Catherine's, within a framework of the complete architecture and artistic monuments. But my own studies soon began to focus on the monastery's unique collection of icons, whose publication would require many volumes. I realized that the icon project alone would absorb most of my available time, and so I decided to engage a collaborator for the publication of the illustrated manuscripts.

My choice was Professor George Galavaris, a pupil, colleague, and close friend. As a graduate student at Princeton he had written a dissertation on the illustrated Homilies of Gregory of Nazianzus, a comprehensive study that shortly thereafter was published as a monograph in the Princeton Department of Art and Archaeology's series "Studies in Manuscript Illumination," of which I am editor. Since then he has written copiously on Byzantine book illumination and established himself as an expert in this field. I could not have found a more experienced scholar for this task, since his book on the illustrations of the Homilies of Gregory of Nazianzus had already treated some of the most important manuscripts from Sinai. Our collaboration has been most harmonious and whenever we have had a difference of opinion, it was either resolved in a discussion or—in rare cases—both opinions have been stated. When I invited Professor Galavaris only a few years ago, I handed over to him my notes and a complete set of photographs. He then wrote the text of the entries, which I reviewed. It was of the greatest importance to me that, after the manuscript was finished, Professor Galavaris went to Sinai in 1985 to check the texts. For reasons of health I could not share this task, and for this I am especially grateful to him.

This manuscript is the first of two volumes. It comprises the manuscripts up to around the year 1200. The second volume, on which we have already begun work, will contain the manuscripts from ca. 1200 through the fifteenth century. The post-Byzantine manuscripts will be published separately.

The project has enjoyed the characteristic interest and generosity of my wife, Dr. Josepha Weitzmann-Fiedler, whom I wish to thank for her sustained support over the years when I was traveling to Sinai and thereafter.

Kurt Weitzmann

My devotion to Sinai and my love for Kurt Weitzmann have a long history. As a graduate student, I enrolled in a widely known seminar on illuminated manuscripts given by Professor Weitzmann at Princeton University. Sinai entered my life when my teacher returned from his first successful expedition to the Monastery of St. Catherine and presented me with a set of photographs of cod. Sinai 339, the Homilies of Gregory Nazianzenus. In the years that followed, apart from its illuminated manuscripts, other holy objects have attracted me to Sinai: bread stamps and icons. Over the years I have profited from the vast knowledge and experience of Professor Weitzmann and I have enjoyed the special privilege of his friendship. When he invited me to join him in the present project, I was happy to accept the invitation and embark upon a new rewarding experience—a most gratifying collaboration with him. The material is overwhelming and the distance separating me from St. Catherine's Monastery is very great. While engaged on this project I have divided my time between Montreal, where I am occupied by academic duties, Princeton, Europe, and Sinai.

My work began when Professor Weitzmann put at my disposal the photographic material of the Alexandria/Michigan/Princeton Universities' expeditions to Sinai, as well as some photographs and microfilms from the collection of the Library of Congress. Later the Public State Library of Leningrad provided films and photographs of items deposited there. But I must emphasize that if this demanding work has been accomplished within a reasonable time, it is due to the initial work on these materials done by Professor Weitzmann during his Sinai sojourns, which took the form of rich notes. It was on these that I based my work. My own notes were added later, in 1981 and 1985, when I had the chance to study each of these manuscripts during two visits to the Monastery of St. Catherine. The second trip was devoted primarily to checking the texts for this volume.

Professor Weitzmann says that I have written the text. But I must stress that we discussed every line of the text before it was written down, that together we criticized the text after it had taken written form, and that we jointly decided on necessary changes. What we present here is thus the result of a close, meaningful collaboration.

It was sad that my visits to Sinai took place without Kurt Weitzmann's company. I was fortunate, however, to enjoy the kindness and benefit from the learning of the Brethren who cared for the holy treasures entrusted to them and took interest in my work. The Monastery of St. Catherine, under the guidance and inspiration of its present

archbishop, His Beatitude Damianos, has launched an extensive publication program. In this regard I would like to mention here two books that were placed at our disposal in proof state by their authors, both dealing with the new finds: one on the Arabic manuscripts by Dr. Ioannis Meimaris, which has since been published, and the other on the Greek manuscripts by Dr. Panayotis Nikolopoulos, which is now in press. In the meantime, at the invitation of the monastery, Professor Dieter Harlfinger and his collaborators carried out paleographic research on dated manuscripts which resulted in a splendid book, *Specimina Sinaitica*, that has been most valuable to us. Two other studies now in preparation should be mentioned because they bear some relation to our own work: one, on the scribes of the Greek manuscripts in the library, undertaken by Dr. Nikolopoulos, and another, in which all entries in the Greek manuscripts will be published by the librarian of the monastery, Father Demetrios Sinaitis. Both these undertakings will be most useful to philologists and all those concerned with the level of literacy of Sinai's scribes and its general public, as well as with pilgrimages to the monastery, its later history, and the nature of popular piety. Our work infringes in no way upon any of these studies. In this volume and the next we have recorded only those entries that have direct bearing on the history of the manuscripts.

With regard to the work on the manuscripts in recent years, our deep gratitude is given first and foremost to the Monastery of St. Catherine and His Beatitude Archbishop Damianos. He, the Holy Synaxis, and the late Father Sophronios showed great understanding and did everything possible to facilitate my work. I was offered hospitality and given unlimited access to every manuscript, including the new finds, among which some noteworthy discoveries were made. I profited from the conversations I had with His Beatitude and from the generosity, knowledge, kindness, and unlimited patience of Father Demetrios. An excellent photographer, he also provided me with some important new prints. I shall not forget the excitement we both experienced whenever a page, or complete gatherings, or even an initial of an old manuscript was discovered among the new finds. It is with affection that I remember cold, winter days in the library made warm by Father Demetrios' warmth of heart and that of the Brethren, Father Makarios in particular. Special thanks are due to each and all of them, for they made

my stay in the Monastery of the God-trodden Mountain a memorable one.

I have received help from many friends and colleagues. For advice on matters of paleography I am indebted to Professor Dr. Herbert Hunger, Professor Dr. Johannes Koder, and Dr. Ernst Gamillscheg of the Institut für Byzantinistik of the University of Vienna. Dr. Panayotis Nikolopoulos, Director of the National Library of Greece, and Dr. Ioannis Meimaris of the National Hellenic Research Foundation, Athens, put the proofs of their books and their knowledge at our disposal. Professor Dr. Heinz Fähnrich of the University of Jena and Dr. Werner Seibt of the Institut für Byzantinistik, University of Vienna, have helped in reading a Georgian inscription. The late Alice Bank of the Hermitage, Leningrad, whose death deprived us of a special friend, assisted us with the Leningrad material.

Thanks are due to the libraries and their directors who facilitated our work, especially the Princeton University Library and that of the Institut für Byzantinistik in Vienna; the Department of Art and Archaeology, Princeton University, and its Sinai and Spears funds for financial assistance; the Humanities and Social Sciences Research Council of Canada, Dean Michael Maxwell, and McGill University for making my sabbatical leave possible.

We have received assistance in various other ways from: Mrs. Maria Galavaris-Damianos, my sister, Athens, and Professor Dr. Athanasios Markopoulos, Rethymnon, Crete; Professors Rigas Bertos and Anne Farmakides, Montreal; Professor Dr. Marcell Restle, Munich; Dr. Josepha Weitzmann-Fiedler, Princeton. To all these kind friends we here express our most sincere thanks.

Our gratitude is due Professor William A. P. Childs, former chairman of the Department of Art and Archaeology of Princeton University, who made the necessary arrangements with Princeton University Press for the publication of this book. Special thanks go to Lynda Emery, Kurt Weitzmann's past and present secretary, who edited this text as so many before, improving its style, and wordprocessing the manuscript. The final editing and typesetting were done by Dr. Christopher Moss, who paid meticulous attention to every detail, and we both wish to express to him our deep gratitude.

George Galavaris

Abbreviations

Anderson, "Vat. gr. 463": J. C. Anderson, "Cod. Vat. gr. 463 and an Eleventh Century Painting Center," *DOP* 32 (1978) pp. 177–96.

Beckwith, *Constantinople*: J. Beckwith, *The Art of Constantinople*, London and New York 1961.

Belting, *Buch*: H. Belting, *Das illuminierte Buch in der spätbyzantinischen Gesellschaft* (Abhandlungen der Heidelberger Akademie der Wissenschaften, Philos.-hist. Klasse, 1970, 1), Heidelberg 1970.

Beneševič: V. N. Beneševič, *Catalogus codicum manuscriptorum graecorum qui in monasterio Sanctae Catharinae in Monte Sinai asservantur*, I and III.1, St. Petersburg 1911, 1914, repr. Hildesheim 1965.

Beneševič, *Mon. Sinaitica*: V. N. Beneševič, *Monumenta Sinaitica archaeologica et palaeographica*, Fasc. I, Leningrad 1925; Fasc. II, St. Petersburg 1912.

BSl: *Byzantinoslavica*.

Buchthal, Belting, *Patronage*: H. Buchthal and H. Belting, *Patronage in Thirteenth-Century Constantinople. An Atelier of Late Byzantine Illumination and Calligraphy* (Dumbarton Oaks Studies, 16), Washington, D.C. 1978.

Byzantium at Princeton: *Byzantium at Princeton. Byzantine Art and Archaeology at Princeton University* (Exhibition Catalogue), S. Ćurčić and A. St. Clair, eds., Princeton 1986.

BZ: *Byzantinische Zeitschrift*.

CA: *Cahiers archéologiques*.

Canart, "Chypriotes": P. Canart, "Les écritures livresques chypriotes du milieu du XIe siècle au milieu du XIIIe et le style palestino-chypriote 'epsilon'," in *Scrittura e civiltà* 5 (1981) pp. 17–76.

Carr, A. Weyl. See Weyl Carr, A.

Cavalieri, Lietzmann, *Specimina*: P. Franchi de' Cavalieri and J. Lietzmann, *Specimina codicum graecorum Vaticanorum*, 2nd ed., Berlin and Leipzig 1929.

Cereteli 1904: G. Cereteli, *Sokrascenija v greceskich rukopisjach preimuscestvenno po datirovannym rukopisjam S.-Peterburga i Moskvy*, St. Petersburg 1904.

Cereteli, Sobolevski: G. Cereteli and S. Sobolevski, *Exempla codicum graecorum litteris minusculis scriptorum annorumque notis instructorum, II: Codices Petropolitani*, Moscow 1913.

Chatzidakis, *Icônes à Venise*: M. Chatzidakis, *Icônes de Saint-Georges des Grecs et de la collection de l'Institut Hellénique de Venise* (Bibliothèque de l'institut hellénique d'études byzantines et post-byzantines de Venise, 1), Venice 1962.

Chatzidakis, *Patmos*: M. Chatzidakis, Εἰκόνες τῆς Πάτμου, Athens 1977.

Colwell, Willoughby, *Karahissar*: E. C. Colwell, *The Four Gospels of Karahissar*, 1, *History and Text*; H. R. Willoughby, 2, *The Cycle of Text and Illustrations*, Chicago 1936.

Cutler, "Aristocratic": A. Cutler, "The Aristocratic Psalter; The State of Research," *Actes du XVe Congrès International d'Études Byzantines (Athens 1976)*, 1, Athens 1979, pp. 421–49, pls. 60–64.

Cutler, *Psalters*: A. Cutler, *The Aristocratic Psalters in Byzantium* (Bibliothèque des Cahiers archéologiques, 13), Paris 1984.

Cutler, Weyl Carr, "Benaki Psalter": A. Cutler and A. Weyl Carr, "The Psalter Benaki 34.3. An Unpublished Illuminated Manuscript from the Family 2400," *REB* 34 (1976) pp. 281–323.

DChAE: Δελτίον Χριστιανικῆς Ἀρχαιολογικῆς Ἑταιρείας.

Deliyanni-Doris: H. Deliyanni-Doris, "Εἰκονογραφημένα χειρόγραφα τοῦ Μηνολογίου τοῦ Μεταφραστῆ," *Parousia* 1 (1982) pp. 275–313.

Demus, *Norman Sicily*: O. Demus, *The Mosaics of Norman Sicily*, London 1949.

Der Nersessian, *Études*: S. Der Nersessian, *Études byzantines et arméniennes*, 1–2, Louvain 1973.

Der Nersessian, *Psautiers*: S. Der Nersessian, *L'illustration des psautiers grecs du Moyen-âge, II, Londres, Add. 19.352* (Bibliothèque des Cahiers archéologiques, 5), Paris 1970.

Devreesse, *Introduction*: R. Devreesse, *Introduction à l'étude des manuscrits grecs*, Paris 1954.

DOP: *Dumbarton Oaks Papers*.

Dufrenne, "Ateliers": S. Dufrenne, "Problèmes des ateliers de miniaturistes byzantins," *XVI. internationaler Byzantinistenkongress (Vienna, 1981), Akten I/2, JÖB* 31/2 (1981) pp. 445–70 and 32/1 (1982) pp. 280–81.

Duplacy, "Lectionnaires": J. Duplacy, "Les lectionnaires et l'édition du Nouveau Testament grec," in *Mélanges bibliques en hommage au R. P. Béda Rigaux*, Gembloux 1970, pp. 509–49.

Ebersolt, *Miniature*: J. Ebersolt, *La miniature byzantine*, Paris and Brussels 1926.

EEBS: Ἐπετηρὶς Ἑταιρείας Βυζαντινῶν Σπουδῶν.

Ehrhard, *Überlieferung*: A. Ehrhard, *Überlieferung und Bestand der hagiographischen und homiletischen Literatur der griechischen Kirche*, 1–3 (Texte und Untersuchungen zur Geschichte der altchristl. Literatur, 50–52), Leipzig 1937–1952.

Eustratiades, *Hagiologion*: S. Eustratiades, Ἁγιολόγιον τῆς Ὀρθοδόξου Ἐκκλησίας, Athens, n.d.

Exhibition Leningrad: *Iskusstvo Vizantij v sobranija SSSR*, 1–3, Moscow 1977.

Frantz, "Ornament": A. Frantz, "Byzantine Illuminated Ornament. A Study in Chronology," *The Art Bulletin* 16 (1934) pp. 43–76.

Friend, "Evangelists": A. M. Friend, "The Portraits of the Evangelists in Greek and Latin Manuscripts: 1," *Art Studies* 5 (1927) pp. 115–47.

Galavaris, "Homilienillustration": G. Galavaris, "Homilienillustration," *RzBK* (1973), cols. 260–64.

Galavaris, *Icons-Wisconsin*: G. Galavaris, *Icons from the Elvehjem Center, University of Wisconsin*, Madison 1973.

Galavaris, *Liturgical Homilies*: G. Galavaris, *The Illustrations of the Liturgical Homilies of Gregory Nazianzenus* (Studies in Manuscript Illumination, 6), Princeton 1969.

Galavaris, *Prefaces*: G. Galavaris, *The Illustrations of the Prefaces in Byzantine Gospels* (Byzantina Vindobonensia, XI), Vienna 1979.

Galavaris, "Sinaitic Mss.": G. Galavaris, "Sinaitic Manuscripts in the Time of the Arabs," *DChAE*, per. 4, vol. 12, 1984 (1986) pp. 117–44.

Galavaris, *The Icon in the Church*: G. Galavaris, *The Icon in the Life of the Church* (Iconography of Religions, XXIV,8), Leiden 1981.

Galey 1979: J. Galey, *Sinai und das Katharinen Kloster*, Stuttgart and Zurich 1979.

Gardthausen, *Catalogus*: V. Gardthausen, *Catalogus codicum graecorum Sinaiticorum*, Oxford 1886.

Gardthausen, *Palaeographie*: V. Gardthausen, *Griechische Palaeographie*, 1–2, 2nd ed., Leipzig 1911–1913.

Gerstinger, *Griech. Buchmalerei*: H. Gerstinger, *Die griechische Buchmalerei*, 1–2, Vienna 1926.

Goldschmidt, Weitzmann, *Elfenbeinskulpturen*: A. Goldschmidt and K. Weitzmann, *Die byzantinischen Elfenbeinskulpturen des X.–XIII. Jahrhunderts*, 1–2, Berlin 1930, 1934; 2nd ed., Berlin 1979.

Grabar, *Empereur*: A. Grabar, *L'Empereur dans l'art byzantin*, Paris 1936, repr. London 1971.

Grabar, *Fin de l'Antiquité*: A. Grabar, *L'art de la fin de l'Antiquité*, 1–3, Paris 1968.

Grabar, *Manuscrits grecs*: A. Grabar, *Les manuscrits grecs enluminés de provenance italienne (IXᵉ–XIᵉ siècles)* (Bibliothèque des Cahiers archéologiques, 8), Paris 1972.

Grabar, "Pyxide": A. Grabar, "Une pyxide en ivoire à Dumbarton Oaks. Quelques notes sur l'art profane pendant les derniers siècles de l'empire byzantin," *DOP* 14 (1960) pp. 121–46, repr. in *Fin de l'Antiquité*, no. 20.

Granstrem, *VV*: E. E. Granstrem, "Katalog grečeskich rukopisej Leningradskich chranilišč," *VV* N.S. 16 (1959) pp. 216–43, 18 (1961) pp. 254–74, 19 (1961) pp. 194–239, 23 (1963) pp. 166–204.

Greek Mss. Amer. Coll.: *Illuminated Greek Manuscripts from American Collections: An Exhibition in Honor of Kurt Weitzmann*, G. Vikan, ed., Princeton 1973.

Gregory, *Textkritik*: C. R. Gregory, *Textkritik des Neuen Testaments*, 1–3, Leipzig 1900–1909.

Harlfinger et al.: D. Harlfinger, D. R. Reinsch, J. A. M. Sonderkamp, and G. Prato, *Specimina Sinaitica. Die datierten griechischen Handschriften des Katharinen-Klosters auf dem Berge Sinai, 9. bis 12. Jahrhundert*, Berlin 1983.

Hatch, *Jerusalem*: W. H. P. Hatch, *Greek and Syrian Miniatures in Jerusalem*, Cambridge, MA 1931.

Hatch, *N. T. Mss. Jerusalem*: W. H. P. Hatch, *The Greek Manuscripts of the New Testament in Jerusalem, Facsimiles and Descriptions* (American Schools of Oriental Research, Publications of the Jerusalem School, 2), Paris 1934.

Hatch, *Sinai*: W. H. P. Hatch, *The Greek Manuscripts of the New Testament at Mount Sinai, Facsimiles and Descriptions* (American Schools of Oriental Research, Publications of the Jerusalem School, 1), Paris 1932.

Hunger, "Auszeichnungsschriften": H. Hunger, "Minuskel und Auszeichnungsschriften im 10.–12. Jahrhundert," in *Paléographie grecque*, pp. 201–20.

Husmann: H. Husmann, "Die datierten griechischen Sinai-Handschriften des 9. bis 16. Jahrhunderts. Herkunft und Schreiber," *Ostkirchliche Studien* 27 (1978) pp. 143–68.

Hutter, *Oxford*: I. Hutter, *Oxford, Bodleian Library* (Corpus der byzantinischen Miniaturenhandschriften, I,1–3), Stuttgart 1977–1982.

Ikonen, Munich 1970: *Ikonen 13. bis 19. Jahrhundert*, H. Skrobucha, ed. (Exhibition Catalogue, Haus der Kunst), Munich 1970.

JÖB (*JÖBG*): *Jahrbuch der Österreichischen Byzantinistik (Byzantinischen Gesellschaft)*.

Kamil: M. Kamil, *Catalogue of All Manuscripts in the Monastery of St. Catherine on Mt. Sinai*, Wiesbaden 1970.

Karakatsani, "Stavronikita Icons": Ch. Patrinelis, A. Karakatsani, M. Theochari, Μονὴ Σταυρονικήτα. Ἱστορία, Εἰκόνες, Χρυσοκεντήματα, Athens 1974.

Kondakov 1882: N. P. Kondakov, *Putešestvie na Sinaj v 1881 godu. Iz putevych vpečatlěnij. Drevnosti sinajskago monastyrija*, Odessa 1882.

Kondakov, *Histoire*: N. P. Kondakov, *Histoire de l'art byzantin considéré principalement dans les miniatures*, 2, Paris 1891, repr. New York 1970.

Kondakov, *Initiales*: N. P. Kondakov, *Zoomorfičeskie inicialy grečeskich i glagoličeskich rukopisej X-go–XI-go stol. v biblioteke sinaijskago monastyrja*, Moscow 1903.

Lake, *Dated Mss.*: K. and S. Lake, *Dated Greek Minuscule Manuscripts to the Year 1200*, 1–10, Indices, Boston 1934–1945.

Lazarev 1947: V. N. Lazarev, *Istorija vizantijskoi zivopisi*, 1–2, Moscow 1947, 1948.

Lazarev, *Storia*: V. N. Lazarev, *Storia della pittura bizantina*, Turin 1967.

Lichačev 1911: N. P. Lichačev, *Istoričeskoe značenie italo-grečeskoj ikonopisi*, St. Petersburg 1911.

Lichačev, *Materialy*: N. P. Lichačev, *Materialy dlja istorij russkogo ikonopisanija*, Atlas, St. Petersburg 1906.

Lichačeva, *Iskusstvo knigi*: V. D. Lichačeva, *Iskusstvo knigi. Konstantinopol' XI vek*, Moscow 1976.

Marava-Chatzinicolaou, Toufexi-Paschou: A. Marava-Chatzinicolaou and Ch. Toufexi-Paschou, *Catalogue of the Illuminated Byzantine Manuscripts of the National Library of Greece, 1: Manuscripts of New Testament Texts, 10th–12th Century*, Athens (Academy of Athens) 1978.

Martin, *Heavenly Ladder*: J. R. Martin, *The Illustration of the Heavenly Ladder of John Climacus* (Studies in Manuscript Illumination, 5), Princeton 1954.

Millet, *Recherches*: G. Millet, *Recherches sur l'iconographie de l'évangile au XIV^e, XV^e et XVI^e siècles, d'après les monuments de Mistra, de la Macédonie et du Mont-Athos* (Bibliothèque des écoles Françaises d'Athènes et de Rome, 109), Paris 1916.

Mioni, *Paleografia*: E. Mioni, *Introduzione alla Paleografia Greca* (Studi bizantini e neogreci, 5), Padova 1973.

Nordenfalk, *Zierbuchstaben*: C. Nordenfalk, *Die spätantiken Zierbuchstaben*, Stockholm 1970.

Noret, *Byzantion* 1978: J. Noret, "Les manuscrits sinaitiques de Grégoire de Nazianze," *Byzantion* 48 (1978) pp. 146–207.

Oikonomaki-Papadopoulou, *Argyra*: G. Oikonomaki-Papadopoulou, Ἐκκλησιαστικά ἀργυρά, Athens 1980.

Omont, *Mss. datés*: H. Omont, *Fac-similés de manuscrits grecs datés de la Bibliothèque Nationale du IX^e au XIV^e siècle*, Paris 1891.

Paléographie grecque: *La paléographie grecque et byzantine* (Colloques internationaux du Centre National de la Recherche Scientifique, no. 559), Paris 1977.

Paterson Ševčenko, "Menologium": N. Paterson Ševčenko, "An Eleventh Century Illustrated Edition of the Metaphrastian Menologium," *East European Quarterly* 13 (1979) pp. 423–30.

PG: *Patrologia Graeca*.

Pokrovskij 1892: N. P. Pokrovskij, *Evangelie v pamiatnikakh ikonografij preimushchestvenno vizantiiskikh i russkikh*, St. Petersburg 1892.

Rabino: M. H. L. Rabino, *Le Monastère de Saint-Catherine du Mont Sinai*, Cairo 1938.

Rahlfs: A. Rahlfs, *Verzeichnis der griechischen Handschriften des Alten Testaments für das Septuaginta-Unternehmen* (Königl. Gesellschaft der Wissenshaften zu Göttingen, Nachrichten, Philos.-hist. Klasse, 1914, Beiheft), Berlin 1914.

REB: *Revue des Études Byzantines*.

van Regemorter, "Reliure": B. van Regemorter, "La reliure des manuscrits grecs," *Scriptorium* 8 (1954) pp. 3–23.

REG: *Revue des Études Grecques*.

Restle, *Wandmalerei*: M. Restle, *Die byzantinische Wandmalerei in Kleinasien*, 1–3, Recklinghausen 1967.

RSBN: *Rivista di Studi Bizantini e Neoellenici*.

RzBK: *Reallexikon zur byzantinischen Kunst*.

Schlumberger, *Epopée*: G. Schlumberger, *L'épopée byzantine à la fin du X^e siècle*, 1–3, Paris 1896–1900.

von Soden: H. von Soden, *Die Schriften des Neuen Testaments in ihrer ältesten erreichbaren Textgestalt, I,1: Untersuchungen*, Göttingen 1911.

Sotiriou, *Icônes*: G. and M. Sotiriou, *Icônes du Mont Sinai*, 1: Plates, 2: Text; Athens 1956, 1958 (in Greek with French summary).

Spatharakis, *Dated Mss.*: I. Spatharakis, *Corpus of Dated Illuminated Greek Manuscripts* (Byzantina Neerlandica, fasc. 8), 1: Text; 2: Plates, Leiden 1981.

Spatharakis, *Portrait*: I. Spatharakis, *The Portrait in Byzantine Illuminated Manuscripts* (Byzantina Neerlandica, fasc. 6), Leiden 1976.

Stasov: V. V. Stasov, *Slavjanskij i vostočnyj ornament po rukopisjam drevnjago i novago vremeni:—L'ornament slave et orientale d'après les manuscrits anciens et moderns*, St. Petersburg 1887.

Tikkanen, *Psalterillustration*: J. J. Tikkanen, *Die Psalterillustration im Mittelalter, 1: Die Psalterillustration in der Kunstgeschichte*, Helsingfors 1895–1900, repr. Soest 1975.

Treasures: S. M. Pelekanides, P. C. Christou, Ch. Tsoumis, S. N. Kadas, and A. Katsarou, *The Treasures of Mount Athos: Illuminated Manuscripts*, 1–3, Athens 1973–1979.

Treu, *Handschriften*: K. Treu, *Die griechischen Handschriften des Neuen Testaments in der UdSSR* (Texte und Untersuchungen zur Geschichte der altchristlichen Literatur, 91), Berlin 1966.

Treu, "Kaiser": K. Treu, "Byzantinische Kaiser in der Schreibnotizen griechischer Handschriften," *BZ* 65 (1972) pp. 9–34.

Treu, "Schreiber": K. Treu, "Die Schreiber der datierten byzantinischen Handschriften," in *Beiträge zur byzantinischen Geschichte im 9.–11. Jahrhundert*, V. Vavřinek, ed., Prague 1978, pp. 235–51.

Vailhé, "Répertoire": S. Vailhé, "Répertoire alphabétique des monastères de Palestine," *Revue de l'orient chrétien* 4 (1899) pp. 512–42; 5 (1900) pp. 19–48, 272–92.

Velmans, "Fontaine de vie": T. Velmans, "L'iconographie de la 'Fontaine de vie' dans la tradition byzantine à la fin du Moyen Age," in *Synthronon. Art et archéologie de la fin de l'antiquité et du moyen âge* (Bibliothèque des Cahiers Archéologiques, 2), Paris 1968, pp. 119–34.

Vogel, Gardthausen: M. Vogel and V. Gardthausen, *Die griechischen Schreiber des Mittelalters und der Renaissance*, Leipzig 1909, repr. Hildesheim 1966.

Voicu, D'Alisera: S. J. Voicu and S. D'Alisera, *I.MA.-G.E.S.: Index in manuscriptorum graecorum edita specimina*, Rome 1981.

VV: *Vizantijskij Vremennik*.

Walter, *Art*: Ch. Walter, *Art and Ritual of the Byzantine Church*, London 1982.

Weitzmann, *Ancient Book Illumination*: K. Weitzmann, *Ancient Book Illumination* (Martin Classical Lectures, 16), Cambridge, MA 1959.

Weitzmann, *Athos*: K. Weitzmann, *Aus den Bibliotheken des Athos*, Hamburg 1963.

Weitzmann, *Book Illumination and Ivories*: K. Weitzmann, *Byzantine Book Illumination and Ivories* (Variorum Reprints), London 1980.

Weitzmann, *Buchmalerei*: K. Weitzmann, *Die byzantinischen Buchmalerei des 9. und 10. Jahrhunderts*, Berlin 1935.

Weitzmann, "Byzantine Influence": K. Weitzmann, "Various Aspects of Byzantine Influence on the Latin Countries from the Sixth to the Twelfth Century," *DOP* 20 (1966) pp. 1–24.

Weitzmann, "Classical Mode": K. Weitzmann, "The Classical Mode in the Period of the Macedonian Emperors: Continuity or Revival?" in *Byzantina kai Metabyzantina 1: The "Past" in Medieval and Modern Greek Culture*, S. Vryonis, Jr., ed., Malibu 1978, pp. 71–85, pls. I–XXXI.

Weitzmann, "Cyclic Illustration": K. Weitzmann, "The Selection of Texts for Cyclic Illustration in Byzantine Manuscripts," in *Byzantine Books and Bookmen*, Dumbarton Oaks, Washington, D.C. 1975, pp. 69–109, repr. in *Book Illumination and Ivories*, no. II.

Weitzmann, "Cyprus": K. Weitzmann, "A Group of Early Twelfth-Century Sinai Icons Attributed to Cyprus," in *Studies in Memory of D. Talbot Rice*, G. Robertson and G. Henderson, eds., Edinburgh 1975, pp. 47–63, repr. in *Sinai Studies*, no. IX, pp. 245–70.

Weitzmann et al., *Die Ikonen*: K. Weitzmann, M. Chatzidakis and S. Radojčič, *Die Ikonen: Sinai, Griechenland und Jugoslawien*, Herrsching-Ammersee 1977.

Weitzmann, "Eleventh Century": K. Weitzmann, "Byzantine Miniature and Icon Painting in the Eleventh Century," *The Proceedings of the XIIIth International Congress of Byzantine Studies, (Oxford, 1966)* J. M. Hussey, D. Obolensky, and S. Runciman, eds., London 1967, pp. 207–24, repr. in *Studies*, no. 2, pp. 270–313.

Weitzmann, "Illustrated New Testament": K. Weitzmann, "An Illustrated New Testament of the Tenth Century in the Walters Art Gallery," in *Gatherings in Honor of D. E. Miner*, U. E. McCracken et al., eds., Baltimore 1974, pp. 19–38, repr. in *Psalters and Gospels*, no. IX.

Weitzmann, "Islamische Einflüsse": K. Weitzmann, "Islamische und koptische Einflüsse in einer Sinai-Handschrift des Johannes Klimacus," in *Aus der Welt der islamischen Kunst: Festschrift für E. Kühnel*, Berlin

1959, pp. 297–316, repr. in *Book Illumination and Ivories*, no. III.

Weitzmann, "Kaiserliches Lektionar": K. Weitzmann. "Ein kaiserliches Lektionar einer byzantinischen Hofschule," *Festschrift Karl M. Swoboda*, Vienna 1959, pp. 309–20, repr. in *Psalters and Gospels*, no. VIII.

Weitzmann, "Lectionary Dionysiou": K. Weitzmann, "An Imperial Lectionary in the Monastery of Dionysiou on Mt. Athos. Its Origin and Its Wanderings," *Revue des Études Sud-Est Européennes* 7 (1969) pp. 239–53, repr. in *Psalters and Gospels*, no. XII.

Weitzmann, *Makedonische Ren.*: K. Weitzmann, *Geistige Grundlagen und Wesen der Makedonischen Renaissance*, Cologne-Opladen 1963, repr. in *Studies*, no. 8, pp. 176–223.

Weitzmann, "Morgan Lectionary": K. Weitzmann, "The Constantinopolitan Lectionary, Morgan 639," in *Studies in Art and Literature for Belle da Costa Greene*, D. Miner, ed., Princeton 1954, repr. in *Psalters and Gospels*, no. XIV.

Weitzmann, *Mythology*: K. Weitzmann, *Greek Mythology in Byzantine Art* (Studies in Manuscript Illumination, 4), Princeton 1951; 2nd ed., Princeton 1984.

Weitzmann, "Psalter Vatopedi": K. Weitzmann, "The Psalter Vatopedi 761. Its Place in the Aristocratic Recension," *The Journal of the Walters Art Gallery* 10 (1947) pp. 21–51, repr. in *Psalters and Gospels*, no. III.

Weitzmann, *Psalters and Gospels*: K. Weitzmann, *Byzantine Liturgical Psalters and Gospels* (Variorum Reprints), London 1980.

Weitzmann, *Roll and Codex*: K. Weitzmann, *Illustrations in Roll and Codex: A Study of the Origin and Method of Text Illustration* (Studies in Manuscript Illumination, 2), Princeton 1947; 2nd ed., Princeton 1970.

Weitzmann, *Sacra Parallela*: K. Weitzmann, *The Miniatures of the Sacra Parallela: Parisinus Graecus 923* (Studies in Manuscript Illumination, 8), Princeton 1979.

Weitzmann, *Sinai Icons*: K. Weitzmann, *The Monastery of Saint Catherine at Mount Sinai. The Icons*, 1, Princeton 1976.

Weitzmann, *Sinai Mss.*: K. Weitzmann, *Illustrated Manuscripts at St. Catherine's Monastery on Mount Sinai*, Collegeville, MN 1973.

Weitzmann, *Sinai Studies*: K. Weitzmann, *Studies in the Arts at Sinai*, Princeton 1982.

Weitzmann, *Studies*: K. Weitzmann, *Studies in Classical and Byzantine Manuscript Illumination*, H. L. Kessler, ed., Chicago and London 1971.

Weitzmann, "Study": K. Weitzmann, "The Study of Byzantine Book Illumination, Past, Present, and Future," in K. Weitzmann, W. C. Loerke, E. Kitzinger and H. Buchthal, *The Place of Book Illumination in Byzantine Art*, Princeton 1975, pp. 1–60.

Weitzmann, "The Classical": K. Weitzmann, "The Classical in Byzantine Art as a Mode of Individual Expression," in *Byzantine Art, an European Art, Ninth Exhibition, Council of Europe. Lectures*, Athens 1966, pp. 149–77, repr. in *Studies*, no. 7, pp. 151–75.

Weitzmann, *The Icon*: K. Weitzmann, *The Icon. Holy Images—Sixth to Fourteenth Century*, New York 1978.

Weitzmann, "The Icons of Constantinople": K. Weitzmann, G. Alibegašvili, A. Volskaja, M. Chatzidakis, G. Babić, M. Alpatov, and Th. Voinescu, *The Icon*, New York 1982, pp. 11–84.

Weitzmann-Fiedler, "Begleitfiguren": J. Weitzmann-Fiedler, "Ein Evangelientyp mit Aposteln als Begleitfiguren," in *A. Goldschmidt Festschrift*, Berlin 1935, pp. 30–34.

Weyl Carr, "Gospel Frontispieces": A. Weyl Carr, "Gospel Frontispieces from the Comnenian Period," *Gesta* 29 (1982) pp. 1ff.

Weyl Carr, "A Group": A. Weyl Carr, "A Group of Provincial Manuscripts from the Twelfth Century," *DOP* 36 (1982) pp. 39–81.

Weyl Carr, "McCormick New Testament": A. Weyl Carr, "The Rockefeller McCormick New Testament: Studies Towards the Reattribution of Chicago University Library, MS. 965," Ph.D. dissertation, The University of Michigan, 1973 (University Microfilms International, Ann Arbor 1977).

THE MONASTERY OF SAINT CATHERINE AT MOUNT SINAI

THE ILLUMINATED MANUSCRIPTS

VOLUME ONE:
FROM THE NINTH TO THE
TWELFTH CENTURY

Introduction

ST. CATHERINE'S MONASTERY at Mount Sinai possesses the oldest monastic library with an uninterrupted history, and its still rich holdings, despite great losses which probably occurred in the early centuries of its existence, reflect the library's vicissitudes. A foundation of the Emperor Justinian between the death of his wife Theodora in the year 548 and his own death in 565, it surely must have been endowed with a rich collection of books worthy of an imperial donor. The greatest treasure of the monastery's early period, the Codex Sinaiticus, a fourth-century Bible manuscript, is no longer in the monastery except for some fragments which have been discovered among the new finds. The story of how Constantine von Tischendorf took this manuscript to Russia (today it is in the British Library) has often been told.

The Arab Conquest surely had a serious and long-lasting effect on the monastery, which, cut off from imperial protection and the Constantinopolitan mainstream, oriented itself toward the Christian centers which were under Arab domination, foremost Palestine and especially Jerusalem, with whose Greek patriarchate St. Catherine's has kept the closest ties to the present day. The books produced in the monastery between the seventh and the ninth centuries show very limited ornamental decoration and were primarily service books, Gospels, Psalters, and the like.

Such books must have been easily accessible and kept in a place close to the bema where the service was conducted. Their location was most likely the former sacristy, at the east end of the south aisle and easily accessible from the bema.[1] This room has two floors, the upper one with a bench-like elevation at its south wall which could well have served for the deposit of manuscripts.

In 1975 an important collection of manuscript fragments was discovered in a building close to the northern wall.[2] These fragments were well-stored in boxes, but had apparently been forgotten in modern times. It is not unlikely that the room where these fragments were discovered actually served at one time as the monastery's library. The existence of such an intermediary library, based on the fact that none of the new finds is later than the eighteenth century, must, of course, remain hypothetical. But even if its existence could be substantiated, there is documentary evidence that at the time a "proper" library was established manuscripts and books were not deposited in one place.

The first record of a "library" in the modern sense is found in a 1734 inscription by Archbishop Nicephoros Marthales Glykys (at Sinai from 1728 to 1747, he died the following year). The inscription is carved in wood at the entrance of the building situated in the monks' quarters.[3] It is stated in documents that one of the primary concerns of Nicephoros was to collect and secure the "dispersed" books and manuscripts and that he assigned this task to the "most learned, holy teacher Protosyngelos Isaiah, who with great labor and care collected from every place the books and listed them and placed them in the proper place, as they appear today in the library."[4] Nicephoros also attempted to save damaged codices or dispersed fragments by copying them, and showed interest in publications relating to the monastery. During this period it may well be that the rooms at the north wall were utilized as depositories for codices fallen into disuse.

But the collection of manuscripts and books could not have been long in the Marthales Library, because sometime in the nineteenth century the holdings were transferred to

[1] On the plan of the church published by G. Forsyth (in G. H. Forsyth and K. Weitzmann, *The Monastery of Saint Catherine at Mount Sinai. The Church and Fortress of Justinian*, Ann Arbor 1973, text figure B), this is indicated by the letter H. See also Weitzmann, *Sinai Mss.*, p. 7.

[2] For an account of the discovery and its significance see Damianos, Archbishop of Sinai, "Εἰσήγησις ἐπὶ τῶν νεωστὶ εὑρεθέντων παλαιῶν χειρογράφων ἐν τῇ Ἱερᾷ Μονῇ Σινᾶ," *XVI. internationaler Byzantinis-*

tenkongress (Vienna, 1981), Akten II/4, JÖB 32/4 (1982) pp. 105–15.

[3] Rabino, pp. 49 and 110 no. 125. See also Prinz Johann Georg, Herzog zu Sachsen, *Das Katharinenkloster am Sinai*, Leipzig and Berlin 1912, pl. VI, fig. 16.

[4] The Greek text is cited by K. Amantos, Σύντομος ἱστορία τῆς ἱερᾶς μονῆς τοῦ Σινᾶ, Thessalonika 1953, pp. 62–63; and Σιναϊτικὰ μνημεῖα ἀνέκδοτα, Athens 1928, pp. 71ff., 82–83.

new quarters, a double room next to the Panagia Chapel. Most likely the stream of scholars which had begun to arrive, especially after Tischendorf discovered the Codex Sinaiticus in 1844, necessitated a new depository where the scholars apparently had no direct access to the shelves, but the books were handed out to them. An old photograph (text fig. 1) shows the books lined up on wooden shelves behind a protective grille with an opening through which the books were passed. As another old photograph indicates (text fig. 2), some of the most valuable ones were kept in a cupboard under glass, together with some of the most precious icons.

This installation of the books was in a place that was not fireproof, which was of great concern to Porphyrios III, the archbishop with whom we dealt during our expedition and who had shown a great interest in our scholarly enterprise. Having become archbishop in 1926, he found in 1930 a wealthy Greek who donated the money to construct a new wing of concrete. Completed in 1942, this wing houses not only the library but also, in other rooms, the most valuable icons and the treasures. When the books were transferred to the new wing, the old wooden shelves were used in the installation of a magazine for icons. In 1956 this double room contained about 600 icons (text fig. 3); after our last expedition in 1965 the number had swelled to about one thousand. However, the icons are just as valuable as the books, and now the icons were exposed to the danger of fire as the books had been. Just as the books were being placed on steel shelves in the new library, a plan to replace the wooden bookshelves with metal ledges was worked out with Pater Gregorios, the secretary of the monastery who later succeeded Porphyrios III as archbishop. He agreed, and the money was raised by Kurt Weitzmann through Princeton University.

In the very spacious new library the manuscripts are kept on the upper of two floors, and the lower level holds on its shelves the incunabula and other printed books. Here we photographed the manuscripts with electric light, for which we had taken along our own generator (text fig. 4). Today the library is equipped to some extent with various modern facilities, and certain preliminary measures for the preservation and restoration of manuscripts have been taken by the monastery under the guidance of Archbishop Damianos and with the assistance of the National Library of Greece and the Greek Ministry of Culture.

In some ways the Sinai library is different from those of other Greek monasteries and to some extent it is quite unique. St. Catherine's Monastery, although basically Greek, is a pilgrimage place belonging to the whole of Orthodox Christianity; at an early time there existed within its walls colonies of Syrian-, Georgian-, and Arabic-speaking monks. This is clearly manifested by the polyglot holdings of the library where, to be sure, the Greek codices, more than two thousand in number, predominate, but where also are found about 600 Arabic, more than 250 Syriac, almost a hundred Georgian, and forty Slavonic manuscripts.[5] A certain number of these non-Greek manuscripts were actually written at Sinai alongside the Greek ones produced there. No doubt there was mutual influence among scribes and illustrators of many nationalities. At the same time it was never forgotten that Sinai was an imperial foundation. Constantinopolitan influence was exerted either through gifts and imports or by scribes and illustrators who had gone to Sinai and worked there under the influence of the capital. Thus we must distinguish between those illustrated manuscripts whose decoration derives from a local tradition of countries which since the seventh century had come under Moslem domination, and those in which Constantinopolitan influence prevailed. This dependence on two different traditions, one oriental and the other Hellenistic Greek, are unequally represented: in some centuries, as we shall see, the first predominates, and in others the second.

The first five books in our catalogue, all written in majuscule, cods. 30, 32, 210, 211, and 863 (figs. 1–14), form a coherent group, and there is good evidence that they were produced at Sinai. Typically they are all service books (two Psalters, two Lectionaries, and a Horologion) with only the simplest ornament, one rather abstractly designed fish (fig. 13) being the only exception in an ornamental decoration otherwise confined to simple interlace and other geometric forms. All dating to the ninth century, these manuscripts reveal a spirit of great austerity which must have prevailed in the monastery at that time. This austerity is seen as well in the few codices without ornament, some of which may perhaps reach back to the eighth century.

The only other two manuscripts with ornament from the ninth century, written in minuscule, are obviously imported and unrelated to the Sinai scriptorium. We actually know that one, cod. 375 with Homilies of John Chrysostom, had come early in the sixteenth century to Sinai from Crete (fig. 17). The other one, cod. 1112 containing Canons (figs.

[5] See the statistics in K. W. Clark, "Exploring the Manuscripts of Sinai and Jerusalem," *The Biblical Archaeologist* 16 (1953) p. 34.

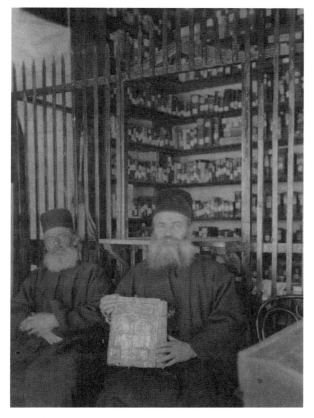

1. Manuscripts on shelves in the old library and monk holding a precious lectionary

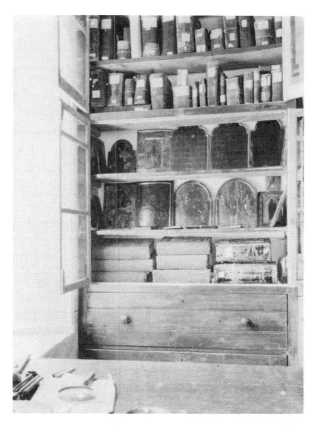

2. Cupboard in the old library holding manuscripts as well as icons

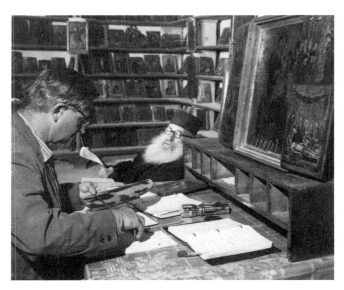

3. K. Weitzmann working in the old library, now a magazine with icons on the shelves instead of books

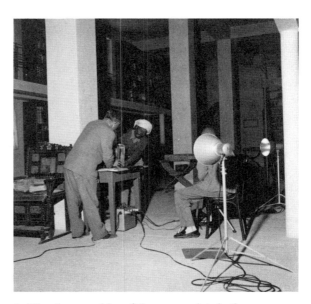

4. The photographing of the manuscripts in the new library by the Alexandria-Michigan-Princeton expedition

18–20), has some ornaments in blue and gold, colors one finds especially in Constantinopolitan manuscripts, but this characteristic is not sufficient evidence to assure the manuscript's Constantinopolitan origin. The ninth-century manuscripts have only meager ornamentation, but this may very well reflect conditions in the monastery, which in the first three centuries after the Arab occupation was apparently much cut off from the mainstream of Byzantine civilization.

Not before the tenth century do we find Sinai manuscripts with decorations on a high artistic level. The codex 283 with Acts and Epistles (figs. 21–31, colorplate i:a) shows for the first time elaborate headpieces including almond rosettes (fig. 22), which are the mark of an oriental, ultimately Sassanian tradition that was beginning to take hold in manuscript decoration. This manuscript presumably originated somewhere in Asia Minor. Two even more elaborately ornamented manuscripts in this orientalizing tradition have a very great chance of actually having been produced at Sinai. One is a Climacus manuscript, cod. 417 (figs. 32–44, colorplate i:b). While its figurative decoration is confined to a medallion portrait of the author, its ornamental decoration is exuberant and of an extraordinary variety of motifs, partly influenced by Islamic art. Not only can some rinceau motifs be compared with those in mosaic at the Dome of the Rock at Jerusalem, but the elegant script gives some indication that it imitates Kufic writing and also Coptic script. This cross-fertilization of different cultures fits well into the picture of a monastery which had within its walls colonies of monks from different orthodox countries, and was open to cultural and artistic influences from these countries.

The other manuscript is known as the Lectionary of Mount Horeb, cod. 213, dated A.D. 967 (figs. 60–82, colorplate ii). Its rich ornamental decoration likewise derives ultimately from Sassanian art, which in general had become one of the mainsprings of Islamic art. Besides a rich repertory of rinceaux and other vegetal motifs, it is distinguished by stylized griffins and peacocks (figs. 61, 65, 66, 69, 73, 79). But the human figure is restricted to one rather inconspicuous medallion of Christ (fig. 74, colorplate ii:c), and one may well ask whether this restraint was due to the monks' awareness that their monastery was situated in Moslem territory.[6]

At the same time we find among the tenth-century Sinai manuscripts several with outspokenly Constantinopolitan ornamentation, basically different from that of the earlier discussed Climacus manuscript and Horeb Gospel Lectionary. None of these early Constantinopolitan manuscripts has any figurative representation. The classicizing Canon tables of the Gospel book cod. 166 (figs. 45–49, colorplate i:c), inserted into a thirteenth-century Gospel book with evangelist pictures (figs. 50–54), represent the highest level of the style of the capital, reflecting quite clearly the Macedonian Renaissance. The Constantinopolitan ateliers had developed two characteristic types of ornament: the first, predominant in the first half of the tenth century, was a fretsaw pattern which in itself is widespread and not confined to the capital, but achieved its distinctive form there by the intensive use of gold and blue.[7] It is represented at Sinai by cod. 183, a Gospel book, and cod. 734–5, a Triodion (figs. 57–59). In the second half of the tenth century, under the impact of the Macedonian Renaissance, Constantinople had developed an entirely new form of ornament, the flower petal, which not only revolutionized ornamental decoration in the capital, but spread from there through the whole Byzantine world.[8] The earliest dated example is found in a John Chrysostom manuscript in Dionysiou at Mount Athos dated 955.[9] This early phase of the flower petal style is well-represented at Sinai by cod. 360 (figs. 88–91), which happens likewise to contain Homilies of John Chrysostom. By the end of the tenth century the flower petal style had acquired a more or less standardized form, as seen in the Psalter cod. 68 (figs. 109–11).

While there were certainly some losses from the period up to the end of the tenth century, there is evidence that some manuscripts fell into disuse, and were either discarded or their folios reused. This is true especially of the Gospel Lectionaries, which at all times were most lavishly decorated, if not with figurative pictures at least with rich ornamental decoration, and usually bound in precious covers for display on the altar table. But there was in the ninth to tenth century a change in the order of the lessons: the traditional system listed the fixed and the movable feasts together, while the new order divided the lessons into two groups: one listing the movable feasts beginning with Easter Sunday and running to the Saturday before Easter, and the second with the readings arranged according to the calendar year from September 1 to August 31. The new order made the older type of Lectionary obsolete, and at Sinai quite a number of leaves from the old Lectionaries, written in large uncials, were used as flyleaves or for repairs in later codices.[10]

[6] See Galavaris, "Sinaitic Mss."

[7] Weitzmann, *Buchmalerei*, ch. B 6, "Die Laubsage-Ornamentik," pp. 18ff.

[8] Ibid., ch. B 7, "Die Blütenblattornamentik," pp. 22ff.

[9] Ibid., pl. XXIX, figs. 160–66.

[10] E.g., cods. 188 and 218, nos. 21 and 45 below.

Among the twenty-three illustrated manuscripts from the eleventh century we have attributed no fewer than twelve to Constantinople, either with certainty or with a high degree of probability, with one more—the Gregory manuscript cod. 341 (figs. 336–39)—being closely related to the style of the capital. The greatest artistic splendor was traditionally lavished on the Gospel Lectionary, the one service book to be deposited on the altar table and carried in procession during the liturgy, but normally not used for the reading of the daily lesson. Thus it is not surprising that two of the Sinai codices of the highest artistic level are Lectionaries. Cod. 204 (figs. 93–107, colorplates III–VIII), from around the year 1000, represents the high point of the Macedonian Renaissance in its elegant court style depicting classicizing evangelists alongside more abstract figures of Christ, the Virgin, and the monk Peter of Monobata. Since it was obviously made for the monastery of Monobata, it is reasonable to assume that the manuscript came only later to Sinai. The second Lectionary, cod. 205 (figs. 277–84, colorplate XVI:c–d), was likewise surely not made at Sinai. Probably Constantinopolitan in origin, it must have come to Sinai from a location that was under strong Western influence, as may be inferred from the Western Anastasis on the back cover (figs. 285, 286).

Moreover, it can be proved that all three of the Menologia with figurative illustrations entered the monastery at a later date. Cod. 512 (figs. 196–98, colorplate XV) with its full-page miniature was still in a monastery in Jerusalem in the thirteenth century; codex 500 (figs. 199–217, colorplate XVI:a) with numerous figures of saints in its text, came from Crete between the years 1609 and 1632; and the Menologion cod. 499 (figs. 287–91) came from Crete a bit earlier, in the year 1553.

There is no written evidence in the other two Constantinopolitan manuscripts with rich miniature cycles as to when they may have entered the Sinai monastery. The elegant and at times classicizing figure style of the marginal Psalter cod. 48 (figs. 232–70) points to a Constantinopolitan atelier different from that of the Studios monastery which produced the Theodore Psalter (now in London) in a more abstract style at about the same time. The other manuscript, cod. 3 (figs. 298–323, colorplate XVII), however, is close in style to the products of the Studios monastery and may have been produced there. Whatever the truth may be about the provenance of these two manuscripts, one gets the impression that during the eleventh century the Sinai monastery did not possess many luxury manuscripts either with portrait miniatures or narrative picture cycles, and one wonders whether this situation reflected a reticence that character-

ized the preceding centuries with regard to illustrations, particularly in service books.

There are a certain number of eleventh-century manuscripts at Sinai decorated in the Constantinopolitan flower petal style, which by now not only dominated in the ateliers of the capital but was imitated in practically every corner of the orthodox world. Yet it is often difficult to distinguish between products of the capital, which at their best show a very brilliant coloration, and those of the provinces, in which the colors are quite subdued. Chiefly on the basis of quality and technical perfection we should like to attribute to Constantinople the Easter tables in the Psalter cod. 68 (figs. 109–11); the headpieces in the Gregory cod. 342 (figs. 187–90), and those of the Menologion cod. 503 (figs. 292–94); furthermore, the figured initials of the Gregory cod. 346 (figs. 324–35); and the headpiece of the Basil manuscript cod. 326 (fig. 340) which surrounds the saint's bust with flower petal ornament. In the case of one manuscript, the Gregory manuscript cod. 341 (figs. 336–39), there remains uncertainty whether or not to make an attribution to Constantinople solely on the basis of the ornament.

In contrast to the ninth and tenth centuries, when we can be quite sure that a group and some individual illuminated manuscripts were made at the Sinai monastery, we are less certain for the eleventh century. There is only one eleventh-century manuscript, and indeed one of the most important ones, which can with a high degree of probability be ascribed to Sinai, and that is the richly illustrated Cosmas Indicopleustes cod. 1186 (figs. 122–83, colorplates IX–XIII). If this attribution could be substantiated, we would have proof that the first Sinaitic manuscript with a large picture cycle is not a liturgical book, where the proscription against figurative illustration which we noticed in the ninth- and tenth-century manuscripts may still have lingered. Besides the Cosmas only one other manuscript—and this too only with some reservation—has been attributed to Sinai: the John Chrysostom cod. 368 (figs. 112–14), on the basis of a similar pale-colored fretsaw ornament.

It is to be expected that Sinai, being open to influences from all the orthodox countries which adhered to the Chalcedonian doctrine, would harbor manuscripts of diverse origins. The monastery's closest contact has always been with Jerusalem and its surroundings. Yet there is no manuscript at Sinai which can be ascribed with certainty to Palestine, and there are only two Gospel books with a possible Palestinian origin: cod. 188 (figs. 115–18) and cod. 155 (figs. 119–22). For other manuscripts it is safer to suggest, until more research has been done on the ornament and other aspects, an origin in some Eastern province; these are

cod. 293 (figs. 191–95), with its rough initials and unarticulated human figures, and cod. 150 (figs. 274–76), a Gospel book whose simple and yet characterful Canon tables are distinct, but for which no parallels have been found in any other Gospel book. Another open question is the localization of the Climax manuscript cod. 423 (fig. 295), whose ladder picture shows climbing monks who are quite rough in design and yet very lively.

We are fairly confident of an identifiable Eastern locality for only two Sinai manuscripts, one for historical and the other for stylistic reasons. The Gospel book cod. 172 (figs. 218-31, colorplate xvi:b), has a portrait of the donor Gabras, who, as governor of Chaldia and Coloneia, resided in Trebizond where the manuscript must have been made. It is to be hoped that other manuscripts may be found and grouped around its provincial and yet outspoken figure style, since Trebizond apparently had a tradition of producing illuminated manuscripts since the tenth century.[11] The other instance is the John Chrysostom manuscript cod. 364 (figs. 184–86, colorplate xiv), with stately miniatures of the imperial portraits of Emperor Constantine Monomachos and Empress Zoe, and the dedicatory picture with Matthew handing over his Gospel to John Chrysostom. Although the manuscript was in the Mangana monastery at Constantinople in the thirteenth century, the style of the miniatures is somewhat different in color and design from eleventh-century miniatures of the capital: the features of the figures and the pale coloration have their closest parallels with works from Cyprus and the manuscript may have been made there. It is also possible that the manuscript may have been illustrated in the capital by a Cypriot painter.

One manuscript which in its ornamentation stands apart from all the others described so far is the cod. 401 (figs. 271–73), which contains writings by Theodore Studites. The initial with a ball-like head biting into the stem (fig. 271) is typical of South Italian manuscripts[12] which in such motifs show north European insular influence. The manuscript may well have been made in Calabria, whose numerous Greek monasteries apparently had contacts with Sinai. Scanty as this evidence may be, based only on the artistic decoration of the manuscripts, it clearly reveals that Sinai had relations with orthodox monasteries far to the east in remote places in Asia Minor, as well as to the west in various provinces in southern Italy.

While richly decorated manuscripts from the eleventh century are numerous at Sinai, such as the Lectionaries cod.

204 and 205, the Job manuscript cod. 3, and the Menologia cods. 500 and 512, to mention only a few, the twelfth century is at least as rich, if not even richer, in splendidly illustrated manuscripts. These luxury manuscripts came not only from Constantinople itself but from centers under strong Constantinopolitan influence as well. Yet some of these luxurious manuscripts did not, we know, come to Sinai at the time of their production; for others we simply have no knowledge of when they reached Sinai. One of the most splendid manuscripts at Sinai, the Gregory cod. 339 (figs. 470–580, colorplates xxi–xxv), a product of the imperial monastery of the Pantocrator, was given to the Sinai monastery only in 1550. The greatest artistic effort was traditionally lavished on the Gospel Lectionary, but the only evidence of what must have been a particularly splendid example is one excised leaf with the representation of the Metamorphosis, which is mounted as an icon (fig. 633). Although its origin in the capital is not certain, it is quite likely. The most refined style of a surely Constantinopolitan scriptorium is represented by cod. 275 (figs. 341–85, colorplate xviii) which contains the Acts and Epistles. This proposed localization is based not only on the elegant figure style but also on the exuberant richness of the delicate ornamental headpieces. The heritage of the Macedonian Renaissance can still be felt in this manuscript from the very beginning of the twelfth century. But there is no indication as to when the codex might have come to Sinai. The elegant Constantinopolitan figure style is also conspicuous in the Climax manuscript cod. 418 (figs. 587–631, colorplate xxvi) with its very inventive scenic illustrations. But the ornament is not quite up to the level of good Constantinopolitan manuscripts, particularly if it is compared with the Acts manuscript cod. 275 just mentioned. There is some likelihood, though it cannot be proved, that the manuscript was produced at Sinai itself. If so, this would prove that the monastery had overcome the earlier anti-iconic tradition manifested in the tenth-century Climax cod. 417 (figs. 32–44, colorplate i:b), a manuscript of equal splendor but confined to a rich repertory of ornamental forms.

There are quite a number of manuscripts at Sinai that show the typical flower petal ornament. Where it is particularly brilliant one expects a Constantinopolitan origin, but in cases of lesser quality one cannot always be certain, since surely works of lesser quality were also produced in the capital. Due to this reservation, most of the manuscripts mentioned in the following lines seem for one reason or another to be products of provincial centers not identifiable by

[11] Weitzmann, *Buchmalerei*, pp. 59ff.

[12] Ibid., pp. 82ff.

the style of ornament alone. In the Menologion cod. 508 (figs. 398–404, colorplate xix:b) it is more the debased figure style in some initials than the flower petal ornament proper that suggests a provincial center dependent on the capital. In the case of the three Lectionaries, cods. 218, 219, and 2090 (figs. 405–409 and 440 [colorplate xx:c]), we encounter what one might call the canonical flower petal style in a form that may indicate a provincial origin or a center in the area around the capital. The headpieces of the two Psalters, cod. 44 (fig. 447) and cod. 39 (fig. 451) are indeed quite close to the style of the capital, particularly the former with its use of gold. The Canon tables and the cross page of the Gospel book cod. 158 (figs. 454–56) are ambitious creations and, in spite of the slightly muddy coloring, their style reflects a good Constantinopolitan model. Also in the Lectionary cod. 216 (figs. 652, 653) the flower petal style is not of the first quality, and once more the question is raised whether the manuscript originated in the capital. All its figurative representations (figs. 653, 654 and 657) are later additions and of a decidedly provincial style.

Despite the powerful impact of Constantinopolitan art in the eleventh and twelfth centuries, the indigenous style of Sinai, which in the tenth century had produced such splendid manuscripts as the Horeb Lectionary (figs. 60–82) with its characteristic repertory of orientalizing ornamental floral and animal motifs, persisted tenaciously. Typical of the local tradition is the Lectionary cod. 207 (figs. 392–96), for which sumptuous metal covers were made in 1604 at Crete by a Georgian artist (figs. 386–91). In this manuscript the use of the human figure is much restricted, being confined to a small bust of John within a headpiece (fig. 392, colorplate xix:a) and a small figure of the writing Luke at the bottom of a lefthand writing column, while the ornamentation of the headpieces predominates. Related to this manuscript is another Lectionary, cod. 237 (figs. 410–20), whose figurative decoration is similarly limited, being confined to medallion heads of Christ and three evangelists in a headpiece (fig. 419); its ornament is much in the tradition of the Horeb Lectionary. A third manuscript, ascribed to this "Horeb group" on the basis of its main headpiece (fig. 421), is the New Testament and Psalter cod. 259 (figs. 421–26). The ornament of the Gospel book cod. 180 (figs. 711–16) bears enough affinity to that of the cod. 237 to make a Sinaitic origin quite likely, although not certain.

The closest relations of Sinai have always been with Palestine, a connection already visible in the uncial ninth-century manuscripts, and it may well be due to our lack of knowledge at this point that more of the Sinai manuscripts cannot be traced to Palestine. In only one case can we be sure: the Gospel Lectionary cod. 220 (figs. 659, 660), whose colophon mentions the venerable monastery of the Holy Cells in Bethlehem, and whose ornament is similar to what we know of products of that region.

One manuscript with a sure provenance is the Gospel book cod. 157 (figs. 634–44), written between 1127 and 1157 at Patmos, where John's monastery was founded by the Comnenian emperors toward the end of the eleventh century. This Sinai Gospel book is thus an early product of the Patmos scriptorium, and its evangelist portraits and ornamental headpieces reflect a quite accomplished Constantinopolitan style.

Another manuscript with a known provenance is the Lectionary cod. 221 (figs. 661–65) from the year 1175, which was written at Heraklion in Crete for a nunnery. Its splendid, though badly cut, title miniature (fig. 665, colorplate xxviii:a) with Christ and the evangelists reveals a high artistic standard strongly influenced by Constantinople, yet it is apparently the product of a miniature painter not from the capital but trained in its style. This miniature is the best witness we have today of a Cretan scriptorium capable of producing illustrated manuscripts on a high artistic level. It is not surprising that a manuscript from Crete should reach Sinai, since St. Catherine's Monastery has still today three metochia on that island.

It is also through its metochia that Sinai had and still has close connections with Cyprus; thus it is hardly surprising to find among the monastery's holdings several manuscripts which can be attributed to Cyprus on the basis of the figure style of their miniatures. A connection to Cyprus was earlier suggested for the eleventh-century John Chrysostom manuscript cod. 364 (figs. 184–86), but the links become more certain in the twelfth century. There are four Sinai manuscripts which we should like to attribute to Cyprus. One of them, a Gospel book from the early twelfth century, cod. 179 (figs. 427–39, colorplate xx:a–b), contains portraits of evangelists whose faces show a marked fold in their foreheads, a characteristic we find in the frescoes of Asinou at Cyprus and in quite a number of icons which, on the basis of this very peculiarity, have been attributed to Cyprus.[13] This feature is also found in the splendid full-page miniature of the Lectionary cod. 208 (figs. 645–47, colorplate xxvii). This codex, however, did not come directly from Cyprus to

[13] Weitzmann, "Cyprus," pp. 47ff.

Sinai, but, as its metal covers reveal (figs. 648 and 650), was given to the Sinai monastery as a gift in the sixteenth century by one of the princes of Wallachia. However, the two other manuscripts, cod. 163 (figs. 678–80, colorplate xxviii:d) and cod. 149 (figs. 681–93), both Gospel books with evangelist portraits, have been ascribed to Cyprus only on the basis of their close relationship to a large number of manuscripts grouped around the so-called Rockefeller-Mc-Cormick New Testament.[14] Cyprus indeed seems to have been the main center of a vast group of manuscripts, though perhaps not all of them were made there. Thus the attribution of these two manuscripts to Cyprus must remain only a likely hypothesis. We deal here with an atelier that did not continue the tradition of the earlier one which produced cods. 179 and 208, but rather was stimulated by a later Comnenian style.

There are two Sinai manuscripts whose ornamental style points to South Italy. Yet neither of them continues the tradition of the eleventh-century Theodore Studites manuscript, cod. 401 (figs. 271–73), with its outspoken north European elements. The Lectionary cod. 234 (figs. 441–46) from the year 1121 indicates clearly that the Byzantine flower petal style had also reached South Italy. Yet the style of some of its initials is quite un-Byzantine, and a Latin blessing gesture demonstrates a Western influence; its place of origin may be sought in Calabria. Furthermore, the Gospel book cod. 193 (figs. 459–63) has been ascribed to South Italy on account of its script. The possible relation of its ornament to a manuscript produced in Reggio in Calabria supports a south Italian origin, though not necessarily an origin in the same place.

When we study the vast body of Sinai's illustrated Greek manuscripts, principally on the basis of often subtle distinctions within ornamental forms still in the initial stage, it is hardly surprising that some attributions must be followed by a question mark. This is the case with two manuscripts with evangelist portraits. The first, the Gospel book cod. 178 (figs. 694–700), has a set of four evangelist portraits of very familiar types, but the paint is so flaked that a stylistic analysis does not yield any conclusion, and the ornament is so simple and indistinct that an attribution to Jerusalem, hinted at in the text, does not carry much weight. The second, a New Testament manuscript, cod. 260 (figs. 703–10), has in its ornament—the evangelists were added later—certain affinities to south Italy, and although an origin there cannot be ruled out, it must remain an open question.

If one compares the holdings of the Sinai library with those of other monasteries, particularly those of western Europe, two facts stand out: first, that the number of manuscripts which can be proved to have been written at Sinai proper is relatively small compared with those imported from outside; and, second, that these manuscripts, although they have common, distinct features, lack a certain homogeneity. In other words, a characteristic Sinaitic "style" did not develop at any time. This is easily enough explained by the isolation of the desert site, which, remote from any greater artistic center, did not lend itself to the development of an indigenous style. Apparently the monks, who came from all parts of the orthodox world, brought their own styles with them.

Although we cannot calculate the losses which occurred over the course of time, the present holdings as a whole still seem to reflect the history and vicissitudes of the library's growth. This growth in many respects runs parallel to that of Sinai's outstanding and in many ways unique icon collection. From the pre-Islamic period, the famous Codex Sinaiticus is comparable to several encaustic icons of the highest quality from the Justinianic era which we believe to be imports from Constantinople. Three such icons in particular, one with the bust of Christ, another with the bust of Peter, and a third with the Virgin enthroned between two soldier saints,[15] play a central role in the history of early icon painting comparable to that of the Codex Sinaiticus in the history of the Septuagint text.

The icons produced mostly at Sinai and Palestine in the eighth and ninth centuries, after the Moslem conquest, show a provincial style in which relatively abstract forms replace those of earlier centuries where the Hellenistic element had still been strong.[16] Their style corresponds well to the rustic script of Sinai manuscripts of these centuries, and to their rather abstract ornament where there is any at all. Not before the tenth century do we find a renewed Constantinopolitan influence in the Sinai icons,[17] reflecting a revitalization of a classical mode as manifested in the Macedonian Renaissance. In the manuscripts this Constantinopolitan influence can be traced best in the ornament, i.e., the classicizing blue and gold fretsaw and the flower petal motif. In some icons imported from the capital the classicizing human figure predominates, while in others icon painters working at Sinai had adopted the Constantinopolitan mode. The fact that no outspoken tenth-century example of the Macedonian Renaissance figure style exists among the preserved Sinai man-

[14] See bibliography to no. 65 below.

[15] Weitzmann, *Sinai Icons*, pp. 13ff., nos. B.1, B.3, and B.5.

[16] Ibid., nos. B.33–B.51.

[17] Ibid., nos. B.52–B.61.

uscripts may be accidental. It first appears in the splendid figures of the Lectionary cod. 204 (figs. 93–99, colorplates III–VII), a manuscript which, as mentioned above, reached Sinai only much later.

In the eleventh century the number of Sinai icons of Constantinopolitan origin, some of the highest quality,[18] increases drastically. Outstanding and innovative among them are unique sets of calendar icons which had appeared only in the eleventh century, shortly after the turn of the century, when Symeon Metaphrastes had compiled the Saint's Lives in what became a standard ten-volume edition. It is not accidental that among the illustrated manuscripts at Sinai there exist several Metaphrastes Menologia with illustrations closely related to icon painting. The full-page miniature in cod. 512 (fig. 198, colorplate XV) aligns the figures of saints in an icon-like arrangement.[19] Vice versa, the scenic representations within the writing columns, as represented by the Menologion, cod. 500 (figs. 199–217), occur in one set of calendar icons where they are intermingled with standing saints.[20] Whereas in the first case an icon had quite surely influenced the miniature, in the second the icon painter had on the contrary copied miniatures. The relation between icon and miniature painting is so close that in some cases one can draw the conclusion that miniaturist and icon painter were the same person. We even have documentation that the miniaturist Pantoleon, who collaborated on the famous Basil Menologion in the Vatican, cod. gr. 1613, worked in both fields, miniature and icon painting.[21]

That the number of excellent Constantinopolitan icons at Sinai increases in the twelfth century is hardly surprising. There is every indication that, with the exception of the Justinianic period, St. Catherine's Monastery enjoyed one of its most, if not *the* most, flourishing periods in the twelfth and thirteenth centuries. Visual evidence of this fact is provided by the series of chapels decorated at that time with splendid iconostases, whose painted beams on their epistyles and despotic icons placed in their intercolumnar spaces point to a vast program of iconic decoration.[22] On the beams the main subject is the liturgical cycle of the Twelve Great Feasts, which have their counterpart in icon-like, full-page miniatures in the Gospel Lectionary. In light of this relationship it is especially noteworthy that one such Lectionary miniature depicting the Metamorphosis (fig. 633) was apparently cut out of the manuscript, mounted on wood, and thus actually turned into an icon. The collections of illustrated books and icons are thus interrelated, and both reflect the vicissitudes of St. Catherine's Monastery.

[18] Weitzmann, "Eleventh Century," pp. 207ff.

[19] Ibid., fig. 20.

[20] Sotiriou, *Icônes*, 1, figs. 136–43.

[21] I. Ševčenko, "On Pantoleon the Painter," *JÖB* 21 (1972) pp. 241ff.

[22] K. Weitzmann, "Icon Programs of the 12th and 13th Centuries at Sinai," *DChAE*, per. 4, vol. 12 (1986) pp. 63ff.

Explanatory Remarks

THE study of illuminated manuscripts in monastic collections presents diverse problems to the scholar. Generally, a collection may reflect the history of the monastery and may illuminate its relations to other communities and even to important individuals; it may help us understand the impact of pilgrimages, the piety of pilgrims and donors, and the nature of their donations. More particularly, if one is able to estimate the losses that have occurred in a library and consider the movement of books, and has the courage to build hypotheses on statistics, a collection may reflect the types of books produced at a given period. Furthermore, there are always questions pertaining to the activities of scribes and illuminators, the nature of book production, and other related matters.

All these problems, large and intricate by nature, have no place within the limits of a catalogue, but deserve special investigation. It is our hope that such studies will be undertaken, by us or other scholars, based on the material contained in this catalogue. A keystone of any such undertaking must be the attribution of the various manuscripts. Hence, this is the focal point of this work.

In this catalogue we have attempted to give comprehensive art historical information on the Sinai manuscripts. All codices with figural illustrations or ornament from the ninth to the end of the twelfth century have been included. A few manuscripts containing scanty and/or poor ornament which add nothing to the ornamental repertory represented in this volume have been omitted. All miniatures and representative examples of the ornament and initials have been reproduced in black and white. There are certain outstanding codices of which nearly everything has been reproduced, including figurative forms taken by the text. We regret that it is not possible to present complete color reproductions. The color descriptions may compensate for this shortcoming to a certain extent.

In the structure of each entry the following scheme has been followed:

Codicological data are limited to basic information. We are fully aware of the paleographic debate and unresolved problems, and the variety of terminology proposed to characterize a type of script or style or even the tendencies a script may take. For the early codices we have opted for terms introduced by G. Cavallo, such as *maiuscola biblica* (biblical majuscule), *maiuscola ogivale* (oval majuscule, formerly called "slavic uncial"), *ogivale inclinata* (sloping majuscule), *ogivale diritta* (upright majuscule), and *rotonda liturgica* (round, liturgical majuscule).[1] From the tenth to the twelfth century, however, the majuscule script was associated with the minuscule in a variety of ways, and here we have used the general terms proposed or adopted by H. Hunger,[2] for instance, *Auszeichnungs-Majuskel* (distinctive majuscule, a term replacing the "small uncial" or "semiuncial"). We have not followed the various styles of this script except for the *Epigraphische Auszeichnungs-Majuskel* (epigraphic distinctive majuscule), the occurrence of which is common, and in one or two obvious examples we refer to the "Alexandrian"[3] style of this script, usually associated with a text in *Perlschrift* minuscule. To define the various minuscule styles or tendencies, Hunger's terminology is again used: *Perlschrift* (small, well-penned, closely linked, round letters); *Eckige Hakenschrift* (hooked, angular letters with pendants or tails ending in hooks);[4] *Keulenstil* (club-shaped, in general a tendency to roundness with pendants or tails thickened to a club form); *Kirchenlehrerstil* (the

[1] G. Cavallo, *Ricerche sulla maiuscola biblica*, Florence 1967; idem, "Funzione e strutture della maiuscola greca tra i secoli VIII–IX," in *Paléographie grecque*, pp. 95–137.

[2] Hunger, "Auszeichnungsschriften"; idem, "Epigraphische Auszeichnungsmajuskel: Beitrag zu einem bisher kaum beachteten Kapitel der griechischen Paläographie," *JÖB* 26 (1977) pp. 193–210; idem, *Studien zur griechischen Paläographie*, Vienna 1954, esp. pp. 22–32, repr. in idem, *Byzantinische Grundlagenforschung, Gesammelte Aufsätze*, Lon-

don 1973, no. I.

[3] This style of script is termed by Irigoin as "onciale grecque du type copte." See J. Irigoin, "L'onciale grecque du type copte," *JÖBG* 8 (1959) pp. 28–51.

[4] For this style of miniscule H. Follieri has proposed the term "minuscola antica oblunga." See "La minuscola libraria dei secoli IX e X," in *Paléographie grecque*, pp. 139–65, esp. p. 144.

Church Fathers style, which seems to be found mostly in manuscripts of Gregory Nazianzus, Basil, and John Chrysostom). These terms, succinct and apt in German, are not adequately translatable into English. We have discussed this problem with Professor Hunger, and have decided to retain his terms. For the second half of the twelfth century, when there was a decline in the minuscule canon and these terms are in most cases no longer applicable, we have reverted to usages introduced by other scholars, such as P. Canart, who have paid special attention to that period.[5] Whenever a script could not be characterized by an existing term, we have described its features. Furthermore, we have chosen the term "gathering numbers" instead of the more common "quire signatures."

Contents. The sequence of the various texts in each manuscript has been cited, and the position of illustrations indicated. We have not been concerned with philological and textual problems. To cite the contents of Lectionaries, the system introduced by C. R. Gregory, which is self-explanatory, has been adopted.

The *History of the Manuscript* comprises information given by colophons or other relevant entries. Entries other than colophons have been included insofar as they make an essential contribution to the history of the codex. The editing of the Greek texts in terms of spelling or completion of lacunae has not been attempted, except to expand abbreviations.

All texts are followed by an English translation, and colophons are reproduced whenever possible.

The *Condition* of each manuscript is discussed, emphasizing its ramifications on the illustrations.

The *Bindings* are reproduced, except for those whose condition prevents a meaningful reproduction. Despite the contributions made by various scholars, the dating of Greek bindings remains a difficult problem. Systematically and critically gathered data have not been established thus far, and the Greek craftsman is conservative in methods and repertory.[6] Some of the proposed dates express our opinion, based on available evidence.

Illustration. All miniatures and ornament, and most of the figural or ornamental initials are described in detail, and their relation to the text is indicated. In this section, both in the description and the corresponding illustrations, we have reunited the "broken" parts of each manuscript, whether leaves or volumes, most of which, stolen by Uspenskij,[7] are now in Leningrad. Thus we reconstruct for the reader the original state of each manuscript's illustration.

The section *Iconography and Style* deals with the iconographic and stylistic features of a codex in order to propose a possible date and a center or area of production.

The *Bibliography* emphasizes art historical studies. Microfilms and photographic negatives have not been included.

[5] See especially his study, "Chypriotes".

[6] In general, see van Regemorter, "Reliure," and cf. G. Petherbridge and A. Muthesius in *Résumés des communications, XV^e Congrès International d'Études Byzantines (Athens, 1976)* (Athens, 1980).

[7] Cf. E. G. Pantelakis, "Β' ὑπόμνημα. Τὰ Σιναϊτικὰ χειρόγραφα τῶν λειτουργικῶν βιβλίων τῆς Ὀρθοδόξου Ἐκκλησίας," *Praktika tes en Athenais Christianikes Archaeologikes Hetaireias*, 1933, per. 3, 2 (1936) pp. 129–57, repr. in *Byzantinisch-neugriechische Jahrbücher* 11 (1934–35) pp. 305–33; for Uspenskij's actions, see esp. pp. 129–33 (repr. pp. 305–309).

Catalogue

1. COD. 30. PSALTER
NINTH CENTURY. FIGS. 1–3

Vellum and paper. 431 folios, 18 x 12.3 cm. One column of twenty lines. Sloping majuscule, *ogivale inclinata*, of medium size (each letter 2.5 mm.) for text,[1] written with very thick pen; titles in upright majuscule, *diritta*; hypothesis and iamboi in another script with round, well-formed letters of the *maiuscola biblica* type (figs. 1–2).[2] Gathering numbers, beginning with gathering β' on fol. 64r, on upper right corner of first recto in black ink with three horizontal lines above and below in red, with strokes and two green strokes at the sides. Parchment mostly thick and hard, but smooth and yellowed white. Ink black for text; titles in red and green, usually but not always alternating. $\Psi\alpha\lambda\tau\acute{\eta}\rho\iota o\nu$, fol. 56r, in yellow; numbers of psalms in red. Simple initials in red and green. Allelouia in red and light green. Later marks for doxa and kathismata on the margins.

The original text begins on fol. 49r and ends on fol. 403v. Fols. 1r–48v and 404r–419v are fifteenth- or sixteenth-century additions by different hands on paper; they are not substitutes for losses from the original manuscript, which begins with the Credo; they contain poems by Andrew of Crete and Theoktistos, as well as various Canons to Christ and Mary. Two unnumbered empty folios follow, and then: fols. 49r–51v, Credo and Lord's Prayer; 51v–54r, hypothesis of the Psalter by (Eusebius) Pamphilos (*PG* 5, 66–68); 54r–55r, extract from John Chrysostom's Homily on Patience and iamboi; 56r–367v, psalms; 367v–368r, list of kathismata (fig. 2); 368v–369r, Psalm 150 (151); 369v–403v, Odes.

On fol. 368r, following the table of kathismata and psalms, there is this text, part of the original manuscript (fig. 2): $\grave{\omega}$C ΠΡΟΚΕΙΤΑΙ CT(ι)X(οι) Δ$\overline{\Psi}$Π / ΚΑΘ$\grave{\omega}$C ΨΑΛΛΟΜΕΝ ἐΝ ΤΗ / ἉΓΙΑ $\overline{X}(\rho\iota\sigma\tau o)\overline{Y}$ ΤΟ\hat{Y} $\overline{\Theta}(\epsilon o)\overline{Y}$

HM$\overline{\omega}$N ἈΝΑ(σ)Τ($\acute{\alpha}$)C($\epsilon\iota$). (The preceding verses are 4780 as we chant [them] in the [monastery of the] Holy Anastasis of Christ our Lord.)

Condition very good. Light brown leather binding on wooden boards over linen in fragmentary state, with pressed medallions containing an unidentifiable motif, perhaps quadrupeds. The front cover is ornamented with a rectangle enclosing the medallions; the back cover bears a lozenge within a rectangle, with medallions and palmettes free or arranged in the form of a large rosette. It probably dates from the sixteenth century. At that time, when the paper folios were added and the codex was bound, three medallions (two small ones flanking a large one in the center) with rosettes against red and a rinceau motif were depicted on the book cut. The motifs derive from painted ceiling panels in various chapels in Sinai.[3]

Illustration

49r Frameless, band-shaped, simple interlace in green, red, and pale yellow, a thin line of strokes with stems and red berries above and below. Credo.

54r Wavy, dark brown line with a red fruit at each end and red and green berries between, on the curves. John Chrysostom's Homily on Patience and the Scriptures.

55r Tailpiece, a wavy line with strokes and buds at ends. Iamboi.

56r Frameless interlace bar. A line similar to that on fol. 54r, but with leaves at ends. Ps. 1 (fig. 1).

369v Frameless interlace in red and green marking the Exodus Ode, Ex. 15:1–19.

403v Tailpiece of green, scroll-like, red berry-tipped stems, ending on either side in red buds. Below, an interlaced Greek cross in olive green and wine red with teardrops and four rays, enclosed in a rinceau-circle in

[1] G. Cavallo, *Ricerche sulla maiuscola biblica*, Florence 1967, vol. 1, pp. 117–23.

[2] The term has been introduced by Cavallo, see note 1 above; Mioni,

Paleografia, pp. 51ff.; also G. Cavallo, "Funzione e strutture della maiuscola greca tra i secoli VIII–XI," in *Paléographie grecque*, pp. 97–137.

[3] See Galavaris, "Sinaitic Mss.," pp. 131f., figs. 19, 21.

light brown, yellow, red, and green (fig. 3). Ode of Manasseh, 2 Chr. 33:12–19, end of the original manuscript.

Iconography and Style

The sign of the Cross in a wreath, a triumphal motif symbolic of *Victoria Christi*, appeared in the Early Christian period in sarcophagi, monumental and minor arts. In book illumination an ornamental cross, often taking the form of a Christogram, is placed at the beginning of a codex or more commonly—a widespread Early Christian practice—it terminates a book.[4] Both placements continue in later years. It is this tradition that is reflected here, although this cross is much more simplified in its rendering than other known examples.[5]

The interlaced ornament and the color scheme of orange, olive green, pale yellow, and light brown have an early history in book illumination. As far as evidence indicates, some of the earliest examples are found in Coptic Egypt.[6] In later centuries and in post-iconoclastic codices of the ninth and tenth centuries this form of decoration is found in manuscripts originating in provincial areas in the Near East.[7]

The sloping majuscule, solemn and elegant, occurs in surviving manuscripts of the seventh, eighth, and ninth centuries.[8] In the present codex the widening and enlargement of certain letters such as the phi, and the decorative tendencies in the tau and delta, adding an angularity to the script, find their best paleographic parallels in the ninth century.[9] The most significant dated example of the *maiuscola inclinata* is the Uspenskij Psalter from 862/3.[10] A comparison of the two Psalters shows that the Sinai script has a certain spontaneity which may indicate an earlier date, in the first half of the century. The statement concerning the number of verses on fol. 368r relates the codex to the Monastery of the Holy Sepulchre in Jerusalem. The phrase καθὼς ψάλλομεν implies that the scribe places himself in this monastic community, and consequently that the codex was written in Jerusalem. It is possible, however, that the Psalter follows the usage of the Anastasis and that it was produced at Sinai. In fact, ornament and script relate the codex to a group of eighth- and early ninth-century manuscripts, Psalters and liturgical manuals, which were produced in Sinai or its region. A number of pages from some of them, removed from Sinai by Tischendorf, were published by Thibaut.[11] That these manuscripts were made in Sinai is proven by their liturgical texts which are written in Greek and Arabic, thus presupposing bilingual readers (see no. 2 below) and by internal, textual evidence found in some of them. Apart from ornament and script, these codices have in common the use of hard parchment and often similar gathering numbers.

Bibliography

Kondakov 1882, no. 89,7.
Gardthausen, *Catalogus*, p. 9.
Beneševič, p. 27.
Rahlfs, pp. 287 no. 30, 360 no. 1187.
Kamil, p. 63 no. 30.
Nordenfalk, *Zierbuchstaben*, p. 143, fig. 33 (here the codex is referred to as a Lectionary).
Galavaris, "Sinaitic Mss.," p. 132, fig. 21.

2. COD. 32. PSALTER
NINTH CENTURY. FIGS. 4–6

Vellum. 410 folios, 19 x 12 cm. One column, number of lines varying between seventeen and twenty-one. Irregular, crude, sloping majuscule script throughout, written with a thick pen. There is no ruling for individual lines, hence the irregularity in the number of lines and size of letters. Gathering numbers with three light red horizontal lines and a

[4] Early Christian examples of this system of decoration have survived in the West. See, for instance, cod. Dublin, Trinity College 55, sixth or seventh century, fol. 147v; Bologna, Bibl. Univ. cod. 70, fol. 122v, second half of the fifth century; the Rufinus codex in Vienna, Latin 847, ca. 600; and other examples including initials containing the cross in a wreath: H. J. Hermann, *Die frühmittelalterlichen Handschriften des Abendlandes* (Die illuminierten Handschriften und Inkunabeln der Nationalbibliothek in Wien, Bd. 1), Leipzig 1923, pl. 7; C. Nordenfalk, "An Illustrated Diatessaron," *The Art Bulletin* 50 (1968) p. 122; Idem, *Zierbuchstaben*, p. 63, fig. 16, pls. 14b, 64d. For the cross in Early Christian and Early Byzantine art see the profound study by Erika Dinkler von Schubert, "Kreuz," in *RzBK*, forthcoming.

[5] See the cross page in cod. Athos, Lavra A 23, fol. 7v (the page belongs to the manuscript), first half of the ninth century; Montecassino gr. 431, fol. 78v, about ninth century, Weitzmann, *Buchmalerei*, pls. II,6,

XCI,572; also cod. Florence, Laur. Plut. XI.9, A.D. 1021 (in this case the cross is not in a wreath), Lake, *Dated Mss.*, 10, no. 369, pl. 693.

[6] M. Cramer, *Koptische Buchmalerei*, Recklinghausen 1964, p. 40, pl. 31.

[7] Cf. cod. Oxford, Laud. gr. 92B, fol. 66v, Hutter, *Oxford*, 1, no. 15, fig. 81; Princeton Gospels, Univ. Lib. cod. Garrett 1, *Greek Mss. Amer. Coll.*, no. 2; *Byzantium at Princeton*, pp. 141–42, no. 168.

[8] Mioni, *Paleografia*, pp. 57f.

[9] Cf. cod. Florence, Laur. Plut. XXVIII.26 (A.D. 886–911), Lake, *Dated Mss.*, 10, no. 363, pls. 674, 675; and Cavalieri, Lietzmann, *Specimina*, p. 8.

[10] See Cavallo (above, note 2), p. 98 with earlier references.

[11] J.-B. Thibaut, *Monuments de la notation ekphonètique et hagiopolite de l'église grecque*, St. Petersburg 1913, figs. 12 and 13, bilingual page in cod. Sin. L, fols. 5v and 19r.

stroke on each side are at the upper right corner of first recto. Parchment very thick and hard but white. Ink black for text; titles and some solid initials in light red. Numbers of psalms are noted, but not always in red. Kathismata are indicated in green.

Fol. 1r blank; 1v–2v, Lord's Prayer and Credo; 3r–374v, Psalms; 41v, 64v, and 321v, blank; 375r–403v, Odes; 403v–408v, varia. On fols. 233v and 408v, lower part, Arabic text of the same date as Greek text, in red and black ink; on fol. 409r, Arabic text of the same date. Fols. 409v–410v, blank; Psalm 151 missing.

On fol. 374v, after the conclusion of the Psalms, is the following text, written in the same script but in red ink (fig. 5): :᾿ΕΧΟΥCΙΝ ΌΥΝ Ο(ι) :ΡΝ: / ΨΑΛΜΟΙ: CΤΙΧ(ους) / ΔΨΠΒ: ΚΑΘΩC / ΨΑΛΛΟΜΕΝ ΕΝ ΤΟ ΑΓΙΟΝ / CΙΝΑ. (The 150 psalms have, then, 4782 verses as we chant [them] in Holy Sinai.)

Fol. 1 is loose. Parchment is blackened at lower edges from much use. Condition fair. Undecorated, very light brown leather binding, probably Byzantine, on wooden boards, in bad condition. Two metal pins on front cover for fastening.

Illustration

1v Band-shaped, frameless headpiece of simple interlace, one line outlined in black and filled with red and the other colorless; an interlaced cross at either end. Another simpler interlace at the bottom of the page. Lord's Prayer and Credo.

3r Band-shaped headpiece of crossed, almond-shaped rosettes, red and colorless, within rectangular frames. Ps. 1 (fig. 4).

193r Π-shaped headpiece in simple red interlace. Ps. 77.

375r Simple interlace in red and colorless marking the Exodus Ode, Ex. 15:1–19.

408v Tailpiece, simple interlace, red and colorless. Three interlaced crosses below in similar colors, end of Greek text (fig. 6).

Iconography and Style

The interlace is similar in type to that in cod. 30 (no. 1 above). The crosses at the tailpiece recall somewhat similar crosses in cod. London, Brit. Lib. Harley 5787, fol. 66r (Lectionary), produced in Bithynia and dated about the year 861.[1] The Sinai crosses, however, are less sophisticated and probably earlier.

The formula on fol. 374v is similar to that in cod. 30,

[1] Weitzmann, *Buchmalerei*, pp. 42, 43, pl. XLVIII,287.

except that the number of verses adheres to the usage followed in Sinai and that the scribe associates himself with this monastery. In addition, according to a note in Arabic, fol. 409r, the copyist was a certain Michael, priest of Sinai. All this points to Sinai as the Psalter's place of production. The ornament, script, and thick parchment provide further evidence for including this manuscript in the group of liturgical texts produced in Sinai in the eighth and ninth centuries (see nos. 1, 3, 4, and 5).[2]

Bibliography

Kondakov 1882, p. 101.
Gardthausen, *Catalogus*, p. 9.
Beneševič, p. 27.
Rahlfs, p. 287 no. 32, 360 no. 1189.
K. W. Clark, "Exploring the Manuscripts of Sinai and Jerusalem," *The Biblical Archaeologist* 16 (1953) p. 26.
Kamil, p. 63 no. 32.
Galavaris, "Sinaitic Mss.," pp. 119, 120, fig. 1.

3. **COD. 210** and NE ΜΓ ($\mu\epsilon\gamma\alpha\lambda o\gamma\rho\acute{a}\mu\mu\alpha\tau os$) 12. LECTIONARY
LENINGRAD, LIBRARY AKADEMII NAUK, SOBR. *RAIK* 194: FOUR LEAVES
A.D. 861/62. FIGS. 7–12

Vellum. 188 folios, 34.3 x 21 cm.; NE: nineteen leaves and five fragments; Leningrad: four leaves, 34.5 x 20.7 cm. One column of twenty-two or twenty-three lines. Sloping majuscule (*ogivale inclinata*) for text, of large size (each letter 5 mm.); upright majuscule (*ogivale diritta*) for titles. Gathering numbers with horizontal carmine lines above and below and grey-green at ends in the form of an S, at upper right corner of first recto, occasionally also on the lower right of last verso. Parchment of average to good quality. Ink black for text; titles in wine red, yellow, dark green. Ornamented initials opening the pericopes in black, wine red, yellow, and orange; solid initials in black and red. Large black or red crosses often accompany the titles.

Selected Readings

The text begins on fol. 1r in the middle of pericope (Lk. 2:40), gathering ϛ′—gatherings α′–ε′ are missing—and ends with gathering λ′, fol. 188v (Mt. 14th day), of which two leaves are lacking; they have turned up in NE ΜΓ 12. The latter includes complete or partial gatherings β′, γ′, δ′.

[2] Galavaris, "Sinaitic Mss.," pp. 118f.

The four Leningrad leaves from the collection of A. A. Dmitrievski belong to gathering δ'. There are occasional holes in the parchment. The new leaves have been restored. There is no cover; the codex is kept between two crude wooden boards.

On the verso of one of the newly discovered leaves, most likely belonging to the very last gathering of the complete manuscript, is a full-page colophon. Badly damaged at important parts, it has been essentially completed by Politis and amended by Harlfinger.[1] The proposals of both scholars are cited here in brackets. Framed by a rinceau of green stems, leaves and red fruit, the text reads (fig. 11):

+ 'ЄІС ΔΌΞΑΝ ΚΑΪ ЄΠΑΙ+/ΝΟΝ ΤΗ͂С
'ΑΓΊΑС 'ΟΜ[ο]ΟΥ/СΊΟΥ 'ΑΚΤΊСΤΟΥ Κ(αὶ)
Ζω/ΟΠΟΙΟΥ͂ ΤΡΙΆΔΟС. [Π](ατ)Ρ(ὸ)С / ΚΑῚ
Υ(ιο)Υ ΚΑΪ 'ΑΓΊΟΥ ΠΝ(εύματο)С. / ΚΑῚ ЄΙС
ΚΌСΜΟΝ ΚΑῚ 'ЄΥ/ΚΛΑΙЄΙ͂ΑΝ ΤΗ͂С
'ΑΓΙωΤΆΤΗС 'ЄΚΚΛΗСΊΑС: / 'ЄΓΡΆΦΗ
ΚΑῚ 'ЄΤЄΛЄ[ι]Ω͂/ΘΗ ΤῸ ΪЄΡΌΝ [καὶ ἅγιον;
Harlfinger: τοῦτον] / 'ЄΚΛΟΓΆΔΙΝ Τ[ῶν
ἁγίων] / 'ЄΥΑΓΓЄΛΊω[ν πασῶν] / ΤωΝ
'ЄΟΡΤ[ῶν ἅμα καὶ] / ΚΥΡΙΑΚῶΝ [τοῦ ὅλου] /
ЄΤΟΥС· ΜΗ(νὸς) [c. 8 letters] / ЄΤΟΥС
ΚΌСΜ[ου ἀπὸ ἀ]/ΔΆΜ [,ςτ]Ο'· 'Ι[ν]Δ[ικτιῶνος]
[c. 7 letters] / СΠΟΥΔΗ͂ ΚΑΙ Π[όνω καὶ;
Harlfinger: πόθω] / ΠΡΟΘΥΜΊΑ·
[...φιλο-]/ΧΡΊСΤΟΥ 'ΑΔ[ελφοῦ καὶ]
ΔΙΑΚΌΝΟΥ [ναοῦ τῶν; Harlfinger: μονῆς] /
ΠΑΝЄΥΦΗΜ[ων ἀποστόλων; Harlfinger
proposes correctly πανευφήμου...] / 'ЄΓΡΆΦΗ
ЄΝ ΤΗ Μ[ονῆ τοῦ] / 'ΑΓΊΟΥ Π(ατ)Ρ(ὸ)С
'ΗΜῶ(ν) [c. 7 letters].

+ For the glory and praise of the Holy Trinity, of one substance, not made, giver of life, of the Father and the Son and the Holy Ghost. And for the adornment and the good fame of the holiest church, the present selection of the [Holy] Gospels for [all] feasts, [including] Sundays of [the entire] year, was written and completed in the month [........] in the year [..]7[.] of the world from Adam, indiction [.......], through the zeal and love and eagerness of the Christ-loving brother and deacon of the [......] most famous [............]. It was written in the monastery of our Holy Father [.......].

Of the world date only the O' (70) has been preserved. Politis' completion 6370 (861/62) is based on the similarities of the Sinai codex to the Uspenskij Psalter dated from that year and ascribed to the area of Jerusalem.[2] Harlfinger completes the last line as ἐν τῆ μονῆ ἁγίου πατρὸς ἡμῶν σάβα, discusses the problem of donor and copyist, and proposes two localities, one relating to the donor and the other to the copyist.

Important information, partly completing the above subscription, is provided by another full-page subscription on fol. 63v, written in the same type of script and by the same hand, which has escaped the attention of Harlfinger and earlier scholars. It reads (fig. 12):

+ ΎΠЄΡ С̄(ωτη)ΡΊΑС̄ СΚΈΠΗС Θ̄(εο)Υ͂ ΚΑΙ /
ΒΟΗΘΊΑС ΤΟΥ͂ ΦΙΛΟΧΡΊС/ΤΟΥ
'ΑΔЄΛΦΟΥ͂ 'ΗΜῶΝ / ΔΙΑΚΌΝΟΥ ΜΗΝΑ͂
Ϊ̈ΑΤ/ΡΟΥ͂. ΠΡΟСΗΝΕΓΚЄΝ ΤῸ / 'ΑΓΙΟΝ
ΚΑΙ Ϊ̈ЄΡΌΝ 'ЄΥΑΓ/ΓΈΛΙΟΝ ΤΗ͂С 'ΑΓΊΑС
ΜΟΝΗ͂С / ΤΟΥ ΑΓΊΟΥ ΌΡΟΥС СΙΝΑ͂· /
ΜЄΤΑ ΘΑΝΑΤΌΝ ΜΟΥ· / ΠΑ͂С ΟΥ̓͂Ν 'Ο
ΑΝΑΓΙΝῶСΚωΝ ΚΑΙ / ЄΝΤΥΓΧΆΝωΝ 'ЄΝ
ΑΥΤὦ· / 'ЄΥΧΈСΘω 'ΥΠЄΡ ΤЀ ΤΟΥ /
ΓΡΆΨΑΝΤΟС ΚΑΙ ΤΟΥ͂
'Α/ΓΟΝΙСΑΜΈΝΟΥ. ΌΠωС / 'Ο
ΦΙΛΑΝ(θρωπ)ΟС Θ̄(εο)С̄· ΔὮΗ ΑΥ/ΤΟΙС
'ЄΥΡЄΙ͂Ν 'ЄΛЄΟС 'ЄΝ ΗΜΈ/ΡΑ ΤΗ͂С
ΑΝΤΑΠΟΔὦСЄω(ς) / ΤΗ͂С ΔΙΚΑΊΑС ΚΑΙ
ΦΟΒЄ/ΡΑ͂С· ΛΙΤΑΙ͂С Τ(ης) 'ΑΓΊΑС
ΘЄ/ΟΤΌΚΟΥ ΚΑΙ ΠΆΝΤωΝ / ΤῶΝ 'ΑΓΊωΝ
'ΑΜΗΝ:–

The text is complete, but different interpretations are possible depending on tenses, cases, and punctuation. We propose the following:

+ For the salvation, God's protection and help of our brother, the Christ-loving deacon Menas the physician who offered this (the) saint and holy Gospel of (to) the Holy Monastery of the Holy Mount Sinai. After my death let everyone who reads it and comes across it pray for him who wrote it and for him who strove (for its production) so that God who loves man grant them mercy on the day of the just and fearful reward through the prayers of the Holy Theotokos and all saints. Amen.

[1] L. Politis, "Nouveaux manuscrits grecs découverts au Mont Sinaï," *Scriptorium* 34 (1980) pp. 5–17, pls. 1–9; Harlfinger et al., p. 14.

[2] For the Uspenskij Psalter see E. Follieri, "Tommaso di Damasco e l'antica minuscola libraria greca," in *Atti Acad. Naz. Lincei, Anno CCCLXXI* (1974), series VIII (Rendiconti di classe di scienzi morali, vol. 29), fasc. 3–4, Rome 1974, pp. 145–63.

There is no doubt that we are dealing here with two different persons, of whom only the name of the donor and his titles, "Menas the deacon and physician," are mentioned; the scribe remains anonymous. On this basis the second paragraph of the NE leaf, end of line 11ff., should be completed as [τοῦ φιλο-]/ΧΡΙΣΤΟΥ ΑΔ[ελφοῦ ἡμῶν] / ΔΙΑΚΟΝΟΥ [μηνᾶ ἰατροῦ] / the last two words instead of ναοῦ τῶν. All else remains hypothetical.

From the subscription added here we know that the codex was originally produced for Sinai or that it was intended for Sinai after the death of the scribe. Whichever interpretation one chooses, the Lectionary was related to Sinai from the time of its production, even though it may have been produced in the Monastery of St. Sabas as Harlfinger suggests.

Style

The codex belongs to a group of manuscripts produced in the Sinai area which have striking paleographic and artistic similarities and include, among others, the Psalters cods. 30 and 32 (see nos. 1 and 2 above), not all of which can be given the date of the Uspenskij Psalter on the basis of our present evidence.

The decoration is limited to simple vignette lines or strokes in red and black with stylized, leaf-like endings (figs. 7–10). The titles provide an ornamental effect by alternating lines of color, as for example on fol. 58v, where red lines alternate with green. Initials are drawn and tinted or are ornamented by a simple geometric, zigzag line enclosing colored dots. This unpretentious ornament recalls the similar ornament in the cod. Meteora, Metamorphosis 591 (Homilies of John Chrysostom), dated 861/62 and produced in Bithynia,[3] but is more primitive. The striking rinceau of the new leaf (fig. 11) has no contemporary parallel, but it does point toward the more developed forms of this type of ornament as seen in cod. Venice, Marc. gr. I,18 (Old Testament).[4]

Bibliography

Gardthausen, *Catalogus*, pp. 41–42.
Gregory, *Textkritik*, pp. 447, 1245 no. 844.
Beneševič, p. 636, fig. 16, no. 844.
Kamil, p. 70 no. 235.
Harlfinger et al., pp. 13–14, 62, no. 1, pls. 1–4 and frontispiece in color.
Galavaris, "Sinaitic Mss.," pp. 120, 121.

Leningrad leaves:
Granstrem, *VV* 16 (1959) pp. 230–31 no. 56.
I. N. Lebedeva, *Opisanie rukopiskogo otdela Biblioteki Akademii Nauk SSSR, 5: grečeskie rukopisi*, Leningrad 1973, pp. 19f.

[3] Weitzmann, *Buchmalerei*, pp. 39, 40, fig. 32, pl. XLVI,271.

4. COD. 211. LECTIONARY
FIRST HALF OF NINTH CENTURY. FIG. 13

Vellum. 253 folios, 24.8 x 18 cm. One column of twenty-four lines. Sloping majuscule of medium size (each letter 4 mm.) for text; titles in upright majuscule of smaller size. Gathering numbers with one horizontal line above at upper right corner of first recto. Parchment very hard and rough, whitish. Ink black for text and calendar indications; titles, few initials, and ekphonetic signs in terracotta red. Calendar indications in red. Paragraphs begin with larger, solid letters in black. Initials are outlined in black and tinted in terracotta red. A square breathing mark over the large initials is often outlined and tinted like the initial itself.

Jo. hebd. Mt. Lk. Sab-Kyr., Holy week pericopes, Menologion, varia, Eothina.

Fols. 1r–2v blank; 3r–56v, John weeks; 43v, text by a later hand; 56v–85r, Matthew weeks; 55r–118v, Luke weeks; 119r–151r, Mark readings; 151v–191v, Holy week pericopes; 192r–243r, Menologion, September–August; 243r–244r, varia; 244r–249r, Eothina; 249r–250r, varia; 250v, colophon, epigram at bottom of folio in upright majuscule of a larger size by a different hand; 251r–252r, Mt. 23:23–28, text in upright majuscule as on fol. 250v; 252v–253v, blank.

Colophon on fol. 250v reads:

+ ΜΝΗΣΘΗΤΗ Κ(ύρι)Ε ῾Ο Θ(εὸ)C Τῶ Cῶ ΔΟΥΛω· / ΛΕωΝΤΙ Τῶ ΠΊCΤΕΙ ΚΑῚ ΠΌΘω / ἌΤΙCΑΜΈΝω ΤῊΝ ᾽ΕΚΛΟΓΑΔΑ ΤΑΥ͂ΤΗ(ν) / ΤῊC ΝΈΑC ΔΙΑΘΉΚΗC Ι(ησο)Υ ΧΡ(ιστοῦ) ΤΟΥ͂ Κ(υρίο)Υ / ῾ΗΜῶΝ· ΚΑΙ ΔΌC ᾽ΑΥΤῷ ᾽ΕΥΡΕῖΝ ΜΈ/ΡΟC, ᾽ΕΝ ΤΗ ΒΑCΙΛΕΊΑ CΟΥ ᾽ΑΜΗΝ·

+ Remember, Lord God, thy servant Leo who with faith and love made this Lectionary of the New Testament of Jesus Christ our Lord and grant him a place in thy kingdom. Amen.

The name Leo is an insert written by the hand that added the epigram following the colophon at the bottom of the folio:

CΟΦΙCΜΑ ΚΑΙ ΧΑΡΙCΜΑ ΚΑ(ι) / ΒΑΘΥΝ ΝΟ ͞ωΝ ΠΟΡΙΖΕ C(ῶτε)Ρ / ΤΥC ΓΡΑΦΟΥCΙΝ ΕΝ ΠΟ/ΝΟ(ι)C.–

Grant, O Lord, wisdom and grace and deep understanding to those who write with labor.

[4] Ibid., p. 43, pl. VIII,41.

On fol. 151v, the following typikon precedes Mt. 21:1f:

Δέον γινώσκειν· ὅτι ἀπόδε ἄρχεται / τὰ εὐαγγέλια
κατὰ τὸν κανόνα τῆς / ἁγίας πόλεως· ἀπὸ τῶν
βαΐων ἐσπέ/ρας τοῦ σαββάτου· καὶ μέχρι τοῦ
ἁ/γίου σαββάτου ἐσπέρας τῆς λειτουργίας.

It should be known that from this point begin the
Gospels according to the Canon of the Holy City,
from Palm Sunday at Saturday vespers to the Holy
Saturday vespers liturgy.

The first two and last two gatherings are loose, with
parchment blackened on the edges and some corners mis-
sing; otherwise the condition is fair. Old binding of dark
brown leather on wooden boards, with simple ornamenta-
tion preserved on the front cover only. The back cover is
completely worn. In the center of the front cover there is a
rectangle framed by a border of simple crosslets. Above and
below the rectangle and the inner corners of the border are
stamped rosettes. A metal Greek cross originally attached at
the center is now missing. Of the small bronze studs that
were along the sides only two remain.

Illustration

3r Band-shaped headpiece of simple interlace, one line
 in red brown and another colorless. Jn. 1:1–17.

4r Initial O in the form of a stylized fish outlined in black
 and tinted in terracotta red. Monday, New Week, Jn.
 1:18–28.

189r A similar initial outlined and colored as on fol. 4r.
 Holy Saturday, vespers, Mt. 28:1–20 (fig. 13).

The remaining decoration consists of simple lines of short
wavy strokes, creating the faint impression of stems spring-
ing from calyxes or red fruit at the ends of the lines. These
decorative lines serve to separate the pericopes.

Iconography and Style

The interlace ornament recalls ornamental frames
found in cod. Meteora, Metamorphosis 591, dated 861/62
(Homilies of John Chrysostom), whose provenance is Bi-
thynia, but in concept and execution the Sinai ornament is
much more primitive.[1] The fish, with or without symbolic
significance, is used as an initial letter in numerous majus-
cule manuscripts especially of the tenth century, such as
Patmos 70 and London, Brit. Lib. Add. 39602, to mention
only two examples.[2] None of them, however, relates stylisti-

[1] Weitzmann, *Buchmalerei*, pl. XLVI,270.

[2] Ibid., pl. LXXI,422; Grabar, *Manuscrits grecs*, pl. 54, fig. 212;
pl. 50, fig. 191. Fish initials have existed since the sixth-century
Latin manuscripts of Italy and Gaul (see Nordenfalk, *Zierbuchstaben*,
pp. 149ff., pls. 60–80). However, it cannot be proven that Western

cally to the Sinai fish initials, which indicate an earlier date
also supported by the paleography. The script, distin-
guished by the extensive use of angular breathing marks, the
use of commas, and the rendering of the psi in the form of a
cross (which is characteristic of an early date), is related to
the cod. Vat. gr. 2066, Gregory of Nyssa, from the ninth
century.[3]

The typikon on fol. 151v relates the codex to the Canon
of the Holy City. The absence, however, of any specific or
personal indication may mean that the Lectionary was not
produced there but in a nearby center that had close connec-
tions with Jerusalem. The paleography, hard parchment,
and manner of decoration are all characteristic of a group of
manuscripts probably made in Sinai and its environs in the
eighth and ninth centuries (see nos. 1–3 above). This codex,
probably dating from the first half of the ninth century, be-
longs to the same group.

Bibliography

Kondakov 1882, p. 104, pl. 89.1.
Gardthausen, *Catalogus*, p. 42.
Gregory, *Textkritik*, pp. 447, 1245 no. 845.
Kamil, p. 70 no. 236.
Weitzmann, *Sinai Mss.*, p. 9, fig. 2.
Marava-Chatzinicolaou, Toufexi-Paschou, p. 35.
Voicu, D'Alisera, p. 557.
Galavaris, "Sinaitic Mss.," p. 120.

5. COD. 863. HOROLOGION NINTH CENTURY. FIG. 14

Vellum. 104 folios, 17.3 x 13.8 cm. One column of
eighteen lines. Sloping majuscule of medium size (each let-
ter 3 mm.) written upon the line for text; titles in less sloping
majuscule. Simple black gathering numbers with red hori-
zontal lines above and below and a stroke at upper right
corner of first recto, a red cross on the opposite corner.
Parchment hard and rough but white. Ink black for text;
titles, numbers of psalms, Doxa, Allelouia, Hours in red;
small, simple, solid initials outlined in black and tinted
in red.

On fol. 1r the title reads: ωρολόγιον κατα / τον κα-
νό(να) τῆς λαυρας / τοῦ ἁγί(ου) π(ατ)ρ(ὸς) ημ(ῶν) σαβα.

manuscripts provided the models for the fish initials found in the East (see
Weitzmann, *Sinai Mss.*, p. 9, fig. 2).

[3] H. Follieri, ed., *Codices graeci Bibliothecae Vaticanae selecti* (Ex-
empla scripturarum 4), Vatican 1969, pl. 6.

(Horologion according to the rule of the Lavra of our Father Sabas.)

The codex in its present state is incomplete. Parchment bears evidence of much use. Old, simple, dark brown leather binding on wooden boards in bad condition; back cover missing.

Illustration

1r Π-shaped headpiece of red and colorless interlace against dark brown ink with rough red palmettes on the two upper corners. Initial M in red. Ps. 1.

44r Frameless, band-shaped headpiece consisting of a rinceau, the black stems of which end in ivy-like red leaves. Initial O in red. Sixth hour, Ps. 53 (fig. 14).

75r Headpiece similar to that on fol. 44r. Initial M in red. The Beatitudes, at Communion.

77v Band-shaped headpiece of cross-almond rosettes in red. Vespers, Ps. 103.

Occasionally a wavy black line with red endings or fillings divides the Hours.

Iconography and Style

The type of interlace, the color scheme (the combination of a red and a colorless line), and the red used for the small solid initials recall the decoration of cod. Sinai 32 (Psalter; see no. 2 above) produced at Sinai, while the simple vignette lines resemble those of cod. Sinai 210 (no. 3 above) from the same area, both of which have been assigned to the ninth century. The vignettes in the present manuscript also recall those found in cod. Leningrad, Public Lib. gr. 219, fol. 263r, dating from the year 835 and hypothetically ascribed to Mt. Athos, although it should rather be considered a product of a monastic community.[1]

The scroll motif with ivy leaves appears in tenth-century manuscripts such as Megaspelaeon 1 (Lectionary).[2] The Sinai ornament, however, is less sophisticated and points to a date in the first half of the ninth century.

The ornament, the type of initials introducing each psalm, the script, and the hard, rough parchment leave no doubt that this manuscript belongs to a group of codices produced in Sinai or centers directly related to it in the eighth and ninth centuries. The title on fol. 1r relates the manuscript to the Lavra of St. Sabas and the indication "of our father Sabas" may indicate that the codex was made there.

Bibliography

Gardthausen, *Catalogus*, p. 186.
Kamil, p. 106 no. 1160.

[1] See Weitzmann, *Buchmalerei*, pl. XLII,236.
[2] Ibid., pl. XVII,90.

6. COD. 375. JOHN CHRYSOSTOM, 21 HOMILIES
LENINGRAD, STATE PUBLIC LIBRARY COD.
 GR. 343: ONE LEAF
LATE NINTH CENTURY (A.D. 892/93?).
FIGS. 15–17

Vellum. 463 folios, 34.3 x 25.5 cm.; *Leningrad*: one leaf, 29 x 10 cm. Two columns of thirty-two lines. Carefully executed, compact minuscule script (upright, elongated letters) of the *Keulenstil* type written upon the line, for text (an example of E. Follieri's *minuscola antica oblunga*);[1] titles in *Auszeichnungs-Majuskel* and *Epigraphische Auszeichnungs-Majuskel*. Gathering numbers on the lower right margin of first recto and lower left margin of last verso. Parchment mixed: very fine and white and hard. Ink light brown for text; titles in terracotta red. Most initials outlined in brown and tinted in red; a few drawn in ink without any color; several are huge in size.

The original text begins on fol. 3r. Fols. 3r–4r, table of contents; 5r–207v, selection of 21 homilies[2] (Leningrad leaf at the end of Homily to Those who are about to be Baptized, *PG* 49–50, 222–42); 208r–280v, Homilies on Priesthood, 1–6 (*PG* 47–48, 624–92); 281r–352r, Homilies addressed to the Jews, 1–5 (ibid., 843–942); 352v–406v, Homilies on the Incomprehensible, 1–6 (ibid., 701–56); 406v–436r, Homilies on Repentance (*PG* 49, 277–350). Fols. 1–2, 6–7, 4–16 are of paper and written by a later hand; they may constitute a restoration of original pages.

Colophon, fol. 436r at bottom of right column, contains only the year, ͵ϛυα' (893). In pale black-brown ink, it was definitely written by another hand; the year has been copied once more on fol. 436v by a later hand (fifteenth-century?) in an entry that includes the name of Leo the Isaurian. It reads:

+ αὕτη ἡ βίβλος ἐστὴν τοῦ ἐν ἁγίοις π(ατ)ρ(ὸ)ς ἡμῶν, νικολάου τοῦ ἐν το ρικόνδι· [A curse against book thieves follows, almost completely erased, and then:] ἔτους ͵ϛυα'. / βασιλεβόντ(ος) τοῦ [εὐσεβε?]στάτου λέον(τος) ἰσαύρου / καὶ ἀρχιερατέβοντος οἰκουμενικοῦ [πατριάρχου] κυροῦ σεργίου οὗ καὶ τοὺς οἴκους(?) ἐπίησ(εν).

+ This book belongs to our Father Nicholas who is in Rikoudi [.....] in the year 6401 (893) in the reign of the most pious(?) Leo the Isaurian and the patriarchate of the Ecumenical (Patriarch) Sergios [......?].

[1] E. Follieri, "La minuscola libraria dei secoli IX e X," in *Paléographie grecque*, p. 144.
[2] For detailed contents, see Beneševič in Bibliography.

According to another entry (fol. 4v) important for the history of the codex, the manuscript was brought to Sinai from Crete on November 20, 1597:

ἔτους ͵ζρϛῷ νοεμβρίῳ μηνί κ̄ / ἦλθα ἐγώ ὁ γεράσιμος ἱερομόναχο(ς) ἐκ τὸ οἰκονομίον τῆς κρήτης· καὶ ἤφε/ρα τὸ παρ(ὸν) βιβλίον, καὶ το ἀφιερώνω / εἰς τό ἅγιον ἡμ(ῶν) μοναστήριον τὸ σίναιον·

In the year 7106 (1597) on November 20, I, Gerasimos the hieromonk, came from the oeconomeion of Crete and brought this book and I dedicate it to our holy monastery of Sinai.

The entry concludes with a curse against book thieves. Another hand has added an Arabic text on the lower part of the page.

With the exception of occasional holes and some cuts along the right-hand margins, on the whole the condition is good. Old reddish brown leather binding with tooled decoration of a sixteenth-century date. The front cover is framed by three bands (fig. 15), the first of which consists of a series of lyre- or heart-shaped clusters stamped with rectangular stamps and arranged in pairs facing each other. The next band is decorated with almond rosettes enclosed in triangles or lozenges, while the third, inner band consists of a scroll motif. The enclosed ground is marked by diagonal lines crossing one another and forming a star-like cross. Diamonds and medallions with fleurs-de-lis, a double-headed eagle and possibly a griffin, floral motifs, and rosettes are scattered over the entire ground.[3] Similar patterns and ornaments appear on the back cover (fig. 16), except that the cross in the center has been replaced by diamonds and half diamonds. Large metal studs mark the corners and the centers of each cover; the upper right and the central studs of the front cover and the lower right stud of the back cover are missing. Designs and motifs are comparable but not identical to two Byzantine covers found on cods. Oxford, Auct. T. inf. 2.6, assigned to the fifteenth century, and Cromwell 16, possibly of a similar date.[4] The type of leather used is found in a number of Cretan bindings on manuscripts now at Sinai. Some of them, it can be proved, were made in Sinai itself. Hence this binding is a Cretan or Sinaitic work.

Illustration

3r Band-shaped headpiece of simple interlace in brown, in left column. Table of contents.

Thereafter the title, which lists the contents of each homily, is enclosed in a rectangular frame whose interlace consists of a red and a colorless band placed either in the left or the right column. In each case there is a simple, large initial in red or, in several instances, colorless, outlined only in brown or ornamented with an interlace. Both title frames and initials are found on the following folios: 5r (fig. 17), 13v, 27v, 40v, 50r, 64r, 75v, 82r, 87v, 96v, 105r, 113v, 123r, 131r, 141v, 150r, 160r, 169r, 177r, 187r, 198r, 208r, 216v (in this case an interlace forming three crosses heads the contents in the left column and a title frame appears in the right column), 225v (similar to fol. 216v), 246r and v, 260r, 265v, 266r, 281r, 291v, 312v, 325r, 336r, 352v, 360v, 370v, 380r, 389r, 400r. The Homily on Repentance, fol. 406v, has no title frame.

Iconography and Style

The date given by the colophon has been justifiably disputed since it was applied by a later hand. Yet a date in the late ninth century is supported by evidence provided by the codex itself. The type of script is found mainly in ninth- and tenth-century manuscripts.[5] The simple interlace used as ornament is common in Byzantine codices, particularly those produced in the provinces. With certain variations it is found in manuscripts assigned to a Palestinian or Egyptian area, and it is comparable to that in cod. Sinai 32 (see no. 2 above), but is more sophisticated in its execution.[6] Furthermore, the combination of a colored (preferably red) band with a colorless one occurs frequently, although not exclusively, in codices from Egypt or Palestine.[7] But the initials find their best parallels in codices assigned to the eastern provinces of the Byzantine empire. They are characterized by simple, flat stems without knots, whose frames are outlined in ink and end in triangles with teardrops. They are comparable to the initials of a group of early manuscripts centering around the codex Meteora, Metamorphosis 591, from the year 861/62 (Homilies of John Chrysostom).[8]

All of this evidence suggests a provincial origin for this codex, and although its script is not related to that of the early group of "Sinaitic" manuscripts, the quality of

[3] For the double-headed eagle see G. S. Spyridakis, "Ὁ δικέφαλος ἀετὸς ἰδίᾳ ὡς σύμβολον ἢ ὡς θέμα κοσμήσεως κατὰ τὴν βυζαντινὴν ... περίοδον," *EEBS* 39–40 (1972–73) pp. 162–74.

[4] Hutter, *Oxford*, 1, figs. 33, 34.

[5] Hunger, "Auszeichnungsschriften," pp. 203, 213, figs. 5, 6.

[6] This ornament occurs also in later manuscripts from the same area, such as Jerusalem, Sabas 82, A.D. 1027, Weitzmann, *Buchmalerei*, pl. LXXXI,508.

[7] Ibid., pp. 72ff.

[8] Ibid., pp. 39, 40, fig. 32.

its ornament may point to Sinai itself as the place of its manufacture.

Although this manuscript has no figurative illustrations and its ornament is not of exceptional interest, it is of importance because of its contribution to our understanding of the role played by ornament in manuscripts whose text was on the whole not suitable for figurative illustration. The titles have been emphasized and to a certain extent they have taken the place of ornament, distinctly separating each homily.

Bibliography

Gardthausen, *Catalogus*, pp. 85–86, pl. 3,1.
Beneševič, pp. 210–13, no. 384.
Devreese, *Introduction*, pp. 54 n. 10, 288 n. 2.
Kamil, p. 78 no. 437.
Husmann, p. 145.
Voicu, D'Alisera, p. 560.
Harlfinger et al., pp. 59, 60, 65 no. 35.

Leningrad leaf:
N. A. Bees, "Un ms. des Météores de l'an 861/2," *REG* 26 (1913) p. 73.
Beneševič, pp. 210–13, 619 no. 384.
Idem, *Mon. Sinaitica*, 2, pl. 40.
Cereteli, Sobolevski, pl. 1b.
Th. L. Lefort and J. Cochez, *Palaeographisch album van gedagteekende grieksche minuskelhandschriften uit de IX^e en X^e eeuw*, 1–2 (Katholieke Universiteit te Leuven, Philologische Studien, Albumrecks no. 1), Louvain 1932–34, pl. 8.
Devreese, *Introduction*, pp. 54 n. 10, 288, n. 2.
Granstrem, *VV* 16 (1959) p. 235 no. 74.
Voicu, D'Alisera, p. 356.

7. COD. 1112. CANONS
NINTH–TENTH CENTURIES. FIGS. 18–20

Vellum. 186 folios, 17.5 x 12.6 cm. One column of twenty-five lines. Very thin, sloping, irregular minuscule (letters of minute size) with *Keulenstil* elements for text; titles in *Auszeichnungs-Majuskel*. Gathering numbers of different periods at upper right and lower left corners of the first recto. Parchment hard and white. Ink light brown; titles in carmine and brown; solid initials in carmine.

The chapters on Canons begin on fol. 5r; fols. 1r–3v contain prefatory matter; 3r–4v, list of Synods; 5r–76v, various Canons; 77r–186v, apostolic Canons, oecumenical and topical synods.[1]

[1] For the synodical Canons, texts, discusssion, and bibliographical references see J. Karmires, Τὰ δογματικὰ καὶ συμβολικὰ μνημεῖα τῆς Ὀρ-

Parchment torn at edges and wrinkled, first and last folios loose; fols. 22–23 are later replacements, original text continues on fol. 24r; codex incomplete, text breaks off on fol. 186v; otherwise condition fair. There are no covers. The codex is kept in a paper envelope.

Illustration

4v Cross page, text written in the form of a chalice or goblet, marked in its center by a horizontal text band indicating the place of the knop. Red-lined lobes roughly suggesting palmettes outline the chalice, the top of which is formed by two stylized red, green, and blue palmettes joined by a line of strokes in similar colors. From the base of the chalice spring palmettes outlined in green and blue with green leaves and fruit. Sassanian red-blossomed, olive green palmettes are at the corners of the horizontal text bar. End of prefatory material (fig. 18).

5r Π-shaped headpiece consisting of an interlace on either side of an arch with half palmettes in green, red, and blue. Titlos 1: On Theology, Orthodox Doctrine, Canons and Ordinations (fig. 19).

12r Ornamental band on either side of the word Titlos with green and blue palmettes outlined in red. Titlos 2.

51v Ornamental band above contents of chapter, flanking the word Titlos, with Sassanian palmettes left and right in green and dark red. Titlos 10, On Administering Affairs of the Church.

55v Ornamental bar with Sassanian palmettes at each end; colors as on fol. 51v. Titlos 11: On Monasteries and Monks.

76r Ornamental bar with rough Sassanian palmettes at ends. Titlos 14: On Avarice.

77v Π-shaped headpiece of simple interlace in dark blue, terracotta red, and green with part of a cross on top and two half palmettes between the vertical bars. Canons of the Holy Apostles.

90v Π-shaped headpiece with simple interlace. Canons of the Synod in Angyra.

94v Π-shaped headpiece with olive green, blue, and red palmettes. Sassanian palmettes at corners. Canons of the Synod in Caesarea (Neo-Caesarea).

95v Π-shaped headpiece in a zigzag pattern, mostly destroyed. Canons of the Synod in Gaggra.

θοδόξου καθολικῆς ἐκκλησίας, 2nd ed., 1, Athens 1960.

104r Π-shaped headpiece with green and red crosses, badly damaged. Canons of the Synod in Laodicea.

108v Π-shaped headpiece with chain and diamond pattern in olive green, dark blue, and carmine. Canons of the Fathers who met in Constantinople (B. Oecumenical Council).

111r Ornamental band with Sassanian palmettes at ends and on either side of the title. Canons of the Fathers who met at Ephesos.

115v Π-shaped headpiece with cross pattern. Canons of the 630 Fathers who met in Chalcedon.

122r Π-shaped headpiece with diamonds and crosslets; Sassanian palmettes at top center and corners. Canons of the Synod in Sardiki.

173v Ornament in the form of a flat arch over the title with whole and half palmettes in dark blue and olive green, outlined in red; those in the center are blossomed. From the Acts of the Synod in Constantinople concerning Agapios and the bishopric of Bostra (fig. 20).

175r Π-shaped headpiece of a plaited pattern in red, blue, olive green, and colorless; palmettes at center and corners. Canons of the Synod in Troullo.

In addition, in several instances not listed here, titles are marked by a palmette and/or rosette; Sassanian palmettes are also found on various margins.

Iconography and Style

The design of the headpieces and the ornamental patterns recall "orientalizing" motifs and such decorative forms as the Sassanian palmettes and their candelabra construction found in manuscripts assigned mainly to the Eastern provinces during the late ninth and early tenth centuries (see the Princeton Gospels, Univ. Lib. cod. Garrett 1).[2] However, the ornament in the Sinai codex is less intricate in design and simpler in its rendering than the Garrett codex. Another point of similarity between these two codices is the presentation of text pages in figurative form, a feature not unusual in ninth- and tenth-century manuscripts. This is an old phenomenon which was revived in the Macedonian period. We know works from the ninth to the eleventh century whose text is presented in a figurative shape, particularly that of a cross:[3] the Princeton Gospels; Athens, Nat. Lib.

cod. 204 (Four Gospels, tenth-century—in this case the scholia are in the form of a cross);[4] the Lectionary London, Brit. Lib. Add. 39603 (eleventh century); New York, Morgan Lectionary M 692 (eleventh–twelfth century); and several other Gospels in which this form is applied to the letter of Eusebius.[5] A distinct characteristic of the Sinai codex is that the cross page text takes the shape of a chalice; this, nevertheless, is not a unique motif. Texts in this form are found in the cod. Paris gr. 438, fol. 180v, from the year 992,[6] in cod. Meteora, Metamorphosis 550, fols. 43r and 233v,[7] and in other codices. This feature in our manuscript may indicate the influence of Gospel books in which the cross page is preserved for the Eusebius letter or for the opening chapter of the Gospel text. It is not coincidental that the Sinai illustrator has used this form for the prefatory material. In the Gospels and the Canons, the cross or the chalice opens the book.

Paleographically the codex is related to ninth- and tenth-century manuscripts of provincial provenance. More particularly, the roughness of the script recalls that found in the cod. Princeton, Univ. Lib. Garrett 14, dating from the year 955 and attributed to the scriptorium of St. Sabas near Jerusalem.[8]

Bibliography

Gardthausen, *Catalogus*, p. 227.
Kamil, p. 118 no. 1540.

8. COD. 283. ACTS AND EPISTLES LENINGRAD, STATE PUBLIC LIBRARY COD. GR. 220: FOUR GOSPELS FIRST HALF OF THE TENTH AND LATE TWELFTH CENTURY. FIGS. 21–31, COLORPLATE I:a

Vellum. 240 folios, 17.2 x 12.2 cm.; *Leningrad*: 214 folios, 17.3 x 11.2 cm. One column of twenty-seven lines. Very round, erect minuscule for text; regular, clear writing with small letters running through the ruling line, *Kirchenlehrerstil*; titles and calendar indications in *Auszeichnungs-*

[2] *Greek Mss. Amer. Coll.*, no. 2; *Byzantium at Princeton*, pp. 141–42, no. 168.

[3] See H. Belting and G. Cavallo, *Die Bibel des Niketas*, Wiesbaden 1979, p. 21.

[4] Marava-Chatzinicolaou, Toufexi-Paschou, no. 7.

[5] Ibid., p. 50; also H. Belting, G. Cavallo, *Die Bibel des Niketas*,

Wiesbaden 1979, p. 21.

[6] Omont, *Mss. datés*, pl. 9.

[7] N. Bees, Τὰ χειρόγραφα τῶν Μετεώρων, 1, Athens 1967, pls. 63, 64.

[8] *Greek Mss. Amer. Coll.*, no. 4; *Byzantium at Princeton*, p. 144, no. 170.

Majuskel.[1] Gathering numbers in red with a line above and below and a stroke at upper right corner of first recto. Parchment extremely fine and white. Ink brown to dark brown; most titles and simple solid initials for opening lines in gold; chapter and calendar indications and small initials in text in carmine.

Leningrad: fols. 1r–2v, Eusebius' letter; 3r–6v, Canon tables; 7r, blank; 7v–8v, Matthew chapters; 9r (inserted page), verses to Matthew; 9v, miniature; 10r–66r, Matthew; 66v, Mark chapters; 67r (inserted page), verses to Mark; 67v, miniature; 68r, Mark chapters; 68v–103r, Mark; 103v–105r, Luke chapters; 105v, blank; 106r (inserted page), verses to Luke; 106v, miniature; 107r, Luke chapters; 107v–167r, Luke; 167v, John chapters; 168r (inserted page), verses to John; 168v, miniature; 169r–214r, John; a short hypothesis at the end of each Gospel.

Sinai: fols. 1r–4v, chapters of Acts and Epistles; 5r–240v, Acts and Epistles (hypothesis for each of the Epistles; fol. 95v, Prologue to the Bible by Paul, *PG* 85, 693f.; fol. 103v, Paul's martyrdom); 72r (inserted page), blank; 72v, miniature; 107r (inserted page), blank; 107v, miniature.

In its original state, therefore, the codex contained the Eusebian Canons, the Four Gospels, and the Acts and Epistles; that is, it comprised a New Testament. A reconstruction of these original contents is presented below.

The inserted pages with full-page miniatures are later additions. The manuscript's initial decoration was limited to the Canon tables and ornamentation of titles. The miniatures have suffered minor flaking, and the colors are distorted by a later application of varnish. Modern, light brown leather binding. Parchment from a twelfth-century Sticherarion is glued on the inner sides of front and back covers.

Illustration

Vol. 1, Leningrad

1r–2v Eusebius' letter, written throughout in the form of a cross, framed by a simple, narrow gold band with small palmettes at the corners and discs between.

3r–6v Canon tables (ca. 12.6 x 7.6 cm. each).

3r Two pointed arches almost in the form of a circle with a heart-shaped ornament at their upper junctures are supported by three columns, their bases and capitals marked by chevron ornament. Canon I (fig. 21).

All remaining Canon tables have the same structural form, but the supporting columns have different patterns of ornamentation, as follows:

3v, 4r Gold and brownish purple stripes. Canon II.

4v Heraldically set, parallel convex lines. Canon III.

5r Circles with a dot in the center, placed one upon the other. Canon IV.

5v Gold discs with blue and green cushions between. Canon V.

6r As on fol. 5v. Canons VI–IX.

6v Blue and green wavy band with gold filling. Canon X.

9v Matthew, *ο αγιος ματθαίος* (13 x 8.5 cm.) (fig. 26). Seated and facing to the right, he rests his left hand on a table and supports a codex on his lap with his right hand. His huge nimbus is only outlined. The border is ornamented with crosslets. Similar borders appear on the other miniatures. The composition, on an inserted page, faces the beginning of Matthew's Gospel.

10r Π-shaped headpiece with eight-petalled rosettes alternating with almond rosettes, their blue and white petals set in rectangles (fig. 22). Simple initial B with a leafy bow. Mt. 1:1ff.

67v Mark, *ὁ ἅ(γιος) μαρκος* (13.4 x 8.9 cm.) (fig. 27). Represented frontally, Mark sits on a cushioned throne holding with his left hand a jewel-studded codex that rests on his thigh, and blessing with his right. He rests his feet on a footstool. Miniature is on an inserted sheet.

68r Π-shaped headpiece with interlace forming the border (fig. 23). Simple initial A with an ivy leaf suspended from the left bar. Mk. 1:1ff.

106v The pensive Luke, *ὁ ἅγιος λουκας* (13 x 8.3 cm.), facing to the right in three-quarter view, is seated on a high-backed chair before a lectern on which lies an open book (fig. 28). He holds a pen in his right hand, resting the other on his knees. Inserted page.

107r Π-shaped headpiece with grille pattern in gold, green, and blue. Lk. 1:1ff.

168v John and Prochoros, *ὁ ἅγιος ἰωαν(νης) ὁ θεολόγος, ὁ ἅγιος πρό(χ)ορ(ος)* (13 x 9.3 cm) (fig. 29). John, standing at the right, turns to the left and dictates to the seated Prochoros, behind whom is a desk with writing implements. At the upper right corner appears the hand of God from a segment of sky. The following caption is set between the two figures: *γράψον τέκνον πρόχορε· εν ἀρχη ἦν ὁ λόγος*. Inserted page.

169r Π-shaped headpiece with scale pattern in light green, blue, and gold. Jn. 1:1ff.

[1] Hunger, "Auszeichnungsschriften," p. 204 n. 17.

Vol. 2, Sinai

1r Frameless band-shaped headpiece adorned with a simple interlace pattern in gold. Chapters of Acts and Epistles.

5r Π-shaped headpiece of strong, geometric interlace in blue, light green, white (or colorless), the bands outlined in red, with dots in the empty spaces, in a heavy, tarnished gold frame. Initial T with a ring on the vertical bar. Acts 1:1ff. (fig. 24).

64v Frameless band-shaped headpiece of simple interlace in gold, initial T. Chapters of James' Epistle.

65v Π-shaped headpiece of plain gold without ornament. James 1:1ff.

72v Peter, (12.7 x 8.6 cm.) (fig. 30). Frontally seated on a brown bench with a reddish brown cushion, resting his feet on a grey-brown footstool, Peter presses a white bound codex against his body with his left hand and blesses with his right. He turns his head to the right toward the hand of God, outlined in carmine and partly flaked, that issues from a blue segment of sky. Peter wears a dull green tunic and brown himation. His face, rendered in dark brown with dark olive green shadows, is framed by soft green hair and beard and a nimbus outlined in carmine; heavy varnish has been applied overall. His name, ὁ ἅγιος πέτρος, is inscribed in red against the gold background. The border has a crenellated pattern. Inserted page.

73r Frameless, band-shaped headpiece adorned with interlace similar to that on fol. 64v, I. Peter 1:1f.

85r Π-shaped, frameless headpiece adorned with gold interlace similar to that on fol. 73r. I. John 1:1f.

106v Π-shaped headpiece adorned with gold interlace as on fol. 64v. Romans 1:1ff.

107v Paul (13 x 8.4 cm.) (fig. 31, colorplate I:a). The apostle, in a grey-green chiton and yellow-brown mantle, seated frontally on a purple cushioned, brown and carmine throne and resting his feet on a grey-blue footstool, addresses two persons, one at either side. The figure at the left, dressed in carmine, is almost completely flaked, and the one at the right wears a carmine tunic and dark blue mantle, all heavily varnished. The left-hand figure is shown as if cut off by the frame of the miniature, which is adorned with the same crenellated pattern as fol. 72v, in red and black. Paul's expressive face is rendered in dark

brown with olive shadows and reddish highlights, his hair and beard in dark brown. The huge nimbus is only outlined in carmine, as is his name, which is inscribed vertically on the gold background: ὁ ἅγιος παῦλος. The miniature is painted on a single sheet that is pasted in, opposite the Epistle to the Romans.

121v Π-shaped frameless headpiece of gold interlace as on fol. 73r. I. Corinthians 1:1f.

150v Band-shaped headpiece in plain gold. II. Corinthians 1:1ff.

169r Π-shaped headpiece filled with carmine, green, blue, and colorless stripes in a diamond pattern and framed by a broad gold border. Galatians 1:1ff. (fig. 25).

173r Π-shaped headpiece of gold interlace as on fol. 73r. Ephesians 1:1ff.

181v Band-shaped headpiece of gold interlace as on fol. 73r. Philippians 1:1ff.

187v Band-shaped headpiece with gold rosettes. Colossians 1:1ff.

193v Band-shaped headpiece of solid gold. I. Thessalonians 1:1ff.

199v Band-shaped headpiece of gold interlace as in several previous instances. II. Thessalonians 1:1ff.

203v Band-shaped headpiece of solid gold. I. Timothy 1:1ff.

210v Band-shaped headpiece of gold interlace as on fol. 199v. II. Timothy 1:1ff.

216r Band-shaped headpiece of solid gold. Titus 1:1ff.

219r Band-shaped headpiece of gold interlace as on fol. 210v. Philemon 1:1ff.

223r Band-shaped headpiece of gold interlace as on fol. 79v. Hebrews 1:1ff.

Iconography and Style

a. The Initial Illustration

The original decoration of the codex consisted only of the Canon tables and the headpieces; the full-page miniatures, pasted on single sheets, are later insertions. The repertory of the ornament, comprising a bold geometric interlace, rosettes alternating with almond rosettes,[2] and a simple chevron pattern, as well as the simple initials find their closest parallels in the ornament of a group of manuscripts placed at the end of the ninth and the beginning of the tenth century and originating, possibly, in Asia Minor.[3] However, it must be pointed out that the execution

[2] Weitzmann, *Buchmalerei*, p. 42 and figs., pl. XLVII,285.

[3] See also cods. Meteora, Metamorphosis 591, *anno* 861/62; Patmos 126; Paris gr. 2389, ibid., pp. 39ff. Cf. the interlace in cod. Oxford, Laud.

gr. 92B, fol. 66v, assigned to the end of the tenth century and localized in western Asia Minor; Hutter, *Oxford*, 1, no. 15, fig. 81.

of the ornament is extremely fine and a great deal of gold has been used to frame the ornamental bands. The blue has a lustre found in Constantinopolitan manuscripts of the early tenth century in the so-called *Blau-gold Ornament-Gruppe*, such as the Book of Acts in Florence, cod. Laur. Plut. IV.29.[4] Our manuscript may have been produced in the Constantinopolitan area or in a province under the influence of the capital. A Constantinopolitan origin is supported by the use and quality of gold for the title pieces. Bands of gold interlace alternate systematically with bands of solid gold throughout the manuscript.

In the rather simple Canon tables (fig. 21), the columns supporting the arches have lost their architectural solidity through the use of various ornament, a feature recalling a similar treatment in a Psalter in Oxford, cod. Auct. D.4.1 from the year 951.[5]

The proposed tenth-century date, based on the ornament, is supported by the paleography as well. The script is peculiar in that the projecting upper and lower parts of the letters are much reduced in size in the typical manner of the script style, termed by Hunger the *Kirchenlehrerstil*, found in tenth- and eleventh-century manuscripts.[6]

b. The Inserted Author Portraits

The evangelist portraits present familiar iconographic types (figs. 26–29). Matthew is a variant of the evangelist type who dips his pen into an inkwell or is about to take a knife or a stylus from the table. It appears in the Gospels cod. Stavronikita 43 (portrait of Luke), in examples from the eleventh and twelfth centuries, and from the Palaeologan period.[7] The type of Mark holding the Gospel and blessing ultimately goes back to the type of Mark in the Philotheou codex 33 of the tenth century.[8]

The pensive type who holds the pen in his left hand and rests his right hand on his knee is also familiar. Ultimately reflecting a classical prototype and found in manuscripts of the Macedonian Renaissance such as Paris, Coislin 195, it continues to appear in the eleventh and later centuries.[9]

Luke's portrait (fig. 28) comes closest to that of John in the cod. Athos, Dionysiou 20, a Lectionary from the beginning of the twelfth century, where the pen is likewise held in the left hand.[10]

John dictating to Prochoros first appeared at the end of the tenth or the beginning of the eleventh century, and the table with the implements of writing and the footstool were introduced following the model of a writing evangelist. The first known example of this type may well be a miniature in the tenth-century New Testament in Baltimore, Walters W. 524, fol. 231r.[11] Our miniature (fig. 29) is comparable to that in a fifteenth-century New Testament at Sinai (cod. 266),[12] except for the background, which in the later manuscript includes the landscape of the island of Patmos.

The Praxapostolos is typically illustrated by the portraits of the authors at the beginning of Acts and Epistles, either standing, seated, or in bust form. In each case the portrait follows the iconography of the evangelists, as shown, for example, by the figure of James in cod. Oxford, Canon gr. 110.[13] The apostle can also be shown teaching, with his audience opposite him, as in the New Testament codex in Baltimore, Walters W. 524.[14] In other instances, however, the audience flanks the apostle, as in cod. Oxford, Auct. T. inf. 1.10.[15] Both miniatures of the Sinai Praxapostolos (figs. 30, 31, colorplate I:a) must be viewed within the tradition of the teaching scene.[16]

The imposing evangelist and apostle figures have stylistic parallels in late Comnenian mosaics and wall paintings of the "dynamic style" in Sicily, Cyprus, Patmos, and a group of related manuscripts such as Athens, Nat. Lib. 163.[17] The faces have vigorous, strong characteristics, deeply set, expressive eyes, vivid expressions. The highlights on the faces are not strong but patternized, recalling the frescoes of St. Demetrius in Vladimir, ca. 1195.[18] They indicate wrinkles and impart a relief quality to the faces, while they strengthen the intensity of expression and convey an inner tension. There is a plasticity in the heads, the physiognomy has vitality, the power of expression is intensified by

[4] Weitzmann, *Buchmalerei*, p. 7.

[5] Hutter, *Oxford*, 1, no. 18, fig. 105.

[6] Hunger, "Auszeichnungsschriften," p. 204.

[7] Friend, "Evangelists," pl. VIII,97.

[8] See *Treasures*, 3, fig. 305; other examples: Oxford, Canon gr. 110, portrait of John, mid-tenth century; Athos, Dionysiou 23, thirteenth century: Hutter, *Oxford*, 1, no. 3, fig. 18; *Treasures*, 1, fig. 57.

[9] Friend, "Evangelists," pls. IX,99, X,106; *Treasures*, 1, figs. 85, 299; see also Athens, Nat. Lib. cod. 57, Marava-Chatzinicolaou, Toufexi-Paschou, no. 26, fig. 219.

[10] *Treasures*, 1, fig. 52.

[11] Weitzmann, "Illustrated New Testament," p. 23, fig. 14.

[12] Gardthausen, *Catalogus*, p. 54.

[13] Hutter, *Oxford*, 1, no. 3, fig. 15.

[14] Weitzmann, "Illustrated New Testament," fig. 16.

[15] Ibid., fig. 17; Hutter, *Oxford*, 1, no. 39, fig. 242.

[16] In the case of Peter, there most likely were listeners in the model, but they were not copied. For some examples of teaching scenes in Acts and Epistles, see cods. Athens, Nat. Lib. 2251, twelfth century; Baltimore, Walters W. 533; Moscow, Univ. Lib. 2280, dating from 1072 (here the scene appears in the historiated initials); Weitzmann, "Illustrated New Testament," pp. 24ff.

[17] Marava-Chatzinicolaou, Toufexi-Paschou, no. 46, pp. 189ff.; see also Athos, Panteleimon 25 and Lavra A 44 in *Treasures*, 2, figs. 323–25; and *Greek Mss. Amer. Coll.*, no. 36, fig. 63.

[18] Lazarev, *Storia*, figs. 310, 311.

oblique glance and raised eyebrows. This particular feature recalls some icons at Sinai.[19] The form of the figures and the drapery, however, are distinguished by a monumentality not found in those icons. A roundness of the abdomens is emphasized by a circular form recalling late twelfth-century works like the enthroned Peter in the mosaics of Monreale.[20] The draperies are overloaded with folds, and like those in Monreale are distinguished by a panel hanging from the shoulders and one falling between the legs. These characteristics suggest a similar date for the miniatures, the last years of the twelfth century, and their inclusion in the so-called "dynamic style." The refinement in execution and color scheme would relate these miniatures to Constantinopolitan art.

Bibliography

Gardthausen, *Catalogus*, p. 57.
Gregory, *Textkritik*, pp. 291, 1186 no. 1880.
Hatch, *Sinai*, pl. II.
Kamil, p. 72 no. 307.
Spatharakis, *Portrait*, p. 55, fig. 23.
Hunger, "Auszeichnungsschriften," p. 204 n. 17.
Voicu, D'Alisera, p. 559.
Dufrenne, "Ateliers," p. 453.

Leningrad codex:
Gregory, *Textkritik*, p. 1105 no. 339.
Lazarev 1947, p. 316 n. 36.
Granstrem, *VV* 18 (1961) p. 266 no. 147.

9. COD. 417. JOHN CLIMACUS, THE HEAVENLY LADDER
MID-TENTH CENTURY. FIGS. 32–44, COLORPLATE I:b

Vellum. 254 folios, 25.5 x 18.8 cm. One column of twenty-one lines. Very stylized, minuscule script, *Kirchenlehrerstil*, for text; fols. 13v and 254v partly in "kuficized" script also used for a few titles; most titles in Alexandrian *Auszeichnungs-Majuskel*, some in *Epigraphische-Majuskel*. Gathering numbers at upper left corner of last verso are later. Parchment hard and rough. Ink dark brown for text but not throughout; brown and carmine red, and occasionally green for marginalia (cf. fol. 3r); titles outlined in carmine or red-brown and filled with deep green, or simply written in carmine. Initials all outlined in carmine and filled with green and/or blue. Originally these colors were gilt,

and this is true for several ornamental bands (cf. fols. 6r, 87v–91r and others).

The first two quaternia are in disorder. The original arrangement should have been as follows:

1. The arch decoration now on fol. 14r, as a frontispiece to the whole work, should have been fol. 1r.

2. The Life of John Climacus ascribed to the monk Daniel of Raithou (*PG* 88, 596–608); now begins on fols. 14v–16v and ends on fols. 2r–4r.

3. The letter of John of Raithou to John Climacus asking him to write the *Scala paradisi* (*PG* 88, 624–25), now on fols. 1r–1v and ending on fol. 11r.

4. The letter of John Climacus answering John of Raithou, fols. 4r–5v (*PG* 88, 625–28), now preceding instead of following Raithou's letter.

5. The Prologue (*PG* 88, 628) also begins on fol. 11v, on the recto of which is the letter of Raithou; this proves the reversed order of the letters.

6. The table of contents, fols. 12r–13r.

7. The page with the Ladder, fol. 13v.

8. The first homily, which now begins on fols. 6r–10v and continues on fols. 17r–18v.

From this point on the codex is intact, hence: fols. [14r–18v] 19–233v, homilies [1] 2–30 (*PG* 88, 632–1161); 234r and v, table of contents in reversed order; 235r–254v, the Homily to the Pastor (*PG* 88, 1165–1208).

A few title pieces and initials have suffered flaking, otherwise condition good. There is no binding; the codex is kept between two crude boards.

Illustration

Most of the ornamentation of the manuscript consists of ornamental bands in an unusually great variety of patterns such as diamonds, rosettes, beads, rinceaux, palmettes, interlace, and crosses, in very imaginative combinations. The bands are applied at chapter title and, in several instances, at chapter end, in the form of a tailpiece; or there can be several bands on one page if special distinction of a particular text is sought (cf. fol. 4r). In addition, there are various types of vignettes in the margins as reference to the beginning of a chapter (cf. fol. 27r). Numerous stylized initials throughout the codex derive either from floral motifs—leaves, knots, rosettes—or represent simple but heavy geometric forms; this latter mode is followed consistently from fol. 55r on. All initials, however, convey the impression of pieces of jewelry enhanced by the addition of beads or the jewel-like fruit that crowns a stem or hangs from a bar. In

[19] See, for example, a tetraptych with the dodecaorton (cf. especially Paul in the Pentecost and Dormition scenes) assigned to the second half of

the twelfth century: Sotiriou, *Icônes*, 1, pls. 76–79; 2, pp. 90f.

[20] Demus, *Norman Sicily*, fig. 84.

only few instances have fish, and in one instance a blessing hand, been applied to an initial.

1r Rectangular title frame, badly rubbed, but its intense green rinceau pattern still distinguishable. Initials T and H in blue and green. Letter of John of Raithou.

4r Three geometric bands with rosettes and leaves and two kinds of interlace (the third enclosing stylized rosettes) separating the text, in green-blue, carmine, and blackened gold; small rectangular title frames on either side of a rosette—the Spiritual Tablets—initial A. Conclusion of John's Life, verses by Daniel and beginning of John's answering letter (fig. 35).

6r Frameless band of heavy, deep green rinceau, half palmettes with gold and blue buds, and flowers springing from cornucopias. Initial T. On the opposite margin, homocentric discs within a square. Homily 1, On Renunciation of Life.

6v Initial Є with two fish outlined in red, tinted in green and gilt.

7r Initial Є with two fish, variant of fol. 6v, and several others.

7v Several initials and a vignette on lower margin in a diagrammatic form explaining repentance.

11r Tailpiece, a central interlace in large green half palmettes with gold outlined in carmine. Letter of John of Raithou, conclusion (fig. 36).

11v Band with stylized rosettes on either side of an interlaced cross, and several others. Contents.

12v Band with trapezoids and leafy almond forms; initial Є. Conclusion of contents, beginning of preface.

13r Medallion portrait of the author, ʿO ″OCIOC ʾIѠANNHC (11.9 x 12.1 cm.) (fig. 32). Portrait is surrounded by a heavy rinceau consisting of deep carmine cornucopias adorned with blue pearl rings from which spring deep green half palmettes outlined in carmine; four corner medallions with star pattern marked by pearl rings in similar colors. The saint is clad in a purple cloak and black *megaloschema* with red and white ornament. His face is painted in red-brown with grey shadows, his hair and beard in grey; his nimbus and inscription are deep green with traces of gold against a colorless background. The rinceau frame and the discs are designed in red and filled with green and blue on colorless ground.

13v A schematic vertical ladder in green and carmine with rungs numbered from top to bottom, and a diagonal flight of steps in green and blue. The main writing is in thick green letters outlined in carmine (fig. 33).

14r An arch in green, dark blue, red, and carmine, containing in its lower part a vertical ladder; on the top step, a much later drawing of Christ standing with a book and a crown, I̅C̅ X̅C̅ (fig. 34). The columns of the arch are filled with different types of interlace; huge leaves are placed at the two ends of the arch, resting on the capitals. The tympanum encloses three smaller arches, the central one containing a palmette.

14v Band-shaped headpiece ornamented with rosettes, against carmine and gold. Beginning of the Life of John Climacus.

19v Two bands, one with rosettes and diamonds and the other with a blue rinceau of half palmettes, mark the title. Homily 2, On Dispassionateness (fig. 37).

21v Initial Є with two fish, and several others.

22v Two bands, one with heart shapes in a chain pattern, the other with a rinceau. End of Homily 2.

23r Band-shaped headpiece with half diamonds enclosing gold leaves against blue, and several initials. Homily 3, On Pilgrimage.

27r Band with a rich interlace and different types of palmettes at the two ends (fig. 38). Rich initial O and on the opposite side a small vase-like frame with floral motifs enclosing the number of the homily; next to it part of a square with homocentric discs as on fol. 6r. Homily 4, On Dreams.

28v Band with rosettes and almond forms. Homily 5,1, On Obedience.

61v A variant of fol. 28v.

62r Band with an interlace and a chevron pattern. Homily 5,2, On Repentance.

74v Two bands with interlace and diamonds. Homily 6, On Remembrance of Death.

78v Band-shaped headpiece of blue, red, and gold crenellation and another smaller band above with rosettes. Homily 7, On Sorrow.

89v Gold rosettes in blue circles, the central one in the form of a Maltese cross flanked by almond forms. Homily 8, On Placidity and Meekness (fig. 39).

95r Band of geometric pattern. Homily 9, On Malice.

97v Band with a central rosette flanked by plaited bands. Another smaller band above with an interlace. Homily 10, On Slander, and conclusion of Homily 9.

100r Band with an interlace and another smaller one above with rosettes and almond. Homily 11, On Talkativeness and Silence, and conclusion of Homily 10.

101v Band with red half diamonds enclosing green-blue leaves. Homily 12, On Falsehood.

103r Band with leaves and palmettes. Homily 13, On Sloth.

29

105r Band with simple interlace. Homily 14, On Gluttony.

111r Band with crenellation. Homily 15 (preface), On Chastity and Temperance.

111v Band with a plaited pattern and several initials. Homily 15.

127v Band with a heavy rinceau and initial Π. Homily 16, On Avarice.

128v Band with crenellation. Homily 17, On Poverty.

130v Band with a plaited pattern. Homily 18, On Insensibility.

133r Band with a heavy rinceau. Homily 19, On Sleep, Prayer, and Psalm-singing.

134v Band with a cross pattern. Homily 20, On Wakefulness.

136v Band with rosettes and diamonds. Homily 21, On Timidity.

138r Band with interlaced rectangles. Homily 22, On Vainglory.

144r Band with half diamonds. Homily 23,1, On Pride.

148r Band with an almond, jewel-like form joined at the sides by rectangles with interlace pattern. Homily 23,2, On Blasphemy (fig. 40).

151v Band with a rinceau of half palmettes and buds. Homily 24, On Meekness, Simplicity, Guilelessness, and Wickedness.

155r Band with rosettes flanking a central interlace. Homily 25, On Humility.

166v Band with crenellation and rinceau patterns. Homily 26, On Discretion.

179r Diagram explaining passion, in right margin.

184v Band with rinceau.

198v Band with a rosette flanked by stylized palmettes. Recapitulation of Homily 26.

204r Band with geometric patterns and two large palmettes. Homily 27, On Solitude.

208r Band with rosettes and almonds between them. Initial Є with a blessing hand in green and red.

209r Two diagonal ladders framing the title with a green and blue rinceau below and a simple ornament above (fig. 41).

217v Band with crenellation. Homily 28, On Prayer.

226v Band with plaited pattern. Homily 29, On Tranquillity.

229r Tailpiece with two rosettes flanking the text and a plaited band below.

229v Band with medallions interlaced with star and cross motifs in green, blue, carmine and gold. Homily 30, On Faith, Hope, and Charity (fig. 42).

234v Band with palmettes. Table of contents in reverse order.

235r Band with a narrow rinceau at center developing into a square enclosing a rosette at either end (only the one on the left is fully preserved). A rosette is attached to the outer right side of the band, and two squares with plaited ornament flank part of the title. At the top of the page, another band with a heavy rinceau. Homily to the Pastor (fig. 43).

244v Latin cross with rays and teardrops in right margin.

254v Tailpiece with a heavy green rinceau. End of text (fig. 44).

Iconography and Style

The two miniatures illustrating the Heavenly Ladder (figs. 33, 34), a motif at the beginning and/or the end of the text in many Climacus manuscripts, represent the earliest tradition of the illustration of this text in a simple, schematic manner: an ornamental ladder, its rungs numbered from top to bottom suggesting the sequence of chapters in descending progression.

The bust portrait of medallion type, depicting the author as an aged, bearded man with hands held before his chest in prayer (fig. 32, colorplate I:b), has been related to the medallion pictures contained in the Paris manuscript of the Sacra Parallela of John of Damascus (Paris gr. 923),[1] written in the ninth century, most likely in Palestine. The Sinai portrait follows the same tradition of standardized author portraits.

Unusual in this manuscript, however, are the script and the ornament. Most of the script belongs to the *Kirchenlehrerstil*, as defined by Hunger, which is found in several dated tenth-century manuscripts.[2] Another style of script, found at the end of the Letter to the Pastor and the Life, attempts to imitate Coptic script, as comparison with the Coptic Synaxarion in the Morgan Library, Ms. 588 from the year 842, shows.[3] Still another script variant on the last folio and in the title miniature with the Ladder (fig. 33) imitates kufic script, with its characteristic technique of outlining letters and filling them with color or gold. The Sinai illustrator must have received his inspiration from a manuscript of the Koran.

The Islamic influences apparent in the paleography appear in the ornament as well. The frame of the author

[1] Weitzmann, *Sacra Parallela*, p. 246, pl. CLII,713.

[2] See examples in Hunger, "Auszeichnungsschriften," p. 204 n. 17.

[3] Weitzmann, "Islamische Einflüsse," p. 308, fig. 12.

portrait with the cornucopias sprouting green leaves consisting of almond forms adorned with rings of pearls also found in the inner, braided band, and the color scheme recall the mosaics of Damascus and of the Dome of the Rock in Jerusalem.[4] They therefore bring the codex into close relation to Palestinian art. This relation is further confirmed by the use of the rosettes in the margin on the left-hand side of an ornamental band, which is unusual in Byzantine manuscripts but common in Koran manuscripts, where the beginning of a *sura* is indicated by such an artistic device. Other elements, however, relate the codex to the art of Constantinople. Despite Grabar's hypothetical assignment of the manuscript on the basis of its ornament to a Greek workshop in southern Italy, the initials, very often several on one page (cf. fols. 4r–5v, fig. 35), find their best parallels in Constantinopolitan manuscripts of the mid-tenth century. The manuscript's close relation to cod. Paris gr. 139 has already been pointed out,[5] while the form of the arch on fol. 14r (fig. 34) occurs in Constantinopolitan Gospels such as the Lectionary Paris gr. 70, from the year 964.[6] Yet the ornament applied to this arch lacks the refinement of the Constantinopolitan parallels. Furthermore, the strong colors used throughout reveal once more Islamic influences and suggest a place where the convergence of the various cultural traditions was achievable—possibly Sinai itself.

Bibliography

Kondakov 1882, p. 153 no. 88.
Gardthausen, *Catalogus*, p. 100.
Beneševič, *Mon. Sinaitica*, 2, pl. 42.
Lazarev 1947, p. 304 n. 37.
Martin, *Heavenly Ladder*, pp. 10, 19, 22, 42, 79, 121, 186ff., figs. 1–4.
Weitzmann, "Islamische Einflüsse," pp. 297–316, figs. 1, 3, 4, 7, 9, 11, 13.
Lazarev, *Storia*, p. 176 n. 69.
Kamil, p. 87 no. 641.
Grabar, *Manuscrits grecs*, pp. 10, 44, 75–76 no. 49.
Weitzmann, *Sinai Mss.*, p. 11, figs. 6, 7.
Idem, *Sacra Parallela*, p. 245.
Dufrenne, "Ateliers," p. 453.
Voicu, D'Alisera, pp. 560–61.
Hutter, *Oxford*, 3, pp. 8–9.
D. Barbu, *Manuscrise bizantine în colectii di România*, Bucharest 1984, p. 24.
Galavaris, "Sinaitic Mss.," pp. 121–22, figs. 2–4.

10. COD. 166. FOUR GOSPELS
TENTH, END OF TWELFTH, AND
THIRTEENTH CENTURIES. FIGS. 45–54,
COLORPLATE I:c

Vellum. 200 folios, 19.8 x 15 cm. One column of twenty-three lines. Very carefully written minuscule script with elements of *Perlschrift*[1] for text; titles in *Epigraphische-Auszeichnungs-Majuskel*, calendar indications in *Auszeichnungs-Majuskel*. Gathering numbers with the usual strokes above and below at the lower left corner of the recto, beginning on fol. 7r. Parchment fine. Finer but yellowed parchment for the Canon tables. Ink brown for text; titles in the Gospels, tables of chapters (fols. 6r, 60r and v), and calendar indications in carmine and brown; initials outlined or solid, in carmine.

All introductory material is not part of the original manuscript. Fols. 1 and 2, parchment flyleaves from another Gospel book; 3r–5r, Canons III–X (Canons I and II are missing) taken from another, larger Gospel book; 5v, blank; 6r, cut-in leaf with Matthew chapters continuing on fol. 6v, over the text of which a miniature of Matthew has been painted; 7r (gathering *a'*)–59v, Matthew; 60r and v, Mark chapters by the same hand as fol. 6r; 96r (inserted page), blank; 96v, miniature with portrait of Luke by the same hand as that of Matthew; 97r–155r, Luke; 155v, John chapters (initials have been cut out); 156r, beginning of John (text breaks off on fol. 197v); 198r, blank; 199 and 200 are flyleaves from the same manuscript as fol. 1, cut to size.

Some gatherings are loose. The inserted miniatures have suffered considerable flaking. Old leather binding in red-brown color. Front and back covers (figs. 53, 54) have scroll, guilloche, and heart-shaped patterns on the border, medallions with double-headed eagles, pelicans, simple and star-like rosettes, lilies, and small rectangles with upright lions set in a diamond pattern; on the back cover holes for two clasps. Byzantine, probably fourteenth-century.

Illustration
3r, 3v, 4r, 4v, 5r Canon tables (ca. 17.8 x 13.4 cm. each) (figs. 45–49). In each of these the concordance, with titles written in gold, is contained within a structure consisting of two small arches spanned by a larger arch (except for fol. 3v where we have a large arch only) supported by two columns joined at top and bottom by two blue fillets. The variegated shafts of the

[4] Ibid., p. 305, figs. 5, 6.

[5] Ibid., p. 307; idem; *Buchmalerei*, pl. X,47.

[6] Weitzmann, "Islamische Einflüsse," pp. 310f.; idem, *Buchmalerei*, p. 14, pl. XVII,87–88.

[1] Cf. H. Hunger, "Die Perlschrift: eine Stilrichtung der griechischen Buchschrift des 11. Jahrhunderts," in *Studien zur griechischen Palaeographie*, Vienna 1954, pp. 22–32, repr. in idem, *Byzantinische Grundlagenforschung, Gesammelte Aufsätze*, London 1973, no. I.

columns and the lyre-shaped (fols. 3v, 4r) or acanthus capitals (4v, 5r) are gold, while the imposts and bases are blue. The arches formed by golden bands are lavishly decorated with triangles containing trefoils or heart-shaped leaves against white; a scroll motif of tendrils (fols. 3r and v and 4r); gold circles with dots against white; and blue, heart-shaped leaves between (fol. 4v); double diamonds joined with rosettes in gold against blue (fol. 3r); or gold palmettes in scroll arrangements against blue (fol. 3v, 4r). Atop the arches, a delicate scroll of blue and green heart-shaped leaves centered around an "open" palmette (fol. 3v), rich foliage around a fountain (fols. 3v, 4r), or even purple lilies on either side of a gold fretsaw palmette (fols. 4v, 5r) and in the spandrels pairs of blue birds with gold feathers. The tympana are filled with delicate scrolls of heart-shaped leaves in blue and flowers with gold tendrils; or a net-like ornament in gold with heart-shaped leaves in blue; or a simple scroll. Over the two small arches are discs with a spoked wheel, sunflowers, or scrollwork ornament.

6v Matthew (11.7 x 9.2 cm.), ὁ αγι(ος) μαθαιο(ς) (fig. 50). Facing to the right, he is seated in front of a lectern and writes in a codex held on his lap. His nimbus is outlined in red against the gold background. In the background at the left there is a long, terraced building topped by an aedicula. A thin red fillet, almost rubbed off, frames the miniature, which is placed opposite the first chapter of Matthew's Gospel.

7r, 61r Π-shaped headpieces decorated in carmine with flower petals, trefoils enclosed in medallions, in symmetrical patterns. Initial A decorated with a bird and a foliated stem. Mt. 1:1ff.; Mk. 1:1ff.

96v Luke (12.3 x 9.3 cm.), ο αγι(ος) λ(ου)κας, in red (fig. 51). With frontal upper body and three-quarter view lower body, he sits holding a codex on his lap. A lectern is at his left and a tall building with a saddled roof in the gold background to his right. His nimbus is outlined in red. The miniature is framed by a thin line.

97r, 156r Headpieces in the form of trefoiled arches, trefoils and palmettes in carmine. Initials Є with foliated knots. Lk. 1:1ff.; Jn. 1:1ff. (fig. 52).

Iconography and Style

The codex reached its present state in several phases over a period of time. The script of the Gospel text relates to manuscripts from the tenth century.[2] The style of the title pieces and the initials is rough, the flower petals and palmettes are flat, stylized, and patternized, and recall twelfth- to early thirteenth-century manuscripts such as the cod. Paris. gr. 550 and others.[3]

The obvious conclusion is that the ornamental headpieces, the initials, and the titles were added about 1200 to a tenth-century manuscript which had remained unfinished. The twelfth-century date must also apply to the table of chapters, written in the same carmine as the initials, on pages which were left blank originally (fols. 60r and v). And since the chapters of Matthew on fol. 6r are written on the bifolio containing the tables of Canon I, we may assume that the Canon tables, taken from another manuscript, were added at this time.

In their architectural form, ornament, the subtlety of the color scheme, and the refined execution, the five Canon tables reflect some of the best Constantinopolitan manuscripts from the middle and second half of the tenth century. More specifically, they are closely related to the Canon tables in cod. Paris gr. 70, dating from the year 964 and belonging to a group of manuscripts centered around the cod. Paris gr. 139.[4] The similarity extends to the architectural form, the type of ornament (note, for instance, the fretsaw-like ornament in both codices, the discs marking the tympana of the arches, and the lyre-shaped acanthus capitals), the variety and poses of the birds, and the paleography of the titles written within the arches. There can be no doubt that the Sinai Canon tables originated in a Constantinopolitan manuscript of the same group and period.

The two inserted evangelist portraits represent the types of the "writing evangelist" and the "philosopher." Luke (figs. 50, 51) best reflects a tenth-century prototype, modified, however, by the addition of the implements on the table.[5]

These miniatures have suffered considerable flaking. Nevertheless, in the rendering of the faces one can see a painterly quality; the brush strokes are soft, and the volume is stressed without any dramatic contrasts. The drapery follows the articulation of the body but the pleats are

[2] Cf. cods. Jerusalem, Stavrou 55; Athos, Lavra A 19: Lake, *Dated Mss.*, 1, no. 2, pl. 3; 2, no. 92, pl. 162.

[3] Galavaris, *Liturgical Homilies*, pls. LXXXVII,402, XC,411. Other features pointing to the end of the twelfth and the early thirteenth century are the alternation of petals and crosslets, the rendering of the trefoil, and the form of the leaves, cf. Athos, Pantocrator 10, Vatopedi 918, and Ox-

ford, Roe 6: *Treasures*, 3, fig. 173; Galavaris, *Prologues*, fig. 92; idem, *Liturgical Homilies*, pl. XCVIII,436; Hutter, *Oxford*, 1, no. 53, fig. 309.

[4] Weitzmann, *Buchmalerei*, pp. 14ff., pl. XVII,87–88.

[5] Cf. John the Evangelist in cod. Oxford, Canon gr. 110, fol. 142v, ibid., pl. XIV,74; Hutter, *Oxford*, 1, no. 3, fig. 18.

patternized. Painterly style and drapery recall some figures in cod. Oxford, Barocci 31, assigned to Constantinople at the end of the thirteenth century.[6] In the portrait of Luke a notable feature is the height of the lectern and its relation to the background building. This creates a feeling of tension, the like of which, conveyed by similar means, is seen in many thirteenth-century manuscripts.[7] A thirteenth-century date for these miniatures seems plausible.

The body of the manuscript and its ornament of the late twelfth to thirteenth century point to a provincial monastery where Constantinopolitan manuscripts must have been available for the extraction of the tenth-century Canon tables, assuming, as we do, that their addition was made at the time of the completion of the headpieces. The possibility remains, however, that a provincial manuscript reached Constantinople and received the miniatures there.

The production of this codex is of special interest. Left unfinished for a long time, it was completed in different stages.[8]

Bibliography

Gardthausen, *Catalogus*, p. 32.
Gregory, *Textkritik*, pp. 246, 1134 no. 1203.
Hatch, *Sinai*, pl. V.
Lazarev 1947, p. 320 n. 53.
Kamil, p. 68 no. 191.
Voicu, D'Alisera, p. 554.

11. NO. 956, ROLL. EUCHOLOGION FIRST HALF OF TENTH CENTURY. FIGS. 55, 56

Vellum. 755 x 24 cm. Minuscule script (letters 2 mm.), very stylized, approaching the *Kirchenlehrerstil* for text; titles and typikon in *Auszeichnungs-Majuskel*. Parchment thick but smooth and white. Ink brown for text; titles and typikon in carmine. Solid initials outlined in red and tinted in blue and green, touches of gold.

[6] Hutter, *Oxford*, 1, no. 59, figs. 369, 371.

[7] See Athos, Lavra A 106, fols. 1v, 41v, 59r, and Dochiariou 22, fol. 159v, *Treasures*, 3, figs. 47–49, 270.

[8] A somewhat similar case is presented by the codex Athens, Nat. Lib. 149, late tenth or eleventh century, in which the original ornamental bands were repaired and new embellishments and titles were added at a later date, see Marava-Chatzinicolaou, Toufexi-Paschou, no. 8, pp. 51ff.

[1] For the text see P. N. Trempelas, Μικρὸν Εὐχολόγιον, 1, Athens 1950, pp. 311ff., 402, 403; A. Dmitrievskiy, *Opisanie liturghicheskikh rukopisey, Khranyashchiklsya v bibliotekakh pravodlsvsho vostoka*, 2. *Evko-*

The text on the verso side of the roll follows the same direction as that on the recto, so that one must roll the manuscript back in order to continue reading. An additional, unpublished fragment is included among the new Sinai finds. The roll is badly destroyed all along the right margin, and part of the text is torn off.

Illustration

Simple initials and a line of red-brown strokes separating prayers constitute the sole decoration. The initials can be simple, geometric, or adorned with floral motifs or an occasional bird.

Section I: initial K with a flower pendant at the vertical bar; another one with a palmette on top of the vertical bar; Δ with a blue-green bird perching on the base of the letter; traces of gold lines. Prayer of καταγύρων read in the skevophylakion Baptismal rite (fig. 55).

Section II: initial Δ adorned with a bird picking grapes and O in rosette form, in blue, dark green, and red. Prayer on the ordination of a deaconess (fig. 56).

Section III: initial K decorated with a peacock, and another one with a peacock, at the very end of verso. Prayer on the bowing of heads at Matins.

Date and Style

Liturgists and paleographers have assigned the roll to the tenth century and have pointed out the importance of its text.[1] This is one of the earliest extant Euchologia, which should be placed after the ninth-century Barberini codex.[2] Recent research has allowed us to date it with greater certainty. Its script is close to that of the cod. Jerusalem, Stavrou 55, dated to the year 927.[3] A study of its initials points to a similar date.

The elegant initials single out opening words. At the same time, just as the single lines of strokes distinguish sections of the text, they serve as "pointers" as in another liturgical book, the Lectionary. The refined folding bands, although simple, the delicately drawn birds picking at grapes, and the peacock are in style not unlike the initials found in cod. Paris gr. 139.[4] In fact, they have been rendered in the

loghia, 2, Kiev 1911, pp. 12ff.

[2] Cf. A. Jacob, "La tradition manuscrite de la Liturgie de Saint Jean Chrysostome (VIII–XII siècles)," in *Eucharisties d'Orient et d'Occident* (Lex Orandi, 47), Paris 1970, 2, pp. 114–21; idem, "Les prières de l'ambon du Barber. gr. 336 et du Vat. gr. 1833," *Bulletin de l'Institut Historique Belge de Rome* 37 (1965) p. 21.

[3] Hunger, "Auszeichnungsschriften," p. 204 n. 17, fig. 7, with references.

[4] Weitzmann, *Buchmalerei*, pl. X,47; cf. H. Buchthal, *The Miniatures of the Paris Psalter* (Studies of the Warburg Institute, 2), London 1938.

best Constantinopolitan style of the first half of the tenth century. This conclusion is of significance, since early illustrated Euchologia are indeed rare.[5]

Bibliography
Gardthausen, *Catalogus*, p. 204.
Kamil, p. 110 no. 1285.

12. COD. 183. FOUR GOSPELS
LENINGRAD, STATE PUBLIC LIBRARY
COD. GR. 266: TWO LEAVES
MID-TENTH CENTURY. FIGS. 57, 58

Vellum. 127 folios, 24.8 x 19.4 cm. *Leningrad*: two leaves, 25.5 x 19.9 cm. Two columns of twenty-nine lines. Minuscule script for text approaching the *Keulenstil*, clear and elegant, written across, under, and above the line; titles in *Auszeichnungs-Majuskel*. Later gathering numbers in middle of bottom margin of first recto. Parchment white and fine. Ink dark brown for text; titles in gold, but chapter headings in the text in red. Initials for the opening verses of each Gospel in gold; small initials in text only outlined in carmine.

Codex is incomplete, beginning with Mark 5:13. Fols. 1r–15r, Mark; 25v, blank; 26r–27r, Luke chapters; 27v, blank; 28r–82v, Luke (*Leningrad*: Lk. 7:47–8; 16; 10:11–30); 83r, John chapters; 83v, blank; 84r–125v, John; 126r and v, blank; 127r, later Arabic entry; 127v, blank.

First folios are in bad condition. All gatherings are loose. Fols. 25–27, 83, 123–125 are later, probably thirteenth-century, restorations. Headpieces are in excellent condition but initials have lost most of their gold, exposing the red underpainting. The front cover is missing. The back cover is a wooden board covered with dark brown leather pressed with simple geometric patterns: rectangles marked in the center with diagonal lines and stamped with small, worn medallions. Traces of several metal studs along the borders.

Illustration
28r Π-shaped headpiece over right column, with gold palmettes in fretsaw style with red dots on turquoise blue and dark green ground. Two small stylized palmettes

are on the upper two corners. Gold initial Є in similar style. Lk. 1:1ff (fig. 57).

84r Π-shaped headpiece over left column, with gold palmettes with red dots on blue and dark green ground. Three small palmettes on top of the frame, two smaller ones on the inner upper corners, and two half palmettes on the outer center of the vertical sides. Gold initial Є in similar style. Jn. 1:1ff (fig. 58).

Style
The ornamentation and color scheme of gold with red dots on light blue and dark green ground in fretsaw style, with palmettes arranged so as to form a lyre-shaped pattern, is a particular feature of Constantinopolitan scriptoria in the first half of the tenth century.[1] Similar ornament and type of initials are found in several codices of the period, such as Athos, Vatopedi 456 and Athens, Nat. Lib. 56.[2] Paleographically the codex is related to tenth-century manuscripts.[3] The quality of its ornament leaves no doubt that it should be included among Constantinopolitan products of that period.

Bibliography
Gardthausen, *Catalogus*, p. 36.
Gregory, *Textkritik*, pp. 247, 1135 no. 1220.
Beneševič, p. 639.
Hatch, *Sinai*, pl. XIV.
Kamil, p. 69 no. 208.
Voicu, D'Alisera, p. 555.

Leningrad leaves:
Beneševič, p. 639 no. 183.
Granstrem, *VV* 19 (1961) p. 230 no. 266 with earlier bibliography.

13. COD. 734–735. TRIODON
TENTH CENTURY. FIG. 59

Two manuscripts identified as one. Vellum. Folios: Part 1, 1–174; Part 2, 1–200; 25.5 x 19.4 cm. One column of twenty-six lines. Minuscule script for text, written across the line, small letters irregularly spaced with *Hakenschrift* elements; titles in *Auszeichnungs-Majuskel*. Gathering numbers at lower left corner of first recto, beginning with gathering γ′, fol. 19r in Part 1 and gathering ιζ′, fol. 9r, Part 2. Parchment hard and white. Ink black for text except fols. 1r–2v, Part 1, and some folios in Part 2 which

[5] See cod. Vat. gr. 1554 in Grabar, *Manuscrits grecs*, no. 37, pp. 65ff.; cf. Weitzmann, "Cyclic Illustration," pp. 102ff.; Galavaris, *Liturgical Homilies*, pp. 38ff.

[1] Weitzmann, *Buchmalerei*, pp. 18ff.

[2] Ibid., p. 20, fig. 19, pl. XXVI,141; also idem, *Studies*, pp. 239–41, fig. 223–26; Marava-Chatzinicolaou, Toufexi-Paschou, no. 1, figs. 9, 10.

[3] Hunger, "Auszeichnungsschriften," p. 213, figs 5, 6.

are in light brown; titles in carmine. Solid simple initials in carmine.

Cod. 734, beginning missing; fols. 1r–2v, idiomela for Sunday of the Apocreo; 3r–114v, Triodon-Stichera, Canons from Sunday of the Prodigal Son to Saturday of the Holy Week; last gathering ιε' is missing. Cod. 735 in its present state is also incomplete. No binding; codex is kept in a paper envelope.

Cod. 734 contains only one band-shaped headpiece, fol. 3r, in fretsaw style of a striking dark blue color outlined in wine red against gold; the center of the palmettes is left colorless (fig. 59). Unlike the color scheme of all other initials in the manuscript, in this instance the A has the gold and blue colors of the headpiece.

The beautiful fretsaw style is very similar to that found in cod. Oxford, Auct. T. inf. 2.6, fol. 47r, which has been assigned to the middle of the tenth century or shortly thereafter, and to a Constantinopolitan scriptorium.[1] The paleography points to a similar date and origin for the Sinai codex.

Bibliography

Gardthausen, *Catalogus*, pp. 159–60.
Kamil, p. 101 no. 1004–1005.

14. COD. 213. LECTIONARY
LENINGRAD, STATE PUBLIC LIBRARY COD.
GR. 283: ONE LEAF
A.D. 967. FIGS. 60–82, COLORPLATE II

Vellum. 340 folios, 21 x 16.5 cm. *Leningrad*: one leaf, 20.9 x 18.6 cm. Two columns of nineteen lines. Sloping majuscule (*ogivale inclinata*) for text (size of letters 3 mm.); titles in *Auszeichnungs-Majuskel* (size of letters 6 mm.). Gathering marks at upper right corner of first recto, beginning with γ' on fol. 19r. Parchment hard and rough, white. Ink black for text and ekphonetic signs, occasionally brown. Epigrams to evangelists in bright red. Titles and calendar indications outlined and colored in orange-red, light yellow, strong ultramarine, and light and dark green, or simply in bright red; they are often marked with outlined and tinted interlaced crosses. Zoomorphic and/or ornamental initials opening the lessons in same colors and dark brown. Arabic text on margins of several folios in dark red.

[1] Hutter, *Oxford*, 1, no. 4, fig. 27.

Jo. hebd. Mt. Lk. Sab-Kyr. Passion pericopes and Hours, Menologion, varia, Eothina.

Fol. 1v, epigram to John in upright majuscule and colophon; 2r and v, Canon tables (Canon I), on a loose page not part of the manuscript; 3r (gathering α')–76v, John weeks; 77r–116r, Matthew weeks; 116v, epigram to Matthew; 117r–164r, Luke weeks; 164v, epigram to Mark; 165r–196r, Mark weeks; 196v–235v, Passion pericopes (*Leningrad leaf*: fourth passion pericope, Mt. 27:3–7); 235v, Good Friday pericopes; 244r–246v, pericopes for Holy Saturday; 247v–330v, Menologion; 331r–332r, varia; 332v–340r, Eothina; 340v, colophon.

Colophons, on fol. 1v (fig. 80), read:

Μνησθειτη κ(ύρι)ε· τοῦ δουλου σοῦ ἐυστα
θείόυ πρεσβυτὲ ρου ἁμαρτώλου καὶ
ταπεῖνου· τοῦ πο θῶ γραψάντος τὸ
ευ(α)γ(γέλιον) τοῦτῶ ἀμην.

Remember, O Lord, thy servant Eustathios, the presbyter, sinner and humble who wrote this Gospel with zeal. Amen.[1]

Between the half lines, vertically placed, is the last word, βί-βλον, of the verses to John written above.

On fol. 340v (fig. 81), by the same hand: Επληρωθη σὺν θ(ε)ω τῶ ἐυαγγέ/λειον τουτῶ μη(νὶ) ἰανουαριῶ εις τ(ὴν) λ.' ηνδ(ικτιῶνος) ἲ ἐτοὺς απο / κτίσεως κοσμου ‚ϚΥΟΕ'. (This Gospel was completed with the help of God on January 30, 10th indiction in the year 6475 from the creation of the world [967]).

On fol. 340v, in a later, twelfth- or thirteenth-century script, an entry in black ink reads:

+ τὸ παρὸν ἅγιον ἐυαγγέλειον τῆς / ὑπεραγίας θ(εοτό)κου τοῦ αγίου / ορους τοῦ χωρήβ· ἐτέθη / δια χειρὸς μακαρίου τοῦ / ἁγιωτάτου ἀρχιεπισκό/που τοῦ ἁγίου ὄρους σινὰ· / καὶ ἤ της τὸ ἡστερήσει τὴν / θ(εοτό)κον· νά ἔχει τὰς ἀρὰς τῶν / τιη' θεοφορων π(ατέ)ρων·

+ This holy Gospel of the All-Holy Theotokos of the Holy Mount Horeb was dedicated by the hand of Makarios the most holy archbishop of the Holy Mount Sinai. May he who deprives the Theotokos of it have the curses of the 318 Holy Fathers.

On fol. 3r, text in Arabic, somewhat later than the Greek Gospel text, reads in Professor Irfan Shahid's translation as follows: He sat at the Church of the Lord in the

[1] It has been observed that Eustathios' script is similar to that in a leaf in Leningrad, cod. gr. 36, a fragment of a Lectionary from Sinai; see Harlfinger et al., p. 15.

Mountain of Horeb. No one has authority to dislodge Him from it or from inside it.

These last two entries, the Greek and the Arabic, from which the popular name of the Lectionary derives, suggest that the mansucript has been connected with Sinai for several centuries.[2]

The codex is in very bad condition. The Canon page and several gatherings are loose. Between fols. 164 and 165 a leaf is cut out but apparently no text is missing; between 221 and 222 another leaf is missing, which probably had the beginning of the fifth Passion pericope (Mt. 27:3ff.). Gatherings μβ′ and μγ′ are not marked. The codex bears signs of much use, especially along the edges of the pages. Several marks from wax drips.

Old dark brown leather binding on wooden boards, with tooled ornamentation bearing only traces of a rinceau border and faded imprints of metal attachments. Badly torn, it was restored with new, light brown leather which, in turn, has been severely damaged. Between the front cover and the now completely torn out flyleaf, there was pasted a piece of papyrus, of which only traces remain.

Illustration

2r and v Left are two similar Canon tables (ca. 15.8 x 14.1 cm.) contained in two arches, spanned by a larger arch supported by three columns (only outlined) with three elongated acanthus capitals in blue and red, outlined in gold. The tympanum is decorated in flower petal style with a scroll pattern against gold. On the face of the arch are three colorless petals in the form of crosslets on a carmine background. Two partridges on either side of the arch. Canon X (fig. 82).

3r Π-shaped headpiece in a variant of fretsaw ornament: two rows of black circles, each containing four blue palmettes against white, joined by rosettes, set against red and pale yellow ground. Titles in pale yellow, red and some blue filling. Initial Є formed by a blessing hand in similar colors and inner filling in green. Jn. 1:1–17 (fig. 60).

8v Initial T in fretsaw, and a light green, red, and blue griffin below. Wednesday after Easter, Jn. 1:35–52 (fig. 61).

13v Initial T supported by a hand in colors as on fol. 8v. Friday after Easter, Jn. 2:12–22.

14r Initial O in fretsaw. Thomas Sunday, Jn. 20:19–31 (fig. 62).

16v Initial T with hand. Tuesday, second week, Jn. 3:16–21.

18v Initial T as on fol. 16v, Thursday, second week, Jn. 5:24–30.

19v Initial Є with the bows formed by two griffins in red and yellow, carrying a man in the center, in green and with brown hair, recalling Alexander's ascension. Friday, second week, Jn. 5:30–6:2 (fig. 63).

21v Initial T with interlace and fretsaw and with a dog's or dragon's head. Saturday, second week, Jn. 6:14–27 (fig. 64).

27r Initial Є in fretsaw with two snake- or bird-like animals. Thursday, third week, Jn. 6:40–44 (fig. 65).

28v Initial Є with two griffins in red, blue, green, and yellow attacking two hands. Saturday, third week, Jn. 15:17–16:2 (fig. 66).

58v Initial Є with two coiling serpents on the bows attacking a hand and palmette on the vertical. Wednesday, sixth week, Jn. 12:36–47 (fig. 67).

68r Initial Є with two birds of prey. Wednesday, seventh week, Jn. 16:15–23 (fig. 68).

73v A griffin, marginal vignette as on fol. 8v, and initial T in fretsaw style with a dragon at the bottom. Sunday, eighth week, Pentecost, Jn. 7:36–52, 8:12 (fig. 69).

75v Initial Є with hand in fretsaw style and a dove in blue, green, yellow, and brown, flying down from above. Feast of the Holy Ghost, Mt. 18:10–20 (fig. 70).

77r Two bars in rinceau, left column, enclosing seven lines of huge letters filling height of column, marking the end of John's readings. In right column begin stichoi of Matthew weeks (fig. 71).

77v Band-shaped headpiece in interlace with a dragon's head, and initial Є with hand in four colors. Saturday, first week, Mt. 5:42–48.

90r Initial Є with a hand holding a cross with rays. Saturday, seventh week, Mt. 10:37–42; 11:1 (fig. 72).

116r Nine lines of large majuscule script, in red and yellow, fill height of right column and mark the beginning of Luke pericopes.

164r Band-shaped headpiece in fretsaw style, bottom left column, end of Luke readings; right column, eight lines of large letters in yellow, red and green, beginning of Mark. Vignette with two peacocks drinking at a fountain in four colors (fig. 73).

[2] For the dedication of the monastery to Theotokos, see A. Guillou, "Le monastère de la Théotokos au Sinaï," *Mélanges d'archéologie et d'histoire* 67 (1955) pp. 217–58.

174r Vignette with a rosette and two birds in green and yellow. Fourth Sunday of Lent, Mk. 9:17–31.

196v Band-shaped headpiece in interlace with a dragon's head and a hand at the left end and a man's head at the opposite end. Two birds atop either side of a Greek cross in interlace; Latin cross in the form of a stavrogram marks title; below, in margin, medallion with bust of Christ, IC̄ X̄C̄, blessing and holding a Gospel book. Nimbus and Gospel are decorated with crenellation. Beginning of Passion pericopes. Below, a band in fretsaw marking the beginning of John's pericope and initial Є with a blessing hand and fretsaw and almond rosettes ornament. Jn. 13:31–35 (fig. 74).

244r Large initial O in the form of a fish. Holy Saturday, Mt. 28:1–20 (fig. 75).

247v Headpiece, left column, with an interlace above and below and fretsaw at the verticals set on palmettes and a dragon's head at the left of the upper bar. Menologion, September 1. The disjoined lower band serves to mark Lk. 4:16–22 (fig. 76).

264v Band-shaped headpiece in interlace, left column, October 1. Initial Є with blessing hand, right column, October 2, Jn. 10:9–16.

276r Band-shaped headpiece in fretsaw, left column, November 1. Initial T with knots and palmettes, right column. Mt. 10:1 and 5:8.

279v Band-shaped headpiece in interlace, left column, December 1. Initial T. Mk. 5:24–34.

293v Initial A with a peacock at a stem of interlace and palmettes. Sunday after Christmas, Mt. 2:13–23 (fig. 77).

296r Band-shaped headpiece in interlace, initial T. January 1, Lk. 2:20–21, 40–52.

299v Initial A with a quadruped (a lamb?), supporting a leaning column with fretsaw and palmette decoration. Second Sunday after Christmas, Mk. 1:1–8 (fig. 78).

308v Band-shaped headpiece in fretsaw. February 1, Lk. 10:19–21.

312v Band-shaped headpiece in fretsaw style and vignette with a prancing griffin below, left column. Feast of the Discovery of the Head of John the Baptist, February 24, Mt. 11:2–25. In right column, initial Є in fret-

saw style with dragon's head at top and a blessing hand. Feast of the Forty Martyrs of Sebaste, March 9, Mt. 20:1–16. At beginning, cross (fig. 79) as on fol. 196v.

316r and v, 318v, 326v, 331r, 332v Band-shaped headpieces in fretsaw style marking remaining months, April–August, varia, and the Eothina Gospels.

In addition to all this decoration, which distinguishes the major sections and pericopes of the Lectionary and the previously listed initials, the codex has many more ornamental and zoomorphic initials T (τῷ καιρῷ ἐκείνῳ) and Є (εἶπεν ὁ Ἰησοῦς) marking each lection. They are drawn and filled with alternating red, blue, yellow and/or green, colors which have been used for headpieces, tailpieces and vignettes.

Iconography and Style

The text is written in a majuscule of a slightly elongated, sloping form, which persisted for a long time in Lectionaries and is widespread. However, there are some peculiarities in the format taken by the lines within each column. Although each page is ruled, the writing does not always follow the ruling. The size of the title letters is not consistent throughout. The letters themselves also present differences: they can be outlined and filled with color, as, for example, fol. 196v (fig. 74, colorplate ii:c). Often titles start with a cross, implying a stavrogram (see, for example, fols. 196v, 312v [figs. 74, 79, colorplate ii:c, ii:b]), a characteristic sometimes found in manuscripts that have been attributed to the eastern provinces of the Byzantine empire, as for instance, the late ninth-century Princeton Gospels, Garrett 1.[3] There is no gold anywhere, and the overall impression of a page is dominated by certain title lines which acquire emphasis and become colorful, decorative, and vivid. The only conclusion that can be drawn from these observations on the script is that the codex is provincial, written in a monastic milieu.

The bust of Christ in a medallion, fol. 196v (fig. 74, colorplate ii:c), the only figurative representation in the codex, belongs to compositions common in monumental and minor arts as well as icons.[4] Earlier examples appear on the coins of Justinian II (685–695) and Leo VI (886–912), but they are not related in type to this bust.[5] The ornament on the cruciform nimbus—double crenellation—and on the

[3] *Greek Mss. Amer. Coll.*, no. 2, fig. 2; *Byzantium at Princeton*, pp. 141–42, no. 168.

[4] On early icons one sees the head of Christ in a medallion, without the Gospel which is associated with Christ's representation in bust form; see Weitzmann, *Sinai Icons*, nos. B.9, pl. XII; B.11, pl. XIV; B.5, pls. XLVIII, L. For a bust of Christ holding the Gospel, see an extant icon

from the end of the tenth century in Sinai, ibid., no. B.61, pl. CXX, pp. 101, 102.

[5] Beckwith, *Constantinople*, p. 54; J. Breckenridge, *The Numismatic Iconography of Justinian II*, New York 1959, pp. 46ff.; P. Grierson, *Catalogue of the Byzantine Coins in the Dumbarton Oaks Collection*, 2, part 2, Washington, D.C. 1968, pl. XXXVII.

Gospel suggest a relation to enamel work.[6] The choice of form and application of this Christ medallion reflect the tradition of standardized author portraits in medallions, as in the Sacra Parallela, Paris, Bibl. Nat. cod. gr. 923,[7] and the portrait of John Climacus in the codex Sinai 417 (see no. 9 above, fig. 32, colorplate I:b). Both these manuscripts, and especially the Climax, have been assigned with good reason to Palestine.

Stylistically the head of Christ is not unlike that of John Chrysostom in cod. Princeton, Univ. Lib. Garrett 14, fol. 295r, dated to the year 955 and assigned to the monastery of St. Sabas near Jerusalem. A most striking similarity to the Chrysostom bust is presented by the head of a man placed between two griffins, fol. 19v (fig. 63). These two busts are related not only in drawing technique but in the form of the skull-like head and the hairline.[8]

The ornament applied to the headpieces and the initials presents two characteristics: 1) the fretsaw ornament in various patterns, such as tendrils encased in borderlines (*Aussparungsranke*) or pure fretsaw and free tendrils, the most predominant; 2) an exaggerated combination of ornamental motifs in the same band or initial. For example, palmettes, interlace and fantastic animals are combined, often lacking any sense of symmetry (fig. 76). In the initials themselves, apart from the motifs and techniques noted above, there are two distinguishing elements: 1) a forearm with a blessing hand; 2) once more, an animal. There is also a pronounced tendency toward over-ornamentation, achieved by a combination of patterns giving the feeling of "horror vacui."

Initials with blessing hands are known particularly in Lectionaries written in majuscule script. Their localization in Italy, as Grabar proposes, is not tenable, since they occur in various styles and regions. The hands in a Lectionary in Lavra, cod. A 86 from the tenth century, for example, are very different in form, ornament, and in the abundant use of gold.[9] The rich ornamentation of the sleeves with "jewelled" rosettes combined with fretsaw ornament, fol. 196v (fig. 74, colorplate II:c), is very similar to that in cod. Athos, Karakallou 11, fol. 98v, which has been attributed to the eastern

provinces of the Empire (Cappadocia?).[10] But the Sinai hands differ in that they are often combined with imaginary animals. This zoomorphic element becomes the manuscript's most important characteristic. More particularly, the Sinai codex relates to manuscripts produced in Egypt. The stylization of the peacocks on fol. 164v (fig. 73), for example, is like that of a lion and a bird in an initial of the cod. Florence, Laur. Plut. IX.15, fol. 13v, which was written in Africa.[11] Also comparable is the ornament in the cod. Paris gr. 1085 written in the year 1000 by a certain Leo in Egypt, and that of the cod. Jerusalem, Sabas 25, written according to its colophon in that very monastery.[12]

The griffin is the preferred animal, and has been applied in various ways to the initials, the margins, and vignettes, either alone or combined with a human head, as in the ascension of Alexander on the griffin chariot (fig. 63). The griffins as well as other animals, including birds, are strongly ornamentalized in Sassanian style. The thigh of the griffin is adorned with an almond, his wings are striped, his neck has a band, and his tail terminates in a leaf. Sassanian or Islamic sources must also be sought for the variant of fretsaw ornament on fol. 3r (fig. 60) which is not unlike stone carvings such as those on the façade of the mosque El-Hakim in Cairo (990–1003) which, it has been suggested, follows the style of earlier Islamic frescoes.[13]

The type of ornament, the Arabic texts, and the type of parchment—all found in manuscripts produced at Sinai— suggest that the Horeb Lectionary was made in Sinai itself or at least in a nearby area of Egypt or Palestine. The colophon, while giving the name of the scribe and the date, does not cite any locality. Neither is the later, twelfth- to thirteenth-century entry conclusive: it should not be interpreted as referring to contemporary events. The writer of the entry records a fact obviously known to the monastic community (the monastery is still referred to as that of the Theotokos); hence the named bishop Makarios may not be a twelfth-century figure but rather earlier.[14]

There is, however, other additional evidence that may strengthen these conclusions. In the Menologion section, the commemoration of Sabas, December 5, fol. 281r, reads: Τοῦ

[6] See M. C. Ross, *Catalogue of the Byzantine and Early Mediaeval Antiquities in the Dumbarton Oaks Collection*, 2, Washington, D.C. 1965, no. 154, icon frame, and no. 161, pair of enamelled kolti, deriving from Constantinopolitan jewelry, from the mid-eleventh and twelfth centuries.

[7] Weitzmann, *Sacra Parallela*, passim.

[8] *Greek Mss. Amer. Coll.*, no. 4, fig. 4; *Byzantium at Princeton*, p. 144, no. 170.

[9] Weitzmann, *Buchmalerei*, pl. LVI,320, 321.

[10] Ibid., pl. LXXXVI,469. Similarities occur in other codices, such as Paris gr. 63, fol. 206r and Athos, Dionysiou 18, fol. 22v: ibid.,

pl. LXXVI,464–71.

[11] Ibid., p. 73, pl. LXXIX,491.

[12] Ibid., pp. 74, 75, pls. LXXX,497, LXXXI,504.

[13] D. Talbot Rice, *Islamic Art*, London 1965, fig. 86.

[14] For Makarios see Rabino, pp. 83 no. 18, 84 no. 21; see also K. N. Papamichalopoulos, ῾Η Μονὴ τοῦ ὄρους Σινᾶ, Athens and Cairo 1932, pp. 420–26, list incomplete. New material on bishops' lists is contained in the new manuscript finds, the publication of which is being prepared by Dr. P. Nikolopoulos; cf. Galavaris, "Sinaitic Mss.," p. 122.

ἁγίου π(ατρὸ)ς ἡμ(ῶ)ν Cάβα, "Of our Father Sabas." On fol. 307r is the commemoration of the Holy Abbates (τῶν ἁγίων Ἀββάδων), the Martyrs of Sinai, January 14. The latter feast day occurs often in Menologia and its presence here may not be of special significance; this may also be true for the application of "Our Father" to Sabas, as the term seems to be of general use in this codex. More significant is evidence found in the Gospels section. On fol. 113v, next to the pericope of Saturday, Matthew, sixth week (25:16) is the following typikon: Τὸ αὐτὸ λέγεται καὶ εἰς τὴν ἁγίαν θέκλαν (the same [Gospel] is read also on the [feast] of St. Thekla). On fol. 129r, the typikon referring to the pericope of Saturday, Luke, sixth week (8:16ff.) states that "the same Gospel is read at the commemoration of Joachim and Anna." In fact, these are cross-references to the saints' commemorations in the Menologion, namely September 24 (Thekla) and September 9 (Joachim and Anna). Such cross-references are not consistent with all pericopes used also in the Menologion, and they may well indicate a special veneration of these saints. Thekla is indeed worshipped particularly in Jerusalem, Antioch, and Sinai. At Sinai a chapel is dedicated to her and another to Joachim and Anna, where the liturgy is celebrated three times during the year.

The Canon tables, fol. 2r and v (fig. 82) recall in form but not in style tables found in manuscripts of the second half of the tenth century, such as Paris gr. 70, *anno* 964, fols. 7r and 8r.[15] The flower petal style on the tympanum of the arch, springing from the center in a scroll pattern, points to the late eleventh century[16] and quite likely to a provincial area, for it lacks the lustre of Constantinopolitan manuscripts. Its provincial character is stressed by the rosette pattern executed in carmine and the shafts of the columns, which are only outlined.

The illustrator of this codex was not attracted by figurative ornamentation, for figures were avoided in Islamic regions. However, the diversity of the ornament, its wealth of inventiveness, and the care in applying alternating color combinations, shows the monk's love for the text he illustrates.

Bibliography

Kondakov 1882, pp. 104, 127ff., pls. 79–83; 89,8.
Gardthausen, *Catalogus*, p. 42, pl. 2,1.
Kondakov, *Initiales*, pp. 111ff., pls. I–IV.
Gregory, *Textkritik*, pp. 447, 1245 no. 847.
Beneševič, pp. 113–15 no. 107.
Vogel, Gardthausen, p. 123.

[15] Weitzmann, *Buchmalerei*, pl. XVII,87.
[16] Cf. cod. Paris Coislin 239, fol. 6r, reproduced in Galavaris, *Liturgi-*

Gardthausen, *Palaeographie*, 2, pp. 150, 433, 499.
Ebersolt, *Miniature*, p. 50 n. 3.
Weitzmann, *Buchmalerei*, pp. 67, 73–74, 84, 86, pl. LXXX,496.
Devreesse, *Introduction*, p. 291.
K. W. Clark, "Exploring the Manuscripts of Sinai and Jerusalem," *The Biblical Archaeologist*, 16 (1953) p. 30.
K. Amantos, Σιναϊτικὰ μνημεῖα ἀνέκδοτα, Athens 1928, p. 9.
Granstrem, *VV* 18 (1961) p. 255.
Lazarev, *Storia*, p. 176 n. 69.
Kamil, p. 70 no. 238.
Weitzmann, *Sinai Mss.*, pp. 10, 11, figs. 4, 5.
Grabar, *Manuscrits grecs*, pp. 9, 10, 36, 73 no. 44, figs. 321–25.
Husmann, p. 145.
Marava-Chatzinicolaou, Toufexi-Paschou, pp. 34, 40.
Galey 1979, fig. 149.
Spatharakis, *Dated Mss.*, no. 18, figs. 42, 43.
Voicu, D'Alisera, pp. 557–58.
Hutter, *Oxford*, 3, p. 13.
Harlfinger et al., pp. 14–16, 62, no. 2, pls. 5–9.
Galavaris, "Sinaitic Mss.," pp. 122ff., figs. 5–11.

Leningrad leaf:
Stasov, p. 53, pl. 123,3–7.
Kondakov 1882, p. 127.
Gregory, *Textkritik*, p. 1279 no. 1398.
Beneševič, pp. 113, 612 no. 107.
Idem, *Mon. Sinaitica*, 2, pl. 41.
Weitzmann, *Buchmalerei*, pp. 72, 74, pl. LXXX,495.
Devreesse, *Introduction*, p. 291.
Granstrem, *VV* 18 (1961) p. 255 no. 116.
Grabar, *Manuscrits grecs*, p. 73ff., fig. 326.
Spatharakis, *Dated Mss.*, no. 18.
Voicu, D'Alisera, p. 354.
Harlfinger et al., pp. 15, 17.

15. COD. 421. JOHN CLIMACUS, THE HEAVENLY LADDER FIRST HALF OF THE TENTH CENTURY. FIGS. 83, 84

Vellum. 203 folios, 21.8 x 15.8 cm. One column of twenty-four lines. Minuscule script of very small letters, very clearly and carefully written, round, slightly leaning to the left, *Kirchenlehrerstil* for text; titles in *Auszeichnungs-Majuskel*; writing does not always follow the ruling, mostly written across the line and more below than above it. Gathering numbers at upper right corner of first verso. Parchment hard and rough. Ink brown for text; titles in letters alternating green and red, or in red or brown painted over with yellow or green. Small initials with knots and leaves in similar colors.

cal Homilies, pl. XXXV,181.

Fol. 1r, letter of John of Raithou to John Climacus (*PG* 88, 624–25); 2v, table of contents; 3v–9r, Life of John Climacus by Daniel of Raithou and preface (*PG* 88, 596–608); 9r–186v, the 30 homilies (*PG* 88, 632–1161); 186r and v, table of contents in reversed order; 187r–200v, Homily to the Pastor (*PG* 88, 1165–1208); 201, from another, later manuscript; 202v, 203r, Homily to the Pastor continued.

The first folios are damaged by humidity and insects; the last pages are bound upside down. Old, light brown leather binding with tooled decoration, well-preserved, with similar motifs on both covers: a narrow border of a rinceau with ivy leaves encloses bands of somewhat similar ornament arranged in the form of a cross monogram. Byzantine, probably fifteenth century (fig. 84).[1]

Illustration

1r Π-shaped headpiece of unframed interlace in green, red, and yellow. Initial T with knots. Letter of John of Raithou.

2v Drawing of a crude, much later ladder, table of contents.

3v Π-shaped headpiece in a rinceau pattern of lush red acanthus leaves on green stems, with light brown sprouts and palmettes at the corners. Initial T with a cross and knots on the stem and the horizontal bar. Colors as on fol. 1r. Life of John by Daniel (fig. 83).

9r Initial T with elaborate knots and floral decoration. Homily 1.

22v Simple band with strokes and stylized palmettes at the end. Initial O formed by two green and red fish, filled with dirty yellow. Homily 4.

Simple geometric initials in similar colors introduce the text of each remaining homily.

Iconography and Style

The ornament in this codex is of two kinds: an angular, simple interlace, and very lush, wide-lobed, wavy tendrils. The main type of initials presents complicated knots, almost forming an interlace. The colors are green, red, and yellow. The absence of gold is notable. The interlace is somewhat

[1] Somewhat similar patterns and arrangements are seen in the front cover of the cod. Oxford, Auct. T. inf. 2.6, for which a fifteenth-century date has been proposed; see Hutter, *Oxford*, 1, no. 4, fig. 33.

[2] Weitzmann, *Buchmalerei*, p. 65, pl. LXXI,425.

[3] Ibid., pl. LXXI,429.

[4] Ibid., p. 43, fig. 39.

[5] Ibid., p. 66, pl. LXXII,433.

[6] Although the script of the Oxford manuscript is very elegant and the opinion has been expressed that the codex may be a Constantinopolitan product, Weitzmann included it in his Cappadocian group on the basis of

similar to but simpler and probably earlier than that in cod. London, Brit. Lib. Add. 39602 from the year 980, written for a bishop of Caesarea.[2] The knotted initials also find parallels in this codex and its relatives, such as the cod. Jerusalem, Sabas 2, fol. 19r, all of which have been assigned to the eastern provinces of the Empire.[3] Even closer parallels for the initials are found in manuscripts assigned to western Asia Minor in the ninth century, such as the cod. London, Brit. Lib. Harley 5787.[4] The lush, lobed, wavy tendrils are similar to those found in cod. Patmos 70, another tenth-century relative of the same group of manuscripts.[5]

Paleographically the codex is closely related to the cod. Oxford, Auct. E.2.12 (Works of Basil) from the year 953,[6] which has been assigned to Asia Minor. Furthermore, the drawing of colored (green or yellow) lines over the titles for emphasis is found, among other examples, in manuscripts attributed to the eastern provinces in the tenth century, such as the cod. Athos, Dionysiou 1, fol. 60r.[7] The addition of these lines was formerly believed to be typical of Greek manuscripts copied in Italy. But this feature is no longer considered an indication of particular scriptoria, because, as Irigoin has shown, the same practice has been observed in codices executed before the twelfth century in localities ranging from Bithynia to Attica.[8]

Bibliography

Kondakov 1882, p. 110.
Gardthausen, *Catalogus*, p. 101.
Lazarev 1947, p. 304 n. 37.
Kamil, p. 87 no. 645.

16. COD. 214. LECTIONARY
TENTH CENTURY. FIGS. 85–87

Vellum. 153 folios, 27.4 x 22.3 cm. One column of twenty-one–twenty-five lines. Upright majuscule, thick (size of letters 4 mm.), not fine for text and titles (larger sized letters). Gathering numbers with a stroke above at upper right corner of first recto, beginning with gathering β',

the ornament. Today, Hunger's researches have shown that manuscripts of diverse origins can have similar paleographic characteristics, and that elegant script is not a prerogative of the capital. See Oxford, *Greek Manuscripts in the Bodleian Library* (Exhibition, XIIIth International Congress of Byzantine Studies), Oxford 1966, no. 15; Weitzmann, *Buchmalerei*, p. 44; Hunger, "Auszeichnungsschriften," p. 204, fig. 8.

[7] Weitzmann, *Buchmalerei*, p. 66, pl. LXVII,438.

[8] J. Irigoin, "Pour une étude des centres de copie byzantins," *Scriptorium* 12 (1958) p. 226; cf. also Marava-Chatzinicolaou, Toufexi-Paschou, no. 3, p. 33.

fol. 9r. Parchment hard and thick, but smooth, yellowish. Ink black for text to fol. 96r; 96v–145r, dark brown; 145v–153v, black once more. Title on fol. 1r in red-brown, olive green, orange, and dark blue; all other titles and calendar indications outlined in black and tinted in orange-red. Simple solid initials in orange-red and dirty yellow; small initials in text in black; ekphonetic signs in orange-red.

Jo. hebd. Mt. Lk. Sab-Kyr., Passion pericopes and Hours, Menologion, Eothina.

Fols. 1r–26v, John weeks; 26v–48r, Matthew weeks; 48r– 69r, Luke weeks; 69v–99v, Mark readings; 99v–116r, Passion pericopes; 116r–119r, Hours; 119r–122v, Good Friday vespers; 122v, Holy Saturday readings; 123v–149r, Menologion; 149r–153v, Eothina. 152v, + X(ριστὸ)ς παράσχει τοῖς ἐμοῖς / πώνοις χάριν. ἀμην. (+ May Christ grant [me] grace for the sake of my labors. Amen.)

Most gatherings are loose. Most text on fol. 25r is written over. Fol. 24v concludes gathering γ' and fol. 25r begins gathering ζ'. Gatherings δ', ε', ϛ', i.e., twenty-four pages which continued the second half of John's readings, are missing. One excised leaf was reported in Berlin, Staats. Bibl. graec. fol. 29, Zimelien no. 1. Arabic text at bottom of fol. 2v and in various other margins. Several folios cut at bottom; fols. 152v, 153v, late entries.

Front leather cover is lost; there is only a loose wooden board. Back cover has brown leather binding on a thick wooden board, perhaps Byzantine, with a simple tooled ornamentation: four circles on the corners of the border, one circle in the center of each side of the frame, and four circles forming a cross in the inner field. The leather is badly worn.

Illustration

1r Π-shaped headpiece of crude fretsaw in interlaced medallions enclosing palmettes in olive green, blue, and red-brown. Initial Є in same style. Jn. 1:1–17 (fig. 85).

2r, 2v Initials O and T in fretsaw, in cinnabar and light yellow. Several similar initials throughout the text.

26v Π-shaped headpiece with rough palmettes in heart-shaped tendrils colored alternately orange-red and dirty yellow against colorless ground. First Monday after Pentecost, Mt. 18:10–20 (fig. 86).

48r Small, unframed band of fretsaw work in orange-red and yellow. Initial T in similar ornament, right col-

umn. Monday, first of Luke weeks, Lk. 3:19–22 (fig. 87).

69v Small band of interlace pattern in orange and dirty yellow. Initial T Saturday, fourth week of Lent, Mk. 7:31–37.

99v, 116r, 119r Small, simple initials colored as above, opening the pericopes for the Passion, the Hours, and Good Friday vespers.

123v Band-shaped headpiece in jigsaw ornament and simple initial T in right column. Menologion, September 1.

All other months begin without ornament.

Iconography and Style

Both in the ornamental bands and the initials, the predominant ornament is fretsaw of the type found in, among other manuscripts, cod. Paris gr. 668 (compare fol. 1r with Sinai fol. 123v) and Paris gr. 28, fol. 56v,[1] both tenth-century manuscripts ascribed to an Egyptian locale. In addition, the initials and palmettes relate in their patterns to those in cod. Oxford, Laud. gr. 75 (John Chrysostom) from the year 976, which has been attributed to an eastern province in Asia Minor, although recently the possibility of an Italian origin has been proposed.[2]

The color scheme of the Byzantine-Egyptian manuscripts, however, favors above all carminé ornamentation, which is absent from the Sinai codex. Instead, there are in our manuscript cinnabar-red, light yellow, olive green, and the occasional blue, all set against colorless background, features that appear to be reflections of cod. Sinai 213. In fact the color combinations, especially in the initials, come very close to those in the Horeb Lectionary (see no. 14 above). Although its script is different from that of the Horeb codex and other manuscripts that we have assigned to the monastery of St. Catherine, Sinai cannot be ruled out as the manuscript's place of production.

Bibliography

Gardthausen, *Catalogus*, p. 43.
Gregory, *Textkritik*, pp. 447, 1246 no. 848.
Beneševič, p. 643.
Kamil, p. 70 no. 239.
Galavaris, "Sinaitic Mss.," p. 130, fig. 16.

Berlin leaf:
C. de Boor, *Verzeichnis der griechischen Handschriften der königl. Bibliothek zu Berlin*, 2, Berlin 1897, p. 139 no. 267.

[1] Weitzmann, *Buchmalerei*, pl. LXXIX,488, 485.

[2] Ibid., p. 64, pl. LXIX,412; Hutter, *Oxford*, 1, no. 16, figs. 82, 84.

17. COD. 360. JOHN CHRYSOSTOM, HOMILIES ON HEXAEMERON
SECOND HALF OF TENTH CENTURY.
FIGS. 88–91

Vellum. 370 folios, 36 x 25.2 cm. Two columns of twenty-five lines. Minuscule script, clear, round letters, well-spaced for text; titles in *Auszeichnungs-* and *Epigraphische Auszeichnungs-Majuskel*. Gathering numbers at lower left corner of first recto. Parchment fine and white. Ink light brown for text; titles in carmine. Initials opening the homilies in flower petal style; solid initials in carmine in text.

On fol. 1r a very late entry, "ex-libris-Sinai." Condition good. A few folios have been repaired or cut along the margins. Some headpieces are slightly rubbed. Codex does not show much use.

Dark brown leather binding on wooden boards with pressed ornament, similar on both covers. Two parallel frames joined at the corners by an octagonal ornament contain interlaced stems forming diamonds at intervals, all pressed with a roll. In the central field free fleurs-de-lis and a rosette form a cross; additional fleurs-de-lis and small rosettes at corners. Two pairs of three plaited leather straps still attached on the back cover. Possibly of fifteenth- or sixteenth-century date.

Illustration

Each of the thirty homilies (*PG* 53, 22–282) is decorated with a Π-shaped headpiece in flower petal style in blue, green, and pink against gold, and opens with an initial in similar style: 1r, 8r, 16r, 25r (fig. 88), 37v, 46v, 57v, 69r, 78r (fig. 89), 86v (fig. 90), 99r, 110r, 119v, 128r, 138v, 150r (fig. 91), 162v, 182v, 197r, 208r, 220v, 235r, 251r, 264v, 281v, 297v, 312r, 329r, 342v, 359r.

The petalled flowers, which are quite flame-like, are enclosed in medallions in one or more rows, or they are contained in a scroll pattern. The spaces between are filled with blossoming stems or calyxes. The initials remain simple. Small leaves and occasional knots are added to the stems.

Style

The forms and treatment of the petalled flowers recall those of Constantinopolitan manuscripts such as Athos, Dionysiou 70 (John Chrysostom) from the year 954, and London, Brit. Lib. Harley 5598, fol. 3r, a Lectionary, from 995.[1] A date in the second half of the tenth century is most probable for the Sinai codex; this is also supported by the

paleography, for the script still has the roundness and clarity of tenth-century letters.[2]

Bibliography
Gardthausen, *Catalogus*, p. 81.
Kamil, p. 77 no. 422.

18. COD. 204. LECTIONARY
CA. A.D. 1000. FIGS. 92–108,
COLORPLATES III–VIII

Vellum. 204 folios (406 pp.) and four later paper folios, 205–208 (pp. 407–14), 28.8 x 21.8 cm. Two columns of sixteen lines. Round, liturgical majuscule of great elegance (*rotonda liturgica*)[1] for text and titles (height of letters 5 mm.), written by several hands; script of titles ornamented in floral style. In text, abbreviations abound, their signs carefully drawn and ornamented. Spacing and roundness of letters vary. Gathering numbers at upper right corner of recto in gold, with three lines above and below and two dots on either side. Parchment is remarkably thick but smooth and white. Text, titles, and initials throughout in gold.

Seventy selected readings from Easter to Eothina.

When the later covers were added, the codex was rebound and paginated. Text begins on p. 15 (fol. 9r), gathering α'; pp. 15–227 (fols. 9r–115r), selections Easter Sunday to Palm Sunday; pp. 228–83 (fols. 115v–143r), selections for Holy Week; pp. 284–86 (fols. 143v–144v), blank; pp. 287–380 (fols. 145r–191v), Menologion, September–August; pp. 334, 381, 382 (fols. 168v, 192r and v), blank; pp. 383–402 (fols. 193r–202v), Eothina; pp. 403–406 (fols. 203r–204v) and pp. 407–13 (fols. 205r–208r, in paper), blank.

Beginning with p. 116 (fol. 59v), every blank page falls on the last page of a gathering. Beginning with gathering ζ', a paper strip is pasted over the right margin of the first page of the gathering and the numbers (gatherings η'–ιγ', ιε'–κε') are not visible; on p. 223 (fol. 113r), the margin is cut; in gathering ιδ' the illustrations have suffered minor damage.

Pages 1–14 (fols. 1r–8v) form a pictorial unit, with seven full-page miniatures, consisting of six leaves bound in one gathering followed by one double leaf bound separately. Of this double leaf, p. 13 (fol. 7r), which is much worn, was surely the first leaf of what was originally bound as a quaternion. This is proved by the offset on p. 14 (fol. 7v), which is that of the ornamental border found only on the Christ

[1] Weitzmann, *Buchmalerei*, pls. XXIX,160–66, XXXVI,200; Spatharakis, *Dated Mss.*, nos. 12, 31.

[2] Cf. Hunger, "Auszeichnungsschriften," p. 204, fig. 8.
[1] Mioni, *Paleografia*, p. 58.

miniature, now p. 1 (fol. 1r). Graphically, the present state of this pictorial unit is the following:

The original state according to our reconstruction is this:

There is no colophon, but the inclusion of unusual commemorations in the Menologion of the manuscript, emphasized also by the ornament, provides important evidence for the possible origin of the codex: p. 341 (fol. 172r) (fig. 107), February 7, Feast of "Our Holy Father Peter;" p. 357 (fol. 180r), May 10, τὰ ἐγκαίνια τῆς θεοτόκου τῆς καθ᾽ ἡμῶ(ν) μον(ῆς) (Dedication [of the church] of the Theotokos of our own monastery).

Front cover of copper, orginally gilt, with a Crucifixion in repoussé (fig. 92). On either side of the Cross are Mary and John and four mourning angels (two full-length and two in bust form); the following inscription is engraved on the Cross: OBTΔΞ (ʿΟ Βασιλεὺς Τῆς Δόξης). Christ's nimbus consists of a separate, nailed piece originally decorated with blue enamel, traces of which are still visible. A crenelated wall with gates suggests the City of Jerusalem. The sky is filled with stars. Enamelled busts of the four evangelists holding books are on the corners in the following sequence, read horizontally top to bottom: John, Mark, Luke, and Matthew, O ΑΓ(ι)O(s) Ἰῶ(αννης) O ΘΕΟΛΟ-Γ(os), O ΑΓ(ι)O(s) MAPK(os), O ΑΓ(ι)O(s) ΛΟΥΚ(as), O ΑΓ(ι)O(s) MAΘEO(s). The names are inscribed in black niello. The remaining enamel colors, blue, green, and red-

brown, are very translucent. Four nailed strips embossed with a floral motif (leaves, petals, calyxes) form the border of the cover.

This metal cover is fixed on a wooden board, the inner side of which has along its three outer borders exposed strips of Byzantine silk with a white pattern on purple ground (fig. 108). A segment of a large roundel in interlace is to be seen on the left border, and a rinceau motif above, inhabited by lions. In recent times cloth and leather have been pasted over the silk, and it is not possible to determine its original extent.

The back cover consists of a red brocade with silver threads, mostly gone, covering the entire surface of a wooden board, and of a baroque, probably seventeenth-century design. This brocade covers Byzantine silk of white pattern on purple ground, which seems originally to have covered the entire back. The metal cover was produced and probably applied to the codex at the end of the sixteenth or the early seventeenth century.

The iconography of the Crucifixion is distinguished from earlier Byzantine representations of the scene by the strong emotional character of the participants. The position of the hands, clenched with emotion, and the bowing of the heads occur at the end of the fifteenth and the beginning of the sixteenth century in Northern Europe. They are common in representations of the Crucifixion in woodcuts.[2] The strip around the composition recalls in its patterns the oklads of sixteenth- and seventeenth-century Russian icons,[3] and this date is also supported by the "baroque" quality of the body of the crucified Christ. While the inscriptions are in Greek, some letters betray familiarity with the Slavic alphabet.[4] It is possible that this cover was produced in one of the Orthodox Slavic lands.

Illustration

p. 1 (fol. 1r) Christ, $\overline{\text{IC}}$ $\overline{\text{XC}}$ in red (16.7 x 13.8 cm.) (fig. 93). Standing frontally in a weightless pose on a jewelled footstool with a gold top, Christ holds a Gospel in his left hand and blesses with his right. Clad in a purple tunic with a yellow-brown clavus and a blue himation, his flesh tones are warm with orange touches and green shades, his hair blue-black,

[2] For example, one can compare a woodcut from Speyer, ca. 1490, showing Christ on the Cross (now in the National Gallery, Washington). Closer to our representation is a woodcut from Cologne, which includes the angels, dated to the year 1481. In woodcuts we also see the starry background taking the form of rosettes, as in a woodcut of the Crucifixion from the upper Rhein, ca. 1460. Ultimately many of these elements derive from the traditional *Andachtsbild* of the Crucifixion. See R. S. Field, *Fifteenth Century Woodcuts and Metalcuts from the National Gallery of Art*, exhibition catalogue, Washington, D.C., n.d. (1965–66), nos. 55, 142, 342; A.

Shestack, *Fifteenth Century Engravings of Northern Europe from the National Gallery of Art*, Washington, D.C., Dec. 3, 1967–Jan. 7, 1968, no. 228.

[3] Akademia Nauk CCCP, *Istorii istkusstvo*, 4, Moscow 1959, fig. on p. 535, sixteenth-century icon of St. Nicholas.

[4] It seems the artist copies a Greek inscription without understanding fully the meaning or the correct form of accepted abbreviations and their variants. Instead of Aγιos, for example, we have Aγo, and the Ξ in the inscription over Christ's head (Δόξης) has a Slavonic character.

and his beard dark brown. Ornamental border of open, four-petal flowers. Background of this and all following miniatures in gold.

3 (2r) The Mother of God, $\overline{\text{MHP}}$ $\overline{\Theta Y}$ (16.6 x 13.7 cm.) (fig. 94). Standing frontally, in a slightly stiffer pose than Christ, Mary holds a scroll in her left hand. Border of delicate flower petal style with large, four-petal, wheel-like flowers at the inner corners.

5 (3r) Hosios Peter, O OCIOC ΠETPOC (16.3 x 13.7 cm.) (fig. 95). Frontally standing in a hieratic pose, dressed in a monk's *megaloschema*, his white hair with olive undertones, his beard long and grey-white, Peter raises his hands in prayer, palms outward, in front of his breast. Border of flower petal style taking the form of rosettes.

8 (fol. 4v) Matthew, MATΘ(αιos) above the frame (16.1 x 13.5 cm.) (fig. 96). The evangelist is shown frontally in a relaxed stance. Clad in a grey tunic with white highlights and grey-brown mantle, he is an aged man with grey-white hair. With his right arm in the sling of his mantle, and his left hand covered, he holds a jewel-studded Gospel book. Border of flower petal style in a zigzag pattern.

10 (5v) Mark, MAPKOC, above the frame (16.6 x 13.4 cm.) (fig. 97). In a contrapposto stance, wearing grey-purple tunic and grey-yellow himation, the evangelist holds a jewel-studded gold book with a blue cut in his left hand and steadies it with his right. Flower petal style border in zigzag pattern.

12 (6v) Luke, ΛOYKAC, above the frame (16.4 x 13.7 cm.). (fig. 98). The evangelist, standing frontally and slightly raising his right leg, clad in a blue tunic with a purple clavus and a grey-brown himation, holds a jewel-studded Gospel book of unusually tall format in his left hand and blesses with his right. His tense face is rendered in dark tones with red touches, and his hair in dark brown. Border of flower petal style in a blue crosslet pattern.

14 (8v) John, $\overline{\text{I}\omega}$(αννηs), above the frame (16.8 x 13.8 cm.) (fig. 99). Clad in blue-grey tunic with black clavus and grey-brown himation, with warm, red-brown flesh tones and blue-grey hair, the evangelist is represented standing, his left arm in the sling of his mantle. Border of flower petal style arranged in diamond pattern.

15 (9r) Π-shaped headpiece of gold, linear design imitating fretsaw pattern, drawn upon the plain parchment. A palmette terminating in a cross is atop the headpiece. Fretsaw initial Є in a similar gold linear design. Easter Sunday, Jn. 1:1f. (fig. 100).

22 (12v) Initial T with crossbar supported by a stork-like bird in gold linear design, a style applied to all initials. Tuesday Diakainisimou (New Week), Lk. 24:12–35 (fig. 101).

30 (16v) Initial T variant of that on p. 22, with an eagle-like bird picking at a branch that supports a crossbar. Wednesday, New Week, Jn. 1:35–51 (fig. 102).

117 (60r) Band-shaped headpiece of a rinceau pattern in gold line, in left column. Initial Є with hand. Sunday of All Saints (First Sunday after Pentecost), Mt. 10:32–38, 19:27–30.

161 (82r) Π-shaped headpiece in gold linear design, fretsaw patterns against the plain parchment. Palmette in heart shape at top center. Initial Є with palmettes and knots. Sunday of the Prodigal Son, Lk. 15:11–21 (fig. 104).

189 (96r) Initial Є with two fish heads on the bows. Holy Thursday, at the Liturgy, Mt. 26:1–20ff.

287 (145r) Band-shaped headpiece of gold rosettes and knotted initial T, left column. Menologion, September 1 (fig. 103).

290 (146v) Initial T with eagle-like bird holding a stem that forms the crossbar. Feast of the Birth of the Virgin Mary, Matins, September 8, Lk. 1:39–49, 56.

299 (151r) Initial T, a variant of the above, with a stork-like bird. Feast of the Exaltation of the Cross, Liturgy, September 14, Jn. 19:6–11.

306 (154v) Band-shaped headpiece with rinceau pattern in right column. Feast of the Presentation of the Virgin Mary in the Temple, November 21, title only, without the text of the pericope.

307 (155r) Π-shaped headpiece with stones in rosettes. Initial Є with fishtails. Christmas Eve, December 24, Lk. 2:1–20.

319 (161r) Band-shaped headpiece with fretsaw palmettes and small palmettes as pendula and initial T. Feast of the Circumcision of Christ and St. Basil's Day, January 1, Lk. 2:20–21, 40–52.

323 (163r) Band of a stylized rinceau and initial Є, Eve of the Epiphany, January 5, Mt. 3:1–6 (fig. 105).

335 (169r) Band-shaped headpiece with crosslets and plaited initial T in left column. Feast of the Presentation of Christ in the Temple, February 2, Lk. 2:22–40.

340 (171v) Tailpiece in the form of a Sassanian palmette, right column. Lk. 2:39–40 (fig. 106).

341 (172r) Band-shaped headpiece with split palmettes in circles formed by a rinceau and initial Є, left column. Feast of Hosios Peter of Monobata, February 7, Mt. 11:25f. (fig. 107).

346 (174v) Band-shaped headpiece with three different rosettes and geometric initial Є, left column. Feast of the Annunciation, March 25, Lk. 1:24–38.

357 (180r) Band-shaped headpiece in a linear rinceau and initial T, right column. Τὰ ἐγκαίνια τῆς θεοτόκου τῆς καθ' ἡμῶ(ν) μον(ῆς). (Dedication [of the church] of the Theotokos of our own monastery), May 10, Jn. 10:22–27.

362 (182v) Band-shaped headpiece in simple rinceau and initial T, right column. Feast of the Transfiguration, Matins, August 6, Lk. 9:28ff.

377 (190r) Initial Є with hand. On the return of John Chrysostom from his exile. His feast day, November 13, Jn. 10:9–16.

Iconography and Style

The portraits of the four evangelists against a plain gold background represent the "standing type."[5] They recall the classical statues of poets, orators, and philosophers, whose scrolls, however, have been replaced by codices. Iconographically they find counterparts in works of the tenth and eleventh centuries. Luke and John are similar in stance to Luke and Mark of the cod. Paris gr. 70, from the tenth century.[6] Matthew, however, recalls the standing prophet Joel in the codex Rome, Chigi Lib. R. VIII,54, Book of Prophets, datable to ca. 1000.[7] Mark's portrait with its characteristic contrapposto stance reflects earlier Christian monuments, such as an evangelist on an ivory panel in the Fitzwilliam Museum, Cambridge, England.[8]

The evangelists' classical ancestry is also revealed in their physiognomies. Matthew has a distant affinity with Sophocles in the well-known Lateran statue. The thoughtful expression of Mark can be favorably compared to representations of philosophers produced in Roman imperial times, such as the philosopher's head now in Delphi.[9]

The three remaining portraits also display standing types for which there are iconographic parallels in Byzantine book illumination. Christ and Mary recall the frontispieces in the Princeton cod. Garrett 6, fols. 10v, 11r.[10] But a remarkable difference is presented by the pose of Mary, who instead of making an orant gesture holds a scroll in her left hand. While her restrained pose may still reflect "iconic" monumental compositions, the scroll as an attribute indicates that she holds the "Word." Other parallels for Christ can be found in eleventh-century manuscripts such as Vat. gr. 756, fol. 12r.[11]

The portrait of Hosios Peter is given a special position, coming after that of Mary and before those of the evangelists. His importance can be deduced from the emphasis placed on February 7, his feast day, by a special headpiece. On this particular day the *Synaxarion Ecclesiae Constantinopolitana* mentions an ascetic by the name of Πέτρος ὁ ἐν Μονοβάγοις (probably a misprint for Μονοβάτοις) briefly and without comment.[12] From this source his commemoration passed to the Menaea printed in Venice at the end of the sixteenth century and in some of the more recent collections. The monastery of Μονόβατον or Μονοβατῶν is mentioned in Byzantine texts, but without any indication of its precise geographic location.[13] According to some scholars it may have been situated on the border between Pontus and Armenia. Most likely this Peter of Monobata was a local saint whose commemoration did not spread in the Orthodox world.[14] In physiognomic type—his long beard is very characteristic—he recalls Hosios Euthymios, as represented, for instance, in a Sinai icon.[15]

As a technicality, it should be mentioned that all the figures have rotating nimbi, i.e., the nimbi are scratched with circular lines and roughened, conveying a splendid, luminous reflection and giving an aura of light to the faces. The background is of gold sheet; a horizontal line, slightly below their knees, indicates the ground on which the figures stand.

Stylistically, the miniatures represent a juxtaposition of classical and anti-classical modes found in works of the Macedonian Renaissance.[16] The evangelists, and Christ to a

[5] Friend, "Evangelists," p. 124, pl. I,5–8.

[6] Ibid., pl. I,2–3.

[7] Ibid., pl. III,43.

[8] Ibid., pl. II,22.

[9] B. Petrakos, *Delphi*, Athens 1977, fig. 62.

[10] *Greek Mss. Amer. Coll.*, no. 1, fig. 1; Friend, "Evangelists," pl. II,8; *Byzantium at Princeton*, pp. 142–44, no. 169, color pl. F.

[11] Friend, "Evangelists," pl. VII,85; Galavaris, *Prefaces*, pp. 106f., fig. 84, with further bibliography.

[12] See H. Delehaye, ed., *Synaxarium ecclesiae Constantinopolitanae* (Propylaeum ad Acta Sanctorum, vol. 63), Brussels 1902, col. 450, cf. also col. 988.

[13] See Skylitzes, *Synopsis Historiarum*, ed. H. Thurn (Berlin 1973) p. 416, lines 75–76; also *Analecta Bollandiana*, 36–37 (1917–19, pub-

lished in 1922) p. 62, line 1; J. Darrouzès, ed., *Epistoliers byzantins du Xᵉ siècle*, Paris 1960, p. 67 n. 2. See also a letter of the Anonymous Professor of London in R. Browning and B. Laourdas, "Τὸ κείμενον τῶν ἐπιστολῶν τοῦ κώδικος BM 36749," *EEBS* 27 (1957) pp. 186–87 no. 60 (59); I owe this reference to the kindness of Prof. A. Markopoulos, who is preparing a new complete edition of these letters. Cf. I. Ševčenko, "Constantinople Viewed from the Eastern Provinces," in *Eucharisterion*, Essays presented to Omeljan Pritsak on his 60th Birthday = *Harvard Ukrainian Studies* 3/4 (1979/80) p. 738.

[14] See Eustratiades, *Hagiologion*, p. 389, where the troparion to Peter Monobata is cited.

[15] Weitzmann et al., *Die Ikonen*, p. 24, fig. 46.

[16] Weitzmann, "The Classical," p. 165.

lesser degree, despite their over-elongated bodies, display a corporeality stressed by a marked articulation of drapery folds and naturalness of their relaxed poses. This corporeality is emphasized much less in the portraits of Mary and of Hosios Peter. Mary's body is less materialized and her frontality more stressed. Peter's body is completely hidden by his flat, monastic garb. Indeed, he represents the principal anticlassical element in this set of miniatures. The dominant colors for drapery, except for Peter's garment, are blue, light blue, and purple in various shades. In each case the drapery stresses the volume of the bodies. Flesh tones are brownish with reddish tones and slight, very delicate grey-green shadows with variations. In the face of Mary more than in any other face olive shadows have been used. The brush strokes are loose (this is most evident in the face of Christ), and there is a superb transition from the red of the face to the green of the shadow, so that one can speak of a "painterly" style that is characteristic of tenth-century works.[17] The hair is black and brown with blue touches, or grey-white with olive and violet undertones. This painterly quality is found in other creations of the Macedonian Renaissance. Matthew is related to the prophet Naum in the cod. Turin, Univ. Lib. B.I.2, fol. 12r, from about the year 1000.[18] Similar comparisons can be made with figures in the Bible of Leo the Patrician, executed in Constantinople in the third decade of the tenth century.[19] The stance of these Sinai figures recalls the ivory carvings of the "Romanus" group.[20]

These classical draped figures looking into space reveal an intense spirituality; the small feet of the Virgin, which cannot bear her human weight, foreshadow the dematerializing style of the eleventh century. The brown and dark tones in the portrait of Peter of Monobata are in contrast to those of the classicizing evangelists. Spirituality is stressed here by linear design and austere expression. The mortification of the flesh is a manifestation of visionary powers.

The flower petal style frames of the miniatures recall tenth-century Constantinopolitan ornament, such as that in the Turin Book of Prophets and related codices.[21] The ornament of the headpieces, their pattern repeated with minor variations in pure gold against the plain parchment, imitates filigree work and designs found in Byzantine metal work.

The fretsaw patterns and rinceau motifs are not unlike those found in earrings from the tenth or eleventh century[22] or in the gold icon of the archangel Michael from the beginning of the eleventh century in Venice.[23]

The script of the codex has already been compared by Gardthausen to that of the presbyter Konstantinos in a Lectionary in London, Brit. Lib. cod. Harley 5598 from the year 995.[24] Recent research by Cavallo has included in these comparisons the Bible of Niketas, to which further parallels can be drawn with regard to ornament.

This Lectionary is a splendid example of a highly aristocratic art which was much appreciated in the imperial court. Its consistent splendor points to a date around the year 1000 and a Constantinopolitan scriptorium where the taste for the classical had remained particularly strong. Like other deluxe Lectionaries, it was not meant to be read in the service, as indicated by the selectivity of the readings, which do not contain the complete texts. It was destined to be carried at the Little Entrance on certain special occasions during the year and deposited on the altar; that is, it was produced as an altar implement. This also explains the good preservation of the miniatures. Tradition in the monastery identifies it as an imperial gift, either of Theodosios the Great (†395) or Theodosios III (715–717).

As for the structure of the Lectionary, it should be pointed out that the placement of all miniatures at the beginning of the manuscript was intended not to disturb the flow of the lessons, a practice typical of early Lectionaries such as the cod. Vat. gr. 1522.[25] The choice of readings and particularly the choice of feasts in the Menologion, some of them quite uncommon, may be of special significance to students of the Lectionary text and of the typika of the Orthodox Church.

Bibliography

Kondakov 1882, pp. 104, 129, nos. 32–38.
Gardthausen, *Catalogus*, pp. 40–41.
Schlumberger, *Epopée*, 3, p. 641.
N. P. Kondakov, *Ikonografija Gospoda Boga i Spasa Nasego Iisusa Khrista*, St. Petersburg 1905, pl. 57.
Gregory, *Textkritik*, p. 413 no. 300.
Beneševič, pp. 112–13 no. 106.
Idem, *Mon. Sinaitica*, 1, cols. 47–48, pls. 26–28; 2, pl. 39.

[17] Cf., for instance, the head of Naum in cod. Paris gr. 139, reproduced in color in A. Grabar, *Byzantium*, London 1966, p. 136.

[18] Weitzmann, *Buchmalerei*, pl. XXXVIII,210; also H. Belting, G. Cavallo, *Die Bibel des Niketas*, Wiesbaden 1979, p. 11.

[19] Belting and Cavallo, *Die Bibel des Niketas*, pp. 37, 39, 40, 41.

[20] Goldschmidt, Weitzmann, *Elfenbeinskulpturen*, 2, pp. 44ff., nos. 65ff.

[21] Weitzmann, *Buchmalerei*, pl. XXXVIII,210.

[22] See earrings in the Mistra Museum and a bracelet in the Benaki Museum, Athens, *Byzantine Art, An European Art*, Ninth Exhibition of the Council of Europe, 2nd ed., Athens 1964, nos. 434, 461.

[23] For a good color reproduction, see Grabar, *Byzantium*, pl. 44.

[24] Gardthausen, *Catalogus*, p. 40; Spatharakis, *Dated Mss.*, no. 31.

[25] Weitzmann, *Buchmalerei*, p. 6, pls. V,21, VI,26.

Johann Georg, Herzog zu Sachsen, *Das Katharinenkloster am Sinai*, Leipzig and Berlin 1912, pp. 22, 23, pl. X.

N. P. Kondakov, *Ikonografija Bogomateri*, 2, St. Petersburg 1915, p. 391, fig. 224.

H. Glück, *Die christliche Kunst des Ostens*, Berlin 1923, pls. 66, 67.

A. Xyngopoulos, "Τὸ ἀνάγλυφον τῆς ἐπισκοπῆς Βόλου," *EEBS* 2 (1925) pp. 105–21, fig. 6,3.

Ebersolt, *Miniature*, pp. 33 n. 4.

Friend, "Evangelists," pp. 125, 128, 130, pl. I,5–8.

J. J. Tikkanen, *Studien über die Farbengebung in der mittelalterlichen Buchmalerei* (Societas Scientiarum Fennicae Commentationes Humanorum Litterarum, V,1), Helsingfors 1933, pp. 107, 117, 178.

K. Weitzmann, "Probleme der mittelbyzantinischen Renaissance," *Archaeologischer Anzeiger* (1933), p. 356.

Idem, *Buchmalerei*, pp. 28, 30, 32, pls. XXXVII,209, XXXVIII,211, 212.

A. Protič, "Der Barock der byzantinischen Monumentalmalerei," *Atti del V Congresso Internazionale di Studi Bizantini (Rome, 1936)*, 2, *Studi Bizantini e Neoellenici* 6 (1940) pl. CV,2.

S. Der Nersessian, *The Art Bulletin* 25 (1943) p. 86; repr. in eadem, *Études*, p. 34.

Lazarev 1947, pp. 83, 302 n. 30, pls. 78, 79.

Van Regemorter, "Reliure," p. 11.

A. M. Ammann, *La pittura sacra bizantina*, Rome 1957, fig. 30.

Weitzmann, "Kaiserliches Lektionar," p. 310.

E. Wellesz, *A History of Byzantine Music and Hymnography*, 2nd ed., Oxford 1961, pl. II.

Beckwith, *Constantinople*, p. 83, fig. 104.

Weitzmann, *Makedonische Ren.*, pp. 49ff., color pl. 1, repr. in *Studies*, p. 22, fig. 209.

Idem, "Mount Sinai's Holy Treasures," *National Geographic* 125 (1964) p. 126 and figure.

Idem, "The Classical," pp. 164–66, figs. 143, 144.

Idem, "Byzantine Influence," p. 4, pl. 2.

Lazarev, *Storia*, pp. 141, 174 n. 62, pls. 137, 138.

Ch. Delvoye, *L'art byzantin*, Paris 1967, p. 270.

H. Buschhausen, "Ein byzantinisches Bronzekreuz in Kassandra," *JÖBG* 16 (1967) p. 283.

M. Restle, *Die byzantinische Wandmalerei in Kleinasien*, 1–3, Recklinghausen 1967, 1, pp. 27, 34 n. 93.

Kamil, p. 69 no. 229.

Greek Mss. Amer. Coll., p. 54.

Weitzmann, *Sinai Mss.*, pp. 14ff., pls. VII–IX, figs. 12, 13, 15.

Idem, "Cyclic Illustration," pp. 69ff., 99, figs. 49a, 49b, 50.

Idem, "Study," pp. 4–5, fig. 5.

Idem, *Sinai Icons*, p. 99.

Idem, "Classical Mode," p. 72, figs. 3, 4.

C. Mango, "Storia dell'arte," in *La civiltà bizantina dal IX all'XI secolo* (Università degli studi di Bari, Corsi di studi II, 1977), Bari 1978, p. 283, fig. 62.

Buchthal, Belting, *Patronage*, pp. 90, 95.

H. Belting, G. Cavallo, *Die Bibel des Niketas*, Wiesbaden 1979, pp. 37 n. 21, 39–41, pls. 60a, 61a, b.

Marava-Chatzinicolaou, Toufexi-Paschou, p. 146.

P. Huber, *Heilige Berge*, Zurich, Einsiedeln and Cologne 1980, pp. 15, 20, figs. 7–10.

Voicu, D'Alisera, p. 557.

Th. Chatzidakis, *Les peintures murales de Hosios Loukas. Les chapelles occidentales* (Τετράδια Χριστιανικῆς Ἀρχ. Ἑταιρείας, 2) Athens 1982, p. 163 n. 101.

A. Cutler, "The Dumbarton Oaks Psalter and New Testament. The Iconography of the Moscow Leaf," *DOP* 37 (1983) p. 39.

D. Barbu, *Manuscrise bizantine în colecții di România*, Bucharest 1984, p. 52 n. 121.

H. Belting, "Kunst oder Objekt-Stil?" in *Byzanz und der Westen. Studien zur Kunst des europäischen Mittelalters*, I. Hutter, ed., Vienna 1984, p. 78, fig. 10.

Galavaris, "Sinaitic Mss.," p. 127, fig. 12.

19. COD. 68. PSALTER
LATE TENTH OR EARLY ELEVENTH CENTURY. FIGS. 109–111

Vellum. 274 folios, 15 x 12 cm. One column of seventeen lines. Minuscule script, carefully written, beautiful *Perlschrift* for text; titles in *Auszeichnungs-Majuskel*, that of Ode 1, fol. 250v, in *Epigraphische Auszeichnungs-Majuskel*. No visible gathering numbers. Parchment rough. Ink black for text; red for Easter tables; titles in gold. Simple, unadorned solid initials in text. Doxa and kathismata not always indicated.

Fols. 1r–3v, blank; 4r, late entry, "ex libris" Sinai; 4v, blank; 5r and v, Horologion tables; 6r and v, Easter tables; 7r and v, Horologion tables; 8r, blank; 8v–9r, Credo, written by a later, thirteenth-century hand, late entry; 10r–249r, Psalms; 249v, late entry; 250r–274v, Odes. The text breaks off on fol. 274v, Prayer of Manasseh incomplete; 275r–280v, blank flyleaves.

Of the late entries, that on fol. 9r has a direct relation to the history of the manuscript. Written by a sixteenth-century hand, it reads: + τό παρὸν ψαλτήριον / ὑπάρχει δανιήλ ἱε/ρο(μον)αχ(ου) χαμαρέτου· / καὶ το ἀφηερών(ω) εἰς τό / σινα(ῖον) ὄρος (+ This Psalter belongs to the hieromonk Daniel Chamaretos and I dedicate it to Mt. Sinai.) It is followed by a curse against book thieves.

Fols. 1–4 are later paper additions. Ornament has suffered some rubbing. Parchment soiled or blackened at parts by humidity. On Easter tables, in each case numerals after the *stigma* have been erased or rubbed off, names of months have been altered.

Simple light brown leather binding on wooden boards.

Illustration

5r and v Two identical Horologion tables, each of the two arches with spandrels decorated in flower petal style.

6r and v Easter tables, six medallions, gold framed, spaces between filled with flower petals in cross forms centered around star-like rosettes in blue and red against gold (fig. 109).

7r and v Two identical Horologion tables, as on fol. 5r and v (fig. 110).

9r A tailpiece of an interlace band and a cross at the bottom of the page. Not part of the original decoration, it was probably added when the Credo was written, possibly in the thirteenth century.

10r Rectangular headpiece in flower petal style with tendrils forming roundels arranged in a scroll pattern, badly flaked. Palmettes and half palmettes at the outer corners. Initial M. Ps. 1 (fig. 111).

Iconography and Style

This cannot be considered a dated manuscript. The Paschal tables are useless for establishing a date, because they have been reused twice and the original dates cannot be deciphered. Nevertheless, a date around 1000 seems to be correct on the basis of the form of the tables, the ornament, and the paleography of the text. The system of the Easter tables parallels that found in cod. Milan, Ambros. F.12 sup. from the year 961.[1] In the ornament, the common scroll pattern encloses five-petaled flowers rendered with plasticity in bright blue and green against gold. The tendrils often terminate in palmettes and, despite flaking, a clarity and delicacy in the execution of the ornament is recognizable.

This type of decoration characterizes codices of the end of the tenth and the beginning of the eleventh century, such as the cod. Vat. gr. 364.[2] More specifically, the plastic treatment of the flowers and the pattern on fol. 10r (fig. 111), as well as the script, relate to the cod. Athens, Nat. Lib. 2364 (Four Gospels) assigned to the first half of the eleventh century.[3]

The carefully executed ornament and the brilliance of blue and gold argue for the inclusion of this manuscript among Constantinopolitan products.

Bibliography

Kondakov 1882, p. 102.
Gardthausen, *Catalogus*, p. 16.
Rahlfs, pp. 289 no. 68, 360 no. 1204.
Kamil, p. 65 no. 67.
Husmann, p. 151.
Harlfinger et al., pp. 60, 65 no. 36.
E. Kitzinger, "'The Descent of the Dove.' Observations on the Mosaic of the Annunciation in the Capella Palatina in Palermo," in *Byzanz und der Westen. Studien zur Kunst des europäischen Mittelalters*, ed. I. Hutter, Vienna 1984, p. 109 n. 38.

[1] Weitzmann, *Buchmalerei*, p. 23, pl. XXIX,168; Spatharakis, *Dated Mss.*, no. 15, fig. 36.
[2] See also Vienna, suppl. gr. 50, Weitzmann, *Buchmalerei*, pp. 26, 27,

20. COD. 368. JOHN CHRYSOSTOM, HOMILIES ON THE GOSPEL OF MATTHEW, PART II FIRST HALF OF ELEVENTH CENTURY.
FIGS. 112–114

Vellum. 372 folios, 34.3 x 16.6 cm. Two columns of thirty lines. Minuscule, well-penned, dense script for text of homilies, very small, erect, round letters, written mostly through the line; titles and Gospel text in *Auszeichnungs-Majuskel*. Gathering numbers at lower right corner of first recto. Parchment mostly thick and rough, white. Ink dark brown to black for text of homilies; Gospel text in carmine red; the word OMIΛIA, often flanked by plaited crosses, and numbers of homilies outlined in carmine and tinted in cool green-blue. Initials tinted in blue and yellow-orange; small solid initials in text in carmine.

Fols. 1r–372r, forty-five homilies on Matthew by John Chrysostom (*PG* 58, 471–694); 372v, blank.

On fol. 1r, top margin, the following entry in red by a late hand: ἁμαρτωλοῦ Θεοδούλου ἐν τῷ Ἁγίῳ ὄρει Cινᾶ. (Of the sinner Theodoulos in the Holy Mount Sinai.) On fols. 94r, 372r, still later entries, "ex libris" Sinai.

First folios not in good condition. Book shows much use. Red leather binding on wooden boards badly worn, original color faded. Repaired along the spine with tape. The tooled ornamentation consists of intersecting diagonals forming irregular patterns stamped with medallions containing the "classical" fleur-de-lis and lions. Fourteenth- or fifteenth-century, possibly made at Sinai.

Illustration

1r Π-shaped headpiece in a flourished fretsaw style and large initial A in similar style, in yellow and light green-blue, left column. Homily 45 (fig. 112).

5v Frameless band with an outlined, colorless fretsaw, right column. Homily 46.

12r A frameless band in a flourished fretsaw as on fol. 1r and initial O in similar style, right column. Homily 47.

18v Frameless band in fretsaw, palmettes, and initial T, left column. Homily 48.

29r Tailpiece of two frameless bands with rinceau and palmettes in carminé, right column. End of Homily 48.

29v Band-shaped headpiece in fretsaw style: a heart-shaped ornament in center containing a palmette with

pls. XXIV,192–94; XXXV, 196–97.
[3] Marava-Chatzinicolaou, Toufexi-Paschou, no. 16, figs. 128, 129; see also p. 79 for other examples and references.

tendrils in a rinceau pattern on either side, prefiguring the carminé style. Large initial O in the form of a fish in fretsaw style, outlined in carmine and colored with green-blue and orange-yellow, left column. Homily 49.

46v Band-shaped headpiece in fretsaw style in watery blue and dirty yellow, right column. Homily 51.

57r Frameless band in fretsaw style in colors as on fol. 46v, and initial O, right column. Homily 52.

66r Band-shaped headpiece with crenellation in similar colors, initial K, left column. Homily 53.

75r Frameless band in very mannered fretsaw with Sassanian palmettes and initial T, in style and colors as previous headpieces, left column. Homily 54 (fig. 113).

84v Frameless band with a mannered fretsaw in a rinceau pattern, initial T, left column. Homily 55.

94v Frameless band with a plaited pattern, initial Є with band, left column. Homily 56.

105v Frameless band with yellow palmettes in a blue rinceau in fretsaw style, initial O, left column. Homily 57.

115r Band-shaped headpiece with yellow and brown crosses, initial T, left column. Homily 58.

124r Frameless band with a rough fretsaw, initial K, right column. Homily 59.

136r Band-shaped headpiece with rinceau in fretsaw style, initial Є, right column. Homily 60.

141r Frameless band with palmettes in circles in fretsaw style, initial Є. Homily 61.

150r Band-shaped headpiece with rough rinceau, initial C, left column. Homily 62.

158v Frameless band with rinceau and initial T, left column. Homily 63.

165r Band-shaped headpiece with palmettes in half diamonds and initial Π, right column. Homily 64.

174v Frameless band with palmettes and a rosette in joined roundels, initial O, left column. Homily 65.

184r Frameless band with a simple rinceau, initial T, left column. Homily 66.

191v Frameless band in flourished fretsaw style with evergreen shrubs springing from a leafy stem in the center and forming a rinceau pattern. Large initial T with a knot and shaft ring, outlined in carmine and tinted in light blue and yellow, left column. Homily 67.

199r Frameless band in a fretsaw style in a pattern formed with tendrils springing from a central rosette, in blue, yellow, and carmine, left column. Homily 68 (fig. 114).

208v Frameless band with a floral motif, right column. Homily 69.

217v Frameless band with palmettes in roundels, initial T, left column. Homily 70.

225v Frameless band with palmettes in diamonds, initial M, left column. Homily 71.

231v Band-shaped headpiece with rinceau. Initial T, left column. Homily 72.

237v Frameless band with palmettes in carmine, initial Є, left column. Homily 73.

244v Band-shaped headpiece with palmettes in heart forms, initial O, left column. Homily 74.

252r Frameless band with rosette and rinceau, initial Є, right column. Homily 75.

Framed or frameless bands in similar style and ornament or variants of it have been applied to the remaining homilies on the following folios: 260v, 269r, 279r, 286r, 294v, 301v, 309r, 318r, 324v, 331r, 338r, 344v, 351v, 359r and 366r.

Iconography and Style

The ornament is characterized by its late flourished fretsaw style outlined in carmine and tinted in light watercolors. Its elements, such as the heart-shaped design (fol. 29r) and the Sassanian palmettes (fol. 75r, fig. 113), recall those in such tenth-century codices as a Gospel book probably from Sinai, now in Leningrad, Public Lib. cod. gr. 33,[1] while the initial T, in a pure fretsaw style, echoes certain initials in cod. Sinai 213 (see no. 14 above). But their execution is harder and more mannered, like that in cod. Vat. Barb. gr. 319, fol. 86r from the year 1039, ascribed to Egypt or Palestine,[2] and the cod. Sinai 188 which, in our opinion, belongs to the early eleventh century and possibly to a Palestinian center (see no. 21 below). The technique of applying color, too, is more akin to early eleventh-century examples. Paleographically the codex is related to manuscripts of the late tenth and early eleventh centuries,[3] supporting the proposed date.

The large initial O in the form of a fish is also noteworthy. It is not uncommon in manuscripts from eastern provinces, such as Patmos 70, Moscow, Hist. Mus. 134, and others.[4] The ornamental patterns in the present example

[1] Weitzmann, *Buchmalerei*, pl. LXXIX,489; for bibliography see Granstrem, *VV* 16 (1959) p. 241 no. 104.

[2] Weitzmann, *Buchmalerei*, pl. LXXX,493.

[3] See, for instance, cod. Jerusalem, Sabas 107, Hatch, *N. T. Mss. Jerusalem*, pl. IV.

[4] See also the cods. Athos, Karakallou 11, fol. 147v; Grottaferrata

reflect the earlier tradition of the ninth-century Lectionary Sinai cod. 211 (no. 4 above) fol. 189r, possibly produced at Sinai.

Considering these specific relations to Sinai manuscripts, and taking into account the distinctive, stiff parchment used here and in so many other manuscripts assigned to Sinai, we can assume that cod. 368 is a product of Sinai itself.

Bibliography

Gardthausen, *Catalogus*, p. 83.
Beneševič, p. 207 no. 376.
Kamil, p. 78 no. 430.

21. COD. 188. FOUR GOSPELS
EARLY ELEVENTH CENTURY. FIGS. 115–118

Vellum. 249 folios, 22.2 x 17.6 cm. Two columns of twenty-four lines (thirty in letter of Eusebius). Minuscule script for text, clear but not calligraphic, words separated, all written under the line; titles and Eusebius' letter in *Auszeichnungs-Majuskel*. Gathering numbers at upper right corner of first recto. Parchment thick and rough, white. Ink brown for text; titles in gold. Initials in flower petal style only at the opening of each Gospel; very small solid initials in text in gold, mostly gone and exposing red.

Fols. 1–10r, Calendar table of readings; 11r and v, letter of Eusebius; 12r–15v, Canon tables; 16r–17v, Matthew chapters; 18r–81v, Matthew; 82r, blank; 82v–83v, Mark chapters; 84r–124v, Mark; 125r, blank; 125v–127r, Luke chapters; 128r–196v, Luke; 197r, blank; 197v, John chapters; 198r–247v, John; 248r, blank; 248v, typikon; 249r, a flyleaf from a ninth- or tenth-century manuscript.

Headpieces have suffered rubbing; some gatherings are loose. Arabic text on margins of several folios.

Red-brown leather binding on wooden boards. The back cover is repaired with a piece of parchment with eleventh- or twelfth-century writing. A small piece of parchment with an interlace cross in black was probably glued later to the center of both covers, which bear the following stamped ornament (fig. 115): an outer border in heart shape done with rectangular stamps; a second parallel band with

an interlace; and finally, intersecting lines with lozenges enclosing double-headed eagles and another, unidentifiable motif. Three metal studs on the front, four on the back cover. One leather lace with a ring attached to the back cover, and a pin for closing on the front. Byzantine, probably fourteenth-century.

Illustration

12r and v, 13r and v, 14r and v, 15r and v Eight Canon tables (ca. 16.6 x 15.2 cm.) (fig. 116). Each consists of two arches spanned by a larger arch and supported by two slender columns in blue and red with capitals and bases drawn in gold over red. The tympana and arches are ornamented in a fretwork style with palmettes and tendrils in rinceau, roundels, heart-shaped designs, and crenellations, all in carmine-red and dark blue-green, drawn against the parchment.

16r Simple interlace in carminé. Matthew chapters.

18r Π-shaped headpiece in conventional flower petal style in blue and green against a gold background. Initial B in similar style. Mt. 1:1ff (fig. 117).

84r Π-shaped headpiece in flower petal style, roundels with inverted palmettes between, and initial T, in thick, not brilliant colors. Mk. 1:1ff.

125v Simple interlace in carminé. Luke chapters.

128r Π-shaped headpiece in flower petal style, palmettes in roundels with large palmettes between, and initial Є. Lk. 1:1ff.

198r Π-shaped headpiece and initial Є, both in flower petal style similar to that on fol. 128r. Jn. 1:1ff. (fig. 118).

Iconography and Style

Fretsaw and flower petal ornament occur side by side in the same manuscript, as is not unusual in Byzantine book illumination.[1] These types of ornament represent two different traditions in Byzantine manuscript illumination, the fretsaw being the older.[2] The extreme density and overcrowding point to the last phase of the ornament's production.[3]

The flower petal style represents a form of decoration that appeared around the mid-tenth century and became dominant thereafter.[4] However delicate the pattern may be, the colors are thick and lack the brilliance of Constantinopolitan products. Stylistically, the flower petal headpieces

B.a.XX, fol. 2v (southern Italy); see Weitzmann, *Buchmalerei*, pls. LXII, 435; LXXV,454; LXXVI,467; XCII,606.

[1] See, for example, cod. Athens, Nat. Lib. 56, mid-tenth century,

Marava-Chatzinicolaou, Toufexi-Paschou, no. 1, figs. 7–18.

[2] Weitzmann, *Buchmalerei*, pp. 18ff.

[3] Ibid., pp. 21ff., pl. XXVIII,159, cod. Vat. Pius II, gr. 50, fol. 128r (New Testament), from the end of the tenth century.

[4] Ibid., pp. 22f.

come close to that in cod. Vat. Ottob. gr. 457, fol. 11r, dated in the year 1039, which has been assigned to an Egyptian or Palestinian area.[5]

Paleographically the codex is related to late-tenth- and early eleventh-century manuscripts, such as the cods. Jerusalem, Stavrou 74 and Taphou 42.[6] In both cases the script is neither elegant nor consistent.

The quality of the ornament and the hard parchment point to a provincial milieu, perhaps Palestine.

Bibliography

Gardthausen, *Catalogus*, p. 37.
Gregory, *Textkritik*, pp. 247, 1135 no. 1225.
Hatch, *Sinai*, pl. XVIII.
Kamil, p. 69 no. 213.
Voicu, D'Alisera, p. 556.

22. COD. 155. FOUR GOSPELS
EARLY ELEVENTH CENTURY. FIGS. 119–122

Vellum. 243 folios, 21.5 x 16.6 cm. One column of twenty-five lines. Minuscule script for text with elements of *Perlschrift* written below the line, very regular, round letters, erect (words divided and spaced, alternating use of majuscule for some letters), individual letters also spaced out; titles in *Auszeichnungs-Majuskel*. Gathering numbers in upper right margin of first recto and lower right margin of last verso. Parchment fine and smooth, yellowed. Ink deep black for text; titles and ornamental initials in gold over red and steel blue; calendar indications and chapter headings in carmine-red.

Fol. 1r, blank; 1v, letter of Eusebius; 2r–5v, Canon tables; 6r, blank; 6v–26v, lections calendar; 27r–28r, Matthew chapters and preface; 28v, blank; 29r–89v, Matthew; 90r and v, Mark chapters; 91r–129r, Mark; 129v–130v, Luke chapters; 131r–195r, Luke; 195r, John chapters; 195v, blank; 196r–243r, John; 243v, blank. Hypotheses for each Gospel. Occasional marginal annotations in Arabic.

Parchment torn in places, showing evidence of extensive use. Binding modern: green silk, much torn, on wooden boards.

[5] Ibid., p. 75, pl. LXXXI,503.
[6] Hatch, *N. T. Mss. Jerusalem*, pls. III, XIV.

Illustration

2r–5v Ten Canon tables (ca. 19.7 x 13.6 cm.) starting in right column of fol. 2r (left half, end of Eusebius' letter) (fig. 119). They consist of two arches supported by three columns decorated in crude, wavy tendrils in a watery steel blue color in fretsaw style or in interlace pattern with crude palmettes partly in blue and partly in carmine. Palmettes of various forms in fretsaw style and tendrils decorate the arches or fill the tympana. Small crests of similar form are on top center at the joining point of the arches.

29r Π-shaped headpiece of an unframed interlaced palmette pattern in crude fretsaw style in steel blue and gold, with tendrils and half palmettes sprouting at the corners. Initial B in same style and colors. Mt. 1:1ff (fig. 120).

91r Π-shaped headpiece, interlaced palmettes in carminé style, and initial A in steel blue and gold. Mk. 1:1ff.

131r Π-shaped headpiece, chain pattern of interlaced squares with gold in center, and initial Є in steel blue and gold. Lk. 1:1ff. (fig. 121).

196r Π-shaped headpiece with medallions with palmettes framed in zigzag borders and fretsaw spandrels in carmine and some steel blue. Initial Є with hand in steel blue and gold. Jn. 1:1ff. (fig. 122).

Iconography and Style

The fretsaw ornament predominant in this codex has basically retained tenth-century forms.[1] Nevertheless, its flamboyance points to a slightly later date. The design is crude and hasty, the color scheme is poor; the prevalent blue is watery and steely, the use of gold sparse. In type only, the ornament can be compared with cod. Jerusalem, Taphou 13, which according to its colophon was made in the Studios monastery in Constantinople, probably in the early eleventh century.[2] The initials and their leafy forms also place this provincial product in the early eleventh century.

Bibliography

Kondakov 1882, p. 103.
Gardthausen, *Catalogus*, pp. 29–30.
Gregory, *Textkritik*, pp. 246, 1134 no. 1192.
Hatch, *Sinai*, pl. IV.
Kamil, p. 68 no. 180.
Voicu, D'Alisera, p. 554.

[1] Cf. headpieces and chapter titles in cod. London, Brit. Lib. Add. 22732 (Homilies of Gregory), fols. 3r, 4r, and Oxford, Auct. E.V.11,

fol. 138r: Weitzmann, *Buchmalerei*, pl. XXII,116, 118; Hutter, *Oxford*, 1, no. 2, fig. 3.
[2] Weitzmann, *Buchmalerei*, pl. XXIII,127. Best parallels for the ornament and color scheme are found in the Lectionary Paris, supp. gr. 75, which belongs to the same group of manuscripts distinguished by the fretsaw ornament; Ebersolt, *Miniature*, pl. XLI,2.

23. COD. 1186. COSMAS INDICOPLEUSTES, CHRISTIAN TOPOGRAPHY EARLY ELEVENTH CENTURY.
FIGS. 123–183, COLORPLATES IX–XIII

Vellum. 211 folios, 25.2 x 18.3 cm. One column of twenty-seven lines. Minuscule script, beginning on fol. 4v, carefully written across and below the line, *Kirchenlehrerstil* for text; titles of chapters and some captions in *Auszeichnungs-Majuskel*. Gathering numbers are at the lower right corner of first recto. Parchment mostly hard, whitish. Ink brown to dark brown for text and most captions; titles and some captions in gold; captions occasionally in white and red. Small, simple initials in fretsaw or flower petal style, very few solid initials in gold.

Fol. 3r and v, Prologue; 4r, table of contents; 4v–5v, hypothesis; 6r–209v, Books 1 and 2; 210r, blank; 210v, later entries by monks who read the manuscript, including one by Porphyrij, the Russian archimandrite, in 1850.

Condition most deplorable. Gatherings are falling apart, with several lacunae. Fols. 1–2 are flyleaves in parchment with later text. Fol. 3 begins quaternion. Gathering *a'*, two leaves missing, the first (between 2–3) and the fifth (between 5–6), and perhaps a full-page miniature lost between the latter folios. Gathering *ϛ'*, fols. 41–46, two leaves missing (between 41–42); gathering *θ'*, fols. 63–69, the last leaf cut out; fol. 67v with illustration of the "antipodes" is missing; gathering *λ'*, fols. 70–75, two leaves missing, the first (between 69–70), and the seventh (between 74–75); gathering *ιβ'*, fols. 84–91, totally loose; gathering *ιγ'*, fols. 91–100, nine irregular leaves, a single one inserted between 97–99 as 98, totally loose gathering; gathering *ιδ'*, fols. 100–106, irregular trinium (one double sheet lost, probably illustration of the choir of David), totally loose gathering; gatherings *ιε'*, *ιϛ'* also loose. Gathering *ιθ'*, fols. 139–46, consists of eight sheets but is not a regular quaternion, fols. 141 and 144 are single sheets; fol. 170v missing miniature; text breaks off on fol. 209v; fols. 210–11, only a double flyleaf with late entries on fol. 210v; fol. 201, pictures cut out; *ταυρέλαφος* on the recto and *ἀγριόβους* on the verso.

The following illustrations have been mutilated: fols. 30v, cut at both margins; 31r, head of Persian cut out; 59v, figure of Eve rubbed, probably intentionally; 74r, birds, mostly rubbed; 75r, lower part of page cut out and repaired, perhaps miniature missing; 75v, lower part of the miniature cut, while lower part of page has been repaired with new parchment; 81r, left part of miniature damaged, pieces of new parchment glued on torn parts; 82r, figures slightly rubbed; 91v, miniature slightly cut off at left and bottom; 126r, miniature slightly cut off on top; 145r, bottom slightly cut off; 174v, miniature cut on two sides; 202r, miniature cut at lower right. Some of the explanatory captions are later.

Old red-brown leather binding. Front cover is partly restored on the left side with new leather, which is in turn torn and repaired; back cover completely torn. On the front there are two large corner buckles and one in the center in the form of a rosette in hammered brass; the back cover has three. There is an arabesque on the border of the leather with pressed star-like rosettes and palmettes on the corners. In the central part are pressed medallions with fleurs-de-lis (fig. 123). The composition and ornament would probably assign the binding to the fourteenth–fifteenth century.[1]

Illustration

The compositions can be with or without frames. Framed illustrations are always indicated below. The frames consist of yellow-brown fillets, occasionally in gold, decorated alternately with variations of triangles, zigzags, ringlets, and dots.

3r Band-shaped headpiece in fretsaw in green, red, and blue, outlined in gold. Prologue (fig. 124).

3v Two quails in red-brown and violet with blue-yellow underbodies. End of Prologue (fig. 125).

6r Band-shaped headpiece in flower petal style, initial O in fretsaw. Book I (fig. 126).

13r Band-shaped headpiece in gold fretsaw, small initial O in same style. Bk. II.

28r The "Ptolemaic throne" set at the Ethiopian city of Adouli; the harbor of the city of Axomi, rectangular, framed composition (13.5 x 12.5 cm.) on the lower half of the page (fig. 127). At the upper left corner a gabled structure with a gate in a blue and black design, the city of Adouli, πόλις ἀδουλη. Three black-skinned Ethiopians carrying staffs with mantles on them walk from left to right toward the fortified city of Axomi, painted in blue on the opposite side, πο(λις) ἀξώμη. They wear short tunics in blue, red, and blue-white, and red turbans, ἀιθίοπαις πεζένοντες. Outside the frame of the miniature, this caption: ὁδός ἀπάγουσα ἀπὸ ἀδούλη εἰς ἀξώμην. In the center below is depicted the throne, δίφρος πτολεμαϊκός, as described in the text: it is rectangular with four small columns at the corners and a large, cone-shaped, spiral one in the center. The seat, with reclining back, is set atop the columns. Two figures dressed as consuls

¹ Cf. Hutter, *Oxford*, 1, nos. 5, 60, pp. 10, 99, figs. 34, 381; E. Ph. Goldschmidt, *Gothic and Renaissance Bookbindings*, London 1928, repr. Amsterdam 1967, 2, pl. 49.

are drawn in black between the columns. On the floor of the throne the letters μϵ (?). On the lower left, "behind" the throne, is a blue-white *stele* crowned by a gable-pediment upon which stands a red-skinned soldier wearing a blue loincloth, a shield in his left hand and a gold lance in his right; on the stele the caption βασιλεύ(s) μέγαs πτολεμαῖοs. Bk. II:56.

30v, 31r Daniel's vision of the Four Beasts (Daniel 7:1ff.) (8 x 13.2 cm. and 4.4 x 11.7 cm.). On the bottom margin.

30v At the left corner, Daniel reclines in an angel's lap (fig. 128). The angel, ἄγγϵλοs κ(υρίο)υ, in blue and grey-green garments with golden nimbus and outspread black-violet wings with gold striations, holds a scepter in his left hand and points upward with his right. To the right a Babylonian in a blue and red chlamys, red trousers, and a tiara, rides on a lioness: a′ (in gold) βαβυλονίω(ν). He is followed by a Median, dressed in chlamys and trousers in grey-violet and yellow-brown and with a tiara on his head, who rides on a bear, β′ (in gold) μηδῶν. The flesh tones are red and green; the animals are painted yellow-brown. A later hand has added the following identifications: ναβουχοδονόσορ over the first rider and δαρεί(οs) over the second. Bk. II:67.

31r The vision continues with two more riders (fig. 129). One, a Persian (of his head, only the remains of a red tiara are still visible), in green and blue garments and red trousers, rides on a grey leopard, γ′ πϵρσῶν, partly flaked and repeated below by a later hand. The second rider to the right, a Macedonian on a horse, wears a Byzantine diadem decorated with pearls and pendulia, δ′ μακϵδόνιῶν. All faces are in green-grey tones with strong touches of red. The following explanatory names have been added by a later hand: κύροs, ἀλέξανδροs. Bk. II:69.

33v The Earth, γῆ, according to the philosopher Ephoros (3.5 x 13.16 cm.), at the bottom of the margin (fig. 130), takes the form of a rectangular blue frame filled with brown-gold. On the inner side of the rectangle are indicated the following: at the left, the North, βορράs; at the upper center, the South, νότοs; at the right side, the Gallus, γάλλοs; a later hand has added ἄρκτοs at the lower center. Outside the frame, at the upper left corner, is the sun-disc, ἥλιοs ανατέ(λων), and along the left side of the frame, ἀνατολη. A half disc of the sun, in the center of the righthand side of the frame, sets behind the frame, ἥλιο(s) δύνω(ν), and next to the disc, δυσιs. In the center above, μϵσημ-βρία. Bk. II:79.

34r The earth and its inhabitants (3.3 x 12.1 cm.), in the middle of the column (fig. 131). A brown-gold rectangle as above with these captions: inner part, γῆ, βορράs, νότοs, all in gold; ἰνδοὶ, αἰθίοπαιs, κέλτιοι, σκύθαι, in black ink. Outside the frame the following, read clockwise: θϵρινὴ ἀνατολή· ἀπηλιώτηs· χϵιμϵ-ρινὴ ἀνατολή· νότοs· χϵιμϵρινὴ δύσιs· ζέφυροs· θϵρινὴ δύσιs. Bk. II:80.

59v The Temptation and Fall (Gen. 3:1–3) (8 x 11.3 cm.), on the lower part of the page (fig. 132). Adam and Eve, ἀδάμ · ἔva, are depicted on either side of the Tree of Knowledge in red flesh colors with grey-green tones and brown hair. They have covered themselves with fig leaves, suggesting their state after the Fall. Eve is shown in conversation with the serpent-dragon coiled on the tree. Plants and shrubs on brown hillocks indicate Paradise. Bk. III:70.

64v Band-shaped headpiece in an unframed fretsaw pattern. Bk. IV.

65r The firmament, a framed, rectangular composition (11.1 x 12 cm.) in the middle of the column (fig. 133). At the lowest part is a blue stream of water inscribed in white ὠKΕANÓC, atop which is the earth/universe in the form of a yellow-brown conical mountain, γῆ οἰκουμένη. The heavens in the form of an arch springing from the sides (the corners of the earth) and marked with dark blue wavy lines reach to the height of the miniature. At the upper part the arch is joined by another horizontal wavy segment—the firmament, στϵρέωμα—which divides the sky into the two areas of which Cosmas speaks. Bk. IV:2.

65v The waters above the firmament, the side view of cosmos (10.3 x 6 cm.), in the middle of the column (fig. 134). An elongated arch, window-like, consisting of thin fillets colored (from outer to inner part) in red, a gold line, yellow, an ink line, and green; stream-like blue bands join the arch on the upper part and at the bottom. There is no painted background. Caption in gold on the highest part of the arch: ὕδατα ἐπάνω τοῦ στϵρϵώματοs. On either side of the stream the following in black ink: top left, καὶ ἐκάλϵσϵν ὁ θϵό(s) τὸ στϵρέωμα οὐ(ρα)νὸν·; right, στϵρέωμα συνδϵδϵμένον τῷ πρώτω οὐρανῶ; at the bottom, γῆ συνδϵδϵμένη τῷ πρώτω οὐρανῶ κατὰ τὸ πλάτοs. Bk. IV:4.

66r The world and the pillars of heaven (10.6 x 13 cm.), on the lower part of the page (fig. 135). In the center of the frame is the earth in the form of a brown mountain, γῆ οἰκουμένη. On the lower part, the earth is surrounded by a blue strip of water, lettered in white

ʼΩΚΕΑΝΌC. On either side and on top of the earth is a blue band supported by two white columns on the sides, inscribed in gold outside the frame ὁι στύλοι τοῦ ὀυρανου. On the upper side are two discs with busts: the red sun on the left and the blue-green moon on the right. Above, outside the frame, the word στερέωμα in gold. Bk. IV:6.

66v Map of the world and Paradise, a framed composition (10.8 x 17.7 cm.) on the lower part of the page (fig. 136). The earth takes the form of a light yellow-brown rectangle with the following features: its inner part is marked by a blue water strip on four sides, inscribed ΩΚΕΑΝΌC in gold; its waters penetrate the land and form to the west (the left of the composition) the ῥωμαικός κόλπος, to the southeast the ἀραβικός κόλπος and and next to it the περσικός κόλπ(ος), to the northwest the κάσπια θάλασσα. The land encircled by the ocean is marked by the following inscriptions, read clockwise, left to right: δυτικὰ μέρη χαμηλὰ (at the water, partly flaked), δυτικὰ μέρη ὑψηλὰ, βόρεια μέρη ὑψηλὰ, ἀνατολικὰ μέρη ὑψηλὰ (completely rubbed off), ἀνατολικὰ μέρη χθαμαλά, τιγρις (almost flaked), ευφρατης. On the ocean are set four medallions, one in each direction with wind gods (in reddish flesh tones) blowing horns. Beyond the ocean, the lefthand part of the earth is cut off and the inscription lost. (It has survived, however, in a similar miniature in the Cosmas codex in Florence). On the upper strip of earth, γῆ πέραν τοῦ ὠκεανοῦ, ἔνθα πρὸ τοῦ κατακλυσμοῦ κατώκουν οἱ ἄν(θρωπ)οι. On the lower strip only part of the inscription has survived: τό πέρας τοῦ ὠκεανοῦ...ποταμός. To the extreme right a band consisting of four rectangles, each with blossoming trees and flowers, is identified by an inscription outside the frame as ὁ ἐν ἐδέμ παράδεισος. On the strip between Paradise and ocean the following inscription can be read (from top to bottom): γῆ πέρα τοῦ ὠκεανοῦ· [...] τὰ ἔξω τοῦ παραδείσου· [...] γῆ πέρα τοῦ ὠκεανοῦ. Bk. IV:7.

67r The world and the ocean (10.3 x 14 cm.), on the upper part of the page (fig. 137). The light brown earth, of an almost trapezoidal form, γῆ ὀικουμένη, penetrated around its center by a strip of water on which is the caption ΩΚΕΑΝΟC ΚΥΚΛΩΝ ΤΗΝ ΓΗΝ ΑΠΑCΑΝ. Outside the ocean, at the upper left, rises the red disc of the sun, ηλιος ανατελων; to the lower right the sun in the form of a half disc sets behind the water, ἥλιος δύνων. Bk. IV:8.

68v "The Mountain in the North": elevation of the earth seen from the northwest (11.5 x 12 cm.), on the lower part of the page, within the written column (fig. 138). Within a rectangular frame, the earth takes the form of a conical mountain, γῆ πᾶσα οἰκουμένη. The peak of the mountain is marked by three encircling red lines, with the following inscriptions, read from top to bottom: μικρα νύξ, μέση νύξ, μεγαλη νύξ. At the bottom, the earth is surrounded by the ocean, ΩΚΕΑΝΟC, in gold. Outside the earth and against the parchment on the left, is the sun-disc; another sun-disc in red is set behind the mountain: ἥλιος ἀνατέλων· ἥλιος δύνων. The remaining captions, in brown-black ink, read: τὰ ὑπερβόρεια μέρη τ(ῆς) γ(ῆς) τὰ ἀοίκητα· ἔνθα τὴν νύκτα διατρέχουσιν οἱ φωστ(ῆρες). Bk. IV:15.

69r The universe (a cosmogram of the "Christian Topography") (11 x 12.4 cm.), on the lower half of the page (fig. 139). The earth is represented as on fol. 68v with the following inscriptions: ΓΗ̅ in gold; βόρεια μέρη ὑψηλά · δυτικα μέρη ὑψηλά · ἀνατολικὰ μέρη χθαμαλά · κόλποι δ̅ · νότια μέρη χθαμαλά. The earth is enclosed by the ocean, ΩΚΕΑΝΟC, in white. The sun-disc is shown rising to the upper right, and setting to the lower left, ἥλιος ἀνατέλων· ἥλ(ι)ος δύνων. The earth and the ocean, the universe, are enclosed in a chest-like structure, the sides of which are formed by brown arches filled with blue. The following inscriptions in gold are found on the sides: right, τοῖχος ἀνατολικὸς τοῦ οὐρανοῦ·; left, τοῖχος δυτικὸς τοῦ οὐρανοῦ. The semicylindrical top, decorated in the center with a diamond pattern with crosslets, contains within a medallion a bust of Christ in red and blue garments, with brown hair and gold nimbus marked by a light blue cross. Below, on the blue strip, is the word CΤΕΡΈΩΜΑ in huge gold letters. Outside the composition, above Christ, is the following inscription: ὁ κ(ύριο)s ἡμῶν ι(ησοῦ)s χ(ριστὸ)s, and on either side on top, written vertically, ἡ βασιλεία τῶν οὐρανῶν. Bk. IV:16.

69v The nine heavens and the signs of the zodiac (diam. 17 cm.), full-page miniature (fig. 140). The composition consists of nine homocentric circles. The first, in the center, is the earth depicted in yellow-brown. The next seven circles (only delineated against the parchment) are inscribed as follows: κρόνου, διός, ἄρεος, ἡλίου, ἀφροδίτης, ἑρμοῦ, σελήνης. The last and outer circle contains the signs of the zodiac, painted on blue ground and with frames marked by gold lines. All inscriptions, naming the signs and the names of

the months according to the Egyptian calendar, are outside the medallions on the parchment, and read: ὑδριαχόος μεχείρ ιᾱ· αἰγόκερος τύβη ῑ· τοξότης χυάκ θ̄· σκόρπιος ἀθύρ η̄· ζυγός φαωφι ζ̄ παρθένος θώθ ς̄· λέων μεσώρη ε̄· καρκίνος ἐπιφι δ̄· δίδυμος παΰνη γ̄· ταῦρος παχών β̄. Two more inscriptions are rubbed off. Bk. IV:16.

70r Band-shaped headpiece with rosettes and palmettes; initial Π in fretsaw style. Bk. V:1.

73r The Israelites' arrival at the twelve springs (Ex. 15:27) (13 x 13.4 cm.), on the lower half of the page (fig. 141). A rectangular, framed miniature. To the right Moses, μωϋσής, clad in a light blue chiton and a pink-brown himation, dips a rod to a light yellow-brown ground (cf. Ex. 20:25; at this part the miniature is slightly damaged) from which the twelve springs at Elim gush forth. Above the springs is the red pillar of fire: στύλος πυρός. Behind Moses stands Aaron, ἀαρών, clad in a light blue chiton and an orange-yellow himation; like Moses, he wears a golden nimbus. To the left of the composition are four groups of Israelites, two groups of men and two of women, dressed in blue, pink, and brown garments. On the upper part of the composition is spread the protective cloud, νεφέλη, in violet and blue colors with yellow shades. At the right corner the blessing hand of God appears from a segment of sky. Bk. V:13.

73v The miracle of the manna (Ex. 16) (13 x 13.7 cm.), on the lower half of the page (fig. 142). The rectangular framed miniature represents in the lower right foreground Moses, μωϋσής, in blue and carmine garments, and Aaron, ἀαρών, in blue and yellow-brown. Both are depicted facing to the right. In front of them, the remaining traces of a destroyed triangular area most likely indicate a representation of Mt. Sinai before which stands the pillar of fire and the pot urn: στύλος πυρό(s)· στάμνο(s). Moses and Aaron are followed by a child who seems to talk to them, a group of Israelite men and women, and another boy carrying a basket with the manna on his back. They are all walking on and above a strip of green, red-blossomed shrubs. The scene of the gathering of manna is depicted at the upper right: four Israelites, two on either side, gather the manna: λαὸς ἰσραηλιτῶν τὸ μάννα ἐκλέγ(ων). At the upper left corner are the twelve springs in the form of a segment of ground with water issuing from it, αἱ δώδεκα πηγαί. Next to the springs are the sun, ἥλιος, the protective, multicolored cloud, νεφέλη, and the hand of God open and distributing

the manna. Beneath the twelve springs, at the extreme left, a water stream flows down (Ex. 17:6); six palm trees are next to it, οἱ φοίνικες, and above them is the city of Elim: πό(λις) ἐλείμ ἥν νῦν καλοῦ(σιν) ραιθοῦ. Emerging from the city or next to it is a male figure clad in a short carmine tunic with sleeves and high boots, shepherding two oxen, a sheep, and two goats. Bk. V:14.

74r The quails and the smiting of the rock at Kadesh (Ex. 16:13, Numbers 11:7–9, 20:1–11) (12.6 x 13.5 cm.), on the lower half of the page (fig. 143). A framed rectangular composition depicts in the lower right foreground Moses, μωϋσής, and Aaron, ἀαρών, who are represented as on fol. 73v. Moses touches or strikes with his wand a long stream of light blue waters, within which twelve deep blue water strips are shown, one above the other: πηγαὶ ῑβ. Behind Moses and Aaron, in the center foreground, is a group of Israelite men and women, and to the extreme left, next to the group, several animals followed by three young men who carry on their shoulders a staff with a piece of drapery, a characteristic attribute of travellers. In the upper half of the composition are the flying quails, painted in black. Most of them have been rubbed off. An inscription outside the frame, along the vertical sides, reads: ὀρτυγομήτρ(α). On the upper corners of the miniature are two cities: at the left the walled, towered city of Elim, πό(λις) ἐλήμ, and at the right the city of Raithou, πό(λις) ῥαϊθοῦ. The latter takes the form of a temple with a two-columned facade and a pediment. Between the two cities is the protective cloud, ἡ νεφέλη, and below the city of Raithou the column of fire, στύλος πυρό(s). Bk. V:15.

75v The vision of Moses on Mt. Sinai and the receiving of the law (Ex. 19; 24:12–18; 31:18, 34:1ff.; Deut. 9:9–11), the lower part of the miniature cut off (11.4, originally 13.1 x 13.3 cm.), in the middle of the page (fig. 144). The framed rectangular composition represents at the lower right corner Moses, prostrate to the right, within a green and violet arc representing a cloud, νεφέλη. His veiled hands extend toward the rocks of Mt. Sinai, from which issue tongues of fire, ὄρος σινά. Outside the cloud, at the lower left part of the miniature, is a group of Israelites—all men, of various ages—gesticulating in astonishment. One of them points to a red tent with a conical roof set on a gold tripod, σκηνή. At the upper right, Moses, ascending the green mountain, is about to receive the tablets from the hand of God: μωϋσης λαμβάνων τὸν

νόμον ὑπο θ(εο)ῦ. He turns his head toward a group of Israelites: λαὸς ἰσραηλιτῶν. A second tent, σκηνή, similar to the one described above, is depicted behind the group. Below this tent, at the left, three children point toward Moses. A long inscription at the left margin has been partly cut off but it has been fully preserved in the Vatican copy and can be completed as follows: (μ)ωυσῆς ἔσωθεν. τῆς (ν)εφέλης ἄβρωτος δι(α)μείνας ἡμέρας τε(σ)αράκοντα καὶ νύκτας (τεσ)-σαράκοντα (ἐνταῦ)θα ἠξιώθη ὁ μέ(γας μ)ωυσῆς μετὰ τὰς (τεσσα)ράκοντα ἡμέρας (ἐν ἄ)λλαις ἕξ ἡμέ-ραις (ἰδεῖν) δι ὀπτασιῶν πῶς (ἐν τ)αῖς ἐξ ἡμέραις (ἐποίησεν) ὁ θ(εὸ)ς τὸν οὐ(ρανὸν) κ(αὶ) τὴν γῆν καὶ (πάντα) τὰ ἐν αὐτοῖς (κατὰ) τάξιν μιᾶς ἑκά(στης) ἡμέρας ὁ θ(εὸ)ς κα(τε)θάρρησεν (καὶ) συγγρά(ψαι) ταῦτα δοξασθείς (καὶ) τὸ πρόσωπον ὑπό (τοῦ θεοῦ). Bk. V:16.

77r Two Attic rhetoricians, οἱ ἔξωθεν ἀττικοί, are represented standing frontally, dressed in chlamides and tablia and holding scrolls (5.6 x 6.4 cm.), on the lower margin. Bk. V:26 (fig. 145).

77v The tabernacle (Ex. 26:15–35) (6.1 x 12.2 cm.), in the upper part of the page (fig. 146). A rectangular precinct is depicted in perspective; the two exterior, light yellow-brown sides and the tops of the other two sides are shown. The tabernacle consists of a railing of upright golden spikes, with a conical top, a base, and a yellow curtain with a blue border, joined on top by a black line and in the middle by a scalloped bar outlined in black and red. Inscriptions on the four sides indicate the corresponding cardinal points: βορρᾶς· νότος· ἀνατοληί· δύσις. The interior space is divided into two "rooms" by means of a gold strip identified as the curtain, καταπέτασμα. The room to the right contains the table, ἡ τράπεζα, in the form of a gold rectangle with three ringlets, the shewbread, on each corner; the menorah, λυχνία; the rod of Aaron, ράβδος; the pot of manna, στάμνος; the tablets of the Law, αἱ πλάκ(ες); and the brazen, green-grey serpent of Moses, ὄφις. The text written along the right side, outside the precinct, indicates the position of the door, ἡ θύρα τῆς σκηνῆς. The room to the left—the inner tabernacle—contains the Ark of the Covenant in the form of a flat, gold trapezoid: ἡ κιβωτὸς τοῦ μαρτυ-ρίου· ἐσωτέρα σκηνὴ· ἄγια ἀγίων. The following inscriptions, referring to structure and size, are outside the tabernacle: on the upper right corner, ἔχουσα βί-λον συρτ(όν) λεγόμενον ἐπίπαστρον; on the lower left corner, τὰ ὀπίσθια τῆς σκηνῆς· στύλοι ἕξ· ἀπὸ

πήχας γινόμεν(οι) πήχ(εις) θ'· καὶ δύο στύλοι εἰς τὰς γωνίας ἀπὸ πήχης C (= το ἥμισυ) γινόμεναι τῶν $\overline{η}$ στύλων πήχ(εις) $\overline{ι}$· τοῦτο τὸ $\overline{π}$λάτος τῆς σκηνῆς. Bk. V:23.

79r The coverings of the tabernacle (Ex. 26:1–4) (ca. 8.8 x 14 cm.), on the upper part of the page (fig. 147). Six rectangular panels, four above and two below, each framed in yellow, are coupled in pairs, by the following patterns: yellowish stars and green dots on a blue field, black grille with yellowish dots in the center on a brown-red field, and a checkerboard pattern in blue and dark purple. Along one long side of each pair a row of clasps on the right border of one covers a row of loops on the left border of the other. The inscriptions read: τὰ σκεπάσματα τῆς σκηνῆς, σκεπάσματα πρῶτα, σκεπάσματα δεύτερα, σκεπάσματα τρίτα. Vertically, along the exterior sides of each pair: κρί-κοι, ἀγκύλαι. Bk. V:32.

81r The shewbread table and the seven-branched candlestick (Ex. 25:23, 28) (11 x 14 cm.), on the lower part of the page (fig. 148). The table takes the form of a rectangular panel on the left; the word τράπεζα is repeated along the left and right sides of the rectangle, which contains an inner golden field whose four corners hold three roundels, each marked by a crosslet, representing the loaves of bread, and an inner blue border with a gold rinceau and stylized railing decorated with a series of red strokes. The seven-branched candlestick to the right, made of lilies and knops, is depicted in gold, but pale orange has been used for the knops. Six branches are crowned by lamps in the form of doves, issuing flames from their beaks. The following inscriptions in gold, above the composition, give the title of the composition and name the lamp and its various parts: διαγράψομεν καὶ τὴν λυχνίαν καὶ τὴν τράπεζαν· ἔστιν οὖν καὶ αὐτὰ οὕτως. Between the feet of the lamp, λυχνία ἑπτάμυσσο(ς); along the shaft, καυλός; around the upper part of the lily-like holder, on the left, κρίνον αἰρῶ· σφεροτήρ καρνίσκος; on the right, κρατὴρ τορευτός; along the outer branches, repeated twice, left and right, τρεῖς καλαμί-σκοι. Bk. V:33.

82r Zacharias and Abias, the priests, keeping watch on either side of the Ark of the Covenant (Ex. 25:20–21) (8.2 x 12 cm.), a framed composition in the upper part of the page (fig. 149). Zacharias, ζαχαρ(ίας), with grey hair and grey beard, is represented at the left. He wears a dark blue tunic with a golden clavus over it, a shorter green tunic, and a green cloak. Abias,

ἀβία(s), with brown hair and beard, is depicted on the right. He is clad in a brown-red tunic with a golden clavus, a shorter tunic in dark blue, and a green cloak. Both wear gold nimbi, hold gold scepters, and touch the roof of the ark with their hands. The ark, ἡ κιβωτὸς τοῦ μαρτυρίου, chest-like with a vaulted lid in gold, ἱλαστήριον, has a door of two gold leaves with light green inner panels framed by an orange-red rinceau with large, dark blue dots. Above the ark is a pair of cherubim in gold, each inscribed χερουβίμ. Bk. V:37.

82v The tabernacle and its court (Ex. 27:9–18) (7.3 x 12.1 cm.), within the column, in the middle of the page (fig. 150). The inner tabernacle is shown in the center, in the form of a panel with a checkerboard decoration in red and blue, framed in gold and held by four red ground wires fixed to the ground by four gold pegs. The empty field around it is identified as the courtyard by large letters in cross form, ΑΥΛΗ, and by an added inscription in black: αὐλὴ τῆς σκηνῆς. The colonnaded precinct is represented in the manner of a ground plan. It consists of gold columns with blue curtains between them; in the middle of the right side a large curtain decorated with a gold fleur-de-lis pattern is identified as the entrance, εἴσοδος. The sides correspond to the cardinal points: ἄρκτος· μεσημβρία· ἀνατολή· δύσις. Outside the miniature is found ἡ σκηνὴ κατακεκαλυμμένη, and an explanatory inscription, καὶ ἀποτεταμένη διὰ τῶν κάλων καὶ τῶν κρίκων. Bk. V:39.

84r The vestment of the priest (Ex. 28:4–43), a rectangular, framed composition (9.1 x 12.1 cm.), on the upper part of the page (fig. 151). Aaron dressed as an archpriest, holding a bejewelled gold censer and a pyxis, is represented twice: on the left, as if he were seen from the rear, ἀαρὼν μέγας ἀρχιερεὺς ὀπιστοφανής, and on the right frontally, with his head turned slightly to the left, ἀαρὼν μέγας ἀρχιερεὺς ἐμπροστοφανής. The costume follows closely the description given in the text: a light steel blue, long-sleeved, full-length robe with a wide gold and jewelled border; over it, a green tunic with a fringe of small gold bells, a breastplate of light brown decorated with a diamond pattern of twelve red stars (reflecting the number of tribes), a shoulder-piece with a gold collar affixed to it, a gold girdle, a gold and red tiara, and pale yellow shoes. Outside the miniature, an inscription in gold: Τὸ σχῆμα τοῦ ἱερέως. On the right margin, an explanatory inscription partly cut off along the margin reads:

ἐνταῦθα τὸ (σχῆμα τῶν) ἐνδυμάτ(ων) τοῦ (ἱε)ρ(έως) δι)εγράψαμεν ἐμπρ(οστο)φανῆ καὶ ὀπισθοφ(ανῆ) ἀκριβέστερον (δὲ ἐν τῇ) ἐξηγήσ(ει) δε(δήλωται) περὶ αὐτοῦ. Bk. V:45.

86v The twelve tribes (the encampment of the Israelites in the desert), a rectangular, framed miniature (15.8 x 15.8 cm. without the tip of the lances), on the lower part of the page (fig. 152). In the center, a rectangle encloses the tabernacle, σκηνὴ, chest-like, as in previous depictions, with a square panel in its lower part and an arched one on the lid, both in gold; they are framed by a blue field decorated with a rinceau motif in white. Moses and Aaron, μωϋσῆς· ἀαρών, are shown to the right, both in blue chitons, Moses clad in a pale carmine himation and Aaron in a dull yellow-brown one. Around the other three sides of the tabernacle are represented seven Levites, λευΐται (written twice), all standing frontally. Those behind the tabernacle are shown as half figures. They are all dressed in chitons and himations in colors ranging from pale carmine to yellow-brown and green. Around the four sides of the central rectangle are twelve compartments, three on each vertical side, each containing four warriors, and three smaller compartments above and below, each with three warriors. This arrangement of the tribes agrees with Cosmas' text. The colors of the military costume are green and pale carmine for the tunics, brown for the armor, pale carmine and red for the shields, with blue-green borders and blue helmets. The names of the tribes are inscribed outside the frame, clockwise as follows: φυλὴ δανβώρας· φυλὴ συμεών· φυλὴ νεφθαλείμ· φυλὴ ἰσαχάρ· φυλὴ ἰούδα· φυλὴ ζαβουλώμ· φυλὴ γάδ· φυλὴ ρουβίμ· φυλὴ βενιαμίν· φυλὴ (αἰφραὶμ? totally flaked)· φυλὴ μανάσσ(η)· φυλὴ ἀ(σ)ήρ. Bk. V:55.

89r The crossing of the Jordan (Joshua 3:14ff.), a framed composition (10 x 14 cm.) on the lower half of the page (fig. 153). The Ark of the Covenant, depicted as previously in yellow-brown with gold ornamentation and pearl-like jewels, is carried across the Jordan on staffs passed through rings by four Israelites clad in carmine, yellow, red, and blue tunics. The river is represented as a light blue current with darker blue streams at either end and an indication of green ground below and trees above. Behind the ark are two Levites in half-figure, the one on the left wearing a carmine, and the one on the right a yellowish mantle: λευΐται. To the right of the composition stands Joshua, ἰ(ησοῦ)s ὁ τοῦ ναυῆ. He is old and bearded,

clad in light blue chiton, a yellow-brown himation, and a nimbus. Another figure, beardless and youthful, clad in a light blue chiton and pink himation, stands directly below Joshua. Next to them are three pairs of figures, one above the other. Dressed in knee-length tunics like the carriers of the ark, they carry on their shoulders pink and blue stones for the erection of the altar, the colors of the stones alternating with those of the tunics. On the left are two groups of men and women, one above the other, clad in blue and carmine robes, though some of the women appear in very dark purple. Above the miniature is the picture title: ἔστιν οὖν οὕτως ἡ διάβασις τῶν ἰσραηλιτῶν ἐν ἰορδάνη μετὰ ἰ(ησο)ῦ τοῦ ναυῆ. Bk. V:62.

89v Adam and Eve (6.5 x ca. 6.4 cm.), middle of the page (fig. 154). Both are standing, wearing gold nimbi: ἀδὰμ καὶ ἔυα. Adam, with grey hair and dressed in a blue chiton with carmine clavus and a yellow-brown himation, holds a scroll. Eve is in blue and red, with red shoes. Bk. V:62.

91v Abel as shepherd (Gen. 4:2) (8 x ca. 15 cm.), on the lower left and bottom margins (fig. 155). Standing frontally, but crossing his legs like a *boukolos*, Abel, ΑΒΕΛ, wears a gold nimbus and a short, dark brown tunic of sheep skin, the *tunica exomis*. In his left hand he holds a *pedum* diagonally against his thigh, while his right hand is folded on his breast. His flesh tones are brown. To the right a goat jumping at Abel's pedum is followed by two ewes, a grey dog with a red collar, a ram, and a kid, seated on the ground. Two goats jump against one another at the extreme right, recalling classical motifs. The animals are painted in various shades of grey and brown. Bk. V:59.

93v Enoch and Thanatos (Gen. 5:22–24) (ca. 7.5 x 9.7 cm.), in the middle of the page (fig. 156). Standing to the right in a slightly contrapposto pose, Enoch, ἐνώχ, has brown hair and beard, a gold nimbus, blue and pale violet robes, and a green sash across his breast. Resting his right hand on his breast and concealing the other under the himation, he turns his head slightly to the right. To the left is the seated personification of Death: θάνατος αὐτὸν ἀποστρεφόμενος. His legs, resting one on the other, are directed toward the right, while his upper body and head turn to the left, a direction followed also by his right hand. Thus Death is turning away from Enoch. The personification in olive flesh tones, brown hair and green loin-

cloth, is intentionally rubbed and has a hole in the center. Small initial O in fretsaw style. Bk. V:82.

94v Noah and the ark (Gen. 6:6ff.), two illustrations, one in the upper part of the page and one in the bottom margin (figs. 157, 158):

1) (11 x 12.7 cm.) Noah emerges from the ark, ἡ κοσ-μοφό(ρος) κιβωτός, through an opening under the gabled roof. With steel blue hair, beard, and garments, he extends his hands to the right toward a flying steel blue dove carrying a green branch. The ark, represented as a square structure with planks indicated by vertical and horizontal stripes in dull red and brown, floats in blue waters. Before the ark in the water appear the heads of drowned people, outlined in brown, and in the foreground a black raven perches on a corpse. Below the ark is the title in gold: τοῦτο τὸ μῆκος τῆς κιβωτοῦ.

2) (3.4 x 7.6 cm.) The ark, a yellow-brown trapezoidal structure viewed from the left corner and above, displays a three-story division, with a brown window in its upper part: ἡ κοσμοφό(ρος) κιβωτὸς. Bk. V:86.

97r Melchisedek, in the column (7.2 x 5 cm.), lower part of the page (fig. 159). Standing frontally with his hands extended in a gesture of prayer, he has black-brown hair, wears a gold nimbus, blue tunic, and red chlamys, a yellow tablion, a crown with pearls and pendulia, and red shoes. μελχισεδὲκ βασιλεὺς καὶ ἱε-ρεύς. Bk. V:95.

98r The sacrifice of Isaac (Gen. 22:1–4), a framed composition (9.9 x 13 cm.) on the lower part of the page (fig. 160). The following three scenes are represented simultaneously. At the upper left, two youthful servants of Abraham, οἱ παῖδες τοῦ ἀβραάμ, one clad in pink and the other in red, both garments having green borders, lead a violet ass. Below, a violet ram is tied to a blue-green tree, and Isaac carries wood to the altar: ἰσαὰκ βαστάζων τὰ ξύλα. To the right, dressed in blue chiton, light carmine himation, and gold clavus, is Abraham, ἀβραάμ, in a striding posture. Grasping Isaac by the hair with his left hand and pulling him violently backward, Abraham is about to thrust his knife into his son's throat. Isaac, in a half kneeling position with his arms fettered behind his back, is clad in a light blue tunic also with a gold clavus: ἰσαὰκ συμποδιζόμενος. Father and son are looking upward to the hand of God depicted in the right corner, emerging from a segment of blue sky, and issuing green rays. Below is the altar, a light brown vessel

with fire, θυσιαστήριον. A triangular area of ground at the lowest right corner refers to the location, Mount Moriah. Bk. V:101.

99v Isaac (6 x 2.1 cm.), on the lower margin (fig. 161). He is shown frontally, his right hand in a gesture of speech and his left under his mantle. He has blue-grey hair, a gold nimbus, and blue-carmine garments. ἰσαάκ. Bk. V:103.

100v Jacob and Judas, in the column (ca. 6.2 x 7.3 cm.), middle of the page (fig. 162). Jacob on the left and Judas on the right, in three quarters view, address one another. Jacob, with violet-grey hair, is clad in blue and light carmine garments with green borders. Judas, rubbed off, wears blue and carmine robes. Both wear nimbi. ἰακώβ· ἰούδας. Bk. V:107.

101v The miracle of the burning bush and the receiving of the law (Ex. 3:1–16; 24:12–18; 31:18), a framed composition (10.4 x 14.3 cm.) on the lower half of the page (fig. 163). Moses is represented frontally at the left of the composition, amidst his flock of five sheep and a resting dog, all painted in grey and brown-grey and on olive green patches of ground. He wears a short, sleeveless red-orange tunic with two square patches in front and epaulettes, all in gold, black pearl-dotted clavi, and a blue-white girdle with a tasseled end. His youthful face has grey-green flesh tones with red spots. Framed by a gold nimbus and barefooted, he supports his staff against his left thigh, while his right hand is folded to his breast. Above him to the right appears the hand of God out of a segment of blue sky, in a purple sleeve with golden stripes, issuing rays. The text reads: μωϋσῆς θεωρῶν τὴν βάτον. Next to Moses, above the flock, is a pair of orange and white-blue boots, ὑποδήματα. On the right part of the composition Moses, μωϋσῆς, in blue and pale carmine garments with strong white highlights, is shown climbing a mountain and receiving with his veiled hand a blue scroll from the hand of God. In front of Moses and to the right, a yellow-brown, chalice-like vessel with a green top from which issue red flames, is inscribed ἡ βάτος. At the lower right is a triangular segment of brown ground with six red tongues of fire. It is inscribed as the ὄρος. Bk. V:111.

107v Elijah's ascension (II [IV] Kings 2:1–4), a framed composition (10.3 x 14 cm.) in the column (fig. 164). Elijah is shown with blue-grey hair and gold nimbus, clad in a blue tunic and olive grey himation, riding on a gold chariot drawn by two fire-red horses with red,

gold-framed saddles, ἅρμα πυρός. He throws his dark brown mantle to Elisha at the left, depicted in blue tunic and light yellow-brown himation, ἐλισσαος δεχόμε(νος) τὴν μηλωτ(ὴν). At the top left corner, a group of Israelite men in yellow-brown and grey-green himations and blue tunics witnesses the scene: π(άτ)ερ π(άτ)ερ· ἅρμα καὶ ἱππεὺς αὐτοῦ. Next to them, a black raven carries a loaf of golden bread, and in the opposite corner the hand of God, sleeved as in previous representations, emerges from a blue segment of sky, issuing green rays. At the lower right corner is the reclining river god Jordan, ἰορδάνης, in a green *tunica exomis* with his right hand raised over his head, holding in his left a golden vessel from which blue water flows along the frame of the miniature. Behind the Jordan is a rocky mountain, the rocks rendered in pinkish circular forms outlined in olive: ὄρος. Bk. V:140.

110r The story of the prophet Jonah, three scenes (ca. 13.3 x 14.4 cm.), on the lower part of the column (fig. 165). 1) In the center two naked men, one bearded and the other beardless, are throwing Jonah from a yellow-brown sailing boat into the mouth of the sea monster, painted green with red paws and tail. 2) Jonah prays as he emerges from the mouth of the monster. 3) Above and to the right, the naked Jonah rests under the gourd tree, painted in green with red fruit, on a red-brown strip of land. Three fish in red-brown and green swim in the water. All figures are rendered with red-brown flesh tones and dark brown hair. The caption is written in gold: ὁ προφήτης ἰωνᾶς. Bk. V:152.

125v Saul keeping the garments of Stephen's executioners (Acts 7:58), a framed composition (8.7 x 12 cm.) on the lower part of the page (fig. 166). At the left, Saul, with dark brown hair and in blue tunic and carmine himation, both strongly highlighted, seated on a backless throne with a footstool, both in yellow-brown tones, with a red cushion, holds a scroll in his left hand and addresses six youthful executioners. Arranged in two rows (the first person on the left is flaked off), and dressed in short, sleeved tunics of very light pink-violet with gold borders, they throw their mantles, rendered in green, steel blue, and yellow-brown, to the ground: σαῦλος φυλάττων τὰ ἱμάτια τῶν ἀναιρούντων τὸν στέφα(νον). Prologue to the Acts of the Apostles. Bk. V:177.

126r The stoning of Stephen (Acts 6:8ff., 7:10), a framed miniature (14.2 x 14.3 cm.) on the upper part of

the page (fig. 167). At the lower center foreground, within a semicircular light blue amphitheater, Stephen in a frontal, striding stance, extends his hands in prayer. He has dark brown hair, wears a gold nimbus, and is clad in blue and light carmine-violet robes. Eight youths, dressed as on fol. 125v, symmetrically arranged at the opposite corners and behind the wall of an arena-like structure, are stoning Stephen. Above, the hand of God holds the martyr's pearl-studded crown. Across Stephen: στέφανος ὁ πρωτομάρτυς λιθαζόμενος; above him: κ(ύρι)ε ἰ(η)σ(οῦ) χ(ριστ)ὲ δέξου τὸ πνε(ῦμα) μου; and on top: λαὸς ἰουδαίων λιθάζων τὸν στέφανον. Bk. V:213.

126v The conversion of Paul (Acts 9:4–19), a framed composition (10.5 x 15.7 cm.) on the lower half of the page (fig. 168). The event is represented in five scenes simultaneously, from left to right: 1) Two archpriests (all figures wear blue tunics but have mantles of different colors), one young and one old, in olive grey and yellow-brown mantles, are seated on a red-brown backless throne with a red cushion. The older one hands Paul a letter in the form of a blue-white scroll: οἱ ἀρχιερεῖς· σάνλο(ς). 2) Paul and two companions, οἱ σὺν τω σάνλω πορευόμε(νοι), look upward to the beams of light issuing from a segment of sky, rendered in three strips of different tones of blue: σαοὺλ σαοὺλ τί με διώκεις· ἐγώ εἰμι ι(ησοῦ)s ὃν σὺ διώκεις. 3) Paul is prostrated and extends his veiled hands forward. 4) Paul, standing with a red book in his hands, now wears a gold nimbus, ὁ ἅ(γιος) παῦλος. The codex in his hand identifies him as an author, and thus not part of a narrative cycle. 5) Ananias in olive green mantle leads Paul away: ἀνανίας ἰώμενος τὸν σαῦλο(ν). At the upper corners are two fortified cities, Jerusalem on the left, πο(λις) ἱερουσαλήμ·, and Damascus on the right, πο(λις) δαμασκός. The city walls are rendered in pink, and the buildings behind are violet with red and blue roofs. Bk. V:215.

137v A band-shaped headpiece in fretsaw style. Bk. VI:1.

140r The sun and the climes (Klimata) on Cosmas' flat earth, a diagram (13.8 x 12 cm.) on the lower part of the page (fig. 169). Above, the sun in bust form, ἥλιος, within a red disk drawn in black and wearing a golden crown, emits nine red rays downward, corresponding to upright golden poles that are joined together below. The eight compartments between the poles represent the zones of the climes with the changeable length of shadows, indicated in the accompanying inscriptions from left to right, i.e., from south to north. On the left: ὠκεανός τὸ κατὰ σασου καὶ βαρβαρίας. On the opposite right, the inscription has been mostly written over: τὸ κατὰ βορυσθένους ποταμοῦ καὶ μαιώτιδος λίμνης. Next to each pole, from left to right, numerals give the length of the shadows in feet. Below the schema, along the horizontal band, are the topographic indications: τὸ κατὰ ἀξώμην· τὸ αἰθιοπικόν· τὸ κατὰ μέση· τὸ κατά συήνην· τὸ κατὰ ἀλεξάνδ(ρεια)· τὸ κατὰ ῥόδον· τὸ κατὰ ἑλίσπόντον· τὸ μέσον τ(οῦ) πόντ(ου). Above the sun-disc: κατὰ τὴν θερινὴν τροπὴν ὁ ἥλιος διατρέχων παϋνὶ κε̅ ὥρ(α) ϛ' τῆς ἡμέρ(ας). The lengthy texts on either side and below the diagram belong to Cosmas' text and have been transcribed by the editors of the Cosmography.[2] Bk. VI:12.

140v Band-shaped headpiece in fretsaw style.

145r The two strata of the universe (10.8 x 7 cm.), on the lower part of the page (fig. 170). A simple scheme in the form of a gold archway divided into two unequal parts, a rectangle below and a gable above. According to the inscriptions, the lower part indicates the realm of men and angels, ὁ κόσμος οὗτος ἐν ᾧ εἰσὶ νῦν ἄγγελοι καὶ ἄνθρωποι. καὶ ἡ νῦν κατάστασις, while the upper part signifies the heavens, ἡ δευτέρα σκηνὴ τὰ ἅγια τῶν ἁγίων· ἡ βασιλεία τῶν οὐ(ρα)νῶν ὁ μέλλων κόσμος· ἡ δευτέρα κατάστασις· ὁ τόπος τῶν δικ(αί)ων.

145v The heavens attached to the earth, a projection of the universe on one plane. A scheme (13 x 16.8 cm.) on the upper part of the page (fig. 171). A plan in the form of a Greek cross in gold, filled in light blue, whose center is the earth, rendered in yellow-brown and surrounded by a darker blue band, indicating the sea and its gulfs, γῆ μέση. The arms of the cross are the heavens; the top and bottom arms and the semicircular endings, left and right, indicate the vaults or walls of heaven. Top: στερέωμα· βόρειος τοῖχος οὐ(ρα)νοῦ. Bottom: στερέωμα· νότιος τοῖχος οὐ(ρα)νοῦ. At right: στερέωμα· ἀνατολικὴ καμάρα οὐ(ρα)νοῦ ἤτοι τοῖχος. At left: στερέωμα· δυτικὴ καμάρα οὐ(ρα)νοῦ ἤτοι τοῖχος. Bk. VI:33.

146r A gazelle scratching its head with its hind leg, flanked by two palm trees with two exotic birds meant to be peacocks perched on top, facing each other and symmetrically arranged, in the upper part of the page (16

[2] See E. O. Windstedt, *The Christian Topography of Cosmas Indicopleustes*, Cambridge 1909, p. 234 n. 1.

x 13.7 cm.) (fig. 172). The colors range from brown, red-brown, olive and yellow-green, to blue, pink, and white. Inscriptions: ταῦτά εἰσι τὰ λεγόμενα μοζά; οἱ φοίνικες οἱ ἰνδικοί. Bk. VI:34.

146v The climes on the spherical earth (17.3 x 4.3 cm.), on the right half of the page (fig. 173). Within a red disc, the sun in bust form wearing a gold crown with a gold ribbon flowing behind, and a gold fibula, issues six red rays on the discs of the yellow-brown earth below, from which project ten poles in similar colors: ὁ ἥλιος· γῆ. Bk. VI:34.

147v Band-shaped headpiece in fretsaw style. Bk. VII:1.

168r The tabernacle (5.4 x 12.4 cm.), at the bottom of the page (fig. 174). A drawing in gold with no other color depicts at the front eighteen rectangles of equal size, on top of which is a long rectangle containing the following, in larger rectangles from left to right: the table, τράπεζα, with twelve shewbreads, three on each corner, ἄρτοι (twice); the rod of Aaron, ῥάβδος; the seven-branched candlestick, λυχνία; the vessel with the manna, στάμν(ος); the two tablets of the law, αἱ πλάκες; and the brazen serpent, ὄφις ὁ χαλ(κινος). Bk. VII:84.

171r Band-shaped headpiece and initial Є in fretsaw style, Hezekiah's prayer (Is. 38:9–20). Bk. VIII:1. Isaiah warns King Hezekiah about the Babylonian ambassadors (Is. 39:4–8; II IV Kings, 20:12–19) (4 x 14.7 cm.), at the bottom margin (fig. 175). King Hezekiah, ἐζεκίας ὁ βασιλεύς, with white hair and beard, wears a crown, light blue tunic, and dark purple chlamys with a gold tablion and borders, and stands in front of a large bed addressing Isaiah, ἠσαΐας ὁ προφή(της), depicted with blue-white hair, blue tunic, and pale violet himation. The bed is rendered in red-brown with gold highlights and has a carmine hanging with green borders and a large blue mattress with gold spots. The three ambassadors, πρεσβευτ(αὶ) βαβυλῶνο(ς), are represented next, all carrying brown pyxides with gold highlights. All three are shown with dark brown hair, short tunics of blue, red, light violet, and green, and blue tiaras. Their flesh tones are green with touches of red. Bk. VIII:14.

174v Hezekiah and the miracle of the retreating sun (II IV Kings 20:9–11) (8.3 x 15.6 cm.), left margin (fig. 176). From a segment of a sun-disc, [ἀνα]ποδι-ζω(ν), rays emanate over a sundial, its structure rendered in the form of a tempietto with one visible green

column, a red architrave with a dark green and gold roof, and a piece of dark blue-black drapery hanging from the architrave, all set on four high steps in light and dark blue, ἐζεκίου οἱ δέκα ἀναβαθμόι. To the right, the king of Babylon, βασιλέ(υς) βαβυλῶνος, and the four Babylonian ambassadors, gesticulating vividly, shrink backward, expressing their awe at the miracle. The nimbed king is dressed in a light blue tunic, a dark purple chlamys, light blue cap, and red trousers. The four men wear tunics, chlamydes, and trousers in alternating colors of green, red, pale violet, and dull yellow-brown. The flesh tones are rendered in red-brown with greenish tones and strong red patches on the cheeks. Bk. VIII:19.

179r "Mount Conon," the earth plunged into shadow, a framed miniature (8.2 x 12.2 cm.) on the lower part of the page (fig. 177). Within an elipsis the Mount is depicted in brown against a brown background. The two spandrels at the lower left and right corners of the frame are left colorless. Inscription in gold, ὄρος κώνον. End of Bk. VIII (end of Hezekiah's prayer), Bk. IX:1.

180r The cycle of the seasons (diameter 13.7 x 14 cm.), on the lower part of the page (fig. 178). A zodiac-like circle with twelve compartments, each containing the fruit of a month. Inscriptions outside the circle on the periphery name the twelve months according to the Egyptian calendar and the seasons. Inscriptions on the inner part of the circle name the fruits; each season comprises three months. The outside captions, arranged in two circles, are to be read spirally beginning at the lower left of the illustration and moving counter-clockwise to the right: τροπὴ ρ′ ἐα(ρινή)· (τροπὴ) θερινή· τροπὴ θερινή· τροπὴ μεθοπορινή· τροπὴ χειμερινή. The corresponding months on the inner circle of the periphery: φαρμουθί ᾱ, παχών β̄, παϋνοῦ γ̄, ἐπιφί δ̄, μεσώρη ε̄, θώθ ς̄, φαωφι ζ̄, ἀθυρ η̄, χυάκ θ̄, τύβη ῑ, μηχείρ ῑᾱ, φαμενώθ ῑβ. The names of the fruits along the inner circle of the zodiac and in the same direction as above, are as follows: σίκιοι ρόδα· κίνναι· κάρυα ἀρμένια· σῖτος σκοπυμωρα· σύκα σταφύλια καὶ κοστουμῖ· ἐλαιοροδάκινα· φοίνικες· ασπαραγει· μαλαχαι· ἐντύβια· ἀλάτια· κίτρα. All fruits are painted against a yellow-brown ground and their colors range from green and yellow to red and carmine. End of Bk. VIII; Bk. IX:1.

180v Band-shaped headpiece in fretsaw style and initial O. Beginning of Bk. IX.

181v The motion of the stars (15.1 x 15.4 cm.), on the lower part of the page (fig. 179). A zodiac-like circle, as on fol. 180r, with twelve compartments, each containing a full-length angel represented in three-quarter view, clad in mantle painted in blue grisaille, with gold clavi and brown wings with gold highlights. Painted against a blue background, each angel holds in his up-lifted right hand a spherical, gold constellation. Two smaller inner circles are delineated in red. The outer one contains two youthful figures who according to Cosmas' text are angels but have no wings; they are clad in blue and red, each lifting up with his right hand the sun in the form of a gold sphere framed by red. That at the lower left is ascending, ἥλιος ἀνατέλων; the other, at upper right, is descending, ἥλιος δύνων. In the second circle is the blue disc of the moon, represented twice: setting at the lower left part, and rising at the upper right, σελήνη (twice); between the circle with the constellations and the circle with the sun and moon on the lower part is a conical mountain projecting beyond the circle, on the peaks of which is the following inscription: ὑπερβόρεια μέρη τῆς γῆς ἀοίκητ(α). The earth is represented on either side of the mountain, in the form of two vertical pillars outside the main circle. The names of the months are inscribed outside the circle along the periphery: φαρμουθί ā, π[αχών] β̄, [παϋνοῦ γ̄], ἐπιφί δ̄, μεσώρη ε̄, θώθ ς̄, φαωφι ζ, αθυρ η̄, χυακ θ, τύβη ῑ, μηχείρ ῑā, φαμενώθ ῑβ. Bk. IX:1.

186r Band-shaped headpiece in fretsaw style and initial I. Beginning of the Sayings of the Fathers, Bk. X:1.

201r Headpiece as on fol. 186r. Bk. XI:1.

202r Hunter and animals (6.2 x 18 cm.), on the lower margin (fig. 180). On the left is a partly flaked archer in red garments and blue helmet, shooting at a yellow-brown, fox-like animal inscribed μόσχος; next to it, larger in scale, in the midst of the composition, are two animals facing one another, much flaked; one, in olive grey tones and with one horn, is inscribed μονόκερως; the other, in blackish tones, χοιρέλαφος; a fourth animal, in red-brown, also flaked, facing to the right and resembling a horse, is inscribed ἱπποπόταμος. Bk. XI:9.

202v A pepper tree and sea creatures (5.3 x 14.2 cm.) on the lower margin (fig. 181). A boy in short blue tunic with a gold staff and a black bucket collects fruit from a bent, arch-like tree resembling a grapevine, πιπερέα. Under the pepper tree are two coconut trees in green-blue with yellow-brown fruit. To the right are a hybrid animal with canine forequarters and a snake-like or fish-like tail, all in olive-brown color, inscribed φώκη, a dolphin in colors ranging from dark blue to light green with red-brown fins, δελφῖνος, and an olive grey turtle, χελώνη. Bk. XI:10.

203r Indian "nuts" (5.5 x 6.2 cm.), on the lower margin (fig. 182). A man in pink-violet flesh tones, wearing a blue loincloth and holding a blue scythe with gold handle in his left hand, stands in front of a coconut tree with fruit, painted green-blue with gold highlights: κάρυα ἰνδικά. Bk. XI:11.

204v A lion (4.3 x 5.7 cm.) in yellow-brown tones attacks a horse rendered in grey-green with white highlights, in the lower margin (fig. 183). Bk. XI:20.

206r Band-shaped headpiece in fretsaw style. Bk. XII:1.

Iconography and Style

On paleographic grounds the codex has been assigned to the eleventh century.[3] The illustrations, an integral part of the text, must be of the same date. A detailed analysis considering all its components together, however, shows that the style is rather uncommon for the period. This is true particularly for the colors. Leaving aside the specific feature of flattened-out surfaces which reduce corporeality, more distinct characteristics of the figure style include the following: the faces are round and unmodelled, with distinct patches of strong red color on the cheeks, the foreheads, and the tips of the noses, occasionally over green or pale violet tones; the eyes are round, beady, staring and expressionless; the hands are disproportionately large. The gestures, however repetitious they may be, add an expressionistic force found in works such as the Job manuscript in Venice (cod. Marc. gr. 538) from the year 905, and the Sacra Parallela (cod. Paris gr. 923), both of which seems to stem from pre-iconoclastic models and for which a Syro-Palestinian origin has been proposed.[4]

The garments have a linear quality and an angularity, while highlights are not stressed; the drawing is dry and hard; the colors are strong and without lustre. Most characteristic are the brown, red, and blue used for the garments and for rendering the ground. The use of gold is confined to

[3] W. Wolska-Conus, *Cosmas Indicopleustès, Topographie chrétienne*, 3 vols., Paris 1968–73, 1, pp. 47ff.

[4] Cf., for instance, fol. 246r of the Job manuscript in Venice, reproduced and discussed by I. Furlan, *Codici greci illustrati della biblioteca Marciana*, 1, Milan 1978, pp. 27ff., figs. 13, 15, 17, 19; also Weitzmann, *Sacra Parallela*, figs. 576, 582; the motif of the "expressionistic" gesture runs throughout this manuscript.

some parts of objects, a scheme, an occasional ornament, a nimbus, a few small painted solid initials, and a few inscriptions; all figures are painted against uncolored parchment. These non-Constantinopolitan features, considered separately, find parallels in tenth- and eleventh-century works, Sinai icons in particular, which have been characterized as Syro-Palestinian.[5] However, the rather uncommon features of some of the picture frames, carelessly drawn, with ringlets or dots suggesting precious stones, reflect an earlier system, such as that followed in the medallion portraits of the Sacra Parallela codex in Paris or the codex Sinai 417 (see no. 9 above), but without its original clarity and function.[6]

The simple fretsaw style of the ornamental bands echoes that found in the earlier Horeb Lectionary, cod. 213 (see no. 14 above), but without its richness and complexity.[7] In fact, in its treatment it parallels the ornament found in cod. Vat. Ottob. gr. 457 from the year 1039, also assigned to a Palestinian area.[8]

All these considerations indicate an early eleventh-century date and point to Sinai as a possible place of the manuscript's production.

The Sinai Codex and its Relatives

Cosmas wrote his text between 547 and 549 at Alexandria, as has been shown by Anastos.[9] The text comprises ten chapters or books (λόγοι). Some copies have two further books at the end, constituting an appendix derived from another work by Cosmas. The Sinai copy contains all twelve books and is one of four illustrated Cosmas manuscripts that have survived from the Byzantine period. The other three are Vat. gr. 699, datable to the second half of the ninth century, containing only the ten books (the only Cosmas manuscript assigned to Constantinople);[10] Florence, Laur. Plut. IX.28, with twelve books, dated to the second half of the eleventh century;[11] and Smyrna B-8 (*olim* Evangelical

School) from the end of the fourteenth century, containing only excerpts from the Cosmas text, which perished in the fire of 1922.[12]

The complex problem of the interrelationship of these copies has been dealt with by Wolska-Conus.[13] She has collated the text and studied the illustrations, and has come to the following conclusions: leaving aside the illustrations of the Smyrna codex, the miniatures of the other three copies belong to two families. The older family is represented by the Vatican copy, and the younger by the two eleventh-century manuscripts. The parent of both families was not the archetype itself but a later copy.[14] Between this later copy and the eleventh-century manuscripts Wolska-Conus places another lost, "revised" copy to which the two supplementary books were added. The textual collation, however, does not correspond to the pictorial collation. That is, the Vatican copy is textually close to the archetype and yet pictorially is removed from it; it favors a picture-frame in which the original material is reorganized with a view to its condensation. Vice versa, the Sinai and Florentine copies, less faithful to the textual tradition, come nearer to the archetype where the pictorial tradition is concerned. The Sinai copy, despite some lacunae, is the richest surviving illustrated copy in that it preserves a number of miniatures that were either never in the Vatican copy or were excised from the Florentine copy.[15]

The problem of reconstructing the pictorial archetype, which may well have been created in Alexandria, is complicated. It involves disentangling the various pictorial elements—some of them shorter sections of a larger cycle—of which the Cosmography is made, and determining their sources and dates. It is generally agreed that the cosmographic diagrams may have been invented for the archetype. It is arguable, however, whether illustrated World

[5] For the gestures, the emphasis on the eyes, and the flat linear drapery, cf. a ninth/tenth-century icon of the Ascension in Sinai displaying distinct red colors on the faces, which has been assigned to Palestine or even characterized by the Sotiriou as "eastern monastic," (see Sotiriou, *Icônes*, 1, fig. 49; 2, p. 66); also the earliest icon of Sts. Chariton and Theodosios, also of Palestinian origin, see Weitzmann, *Sinai Icons*, pp. 64–65, no. B.37, pl. XCI; pp. 69–71, no. B.42, pls. XXVIII, XCVI, XCVIII.

[6] Weitzmann, *Sacra Parallela*, fig. 720 and several other instances, and no. 9 above, fol. 13r, fig. 32 (colorplate I:b).

[7] Compare fol. 31 of the Cosmas codex with fol. 312v of the Horeb Lectionary, no. 14 above, fig. 79 (colorplate II:b).

[8] Weitzmann, *Buchmalerei*, pl. LXXXI,502; Spatharakis, *Dated Mss.*, p. 20, no. 52.

[9] M. V. Anastos, "The Alexandrian Origin of the Christian Topography of Cosmas Indicopleustes," *DOP* 3 (1946) pp. 74–80, repr. in idem, *Studies in Byzantine Intellectual History*, London 1979, no. XIII.

[10] C. Stornajolo, *Le miniature della Topografia Christiana di Cosma Indicopleuste* (Codices e Vaticanis selecti, 10), Milan 1908.

[11] Several miniatures of this manuscript have been reproduced as engravings in J. W. McGrindle, *The Christian Topography of Cosmas*, London 1897, pls. I–IV, and Windstedt, *op. cit.* (note 2), pp. 377ff.; Weitzmann, *Buchmalerei*, p. 37, pl. XLV,264–68.

[12] The codex was considered to be eleventh-century until the publication of Otto Demus, "Bemerkungen zum Physiologus von Smyrna," *JÖB* 25 (1976) pp. 235–57, with the older bibliography.

[13] W. Wolska-Conus, *La topographie chrétienne de Cosmas Indicopleustès. Théologie et science au VIe siècle* (Bibliothèque byzantine, 3), Paris 1962, pp. 147–92; eadem, in *Reallexikon für Antike und Christentum* 10, Stuttgart 1976, pp. 185–87; and *op. cit.* (note 3).

[14] See Wolska-Conus, *Cosmas Indicopleustès*, (supra note 3), 1, pp. 54ff., 151.

[15] Ibid., pp. 96, 104, 129ff., 179, 183; Weitzmann, *Buchmalerei*, p. 59; idem, *Sinai Mss.*, p. 19.

Chronicles exercised any influence on the conception of these illustrations.[16]

More complex is the problem of the biblical illustrations, which certainly were not invented for the Topography texts but were borrowed from biblical manuscripts. The investigation is centered particularly on the relation of this cycle to a cycle of Genesis and Exodus illustrations iconographically similar to the corresponding ones in surviving Byzantine Octateuchs. It has been debated whether the illustrator of the archetype used a biblical edition including only the first five books, i.e., a Pentateuch, as Mouriki has suggested, or an actual Octateuch.[17] Furthermore, another issue which has been raised concerns the iconographic impact of the Topography itself on Byzantine Octateuchs.[18] Related to these problems, and not fully investigated thus far, is the extent of the influences of the Topography on other types of illustrated manuscripts, such as the marginal Psalters.

Bibliography

Ep. Porphyre, *Premier voyage au monastère sinaïtique*, St. Petersburg 1856, p. 241.

Kondakov 1882, p. 116.

Gardthausen, *Catalogus*, p. 241.

Kondakov, *Histoire*, pp. 1, 56ff.

Schlumberger, *Epopée*, 3, pp. 441, 572–73, 620.

A. Bauer and J. Strzygowski, *Eine Alexandrinische Weltchronik* (Akademie der Wissenschaften, Phil.-hist. Klasse, 51), Vienna 1906, p. 137, figs. 3, 4.

E. O. Windstedt, *The Christian Topography of Cosmas Indicopleustes*, Cambridge 1909, pp. 16, 17, 26, 29.

A. Muñoz, *L'arte* 12 (1909) pp. 160–62.

Beneševič, pp. 432–39 no. 539.

O. M. Dalton, *Byzantine Art and Archaeology*, Oxford 1911, repr. New York 1961, p. 462, figs. 268, 269.

Johann Georg, Herzog zu Sachsen, *Das Katharinenkloster am Sinai*, Leipzig and Berlin 1912, p. 23, pl. X.

Millet, *Recherches*, p. 604.

Gerstinger, *Griech. Buchmalerei*, p. 22a.

Ebersolt, *Miniature*, p. 76.

J. Strzygowski, *Asiens bildende Kunst*, Augsburg 1930, pp. 307–308, fig. 306.

Weitzmann, *Buchmalerei*, pp. 58–59, pl. LXV,338–91.

H. Buchthal, *The Miniatures of the Paris Psalter*, London 1938, p. 57

A. Grabar, "Le témoignage d'une hymne syriaque sur l'architecture de la cathédrale d'Edesse au VIᵉ siècle," *CA* 2 (1947) pp. 58–59, 62, pl. IV; repr. in idem, *Fin de l'Antiquité*, 1, pp. 44, 46; 3, pls. 7a, 8a.

Lazarev 1947, p. 316.

Weitzmann, *Roll and Codex*, pp. 41–42, 184, 187, 194, 198, fig. 192.

C. O. Nordström, "The Water Miracles of Moses in Jewish Legend and Byzantine Art," *Orientalia Suecana* 7 (1958) (Uppsala 1959) pp. 105ff.

D. Ainalov, *The Hellenistic Origins of Byzantine Art*, New Brunswick 1961, pp. 25, 53, 78.

W. Wolska-Conus, *La topographie chrétienne de Cosmas Indicopleustès, Théologie et science au VIᵉ siecle* (Bibliothèque byzantine, 3), Paris 1962, see index.

Byzantine Art, An European Art, Ninth Exhibition of the Council of Europe, 2nd ed., Athens 1964, p. 366.

S. Dufrenne, "Une illustration 'historique' inconnue de psautier du Mont Athos, Pantocrator cod. 61," *CA* 15 (1965) p. 92, fig. 4.

H. Stern, *L'art byzantin*, Paris 1966, p. 120.

K. Weitzmann, "The Mosaic of St. Catherine's Monastery on Mt. Sinai," *Proceedings of the American Philosophical Society* 110 (1966) p. 400, fig. 1; repr. in idem, *Sinai Studies*, p. 13, fig. 15.

H. Buchthal, "Some Representations from the Life of St. Paul in Byzantine and Carolingian Art," in *Tortulae. Studien zu altchristlichen und byzantinischen Monumente* (*Römische Quartalschrift*, supp. 30), Rome 1966, pp. 44ff., fig. 13a.

H. Buchhausen, "Ein byzantinisches Bronzekreuz in Kassandra," *JÖBG* 16 (1967) p. 287.

Lazarev, *Storia*, p. 251 n. 36.

W. Wolska-Conus, *Cosmas Indicopleustès, Topographie chrétienne*, 1–3, Paris 1968–73, 1, pp. 47, 129, 134ff., 224, 246–49.

I. Ehrensperger-Katz, "Les représentations de villes fortifiées dans l'art paléochrétien et leurs dérivées byzantines," *CA* 19 (1969) p. 17, fig. 23.

Kamil, p. 125 no. 1743.

D. Mouriki-Charalambous, "The Octateuch Miniatures of the Byzantine Manuscripts of Cosmas Indicopleustes," unpublished Ph.D. dissertation, Princeton University, 1970, passim.

R. Stichel, *Studien zum Verhältnis von Text und Bild spät- und nachbyzantinischer Vergänglichkeitsdarstellungen* (Byzantina Vindobonensia, 5), Vienna 1971, p. 20.

A. Khatchatrian, *L'Architecture arménienne du IVᵉ au VIᵉ siècle*, Paris 1971, p. 74, fig. 113.

E. Rosenthal, *The Illuminations of the Vergilius Romanus (Cod. Vat. Lat. 3867). A Stylistic and Iconographic Analysis*, Zurich 1972, p. 93.

Weitzmann, *Sinai Mss.*, pp. 19–20, figs. 24, 25.

L. Bouras, "Δύο βυζαντινὰ μανουάλια ἀπὸ τὴ μονὴ Μεταμορφώσεως τῶν Μετεώρων," *Byzantina* 5 (1973) p. 141, fig. 6γ.

H. L. Kessler, "Paris gr. 102: A Rare Illustrated Acts of the Apostles," *DOP* 27 (1973) pp. 215ff.

J. Leroy, *Les manuscrits coptes et coptes-arabes illustrés* (Institut Français d'archéologie de Beyrouth, 96), Paris 1974, p. 49.

Weitzmann, "Cyclic Illustration," pp. 106, 107, figs. 64, 65.

B. Brenk, *Die frühchristlichen Mosaiken in S. Maria Maggiore zu Rom*, Wiesbaden 1975, pp. 88, 93, figs. 30, 31.

L. Kötzsche-Breitenbruch, *Die neue Katakombe an der Via Latina in Rom*, Münster, Westfalen 1976, p. 28.

L. Brubaker, "The Relationship of Text and Image in the Byzantine Mss. of Cosmas Indicopleustes," *BZ* 70 (1977) pp. 42–57.

[16] The role the World Chronicles may have played in transmitting early iconography to the Cosmas miniatures is discussed by Wolska-Conus (*op. cit.*, note 13) pp. 113–43, 152ff.; for the opposite view see D. Mouriki-Charalambous, "The Octateuch Miniatures of the Byzantine Manuscripts of Cosmas Indicopleustes," unpublished Ph.D. dissertation, Princeton University, 1970, p. 184 with earlier bibliography.

[17] Mouriki, "Octateuch Miniatures," pp. 168–70, 180; Weitzmann, *Roll and Codex*, pp. 141ff.

[18] C. Hahn, "The Creation of the Cosmos: Genesis Illustration in the Octateuchs," *CA* 28 (1979) pp. 29–40; M. Bernabò, "Considerazioni sul manoscritto Laurenziano Plut. 5.38 e sulle miniature della *Genesi* degli *Ottateuchi* bizantini," *Annali della scuola normale superiore di Pisa* (Classe di Lettere e Filosofia), serie 3, vol. 8.1 (1978) pp. 135–57.

L. Eleen, "Acts Illustration in Italy and Byzantium," *DOP* 31 (1977) pp. 268, 274 n. 54, 276 nn. 60, 62.

J. Gutmann, "Noah's Raven in Early Christian and Byzantine Art," *CA* 26 (1977) p. 67, fig. 7.

A. D. Kartsonis, "Problems in the Illuminated Manuscripts of Cosmas Indicopleustes," *Third Annual Byzantine Studies Conference. Abstracts of Papers*, New York 1977, p. 59.

H. L. Kessler, *The Illustrated Bibles from Tours*, Princeton 1977, pp. 114f., 117, 119f., 123, fig. 176.

M. Bernabò, "Considerazioni sul manoscritto laurenziano Plut. 5.38 e sulle miniature della *Genesi* degli *Ottateuchi* bizantini," *Annali della scuola normale superiore di Pisa* (Classe di Lettere e Filosofia), serie 3, vol. 8.1 (1978) p. 141.

S. Dufrenne, *Les illustrations du psautier d'Utrecht*, Paris 1978, p. 70 n. 5, 140 nn. 456, 457.

Z. Kádár, *Survivals of Greek Zoological Illuminations in Byzantine Manuscripts* (Budapest, 1978) p. 122.

C. Hahn, "The Creation of the Cosmos: Genesis Illustration in the Octateuchs," *CA* 28 (1979) pp. 30f., 34.

Galey 1979, pp. 157, 158, figs. 164–67.

P. Huber, *Heilige Berge*, Zurich, Einsiedeln and Cologne 1980, see index.

Voicu, D'Alisera, pp. 562–63.

Th. Chatzidakis, *Les peintures murales de Hosios Loukas. Les chapelles occidentales* (Τετράδια Χριστιανικῆς 'Αρχ. 'Εταιρείας, 2), Athens 1982, p. 52.

L. Eleen, *The Illustration of the Pauline Epistles in French and English Bibles of the Twelfth and Thirteenth Centuries*, Oxford 1982, pp. 27, 28, 29, 30, 35, 83–84, 87, fig. 10.

A. Grabar, "L'iconographie du Ciel dans l'art chrétien de l'Antiquité et du haut Moyen Age," *CA* 30 (1982) p. 24 n. 29.

E. Revel-Neher, *L'arche d'alliance dans l'art juif et chrétien du second au dixieme siècles*, Paris 1984, pp. 149 n. 217, 155, 177–82, 199, 206, 215.

24. COD. 364. JOHN CHRYSOSTOM, 45 HOMILIES ON MATTHEW
A.D. 1042–1050. FIGS. 184–186, COLORPLATE XIV

Vellum. 370 folios, 33 x 25 cm. Two columns of thirty lines. Very thin, clear, elegant minuscule script with elements of *Perlschrift* for the text; titles in *Auszeichnungs-Majuskel*; main title in *Epigraphische Auszeichnungs-Majuskel*. Gathering numbers at lower left of first recto and later ones at lower right corner of first recto and left corner of last verso. Parchment mixed, on the whole good but not of best quality; wide right and lower margins. Ink brown for text; titles and small solid initials in text in gold; ornamental initials in flower petal style.

Fols. 1r and v, 2r, blank; 2v, 3r, miniatures; 3v, blank; 4r–7r, table of contents, almost exclusively in gold script; 7v, blank; 8r–369r, John Chrysostom, forty-five homilies on Matthew (*PG* 57, 13–472). On fol. 369r, right column, a later (sixteenth-century?) entry in flowery script, reading:

τοῦτο τῷ βιβλίον ἔδοσεν ὁ κῦρ μιχαὴλ ἰαλυνᾶς /
εἰς τὸ ἅγιον ὄρος τὸ σίναιον· κ(αὶ) ὁποῦ ξενώσει /
αὐτῶ ἐκ τῆς μον(ῆς) ταύτ(ης), να ἔχει τὰς ἀρὰς τῶν
π(ατέ)ρων· / ἀμήν.

This book was given to the Holy Mount Sinai by Michael Ialynas; whoever takes it away from this monastery may have the curses of the Fathers; amen.

Later entries also on fols. 369v and 370r. On fol. 370v a thirteenth-century Latin entry reads: *hic liber est quintus monasterii beati georgii de mangana in Constantinopoli.* Other later entries include one on fol. 7r with the monokondylon signature of Kallinikos III, Patriarch of Constantinople, who lived in Sinai between 1757 and 1761.

First seven leaves consist of a quaternion of which the last leaf is cut out, probably blank since fol. 7v is blank; gatherings β', γ', δ' are loose; often holes in the margins; otherwise condition excellent. Miniatures, all full-page, have suffered minor flaking; their margins have been slightly cut; miniature on fol. 3r has been cut on the right corner.

Plain, dark brown leather binding on wooden boards, worn. Three large bronze, almond-shaped studs on three corners of front cover. Three similar ones on corners and a large rosette stud in center of back cover. Remains of two fasteners at front. Color changes on front cover indicate that at one time it had a central metal piece and square "icons" at corners. Probably of sixteenth-century date.

Illustration

2v Matthew offering his Gospel to John Chrysostom (27 x 21 cm.) (fig. 184). The evangelist, dressed in light blue chiton and light green himation, has grey-green hair and light brown beard; John, in light brown sticharion and dark brown bishop's vestments with gold ornament, white peritrachilion and omophorion with black crosses, has warm brown flesh tones and black-brown hair. Their large nimbi are delineated only by large double circles; the background is gold. A border of flower petal style frames the composition. The inscriptions within and outside the frame are in red, in *Epigraphische Auszeichnungs-Majuskel*. Within the frame, flanking the two figures, are: 'Ο ἍΓΙΟС ἈΠΌ(στολος) Κ(αὶ) 'ΕΥΑΓΓΕΛ(ιστὴς), and ΜΑΤΘΑῙΟС 'Ο ἍΓΙΟС 'ΙΩ(άννης) 'Ο ΧΡΥ-(σο)СΤΟΜΟС. Around the outside edge of the frame: ΕἸС ἘΥСΎΝΟΠΤΟΝ ΤΟῦ ΤΕΛΌΝΟΥ ΤΟὺС ΛΌΓΟΥС / ΤΙΘΕὶС 'Ο ΧΡΥСΟῦС ΤὸΝ ΛΌΓΟΝ ΚΑὶ ΤὸΝ ΤΡΌΠΟΝ / ΑἸΤΕῖ

CϒN AϒTῶ TOῖC KPATOῦCI TῶN KÁTω /
BίOϒ ΓAΛÍHNHN KAI MέΘEΞIN TῶN "ANω·
(Having placed in clear view the word of the publi-
can, he who is gilded in language and style, requests
together with him, for those who rule below, serenity
of life and a share with those above.)

3r Constantine IX Monomachos flanked by the Empress
Zoe on his right, and her sister Theodora on his left;
above, Christ in a mandorla with two hovering angels
holding crowns intended for the Empresses; the crown
for the Emperor is at Christ's feet (26.8 x 21.2 cm.)
(fig. 185). The Emperor, clad in a purple skarama-
gion, a gold loros, purple shoes, and a golden crown
stands on a suppedaneum and holds a red scepter in
his right hand and a scroll in his left; his beard is black
and his flesh tones violet with deep olive shadows.
The Empresses wear the thorakion—Zoe is clad in
red, Theodora in blue—and gold crowns, and carry
gold scepters. Their large nimbi are delineated by
double red circles. Christ is depicted wholly in gold,
seated on a grey rainbow and within a blue mandorla;
he has black hair and a yellow cross in his nimbus.
Grey rays emanate from his hands; those on the left
include a star-like rosette. The angels are depicted in
light blue and red-brown garments; they have brown
hair and black wings with green tips. A frame in
flower petal style, similar to that on fol. 2v, encloses
the scene. The inscriptions within and around the
frame are in similar red script and with star-like
rosettes. Flanking the figures: Zωῆ EϒCEBE-
CTÁTH AϒΓOϒCT(α) Ἡ ΠOPΦϒPOΓÉNNH-
T(os)—KωNCTANT(ĩvos) EN X(ριστ)ῷ Tῷ
Θ(ε)ῷ ΠICTÒC, BACIΛE(ὺs) AϒTOKPÁT(ωρ)
ῬωMAῖωN Ὁ MONOMÁXOC—ΘEOΔώPA
AϒΓOϒCTA Ἡ ΠOPΦϒPOΓÉNNHT(os). Around
the exterior of the frame: ὡC TῆC TPIÁΔOC Cῶ-
TEP EἷC ΠANTOKPÁTωP / TῶN ΓῆC 'ANÁ-
KTωN TὴN ΦAEINὴN TPI[άδα] / CKέΠOIC
KPÁTICTON ΔECΠÓTHN MONOMÁXON /
ὉMAIMÓNωN ZEῦΓOC Tὲ ΠOPΦϒPAC
KΛÁΔ[ον]. (Oh Savior, as the one Pantocrator of the
Trinity, may you protect the radiant trinity of the
earthly rulers, the mightiest lord Monomachos and
the pair related by blood, the offshoot of the purple).

4r Headpiece, table of contents (12 x 20 cm.) (fig. 186).
Frames with lozenges in cloisonné pattern in blue and
red with white crosses or dots enclose the title, and
two gold cypresses with blue and white points.

8r Π-shaped headpiece and initial E in flower petal
style, flower petals in joined roundels with petals be-
tween against gold, initial E, left column. Homily 1.

All remaining homilies are introduced by band-shaped
headpieces, a total of forty-four, on right or left column,
with variants of flower petal motifs and initials of relevant
style, in fixed, ordinary forms: roundels, heart shapes,
rosettes (free or in frames), diamonds and half dia-
monds, semicircles, scroll and scalloped patterns, almonds,
quatrefoils.

6v, 23v Ordinary flower petal style, initials E, I. Homilies
2 and 3.

30r Petals in roundels, initial E. Homily 4.

45r Petals in heart forms, initial Π. Homily 5.

51v Degenerated petals in rosette or cross forms. Hom-
ily 6.

61r Roundels with scattered petals between. Homily 7.

69v Petals in half diamond patterns, initial Π. Homily 8.

76r Petals in semicircles, initial K. Homily 9.

84r Petals in diamonds in a rosette pattern, initial Π.
Homily 10.

92r Petals in heart-shaped patterns, initial Π. Homily 11.

102r Petals in semicircles, initial M. Homily 12.

108v Degenerated flower petal in diamonds in a rosette
pattern, initial T. Homily 13.

118r Petals in heart forms, initial T. Homily 14.

123v Rosettes in panels, initial O. Homily 15.

140v Degenerated rosettes, initial T. Homily 16.

156v Cloisonné patterns, similar to those on the table of
contents (fol. 4r), initial A. Homily 17.

166v Flower petals in roundels with pink blossoms be-
tween, initial O. Homily 18.

175v Petals in heart-shaped patterns, initial T. Homily 19.

189r Petals in heart forms imitating fretsaw style, initial K.
Homily 20.

197v Scattered petals, initial O. Homily 21.

202v Petals in scalloped patterns, initial E. Homily 22.

211r Petals in heart-shaped patterns, initial T. Homily 23.

223r Ivy leaves in an inverted pattern, initial Δ. Hom-
ily 24.

229r Petals in heart-shaped patterns, initial K. Homily 25.

234v Petals in tetrafoils or rough rosettes, initial O. Hom-
ily 26.

245v Flower petals in cross forms, initial O. Homily 27.

251v, 259r Petals in half diamonds, initials O, T. Homi-
lies 28, 29.

263r Petals in cross forms, initial Π. Homily 30.

271v Ordinary flower petal style, initial K. Homily 31.

278r Diamond patterns with rosettes, initial T. Homily 32.

289r Crosslets in a cloisonné pattern, initial E. Homily 33.

299v Ordinary flower petal, initial Є. Homily 34.

306v Half diamonds, initial Π. Homily 35.

314v Rosettes in blue diamonds and circles against gold, initial Є. Homily 36.

320v Ordinary flower petal, initial T. Homily 37.

328v Roundels with rosettes in cross form, initial O. Homily 38.

333r Half diamonds, initial O. Homily 39.

337r Ordinary flower petal, initial Π. Homily 40.

343r Almond rosettes in diamond patterns, initial K. Homily 41.

347v Half almond rosettes, initial Π. Homily 42.

352r Ordinary flower petals in semicircles, initial A. Homily 43.

359r Quatrefoils or rosettes, initial O. Homily 44.

365v Rosettes, flower blossoms between, initial A. Homily 45.

Iconography and Style

Summer of 1042, the date proposed by Spatharakis[1] for the execution of the codex, has been rejected by Harlfinger et al. (the controversy centers around a text by Psellos), who date the codex between 1042 and 1050, the year of Zoe's death.[2] The presence of the manuscript in the first half of the thirteenth century in the monastery of St. George of Mangana in Constantinople, which was founded by Constantine IX Monomachos shortly after June 1042, has led Harlfinger to the correct conclusion that the manuscript was an imperial gift, perhaps with other codices, to that monastery, the "imperial" inauguration of which took place in May 1047.[3]

The manuscript was in Crete in the sixteenth century and later came to Sinai, a gift from a member of the well-known Ialynas family,[4] which in the second half of the seventeenth century included Gerasimos Ialynas, a hieromonk in the Sinai metochion in Candia, a copyist and owner of manuscripts.[5]

The portraits of Constantine and Zoe are known from the mosaic panel in the south gallery of the church of St. Sophia.[6] The group of the three, including Theodora, is found in the enamel plaques of the Crown of Budapest.[7]

[1] Spatharakis, *Portrait*, p. 102.

[2] Harlfinger et al., no. 9, p. 24.

[3] Ibid., *loc. cit.*, with further references.

[4] For the Ialynas family in Crete cf. N. B. Tomadakis, "Πρωτοπα-πάδες Κρήτης (1210–1669)," *Kretologia* 4 (1977) pp. 39–48, esp. p. 40; A. Markopoulos, "Συμπληρωματικὰ γιὰ τὸν Μιχαὴλ Λουλούδη," *Pepragmena tou Tetartou Diethnous Kretologikou Synedriou (Herakleion, 1976)* 2 (Athens 1981) pp. 235–36.

[5] See note 3 above; Harlfinger et al., no. 9, p. 24. Sinai possesses other codices given by the Ialynas family.

The theme of the emperor alone or with his family under the protection of Christ or receiving the crown from Christ through angels is not uncommon in Byzantine art.[8] Among extant examples in Middle Byzantine book illumination, the best parallel is provided by the cod. Vat. Barb. gr. 372.[9]

The figure style presents certain striking features: with the exception of the figure of Matthew, a reflection of the Macedonian Renaissance, the bodies of all other figures do not have organic structure with a convincing corporeality; they are flattened out by means of straight folds and decorative rhythmic design. Their linearity is accentuated by the color scheme, particularly that of the imperial figures, or by its absence, as in the figure of Christ, whose garments stress two-dimensionality and rhythmic lines through the exclusive use of gold. The overall effect of the bodies is one of stiffness and hieratic pose. Linearity is also seen in the design of the heads. While the heads of the saints are expressive, those of the imperial family are stereotyped. The facial types recall those found in some early twelfth-century icons in Sinai which on stylistic grounds have been assigned to Cyprus. In particular, an icon with Abraham and Melchisedek compares well with the figures on fol. 2v (fig. 184, colorplate XIV) in the rendering of the faces and the flattened drapery.[10] However, our miniatures lack the vertical groove-like line in the foreheads of the icon figures and the concentric lines on the drapery over the shoulders, features that have been associated with the "Cypriot" style. The manuscript was most probably produced in Constantinople, and possibly illuminated by a Cypriot. Nevertheless, the codex has a provincial character confirmed by the quality of its ornament, a degenerated flower petal style in ordinary patterns, which does not conform to the best Constantinopolitan standards.

Bibliography

Gardthausen, *Catalogus*, p. 82.

Beneševič, pp. 205–206 no. 373.

Idem, *Mon. Sinaitica*, 1, col. 48, pls. 29, 30.

Frantz, "Ornament," p. 72, pl. 11,5.

Grabar, *Empereur*, pp. 18 n. 3, 117 n. 3, pl. XIX,2.

Lazarev 1947, p. 304 n. 37.

[6] T. Whittemore, *The Mosaics of Hagia Sophia at Istanbul*, 4 vols., Paris and Boston 1933–52, 3, pp. 9–20, 42–59, pls. III, IX–XIX with a color reproduction of Constantine; Spatharakis, *Portrait*, p. 101.

[7] K. Wessel, *Die byzantinische Emailkunst von 5. bis 13. Jahrhundert*, Recklinghausen 1967, no. 32, fig. 32b with older bibliography.

[8] Grabar, *Empereur*, pp. 114ff. and passim.

[9] Spatharakis, *Portrait*, pp. 26ff., fig. 7.

[10] Weitzmann, "Cyprus," pp. 54f., pl. 21; cf. also faces in an iconostasis beam with the life of St. Eustratios: ibid., figs. 20a–b.

F. Dölger, "Die Entwicklung der byzantinischen Kaisertitular und die Datierung von Kaiserdarstellungen in der byzantinischen Kleinkunst," in *Studies Presented to D. M. Robinson*, 2, St. Louis 1953, p. 1002, repr. in F. Dölger, *Byzantinische Diplomatik*, Ettal 1956, p. 149.

I. Ševčenko, "The Anti-Iconoclastic Poem in the Pantocrator Psalter," *CA* 15 (1965) p. 49 n. 16.

G. Cames, *Byzance et la peinture romane de Germanie*, Paris 1966, pp. 27, 65, 68, 69, fig. 87.

A. Grabar, "L'art byzantin au XIᵉ siècle," *CA* 17 (1967) p. 264.

Kamil, p. 78 no. 426.

Der Nersessian, *Psautiers*, p. 72.

Weitzmann, *Sinai Mss.*, p. 16, figs. 18, 19.

Greek Mss. Amer. Coll., p. 96.

Galavaris, "Homilienillustration," cols. 250–55.

H. Belting, "Byzantine Art among the Greeks and Latins in Southern Italy," *DOP* 28 (1974) p. 21 n. 71.

I. Kalavrezou-Maxeiner, "Eudokia Makrembolitissa and the Romanos Ivory," *DOP* 31 (1977) p. 317 n. 58.

Spatharakis, *Portrait*, pp. 99–102 and passim, fig. 66.

Spatharakis, *Dated Mss.*, no. 53, figs. 96–98.

Marava-Chatzinicolaou, Toufexi-Paschou, p. 93.

Voicu, D'Alisera, p. 560.

M. Frazer, "Abbot Desiderius' Revival of the Arts at Montecassino: Additional Evidence," in *Studien zum europäischen Kunsthandwerk: Festschrift Yvonne Hackenbroth*, J. Rasmussen, ed., Munich 1983, p. 16, fig. 11.

Harlfinger et al., pp. 23–25, 62, no. 9, pls. 41–44.

25. COD. 342. GREGORY OF NAZIANZUS, 16 LITURGICAL HOMILIES
LENINGRAD, STATE PUBLIC LIBRARY COD. GR. 330: ONE LEAF
A.D. 1051. FIGS. 187–190

Vellum. 239 folios, 28.4 x 23.7 cm. *Leningrad*: one leaf, 28.6 x 23.3 cm., originally between Sinai fols. 144 and 145. Two columns of twenty-five lines. Minuscule script with elements of *Perlschrift* for text; titles in *Auszeichnungs-Majuskel*; the same for numbers of homilies. Gathering numbers with one line above, three below and strokes, at the lower right corner of first recto, beginning with gathering γ', fol. 17r. Parchment mostly fine and of good quality. Ink brown for text. Titles and small solid initials in gold. Initials opening each homily in flower petal style.

Gregory of Nazianzus, sixteen liturgical homilies.[1]

Condition excellent. Blackened edges of parchment indicate heavy use. Colophon in gold letters on fol. 239r (fig. 189) reads: + ἐγράφη ἡ παροῦσα / βίβλος εἰς μῆνα /

δεκέμβριον ἰν/δικτιῶνα πέμπτ(ην) / ἐν ἔτει τῷ / ‚ϛφξʹ. (+ The present book was written in the month of December, fifth indiction, in the year 6560 [1051].)

A number of later entries. On fol. 73r, twelve-syllable verses on Homily on the Nativity by the Sinaite monk Mathusalas Kabbades,[2] sixteenth century, and on fol. 1r, a Sinai ex libris with monokondylon of the exiled Patriarch of Constantinople Kallinikos III, who lived in Sinai from 1757 to 1761.

Plain red-brown leather binding on wooden boards, partly restored with fabric. Traces of two leather fasteners on the upper part of the back cover.

Illustration

All homilies are introduced by Π-shaped headpieces on right or left columns, in flower petal style: 1r (fig. 187), 3v, 23r, 30r, 42r, 52r, 63v, 73r (fig. 188), 83v, 135r, 145r, 173v, 177v, 194v, 208r, 228r. The patterns are either in roundels, alternating with freely set palmettes or circles and diamonds (as on fol. 73r, fig. 188), crosslets, rosettes in panels (fol. 177v), or a scroll motif. On fol. 1r (fig. 187), instead of the usual palmettes, two gold cypresses are on the extended line of the frame. Small initials at the beginning of each homily in similar style. Flyleaf with head of Gregory in black ink, drawn later (fig. 190).

Iconography and Style

Script and style of ornament confirm the date given by the colophon. The manuscript is related closely to Constantinopolitan codices of the mid-eleventh century, as indicated by the use of gold and the enamel-like blue in the flower petals, as well as the finesse of the design. Patterns, style of ornament, and initials find their best parallels in manuscripts of the period, such as the cod. Oxford, Auct. E.2.1 (Theodore Magister, Homilies of John Chrysostom).[3] The drawing of Gregory's portrait on the flyleaf cannot be dated prior to the sixteenth century.

Bibliography

Kondakov 1882, p. 107.

Gardthausen, *Catalogus*, p. 73.

Beneševič, pp. 200, 618 no. 360.

Devreesse, *Introduction*, p. 297.

Kamil, p. 77 no. 404.

Husmann, p. 148.

Noret, *Byzantion* 1978, pp. 172–75, 200ff.

Voicu, D'Alisera, p. 560.

Harlfinger et al., pp. 29–30, 63 no. 12, pls. 57–59.

[1] For detailed contents see Noret in bibliography.

[2] On Kabbades, see the observations by Noret, *Byzantion* 1978, p. 172 n. 49.

[3] Hutter, *Oxford*, 1, no. 26, figs. 137, 140, 141.

Leningrad leaf:
Cereteli 1904, pp. 7, 16, 48, 83, 100, 166, pls. 1–8.
Beneševič, p. 618 no. 360.
Idem, *Mon. Sinaitica*, 2, pl. 50.
Lake, *Dated Mss.*, 6, no. 253, pl. 448.
Devreesse, *Introduction*, p. 297.
Granstrem, *VV* 19 (1961) p. 202 no. 202.
Harlfinger et al., pp. 29–30.

26. COD. 293. ACTS AND EPISTLES
LENINGRAD, STATE PUBLIC LIBRARY COD. GR. 318: ONE LEAF
A.D. 1053. FIGS. 191–195

Vellum. 145 folios, 22 x 16.5 cm. *Leningrad*: one leaf, 22.8 x 16.5 cm. Two columns of twenty-one lines. Irregular, not fine majuscule with elements of minuscule script for text; a later example of the application of the "Alexandrian" majuscule as text script;[1] titles in *Auszeichnungs-Majuskel*. Gathering numbers at upper right corner of first recto. Parchment thick and rough. Ink black-brown for text; titles, calendar indications, very small solid initials, and ekphonetic signs in carmine or in text ink and underlined in yellow; ornamental initials underlined in carmine and tinted in blue, yellow, or green.

Fols. 1v–4v, Acts; 42r–85v, Epistles; 86r–145r, Menologion readings, September–August. Occasional marginal notes in Arabic.

On fol. 145v, right column, colophon (fig. 195) reads:

ὥσπερ ξένοι χαίροντες ἰδὴν / πατρίδ(α): οὗτω /
κ(αὶ) τοῖς γράφου/σιν βιβλήου / τέλος:– /
ἐτελειώθ(η) ἡ δέλτ(ος) / αὕτη δια χει/ρος
βασιλεί(ου) / ὑπ(ο)διακό(νου) πὸ(λεως) /
δαλισανδ(οῦ) / μην(ὶ) ιουλίω ἰνδ(ικτιῶνος) ε':– /
ἔτους ,ϛφξα'. / ἰνδ(ικτιῶνος) ϛ'

Just as strangers rejoice upon sighting their homeland, so do writers upon completion of a book. This book was completed by the hand of Basil, subdeacon of the city Dalisandos in the month of July, 5th indiction, year 6561 (1053). 6th indiction.[2]

Text begins with gathering β' to which belonged the leaf in Leningrad. Fols. 7–8 and 135 are of paper (thirteenth-, fourteenth-, fifteenth-century) replacing missing parts; original text continues on fol. 9r. Gatherings are loose and parchment indicates much use as well as exposure to humidity.

Light brown leather binding in very bad condition. Front cover is lost. Back cover has a frame of triple lines and diagonals in the main field forming a half-diamond pattern. Greek technique, probably sixteenth century.

Illustration

The manuscript contains ornamental initials, the principal components of which are blessing hands, hands holding pens or snakes, crude human figures with or without snakes, an occasional bird, and half palmettes. Small, band-shaped, framed headpieces over the Menologion commemorations in the right or left column, ornamented with palmettes, half palmettes or simple interlace. The colors are thick: dull blue, terracotta-red, light green and dirty yellow or olive green and orange-red. There are also several initials in interlace and fretsaw motifs.

Initials
1r Initial Є with rough half palmettes and several initials like it throughout.
27v, 28r, 29r, 30v, 32r and v Initial Є with hand holding pen.
30r, 33r, 34r, 35v, 38r, 41r, 93v, 104v, 106v, 128v, 129v, 142r Initial Є with hand blessing.
59v (fig. 191), 62r, 88v, 102v Initial A with bird (peacock on fol. 88v) picking at a flower, or a coiling snake.
89r, 90v (fig. 192) Initial A with human figure.
104r (fig. 193), 122r Initial A with human figure holding snake.
108v (fig 194), 111v, 113v Initials A and X with one or two human arms, holding a snake and a green leaf.
132v, 136r, 143v Initials A and T with snake.

Headpieces
86r In the form of a *tabula ansata* decorated with half palmettes, beginning Menologion commemorations.
111r, 121v In band-shaped form with palmettes and half palmettes.
93v, 97v, 103v, 117v, 124v, 127r, 134r, 138v (unframed) Band-shaped with various forms of simple crude rinceau, interlace, chain, and zigzag patterns. All headpieces are in flat hues ranging from blue to olive green, dirty yellow, brown, and orange.

[1] For parallel examples see G. Cavallo in *Paléographie grecque*, p. 109, pl. 50; Harlfinger et al., p. 30 no. 13.

[2] The formula of this subscription is found in several manuscripts, such as Paris gr. 710 and gr. 781; Milan, Ambros. B.52 sup.; Vat. gr. 465; Vat. Ottob. gr. 214; and Athens, Nat. Lib. 2551. See Mioni, *Paleografia*, p. 84; Marava-Chatzinicolaou, Toufexi-Paschou, no. 60, p. 222. For the citation of two indictions see the introduction offered by Husmann, pp. 147ff., and Harlfinger et al., p. 30.

This type of manuscript, with headpieces and initials but no miniatures, reflects a tradition related to codices assigned to the eastern provinces of the empire.[3] Most indicative is the application of snakes to the initials, the extended arms and the crude human figures, the use of palmettes, and the muddy color scheme.[4] Such features are known in tenth-century codices[5] but continued to be used later, when various traditions of ornamentation often seem to mingle in one manuscript.

The city of Dalisandos was indeed in one of the eastern provinces. But whether this is the Isaurian Dalisandos which later belonged to Pamphylia II, or that city with the same name located further northwest, cannot be determined at present.[6]

Bibliography

Gardthausen, *Catalogus*, p. 57.
Gregory, *Textkritik*, pp. 291 no. 412, 1283 no. 1443.
Beneševič, p. 122 no. 125.
Devreesse, *Introduction*, pp. 57, 298.
Duplacy, "Lectionnaires," pp. 521 n. 10.
Kamil, p. 73 no. 317.
Treu, "Schreiber," p. 447.
Husmann, pp. 147ff., 167.
Harlfinger et al., pp. 30, 31 no. 13.

Leningrad leaf:
Cereteli 1904, pp. 11, 16, 178, pls. 1, 2.
Gregory, *Textkritik*, p. 1281 no. 1413.
Beneševič, pp. 122, 615–16, no. 125.
Idem, *Mon. Sinaitica*, 2, pl. 51.
Lake, *Dated Mss.*, 6, no. 254, pl. 449.
Devreesse, *Introduction*, p. 298.
Granstrem, *VV* 19 (1961) p. 202 no. 203.
Duplacy, "Lectionnaires," pp. 521 n. 10, 525, 529, 538.
Harlfinger et al., pp. 30–31.

27. COD. 512. MENOLOGION, FIRST HALF OF JANUARY
CA. A.D. 1055–1056. FIGS. 196–198, COLORPLATE XV

[3] Weitzmann, *Buchmalerei*, pp. 65ff., 68ff.

[4] Ibid., p. 66. It should be noted, however, that both the snake and the hand, old motifs within the so-called "monastic" tradition, were widely disseminated in the latter part of the eleventh and the twelfth centuries in combination with other elements and were not confined to a few provincial centers.

[5] The cods. Paris gr. 277 and Patmos 70, both from the tenth century, can be mentioned as examples; see ibid., fig. 63, pl. LXXII,432, 434.

[6] For Dalisandos, see R. Janin in *Dictionnaire d'histoire et de géographie ecclésiastiques*, 14 (Paris 1960) cols. 26f.; Harlfinger et al., p. 30;

Vellum. 259 folios, 36.3 x 28.5 cm. Two columns of twenty-five lines. Minuscule script, regular, elegant and calligraphic for text; titles in *Auszeichnungs-Majuskel*. Gathering numbers at center of bottom margin of first recto with the usual strokes above and below. Parchment thick but fine, yellowish. Ink brown to dark brown for text; titles and small solid initials in text mostly (but not to the end) in gold, some only in red; larger initials in flower petal style contoured in gold.

The codex consists of nine saints' lives arranged in consecutive days, January 5, Paul the Theban, to January 17, Anthony the Great. Fols. 1r and v, table of contents, beginning missing; 2v, illustration; 3r–259r, saints' lives.

Several entries have been published and discussed by Harlfinger et al.[1] Here we cite only entries which have a direct bearing on the history of the manuscript. On fol. 1r in a thirteenth-century script: + βίβλος τοῦ ἁγίου χαρίτωνος. This indicates that at the time of the entry the codex was in the Lavra of Khareitoum, founded by Chariton not far from Jerusalem.[2]

On fol. 45v by another thirteenth- or fourteenth-century hand: + θεῶδοριτοῦ ἀπο τὸν πρώδρωμον ἰω(άννην) τοῦ εἰόρδανοῦ. The codex was in the hands of a Theodoritos from the Monastery of St. John the Forerunner in the Jordan valley (Kasr el-Yehoud) not far from Jericho.[3]

On fol. 2r by a thirteenth-century hand:

+ ἡ τοιάυτη βίβλος ἠχμαλωτίσθην ἀπὸ τῆς πτο/λεμαΐδος τὴν αἰχμαλωσίαν· παρὰ τῶν ἀγαρι/νῶν· καὶ ἐξηγόρασεν αὐτὴν ἀπὸ τὰς χεῖρας / τῶν ἀγαρινῶν· ὁ μοναχό(s) βησαρίων ὑπο τοῦ / κόπ(ου) αὐτοῦ· λοιπὸν γοῦν παρακαλῶ ὑμῖν ὦ / ἀδελφοὶ οἱ ἀναγινώσκον(τες) τὴν τοιαύτ(ην) δέλτον / εὔχεσθαί μοι διὰ τὴν τοῦ κ(υρίο)υ ἀγάπ(ην)· ὡς πολλὰ ἁ/μαρτωλὸν· καί μὴ ποιοῦντα τί ἀγαθὸν ἔργον· / καὶ ὁ θ(εὸ)s συγχωρήσει ὑμᾶς· καὶ ἡμῖν· ἐν τῷ νῦν / αἰῶνι καὶ ἐν τῷ μέλλοντ(ι) ἀμήν:–

+ This book was taken (as spoil) by the Agarenes (Arabs) during the conquest of Ptolemais (Akka/

K. Belke, M. Restle, *Tabula Imperii Byzantini* 4: *Galatien und Lykaonien*, Vienna 1984, p. 53.

[1] See Harlfinger et al. in Bibliography.

[2] For this monastery see Vailhé, "Répertoire," 4, pp. 524–25 no. 21; also Harlfinger et al., p. 32. It should be noted that the September volume in Oxford, cod. Barocci 230, belonging to the same set, is also related to the same Lavra; see Spatharakis, *Dated Mss.*, fig. 114.

[3] For this monastery see Vailhé, "Répertoire," 5, pp. 19–22 no. 61.

Acre) and it was bought back from the hands of the Agarenes by the monk Bessarion through his toils (by his own money). I beg you, then, o brethren, you who read this book to pray for me, for the love of the Lord, for I am a great sinner and I have not done any good work. May God forgive you and me now and forever, amen.

This entry refers to the conquest of Akka by the Mameluks under Sultan al-Ashraf Khalil in 1291 which brought an end to the Crusaders' dominion of the city.[4]

On fols. 2r and 259v entries referring to the dedication of the codex to Sinai. That on fol. 259v, which gives the exact date, reads:

+ τούτο το θ̅ρ̅ο· καὶ εἱερὸν βηβλήων / ἀφηερόθη· εις την θήαν κ(αὶ) ειε/ράν μεγάλην βασιλικῆν μο/νῆν τοῦ σινέοι όρους· καὶ μη/δής πάντολμος· ἀναφανῆ κ(αὶ) / ἐξόσε της μονῆς· εἰ ναμή εξή τον ειεροσίλον τὸ ἐπίτιμηον. / ͵ζλη'.

+ This divine and holy book was dedicated to the divine and holy, great monastery of Mount Sinai and no one dare appear and take it away from the monastery so that he may not receive the penalty of sacrilegious men. 7038 (1530).

Among other entries recording the names of visitors or readers is one containing the signature of Kallinikos III, Patriarch of Constantinople, who was exiled to Sinai between 1757 and 1761.

The codex has suffered from humidity. Fol. 3r, right half, is in bad condition. Several gatherings are loose, and fol. 185r, bottom margin, is cut out. On fol. 155v, left column, the frame of a band-shaped headpiece is outlined, but the ornament remains unexecuted, Life of John the Poor in Christ (Kalybites); on fol. 196v, left column, space was left for a band-shaped headpiece which was not executed, Life of Anthony the Great. The decoration of the codex was thus not completed. Text ends on upper part of right column, fol. 259r. Full-page miniature, fol. 2v, is flaked considerably.

Old brown leather binding on wooden boards (front board broken). On both covers, bands separated by fillets along the border, square stamps with floral and animal motifs; crossing, diagonal lines in center and small medallions with simple rosettes at the inner corners, all in bad condition. Metal studs in rosette form on corners and center; only the two upper studs have survived on the back cover. Greek work, probably of the second half of the fifteenth century.

[4] S. Runciman, *A History of the Crusades*, 3, Cambridge 1954, pp. 412ff.

Illustration

1r Π-shaped headpiece in flower petal style in roundels, and two panels with rosettes on top, left column (fig. 196). The flowers in this and remaining headpieces are set in gold. Above, + μη(νὶ) ἰαννουαρίω ε'. Table of contents, continuation.

2v Saints of the first half of January, in three rows, full-page (22.4 x 15.7 cm.) (fig. 198).
 1) January 5, Paul of Thebaid, ο α(γιος) παυλο(s) ο θιβηος, wearing monastic garments of light olive, yellow-brown, and dark green, with a carmine megaloschema, black cowl and a staff, converses with Anthony, ο α(γιος) ἀντωνιος, who raises his arm in a gesture of speech. Anthony's face and part of his light grey-brown and black-brown garments are flaked. A stylized tree separates them from the next pair of saints who are represented standing frontally, like the rest. January 9, Polyeuktos of Armenia, ο α(γιος) πολυευ[κτο]s, with pointed beard, in light blue tunic and red chlamys with gold tablion and gold border, holds a white cross; January 10, Marcian of Constantinople, ο α(γιος) μαρκιανος, clad in grey garments and a white stole with a gold ornament on it, holds a gold book in his covered left hand. His face is flaked.
 2) January 11, Theodosios the Coenobiarch, ο οσ(ιος) θεοδο[σιος] ο κ[οι]ν[ο]β[ιάρχης], in olive and brown monastic garments and a black megaloschema, holds a scroll in his left hand. January 13, Hermylos, ο α(γιος) ερ[μ]υ[λ]ο[s], in red and pale violet, is almost totally flaked. January 13, Stratonikos, ο α(γιος) στρατονικος, black-haired, in light green tunic with gold borders and light blue mantle. January 14, the Holy Fathers martyred at Raithou, [οἱ ὅσιοι πατέρες] ο(ι) α(γιοι) τ(ῆς) ρ[α]ιθ[οῦ]. Three soldiers in green, light blue, and pink garments, attack with a lance and decapitate three monks, all nimbed, a bending monk on the extreme right, and two youthful saints above.
 3) January 15, John the Poor in Christ (Kalybites), ο α(γιος) ιω(αννης) ο πτωχ(ὸς) in olive, brown, and dark green monastic garments with megaloschema, stands holding a white cross. January 16, Peter reclining in prison is visited by an angel in light blue and light green with black wings having carmine tips, [ὁ ἅγιος πέτρ]ος εν τη [φυλακῆ]. In the foreground one soldier reclines and another one is seated behind, at the left. Both, almost flaked, wear golden helmets.

The prison takes the form of an apsidal structure, the background of which is painted black. January 17, Anthony, *o a(γιοs) av[τώνιοs]*, in olive and black-brown garments, holds a white cross. In all figures the hair color ranges from grey to olive green and brown, and the flesh is marked by predominantly green tones. All saints wear gold nimbi and stand on a green ground of two different tones against a deep blue background. The captions are in red. A border of crenellated pattern set in gold frames the entire miniature and divides the rows. Outside the illustration, on top, is the following inscription in gold: ΟΙ ΑΓΙΟΙ ΤΟΥ ΠΡΩΤ(ου) ΒΙΒΛΙΟΥ ΤΟΥ ΙΑΝΝΟΥΑΡΙΟΥ ΜΗ(νὸς). (The saints of the first book of the month of January).

3r Π-shaped headpiece and initial Κ in flower petal style; petals in roundels joined by diagonal lines, left column. Life of Paul of Thebaid, January 5 (fig. 197).

18r Band-shaped headpiece and initial Є in flower petal style; petals in roundels with palmettes between, right column. Life of Polyeuktos, January 9.

27v Band-shaped headpiece and initial Π in flower petal style, left column. Life of Marcian of Constantinople, January 10.

46r Band-shaped headpiece and initial Π in flower petal style; flower petals are enclosed in roundels, right column. Life of Theodosios the Coenobiarch, January 11.

102v Band-shaped headpiece in flower petal style with pink palmettes in lozenges and inverted flower petals between. Initial Β in simple flower petal style, left column. Life of Hermylos and Stratonikos, January 13.

111v Band-shaped headpiece in flower petal style in the form of rosettes in squares. Initial Α in simple flower petals, left column. Homily of the monk Neilos on the Martyrdom of the Holy Fathers of Sinai and Raithou, January 14.

155v Outlined frame for a band-shaped headpiece, not executed, left column. Life of John the Hut-dweller, January 15.

172r, 196v Space left empty for headpieces not executed, left column. St. Peter's chains and Life of Anthony, January 16, 17.

Iconography and Style

The publication of a collection of the Lives of the Saints in ten volumes by Symeon Metaphrastes[5] was an important encyclopedic undertaking in the period of Constantine VII Porphyrogenitus. This new edition affected the mode of illustration of the Menologia and produced new types. Each biography was illustrated with one or two miniatures, one at the beginning and one at the end, or with a frontispiece in which the individual miniatures of one volume were collected and placed in rows. Although extensive cyclic illustration did not disappear,[6] in general these two types, predominantly influenced by the Liturgy, replaced the pre-Metaphrastian Menologion containing only cyclic illustrations.[7]

The Sinai codex belongs to the second of the new types. In its frontispiece (fig. 198, colorplate xv), the saints of the first half of the month are represented as hieratic, stereotyped portraits, interspersed, however, with such scenic representations as the martyrdom of the Forty Martyrs of Raithou and St. Peter in Prison, which are excerpted from richer narrative cycles. The pair of Paul of Thebaid and Anthony the Great conversing with one another must also have come from a narrative cycle. In fact, this is the meeting of the two anchorites described in the life of Paul, during which Anthony expressed to Paul his wonder at the site Paul had chosen for, and the many years he had spent in, ascesis.[8] In addition, Anthony is represented once again as the last figure in the frontispiece, following the sequence of the calendar.

A similar arrangement of saints is found in calendar icons of the period, complete sets of which have been preserved at Sinai. Although portraits and scenes on icons go back to illustrated Menologia, the concept of a collective image in a Menologion was inspired by icons with a liturgical function. It is possible that the miniatures were produced by an artist who worked in both media.[9]

The scope of the Sinai volume (January 5–17) leaves no doubt that it was part of a ten-volume set. Other volumes

[5] Ehrhard, *Überlieferung*, 2, pp. 306ff.

[6] See, for example, the cod, Athos, Esphigmenou 14, and Turin, Bibl. Naz. cod. B.II.4, Life of St. Eustratios, in *Treasures*, 2, figs. 327–43, and Weitzmann, "Cyclic Illustration," pp. 85–86, figs. 24a, 24b; Idem, "Illustrations to the Lives of the Five Martyrs of Sebaste," *DOP* 33 (1979) pp. 102ff., figs. 10–27. See also Paterson Ševčenko, "Menologium," pp. 426f., figs. 17–21.

[7] S. Der Nersessian, "The Illustrations of the Metaphrastian Menologium," *Late Classical and Mediaeval Studies in Honor of A. M. Friend,*

Jr., K. Weitzmann, ed., Princeton 1955, pp. 222–31, repr. in eadem, *Études*, pp. 129–38; P. Mijović, *Menolog. Istorijsko-umetnička istraživanija,* Belgrade 1973, with earlier bibliography; Weitzmann, "Eleventh Century," pp. 214–16 (*Studies*, pp. 283–84); Deliyanni-Doris, pp. 275–313.

[8] See *Menaion Ianouariou*, Athens n.d., p. 190; also Eustratiades, *Hagiologion*, p. 380.

[9] Weitzmann, "Eleventh Century," pp. 215–16 (*Studies*, p. 284); Sotiriou, *Icônes*, 1, figs. 126–30; 2, pp. 117ff.

of this set with similar frontispieces executed in similar style have survived in Oxford, cod. Barocci 230 (September); Vienna, Hist. gr. 6 (October); Paris gr. 580 (November 17–25); Paris gr. 1499 (November 25–30: this manuscript contains seven ornamental headpieces only); and Athos, Lavra Δ 82 (second half of December).[10] According to Nancy Paterson Ševčenko, the second half of the Lavra codex was written by the same scribe who wrote the Sinai Menologion, which would have been volume seven within the same set.

The Sinai miniature is distinguished by human figures which are over-elongated and flat, with weightless bodies, asserting the ascetic spirit of monasticism. Green, brown, and red are the predominant colors, set against a deep blue background and framed by pink borders with crenellation ornament in white. The style and coloring belong to the art of Constantinople in the second half of the eleventh century[11] and they are found in the codices cited above. Similarities include the type and high quality of the ornamental bands, gold initials or initials in gold contours, parts of the table of contents in gold, the large inscription on top of the frontispiece, and the paleography. The cod. Paris gr. 1499 contains a colophon (fol. 421r) according to which the codex was completed by the hand of the monk Euthymios for a certain Paul, who may have been the abbot of the monastery in which Euthymios was a monk, in the month of January during the sole rule of Theodora (1055–56) and the patriarchate of Michael (Cerularios, 1043–59).[12] This should then be the approximate date for the extant Menologia of this set, including the Sinai codex.

Bibliography

Kondakov 1882, p. 156.
Gardthausen, *Catalogus*, p. 125.
Kondakov, *Histoire*, p. 115.
Beneševič, pp. 184–86 no. 341.
Idem, *Les manuscrits grecs du Mont Sinai et le monde savant de l'Europe depuis le XVII⁰ siècle jusque à 1927* (Texte und Forschungen zur byzantinisch-neugriechischen Philologie, 21), Athens 1927, p. 54 n. 3.
Ehrhard, *Überlieferung*, 1, p. LIII; 2, pp. 540, 690, 716.
Lazarev 1947, p. 320 n. 53.
Sotiriou, *Icônes*, 2, p. 209.
P. Mijović, "Une classification iconographique des Ménologes enluminés," *Actes du XII⁰ Congrès International d'Études Byzantines (Ochrid, 1961)*, 3, Belgrade 1964, p. 279.
R. Naumann and H. Belting, *Die Euphemia-Kirche am Hippodrom zu Istanbul und ihre Fresken*, Berlin 1966, p. 148 n. 96.
Lazarev, *Storia*, p. 251.
Weitzmann, "Eleventh Century," pp. 213ff., fig. 20 (*Studies*, p. 284, fig. 281).
Kamil, p. 91 no. 735.
Der Nersessian, *Psautiers*, pp. 91 n. 23, 98.
P. Mijović, *Menolog. Istorijsko-umetnička istraživanija*, Belgrade 1973, see index.
Weitzmann, *Sinai Mss.*, pp. 21–22, fig. 27.
Lichačeva, *Iskusstvo knigi*, p. 119.
Paterson Ševčenko, "Menologium," p. 425.
Spatharakis, *Dated Mss.*, pp. 22–23, no. 67, fig. 119.
Voicu, D'Alisera, p. 561.
Hutter, *Oxford*, 3, p. 331.
Deliyanni-Doris, pp. 286, 290 n. 79, 291, 296, 298, 310, fig. 2.
Walter, *Art*, pp. 47 n. 78, 50 n. 100, 153.
Harlfinger et al., pp. 31–32, 63 no. 14, pls. 64–68.

28. COD. 500. MENOLOGION, FIRST HALF OF NOVEMBER
LENINGRAD, STATE PUBLIC LIBRARY COD. GR. 373: ONE LEAF
CA. A.D. 1063. FIGS. 199–217, COLORPLATE XVI:a

Vellum. 305 folios, 38.7 x 27 cm. *Leningrad*: one leaf, 36.8 x 26.2 cm. Two columns of twenty-nine lines. Minuscule script for text, clear but irregular and angular; inscriptions on fol. 4v, title of opening page, fol. 5r, and month indications throughout in *Epigraphische Auszeichnungs-Majuskel*; all other titles and inscriptions in miniatures in *Auszeichnungs-Majuskel*; very wide outer and bottom margins. Gathering numbers with horizontal strokes above and below at the upper right corner of first recto; also later numbers in some folios. Parchment thick but fine, whitish. Ink brown for text; titles, month indications in gold. Larger initials in flower petal style combined with birds and animals and smaller initials in flower petal style throughout the text; small solid initials in text in gold.

The fragment in Leningrad, removed from the Sinai Menologion by P. Uspenskij, contains the end of the Lives of Saints Cosmas and Damian, November 1, and the very beginning of the Lives of the Five Saints, November 2. Its original place was between folios 9 and 10 of the Sinai manuscript. Present gathering numbers must have been written after the excision of the leaf, since they do not take the textual lacuna into consideration. Hence the contents of the codex in its original state were: fols. 1–2, flyleaves; 3r, late

[10] Spatharakis, *Dated Mss.*, pp. 22–23, nos. 63–66, figs. 113–18, and Paterson Ševčenko, "Menologium," pp. 425ff., who is preparing a complete publication of all these Menologia.

[11] Weitzmann, "Eleventh Century," pp. 212ff. (*Studies*, pp. 281ff.); Beckwith, *Constantinople*, pp. 115ff.

[12] Lake, *Dated Mss.*, 4, no. 161, pl. 275.

entry of the year 1632; 3v–4r, table of contents; 4v, page with cross; 5r–9v, beginning of saints' lives, Cosmas and Damian, November 1 (*Leningrad*: one leaf between fols. 9 and 10); 10r–305v, fifteen saints' lives, November 2–16; 305v, blank.

The entry on fol. 3r reads: ὁ παρόν νοέμβριος, ἐμετασταχόθη· ὑπό γερασίμου ἱεροδιακώνου· ἐν τῷ σιναίῳ ἁγίῳ ὄρει ἔτει· ˏζρμ´ κατά μῆνα μάϊον.- (The present November [volume] was rebound by Gerasimos the hierodeacon in the Holy Mount Sinai in the month of May of the year 7140 [1632].) An Italian entry on fol. 250r reads: *1609 la festa di S. Zoane chrisostomi menori giorno era la festa ancor* (?).

Condition good. Some miniatures have suffered considerable flaking. First and last folios wrinkled and blackened by humidity. Several folios missing. Cross page, fol. 4v, is partly damaged and repaired with paper.

Black leather binding on wooden boards, with nearly identical design for both covers (figs. 216, 217). A band along the sides forms a frame with a flourished rinceau. Another band carries an arabesque ornament in the form of leaves, part of a rinceau flanked by medallions with quadrupeds.[1] The frame is further decorated by arabesque motifs at the four inner corners and a fragment of the same band set vertically on the center of the lower part of the frame. Outside the frame are rectangles with fleurs-de-lis. In the enclosed panel are five pressed medallions, each containing a bust of the Virgin Hodegetria inscribed $\overline{\text{MP}}$ $\overline{\text{ΘΥ}}$/$\overline{\text{IC}}$ $\overline{\text{XC}}$, the central one gilded. The back cover is similar except for the addition of two lozenges with fleurs-de-lis above and below the central medallion containing the bust of the Mother of God. The rinceau and the medallions with animal motifs are also pressed on the inside edges of the covers, along three sides of the board. On the inner side of the back cover, a piece of paper has been glued with fragments of the troparion ἄλλα τὰ χείλη τῶν ἀσεβῶν τῶν μὴ προσκυνούντων . . . This cover must be the result of the binding referred to on fol. 3r, which was done in Sinai in May 1632. The Italian entry on fol. 250r may indicate that the codex was in Crete (the form Z[o]an[n]e for Giovanni is common in Venice and Crete) and that it came to Sinai sometime between 1609 and 1632.

Illustration

Sinai

3v Π-shaped headpiece in flower petal style, left column. Table of contents.

[1] Van Regemorter, "Reliure," p. 12, cf. fig. 7,4.

4v Cross, full-page (23.3 x 16.3 cm.) (fig. 199). Within a delineated, rectangular frame stands a Latin cross painted against the parchment. Its three upper arms, with teardrops on the corners, end in smaller Celtic crosses; that on the right has partially disappeared. A band of flower petals in pink, blue, and green against tarnished gold decorates the cross on all four sides. A rosette is in the center of the cross, and flower petals on the discs of the Celtic crosses. The body of the cross is marked by an inscription in gold letters set against the parchment. It is read cross-wise from top to bottom and then from the viewer's left to right: κόσμος πέφυκα / τῆς παρούσης πυξίδος + +. (I am the adornment of the present table of contents + +.) Two trees with leaves and flowers flank the lower arm of the cross and the monogram of Christ, $\overline{\text{IC}}$ $\overline{\text{XC}}$, in gold flanks the upper bar of the cross.

5r Two miracles from the lives of Sts. Cosmas and Damian, over both columns (16.1 x 17 cm. without the palmettes on the corners of the frame, and 11 x 12 cm., the inner panel) (fig. 200). A large rectangular ornamental band encloses two scenes, one above the other, divided by a narrow band with flower petals painted against the parchment. In the upper scene, Cosmas and Damian, clad in mantles (Cosmas in red and Damian in light violet) and dark olive tunics, with dark brown hair and golden nimbi, are depicted walking to a man standing at the right dressed in red, from whose mouth issues a serpent. Two churches marked by crosses and with gabled roofs flank the composition. Figures and buildings, which have suffered flaking, stand on a strip of green ground against the parchment, features found in every illustration in the codex. An inscription in red fills the space between the figures and above the church on the right side. It reads: οἱ ἅγιοι ἀνάρ/γυροι· κοσμᾶς / κ(αὶ) δαμιανὸς· / ἕλκουσι / τὴν ὄφιν / ἐκ τῆς κοιλίας / τοῦ ἀν-(θρώπ)ου· ὅς, ἔν/δον εἰσῆλθεν αὐ/τοῦ κοιμωμένου. / ὁ ἄ(νθρωπ)ος ἰώμενος / παρὰ τ(ῶν) θείων ἀναρ/γύ-ρων: (The moneyless Saints Cosmas and Damian draw out the snake from the belly of the man, that is the snake which entered him while he was asleep. The man being healed by the Divine Anargyroi).

The lower scene represents Cosmas and Damian clad as above. Cosmas, ὁ ἅ(γιος) κοσμᾶς, is standing on the left, facing to the right and making a blessing gesture, while next to him Damian, ὁ αγιος δαμιανός, bends

and touches the left leg of a black camel. At the right is a building with violet walls, grey front, and red roof. A strip of green ground unites the composition. Inscriptions in red read: οἱ ἅγ(ιοι) ἀνάργυροι / κοσμᾶς, κ(αὶ) δαμιανό(s) / ἰώμενοι τὴν κά/μιλον· εἴτ(ι)s ἐν καιρῶ / τῆς κοιμήσεως αὐτ(ῶν) / ἀν(θρωπ)ίαν φωνὴν ἀνα/λαβοῦσα, ἐν ἑνὶ τάφῳ / αὐτούς τεθῆναι παρεκελεύ/σατο: (The Saints Anargyroi Cosmas and Damian are healing the camel which assumed a human voice at the time of their death and ordered that they be placed in one tomb).

The wide frame enclosing the scenes is decorated with squares in flower petals, alternating with a diamond pattern. The initial A is formed by a quadruped biting a serpent, and a rooster on top. On top of the miniature, November 1; below, title Life of Cosmas and Damian.

Leningrad

1v The Five Saints (who suffered martyrdom in Persia) (ca. 10 x 8 cm.), right column (fig. 201). A rectangular frame made of a thin, delicate fillet encloses the saints, οἱ ἅγιοι πέντε, who stand frontally in two registers, three above and two below, holding crosses and wearing golden nimbi. Above: Akindynos in red and green garments, with dark hair and beard; Pegasios in green, violet, and purple garments, with dark hair and a somewhat longer head; Anempodistos, in light blue and red, with bluish hair and beard. Below: the youthful Apthonios in purple and red garments; Elpidophoros in red and steel blue. There is no background but simple ground strips, as on fol. 5r of the Sinai codex. Underneath, a title headpiece in flower petal style, including the names of the five saints. It is Π-shaped on the outside and five-lobed on the inside. Initial Є in flower petal style supported by a peacock. On top of the miniature, November 2; underneath, the title Martyrdom of Akindynos, Pegasios, Anempodistos, Apthonios, and Elpidophoros.

Sinai

25v Sts. Joseph, Akepsimas, Aeithalas (9.4 x 7.9 cm.), left column (fig. 202). A blue and gold fillet-like frame (a gold line broken by dots set against blue, a type of frame used throughout the codex) encloses the three saints represented with large gold nimbi, standing on a green strip of ground and painted against the parchment. Identified by red inscriptions outside the frame on the upper part, the saints who suffered martyrdom in Persia are from left to right: ὁ ἅ(γιος) ἰωσὴφ· ὁ ἅ(γιος) ἀκεψιμᾶς· ὁ ἅ(γιος) ἀειθαλ(ᾶ)s. Joseph, who was a presbyter, is depicted clad as a priest in a brown sticharion, white epitrachelion decorated with a hatched pattern, a gold epigonation or encheirion under his right arm, and a black-purple phelonion,[2] and holding a pearl-studded gold book with a red cut. He is shown with black-purple hair and flesh tones of shaded green, which are shared by his companions. His face is slightly flaked, but his long beard is still visible. Akepsimas, who was a bishop of Anitha, is dressed as a bishop in a light blue grey sticharion, white epitrachelion, golden epigonation, pale violet phelonion, and a white omophorion with three crosses. He has grey-green hair (according to the account of his life he was over eighty years of age when he suffered martyrdom), and a long pointed beard, and is holding a book and blessing. Aeithalas, who was a deacon, wears the appropriate vestments, a light grey-green tunic with black-purple borders around the hem, neck and sleeves. In his right hand he holds a censer covered by a piece of cloth decorated with a cross, the so-called epirriptarion, and in his left a golden pyxis. He is youthful, with short black beard and hair.[3] Underneath, a Π-shaped headpiece in flower petal style. Initial Є in similar style with a red human face in profile. On top of the miniature, November 3; in the miniature, title Martyrdom of Joseph, Akepsimas and Aeithalas.

43v St. Ioannikios (9.3 x 7.4 cm.), lower half of left column (fig. 203). Within the usual rectangular frame, Ioannikios, ὁ ἅ(γιος) ἰῶαννίκιος, stands frontally, wearing the megaloschema in two shades of green, mostly flaked, a brown tunic, and a grey-blue monastic cloak. According to his Life he received the megaloschema in the monastery of Pandemos in Bithynia. In his left hand he holds a scroll, outlined in green, with the following incomplete text in terracotta red: μωρ(οὶ) οὐ / προκό/ψουσι / ἐπὶ τὸ / χειρό(..)/ σ̀—α? (The poor in mind will not thrive on . . . ?).

[2] For the episcopal costume, see T. Papas, *Studien zur Geschichte der Messgewänder im byzantinischen Ritus*, Munich 1965; idem, "Bibliography of Liturgical Vestments of the Byzantine Rite" (in Greek), *Theologia* 45 (1974) pp. 172–93; idem, "Bibliography of Priestly and Liturgical Vestments of the Byzantine Rite" (in Greek), *Theologia* 47 (1976) pp. 313–29.

[3] In the *Hermeneia*, Aeithalas is described as beardless, see Papadopoulos-Kerameus, ed., index; Ph. Kontoglou, Ἔκφρασις τῆς Ὀρθοδόξου εἰκονογραφίας, 1 (text), 2 (plates), Athens 1960, p. 150.

This is not the text that appears in later representations of the saint cited in the *Hermeneia*.[4] Ioannikios' flesh tones are light brown; his hair is grey-green set against a gold nimbus. He stands on a strip of grey-green ground, and as in previous miniatures the composition has no background. Π-shaped headpiece on the upper part of the right column in flower petal style. Initial T in similar style supported by a peacock. On top of the headpiece, November 4; in the headpiece, title Life of Ioannikios of Olympos.

77r Sts. Galaktion and Episteme (8.6 x 7.7 cm.), left column (fig. 204). Galaktion and his wife, whom he had baptized, are represented standing frontally, holding white crosses in their right hands and wearing gold nimbi, ὁ ἅγιος γαλακτίων, ἡ ἁγία ἐπιστήμη. Both, who spent their lives according to the precepts of strict monasticism, are clad in monastic vestments. Galaktion wears a flaked brown megaloschema, and Episteme, in addition to the brown megaloschema, also is clad in a brown tunic and a cloak. Ground, background, and frame as in all illustrations. Miniature has suffered considerable flaking. Underneath, a Π-shaped headpiece in flower petal style and initial T in similar style supported by a bird, partly flaked. On top of the column, November 5; title in the headpiece, Lives of Sts. Galaktion and Episteme.

86r Paul the Confessor (8.3 x 7.4 cm.), on top of the left column (fig. 205). Standing frontally, the archbishop of Constantinople is clad in bishop's vestments and colors similar to those of Akepsimas on fol. 25v: ὁ ἅγιος παῦλος ὁ ὁμολογητής. He has a gold nimbus; his hair and beard are black-brown and flesh tones dark brown. Ground, background and frame as previously. Underneath, a Π-shaped headpiece in flower petal style and initial H formed by two falcons facing each other. On top of the miniature, November 6; title in headpiece, Life of Paul the Confessor.

92v St. Hieron killing his pursuers with the help of an angel (10 x 7.2 cm.), bottom of the right column (fig. 206). Hieron (one of the thirty-three saints who suffered martyrdom in Melitene), clad in red tunic with golden border and with a gold nimbus, steps forward brandishing a club against a man clad in light violet and dark brown and seizing him by the hand. Behind this second man, at the right, is a kneeling soldier in red tunic and with grey-blue tights and red-brown armor. Two more figures, almost

completely flaked, lie prone in the foreground. The scene occurs in front of a black cave in a brown mountain. On the upper righthand side, an angel in bust form, badly flaked, flies downward: ὁ ἅγιος ἱέρων ἀποκτένων / τοὺς ἐλθῶν/τας πρὸς / αὐτὸν / ὁ ἄγγελος ἐ/νισχύων αὐτόν: (St. Hieron killing those who came to him. The angel is strengthening him).

93r Π-shaped headpiece, on top of left column, in flower petal style, initial I in similar style. On top, November 7; within headpiece, title Martyrdom of the Thirty-Three Great Martyrs of Melitene.

98v St. Matrona (10.6 x 7.3 cm.), lower part of the right column (fig. 207). Within the normal frame and setting stands Matrona, the ascetic from Pamphylia, nun and foundress of a nunnery in Constantinople, clad as a nun in light brown and black garments, holding a white cross, and wearing a gold nimbus, ἡ ἁγία ματρώνα. The illustration has suffered considerable flaking.

99r Π-shaped headpiece, left column, in flower petal style alternating with crenellation and initial T in flower petal style supported by a peacock as on fol. 43v (fig. 208). Above the headpiece, November 9; within, title Life of the Holy Martyr Matrona.

118v St. Theoktiste from Lesbos (9.6 x 7.2 cm.), right column (fig. 209). In frame and setting as in all previous illustrations. Theoktiste, ἡ ἁγία θεοκτίστη ἡ λεσβία, is represented half naked and barefoot in the manner of Mary of Egypt, raising her hands before her chest, palms outward. Emaciated and, as described by the hunter who encountered her in the woodland, a sexless being, she wears a blue-violet piece of cloth over her red-brown flesh, has light grey-green hair, and a gold nimbus. Underneath, a Π-shaped headpiece in flower petal style and initial Є in similar style supported by a carmine mask with long ears. On top of the miniature, November 10; within the headpiece, title Life of Theoktiste of Lesbos.

129v Sts. Viktor, Menas, and Vikentios (9.8 x 7.7 cm.), lower part of left column (fig. 210). Identified by inscriptions outside the frame, ὁ ἅγιος βίκτωρ· ὁ ἅγιος μηνᾶς· ὁ ἅγιος βικέντιος·, the saints stand frontally, clad in tunics with gold borders, chlamydes, tablia (colors of costumes are pale violet, olive, red, and dark steel blue), with gold nimbi and holding white crosses in their right hands. Viktor and Vikentios are youthful, the one with black-brown and the

[4] For the text traditionally cited see Kontoglou, *op. cit.* (note 3), 1, p. 330.

other with brown hair. Menas is shown as an older man with white hair and beard; on the cross he holds is a bust of Christ. The latter distinguishes him from his companions—he is the great martyr—and it also alludes to the strength he received from Christ against the idols, as narrated in his Life. The flesh tones of all three are brown with green shadows. Frame, ground, and background as previously. Opposite, in the upper part of the right column, a Π-shaped headpiece in flower petal style in a zigzag pattern and initial B in similar style. On top of the headpiece, November 11; within, title Martyrdom of Sts. Menas, Viktor, and Vikentios.

136r St. John the Almoner (8.7 x 7.7 cm.), right column (fig. 211). John, ὁ ἅ(γιος) ἰω(άννης) ὁ ἐλεήμων, the archbishop of Alexandria, is shown in bishop's vestments, as Akepsimas on fol. 25v, in white, violet, and olive (epigonation is gold), holding a jewel-studded gold book with a red cut in both hands. Wearing a gold nimbus, he has grey-green hair and his beard is rendered in similar colors, while his flesh tones have green shadows. He stands on a grey-green ground against the bare parchment. Underneath, a Π-shaped headpiece in flower petal style with roundels in a scroll pattern and initial T in similar style supported by a canine head. On top of the miniature, November 12; within headpiece, title Life of John the Almoner.

175r St. John Chrysostom inspired by Paul (10.3 x 7.8 cm.), left column (fig. 212). John Chrysostom, ὁ ἅ(γιος) ἰω(άννης) ὁ χρυσόστομ(ος), is dressed as a monk and nimbed, seated on a faldstool, facing to the right and resting his feet on a footstool. He is writing in a codex while taking dictation from Paul, ὁ ἅ(γιος) παῦλος, who is leaning, almost climbing over Chrysostom's shoulders, and whispering to him. The apostle, in grey and dark violet garments and nimbed, has brown flesh and dark brown hair. John's face is almost completely flaked. On the right side of the composition towers a tall black building with a steel-colored roof. Frame, ground, and background as previously. Underneath, a Π-shaped headpiece in flower petal style and initial K partially formed by a bird. On top of the miniature, November 13; within headpiece, title Life of John Chrysostom.

275v Sts. Bartholomew and Mariamne about to receive the body of the apostle Philip (9.3 x 7.8 cm.), right column (fig. 213). On the left Bartholomew, in light blue himation with red clavus and light violet tunic, with dark brown hair and beard, stands beside his sister Mariamne, who is dressed in pale and strong pink garments. Both are nimbed, have brown flesh tones, and are walking with outstretched hands toward the body of Philip on the opposite side. Possibly wearing a loincloth, which has almost disappeared since the image has flaked, and a golden nimbus, Philip is hung on a black T-shaped cross before the wall of a towering building with a tall gate (the city of Hierapolis). The inscriptions read: ὁ ἅ(γιος) φίλιππος / κρεμασθ(εὶς) ἐπὶ τοῦ / τείχους τελειοῦται: ὁ ἅ(γιος) βαρθολομαιος / ἡ ἁγία μαριάμνη·. Frame, ground, and background as previously. Underneath, a Π-shaped headpiece in flower petal style and initial O enclosing a rosette in similar style. On top of the column, November 14; within headpiece, title Hypomnema on St. Philip.

281v The three confessors, Gourias, Samonas, and Abibos (9.3 x 7.7 cm.), upper part of left column (fig. 214). The three confessors (inscribed outside the frame on top, οἱ ἅγιοι ὁμολογηταί) who suffered martyrdom in Edessa are depicted standing on the usual green ground-strip and within a frame similar to those previous. Gourias, a youthful man with blue-black hair, and Samonas, an older person with white hair and beard, wear tunics with gold borders and chlamydes in red-purple and dark steel blue, and carry white crosses. Abibos, a deacon, is suitably clad in grey-blue tunic with gold border and a deacon's orarion marked by a cross; he holds a censer in his right hand and a pyxis in his left hand, veiled by the so-called epirriptarion. All three wear gold nimbi. Underneath, a Π-shaped headpiece in flower petal style in the form of roundels, and initial Є in similar style with a blessing hand forming the horizontal bar of the letter. On top of the miniature, November 15; within headpiece, title Martyrdom of Sts. Gourias, Samonas, and Abibos.

302r The evangelist Matthew writing (8.5 x 7.1 cm.), left column (fig. 215). Clad in grey-blue and grey-violet, Matthew is seated on a folding chair with high back and a red cushion, facing to the right, resting his feet on a footstool and writing on a piece of parchment: ὁ ἅ(γιος) ματθαῖος ὁ ἀπό(στολος):. His head is painted against a gold nimbus. Opposite him is a writing desk with a lectern on which lies an opened roll. The miniature has suffered considerable flaking. Underneath, a Π-shaped headpiece in flower petal style and initial H in similar style. On top of the miniature, November 16; within headpiece, title Hypomnema to Apostle Matthew.

Iconography and Style

In its choice of texts the Sinai Menologion is a typical third volume (first half of November) of the standard Metaphrastian edition of the Lives of the Saints. Among the eight illuminated examples of the third volume which have survived, the Sinai codex is the most richly illustrated.[5] It contains scenes selected from a fuller cycle, and standing portraits of saints placed at the beginning of the relevant Lives. In the system and richness of its illustration the codex is related to the Menologion in Moscow, cod. Hist. Mus. gr. 382 (9/9) (May–August), completed in 1063, which is volume 10 of the same set.[6] Thus the Sinai Menologion was most probably produced in the same year.

The first scene, fol. 5r, the healing of the husbandman (fig. 200), also occurs in the Lectionary cod. Athos, Panteleimon 2, from the eleventh century, in a miniature that must have been copied from a Menologion and is correctly placed before the reading for November 1.[7] Both illustrations must derive from a common model and a fuller cycle.

The same is true for the scene on fol. 92v, referring to an episode in the life of St. Hieron (fig. 206). According to his Vita, Hieron was a "farmer strong in body and pious in soul" whom the servants of the worshippers of idols (this may imply soldiers and may explain the soldier in the miniature) went to capture "like pirates" as he worked. We are told that he took the iron farming tool (mattock) out of its wooden holder and used the holder itself (rendered in the miniature as a club) against the invaders, "who flew away full of blood and sweat."[8] The account makes no mention of any of them being killed or of the miraculous presence of the angel. The accompanying caption, however, states that Hieron is "killing the intruders," thus agreeing with the representation. Does this text, then, reflect another version of the Vita, or are we dealing with a misunderstanding on the part of the scribe who wrote the inscription?

In the extant account of his life, we read that during Hieron's trial, the Christians who were with him were thrown down and torn to pieces with the whip. Is it possible that the figures lying on the ground in the miniature actually belong to another part of the drama, and that the present scene is a conflation which was not understood by the artist and the scribe?

The third scene, on fol. 275r (fig. 213), is also excerpted from a fuller cycle. According to the account of Philip's life, the apostle suffered martyrdom by being hung on a wooden cross. His companions Bartholomew and Mariamne, brother and sister, were also hung from the cross, but were released still alive by the inhabitants of Hierapolis after an earthquake that followed Philip's death. They then took the body of the apostle down from the cross for burial.[9] The gestures of the figures in our miniature leave no doubt that they are about to receive Philip's body. It is the presence of these two figures that relates the scene to a fuller cycle. That is, we are dealing here with a literal illustration of a martyrdom scene, as seen, for example, in a late eleventh-century calendar icon in Sinai, or in cod. Paris gr. 510.[10]

The last scene, John Chrysostom inspired by Paul, fol. 175r (fig. 212), related to the writing of his homilies, is widespread, found in manuscripts and icons in the eleventh century and later.[11]

Matthew's portrait, taken over from a Gospel book, represents the type of the writing evangelist, usually associated with Luke, which had appeared in the tenth century[12] and is also found in eleventh-century works, when it became associated with Matthew as well.[13]

All the other portraits, whether groups or single, follow the tradition of representing saints known in Menologia and in calendar icons from the second half of the eleventh century, most of them found in Sinai, whose scenes, like those in manuscripts, depend on the Synaxaria and on calendars in fresco painting.[14] Their costumes, faithful to the texts, indicate ecclesiastical or secular ranks. The saints carry the cross, the common but not exclusive attribute of martyrs, Gospel books, attributes relating to their clerical position

[5] The other seven examples are Athens, Nat. Lib. suppl. 535; Venice, Marc. gr. 351; London, Brit. Lib. Add. 36636; Athos, Panteleimon 100; Sinai 499; Vat. gr. 859; Thessaloniki, Vlatadon 3(19); see Ehrhard, *Überlieferung*, 2, pp. 410, 412–13.

[6] Spatharakis, *Dated Mss.*, pp. 26–27, no. 78, figs. 141, 142; Paterson Ševčenko, "Menologium," pp. 423–30, figs. 1–3.

[7] Weitzmann, *Sinai Mss.*, pp. 20–21; for a color reproduction see *Treasures*, 2, fig. 278; the entire manuscript has been fully reproduced in this publication, see figs. 272–95.

[8] *Menaion tou Noembriou*, Athens, n.d., p. 63. Very useful for this and other saints is Eustratiades, *Hagiologion*.

[9] *Menaion tou Noembriou*, Athens, n.d., p. 145.

[10] Sotiriou, *Icônes*, 1, fig. 138; H. Omont, *Miniatures des plus anciens manuscrits grecs de la Bibliothèque Nationale*, 2nd ed., Paris 1929, pl. XXII.

[11] A. Xyngopoulos, "Ἰωάννης ὁ Χρυσόστομος, Πηγὴ Σοφίας," *Archaeologike Ephemeris* 81–83 (1942–44) pp. 1–36; also Walter, *Art*, pp. 112–13.

[12] See cod. Athos, Vatopedi 949, in Friend, "Evangelists," pl. XIV,134.

[13] See cod. Athens, Nat. Lib. 76 in Marava-Chatzinicolaou, Toufexi-Paschou, no. 25, fig. 209; also Luke in cod. Athos, Panteleimon 2, *Treasures*, 2, fig. 275.

[14] Sotiriou, *Icônes*, 1, figs. 126, 138; 2, pp. 117, 121ff.; cf. also cod. Koutloumousi 412 (Akolouthia, fourteenth century) in *Treasures*, 1, pp. 465–68, figs. 377–84 (not reproduced fully); S. Der Nersessian, "L'illustration du stichéraire du monastère de Koutloumous No. 412," *CA* 26 (1977) pp. 137–44.

(for example, Aeithalas' censer and pyxis, fig. 202, color-plate XVI:a), or referring to their teachings (the scroll of Ioannikios, fig. 203).

In the iconography of some of these saints there are features, already pointed out, which differ from later representations or formulae given by the *Hermeneia*.[15] And finally, there is an anomaly concerning the feast day of St. Theoktiste of Lesbos, who is normally commemorated on November 9 and not November 10, the date assigned to her in our codex.[16]

The cross page which marks the table of contents and opens the book, an old motif in book illumination[17] associated with various types of books such as Gospels, Psalters, and Patristic literature,[18] has found a place in Menologia as well.[19] As far as the form is concerned—the arms of the cross ending in discs—comparable examples are furnished by a cross page in the Menologion in Vienna, cod. Hist. gr. 6, fol. 1v, from the year 1056, introducing the table of contents, and another in the cod. Vat. gr. 463 (Liturgical Homilies of Gregory Nazianzenus) from the year 1062.[20]

The figures are distinguished by their elegant stance and a calligraphic rendering that imparts a somewhat linear quality to the dematerialized bodies and an intense expressiveness to the faces. The best preserved miniature, that of Paul the Confessor, fol. 86r (fig. 205), shows the characteristics of the style in detail and attests to its high quality. Highlighting takes the form of angular, rhythmic lines that cover and conceal the mass of the body. The ornament of the garments, which are rendered in delicate, light, harmonious colors, enhances this schematization. The faces, modelled in brown with green shades, have penetrating, austere gazes and strong personalities. All these features conform to the style found in the best Constantinopolitan manuscripts of the second half of the eleventh century. The same applies to the richness of the ornament and the initials, delicately drawn and with brilliant colors, and the use of gold, all recalling the Canon tables and headpieces of Constantinopolitan Gospels.[21] The Sinai manuscript's direct relative, however, is the cod. Moscow, Hist. Mus. gr. 382 (9/9), a Menologion to which it relates in ornament, ornithomorphic initials deriving from tenth-century motifs, system of illustration, and figure style.[22] The possible production of these codices in the Studios Monastery, as has been proposed, must, however, be left an open question.[23]

Bibliography

Kondakov 1882, p. 110 no. 76.
Gardthausen, *Catalogus*, p. 122.
Kondakov, *Histoire*, p. 115.
Beneševič, p. 183 no. 335.
Ebersolt, *Miniature*, p. 38 n. 6.
Ehrhard, *Überlieferung*, 2, pp. 411, 690.
Lazarev 1947, p. 320 n. 53.
S. Der Nersessian, "The Illustrations of the Metaphrastian Menologium," *Late Classical and Mediaeval Studies in Honor of A. M. Friend, Jr.*, K. Weitzmann, ed., Princeton 1955, p. 229 (eadem, *Études*, p. 136).
Eadem, "A Psalter and New Testament Manuscript at Dumbarton Oaks," *DOP* 19 (1965) p. 179; repr. in eadem, *Études*, p. 163.
Lazarev, *Storia*, p. 254 n. 51.
F. Bonora and G. Kern, "I manoscritti medici del monastero di Santa Caterina al Monte Sinai (Nota preventiva)," *Scientia Veterum* 16 (1968) fig. 3.
P. Mijović, "Une classification iconographique des Ménologes enluminés," *Actes du XIIᵉ Congrès International d'Études Byzantines (Ochrid, 1961)*, 3, Belgrade 1964, p. 279.
Kamil, p. 90 no. 722.
P. Mijović, *Menolog. Istorijsko-umetnička istraživanija*, Belgrade 1973, see index.
Weitzmann, *Sinai Mss.*, pp. 20–21, fig. 26.
Paterson Ševčenko, "Menologium," pp. 424–26, figs. 4–6.
Voicu, D'Alisera, p. 561.
Hutter, *Oxford*, 3, p. 335.
N. Paterson Ševčenko, "Six Illustrated Editions of the Metaphrastian Menologion," *XVI. internationaler Byzantinistenkongress (Vienna, 1981)*, Akten II/4, *JÖB* 32/4 (1982) pp. 188, 191, fig. 7.
Deliyanni-Doris, pp. 283, 292, 298, 299f., 301, fig. 6.
Walter, *Art*, pp. 47 n. 78, 49.
J. C. Anderson, "The Date and Purpose of the Barberini Psalter," *CA* 31 (1983) pp. 44–46, 51, 53, figs. D6–11, 10, 11.
Ch. Walter, "The London September Metaphrast Add. 1180," *Zograf* 12 (1983) p. 23.
A. Marava-Chatzinicolaou and Ch. Toufexi-Paschou, *Catalogue of the Illuminated Byzantine Manuscripts of the National Library of Greece*, 2 (Athens 1985) p. 174.

Leningrad leaf:
Lazarev 1947, pp. 108, 313 n. 11, pl. 135b.
Granstrem, *VV* 19 (1961) pp. 231–32 no. 274.
P. Mijović, "Une classification iconographique des Ménologes enluminés," *Actes du XIIᵉ Congrès International d'Études Byzantines (Ochrid, 1961)*, 3, Belgrade 1964, p. 279.
Lazarev, *Storia*, p. 188, fig. 218.

[15] See above, pp. 75–76.

[16] See *Menaion tou Noembriou*, Athens, n.d., pp. 87–88.

[17] See Sinai cod. 30, no. 1 above; cf. Weitzmann, "Kaiserliches Lektionar," figs. 75–77.

[18] Examples: cods. Patmos 33, from 941; Athos, Esphigmenou 25, from 1129, Spatharakis, *Dated Mss.*, no. 6, fig. 18; no. 136, fig. 255. Cf. also Sinai cod. 172, no. 29 below, fig. 220; cod. Paris gr. 550, Galavaris, *Liturgical Homilies*, pl. LXXXVI,399.

[19] See the leaf inserted in Princeton, Theological Seminary, cod. acc. no. 11.21.1900: *Greek Mss. Amer. Coll.*, no. 26, fig. 45; Paterson Ševčenko, "Menologium," p. 425.

[20] Spatharakis, *Dated Mss.*, no. 64, fig. 115; Galavaris, *Liturgical Homilies*, pl. XI,79; cf. also cross page in cod. Oxford, E. D. Clarke 15, fol. 19v, from the year 1078, in Hutter, *Oxford*, 1, no. 32, fig. 155.

[21] Cf. cod. Athens, Nat. Lib. 57, Marava-Chatzinicolaou, Toufexi-Paschou, no. 26, figs. 222–31.

[22] Spatharakis, *Dated Mss.*, no. 78, figs. 141–43.

[23] See J. C. Anderson in bibliography for this codex.

F. Halkin, "Fragments du ménologe métaphrastique à Leningrad," *BSl* 24 (1963) p. 64.

V. G. Poutsko, "Dva fragmenta konstantinopol'skikh licevykh rukopisek tre'ej četverti XI v. izsobranija GPB (greč., 334 i 373)," *VV* 31 (1971) pp. 126–27, figs. 5, 6.

P. Mijović, *Menolog. Istorijsko-umetnička istraživanija*, Belgrade 1973, p. 196.

Paterson Ševčenko, "Menologium," pp. 424–25, fig. 7.

I. Furlan, *Codici greci illustrati della biblioteca Marciana*, 4, Milan 1981, p. 17.

Voicu, D'Alisera, p. 357.

N. Paterson Ševčenko, "Six Illustrated Editions of the Metaphrastian Menologion," *XVI. internationaler Byzantinistenkongress (Vienna, 1981)*, *Akten II/4, JÖB* 32/4 (1982) p. 195.

Deliyanni-Doris, p. 301.

Walter, *Art*, p. 49 n. 91.

29. COD. 172. FOUR GOSPELS
LENINGRAD, STATE PUBLIC LIBRARY COD. GR. 291: THREE LEAVES
A.D. 1067. FIGS. 218–231, COLORPLATE XVI:b

Vellum. 207 folios, 21 x 15.7 cm. *Leningrad*: three leaves, 21 x 15.3 cm. One column of twenty-five lines. Minuscule script with elements of *Perlschrift*, pendant from the line, small round letters with inconsistent spacing for Gospel text; other types, including majuscule with minuscule elements, for remaining texts; titles and calendar indications in *Auszeichnungs-Majuskel*. Gathering numbers at lower left side of first recto and lower right side of last verso. Parchment rough and yellow. Ink dark brown for text; titles and various other headings in Gospel text at times in gold over red, but mostly in vermillion. Initials in rough flower petal style in steel blue and vermillion outlined in gold; small solid initials in text in vermillion.

The three leaves of the Leningrad codex were removed from the Sinai Gospels by P. Uspenskij, who wrote some notes on them. Fols. 2 and 3 were originally placed after fol. 10 of the Sinaiticus, and fol. 1, with text from the Gospel of Luke (24:1–24), after fol. 165. Hence the contents of the manuscript in its original state were: fol. 1r, miniature; 1v–2r, Eusebius' letter to Carpianus; 2v, verses to the Gospels; 3r–10v, Canon tables; (*Leningrad*: 2r, Canon table, Canon X; 2v–3v, full-page miniatures;) 11r–65v, Matthew; 66r, verses to Mark; 66v, miniature; 67r–103v, Mark; 104r, verses to Luke; 104v, miniature; 105r–165v (*Leningrad*: 1)–167r, Luke; 167v, blank; 168r, verses to John; 168v, miniature; 169r–196v, John; 197r, colophon; 197v–201v, Menologion.

[1] See Harlfinger et al., p. 34 with references.

The colophon, at the end of the Gospel text on fol. 197r, reads (fig. 231):

+ Ἐτελειώθη σὺν θ(ε)ῶ ἡ θεόπνευστος / βίβλος
αὕτη· διὰ χειρὸς ζαχαρίου / πρεσ(βυ)τ(έρου)
πανελαχίστου, του πραιτωριότ(ου)· / ἐξεπιτροπῆς
θεοδώρου μ(ε)γ(άλου) ὑπάτ(ου) / καὶ
τεποτ(ηρη)τ(οῦ) κολωνείας τοῦ γαβρᾶ· / καὶ τῆς
αὐτοῦ συνεύνου εἰρήνης· / πρὸς σκέπην καὶ
διατήρησιν / καὶ ὑγείαν καὶ σ(ωτη)ρίαν καὶ
ἄφεσιν / τῶν ἁμαρτιῶν αὐτῶν· + / μηνὶ μαΐω
ινδ(ικτιῶνος) Ε'· ἔτους ͵ϛφοε'· / ἐπὶ βασιλέως
αὐτοκράτορος / ῥωμαίων κων(σταν)τ(ίνου) τοῦ
δοῦκα + / + οἱ ἀναγινώσκοντες, εὔχεσθε / ὑπὲρ
τοῦ γράψαντος ἅμα τῷ / κτησαμένω την βίβλον
ταύτην· / + διὰ τὸν κ(ύριο)ν· +

+ This God-inspired book, finished with the (help) of God by the hand of the presbyter Zacharias, the smallest, the praetoriotes, on the commission of Theodoros Gabras, great hypatos and tepoteretes (governor) of Koloneia and his wife Irene; for protection, preservation, health, salvation and forgiveness of their sins; in the month of May, indiction 5, year 6575 (1067) in the reign of Constantine Doukas, emperor of the Romans. + + May the readers (of this book) pray for him who wrote this book as well as for him who acquired it + for the sake of the Lord. +

The information concerning the donor given here is confirmed by the portraits and inscriptions found in the Leningrad leaves and described below.

The name of the scribe also appears on a note on the lower part of folio 168r, following the verses to John: + πάντων τῶν καλῶν χ(ριστὸ)s ἀρχὴ / καὶ τέλος. + χ(ριστ)ε βοήθει ζαχαρία πρεσβυτέ/ρω τῷ γράψαντι· ἀμὴν. +++ (+ Christ is the beginning and end of all that is good. + Christ, help Zacharias, the presbyter, who wrote [this book], amen. +++)

On fol. 168r is another entry in a fifteenth-century script: νικολ(άου) τοῦ πεπαγομένου (In the hands of Nicolaos Pepagomenos). This Nicholas Pepagomenos may be the literary figure belonging to the circle of Nicephoros Gregoras.[1]

In addition to the excised leaves now in Leningrad and two leaves missing at the end of the codex, there are missing gatherings (β', λβ'–λδ'). First and last folios show exposure to humidity. Miniatures have suffered some flaking.

The codex has an old, dark brown leather binding, much worn; the spine is completely missing. Both front and back covers (figs. 218, 219) have tooled borders ornamented in a plaited pattern; a plaited cross, fleurs-de-lis within lozenges, and heart-shaped ornament in triangles in the field. Two pins for locking remain on front cover. Possibly of fourteenth-century date.[2]

Illustration

Sinai

1r Cross in fretsaw style (15 x 9.2 cm.), in faded blue and red, painted against the parchment, full-page (fig. 220). Each arm of the cross consists of two bars terminating in crest-like palmettes, joined at the top by a small palmette. The crests are rendered alternately in ochre and dark olive green. Small ornamented bars interrupt the arms, indicating a second, superimposed cross. $\overline{\text{IC}}$ $\overline{\text{XC}}$ in red.

1v Band-shaped headpiece in fretsaw style, in red, steel blue, and grey-green. Eusebius' letter.

3r–10v Sixteen Canon tables (14.5 x 10 cm.) (figs. 221, 222). Very simple Canons, consisting of plain knotted columns supporting tympana with roundels, and fretsaw-style palmettes in red and steel blue, painted against the parchment.

Leningrad

2r Canon table (Canon X), as in Sinai manuscript (fig. 223).

2v Christ, standing frontally blessing with his right hand Theodore Gabras, who stands outside the panel enclosing Christ (17 x 10 cm.), full-page (fig. 224). Christ, $\overline{\text{IC}}$ $\overline{\text{XC}}$, clad in a dirty yellow-brown chiton and a dirty light steel blue himation, has light brown hair and wears an orange nimbus. The donor, dressed in a green robe and brown chiton with carmine-brown ornament, also has light brown hair. Both figures are painted against a blue background, framed by a red line and fretsaw ornament. The inscription, in red above the donor, reads: θεόδωρος π(ατ)ρι(κιος) κ(αι) τεποτ(ηρητὴ)s ὁ γαβρᾶs δ(ου)λ(ος) χ(ριστο)ῦ. (Theodore Gabras, patrikios and provincial governor, servant of Christ).

3r The Virgin, in three-quarter stance, leads Irene Gabras, who stands outside Mary's panel to the right, by the hand toward Christ (on previous page) (16 x 15 cm.), full-page (fig. 225). The Virgin, $\overline{\text{MHP}}$ $\overline{\text{ΘY}}$, is clad in pale steel blue chiton and pale brown mapho-

rion. Similar colors have been applied to Irene but in reverse order; her large hat is colorless. Background and frame are similar to those in the Christ miniature. The inscription in red reads: θ(εοτό)κε βοηθ(ει) τη σῆ δουλη εἰρήνη τη γαβράβα. (Mother of God help your servant Irene Gabras).

3v Five medallions with bust portraits (13.5 x 10 cm.), full-page (fig. 226). On top: Peter and Paul, ὁ ἅ(γιος) πέτρο(s), ὁ ἅ(γιος) παῦλος, both clad in garments of dirty olive and pale yellow-brown, and with hair rendered in a dirty olive color. Peter is painted against a dirty olive background, while Paul is against blue. Central medallion: the archangel Michael, ὁ ἀρχ(ἀγ-γελος) μιχ(αήλ), in pale and rubbed colors against a pink background. Bottom: Bartholomew, βαρθολο-μαῖος, with short beard and hair of dirty brown, and the beardless Thomas, ὁ ἅ(γιος) θωμ(ᾶς), in similar colors. Frame of the miniature similar to that of fols. 2r and 3r; in spandrels, fretsaw palmettes of dirty steel color against colorless background.

Sinai

11r Π-shaped headpiece in flourished flower petal style in blue and dirty olive on gold. Initial B in similar style, Mt. 1:1ff. (fig. 227).

66v Mark (14 x 10 cm.), full-page (fig. 228). Seated facing to the right in front of a light brown lectern with writing implements, Mark, ὁ ἅ(γιος) μάρκος, is pensive and about to write in a lined codex on his lap. Clad in blue-grey chiton and light brown mantle, he has dull steel blue hair and wears a dull orange nimbus. The flesh tones are light yellow-brown with orange touches, the background blue, and the inscription darkened carmine. The frame is rendered in a fretsaw style in steel blue, grey, and red on a colorless ground.

67r Band-shaped headpiece in very rough flower petal style in steel blue and dirty green on dirty gold ground. Initial A in similar style. Mk. 1:1ff.

104v Luke writing (14.2 x 10.5 cm.), full-page (fig. 229). Seated in three-quarter pose, facing to the right in front of a lectern, Luke, ὁ ἅ(γιος) λουκᾶς, writes in a codex on his lap. Dressed in colors similar to Mark's, he has brown hair and a yellow-orange nimbus. Blue background and frame as on fol. 66v.

105r Band-shaped headpiece in rough flower petal style, the petals enclosed in roundels, and initial Є with blessing hand. Lk. 1:1ff.

[2] The ornament on the cover is comparable to that on the binding of cod. Oxford, Auct. T. inf. 1.3; see Hutter, *Oxford*, 1, no. 43, fig. 288;

cf. Van Regemorter, "Reliure," p. 12.

168v John writing (14.2 x 10 cm.), full-page (fig. 230). Seated facing to the right in front of a lectern on which there is an open codex, John, ὁ ἅ(γιος) ἰω(άννης) ὁ θεολό(γος), is writing the beginning of his Gospel in a codex. Colors, background, and frame as in the previous portraits.

169r Π-shaped headpiece in crude flower petal style and initial Є with blessing hand. Jn. 1:1ff.

197v Frameless band-shaped headpiece in fretsaw style, color as on fol. 1v, against colorless ground. Beginning of Menologion.

Iconography and Style

This is a provincial manuscript, as shown by the lifeless depiction of bodies and the simple, limited use of color. While the draperies have a linear effect, the contours are stressed so that the drapery no longer relates to the bodies; the brush strokes used to fill the space between the contours are loose, stressing linearity and the careless and obscure design; the facial features are monotonous and lack any particular expression. The light yellow-brown flesh tones, the steel-colored hair, the orange nimbi, the brown furniture set against blue background, all in dull tones, stress the provincial character of the manuscript.

The ornament is of two types, the fretwork and flower petal styles, representing two different traditions in Byzantine book illumination;[3] the presence of both in the same manuscript, however, is not unusual in Middle Byzantine illuminated manuscripts, as one finds, for example, in cod. Athens, Nat. Lib. 56.[4] The dull palettes and ornamental effects, seen for instance in the cross, fol. 1r (fig. 220), further indicate the provincial origin of the work. The structure of the Canon tables and the inclusion of medallions in their tympana, but not their actual ornament, reflect earlier, carefully executed models such as the cod. Princeton, Scheide Lib. M 1.[5] A reflection of a flourished, more successful flower petal style is seen in the headpiece on fol. 11r (fig. 227); thereafter the style deteriorates. The color

scheme of the ornament recalls that found in cod. Athens, Nat. Lib. 69, whose center of production had connections with the eastern provinces of the empire.[6] According to the colophon in the Sinai codex and existing historical documentation, the donor Gabras was provincial governor of the eastern themes of Chaldia and Coloneia. The manuscript was most likely produced in Trebizond, where Gabras had resided and where his remains were transferred after his death.[7]

In its iconographic scheme the codex presents familiar patterns. The cross at the beginning of the codex (fig. 220), an Early Christian motif, continues in Middle Byzantine book illumination in various forms and types of works.[8] The evangelist portraits are likewise common, as is the compositional scheme of the page with the five busts in medallions (fig. 226), which is found in frontispieces representing Christ with the four evangelists or their symbols,[9] and in illustrations of the Epistles with Paul in the central medallion (see Sinai cod. 275, no. 41 below). The choice of the apostles, in this case Peter and Paul coupled with Bartholomew and Thomas, and the emphasis given to the archangel Michael are uncommon. They may reveal special venerations of the donors of this manuscript, whose portraits present some iconographic motifs of special interest.

In blessing the donor, Christ places his hand protectively over his head. For this motif there is no exact iconographic parallel in this or in later periods. A possible source may have been a coronation scene with Christ or the Virgin Mary standing next to an emperor and placing the crown on his head.[10] If such a relation does exist, it may not be accidental. Considering the high position of Gabras, it is possible that his intention may have been to emulate imperial iconography and ceremonies. Similarly, the exact motif of Mary guiding the wife of Gabras by the hand has no known contemporary parallels. The motif does occur in later examples, such as the cods. Athos, Iviron 5, and Oxford, Christ Church W. gr. 61, dating from the thirteenth and fourteenth centuries.[11]

[3] Weitzmann, *Buchmalerei*, pp. 18ff.

[4] Marava-Chatzinicolaou, Toufexi-Paschou, no. 1, figs. 1, 2, 7–10.

[5] *Greek Mss. Amer. Coll.*, no. 10, fig. 15; *Byzantium at Princeton*, pp. 147–48, no. 173. For the inclusion of medallions in the tympana of Canon tables see also Sinai cod. 166 (no. 10 above).

[6] Marava-Chatzinicolaou, Toufexi-Paschou, no. 32, figs. 290–308.

[7] Spatharakis, *Portrait*, p. 60 with bibliography. See also additional information, especially on the influence of the dialect of Pontos on the colophon text, in Harlfinger et al., cited in the bibliography for this manuscript.

[8] The cross is often placed at the beginning of a Gospel book, usually after the Canon tables or at the very beginning in other types of books; see,

for example, cods. Athens, Nat. Lib. 56 and 74 (Marava-Chatzinicolaou, Toufexi-Paschou, no. 1, fig. 1; no. 9, fig. 72); Athos, Lavra A 42 (*Treasures*, 3, fig. 28); Vienna, Hist. gr. 6 (Spatharakis, *Dated Mss.*, no. 64, fig. 115); and Sinai 158, 341, and 500 (nos. 53 and 39 below, no. 28 above, figs. 199, 336, 456).

[9] See examples in Galavaris, *Prefaces*, figs. 53, 56, 60.

[10] See the examples in Goldschmidt, Weitzmann, *Elfenbeinskulpturen*, 2, no. 35, pl. XIV; and also Spatharakis, *Portrait*, figs. 68, 124f, 126d.

[11] Spatharakis, *Portrait*, figs. 53, 54; also fresco of Stephen Vladislav in Mileševo from the year 1234, ibid., fig. 55; G. Galavaris, "Mary's Descent into Hell," *Byzantine Studies/Études byzantines* 5 (1977) pp. 189–94.

The originality of the artist is revealed in still another way: the figures of the donors are painted partly outside the frames enclosing Christ and Mary. Certainly this has nothing to do with the artist's free decision not to follow the restrictions of the frame, as has been suggested.[12] Probably the artist conceived the portraits of Christ and his Mother as icons before which the donors are standing and which miraculously bestowed their protection on Gabras and his wife. What we have here, in essence, is the concept of prayer to an icon, and at the same time the "pictorialization" of the divine presence, as it can be seen in the so-called votive icons. The concept was present as early as the catacombs, as a fresco in the Commodilla catacomb in Rome shows.[13]

Bibliography

Gardthausen, *Catalogus*, p. 33.
Gregory, *Textkritik*, pp. 246, 1134 no. 1209.
Beneševič, pp. 93–95 no. 74.
Hatch, *Sinai*, pl. III.
Colwell, Willoughby, *Karahissar*, 1, p. 232.
Devreesse, *Introduction*, p. 300 n. 1.
Treu, *Handschriften*, pp. 122–24.
Lazarev, *Storia*, p. 250 n. 35.
Belting, *Buch*, p. 50 n. 159.
Kamil, p. 68 no. 197.
Treu, "Kaiser," p. 14.
Husmann, pp. 146–47.
Spatharakis, *Dated Mss.*, no. 81, figs. 149, 150.
Voicu, D'Alisera, p. 555.
F. Evangelatou-Notara, "Σημειώματα" Ἑλληνικῶν κωδίκων ὡς πηγὴ διὰ τὴν ἔρευναν τοῦ οἰκονομικοῦ καὶ κοινωνικοῦ βίου τοῦ Βυζαντίου ἀπὸ τοῦ 9ου αἰῶνος μέχρι τοῦ ἔτους 1204, Athens 1982, pp. 71, 115, 167, 168.
Harlfinger et al., pp. 33ff., 63 no. 15, pls. 69–73.

Leningrad leaves:

Cereteli 1904, pp. 104, 108, pl. 8.
Gregory, *Textkritik*, p. 1196 no. 2153.
Lichačev 1911, p. 65, fig. 117.
Idem, *Materialy*, p. 94 no. 699.
Beneševič, pp. 614–15 no. 74.
Idem, *Mon. Sinaitica*, 1, col. 52, pl. 37; 2, pl. 53.
A. Xyngopoulos, "Τὸ ἀνάγλυφον τῆς ἐπισκοπῆς Βόλου," *EEBS* 2 (1925) p. 111, fig. 4,1.
Colwell, Willoughby, *Karahissar*, 1, p. 232.
Lake, *Dated Mss.*, Indices, p. 178.
Devreesse, *Introduction*, p. 300 n. 1.
Lazarev 1947, p. 316.
Granstrem, *VV* 19 (1961) p. 205 no. 209.
Treu, *Handschriften*, pp. 122–24.
Lazarev, *Storia*, p. 250 n. 35.
Belting, *Buch*, p. 50 n. 159.

[12] Spatharakis, *Portrait*, p. 60.

[13] Weitzmann, *The Icon*, p. 48, pl. 5; also idem, "The Icons of Constantinople," p. 12; also Chatzidakis, Babič, "The Icons of the Balkan Peninsula and the Greek Islands," in K. Weitzmann et al., *The Icon* (New York 1982) pp. 147, 156, Serbian icons of the fourteenth century in which

A. Bryer, "A Byzantine Family: the Gabrades, c. 979–c. 1653," *University of Birmingham Historical Journal* 12 (1970) pp. 175 n. 44, repr. in idem, *The Empire of Trebizond and the Pontos*, London 1980, no. IIIa.
S. Der Nersessian, "Deux exemples arméniens de la Vièrge de Miséricorde," *Revue des études arméniennes*, n.s. 7 (1970) p. 198 n. 45, repr. in eadem, *Études*, p. 593 n. 45.
V. G. Poutsko, "Dva fragmenta konstantinopol'skikh licevykh rukopisek tre'ej četverti XI v. izsobranija GPB (greč. 334 i 373)," *VV* 31 (1971) p. 124 n. 19.
A. Bryer, S. Fassoulakis, and D. M. Nicol, "A Byzantine Family: the Gabrades. An Additional Note," *BSl* 36 (1975) p. 39 n. 5, repr. in A. Bryer, *The Empire of Trebizond and the Pontos*, London 1980, no. IIIb.
P. L. Vokotopoulos, "Ἕνα ἄγνωστο χειρόγραφο τοῦ κωδικογράφου Ἰωάσαφ καὶ οἱ μικρογραφίες του. Τὸ Ψαλτήριο Christ Church Arch. W. Gr. 61," *DChAE* 8 (1975–76) p. 192 n. 67.
Spatharakis, *Portrait*, pp. 59–60, 244, figs. 27, 28.
Exhibition Leningrad, 2, no. 492.
Voicu, D'Alisera, p. 354.
Spatharakis, *Dated Mss.*, no. 82, fig. 148.
Harlfinger et al., pp. 33–34.

30. COD. 48. PSALTER
LENINGRAD, STATE PUBLIC LIBRARY COD. GR. 267: THREE LEAVES
A.D. 1074. FIGS. 232–270

Vellum. 220 folios, 19 x 14.5 cm. *Leningrad*: three leaves, 19.3 x 15.1 cm. One column of seventeen–nineteen lines. Minuscule script with elements of *Perlschrift*, thick-penned round letters written under and across the line, for text; title on fol. 10r in *Auszeichnungs-Majuskel*. Gathering numbers by a different hand at lower right corner and mid-lower margin of first recto, and at lower left of last verso, often not visible. Parchment thick, yellowish, good quality. Ink brown for text, carmine for titles and small solid initials in text. Doxa, alleleuia, and kathismata indicated in carmine.

The three Leningrad leaves were removed from the Sinai Psalter by Porphirij Uspenskij; they were identified as part of Sinai cod. 48 by Beneševič. Fol. 1 (Ps. 36:11–21) was originally placed after fol. 41 of the Sinaiticus; fol. 2 (Ps. 37:22–38:10) after fol. 45; fol. 3 (Ps. 52:2–53:9) after fol. 64. Hence the contents of the codex in its original state were: fols. 1r–192r, Psalms; 192r–210v, Odes, later commentary along the margin; 210v–213v, varia, hymns, and

the donors are praying to the icons of their patron saints. Several icons from Cyprus can be included among these examples. See also a fourteenth-century icon in Sinai depicting Moses and Aaron, with the monk/donor kneeling outside the frame, in Sotiriou, *Icônes*, 1, fig. 162.

prayers; 214r–215r, letter of Basil the Great to a nun, in a different, later script; 215v–217v, text by Pseudo-Nonnos in the same script as that of fol. 214r; 218r–219r, blank; 219v–220r, Easter tables.

Easter tables begin with the year ͵ϛφπγ′, 6583 (1074/75) and end with the year ͵ϛχε′, 6605 (1096/97). The first date indicates the year of the manuscript's production (figs. 269, 270).

Condition bad. The codex shows heavy use. Parchment blackened along edges. Text begins in the midst of Psalm 2 (fol. 1r), which contains a commentary all around, probably later and unreadable today, ending on fol. 20r. Several drawings are rubbed or have almost disappeared or been partly cut off. On fol. 23r, a square piece, probably containing an illustration, is cut out of the lower right margin and another leaf is lost between fols. 219 and 220. Plain, very dark brown leather binding without ornamentation.

Illustration

Sinai

15v David, bearded and crowned, with covered hands, kneels in proskynesis and prays to the hand of God, pen-drawing (3 x 2.2 cm.), left margin. Ps. 17:1 (fig. 232).

20r David standing, preliminary drawing in red ink with a light wash, right margin, very rubbed; cannot be reproduced. Ps. 19:1–2.

21v Lot fleeing with his daughters (ca. 5.5 x 2.3 cm.), left margin (fig. 233). The scene is largely destroyed. A stream of fire is recognizable at the lower left and to its right several fleeing figures. Above, Christ enthroned wearing a golden nimbus. Ps. 20:9–10.

22r Christ on the Cross, wearing a tightly fitting loincloth, his body arched violently like a bow and his feet side by side on the suppedaneum. He lifts his face accusingly to the hand of God, which is partly cut off; pen drawing with light brown wash (4.8 x 3.0 cm.), upper right margin. Ps. 21:2 (fig. 234).

23r Christ on the Cross, wearing the conventional loincloth; below, the three soldiers cast lots upon a blue garment held by the soldier in the center; pen drawing with light brown wash (4.8 x 2.2 cm.), right upper margin. Ps. 21:16–19 (fig. 235).

24r The "Worshippers of the Lord." Four men dressed in light blue and orange tunics, moving to the right, their knees bent. A figure of the enthroned Christ, now cut off, may have existed to the right (ca. 3.1 x 2.6 cm.), upper right margin. Ps. 21:28 (fig. 236).

25r "The Earth is the Lord's . . ." Christ, dressed in light brown garments with blue wash, with a blue-crossed, golden nimbus, stands at ease on a hillock over a pond with a few plants at its edge. His right hand is raised as if blessing the world's creation (7.5 x 3.8 cm.), upper right margin. Ps. 23:1–2 (fig. 237).

25v Two angels standing before a closed door which one of them touches with a staff as if demanding that it open. Behind them Christ approaches carrying the patriarchal cross, in a pose recalling Christ of the Anastasis. Drawing with blue and yellow-brown washes (7.5 x 3.3 cm.), upper left margin. Ps. 23:7–9 (fig. 238). Below, on the same margin, a standing figure, most likely David praying, almost completely rubbed off. Ps. 24:1.

27r David in proskynesis receiving the blessing of the enthroned Christ, who wears a mantle in blue wash and a golden nimbus with a blue cross (ca. 4 x 2.3 cm.), right margin (fig. 239).

28r The anointing of David by Samuel (I Kings 12:12). Samuel approaches from the right; the youthful David in a short tunic stands frontally with arms crossed (ca. 4.3 x 1.8 cm.), upper right margin. Ps. 26:1 (fig. 240).

29r Christ before Caiaphas, who sits to the right behind a table and beside the two false witnesses who testify against Christ (Mt. 26:60). Light blue, grey-blue, and light orange washes (ca. 3.6 x 3.0 cm.), right margin. Ps. 26:12 (fig. 241).

30v The Baptism of Christ. Pen drawing with red wash (5.2 x 3.2 cm.), upper left margin. Ps. 28:3 (fig. 242). John the Baptist, standing high on the rocks of the river bank with a scroll in his left hand, bends down to Christ and presses his hand vigorously upon Christ's head. Gazing at John, Christ raises his blessing hand toward him. The bluish green water of the Jordan reaches Christ's shoulders. Two conventional angels, holding Christ's garments, stand on the left bank of the river.

32r King David in proskynesis, clad in red and light blue garments, similar to David on fol. 15v except that his hands are not covered (ca. 1.6 x 2.9 cm.), right margin. Ps. 30:2 (fig. 243).

34r Fragment of a scene consisting of the bust of a man who holds a staff, and the head of another (2.3 x 2.5 cm.), right margin. Ps. 31:1 (fig. 244).

34v Man removing thorn from his raised left foot in a contorted pose, black pen drawing (visible part ca. 2.3 x 1.9 cm.), left margin. Ps. 31:4 (fig. 245).

38r Peter speaking admonishingly to a younger man, depicted on the right, who holds his hand under his chin

(cf. I Peter 3:10). Drawing in red pen (3.5 x 3.4 cm.), right margin. Ps. 33:14 (fig. 246).

39r Christ confronted by a group of adversaries on the right (possibly the Sadducees) partly cut off by the margin, turning his head around to the hand of God in heaven (cf. Mt. 22:23ff.). Red pen drawing (4 x 3.5 cm.), upper right margin. Ps. 34:1 (fig. 247).

39v A figure at the right, probably Christ, holding a scroll in his left hand, addressing what was possibly a group at the left, now totally lost. Pen drawing, severely damaged (ca. 3.8 x 3.1 cm.), left margin. Ps. 34:11 (fig. 248).

41v A youthful warrior drawn in red pencil, with shaggy hair, leans on his shield and holds his hand close to his mouth (ca. 4.2 x 2.4 cm.), left margin. Ps. 35:4–5 (fig. 249).

Leningrad

1r Christ, walking to the right, turning around and addressing a youthful figure, the "wicked man," clad in a himation. Red pen drawing (ca. 3.5 x 5.5 cm.), right margin. Ps. 36:12 (fig. 250).

Sinai

44v John Chrysostom, characterized by his bald head and his sparse beard, depicted as the "man of wisdom," standing and reading from an open book held in his hands. Red pen drawing (ca. 4.2 x 2.4 cm.), left margin. Ps. 36:30 (fig. 251).

45r A youthful, enthroned figure clad in the imperial loros which identifies him as Joseph (cf. Gen. 41:41–42). Very rubbed pen drawing (ca. 3.5 x 1.9 cm), right margin. Ps. 36:30 (fig. 252).

45v Christ enthroned in a mandorla, surrounded by five angels. Pen drawing (4.1 x 4.2 cm.), cut at bottom, lower margin. Ps. 37:2 (fig. 253).

Leningrad

2r King David depicted standing on the right, clad in blue tunic and red mantle, holding his right hand under his chin in a gesture of sorrow. On the left the "wicked" soldier, wearing brown armor, blue tunic, red mantle, and carrying a sheathed sword in his left hand, reproaches David. The faces are merely sketched and colors are in light washes (ca. 5.5 x 3.5 cm.), right margin. Ps. 38:2 (fig. 254).

Sinai

50r Only a youth bending eagerly forward, the "receiver of the alms," is preserved; another figure, that of the "alms giver," is cut off by the margin, lower right margin. Drawing and wash. Ps. 40:2 (fig. 255).

51r The Kiss of Judas (4.2 x 3.4 cm.), right margin. Ps. 40:10 (fig. 256). Christ on the left, gold-nimbed, dressed in golden tunic and blue mantle, and Judas, clad in red and brown, are agitated, almost clashing against each other. Judas refrains from embracing Christ.

51v David, dressed in a red tunic with golden borders, a blue mantle, and a golden crown, standing frontally in a swaying pose. With his left hand he points upward dramatically to the hand of God, and with his right down to a pool of water which is mostly destroyed (4.7 x 5.4 cm.), left margin. Ps. 41:2 (fig. 257).

53v "Our Fathers," the Patriarchs (5 x 2.8 cm.), left margin. Ps. 43:2 (fig. 258). Three standing figures depicted as a group, Abraham, Isaac and Jacob, all white-haired and without distinction of age. The one on the right holds a scroll. Their nimbi and their tunics are in gold. Color (carmine) has been applied only to the mantle at the right.

56r King David, on the left, pointing across his breast to a stately, hieratic, frontally standing figure of Christ on the right, holding a codex in his veiled hand. Above on the left, the hand of God comes out of a segment of sky. Red pencil drawing with gold added on the tunics of both figures, God's sleeve, Christ's nimbus, David's crown, and the book cover (6.7 x 4 cm.), right margin. Ps. 44:2 (fig. 259).

57v A group of people standing on the left, clad in tunics with gold borders and collar-strips, imploring Christ, depicted in bust form, who leans out of a segment of sky and blesses them (4.6 x 4.1 cm.), bottom margin. Ps. 45:2 (fig. 260).

59r Christ dressed in purple and blue garments and wearing a golden nimbus, seated on a brown rainbow within a mandorla, carried by two angels in blue garments and with purplish wings (5.7 x 3.8 cm.), right margin. Ps. 46:6 (fig. 261).

60v John Chrysostom represented standing and touching his mouth (4.1 x 2.6 cm., to the margin), left margin. Ps. 48:4 (fig. 262).

61r Man bending. Miniature totally rubbed, lower margin. Ps. 48:12 (fig. 263).

64r The Penitence of David (7.8 x 5.1 cm.), bottom margin. Ps. 50, title (fig. 264). At the right of the composition the prophet Nathan, nimbed and clad in chiton and himation, holding an open scroll in his left hand, proceeds from a simple building toward David, admonishing him with his right hand. David is seated facing the prophet, holding his hand against his forehead in an expression of penitence. Both figures are

depicted within a precinct indicated by a low wall in the background. Behind David, an angel in half figure leans over a tall, tower-like rampart, turning his head to the left toward Bathsheba. She, in half figure and clad in a gold paenula, leaning her left cheek on her hand, is looking out of her room. Below the roof is a narrow, gabled structure (cf. II Kings 11:1–4; 12:1ff.). Crown and nimbi are gold and a few light washes in blue and red have been employed on figures and buildings.

Leningrad

3v "The Ziphims came . . . to Saul" (6 x 3.5 cm.), left margin. Ps. 53, title (fig. 265). One of a group of Siphites partly cut off by the margin, dressed in a red tunic, addresses Saul on the right. Dark bearded, wearing red and blue garments and a jewel-studded blue crown, with a sword across his lap, Saul is seated in three-quarter view, on a draped, backless, dark brown throne with a red cushion, resting his feet on a blue footstool. He is arguing with the Siphites. The scene is placed in a rich landscape with bushes, with a steep, light yellow-brown mountain on the left, and an architectural setting, a house with blue front and red roof, a pale green wall, and an annex, on the right. From behind the wall emerges David, raising his hands in prayer toward heaven. He wears red tunic, blue mantle, and blue crown, and has grey hair and beard. This is the only miniature fully executed in color but without gold.

Sinai

69r David arrested by the Philistines at Gath (cf. I. Kings 21:10–11) (4 x 4.4 cm.), upper right margin. Ps. 55, title (fig. 266). A group of soldiers in blue and red garments and golden armor reach out their hands to grasp David, whose figure is almost completely rubbed off. He seems, however, to be trying to escape to the right while he turns his head back to his pursuers. There are traces of additional figures at the right, rubbed and partly cut off by the margin.

70r David fleeing from Saul (cf. I Kings 22:1) (ca. 4.8 x 4.3 cm.), right margin. Ps. 56, title (fig. 267). David, clad in red and blue garments, golden armor and crown, and carrying a lance on his shoulder, hurries

toward a cave cut into a steep mountain. The illustration is partly cut off by the margin.

91r The Annunciation (ca. 4.5 x 4.5 cm.), upper right margin. Ps. 71:6 (fig. 268). An unfinished preliminary drawing of Gabriel on the left approaching the Virgin Mary, who is enthroned and faintly visible on the right.

220v A segment of a circle with part of a rosette-cross. Later, incomplete drawing in the center of the page, rubbed off.

Iconography and Style

Compared with other marginal Psalters, the picture cycle of this codex is unfinished. Beginning with Psalm 17, the cycle runs through Psalm 56 and, after a lone miniature for Psalm 71, stops altogether. In the execution of the miniatures, four stages can be distinguished: 1) delicate pen drawings; 2) the application of gold (see fol. 64r, fig. 264); 3) the application of light color washes; 4) a gouache technique marking the finished state, apparently intended for all miniatures. This careful process resembles somewhat that used in a thirteenth-century manuscript in Paris, cod. gr. 54.[1] The lack of contemporary parallels emphasizes the importance of this codex for the study of the techniques of book illumination.

Stylistically the Sinai codex differs from contemporary marginal Psalters, which, as far as their figure style is concerned, adhere to the principle of making the human figure abstract. In contrast, the Sinai Psalter's figures show greater corporeality (the best example is provided by the figure of Christ standing at the brook, fig. 237), better understanding of human proportions, and vivid gestures and postures, partly based on classical models. In this respect it reflects the so-called aristocratic Psalters, like the cod. Paris gr. 139 and its eleventh-century copies.[2] In fact, the Sinai figures are more elegant and refined and closer to the classical tradition than the figures of the cod. *olim* Athos, Pantocrator 49, now in Dumbarton Oaks in Washington, or the cod. Vat. gr. 342, dating from 1089.[3]

Iconographic analysis of the miniatures has shown that the codex does not belong to any of the known families of marginal Psalters.[4] Although the sources of the iconographic cycle are basically the same as those of the other Psalters, the artist has used them in different proportions,

[1] H. Omont, *Miniatures des plus anciens manuscrits grecs de la Bibliothèque Nationale*, 2nd ed., Paris 1929, pp. 47ff., pls. XC–XCVI.

[2] K. Weitzmann, "The Sinai Psalter Cod. 48 with Marginal Illustrations and Three Leaves in Leningrad," *Psalters and Gospels*, no. VII, p. 9, with examples and references.

[3] S. Der Nersessian, "A Psalter and New Testament Manuscript at

Dumbarton Oaks," *DOP* 19 (1965) pp. 153ff. (repr. in eadem, *Études*, pp. 139ff.); M. Bonicatti, "Un salterio greco miniato del periodo comneno," *Bollettino dell' "Archivio Paleografico Italiano"*, N. s. (1956–57) pls. VIII,1, XIV,1, XVII,2; Weitzmann, *op. cit.* (note 2 above), pp. 9, 10.

[4] Weitzmann, *op. cit.*, note 2, pp. 1–12.

and the several additions of New Testament scenes, outnumbering those of the Old Testament, have no parallels. The cycle is more christological than any of the other illustrated Psalters, and most of the New Testament scenes are connected with liturgical readings, indicating the use of a Lectionary as one of its sources. In addition to these unique features, at least one of the scenes, David's penitence, fol. 64r (fig. 264), depends on the corresponding illustration found in the group of so-called aristocratic Psalters.

Whether the iconographic uniqueness of the cycle indicates another recension of marginal Psalters or an innovative illustrator who created a unique masterpiece, we cannot know. It can, however, be considered certain that the codex was made in a Constantinopolitan scriptorium.

Bibliography

Gardthausen, *Catalogus*, p. 12.
Rahlfs, pp. 288 no. 48, 360 no. 1198.
Kamil, p. 64 no. 48.
Greek Mss. Amer. Coll., p. 33.
Weitzmann, *Sinai Mss.*, pp. 17, 18, fig. 22.
Idem, "Sinaiskaja Psaltir's illustratsjami na poliach," in *Vizantiia, južnye slavjane i drevnjaja Rus', zapadnaja Evropa. Sbornik Statej v čest V.N. Lazareva*, Moscow 1973, pp. 121–31; repr. in English, "The Sinai Psalter Cod. 48 with Marginal Illustrations and Three Leaves in Leningrad," in *Psalters and Gospels*, no. VII, pp. 1–12, figs. 1–24.
J. C. Anderson, "An Examination of Two Twelfth-Century Centers of Byzantine Manuscript Production," unpublished Ph.D. dissertation, Princeton University, 1975, p. 234.
A. Cutler, *Transfigurations. Studies in the Dynamics of Byzantine Iconography*, University Park, PA, and London 1975, p. 83.
Cutler, Weyl Carr, "Benaki Psalter," pp. 282, 301, 322.
A. Cutler, "The Marginal Psalter in the Walters Art Gallery. A Reconsideration," *Journal of the Walters Art Gallery* 35 (1977) pp. 46 n. 31, 58.
Idem, "The Byzantine Psalter. Before and After Iconoclasm," in *Iconoclasm, Papers Given at the Ninth Spring Symposium of Byzantine Studies, University of Birmingham, March 1975*, A. Bryer and J. Herrin, eds., Birmingham 1977, p. 93 n. 3.
S. Dufrenne, *Les illustrations du psautier d'Utrecht*, Paris 1978, p. 35 n. 72, 37, 40, 53.
G. I. Vzdornov, *Issledovanie o kievskoi Psaltiri*, Moscow 1978, pp. 7, 40, 52, 57, 66.
Cutler, "Aristocratic," pp. 447 n. 122.
Idem, "A Psalter from Mar Saba and the Evolution of the Byzantine David Cycle," *Journal of Jewish Art* 6 (1979) p. 46 n. 38.
Spatharakis, *Dated Mss.*, no. 95, figs. 177–80.
Voicu, D'Alisera, p. 553.
Walter, *Art*, p. 58.
S. G. Tsuji, "Destruction des portes de l'Enfer et ouverture des portes de Paradis," *CA* 31 (1983) pp. 16, 17, 19, fig. 10.
Harlfinger et al., pp. 35, 36, 63 no. 16.

Leningrad leaves:
Cereteli 1904, pp. 82, 103, 109, 181, pls. 7 no. 21, 8 no. 15, 9.

Tikkanen, *Psalterillustration*, p. 13.
Beneševič, p. 609 no. 48.
Cereteli, Sobolevski, pl. 19.
Rahlfs, pp. 229 no. 267, 360 no. 1198.
Beneševič, *Mon. Sinaitica*, 2, pls. 52, 54.
Lake, *Dated Mss.*, 6, no. 255, pl. 450.
Devreesse, *Introduction*, p. 301.
Granstrem, *VV* 19 (1961) pp. 207–208 no. 211.
Lazarev, *Storia*, p. 250 n. 35.
Weitzmann, "Sinaiskaja Psaltir" (cited above), pp. 1, 5, 7, figs. 12, 16, 22.
Lichačeva, *Iskusstvo knigi*, p. 113.
A. Cutler, "The Psalter of Basil II," *Arte Veneta* 31 (1977) p. 19 n. 61.
Exhibition Leningrad, 2, no. 494, fig. on p. 44.
Spatharakis, *Dated Mss.*, no. 96, fig. 181.
Voicu, D'Alisera, p. 353.
Harlfinger et al., pp. 35, 36, 63.

31. **COD. 401.** THEODORE STUDITES
A.D. 1086. FIGS. 271–273

Vellum. 209 folios, 29.5 x 24.3 cm. Two columns of thirty lines. Minuscule script for text; round, clear, calligraphic letters, upright or inclined to the right, irregular spacing; titles in *Auszeichnungs-Majuskel*, some in *Epigraphische Auszeichnungs-Majuskel*, often headings are not indicated; wide outer and lower margins. Gathering numbers at lower right corner of first recto. Parchment of good quality, yellowish, but blackened by use and humidity. Ink brown for text; titles in light red and brown. Ornamental initials in red, blue, light yellow, and light green. Solid initials in red.

Fols. 1r–18r, Catechisms, Bk. 1; 18r, text in the form of a cross in *Epigraphische Auszeichnungs-Majuskel* terminating with Φ Χ Φ Π (Φῶς Χριστοῦ Φαίνει Πᾶσιν); 18v–19r, table of contents, Catechisms, Bk. 2; 19v–164v, Catechisms, Bk. 2, conclusion of text in cross form with four rays emanating from the cross;[1] 165r–177r, the testament of Theodore; 177v–178r, verses and text to Theodore;[2] 178v–184r, outline of the rules of the monastery of Studios; 184v, blank; 185r–205v, the martyrdom of great Martyr Artemios (*PG* 115, 1209ff.); 205v, colophon; 206r–209r, Homily on Elizabeth and the All Holy Mother of God by Athanasios, Bishop of Alexandria (*PG* 28, 905ff.); 209v (Pseudo-) John Chrysostom, Homily on Easter (*PG* 59, 721–24 = *PG* 99, 709–12), by a later hand.

[1] For the text of the Catechisms see J. Cozza-Luzi, *Nova Patrum bibliotheca*, IX,2, Rome 1888, pp. 1ff.; see also H.-G. Beck, *Kirche und theologische Literatur im byzantinischen Reich* (Handbuch der Altertumswissenschaft, 2. Teil, 1), Munich 1959, p. 493.

[2] See P. Speck in Bibliography.

The colophon, on fol. 205v, right column, in *Epigraphische Auszeichnungs-Majuskel* written in twelve-syllable verses (fig. 273) reads:

+ X(ριστ)Є ΠΑΡΆΣΧΟΥ ΤΟΪΣ ЄΜΗ̄Σ
ΠΌ/ΝΟΙΣ ΧΆΡΙΝ· ΛΎΣΙΝ ΠΑΡΈΧΩΝ / ΤῶΝ
ΠΟΛΛῶΝ ΜΟΥ ΠΤΑΙΣΜΆΤΩΝ· / ΠΈΤΡΟΥ
ΞΎ᾽ΣΑΝΤΙ ΤῊΝ ΘЄΟΦΌΡΟΝ ΒΊ/ΒΛΟΝ·
ΤΟῪ ЄΝ ἉΓΊΟΙΣ Π(ατ)Ρ(ὸ)Σ ΗΜῶΝ
ΣΤΟΥΔ(ί)Τ(ου)· / ΛЄΟΝΤΊ῾Ω ΤЄ ᾽ΑΒΒᾹ ΚΑῚ
ΠΡЄΣΒΙΤΈΡῼ· / ΠΌΘ(ω) ΚΤΉΣΑΝΤΙ
ΟῪ(ρα)ΝῸΝ ΒΑΣΙΛΉΑΝ· /
+ ἐγράφη ἡ βίβλος αυτ(η) μ(η)ν(ὶ) αὐγουστ(ω) εἰς
τ(ὴν) ι̅η̅'· / ἡμέρα δ̅· ωρ(α) θ̅· /
+ ΗΛΊΟΥ ΚΥ(κλου) Ι̅Δ̅ Σ(ε)Λ(ήνης) ΚΥ(κλου)
Α̅· ῎ЄΤΟΥΣ ͵ϚΦ Ϛ Δ' ΙΝΔ(ικτιῶνος) Θ̅·
ΤЄΛ(ος) ΔΌΞΑ ΣΟΙ:

+ Christ, grant me grace, for the sake of my labors, by delivering me from my many offenses, Peter who wrote this divine book of Studites, our Father among the saints (on the commission) of Abba and Presbyter Leontios who procured it by his urge for the kingdom of heaven.
+ This book was written in the month of August, the 18th, Wednesday, 9th hour. + The 14th sun cycle, the 1st moon cycle, the year 6594 (1086), 9th indiction. End. Glory be to thee.[3]

The codex is incomplete, with gatherings α', γ', δ', ε' missing. Text begins with the concluding part of Catechism 4. Condition bad, most gatherings loose. Unbound, kept in a cardboard case.

Illustration

The codex contains only ornamental headpieces and large initials, most of which are zoomorphic.

3r Initial T, knotted, foliated, intertwined; vertical bar terminates in snake-like animals; one bites the stem. Animal head bites the foliate stem below, all colored in red, blue, and dirty yellow. Bk. 1, Catech. 6 (fig. 271).

7r, 8v, 31v, 36r, 44v, 58r, 73v, 81r, 84v, 162v Initial A or Π with one or two birds picking at or holding stems,

in fretsaw style or interlace with foliated stems in red, blue, light yellow, and with brown outlines. Bk. 1, Catech. 8, 9; Bk. 2, Catech. 8, 11, 15, 23, 36, 46, 51, 54, and On Virginity.

15r Initial Π formed of intertwining stems. Bk. 1, Catech. 27.

19v Rectangular headpiece with interlace terminating in snake heads, forming crests in the upper two corners, sticking out their tongues or biting the stems. Initial A in interlace with biting snakes on the upper part. All colored as on fol. 3r. Bk. 2, Catech. 1 (fig. 272).

35r Initial A with snake biting bird, in interlace. Bk. 2, Catech. 14.

37v Initial A with animal head in fretsaw style. Bk. 2, Catech. 17.

41r Initial A with snake swallowing bird, in fretsaw style. Bk. 2, Catech. 21.

69v Initial A with peacock in fretsaw style. Bk. 2, Catech. 44.

165r Π-shaped headpiece with colorless rinceau on red ground, carminé style, and initial A. The Testament of Theodore.

185r Band-shaped headpiece in interlace and initial M outlined only. Martyrdom of Artemios.

Style

The most characteristic features of this manuscript are its zoomorphic or ornithomorphic initials. Most of the first terminate in snake-like animal heads biting the stem of a letter or swallowing birds. The stems can be of a knotted or foliated interlace or in fretsaw style, mostly degenerate in form. The birds are not only "dissected," but are distinguished by their pearl-like decoration. The three headpieces are adorned with interlaced ornament forming crests on the corners with animal heads, or an interlace and rinceau of the carminé style (colorless rinceau on red ground).

All these features are found in provincial manuscripts. Good parallels are provided by the cod. Athens, Nat. Lib. 74 and relatives, particularly the cod. Vienna, Theol. gr. 188 from the early eleventh century, both of which also contain cruciform text pages.[4] Comparable initials terminating in knotted animal heads appear in cod. Vat. gr. 1554.[5] On the

[3] For the correct day of the week (the 18th of August was Tuesday and not Wednesday) and linguistic observations, see Harlfinger et al., p. 36.

[4] Cf. initials of the Sinai codex, fols. 3r, 19v, to those in Athens cod. 74, fol. 216r and v; also the Sinai headpiece fol. 19v to that in Athens, fol. 205v, both ending in snakes; cf. also the initial in cod. Vienna, Theol. gr. 188, fol. 8r, photographs in Princeton University, Department of Art and Archaeology, and Gerstinger, *Griech. Buchmalerei*, p. 37.

The Vienna and Athens codices were in the past assigned tentatively

to Apulia with a dependence, however, on Egyptian-Byzantine models. Grabar has opted for an Italian origin, probably Capua, and has discerned the impact of western models. Most recently, Marava-Chatzinicolaou and Toufexi-Paschou have suggested some ties between these manuscripts and Cyprus. See Weitzmann, *Buchmalerei*, pp. 84, 85; Grabar, *Manuscrits grecs*, p. 68; Marava-Chatzinicolaou, Toufexi-Paschou, pp. 60–61.

[5] See Grabar, *Manuscrits grecs*, p. 66, figs. 268, 269.

other hand, the "jewel-studded" or "dissected" birds, which reflect some initials in cod. Patmos 33, produced in Calabria, reveal similarities to the initials in a Theodore Studites manuscript written in Calabria (now in Milan, cod. Ambros. C.2 sup.), and to those in a Gospel in Escorial, cod. gr. 328 from the year 1013 and the same area.[6] A southern Italian origin, most probably Rossano, is also strongly supported by paleographic and linguistic considerations.[7]

Bibliography

Kondakov 1882, no. 85.
Gardthausen, *Catalogus*, pp. 95–96.
Kondakov, *Initiales*, pls. V, VI.
Ebersolt, *Miniature*, pp. 50, 53.
W. Born, *Seminarium Kondakovianum* 7 (1935) p. 73, pl. I,3.
Lazarev 1947, p. 304 n. 37.
J. Leroy, "Un nouveau témoin de la Grande Catéchèse de Saint Théodore Studite," *REB* 15 (1957) p. 75 n. 1.
P. Speck, "Nachtrag zu den 'Parerga zu den Epigrammen des Theodoros Studites,'" *Hellenika* 18 (1964) pp. 207ff. (with earlier references).
Lazarev, *Storia*, p. 176 n. 69.
P. Speck, ed., *Theodoros Studites, Jamben auf verschiedene Gegenstände* (Supplementa Byzantina, 1), Berlin 1968, pp. 20, 40–43, 46, 59, 60, 62.
Kamil, p. 87 no. 625.
Husmann, pp. 148, 167.
J. Leroy, "Le Parisinus gr. 1477 et la détermination de l'origine des manuscrits italo-grecs d'après la forme des initiales," *Scriptorium* 32 (1978) p. 206 n. 109.
Spatharakis, *Dated Mss.*, no. 103, figs. 196, 197.
Voicu, D'Alisera, p. 560.
B. L. Fonkič, "Scriptoria bizantini," *RSBN* 17–19 (1980–82) p. 91 n. 23a.
J. Leroy, "Caratteristiche codicologice dei codici greci di Calabria," in *Calabria bizantina. Tradizione di pietà e tradizione scrittoria nella Calabria greca medievale*, Reggio di Calabria 1983, p. 64.
P. Canart, "Gli scriptoria calabresi dalla conquista normanna alla fine del sec. XIV," in *Calabria bizantina* (see previous entry), p. 145.
Harlfinger et al., pp. 36–37, 63 no. 17, pls. 78–82.

32. COD. 150. FOUR GOSPELS
ELEVENTH CENTURY. FIGS. 274–276

Vellum. 307 folios, 23 × 17.5 cm. Two columns of twenty-five lines. Minuscule script, dense and irregular, inconsistent in spacing and direction for text; titles are in *Auszeichnungs-Majuskel* and majuscule; occasional use of *Epigraphische Auszeichnungs-Majuskel* for hypotheses. Gathering numbers at upper right corner of recto, but not throughout. Parchment fine and white. Ink dark brown to black for text; titles, liturgical notations, and small solid initials in text in carmine.

Fols. 1r–11r, varia including prefaces to the Gospels by Epiphanios on the sixteen prophets, in black ink; 11v–13r, table of lections; 13v, blank; 14r and v, encyclical by Methodios of Constantinople[1]; 15r–41r, Typikon for Easter and September–August, here begins dark brown ink and another hand that continues to folio 306r; 41v–42r, Matthew chapters; 42r–45v, prefaces to the Gospels; 46r–47r, Eusebius' letter to Carpianus; 47r and v, Christ's ten appearances after the Resurrection; 48r–49r, table of lections, hypothesis to Matthew; 49v–50v, table of lections for various saints' feasts; 51r–54v, Canon tables; 55r–117r, Matthew and hypothesis; 117v–118r, Mark chapters; 118v, blank; 119r–159r, Mark and hypothesis; 159v–160r, Luke chapters; 160v, blank; 161r–233v, Luke; 234r, hypothesis to Luke, John chapters; 234v, blank; 235r–288r, John and hypothesis; 288v–291r, tables of lections for various occasions; 291v–306r, *Canonarion* of feasts, beginning September; 306v–307r, table of lections of the Eothina in black ink by the first hand; 307v, grammar, later text.

Beginning missing; all gatherings are loose, condition bad. No binding. The codex is kept between two pieces of cardboard in a linen bag.

Illustration

15r Π-shaped headpiece with steel grey palmettes on colorless stems in segments against deep red forming an irregular pattern, left column. Typikon.

45r Full-page diagram containing Christ's genealogy in the form of an oval in the center with IC XC / YC $\overline{\Theta Y}$ and ΦΩC ZΩH above and below in carmine. The oval is flanked by four triangles, two on each side, one above the other, with texts in deep red and black referring to Christ's genealogy and the relevant Gospels.

51r–54v Eight Canon tables (12.3 × 18.5 cm. with palmettes on top) (figs. 274, 275). These take the form of structures with two arches (on fol. 54v, a horseshoe form) spanned by a larger arch either set into a frame formed by three rod-like, variegated, interlaced bars on fols. 51r (fig. 274), 51v–53r, or freestanding on fols. 53v, 54r (fig. 275). In the latter case, the large arch is flanked by two upright stem-like rods. These and the vertical bars of the frames rising above the

[6] Weitzmann, *Buchmalerei*, p. 84, pl. CXII, 576, 577; Spatharakis, *Dated Mss.*, nos. 6, 39, figs. 18, 77.

[7] Harlfinger et al., p. 36.

[1] For the text see J. B. Pitra, *Juris ecclesiastici Graecorum historia et monumenta*, 2, Rome 1864, repr. Rome 1963, pp. 353ff.

horizontal bar terminate in plaited crosslets or pal-mettes. The space within the frame is empty. But the tympanon of the larger arch contains a cross painted against the parchment, in one of the following forms: solid cross with flaring arms, corners and center terminating in pearl-drops, with four rays at the center; interlaced cross; cross formed of four palmettes or of fretsaw, in each case flanked by two birds. The arches are supported by three columns, thick in relation to the arches, with interlaced ornament. The colors are muddy blue, terracotta red, deep red, yellow, and colorless.

55r Rectangular headpiece consisting of upper and lower bars with two small interlaced columns and fretsaw palmettes at the corners. The upper bar is decorated with a half-palmette ornament, only outlined in red, interrupted by three roundels, each containing a flower outlined in red, tinted in muddy blue, and set against a muddy olive green. The lower bar is decorated by palmettes alternating with buds, in the tradition of the fretsaw style, in colors as above but set against the parchment. Initial B with a man wearing a hat and shading his eyes. Left column. Mt. 1:1ff. (fig. 276).

119r Rectangular headpiece as on fol. 55r with palmettes, half diamonds, and crenellated patterns, very crude, in carminé style. Plaited initial A. Left column. Mk. 1:1ff.

161r Rectangular headpiece, as in previous folios, with palmettes and interlace in a crude carminé style. Initial Є with blessing hand. Left column. Lk. 1:1ff.

235r Rectangular headpiece. Upper and lower bars each with three roundels with a cross pattern. Half-diamond patterns on the sides, all in carminé style. Initial Є with blessing hand, very crude. Left column. Jn. 1:1ff.

291v Π-shaped headpiece with a very crude rinceau pattern in carminé, abstracted from a palmette motif. Left column. *Canonarion*.

Iconography and Style

The script slants slightly to the left; the mu, nu, and ypsilon are pressed on the sides and angular. The general inconsistency in form and spacing (the words are often not separated) makes classification of the script difficult. However, the inconsistency and certain features such as the short tails, the ligatures related to the rho, the alternating use of two different types of eta, and the general form of the script find parallels in cod. Paris, Coislin 263 (John Climacus), written according to its colophon in 1059, either in Cappadocia or in Mesopotamia, as Devreesse has suggested.[2]

The most interesting stylistic feature of this manuscript is the form of its Canon tables, for which no known parallel seems to exist. The horseshoe arch in at least one of the tables would suggest some relationship with contemporary or earlier codices which have this motif as well as the color scheme of the Sinai Canon tables. The provenance of these manuscripts has been a matter of controversy.[3] However, it is known that one of them, the cod. Paris gr. 81, was written in 1092 in the Monastery of Hosios Meletios in Greece, which had connections with both Cappadocia and Italy.[4]

Another distinct feature is the use of the cross with flaring arms and rays projecting like shoots of plants, and the "illumined" cross decorated with pearls in the Canon tables, and marking the titles in the title frames (figs. 274, 276). The latter should not be confused with the simple, small crosses often found at the beginning of titles or verses. Crosses of comparable forms, particularly the illumined cross in Canons or headpieces, appear as early as the tenth century in manuscripts such as cod. Vat. Palat. gr. 220, Patmos cod. 70, and their relatives,[5] in which Armenian and Byzantine influences intermingle and whose connections to Cappadocia have been pointed out.[6] In fact, the illumined cross on the tympanon of an arch appears in Armenian manuscripts such as Erivan no. 2374 (Etschmiadzin, from the year 989)[7] and the Vashpurakan Gospel in Vienna from about the year 1000,[8] both of which differ from our example in form and ornamentation.

The ornament, eclectic in its patterns, derivative in

[2] R. Devreesse, *Bibliothèque Nationale, Catalogue des manuscrits grecs,* II: *Le fonds Coislin,* Paris 1945, pp. 241ff.; Spatharakis, *Dated Mss.,* no. 70, fig. 125 with more complete bibliography.

[3] For examples see Vienna, Theol. gr. 188; New York, Morgan Lib. M.748, fol. 6v; Milan, Ambros. B.56 sup., fol. 20r, from the year 1022; and Athens, Nat. Lib. 74: Gerstinger, *Griech. Buchmalerei,* pl. 14b; *Greek Mss. Amer. Coll.,* p. 95, no. 17, fig. 29; Marava-Chatzinicolaou, Toufexi-Paschou, no. 9, fig. 73.

[4] Spatharakis, *Dated Mss.,* no. 112, fig. 210 with bibliography; also Marava-Chatzinicolaou, Toufexi-Paschou, p. 135.

[5] Cf. also Leningrad, Public Lib. gr. B.I.5, fol. 119r; see Weitzmann,

Buchmalerei, pls. LXVIII,402, LXXI,430, LXXV,463.

[6] Ibid., pp. 62, 66, 69.

[7] Fol. 6r; see S. Der Nersessian, "The Date of the Initial Miniatures of the Etchmiadzin Gospel," *The Art Bulletin* 15 (1933) fig. 24, repr. in eadem, *Études,* fig. 301.

[8] H. and H. Buschhausen, *Das Evangeliar Codex 697 der Mechitha-risten-Congregation zu Wien,* facsimile ed., Berlin 1981, fol. 2v. Birds flanking a wreath with the illumined cross also appear in the Canon tables of Ethiopian Gospels such as the Abbâ Garimâ, tenth- or eleventh-century, but are different in their ornamentation; see J. Leroy, "L'évangéliar Ethiopien du Couvent d'Abba Garima," *CA* 11 (1960) pp. 131ff.

style, and with thick colors, as a whole belongs to the carminé and fretsaw traditions, which are widely diffused in time and whose various origins include Cappadocia. Plant shoots, for instance, decorated with small, pearl-like drops are found in such Cappadocian manuscripts as London, Brit. Lib. Add. 39598, which is related to Caesarea,[9] while the crest-like palmettes on the corners of the title frames parallel those found in cod. Sinai 172 (fig. 227) from the year 1097, assigned to Trebizond.[10] However, the same palmette motif occurs in other provincial manuscripts which have been attributed to Greece, such as cods. Milan, Ambros. D.545 inf., fol. 230v (Basil), from the tenth century, and Athens, Nat. Lib. 179 from the eleventh.[11]

Apart from the illustration, the codex provides internal evidence which should be considered. There are hypotheses of two different versions for each of the four Gospels. In one version, fol. 117r, it is stated that the Gospel according to "St. Matthew was written and compared to the old copies stemming from Jerusalem which are now deposited in the holy Mount (Athos)" (cf. also fols. 159r, 234r, 288r). If this were to be taken literally, it would suggest that the manuscript was produced in Athos. It is possible, however, that this text existed in the model used by the scribe, and the evidence therefore does not carry much weight. But in the varia there are two dogmatic texts, an account of the Council of Nicaea and the encyclical of Methodios of Constantinople, under whose patriarchate the icon cult was restored,[12] and an anonymous text on the appearances of Christ after the Resurrection. The choice of these texts may suggest a monastery or a province where discussions concerning the doctrine of the two natures of Christ continued in the eleventh century. The inner provinces present themselves as good candidates.

Considering all this, the possibility that the manuscript was written in Cappadocia or central Asia is strong. The eclecticism of its patterns, however, leaves open the possibility, however remote, of an origin in Sinai.

Bibliography

Kondakov 1882, p. 102.
Gardthausen, *Catalogus*, p. 28.
Gregory, *Textkritik*, pp. 245, 1133 no. 1187.
Hatch, *Sinai*, pl. XXVII.
Kamil, p. 68 no. 175.
Voicu, D'Alisera, p. 553.

[9] Weitzmann, *Buchmalerei*, p. 65, fig. 58.
[10] See no. 29 above.
[11] Weitzmann, *Buchmalerei*, pl. LXXV,458; Marava-Chatzinicolaou, Toufexi-Paschou, pp. 81–87, no. 18, fig. 143, cf. with Sinai cod. 150,

33. COD. 205. LECTIONARY
THIRD QUARTER OF ELEVENTH CENTURY. FIGS. 277–286, COLORPLATE XVI:c–d

Vellum. 340 folios, 33.2 x 25.2 cm. Two columns of twenty-four lines. Minuscule script, round, well-penned and spaced, for text (cf. also cod. 512, no. 27 above); titles and calendar indications in *Epigraphische Auszeichnungs-Majuskel* and *Auszeichnungs-Majuskel*. Gathering numbers at lower left corner of recto and lower right of last verso. Parchment fine and yellowish white; wide outer margins. Ink dark brown for text; titles and calendar indications throughout in gold. Twelve text lines at beginning of each Gospel section in gold. Ekphonetic signs in deep red. Inscriptions in miniatures in red. Small initials in flower petal style, gold over red.

Jo. hebd. Mt. Lk. hebd., Passion pericopes and Hours, Eothina, Menologion, varia.

Fols. 3r–44r, John weeks; 44v–45r, blank; 45v, miniature; 46r–112v, Matthew weeks; 113r, blank; 113v, miniature; 114r–199v, Luke weeks; 200r, blank; 200v, miniature; 201r–237v, Mark readings; 238r–257r, Passion pericopes; 257v–273r, Hours readings; 273r–278r, Eothina; 279r–335v, Menologion, September–August; 335v–339, various Gospel lections including pannychides.

First gathering begins on fol. 3r; before this is a double sheet with text from another eleventh-century Lectionary in two columns of twenty-five lines, of which one folio is a flyleaf, while the other is glued on the cover; another flyleaf with text from the same Lectionary is found at the end of the codex, fol. 340, and another page glued on the back cover. Fols. 14–15 are restorations, probably of late fifteenth-century date. Three of the evangelist portraits are painted on the verso sides of inserted sheets (the recto sides are blank), but they are contemporary with the text and belong to the manuscript, as proved, among other indications, by Luke's portrait, which is painted on a binion, gathering ιε′, fols. 110r–113v.

Condition very good. Miniatures bear signs of humidity and have suffered some flaking.

Binding: metal covers consisting of thin, bronze-gilt plaques having crude embossed representations with engraved details, nailed on leather binding over wooden boards covered with worn-out red velvet. Front cover

fol. 55r (fig. 276).
[12] See briefly, W. Buchwald, A. Hohlweg, and O. Prinz, *Tusculum-Lexikon*, Munich 1982, p. 524, with excellent bibliography.

(fig. 285): a narrow fillet-like frame nailed on all four sides onto a large panel with the Crucifixion. The dead Christ ($\overline{\text{IC}}$ $\overline{\text{XC}}$) is nailed to a cross whose lobed arms enclose the nimbed symbols of the evangelists holding Gospels; read counterclockwise from the top, they are: the eagle, the winged lion, the winged calf, and the angel as a half figure. Below the eagle, on the unfurled scroll is the following inscription: O B(a)C(ι)Λ(ευs) T(ηs) ΔΟΞΗC. On the left are the three Maries and on the right the mourning John with the centurion behind holding a shield in his left hand and pointing to Christ with his right. The cross stands on the hill of Golgotha, above the skull of Adam. A rinceau pattern decorates a crenellated wall; beyond this the middle zone is rendered as a series of wavy lines, perhaps suggesting mountains, leading to a starry sky where two mourning angels hover over Christ. Behind the angels are the discs of the sun and the moon, each a bearded head in profile with emanating rays.

Back cover (fig. 286): a separate plaque framed by a narrow fillet marked by a dotted line, with a western style Anastasis in a central panel. Christ ($\overline{\text{IC}}$ $\overline{\text{XC}}$), holding a cross-staff and blessing in the western manner, rises from a sarcophagus marked by a series of steps. Two armored soldiers sleep at the front corners of the sarcophagus and two others are partially visible behind. This representation is surrounded by smaller panels with half-figures of the apostles holding open books or scrolls. On top, John the Theologian, ὁ ἅ(γιος) ιω(άννης) ὁ θεολόγ(ος); Peter, ὁ ἅ(γιος) πέτρος; and Paul, ὁ ἅ(γιος) παυλος; left, vertical row, Matthew, ὁ α(γιος) ματαθαιος; Luke, ὁ ἅ(γιος) λουκὰς; Andrew, ὁ ἅ(γιος) ανδρεα(s); right vertical row, Mark, ὁ ἅ(γιος) μ(άρ)κος; Simon, ὁ ἅ(γιος) σίμων; James, ὁ ἅ(γιος) ἰάκοβος; bottom row, Bartholomew, ὁ ἅ(γιος) βαρθολομέω(s); Thomas, ὁ (ἅγιος) θομας; and Philip, ὁ ἅ(γιος) φιληπος. A rinceau pattern forms the background of each panel. Two separate narrow strips are nailed above and below the central panel. That at the bottom contains a series of thick wavy lines springing from the center, perhaps suggesting the sea, while that on top has a starry sky with the sun to the right and the moon to the left. An outer fillet, similar in pattern to the inner one, encloses the entire composition. The spine, partly of leather and partly of textile, is worn out and is held in place by pieces of paper glued to it.

This metal cover dates from about the sixteenth or seventeenth century. The form of the cross ultimately derives from large Venetian crosses of the thirteenth century.[1] Wooden processional crosses, terminating in lobed arms on which the four zodia are painted, were common in the Greek world in the sixteenth and seventeenth centuries.[2]

Illustration

2v John, ὁ ἅ(γιος) ἰω(άννης) ὁ θεολόγος (22.2 x 17.5 cm.) (fig. 277). The evangelist, seated to the left, writes with a gold pen in a scroll he holds between his knees. Bald-headed, wearing a light blue himation with a golden clavus and a gold nimbus, his hair and beard are white and his flesh rendered in brownish tones. His forehead is bulbous and his contracted brows express concentration. His dark brown wicker chair is decorated with golden striations also found on the table and the lectern supported by a dolphin which are set before him. On the lectern rests an open, blank codex, while a closed book, a roll, and an ink bottle are on the shelves of the table. The background is a series of buildings with tunnel-vaulted and gabled roofs, cupolas, colonnaded loggias, and latticed windows (one shown with an open shutter), with curtains hung over the doors of the principal building left and right, and a piece of blue drapery spread over the roof and turrets. The walls are light pink, the roofs red and blue, and the doors and windowpanes olive green. The background is gold and the border red.

3r A rectangular headpiece (fig. 278). In the center, a four-lobed cruciform panel encloses the title in huge gold letters, and three eight-petalled rosettes or eight-rayed stars. This is surrounded by a rich, carpet-like decoration with Greek crosses alternating with octagonals and hexagonals in a tile-like pattern, all containing flower petals in blue, green, and pink against gold. A narrow border of small four-petalled flowers in blue-green and pink in a diamond pattern frames the headpiece. At the upper corners on an extended groundline are the usual palmettes and small trees with crowns derived from the Sassanian palmette. Initial Є in flower petal style, with a figure of John standing and holding a book on the outer, lower part of the letter; a larger, blessing Christ forming the crossbar, and above, on the bow of the letter, a bust of the Ancient of Days. Jn. 1:1ff.

45v Matthew, ὁ ἅγιος ματθαῖος (22.6 x 17.5 cm.) (fig. 279). Seated to the left on a dark brown wicker chair

[1] Chatzidakis, *Icônes à Venise*, p. 178.
[2] Chatzidakis, *Patmos*, no. 89, pl. 140; Karakatsani, "Stavronikita Icons," pl. 41; cf. also H. Hallensleben, "Zur frage des byzantinischen Ursprungs der monumentalen Kruzifixe, 'wie die Lateiner sie verehren,'" *Festschrift E. Trier*, J. Müller Hofstede and W. Spies, eds., Berlin 1981, pp. 7–34.

with gold striations, and resting his feet on a footstool, Matthew leans forward to touch gently the open, blank codex before him on a lectern whose stand is decorated with what looks like a creature or fish(?), and which is set on top of a cabinet-like writing table with writing implements visible on top and on shelves within. In his left hand he holds an unfurled blank scroll. Dressed in light blue tunic and grey-blue himation with shades of light green-blue, he has a grey beard and a gold nimbus, and looks upward with a visionary gaze. His flesh is rendered in warm brown tones with some red touches. Two tall and narrow pink buildings, one on either side, complete the composition. They have gabled roofs and their entrances are covered with decorated curtains, mostly red. The ground is grey-green, the background gold, and the border red.

46r Rectangular headpiece similar to that on fol. 3r (fig. 280). The entire field is filled with tiny flower petals arranged in quatrefoil patterns, while the border is formed of small three-petalled buds. Sassanian palmettes in cross form are on the lower line. Initial Є in flower petal style. First Monday after Pentecost, Mt. 18:10–20.

113v Luke, ὁ ἅγιος λουκάς (22.6 x 17.5 cm.) (fig. 281). Seated at the left on a dark brown, low-backed chair and resting his feet on a footstool, Luke is writing on a transverse scroll held between his knees. He is clad in a light blue tunic and a light violet himation. His curly hair with two rows of locks is brown, and his flesh tones are in warm brown mixed with a little red. A lectern rising from a writing table and supporting a blank open codex is before him. All of the furniture is brown with gold striations. Two tall pink buildings with red roofs and curtained doorways provide the architectural setting; the curtain on the left shows a cross pattern in gold instead of the usual borders, while the building on the right has a loggia. Ground and background as previously.

114r A rectangular headpiece (fig. 282). The title, enclosed in a central rectangle, is written in gold against the vellum. All sides are filled with rich flower petals in a gracious, ornamental rinceau pattern enclosing peacocks, other birds, and dogs. In the lower border is a brown vase with two dove-like birds on either side. Initial T in similar style. Monday, first of Luke weeks, Lk. 3:19–22.

200v Mark, ὁ ἅγιος μάρκος (22.6 x 17.5 cm.) (fig. 283). Depicted at the left, seated on a brown stool with a red

cushion and resting his feet on a footstool, Mark dips his gold pen into an inkwell. Wearing a white-blue tunic with a golden clavus and a himation in white-violet, he has black-brown hair and beard and flesh tones like those in the previous portrait. His nimbus is faintly delineated. He too holds an unrolled scroll between his knees; another blank unrolled scroll rests on a lectern with a dolphin on its stand, which in turn sits on a writing table holding the usual implements. All furniture is brown with gold striations. Two tall buildings with red roofs, their doors draped with deep red curtains, complete the composition. Here, too, an attempt is made to create the illusion of space by placing the building on the right in the foreground, while that on the left is in the background, behind the evangelist. The ground is blue-green, the background gold, and the border red.

201r A rectangular headpiece (fig. 284). Similar in format to that on fol. 114r, it contains conventional rosette patterns of rich but very regular flower petal style, set in gold. The corner squares are specifically marked. On the corners below, tree-like pink and blue flowers spring from large acanthus leaves in green and pink. Initial T in flower petal style. First Saturday of Lent, Mk. 2:23–3:2.

238r Band-shaped headpiece, right column, in flower petal style. Very delicate initial Є in similar style. Beginning of Passion pericopes.

257v Band-shaped headpiece, left column, and initial T in flower petals in diamond shapes. Beginning of the Hours readings.

273v Band-shaped headpiece and initial T in flower petal style. Beginning of the Eothina.

279r Π-shaped headpiece over both columns in flower petal style with huge discs, their central rosettes surrounded by smaller ones. Initial T in similar style. Menologion, September 1.

Thereafter the first of each month is marked by a small band-shaped headpiece and relevant initial T or Є, over the right or left column: fols. 286v, 289v, 292v, 301v, 310r, 313v, 315v, 317r, 320r, 326r, 330r, in delicate flower petal style with a great variety of patterns.

335v A rectangular headpiece in the right column, in flower petal style with open flowers in diamond forms. Beginning of varia.

Iconography and Style

The evangelists are engaged in writing, except for Matthew who is looking upward receiving inspiration while

he touches the codex on the lectern (fig. 279, colorplate XVI:c). He reflects the philosopher type of the Macedonian Renaissance, as seen in the portrait of Mark in the Stavronikita Gospels, cod. 43.[3] The role of scribe is stressed by the scroll held on or between the knees of the evangelists. This iconographic element, found in several eleventh-century Gospels such as Paris suppl. gr. 1096 from the year 1070,[4] also has its prototype in models dating from the Macedonian Renaissance.[5] The standing type of the evangelist-teacher is represented by the figure of John in the initial Є, combined with the additional figures of the teaching Christ and the Ancient of Days (fig. 278) referring to the opening verses of John's Gospel, for which there are eleventh-century parallels such as the Gospel book Paris gr. 74.[6] It should be stressed, however, that the teaching Christ is a typical iconographic component of Lectionary illustration, with the extended arm serving as index for the text.[7]

In the figures, the classicizing tendencies of the Macedonian Renaissance have given way to a more ascetic style. Classical drapery motifs are still recognizable but they are no longer organic (fig. 279, colorplate XVI:c). A degree of linearism and a rhythmic ornamental effect have been introduced. The necks are unnaturally drawn. The highlights on the ridges of the noses and on the eyebrows convey a feeling of tension and concentration. The flesh tones are rendered in brown and red, and modelling is achieved by small parallel lines drawn with a circular, upward motion.

The gold striations deprive the furniture of solidity, which is lacking as well in the elongated buildings at left and right. Their parallels are found in eleventh- and twelfth-century manuscripts.[8] However, the architectural complexity of the building in the background of John's miniature, with its loggias and drapes, betrays a Renaissance model and ultimate derivation from the *scaenae frons* of the Roman theater (fig. 277).[9] The cool pastels of the walls and the blue-green ground provide subtle harmony with the garments, accentuated by the red draperies on the buildings and the gold sky—all typical elements of Constantinopolitan manuscripts.

The large headpieces, rich in their color schemes and use of gold, and distinguished by their exuberant flower petal style and flanking palmette-trees, are closely related to those in the cod. Milan, Ambros. B.80 sup., dated between 1071 and 1078;[10] the headpiece with the scroll inhabited by birds and quadrupeds in the brilliant colors of cloisonné enamels recalls such Constantinopolitan manuscripts as the cod. Vat. gr. 463 from the year 1062.[11]

Paleographically the codex is related to the cod. Paris suppl. gr. 1096, referred to above, from the year 1070.[12] The script is similar in both codices, although they are not products of the same hand; each verse is separated by a crosslet, and both codices employ the same breathing system and use of ekphonetic signs. The Sinai codex, a work of the capital, can be assigned to a similar approximate date in the third quarter of the eleventh century.

Bibliography

Gardthausen, *Catalogus*, p. 41.
Gregory, *Textkritik*, p. 447 no. 839.
Van Regemorter, "Reliure," p. 11.
Kamil, p. 70 no. 230.
Weitzmann, *Sinai Mss.*, p. 15, figs. 16, 17.
Voicu, D'Alisera, p. 557.

34. COD. 499. MENOLOGION, NOVEMBER 1–16 SECOND HALF OF ELEVENTH CENTURY. FIGS. 287–291

Vellum. 367 folios, 39.3 x 28.3 cm. Two columns of twenty-eight or twenty-nine lines. Minuscule script for text, clear, well-spaced letters; titles in *Auszeichnungs-Majuskel*; title on fol. 1r and indications of months throughout in *Epigraphische Auszeichnungs-Majuskel*. Gathering numbers with two horizontal lines above and below and two strokes at the center of bottom margin; wide outer margins. Parchment fine and white. Ink brown for text; titles and month indications and most solid initials in text in gold; entire page, fol. 2r, in gold script; larger initials in flower petal style on gold.

Fols. 1r and v, table of contents; 2r–366v, sixteen saints' lives, November 1–16; 367r, entry of 1553; 367v, blank.

[3] Weitzmann, *Athos*, pp. 46–47, no. 7.

[4] Spatharakis, *Dated Mss.*, no. 89, fig. 159.

[5] Cf. Luke in the Stavronikita Gospels, fol. 12v: Friend, "Evangelists," pl. VII,97; also Paris, Coislin 195, fol. 171v (Mark), fol. 240v (Luke): ibid., pl. IX,100, 101.

[6] Galavaris, *Prefaces*, pp. 95ff., fig. 78.

[7] S. Tsuji, "Byzantine Lectionary Illustration," in *Greek Mss. Amer. Coll.*, p. 36.

[8] For examples see Friend, "Evangelists," pl. XIV,136–39, 144–47.

[9] Ibid., pl. XVIII,177–79.

[10] Spatharakis, *Dated Mss.*, no. 91, fig. 165; cf. also cod. Athens, Nat. Lib. 57 from the third quarter of the eleventh century; see Marava-Chatzinicolaou, Toufexi-Paschou, no. 26, figs. 229, 230.

[11] Spatharakis, *Dated Mss.*, no. 75, fig. 135.

[12] See note 4 above.

The entry on fol. 367r reads:

+ ετους ,ζξα' μηνί ιουνίω εἰς τας ιγ' ἦλθα εἰς τό
ἅγι(ον) καὶ θεοβά/διστον ὄρος κ(αὶ) ἐπροσκύνησα
ἐγώ ἁμαρτωλός πάπα / μακάριος ἀρχόλαως ἐκ
νισου κριτις ἐκ τ(ῆς) πόλ(εως) ρεθέμνου. ,αφνγ'
ἰουνίου 13.

+ On June 13 of the year 7061 (1553) I, the sinner priest Makarios Archolaos from the island of Crete from the city of Rethymnon, came as a pilgrim to the holy and God-trodden Mount. 1553, June 13.

This indicates that the manuscript was in Sinai by that date. The priest mentioned may be Makarios the Cretan, the scribe who copied two codices in 1554 and one in 1567.[1] An Arabic note is on the right margin of fol. 304r.

Condition on the whole good. Fol. 1r and v in bad state; illustration on fol. 2r has suffered considerable flaking, but ornamental headband is in excellent condition; left bottom corner is repaired; first gatherings are loose; fol. 8r, right column, headpiece is cut off, Life of Akindynos and Pegasios; fols. 337r, 363r, 364r, right margins have been cut; last folios have suffered from humidity.

Faded red-brown leather binding on wooden boards, in bad state of preservation. Torn on upper and lower parts, it has been repaired with new brown leather; the spine is gone and the covers are held together by tape. On back cover four leather straps fixed by one nail, and on front cover a metal pin. Front cover has tooled ornamentation of triple diagonal lines forming diamonds and half diamonds with very small triple circles at the points of crossing. A large, bronze, sun-like rosette in center and a later, plain metal stud on upper right corner. Similar patterns on the back cover.

Illustration

1r Π-shaped headpiece in flower petal style, in left column, petals and rosettes in roundels and heart forms. Table of contents (pinax).

2r Π-shaped headpiece with Sts. Cosmas and Damian, over both columns (entire headpiece without the palmettes on corners, 20.2 x 17.9 cm.; saints alone, 9 x 6.3 cm.) (fig. 287). Painted against the parchment and almost completely flaked, the two physician saints stand frontally. Both wear tunics—that on the left light grey with olive green, and that on the right light violet—and professional mantles, Cosmas' purple and Damian's black. They have gold-ornamented sleeves and each holds a red scroll. Their oval heads are painted against gold nimbi. The flower petal orna-ment in the headpiece consists of leafy stems in a rinceau design forming framed medallions enclosing various birds, and on the upper corners two griffins. Outside the frame, on the lower corners, a three-stemmed plant with flowers springing from a palmette. Two stylized palmettes on the upper corners of the frame. Initial A contains only a fragment of a figure in red chlamys leaning against a blue cypress tree. November 1, Life of Cosmas and Damian.

8r Excised headpiece, right column. Initial Є in flower petal style. November 2, Martyrdom of Akindynos, Pegasios, Anempodistos, Apthonios, and Elpidophoros.

26v Band-shaped headpiece in flower petal style, left column (fig. 288). It consists of two roundels containing symmetrically arranged flower petals between the arms of a cross formed by tendrils, with petals in a scroll pattern between the roundels of blue and wine red against gold. On top are two parrots in green and purple flanking a stylized, plant-like fountain with a pinecone. Initial Є in similar style. November 3, Martyrdom of Akepsimas, Joseph, and Aeithalas.

48r Band-shaped headpiece in left column in flower petal style, with roundels and half roundels in three rows. Initial Π in similar style. November 4, Life of Ioannikios of Olympos.

89v Band-shaped headpiece in flower petal style with two green parrots at the top flanking a golden fountain, left column. Initial T in similar style. November 5, Life and Martyrdom of Galaktion and Episteme.

100v Band-shaped headpiece in flower petal style with two yellow and green parrots flanking a gold and purple fountain at the top, as on fol. 89v, right column. Initial H in similar style. November 6, Life of Paul the Confessor.

109v Band-shaped headpiece in flower petal style and two green and blue parrots at the top as on fol. 100v, right column. Initial I in similar style. November 7, Martyrdom of the Saints in Melitine.

117v Band-shaped headpiece in flower petal style and two violet and red parrots as on fol. 100v, left column. Initial T in similar style. November 9, Life of Matrona.

142v Band-shaped headpiece in flower petal style, a variation of that on fol. 26v, and two blue ducks flanking a stylized gold and blue fountain with a pinecone, above, left column. Initial Є in similar style (fig. 289). November 10, Life of Theoktiste from Lesbos.

[1] Cf. Vogel, Gardthausen, p. 271.

95

156r Band-shaped headpiece in flower petal style, with polygonals and quatrefoils in a tile pattern, left column. At the top, two green and blue parrots flanking a fountain. Initial B in similar style. November 11, Martyrdom of Menas of Egypt.

164r Band-shaped headpiece in symmetrical scrollwork pattern, with two parrots in green, blue, and yellow flanking a gold and violet fountain at the top, left column. Initial T in similar style (fig. 290). November 12, Life of John the Almoner, Archbishop of Alexandria.

213v Band-shaped headpiece in flower petal style, inverted palmettes within intersecting circles, with two birds in yellow, blue, and brown flanking a fountain at the top, left column. Initial K in similar style (fig. 291). November 13, feast day of John Chrysostom.

332r Band-shaped headpiece in flower petal style, two circles with a rosette pattern, and two blue birds flanking a fountain at the top, right column. Initial O in similar style. November 14, St. Philip's feast day.

338v Band-shaped headpiece in flower petal style arranged in roundels in two rows with two green and blue parrots on either side of a fountain at the top, right column. Initial Є in similar style. November 15, Martyrdom of the Confessors Gourias, Samonas, and Abibos.

351r Band-shaped headpiece in flower petal style similar to that on fol. 332r, right column. Initial T in similar style. November 15, the miracle concerning the virgin Euphemia performed by the Holy Confessors.

363r Band-shaped headpiece in flower petal style similar to that on fol. 213v, with two birds in dark yellow and blue flanking a fountain at the top, right column. Initial H in similar style. November 16, St. Matthew's feast day.

Iconography and Style

Cosmas and Damian are represented here following the accepted iconography after Iconoclasm (fig. 287).[2] The

professional mantle which they wear, with an opening cut for the neck, is not known in pre-iconoclastic representations.[3] The scrolls they hold refer to the healing of the soul. Their manner of depiction and the lack of any background recall saints found in icons or Menologia from the second half of the eleventh century.[4] In fact, in their stance, garments, and attributes, they recall an icon at Sinai attributed to about the turn of the century.[5]

Although the illustration has suffered considerable flaking, it is obvious that the figures are elegant and carefully drawn, with oval heads whose size and form are stressed by narrow necks proportionate to the bodies. The drapery is clearly articulated and rhythmic. Stance, proportions, and head types recall the figures found in eleventh-century Constantinopolitan manuscripts, for example, the Psalter-New Testament, Dumbarton Oaks 3, from the year 1084, and in icons from the turn of the century.[6]

The flower petal ornament applied to the headpieces has certain distinct features: leafy stems in interlace or scroll pattern enclosing birds and griffins, carefully arranged symmetrical patterns, and jewel-like arrangement of petals within circles. These characteristics appear in codices produced in the capital in the second half of the eleventh century. Close comparisons can be made with the cod. Vat. gr. 463, from 1062 (cf. Sinai fol. 2r with Vatican fol. 4r)[7] and with the cod. Athens, Nat. Lib. 2804 from the second half of the century (cf. Sinai fols. 26v and 142v with Athens fol. 2r).[8] The birds which appear on top of the headpieces around stylized fountains reflect an old tradition, usually associated with the Canon tables of Gospel books; they are often found in manuscripts of the same period and area of production, e.g., cod. Athens, Nat. Lib. 57 from the third quarter of the century, which is also similar paleographically to the Sinai codex.[9] Furthermore, the motif of stems and flowers springing from palmettes at the lower corners of the headpieces (fol. 2r, fig. 287) is also found with variations in Constantinopolitan manuscripts of the period, such as the cod. Athens, Nat. Lib. 2645, fol. 167r.[10] The initials can be divided into two types: those in simple flower petal style, and

[2] See H. Skrobucha, *Kosmas und Damian* (Iconographia Ecclesiae Orientalis), Recklinghausen 1965; *Lexikon der Christlichen Ikonographie*, 7, W. Braunfels, ed. (Rome, Freiburg, Basel, and Vienna 1974) cols. 344–52 with fuller bibliography.

[3] Cf. Weitzmann, *Sinai Icons*, p. 14, no. B.18, pl. LXV; p. 89, no. B.55, pls. XXXIV, CX.

[4] Weitzmann, "Eleventh Century," pls. 19b, 33a–b, 41.

[5] Sotiriou, *Icônes*, 1, fig. 85.

[6] S. Der Nersessian, "A Psalter and New Testament Manuscript at Dumbarton Oaks," *DOP* 19 (1965) color frontispiece and fig. 54 (repr. in eadem, *Études*, fig. 128); Spatharakis, *Dated Mss.*, no. 101, fig. 191; and

note 5 above.

[7] Spatharakis, *Dated Mss.*, no. 75, fig. 135; Galavaris, *Liturgical Homilies*, pl. XI,80; cf. also Anderson, "Vat. gr. 463," pp. 177–96.

[8] Marava-Chatzinicolaou, Toufexi-Paschou, no. 21, fig. 166.

[9] Ibid., no. 26, figs. 225–29; cf. also Athos, Iviron cod. 2, *Treasures*, 2, fig. 8.

[10] Marava-Chatzinicolaou, Toufexi-Paschou, no. 34, fig. 322. Also compare Paris, Coislin 239, fol. 37v, Galavaris, *Liturgical Homilies*, pl. XXXVII,206; and Oxford, Auct. T. inf. 1.10, fol. 178v, Hutter, *Oxford*, 1, no. 39, fig. 239.

those with cross-like petals attached to the stems, one on top of the other. Both types are found in cod. Athens, Nat. Lib. 2804, to mention one example.[11] Considering all this, we are prompted to place the Sinai manuscript in a Constantinopolitan scriptorium in the second half of the eleventh century, and possibly even within the third quarter of the century.

This codex is the third volume of a set of ten which made up the standard edition of the Metaphrastian Menologion. On fol. 2r, at the top of the page (fig. 287), it is stated that it is ΒΙΒΛΙΟΝ ΤΡΙΤΟΝ, the third book. Whether this implies that the volume was part of the same series by the same scribe, or that it was made for the same patron, we cannot know. Nevertheless, it seems that it was part of a series. The manuscript represents a category of Menologia which honor the first day of the month with portraits of saints' lives, but lack further illustration.[12] Perhaps the manuscript belongs to the same set as cod. Sinai 503 (no. 35 below).

Bibliography

Gardthausen, *Catalogus*, p. 122.
Ehrhard, *Überlieferung*, 2, pp. 411, 691.
F. Bonora and G. Kern, "I manoscritti medici del monastero di Santa Caterina di Alessandria al Monte Sinai (Nota preventiva)," *Scientia Veterum* 16 (1968) fig. 2.
Kamil, p. 90 no. 722.
P. Mijović, *Menolog. Istorijsko-umtnička istraživanija*, Belgrade 1973, p. 211.
Voicu, D'Alisera, p. 561.
Deliyanni-Doris, p. 285.
Walter, *Art*, p. 49 n. 91.

35. COD. 503. MENOLOGION, NOVEMBER 17–30 SECOND HALF OF ELEVENTH CENTURY. FIGS. 292–294

Vellum. 258 folios, 35.6 x 29.2 cm. Two columns of twenty-eight lines. Minuscule script for text, written under the line, small letters with strong *Hakenschrift* elements; titles in *Auszeichnungs-Majuskel*; indications of months in *Epigraphische Auszeichnungs-Majuskel*. Gathering numbers originally must have been at lower right corner of recto (see fol. 87r); at the beginning of each Life the total number

of folios devoted to it is cited by a later hand; wide outer margins. Parchment fine and white. Ink light brown, a few parts written over by a later hand in black; titles, month indications, and small solid initials in text in gold; larger zoomorphic and flower petal style initials all set in gold.

Fols. 1r–258v, twelve saints' lives, November 17–18, 23–28, 30.

The text ends at the upper part of left column, fol. 258v. On the right column there might have been a colophon which has been rubbed off and/or destroyed by humidity. On fol. 257r a later hand, probably of the sixteenth century, has written: οὗτος ὁ μεταφραστῆς ὑπάρ-χ(ει) τῆς ἁγίας αἰκατερίνης τῶν σιναϊτῶν. (This Metaphrastes belongs to St. Catherine of the Sinaites.) It is followed by a curse against book thieves. Since Ἁγία Αἰκατερίνη τῶν Σιναϊτῶν is the name of the principal Sinai metochion in Crete, this indicates that the manuscript came to Sinai from Crete, where it must have been until the sixteenth century.

Condition good. Fols. 93r–100v presently bound out of order: originally they followed fol. 115; fols. 131 and 193 are cut along the right margin; last fols., 257 and 258, are loose and blackened by humidity.

Simple light brown leather binding on wooden boards without ornamentation. Covers have been damaged and repaired.

Illustration

1r Π-shaped headpiece, left column, in flower petal style (fig. 292). Leafy stems arranged in a rinceau design form double medallions enclosing various birds in blue, green, and violet and green calyxes with pink and white flower petals. On top, two green parrots at either side of a porphyry fountain filled with blue water at which drink two lions arranged heraldically. The golden pinecone from which the water jets stands upon a golden cross. Two blue and green-blue parrots with red bands on their necks form the initial O. November 17, Life of Gregory the Wonder Worker of Neocaesarea.

32v Band-shaped headpiece, right column, in flower petal style. Flowers are enclosed in circles between which are palmettes on stems against gold. Initial O in similar style. November 18, Martyrdom of St. Plato.

40r Band-shaped headpiece, left column, in flower petal style, with many-petalled flowers enclosed in circles

[11] Marava-Chatzinicolaou, Toufexi-Paschou, no. 21, figs. 171, 175.

[12] Such as the cods. Thessalonike, Vlatadon 3 (first half of November)

or Florence, Laur. Plut. XI.10 (first half of December); see Paterson Ševčenko, "Menologium," pp. 425ff.

(fig. 293). Initial K in similar style, formed by jumping stag. November 23, Life of Amphilochios.

61v Band-shaped headpiece, left column, in flower petal style. Initial K formed by a peacock. November 24, Life of Gregory, Bishop of Agrigento.

85v Band-shaped headpiece, left column, three circles in a rinceau design. Initial B, right column, in similar style. November 25, Martyrdom of St. Catherine of Alexandria.

107r Band-shaped headpiece, left column, flower petals in roundels. Initial K in similar style. November 25, feast day of Clemens, Bishop of Rome.

158v Band-shaped headpiece, left column, in flower petal style; three roundels with two rows of smaller circles between. Initial Є with blessing hand. November 25, Martyrdom of Peter, Bishop of Alexandria.

168r Band-shaped headpiece, right column, in flower petal style, circles with palmettes between. Initial Δ in similar style. November 25, Martyrdom of St. Mercurios.

178v Band-shaped headpiece, right column, in flower petal style; initial K in similar style. November 26, Life of Hosios Alypios the Kionites.

192v Band-shaped headpiece, left column, in flower petal style; flower petals in roundels, with blue rosettes between them marked by pink-white crosses in the centers. Initial A in similar style. November 27, Martyrdom of James the Persian.

201v Band-shaped headpiece, left column, in flower petal style forming rinceau with various birds in colors as on fol. 1r. Initial O in flower petal style (fig. 294). November 28, Life of Stephen the Younger, the Confessor.

245v Band-shaped headpiece, right column, in flower petal style. Initial A in solid gold. November 30, feast day of St. Andrew.

Iconography and Style

In its system of illustration, the codex in general relates to those Menologia whose decoration is limited to headpieces. It is particularly similar to cod. Sinai 499 (no. 34 above). The ornament of the opening headpieces in both codices is very close in pattern and execution (figs. 287, 292).

The birds at the fountains, a recurring motif in cod. 499, are confined here to the opening headpiece, which has another distinct feature: the lions drinking water. This motif occurs in an unnumbered codex in the Monastery of Iviron, probably from the second half of the eleventh century.[1] Birds have been employed in some initials in both codices, which also share comparable jewel-like initials in flower petal style.

In addition, these two Menologia are of approximately the same size and have the same number of lines per column. Although they may not have been written by the same scribe and the ornament is by a different hand, it is likely that they belong to the same set. Comprising volumes 3 and 4,[2] they provide evidence for another Metaphrastian set, in addition to those known. If indeed cod. 503 follows cod. 499, then the lack of figurative illustration for its opening Life may not be accidental, the illustrator having intended to confine his figures to the Life introducing the month of November.

In discussing the headpiece of Sinai 499 (fig. 287), we made favorable comparisons with Vat. gr. 463 from 1062.[3] This chronological point of reference is corroborated for the present codex by a close stylistic examination of its initials, which show affinities with those in cod. Moscow, Hist. Mus. gr. 382 (9/9), from 1063.[4] For example, the delta is rendered in a similar manner in both manuscripts (cf. fol. 168r of the Sinai codex with fol. 72r of the Moscow, both featuring ivy leaves suspended from the horizontal bar of the letter). Although such initials are common in the second half of the eleventh century, in this case the similarities may indicate that cod. 503 and its possible companion, cod. 499—both Constantinopolitan products—may be confined chronologically to a period not far removed from the Moscow codex, i.e., the third quarter of the eleventh century.

Bibliography

Gardthausen, *Catalogus*, p. 123.
Ehrhard, *Überlieferung*, 2, p. 434.
Kamil, p. 90 no. 726.

36. COD. 423. JOHN CLIMACUS, THE
HEAVENLY LADDER
LATE ELEVENTH CENTURY. FIG. 295

[1] See Iviron, unnumbered cod., fol. 1a, *Treasures*, 2, fig. 270.

[2] Cf. cod. 500, no. 28 above.

[3] See cod. 499, no. 34 above, p. 96, and especially n. 7.

[4] See V. Lichačeva, *Byzantine Miniatures*, Moscow 1977, pls. 10–14; *Exhibition Leningrad*, 2, p. 40, no. 491; Hunger, "Auszeichnungsschrif-

ten," p. 208 n. 28; idem, "Epigraphische Auszeichnungsmajuskel," *JÖB* 26 (1977) p. 208; Paterson Ševčenko, "Menologium," pp. 423–24; J. C. Anderson, "The Date and Purpose of the Barberini Psalter," *CA* 31 (1983) p. 44, with bibliography.

Vellum. 240 folios, 19.2 x 15 cm. One column of twenty-three lines. Minuscule script for text, clear but inconsistent; majuscule for the chapter titles and *Epigraphische Auszeichnungs-Majuskel* for the title of the treatise. Gathering numbers with one horizontal line above and below and a stroke on lower left side of first recto. Parchment mixed, hard and fine. Ink light brown for text and titles. Occasional solid initials in watery carmine.

Fols. 1r–2v, letter of John of Raithou to John Climacus (*PG* 88, 624–25); 2v–3r, table of contents, prologue (ibid., 628); 3v–8v, the Life of John Climacus (ibid., 596); 8v–10r, letter of John Climacus to John of Raithou (ibid., 625–28); 10v–240r, the homilies of the treatise (ibid., 632–1161).

The last folios are extremely damaged and torn. Fol. 240 is glued to a flyleaf of parchment with text in sloping majuscule. Plain, very dark brown leather binding on wooden boards.

Illustration

10v The Heavenly Ladder (height, 19.2 cm.) (fig. 295). The miniature, along the entire left margin and into the lower margin, represents Jacob sleeping at the bottom of the ladder, ὁ Ἰακώβ. Clad in red and light violet and with a yellow nimbus, he reclines, turned to the side with crossed legs, on a brown and dark violet mountain, set on a green ground strip. A monk, in very dark violet garments, runs toward the first rung of the ladder on which climb four other monks, in light brown and black olive garments. The two monks on the upper part of the ladder are pulled upward by angels, the one on the lower rung clad in dark violet and light blue garments, and the angel above him with the same colors but reversed. Both angels have pink nimbi. At the top of the ladder is a bust of Christ emerging from a segment of a mandorla, holding crowns in his hands. Clad in muddy blue and very dark purple garments, Christ wears a dark yellow nimbus marked with a black cross. The ladder itself was first drawn in brown ink and then drawn over in black. Homily 1.

Style

The layout of the sole illustration in the codex and the fact that it does not serve as a frontispiece, i.e., it does not illustrate the title page, suggest that this picture was an afterthought. It may well be that there was originally only a simple ladder in brown ink, which was later redrawn in black when the figures were added.

The figure style, best exemplified by Jacob and the angels, displays control in the human proportions and a sense of corporeality. These features and the system of highlights can be compared to those found in cod. Dumbarton Oaks 3, from 1084, as well as in a large number of other late eleventh-century manuscripts.[1] But the color scheme and the quality of the pigment—the colors are muddy and thick—indicate a provincial scriptorium. The paleography of the text finds parallels in the latter part of the same century and also has provincial characteristics, such as the extremely mannered, florid treatise titles and the general carelessness. The illustration was apparently produced shortly after the codex was written. Since throughout the manuscript there is not the slightest ornament, we may safely conclude that decoration of the codex was never intended.

Bibliography

Gardthausen, *Catalogus*, p. 102.
Martin, *Heavenly Ladder*, p. 190 no. 28, fig. 23.
Lazarev, *Storia*, p. 251 n. 35.
Kamil, p. 88 no. 647.
Voicu, D'Alisera, p. 561.
A. Grabar, "L'iconographie du Ciel dans l'art chrétien de l'Antiquité et du haut Moyen Age," *CA* 30 (1982) p. 19 n. 33.

37. COD. 3. THE BOOK OF JOB WITH SCHOLIA AND *PROTHEORIA* BY OLYMPIODOROS LATE ELEVENTH CENTURY. FIGS. 296–323, COLORPLATE XVII

Vellum. 246 folios, 34.6 x 25 cm. Text on folios without illustrations in two columns of thirty-one or thirty-two lines; text on folios with illustrations varies but most commonly one column of twenty-two–twenty-eight lines. *Auszeichnungs-Majuskel* and large minuscule (3 mm. each letter) with *Perlschrift* elements for Job's text; minuscule of minute size for catena text, written under the line; titles and chapter indications in *Auszeichnungs-Majuskel* (fig. 323). Gathering numbers, beginning with fol. 33r, at upper right corner of first recto; additional, later numbers, beginning with fol. 41r, at lower right corner. Very wide lower margins. Parchment fine and white, good quality. Ink light brown for Job's text and catena. Chapter indications, name

[1] Cf. Dumbarton Oaks cod. 3, fol. 253v, Spatharakis, *Dated Mss.*, no. 101, fig. 192 with earlier bibliography; also cod. Athos, Dionysiou 587,

Treasures, 1, figs. 195, 197, 217, 218.

of Olympiodoros, and small solid initials in text in carmine. All chapters with the exception of 31–35 open with initials in carminé style.

Fols. 1r–6v, hypothesis and table of contents; 7r–246v, Job and *Protheoria* by Olympiodoros (*PG* 93, 13ff.).[1]

On fol. 1r, bottom margin, a very late "ex libris Sinai" note; fol. 6v, another one with the name of Kallinikos; fol. 167v, a longer "ex libris Sinai," followed by the customary threat of excommunication against potential thieves, signed by Kallinikos III, Patriarch of Constantinople, who was exiled in Sinai from 1757 to 1761; another note of similar nature, on fol. 246v, is signed by Makarios, bishop of Sinai, probably Makarios IV, the Cypriot, who became bishop of Sinai in 1545.[2]

Condition good. The first gathering is loose. Fols. 1–32, composition of gatherings is irregular. Gathering I (fols. 1 and 2), single leaves, and (fols. 3–6), binion, perhaps a title miniature which is now lost; gathering II (fols. 8–9), union; gathering III (fols. 10–15), trinion; gathering IV (fol. 16), single leaf; gathering V (fols. 17–18), union; gathering VI (fols. 19–24), trinion; gathering VII (fols. 25–32), quaternion. Gathering numbers begin with gathering VIII (= gathering ε′), on fol. 33r; from this point on, when pictures were not continued, regular quaternia, except for fol. 240, single leaf, and 241–246, trinion. We may assume that the folios with pictures were painted separately, hence the inconsistency in gatherings; fol. 21r, part of the illustration is cut off; fol. 125, lower margin is cut off. Illustrations in very good condition, except for representations of the Devil, which in most cases are rubbed away, apparently on purpose.

Old red leather binding, partly torn and replaced by unadorned red leather (figs. 296, 297). The old binding (both covers) is stamped with two bands along the borders. The rectangular central field is divided by verticals, horizontals, and diagonals, forming lozenges stamped with large and small medallions and diamonds containing fleurs-de-lis and double-headed eagles, small rosettes and poorly preserved triangles. On the front cover, the outer border is filled with rosettes in diamonds and half diamonds and the inner border possibly with a rinceau motif. On the back cover, the outer border consists of an arabesque in the form of small leaves within larger ones in heart-shaped patterns, a motif

whose invention has been attributed to the great printer and humanist Aldus Manutius (1449–1515).[3]

On each cover there are five large metal studs, four on the corners and one in the center. The central one has the form of a wheel or a sun disc; those on the corners are heart-shaped. These characteristics are found in bindings in the National Library at Athens and elsewhere for which a fifteenth-century date has been proposed.[4]

Illustration

All illustrations are found in the Prologue of the Book of Job. Except for the miniatures on fols. 10r and 13r, which are painted on the lower margin, the pictures are within the text column, usually extending over its entire width, placed directly under the Job text verses they illustrate. With three exceptions, they are framed by narrow gold borders enclosed in red lines.

7r Job and his wife (9.2 x 17.2 cm.) (fig. 298). Seated to the right on backless, blue- and red-cushioned thrones and resting their feet on jewelled and pearled footstools with gold tops, they converse with each other. Job, an old man with grey-green hair and beard, is represented as a king, although without a crown, dressed in a white-pink tunic with a gold clavus and a purple chlamys with gold striations. Job's wife, clad in a white-pink tunic and carmine mantle, wears a gold crown. They are inside a structure representing Job's house as a palace. It consists of four columns in *verde antico* with gold capitals and bases supporting a tiled roof with two gables and an arch filled with a grille pattern. The roof is carmine, the tympana white-blue, the ground olive grey. On the left is a walled city (the city of Ausis) in yellow-brown with a high gate with gold doorframe in the center and a blue tympanon. Within the city wall are two basilica-like buildings set at opposite angles, a blue dome with a cross in the center, and beyond, roofs and other buildings. The background is white-blue with purple nuances. The architectural features are subject to the laws of the frame. Above, a Π-shaped headpiece with interlaced ornament and knotted initial A in carminé style. Job 1:1.

7v Job and his family (9.5 x 17.8 cm.) (fig. 299). In a strip-like composition at center right, Job and his

[1] Cf. also G. Caro and J. Lietzmann, *Catenarum Graecarum Catalogus* (Nachrichten von der königl. Gesellschaft der Wissenschaften zu Göttingen, Phil.-hist. Klasse, 1902), pp. 308ff.

[2] See Rabino, p. 86.

[3] Van Regemorter, "Reliure," pp. 12–13.

[4] See cods. Athens, Nat. Lib. 2639 and 68: ibid., pp. 12–15, pls. 11b, 12a. See also E. Gamillscheg, "Die Handschriftliste des Johannes Chortasmenos im Oxon. Aed. Chr. 56," *Codices manuscripti* 7,2 (1981) pp. 52–56, figs. 1, 2.

wife, each in tunic and pallium, stand conversing with one another. To the right are their three daughters in tunics, mantles, and gold diadems, and to the left their seven sons standing in a variety of postures. The sons are clad in short tunics and chlamydes or pallia, heavily striated in gold, and like Job they wear sandals with straps. Two dark brown masonry buildings left and right frame the composition. The undulating ground on which all figures stand is marked by plants set between the figures. Here, as in most of the subsequent miniatures, the atmospheric sky turns from light purple into light blue. Job 1:2.

8r Job's herds (12.3 x 16.5 cm.) (fig. 300). Within the picture frame in two registers are four distinct scenes, each referring to one of the herds named in the text. In the upper register, from left to right, a shepherd in short carmine tunic, flowing dark green-purple mantle, and red cap carries a shepherd's crook and tends a herd of one grey ram with a bell around his neck, one blue goat, and two lambs, one blue and one grey-green with red patches. Above, the shepherd's blue-grey hound, held on a leash, chases a grey-green hare. Next, another shepherd, in long carmine tunic and a dark brown pointed cap, lifts with his right hand a long mace that extends outside the frame of the illustration, and tends three dark brown camels. The scene is set in a rich olive green landscape with plants and flowers; the purple sky changes to blue above.

In the lower register, a shepherd seated on a rock, clad as the second shepherd in the upper register but with a light blue-gold cap, plays a double flute. He is accompanied by his dog, painted in very dark purple. His herd is idyllically represented, as if taken directly from Virgil's *Eclogues*. At the top, two bulls, one brown and the other blue-black, are shown butting against one another; in the foreground below, the winner of the contest, a blackish bull, appears once again enjoying a peaceful bovine life.[5] A light blue cow is feeding her calf of similar color. A fourth shepherd, barefoot and clad in a blue-grey *tunica exomis* decorated with gold, leans on his long staff and watches three asses in blue and black, one of which grazes. Three of the shepherds wear light blue boots with red straps. Shrubs and flowered plants grow in the green and yellow-green landscape of the second register. The sky is purple-blue changing to violet above. Job 1:3.

8v Job's children on their way to the banquet (11 x 16.5

[5] See p. 105 and note 9 below.

cm.) (fig. 301). Job's seven sons, clad as on fol. 7v, joined by his three daughters, have left the house at the right and are about to enter the eldest son's house at the left. All the sons have blackish hair, brown flesh tones, and exaggerated leg muscles. They gesture expressively in invitation, and their masculinity contrasts with the elegance and rather hesitant attitudes of the daughters. Both buildings are tall, and their doorways are of different form, that on the right distinguished by a marble frame. The house on the right is slightly pushed into the background, while the one they are about to enter is in the foreground, thereby emphasizing the direction of the procession. Job 1:5.

9r Job offers sacrifice to God (ca. 10.2 x 8.3 cm.) (fig. 302). An unframed miniature at the left side of the column without ground or background depicts Job, in blue-white and gold tunic and purple himation, slightly bent and holding in his covered hands an olive grey ram; directed toward him are white-blue rays, emanating from the purple-sleeved hand of God which emerges from a segment of white-blue sky with three gold stars and a blue outline. In front of Job is the cube-shaped, blue-grey altar with red flames coming from its openings; on an adjoining block a calf has been laid, its head turned toward the approaching Job. Job 1:5.

10r Job offers sacrifice to God (ca. 6.5 x 12.8 cm.) (fig. 303). A scene on the bottom margin, similar to that on fol. 9r except that on the block before the altar there is a ram. A later doodle repeats the image of the ram between Job and the altar. No ground or background. *Protheoria* 2:1ff.

13r The appearance of the Devil among the angels (6.7 x 14.7 cm.) (fig. 304). On the lower margin on the left, underneath the catena text, are two groups of angels on either side of the hand of God shown above. Each group consists of three angels clad in light blue tunics, grey-brown mantles, and blue diadems, with grey-green and brown wings with light blue tips. The hand of God emanates from a segment of sky, along with three bundles of white-blue rays. The Devil enters from the extreme right. Painted in black with green loincloth, his figure has been intentionally rubbed. Olive grey undulating ground with shrubs and flowers and light blue-purple background. Job 1:6–12.

17r The Lord granting authority to the Devil (ca. 7.8 x 12 cm.) (fig. 305). Within the column of the catena text (ch. 2:19–20), a frameless composition encloses on the

upper left the hand of God with a dark blue sleeve coming out of a segment of blue sky with gold stars and a gold rim. Blue-white rays emanate toward the Devil at the lower right; painted in black with dark green loincloth, his figure is totally rubbed. The composition has no background and it takes the place of the central script panel normally containing Job's text. Job 1:12.

17v Job's children at the banquet (7.7 x 17 cm.) (fig. 307). The scene takes place in a palatial interior with two side doorways in light ochre and light blue walls and between them a red- and carmine-roofed arcade marked by a central pediment (the grilled tympana are blue and light blue). Job's children, with brown hair, are gathered around a semicircular table. Clad in blue-grey tunics with gold borders, they eat, drink, and converse. On the left, heading the group of men, the elder brother reclines on a grey-blue decorated mattress set on a couch covered with a yellow ornamental drape. On the opposite side reclines one of the three sisters (all wear gold diadems) on a similar couch draped in grey-blue. All the others are supposed to be seated. The table has a decorated gold rim, and is covered with a carmine cloth whose hanging has a rich blue border; in the center of the table is a large bowl, with two cups on the sides—all in gold. Below the reclining daughter are three servants. One of them, in a blue-green tunic with golden border, kneels before a large, round, golden wine vessel set on three legs, scooping up wine. Behind him, the two other servants, one in yellow and one in blue, face one another carrying filled glasses. In center foreground, two exuberant male dancers in short grey-blue, gold-decorated tunics, dance to the tune of a portable gold organ carried by a female figure standing at the left in long, bright red and green robes with purple borders and gold ornament. The ground is dark green and the background between the columns of the arcade is purple. Job 1:13.

18r The first disaster: the loss of herds of oxen and asses (7.9 x 16.5 cm.) (fig. 308). On the left are two pairs of yoked oxen, one above the other, pulling their ploughs in cross form; behind each pair, a servant falls to the ground: the one above, viewed frontally, is pierced through by one of the "spoilers" described in the text, who attack from the right. The second, below and viewed from behind, is being killed with a knife by another spoiler. A third spoiler brandishes a mace

with which he has killed another servant, who has fallen to his side. All servants and two of the spoilers are clad in tunics, but the spoiler in the center, whose head has been rubbed away on purpose, is dressed like a soldier, also wearing a chlamys. To the extreme right three she-asses are trotting away, one of them turning her head back. The setting is a bare, diagonally set, undulating landscape against a purple-pink and light blue sky. Job 1:14–15.

18v The second disaster: fire falls from heaven upon the herds of sheep (7.9 x 16.5 cm.) (fig. 309). A large segment of changing blue sky with gold stars emits tongues of fire that devour three shepherds in carmine and green tunics—the one in the middle is violently thrown upside down—and the herds, which consist of a ram, an ass, a lamb, and three (?) oxen. The ground is olive green as elsewhere in this manuscript, and the sky changes from white-blue to light purple. Job 1:16.

19v The third disaster: horsemen steal the camels and slay the servants (9.4 x 17 cm.) (fig. 310). Approaching from the left are three horsemen on dark brown and dark blue horses, clad in military costumes of red, dark blue, and purple colors, and carrying shields and a gold banner with blue and red ornament suggesting letters. Two of them point their spears at a brown camel facing them; next to it two more camels face the opposite direction, toward a group of three attacking soldiers, two of whom are clad in the *tunica exomis* in red and yellow; the third soldier is in a blue and yellow military costume. Their strong, muscular bodies are rendered in red-brown; all wear helmets and carry shields. The foremost bearded soldier wields a spear, while the one to the right brandishes a large blue sword. The third soldier is slightly receding. Two men in grey tunics and grey-blue chlamydes have fallen dead between the feet of the footmen, while a third servant in similar garments has fallen at the feet of the first camel with his head slightly raised and his legs drawn up; he may not be dead, for it seems he is trying to hold the camel's leg. The scene takes place on a plain ground, suggesting an open landscape in the usual olive green, and the purple-blue sky changes into rose. Job 1:17.

20r The fourth disaster: the house falls upon Job's children during the banquet (9 x 16.6 cm.) (fig. 311). At the upper left corner behind a standing column are two black devils, their figures intentionally rubbed, hurling down blocks of stone. On the opposite side,

another devil violently pulls down two columns. Perhaps there was a fourth devil in the center, now completely erased. Between the corners of the house, red tiles and blue stones are falling upon Job's children, who had been seated around the semicircular table, depicted as on fol. 17v. Struck by the stones, some are shown prone and lifeless, with their arms stretched forth on the table or lying on their sides. A few are in the foreground, trying to flee between stones and table implements. The ground is green with purplish background, and brown (?) strokes suggest the motion of falling. Job 1:18.

20v The announcement of the disaster to Job (7.8 x 11 cm.) (fig. 312). The miniature at the bottom of the column text represents four messengers approaching Job, seated at the right. They wear short tunics with a round ornament, and chlamydes with tassels on the right shoulders. Clad as on fol. 7r, Job is seated on a cushioned throne in front of his house, in this case shown as a tall structure with gabled roof and arched doorway. His face is distorted by grief and he raises his right hand in an apprehensive gesture. Green ground, purple and white-blue sky. Job 1:19–20.

21r Job shaves the hair of his head and falls on the earth (6.6 x 14.1 cm.) (fig. 313). The extreme left part of the miniature, surely containing the standing figure of Job rending his garment, as in parallel manuscripts, is cut out. Next, Job kneeling, dressed in a tunic that leaves the upper part of his body naked, is represented twice: cutting his hair with a knife, and sprinkling dust on it. Ground and sky as in previous illustrations. Job 1:20.

21v Job praying (7.2 x 8.2 cm.) (fig. 306). The standing figure of Job has been largely excised by the cut on fol. 21r. There remain only his raised right arm, the bottom of his tunic and the foot of his frontal, praying figure. He is placed in a landscape with shrubs and flowers, possibly under an arc of heaven. Once more the rose-colored sky changes into purple. Job 1:20.

23r Meeting of God, the angels, and the Devil (6.2 x 15.5 cm.) (fig. 314). The hand of God at the upper left, as on fol. 17r, blesses three angels in garments and colors as on fol. 13r. One of them turns his head backward toward the Devil, who is partially rubbed away. He wears a green loincloth and holds a gold staff. His vivid stance and the gesture of his right hand indicate both his spirited argument with and his receiving authority from God. The sky changes from rose to light blue. Job 2:1–6.

25r The Devil goes out from the Lord (8 x 16.8 cm.) (fig. 315). On the left of the composition, the hand of God points to the well-preserved figure of the Devil at the far right. Their separation by a wide, open space is a well-calculated artistic device. Shouldering his staff, the Devil walks out of the picture in a ballet-like movement, his head still turned toward the hand of God. Underneath God's hand, two angels converse with each other. Job 2:7.

25v The Devil smites Job with sore boils (7.2 x 16.6 cm.) (fig. 316). Job sits next to his house on a large, low, rectangular dark brown seat, his body partly covered by his lowered grey-green tunic. He is smitten on the head by a devil, partly rubbed away, who approaches from above. Job's wife, tall and erect, clad in a grey-green tunic and carmine mantle and with her head covered, stands by, addressing Job. On the right side is a walled city similar to that on fol. 7r, in front of which are two children with an expression of grief, clad in tunics and boots. The scene takes place on a green ground with shrubs. Job 2:7.

26r Job sits on the dung heap (8.6 x 17.2 cm.) (fig. 317). The naked Job, his body covered with sores, sits on a heap of dung in the center of the composition, facing his wife. She, clad as on fol. 25v and standing at a distance, offers him food and drink in a cup held out with a long stick, while she pulls her veil over her nose. A red water jug stands on the ground behind her. On the left side of the composition, two onlookers in red and carmine tunics and black boots are talking together about Job, as they cover their noses, one of them with a napkin. Job 2:9.

28v The dialogue between Job and his wife (8.5 x 12.3 cm.) (fig. 318). A miniature at the right side of the text column shows at the left the naked Job, covered with sores and seated on the dung heap. He is talking to his wife, who stands far away to the right depicted as on fol. 25v. Job 2:10.

29r Two of Job's three friends on the march to visit him (6.4 x 16.5 cm.) (fig. 319). On the left two of the friends are represented as kings on horseback according to the text, riding grey horses with gold harnesses. Clad in grey-blue tunics with gold borders and blue-purple chlamydes with gold striations, they wear golden crowns. One has grey-blue hair, the other black. They are escorted by a vanguard to the right, a group of four horsemen on grey and brown horses, clad in military costumes: grey and purple tunics, and red and carmine chlamydes with gold ornament. Two

of them are carrying gold standards, one with a gold cross, and the other with four jewels forming a cross; the one farthest back carries a shield. They move along an olive green ground against a sky that changes from rose to white-blue. Once more the wide space separating the two groups enhances the status of the royal friends. Job 2:11.

29v Job's third friend journeys to visit him (8.7 x 16.6 cm.) (fig. 320). The friend, in royal garments as those on fol. 29r, and riding on a blue-white horse with gold harness, is escorted by a vanguard—two horsemen, clad in light blue and dark purple military costumes and riding black and brown horses. The one in the foreground is carrying a banner with a gold cross and the one behind, slightly rubbed, carries a gold shield and wears a golden headdress. All horsemen ride along on a green and olive-green ground against a sky changing from purple to blue. Job 2:11.

30v Arrival and lamentation of Job's friends. Two illustrations, one above (7.5 x 17.2 cm.) and the other below (8 x 17.2 cm.) (figs. 321, 322):

1) Job, seated on the dung heap to the right, faces his friends on the left. They are depicted lamenting as described in the text. The one next to Job, standing frontally, rends his garments. The second, his tunic already torn, is kneeling and sprinkling dust upon his head. The third, represented in three-quarters pose with garment torn, is weeping. Their three chlamydes with gold striations and their crowns—insignia of their rank—are deposited on the ground. Ground and background, as in other instances, create an atmospheric impression.

2) Job's friends "sit down beside him seven days and seven nights." Job is shown on the right. Seated frontally and wearing a loincloth, he addresses his three friends, who are seated on rocky formations around him in torn tunics. Their insignia are on the ground. Between them stands Elihu. Dressed in tunic and chlamys, he makes a gesture of sorrow with his left hand. Most likely the depiction of Elihu at this point (he appears only in ch. 32:2) means that no more miniatures were contemplated. Job 2:13.

Iconography and Style

The twenty-seven miniatures—all of them in the Prologue of Job's text—display a homogeneous style. The fig-

ures are elegant and slender; the bodies are flat, linear, dematerialized; the faces are rendered without sharp highlights in warm flesh tones. The stances are uncertain. The drapery is distinguished by the widespread use of gold hatching which enhances the dematerialization.

The buildings in the architectural backgrounds, with their *verde antico* colors, their striking red-carmine roofs and pale blue tympana, are exceptionally tall, reaching the frame of the strip-like miniatures. In some instances, for example, in the illustration on fol. 17v, architecture and figures are compressed in height, suggesting the compositional condensation of a model (fig. 307, colorplate xvii:b).

The high quality of the illustrations, the subtlety of colors which often recall pastel hues, and the use of gold on garments and frames point to a Constantinopolitan origin. More precisely, the dematerialized aspect of the figure style and the extensive use of gold striation find their best parallels in eleventh-century manuscripts produced in the Studios Monastery, of which the Theodore Psalter in the British Library from the year 1066 is the best known example.[6] The Sinai codex has already been assigned on stylistic grounds to this Constantinopolitan scriptorium.[7] Paleographic parallels can also be found within this group of manuscripts[8] which support the results of the stylistic investigation and hence a date within the second half of the eleventh century.

The products of this scriptorium represent the monastic reaction to the classicism of the Macedonian Renaissance, which is clearly reflected in this Sinai manuscript. The similarities even suggest that, if not produced in the Studios Monastery itself, the Sinai Job may have been executed in an imperial scriptorium. The last word as to where in Constantinople this Job manuscript was made has not yet been said, although the Studios Monastery must still be considered its likely place of origin.

Along with the striking dematerialization of the bodies, there are other stylistic elements which provide a sharp contrast to those anti-classical traits mentioned above. For example, whenever the feet and legs are not covered, the muscles are extremely exaggerated (figs. 301, 308–10, 312, 317); in the illustration on fol. 8v both the anatomy of the bodies and the use of highlights display awareness of the mass of the human body (fig. 301). These differences should not be seen as evidence of another hand at work, but rather of the use of an "antique" model which is also reflected in the illusionistic backgrounds. Shrubs, rocks, and undulating

[6] For a complete publication of this Psalter see Der Nersessian, *Psautiers*.

[7] Weitzmann, *Sinai Mss.*, pp. 16–17.

[8] Cf. Theodore Psalter, fol. 91v, see Der Nersessian, *Psautiers*,

fig. 149. The Sinai codex is not included in the study of the scriptorium of the Studios by N. X. Eleopoulos, Ἡ βιβλιοθήκη καὶ τὸ βιβλιογραφικὸν ἐργαστήριον τῆς Μονῆς τῶν Στουδίου, Athens 1967.

ground are rendered in impressionistic strokes, a technique also applied to the fire falling from heaven. Furthermore, the codex shows iconographic adaptations from classical book illumination. For example, the hare being hunted by a dog and the contest of the two bulls occur in the *Cynegetika* of Pseudo-Oppian now in Venice, ultimately taken from a classical model as is shown by the bull episode illustrated in the Vatican Virgil, cod. Lat. 3225.[9] These classical adaptations would argue for the relation of the miniature cycle of the Sinai Job to the tradition of the capital. There is another element that further strengthens this connection. This is the only extant Job manuscript in which Job and his wife are depicted as an imperial couple—he dressed in the purple, she wearing a crown.[10] The imperial nature of the codex is also seen in the depiction of Job's sons and daughters, their garments, table furnishings, the color scheme (purple seems to be predominant), and the palatial structures as well. All these elements echo the imperial surroundings that are so clearly emphasized in this manuscript.

The Sinai Codex and its Relatives

Fifteen illustrated copies of the Book of Job, most of them with extensive miniature cycles, have survived. The codices older than Sinai are: Vat. gr. 749, second half of the ninth century; Patmos 171, variously dated between the seventh and ninth centuries; and Venice, Marc. gr. 538, from the year 905.[11] The other copies date from the twelfth and later centuries.[12] All of them, with the exception of the Sinai manuscript, are provincial products.[13]

The illustrations of the Book of Job fall into groups that coincide with the sections of the text and reflect its structure. In general, they can be placed in two groups: 1) illustrations applied to the prose section of the text, the Prologue and the Epilogue; and 2) pictures illustrating the central part of the book, the poem. The first of these groups illustrates a narrative text. The Prologue text was especially attractive to the illustrator, as it gave him the opportunity to depict a sequence of dramatic scenes. The second group contains pictures illustrating the dispute between Job and his friends, a monotonous, repetitive type of illustration.[14]

The Sinai Job codex, the only extant one we believe to have been made in Constantinople, contains illustrations to the Prologue text only. Study of the gatherings has shown that regular quaternia begin only at the point where pictures are discontinued. This means that the picture pages were most likely painted separately and no illustrations were envisioned for the main part of the book. We can speculate that the lack of such pictures may be due not so much to the absence of a complete model as to the attitude of the illustrator toward the repetitive, monotonous type of illustration that was necessary for the conversation scenes. Perhaps the wearisome, unvaried repetition of the same picture, seen in many of the other copies, did not appeal to a sophisticated Constantinopolitan taste that had been nourished by the ambience of the imperial surroundings.

Bibliography

Kondakov 1882, p. 101, pls. 54–59.

Gardthausen, *Catalogus*, p. 1.

Johann Georg, Herzog zu Sachsen, *Das Katharinenkloster am Sinai*, Leipzig and Berlin 1912, p. 25, pl. X,35.

Ebersolt, *Miniature*, pp. 32–33.

Schlumberger, *Epopée*, 3, pp. 453, 705, 708.

Rahlfs, p. 285 no. 3.

Lazarev 1947, p. 316 n. 36.

Weitzmann, *Ancient Book Illumination*, p. 29, fig. 36.

M. Sacopoulo, *Asinou en 1106 et sa contribution à l'iconographie* (Bibliothèque du Byzantion, 2), Brussels 1966, p. 29 n. 24.

Lazarev, *Storia*, p. 251 n. 35.

Kamil, p. 62 no. 3.

E. Rosenthal, *The Illuminations of the Vergilius Romanus (Cod. Vat. Lat. 3867). A Stylistic and Iconographic Analysis*, Zurich 1972, pp. 29 n. 4, 99–100, fig. 123.

Weitzmann, *Sinai Mss.*, pp. 16–17, figs. 20, 21.

C. Eggenberger, "Die Miniaturen des Vergilius Romanus, Cod. Vat. Lat. 3867," *BZ* 70 (1977) p. 72.

Galey 1979, figs. 150–53.

S. Papadaki-Oekland, "The Illustrations of Byzantine Job Manuscripts," unpublished Ph.D. dissertation, Heidelberg, 1979.

Weitzmann, *Sacra Parallela*, pp. 111–13, 119.

P. Huber, *Heilige Berge*, Zurich, Einsiedeln and Cologne 1980, pp. 15, 39, 216, and fig. 11.

Voicu, D'Alisera, p. 552.

[9] See note 7 above with earlier references, and Weitzmann, *Mythology*, fig. 132; idem, *Ancient Book Illumination*, p. 28, figs. 34–36.

[10] Job is depicted crowned in a later Job manuscript in Jerusalem, cod. Taphou 5, thirteenth or fourteenth century. For the manuscript in general, see Hatch, *Jerusalem*, pp. 113ff., pls. LXI–LXIII; cf. also Weitzmann, *Sacra Parallela*, p. 19.

[11] For these manuscripts in general see Grabar, *Manuscrits grecs*, p. 17, pls. 1, 2. For the controversial date of the Patmos Job see Weitzmann, *Roll and Codex*, p. 250 (addendum to p. 120); idem, *Buchmalerei*, pp. 49, 51ff., pls. LVI–LVIII; and I. Furlan, *Codici greci illustrati della*

biblioteca Marciana, 1, Milan 1978, pp. 13, 27–32, 52.

[12] See a listing and bibliography in S. Papadaki-Oekland, "The Illustrations of Byzantine Job Manuscripts," unpublished Ph.D. dissertation, Heidelberg, 1979, p. 23. Problems of the relation of the various copies remain unsolved.

[13] The cod. Vat. gr. 749 may have been produced in Italy, perhaps in Rome, see Grabar, *Manuscrits grecs*, p. 18; for the other codices various attributions have been proposed, including Mt. Athos, Asia Minor, Palestine, and Cyprus; see Papadaki-Oekland, *op. cit.*, p. 23.

[14] Weitzmann, *Sacra Parallela*, p. 117.

38. COD. 346. GREGORY OF NAZIANZUS, 15 LITURGICAL HOMILIES
LATE ELEVENTH CENTURY. FIGS. 324–335

Vellum. 250 folios, 11.2 x 9.8 cm. One column of twenty-five lines. Minuscule script with *Keulenstil* elements for text; script very minute but easy to read, lines and letters spaced out; titles in *Auszeichnungs-Majuskel*. Later gathering numbers at upper right corner of recto but not throughout. Parchment extremely fine and white, good quality. Ink light brown for text; titles and small solid initials in text in gold; larger historiated initials.

Fols. 1r–250r, Gregory of Nazianzus, fifteen liturgical homilies; 250v, table of contents (pinax), incomplete.[1]

On the flyleaf (recto side), a later entry in black ink, probably by the binder, reads: ἐκ μεμβράνης εὗρον δε κ(αὶ) / ἔτος ἐν τοῖς σεσαθρωμένοις / φύλοις: ͵αρμ ω :1140: οὐ μέντοι καὶ τὸ ὄνομα τοῦ γράψαντος. (Of parchment; among the rotten folios I found the year 1140 but not the name of the scribe.) However, no date has been discovered in the extant folios, and the pictorial evidence presented below does not support this date.

At the bottom of fol. 15r, an "ex libris Sinai" with a curse against book thieves.

The codex is incomplete. The First Homily on Easter is missing. Fols. 1–14 of the original manuscript have been replaced by paper pages with recent text. The old text begins on fol. 15r with the continuation of the Second Homily on Easter. Fols. 15v and 61r have holes caused by dripped wax; illustration of the latter folios is partly destroyed; fols. 96 and 113 have outer margins repaired; fols. 157r–160v are blank; fols. 211–212, 217–218, 238–239, 248–250 have been replaced by paper and recent script similar to that of the opening pages; fol. 219r has offset of initial T historiated with the busts of the Seven Maccabees, originally in the relevant homily, the title page of which (fol. 218r) is a recent paper replacement. Poor state of preservation. Some gatherings are loose. Upper margins have been cut throughout, probably at binding, hence the probable loss of original gathering numbers. Illustrations have suffered flaking.

Simple light brown leather binding on wooden boards. At the top of the inner side of each cover has been pasted a fragment of a Sticherarion in parchment, probably twelfth-century in date.

Illustration

Each homily, with the exception of the Funeral Oration for Basil, is decorated with an ornamental band-shaped headpiece in deep blue, pink, and green against gold, in

flower petal style and common patterns: heart-shaped leaves, quatrefoils or rosettes in diamond frames, and ivy leaves in rinceau forms. The only unframed headpiece (on fol. 227r) is decorated with a very delicate gold rinceau imitating fretsaw style. The historiated initials measure approximately 3 x 3 and 2 x 3.5 cm.

27r Leaning against the hasta of the initial Є, Gregory Nazianzenus in dark blue and purple bishop's vestments is teaching (fig. 324). St. Mamas, clad in a dark blue-green tunic and red chlamys, gold-nimbed and represented frontally, stands to the right. Above, a bust of Christ. Homily on New Sunday (*PG* 36, 608).

32r Pentecost in initial Π (fig. 325). Two of the apostles, dressed in tunics and himations, sit opposite each other on faldstools. The gold-nimbed heads of the remaining apostles are lined up along the vertical bars of the letter. Above, Christ in bust form, clad in purple tunic and blue himation with gold striations, extends his hands in blessing over the apostles. Homily on Pentecost (*PG* 36, 428).

42v Gregory addresses Julian the Tax Collector (fig. 326). Dressed in a long red garment and wearing a white cap, Julian is seated on a faldstool and rests his feet on a footstool; he leans over and writes on a piece of parchment. A scribe in a long blue garment stands behind him. Both are represented on the left margin. Julian is addressed by Gregory, clad in bishop's vestments (blue sticharion, white epitrachilion, purple phelonion and omophorion), who forms the hasta of the initial T. Homily to Julian the Tax Collector (*PG* 35, 1044).

51r The Nativity in initial X (fig. 327). At the lower left, the Virgin reclines on a mattress; above her, parallel to her body, are traces of the manger. The bathing of the Child is depicted at the lower right. Christ is in a chalice-like gold font; behind him one can discern the outlines of two figures, the midwife and the servant. Four angels with open wings with red tips fly down from above. Homily on the Nativity (*PG* 36, 312).

60v Text page in cross form. Same homily, conclusion.

61r The Koimesis of Basil (7.5 x 5 cm. including the palmettes on the frame) (fig. 328). A rectangular headpiece in flower petal style arranged in roundels—four on the corners with entwining stems between them, against gold—encloses within a quatrefoil the Koimesis of Basil, and above the title: ἐπιτάφι(ος) εἰς τ(ὸν) μ(έ)γα βασίλ(ειον). Basil lies on a bier with red mattress and blue hanging decorated with gold; Gregory

[1] For detailed contents see Noret, *Byzantion* 1978, pp. 184–88.

of Nazianzus stands behind in the center. Two other nimbed clerics stand at either end of the bier. The one on the right, who stresses his homage to Basil by bowing more deeply, may be identified as Gregory of Nyssa. Seated within the initial Є, Gregory Nazianzenus, clad in purple vestments, is teaching. All figures are gold-nimbed. Funeral Oration on Basil the Great (*PG* 36, 493).

112v The Baptism of Christ forming the initial Π (fig. 329). On the right, Christ stands in the water of the Jordan making a blessing gesture with his right hand toward John on the opposite side. John, clad in tunic and himation and with a gold nimbus, touches Christ's head. Homily on Epiphany (*PG* 36, 336).

123r The Baptism of Christ forming the initial X (fig. 330). Christ is standing in the water of the Jordan on the right, making a speaking gesture toward John the Baptist on the opposite side. John, wearing a tunic and himation, touches the head of Christ with his left hand. The upper part of the letter is formed by two angels who fly toward the two protagonists. Homily on Baptism (*PG* 36, 360).

152v Gregory of Nazianzus, standing frontally in the center, is flanked by Basil to his left and Gregory of Nyssa to his right, who bow their heads slightly. All three are in bishops' vestments and nimbed, and they form the stem and the loops of the initial Φ (fig. 331). Homily to Gregory of Nyssa, the brother of Basil the Great (*PG* 35, 832).

156v Text page in the form of a chalice. The same homily, conclusion.

180r Forming the initial Π, Gregory of Nazianzus on the right in bishops' vestments, addresses a group of bishops standing on the left, mostly flaked. Between them, above, is the outline of a building with a red roof (fig. 332). A Farewell Oration delivered before 150 Bishops (*PG* 36, 1081).

194v Forming the initial A, Gregory on the right is giving alms to two men on the left, clad in red and with hair in two different tones of brown (fig. 333). Homily on the Love of the Poor (*PG* 35, 857).

227r Forming the initial M, St. Cyprian on the right, clad as a bishop in brown and dark purple vestments, bows slightly to Gregory on the left. They hold a V-shaped

scroll between them to form the initial (fig. 334). Homily on the Saint and Holy Martyr Cyprian (*PG* 35, 1169).

237r Gregory standing on the right, forming the hasta of the initial T, addresses his father who stands opposite on a lower level in the margin, badly flaked (fig. 335). Homily to His Father who Kept Silent about the Plague of Hail (*PG* 35, 933).

Iconography and Style

The ornament in the band-shaped headpiece is rather meager and sketchy. In patterns and color schemes it finds parallels in such Constantinopolitan manuscripts as the cod. Athens, Nat. Lib. 57, but it lacks their high quality.[2]

That part of the initials, however, which displays foliate decoration has some distinct features. The initial T, for instance (figs. 326, 335), in its cross-arm which meets the standing figure of Gregory, has heart-shaped leaves hanging at either end. This feature is found in similar initials, combined with figures and ornament, in late eleventh-century manuscripts such as Athens, Nat. Lib. cod. 190 and the Morgan Library Lectionary, cod. 639.[3]

But the exceptional characteristic of this codex is the minuteness of the represented figures. Notwithstanding the poor state of preservation, the figure style shows a smooth, painterly quality of modelling and an absence of strong highlights. Beneath the simply treated folds are discernable elegant, dematerialized figures with uncertain stances. These features occur likewise in late eleventh-century Constantinopolitan manuscripts such as the above mentioned codices Athens 190 and Morgan Library 639.[4] The minuteness of the figures and the detailed execution recall calendar icons produced in Constantinople in the eleventh and twelfth centuries, of which there are some outstanding examples in the Monastery of St. Catherine at Mount Sinai.[5]

In our opinion, paleographic parallels strengthen the suggested date and provenance. The script comes very close to that of the Morgan Library codex and the Dumbarton Oaks cod. 3 from the year 1084.[6]

As a whole, an important feature of this pocket-sized manuscript, which must have been used for private reading, is its system of illustration. The initials are reductions of larger scenes that served as title miniatures. One such title miniature, reduced however to the protagonists, still heads

[2] Cf. fols. 7v and 107v of the Athens codex in Marava-Chatzinicolaou, Toufexi-Paschou, no. 26, figs. 217, 221.

[3] Cf. fols. 56v, 90v, 176v; see ibid., no. 36, pp. 154–61, figs. 350, 361, 378. For the Morgan Library Lectionary, see Weitzmann, "Morgan Lectionary," figs. 296, 297, 299, 302.

[4] To these examples may also be added the cod. Vat. gr. 1156 from the

late eleventh century; see Weitzmann, "Eleventh Century," pl. 33a–b, (*Studies*, figs. 288, 289).

[5] Sotiriou, *Icônes*, 1, figs. 136–43; Weitzmann, "Eleventh Century," pp. 220ff. (*Studies*, pp. 296ff.).

[6] See note 3 above and Spatharakis, *Dated Mss.*, figs. 190–93.

the Homily on Basil the Great (fig. 328). This one exception may suggest special emphasis on Basil for reasons we cannot specify.

The systematic illustration of the initials is well-known within the tradition of the illustrated manuscripts of the Liturgical Homilies of Gregory; a good dated example is provided by the cod. Vat. gr. 463 from 1062.[7] It is, however, more common in codices of the end of the eleventh century.[8] While our manuscript conforms to this system of decoration, it is worth noting that most of the comparisons drawn here, outside the Gregory tradition, are Lectionaries. Perhaps the persistence of this system of decoration in Gregory's Liturgical Homilies reflects the influence of the Lectionaries, which, as has been shown elsewhere, was strong and complex.[9]

Bibliography

Kondakov 1882, pp. 152–53.
Idem, *Histoire*, p. 100.
Gardthausen, *Catalogus*, p. 75.
Lazarev, *Storia*, p. 251 n. 35.
Galavaris, *Liturgical Homilies*, pp. 12ff., 16ff., 40 passim, 103 passim, 179ff., 258–59, pl. LXVI,343–54.
Ch. Walter, "Lazarus a Bishop," *REB* 27 (1969) pp. 207–208, repr. in idem, *Studies in Byzantine Iconography*, London 1977, no. IV.
Kamil, p. 77 no. 408.
Noret, *Byzantion* 1978, pp. 184–88.
Voicu, D'Alisera, p. 560.
Walter, *Art*, pp. 82, 88 n. 16.
Harlfinger et al., pp. 60, 65.

39. COD. 341. GREGORY OF NAZIANZUS, 16 LITURGICAL HOMILIES
LATE, OR END OF ELEVENTH CENTURY.
FIGS. 336–339

Vellum. 336 folios, 28.5 x 22.4 cm. Two columns of twenty-three lines. Minuscule script for text; titles in *Auszeichnungs-Majuskel* and *Epigraphische Auszeichnungs-Majuskel*. Gathering numbers at the lower left corner of the first recto and the lower right corner of the last verso; also later numbers on upper right corner of recto. Parchment rough, thick, yellowed. Ink brown for text; titles of homilies in gold, other headings in carmine. Initials mostly in flower petal style, simple gold initials for opening page of each homily; small solid initials in text in carmine.

Fol. 1r, lower part of page, four dodecasyllables; 1v–2r, table of contents; 2v, page with cross; 3r–302v, Gregory of Nazianzus, sixteen liturgical homilies; 303r–315r, John Chrysostom's Homily to Philogonios (*PG* 48, 742–56); 215v–336v, Homilies on the Nativity and Baptism by Basil the Great (*PG* 31, 1457–76; 424–44).

On fol. 3r, a note "ex libris Sinai" with a book curse, followed by the monokondylon of Kallinikos III of Constantinople, exiled in Sinai from 1757–1761. Another "ex libris Sinai" of sixteenth- or seventeenth-century date on fol. 336v.

Condition bad. Gatherings are loose. Parchment blackened on edges, indicating extensive handling; several folios are badly damaged and repaired. The central part of the cross, fol. 2v, has been cut out; the following headpieces have also been cut out: fol. 5v, right column, Homily 2; 87r, left column, Homily 8 (it has been replaced by a new piece of parchment); 212v, left column, Homily 12.

Reddish brown leather binding on wooden boards with similar stamped ornamentation on both covers, probably of a sixteenth-century date (figs. 338, 339). Each cover has a triple frame formed by three bands, each set between lines, with crosslets in diamonds, rinceau with palmettes, and grape vines. At the four corners, at the joining points of the band-lines, are "classical" fleurs-de-lis, which also appear along the edges of the covers. An arabesque ornament arranged crosswise (front cover) and in a cone form (back cover) is at the center of the panels. Two metal pins with rings are on the front cover, and fragments of leather straps on the back.

Illustration

2v Cross, full page (19 x 13.7 cm. without the doodle at bottom) (fig. 336). The cross has flaring arms (part of the upper arm is repainted), of which the horizontal ones terminate in teardrops. It is ornamented by a series of dark, muddy blue and carmine lyre- or heart-shaped clusters in fretsaw style. Two grey-green plants with carmine blossoms spring from the base of the cross. Above, two birds fly in opposite directions. The dark violet bird on the left is flying upward, and the grey-blue one on the right is flying downward. \overline{IC} \overline{XC} \overline{NI} \overline{KA} in carmine between the arms of the cross.

[7] Galavaris, *Liturgical Homilies*, pls. XI–XIII,80–86ff.; cf. also cod. Istanbul 16, ibid., pls. X–XI,62–77; and Anderson, "Vat. gr. 463," pp. 177–96.

[8] Some examples of the late eleventh and early twelfth century found in the tradition of Gregory's homilies are noted here: Paris gr. 533; Athens, Nat. Lib. 2254; Milan, Ambros. G.88 sup. (Gr. 416); see Galavaris, *Liturgical Homilies*, pls. XLII,235, XLV,241–44, XLVII,253, XLIX, 257–60, LIX, LX,300–302, 304–10, 314.

[9] Ibid., see index.

The missing central part may have contained a bust of Christ that was excised, probably to serve as an amulet. Table of contents.

3r Π-shaped headpiece, left column, in ordinary flower petal style in thick colors set on gold ground. First Homily on Easter.

28v, 36r, 49r (fig. 337), 60v, 74v, 97r, 161v, 175r, 217v, 241v, 260v, 281r Band-shaped headpieces, all on the left column except fol. 49r, on the right column (Homily on the Maccabees), in simple flower petal style. The petals are contained in roundels, or spring from stems forming scroll patterns, or are paratactically arranged. Initials in similar style except the following:

241v Initial X formed by two hands springing from floral stems holding blue swords outlined in gold. A Farewell Oration Delivered before 150 Bishops.

260v Initial A with peacock in gold and blue. Homily on the Love of the Poor.

281r Initial T with a bird pecking at a flower stem. Homily to His Father who Kept Silent about the Plague of Hail.

Iconography and Style

Pages ornamented with crosses of various forms, flanked by plants and accompanied by inscriptions, are common in book illumination generally[1] and in particular in the tradition of the illustrations of the Liturgical Homilies of Gregory Nazianzenus.[2] Comparable in concept but not in style to our illustration (fig. 336) is a representation in the cod. Paris gr. 550, fol. 4r, depicting the cross flanked by trees and with a medallion bust in its center.[3] The ornament on our cross, however, which is seen at its best in tenth-century Constantinopolitan manuscripts, here takes a summary, stereotyped form,[4] recalling in its treatment the ornament found in the Easter tables of the Vatopedi Psalter, cod. 761, from the year 1088.[5] The absence of gold and the heaviness of the palette, with its blue and carmine, indicate that the manuscript is not a product of Constantinople.

The ornamental patterns of the headpieces on which gold was used have some similarities with those in Constantinopolitan codices of the late eleventh century such as the

cod. Athos, Panteleimon 6,[6] but in its actual rendering the ornament, in these instances as well, is formalized, dry and provincial. The few representational initials with birds or arms holding swords—not limited to any particular period—are also found in the late eleventh century,[7] a date we propose for this codex and which is further supported by the paleography.[8]

Bibliography

Gardthausen, *Catalogus*, p. 73.
Devreesse, *Introduction*, p. 97 n. 3.
Kamil, p. 77 no. 403.
Noret, *Byzantion* 1978, pp. 166–72.

40. COD. 326. BASIL THE GREAT, HOMILIES ON HEXAEMERON, MENOLOGION, FEBRUARY–MARCH
END OF ELEVENTH CENTURY. FIG. 340

Vellum. 226 folios, 29.7 x 21.8 cm. One column of twenty-eight lines; fols. 81r–226r, two columns of twenty-seven lines. Minuscule script, small, carefully written letters for text; titles in *Auszeichnungs-Majuskel*. Fols. 81r–224v, a different type of minuscule script, less carefully written and in larger letters. Original gathering numbers beginning on fol. 18v (gathering β') with a horizontal line and a stroke above and below and two dots on the upper line, at the lower corner of the first recto, and the lower right corner of the last verso. Parchment mostly fine and white. Ink brown for text, but words to be distinguished are in carmine; titles in Basil's homilies in gold, in the second part in carmine. Initials in flower petal style opening homilies and small solid initials in gold in text. In second part of the text, solid initials in carmine.

Fols. 1–2, paper flyleaves with a much later, incomplete text; 3r–80r, Basil's homilies (*PG* 29, 3–208); 80v, later writing; 81r–224v, a completely different manuscript with seven saints' lives and one relevant text, February 7–March 6; text incomplete, breaks off on fol. 224v; 225–226,

[1] See cod. 500, no. 28 above, p. 79, notes 17–19, with references.

[2] See, for example, cod. Vat. gr. 463, fol. 21v, from the year 1062 with an inscription glorifying the cross, in Galavaris, *Liturgical Homilies*, pl. XI,79.

[3] Ibid., pl. LXXXVI,399.

[4] Weitzmann, *Buchmalerei*, pp. 18ff.

[5] Weitzmann, "Psalter Vatopedi," fig. 2.

[6] Galavaris, *Liturgical Homilies*, pl. XXVI,138; cf. fol. 5v of the Athos codex with fol. 49r of the Sinai manuscript.

[7] See, for example, cod. Athens, Nat. Lib. 2363, attributed to the late eleventh century, in Marava-Chatzinicolaou, Toufexi-Paschou, no. 35, figs. 335, 340.

[8] A peculiarity of the scribe—writing the concluding letter of a line in an ornamental way—is found in late eleventh- or early twelfth-century manuscripts; cf., for instance, the spiralling last syllable of the word θά-νατος(ν) with similar endings in cods. Paris gr. 533 and 1662, in Galavaris, *Liturgical Homilies*, pl. XLIII,237; and Spatharakis, *Dated Mss.*, no. 116, fig. 220.

two paper flyleaves with text from the same manuscript as those in the front.

Condition bad. Parchment damaged and blackened; gatherings loose and torn; several folios are cut along the margin and repaired with paper.

Simple leather binding in dark reddish brown on wooden boards with pressed, faded ornament. An outer frame, defined by two thin lines, contains a rinceau motif. Converging triple lines forming diamonds and half diamonds with small star-like rosettes on the crossings fill the inner field. Greek work, possibly of sixteenth-century date. The wooden board of the front cover is broken and has been repaired on its inner side with a piece of very dark brown leather glued to it. It is ornamented with a rinceau border recalling that on the metal cover of cod. 216 (no. 61 below, fig. 656), and two rectangular frames with palmettes and anthemia enclosing interlaced lozenges. This added piece most likely dates from the seventeenth or eighteenth century.

Illustration

3r Π-shaped headpiece (7.5 x 18 cm. with palmettes) in flower-petal style arranged in tile-like, polygonal patterns set in gold, very damaged; on top, three medallions with busts. That of Christ is in the center, most likely flanked by those of the Virgin and John the Baptist, forming a Deesis (fig. 340). There are two standing saints on the sides of the headpiece, also badly damaged. The one on the left is recognizable as Gregory of Nazianzus; the one on the right should be Basil the Great. Palmettes are on the outer corners; those on the lower corners take the form of a cross crowned by Sassanian palmettes. On the righthand side, on top of the headpiece, is a crude drawing of a flying bird by a later hand. Initial Π in flower petal style. Homily 1.

11v Band-shaped headpiece in flower petal style, flowers enclosed in roundels with green and pink blossoms between. Initial M. Homily 2.

19r Band-shaped headpiece in flower petal style in roundels, a large single palmette or four small ones centrally arranged between. Initial T. Homily 3.

28v Band-shaped headpiece in flower petal style set in roundels with inverted small carmine blossoms between. Initial Є. Homily 4.

35r Band-shaped headpiece similar to that on fol. 11r. Initial A. Homily 5.

43v Band-shaped headpiece in flower petal style in roundels and diamond patterns. Initial T. Homily 6.

56r Band-shaped headpiece in flower petal style, open flowers in rosette forms in diamonds. Initial K. Homily 7.

63r Band-shaped headpiece in flower petal style, flowers enclosed in roundels connected with stems, arranged in a rinceau pattern. Initial K. Homily 8.

The second part of the codex has decoration consisting of simple wavy lines with or without ivy leaves in carminé style.

Iconography and Style

The sole figurative illustration of the codex (fig. 340) represents a tradition well-known in Byzantine book illumination, that of setting medallions with busts at the top bar and standing figures within the sides of a headpiece. More specifically, the three medallions with the Deesis and the columnar figures below find their best parallels in Constantinopolitan manuscripts produced at the very end of the eleventh century, such as the cod. Oxford, Canon gr. 103, which seems especially to have favored columnar figures.[1] In its patternization the ornament foreshadows twelfth-century codices such as Paris gr. 550, fol. 8v,[2] but the flower ornament in itself is fresher in the Sinai codex, the petals still having a flame-like quality (cf., for example, fol. 28v), pointing to a date within the last years of the eleventh century, a period which is indicated by the paleography as well.[3]

Bibliography

Gardthausen, *Catalogus*, p. 65.
Kamil, p. 76 no. 388.

41. COD. 275. ACTS AND EPISTLES ELEVENTH–TWELFTH CENTURIES. FIGS. 341–385, COLORPLATE XVIII

Vellum. 341 folios, 21 x 16.5 cm. One column of twenty-two lines. Minuscule script for text, clear, written under the line. Titles in large minuscule; title of the opening page in *Epigraphische Auszeichnungs-Majuskel*. A special feature is the use of large gold dots for separating verses; very wide lower margins. Gathering numbers at lower left

[1] Galavaris, *Liturgical Homilies*, pls. LIV,278, LV,279, LVI,284, 285; Hutter, *Oxford*, 1, no. 35, figs. 182, 184, 189, 190.

[2] Galavaris, *Liturgical Homilies*, pl. LXXXVII,402.
[3] E.g., cod. Paris gr. 533; see ibid., pl. XLVI,246.

corner of the first recto. Occasionally numbers are repeated on the righthand side of same folio. Parchment fine and white. Ink brown for text; titles, occasional lines of the hypotheses, simple initials in flower petal or fretsaw styles, and small solid initials in text in gold.

Fols. 1r–90v, Acts; 90v–341r, Epistles; 341v, blank. Lists of chapters for I. and II. John, I. and II. Timothy, Titus, Philemon, and Hebrews; hypotheses for each of the Epistles.

Condition good. Some folios have been torn in the margins and repaired. Fol. 256r and v, beginning of II. Corinthians, is misplaced; it should have been between fols. 205 and 206. Miniatures have suffered some flaking.

Binding green velvet over wooden boards, two triple laces ending in silver rings attached on the back cover and two corresponding silver pins on the front cover for fastening. Five pieces of silver-gilt plaques with embossed representations on the front cover (fig. 385). In the center, an oval lobed medallion contains the Crucifixion with Mary and John and two angels above, the one on the left mourning: M(ήτη)P Θ(εο)Υ, IW(α)N(ν)H(ς). On the corners are the four evangelists seated and without background. On the upper part are John and Matthew, O AΓ(ιος) IW(αvv)HC, O AΓIOC MATΘEOC. The former is contemplating and the latter is holding a Gospel. Below, on the left, is Luke and on the opposite side Mark, both writing, ΛOYKAC, M(α)P-K(ος). Between the metal pieces are four studs, each in the form of a rosette. A similar stud is on the upper left corner of the back cover. Three larger studs in the form of spiral rosettes on the remaining three corners are later. Originally, the back cover also had a lobed plaque in its center.

This type of binding, with velvet covers for the wooden boards and small metal pieces in the center and on the corners with standard representations, appears on Gospels in the eighteenth century, a date to which the Sinai cover should probably be assigned.[1]

Illustration

With the exception of the miniatures on fols. 1r, 139r, and 314r, and the ornamental headbands which extend over the entire width of the column, all other illustrations are small, rectangular, framed compositions in the writing column, on the left side.

1r The Mission of the Apostles (6.4 x 10.5 cm.) (fig. 341). The scene is set within three arches decorated with an egg and dart motif in blue, red and green, in

the center of a rectangular headpiece. Christ ($\overline{\text{IC}}$ $\overline{\text{XC}}$), clad in a light brown tunic with a red clavus and blue himation, holding a red Gospel book and blessing, stands frontally in the center. This and all other inscriptions throughout are in red. Christ is flanked by six apostles on either side, all represented on a smaller scale. They are clad in blue and violet or blue, green, and yellow-brown garments, and are making gestures of speech toward Christ. All figures are painted against a gold background. The headpiece enclosing the composition is decorated with roundels within octagonal frames which contain crosslets in enamel-like style, in alternating blue, red, and green. Between the octagonals are crosses in flower petal style set within patterns of similar style. A rope-like, refined filigree fillet in red outlined in gold frames the headpiece. It ends in sprouting buds with red flowers at the upper corners and the usual palmettes at the lower corners. The initial T is formed by the figure of Christ, partially flaked, standing and holding a Gospel, in colors similar to those in the headpiece. Acts 1:1ff.

90v Band-shaped headpiece in flower petal style, crosses and rosettes against gold. Simple initial Є (fig. 342). Hypothesis of the Epistle of James.

91v Band-shaped headpiece in degenerated flower petals within intersecting circles. Below, James the apostle, ὁ ἅγ(ιος) ἰάκωβος, teaching (5.3 x 5 cm.) (fig. 343). Turned to the right and making a speaking gesture, James is clad in a blue tunic with red clavus and a light grey-pink himation. He has brown hair, flesh rendered in warm brown with white highlights, and wears a nimbus delineated against the gold ground. Depicted under an arch supported by columns, he is flanked by two grey-green cypresses growing between shrubs. The marble-like, grey-pink columns carry Corinthian gold capitals, and the arch is ornamented in degenerated flower petal style, with two large, heart-shaped petals on the spandrels. Initial I on the upper part of the frame. James 1:1ff.

100r Band-shaped headpiece in flower petals arranged in two rows in two different scales. Initial Є in fretsaw style (fig. 344). Hypothesis of I. Peter.

101r Band-shaped headpiece, in heart-formed flower petals in two rows set against a gold ground. Below, St. Peter, ὁ ἅγ(ιος) πέτρος, teaching (4.3 x 5.3 cm.)

[1] See Oikonomaki-Papadopoulou, *Argyra*, p. 9; cf. also covers of cods. Sinai 153 and 180, nos. 64 and 69 below, and figs. 666, 667, 716.

(fig. 345). He is represented standing frontally, holding an open scroll in his left hand and making a speaking gesture with his right. He wears a blue tunic with red clavus and a red-pink himation with grey-yellow highlights. His hair is blue-white and his nimbus is delineated against the gold ground. He is flanked by two green cypresses growing between shrubs. The double frame of the miniature is made up of blue and red leaves with stems forming a scroll pattern, arranged in two rows. Simple initial Π. I. Peter 1:1ff.

110v Band-shaped headpiece with a very elegant ornament consisting of carmine and green palmettes within segments of circles and flowers, with fruit between. Initial Є in fretsaw style in gold, blue and red (fig. 346). Hypothesis of II. Peter.

111v Band-shaped headpiece with flower petals arranged in stylized rosette patterns. Below, St. Peter, ὁ ἁγ(ιος) πέτρος, teaching (3.5 x 4.8 cm.) (fig. 347). He is standing in three-quarters view turned to the right clad in blue tunic and brown mantle with red folds under the usual arch and between cypresses. Only the two vertical sides of the composition have a double frame, ornamented with degenerated flower petals in scroll and zigzag patterns. Initial C. II. Peter 1:1ff.

117v Band-shaped headpiece in flower petal style, in carmine, light blue, blue, green, vermillion, and violet colors, in a lozenge-like pattern. Initial Є (fig. 348). Hypothesis of I. John.

119r Band-shaped headpiece with flower petals imitating fretsaw within intersecting blue circles as on fol. 91v, in green and carmine against gold, at the bottom of the page (fig. 349). I. John.

119v St. John the Theologian, ὁ ἅγ(ιος) ἰω(άννης) ὁ θεολόγος, teaching (4 x 4.4 cm.) (fig. 350). He is represented standing frontally under an arch similar to that on fol. 91v but with greyish pink columns, holding a folded scroll in his left hand and making a teaching gesture with his right. Colors of garments similar to those on fol. 91v but the clavus is gold and the apostle's hair is grey-green. He is flanked by large and small cypresses. Initial O. I. John I:1ff.

128r Band-shaped headpiece in flower petal style forming a rinceau with flame-like leaves. Initial O in fretsaw style (fig. 351). Hypothesis of II. John.

129r Band-shaped headpiece decorated with flower petals alternating with blue and green crosses in a diamond pattern. Below, St. John the Theologian, ὁ αγ(ιος) ἰω(άννης) ὁ θεολόγος), teaching (3.9 x 4.3 cm.)

(fig. 352). He is represented as Peter on fol. 111v, standing in three-quarters view turned to the right, holding a scroll with his left hand and making a speaking gesture with his right. He stands under the usual arch and between cypresses as on fols. 91v, 119v. Initial O in fretsaw style. II. John 1:1ff.

130r Band-shaped headpiece in flower petal style, rosettes with inverted petals in blue, carmine, and green against gold. Initial Є in fretsaw style (fig. 353). Hypothesis of III. John.

131r St. John the Theologian, ὁ αγ(ιος) ἰω(άννης) ο θεολόγος, teaching (4 x 5.1 cm.) (fig. 354). Standing in three-quarters view and facing to the right, similar to Peter's representation on fol. 111v, John is depicted in a similar setting, under an arch and between the usual cypresses and shrubs as in all previous illustrations. Two wide bands in degenerated flower petal style in scroll pattern form the vertical sides of the miniature. Initial O, ornamented with a scroll motif in gold, red, and blue marked by a gold star. III. John 1:1ff.

132r Band-shaped headpiece in flower petal style and medallions filled with cloisonné crenellation (fig. 355). Hypothesis of the Epistle of Judas.

133r St. Judas, ο αγ(ιος) ιουδας (3 x 4.7 cm.) (fig. 356). Clad in a blue tunic and light pink and brown himation, Judas sits on a chair facing to the right under the usual arch. The miniature is flaked. Initial I. Judas 1:1ff.

135v Band-shaped headpiece, two rows of flower petals forming one row with a diamond pattern (fig. 357). Hypothesis of the Epistle of Paul to the Romans.

139r Paul with saints (8.2 x 9.4 cm.) (fig. 358). Based on representations of Christ with the four evangelists, the composition is set within a rectangular frame enclosing a quatrefoil in the center, framed by a crenellated border; four stems with the same pattern connect with four medallions in the corners. A bust of Paul, ὁ ἅγ(ιος) παύλος, is in the center. Clad in a blue tunic and light pink himation, and with brown hair, he holds a gold book in his left hand. The four corner medallions contain busts of saints. Read clockwise, beginning at upper left, they are: Timothy, ὁ ἁγ(ιος) τημόθεος; Lukios, ὁ ἁγ(ιος) λούκιος; Sosipatros, ὁ ἁγ(ιος) σοσϊπατρος; and Jason, ὁ ἁγ(ιος) ηάσων. Clad in blue and brown with red toned garments, blue-grey hair and bluish beard, Timothy holds a scroll in both hands; Lukios is dressed in blue tunic and pink-grey himation, has olive grey hair and beard, and holds a scroll in his right hand. Sosipatros,

with brown hair, is represented in garments of colors similar to those of Timothy, and with a scroll in his left hand. Jason is shown with grey-blue hair, a scroll in his left hand, and garments similar to those of Lukios. The large rectangle of the frame is ornamented with flower petals forming rosettes in delicate color nuances. Initial Π in flower petal style. Romans 1:1ff.

172r Band-shaped headpiece in fretsaw style arranged in scroll or arabesque pattern in blue, light olive green, and deep red against gold ground. Initial K (fig. 359). Hypothesis of I. Corinthians.

173v Band-shaped headpiece in flower petal style, open flowers in a rosette pattern against gold, framed by a delicate crenellation in brilliant tones of blue-pink and carmine. Below, St. Paul teaching (4.6 x 4.3 cm.) (fig. 360). He stands turned to the right making a speaking gesture, under an arch and between cypress trees as in previous compositions. Miniature is partly flaked. I. Corinthians 1:1ff.

205r Band-shaped headpiece in flower petal style; large squares subdivided by patterned crosses and filled with flame-like flower petal palmettes in brilliant colors against gold. Initial Δ in fretsaw in gold (fig. 361). Hypothesis of II. Corinthians.

226r Band-shaped headpiece in flower petals enclosed in two rows of heart shapes. Initial Δ in fretsaw style (fig. 362). Hypothesis of the Epistle of Paul to the Galatians.

227r Band-shaped headpiece in flower petal style, composite palmettes in large heart shapes. Below, St. Paul teaching (4.4 x 4.9 cm.) (fig. 363). He is represented in three-quarters view, turned to the right. Composition and frame are similar to the illustration on fol. 131v. Initial Π. Galatians 1:1ff.

244r Band-shaped headpiece in flower petal style arranged in roundels; four composite palmettes centered, forming larger, rosette-like units. Initial Π (fig. 364). Hypothesis of the Epistle of Paul to the Philippians.

245r Band-shaped headpiece with three rows of flower petals enclosed in heart and diamond patterns. Below, Paul and Timothy (4.5 x 5.2 cm.) (fig. 365). Paul, standing on the left, addresses Timothy, who is represented almost frontally. Each stands under an arch flanked by cypresses. The miniature has suffered some flaking. Initial Π. Philippians 1:1ff.

253v Band-shaped headpiece in flower petal style similar to but slightly different from that on fol. 245r. Initials T and Є (fig. 366). Hypothesis of the Epistle of Paul to the Ephesians.

254v Band-shaped headpiece in flower petal style. Stems with flowers spring from a calyx in the center and unfurl into a rich rinceau. Below, St. Paul teaching (4.8 x 4.4 cm.) (fig. 367). He is represented frontally, making a speaking gesture with his right hand and standing under the usual arch and between stylized trees. Initial Π. Ephesians 1:1ff.

256v Band-shaped headpiece in flower petal style forming a tile pattern. Below, St. Paul teaching (4.8 x 4.4 cm.) (fig. 368). Composition and colors as on fols. 119v, 254v. Originally, the folio was between fols. 205 and 206. Initial Π. II. Corinthians 1:1ff.

260r Band-shaped headpiece in flower petal style, small rosettes in an overall pattern. Initial T (fig. 369). Hypothesis of the Epistle of Paul to the Colossians.

261v Band-shaped headpiece with two rows of inverted palmettes in heart patterns in enamel-like colors against gold. Below, Paul and Timothy (4.8 x 5.3 cm.) (fig. 370). At the left, Paul turns and addresses Timothy to the right, who stands frontally and is represented with grey hair. Stylized plants are between and beside the figures. The composition is similar to that on fol. 245r except that the arches present there have been omitted here. Knotted initial Π. Colossians 1:1ff.

269r Band-shaped headpiece in an arabesque pattern against gold ground, similar but not identical to that on fol. 172r. Initial O. Hypothesis of I. Thessalonians (fig. 371).

270v Paul with Timothy and Silvanos (5.2 x 10.1 cm.) (fig. 372). In the center of a rectangular frame and within an elliptical, mandorla-like form, Paul, ο αγ(ιος) παυλος, stands frontally against a gold ground, holding a red codex in his left hand and blessing with his right. He is clad in blue tunic and light pink and green mantle and has a nimbus outlined in red. On the left, outside the "glory," Timothy is shown as an older man with white hair in three-quarters view, clad as Paul but with colors reversed, holding a white scroll in his hand. On the opposite side is Silvanos in blue tunic and red-brown mantle, a young man also having a white scroll in his left hand and holding his right against his chest in an attentive gesture. Both Timothy and Silvanos are shown on a smaller scale, turning toward Paul. They are flanked on both sides by a rich leaf and flower rinceau. The outer frame is of flower petals forming rosettes. At lower left and right are tree-like plants in gold. Initial Π. I. Thessalonians 1:1ff.

278r Band-shaped headpiece in flower petal style in dia-
mond patterns arranged to form rosette tiles. Initial T
(fig. 373). Hypothesis of II. Thessalonians.

279v Paul, Timothy, and Silvanos (6 x 9.5 cm.) (fig. 374).
The composition is a variant of that on fol. 270v. Paul
is standing within a mandorla with a border in flower
petal style. In medallion segments, bordered by egg
and dart ornament and placed, as it were, behind
Paul's frame, are Timothy on the left and Silvanos on
the right, each flanked by a rinceau in flower petal
style. Intertwined palmettes and sprouting calyxes fill
the spandrels of the enclosing frame which forms ga-
bles in the center above and below. A gold plant in the
form of a double cross marks the top center; the usual
palmettes are on the upper corners while palmettes in
fretsaw style with gold stems and red and green flow-
ers are on the lower corners. Initial Π. II. Thessaloni-
ans 1:1ff.

283v Band-shaped headpiece in flower petal style forming
an elegant rinceau (fig. 375). Hypothesis of I. Tim-
othy.

286r Paul teaching (4.6 x 4.7 cm.) (fig. 376). He is stand-
ing, turned to the right, similar in composition and
setting to the Paul miniatures on fols. 173v and 227r,
except that the arch here is tri-lobed. Initial Π. I.
Timothy 1:1ff.

294v Band-shaped headpiece in an unusual scroll motif
framed by a cyma (fig. 377). Hypothesis of II. Tim-
othy.

296v Band-shaped headpiece in flower petal style in deli-
cate colors; Sassanian palmettes alternating and inter-
laced with small pairs of inverted palmettes. Below,
Paul teaching (4.6 x 4.8 cm.) (fig. 378). He is repre-
sented standing frontally with a scroll in his left hand
and making a teaching gesture with his right. The
composition is similar to those on fols. 119v, 254v, and
256v, except for the arch, which is cusped. Initial Π.
II. Timothy 1:1ff.

303r Band-shaped headpiece in flower petal style forming
crosslets in diamond patterns. Initial Є (fig. 379). Hy-
pothesis of the Epistle of Paul to Titus.

304v Band-shaped headpiece with geometric, woodcarv-
ing-like patterns of intersecting octagons and degen-
erated palmettes on the outside corners. Below, Paul
teaching (4.8 x 4.5 cm.) (fig. 380). He is shown stand-
ing frontally and raising his right arm, under a cusped
arch and between trees as in previous compositions.
Initial Π. Titus 1:1ff.

308v Band-shaped headpiece in flower petal style in a rin-
ceau motif stemming from calyxes. Initial O with a
gold rosette in center (fig. 381). Hypothesis of the
Epistle of Paul to Philemon.

309r Band-shaped headpiece in flower petal style in large
diamonds subdivided into central squares and four
leaves in the spandrels. Below, Paul and Timothy (4 x
5 cm.) (fig. 382). Paul, standing to the left in blue and
green-brown garments, is conversing with Timothy,
standing to the right clad in grey-brown tunic and
blue himation with white highlights, represented as
on fol. 261v, except that here the saints are shown un-
der separate arches. Initial Π. Philemon 1:1ff.

311r Band-shaped headpiece in flower petal style; four me-
dallions with calyxes against gold, framed by a cyma
pattern, between flower petal motifs. Inital Є in fret-
saw (fig. 383). Hypothesis of the Epistle of Paul to the
Hebrews.

314r The Ancient of Days and Paul (fig. 384). In the center
of a band-shaped headpiece, an arched panel encloses
an enthroned Ancient of Days (2.9 x 4.4 cm.). He is
clad in a light grey and brown tunic with a red clavus
and blue himation, and holds a red book in his left
hand while he blesses with his right. He has grey hair
and long beard, wears a cruciform nimbus, and rests
his feet on a red footstool. His red-cushioned, high-
backed throne in gold with white ornament is set be-
tween two cypresses. The background is gold. Stems
with calyxes, flowers and fruit in an elegant symmet-
rical rinceau pattern of brilliant colors decorate the
headpiece left and right. Below, Paul (4.5 x 5.6 cm.) is
standing frontally under an arch and between trees, as
in previous illustrations. He is teaching. Initial Π.
Hebrews 1:1ff.

Iconography and Style

The codex must have been produced in Constantino-
ple, as the brilliant enamel-like colors, their delicate nu-
ances, the abundant use of gold, and the figure style show.
The well-proportioned figures are distinguished by a full-
ness of form and an organic relationship between drapery
and body, reflecting works of the Macedonian Renaissance.
But the use of thin white lines in linear zigzag patterns for
rendering highlights, combined with strong highlights for
certain parts of the drapery and an ambiguity in stance,
point to a date at the end of the eleventh or the beginning of
the twelfth century. The figure style lacks the hard demate-
rialization of the twelfth-century manuscripts, such as Vat.

Urb. gr. 2, datable ca. 1125, and in the decorative treatment of the drapery it reflects late eleventh-century Constantinopolitan codices such as Dumbarton Oaks cod. 3, from the year 1084.[2] In motifs, patterns, and execution the ornament recalls, among others, the Gospels in Athens, Nat. Lib. cod. 57 from the third quarter of the eleventh century, assigned to Constantinople.[3] The unusual variety of motifs makes the manuscript a repertoire of ornaments. The scroll motif springing from a vase, however, foreshadows ornament in twelfth-century manuscripts, particularly the motif of the inhabited scroll.[4] The same applies to the recurring use of trees flanking the represented figures, which is found in such twelfth-century codices as Athos, Dochiariou 5.[5] Paleographically the codex finds good parallels in manuscripts of the same period. The tails of certain letters form hooks and the eta alternates minuscule and majuscule forms, features that appear in cod. Paris suppl. gr. 1262, from 1101, and other examples.[6]

Iconographically the illustrations can be grouped as follows: 1) teaching scenes which do not include the audience; and 2) compositions representing the author of an Epistle with one or more accompanying figures. Scenes of the first group show the apostles standing, making speaking gestures. In contrast, Judas is represented seated, but he too may have been teaching or preaching (fig. 356). There are minor variations in stance and in the setting, which is characterized by arches and trees flanking the teacher; the arch motif has often been used elsewhere in representations of the evangelists.[7]

This type of illustration, with both standing and seated teacher, has a long tradition in book illumination in general and in the illustrated Acts and Epistles in particular. In the latter it is by far the most common theme. It is found, for example, in the tenth- and twelfth-century codices in the Wal-

ters Art Gallery, Baltimore, W. 524 and W. 533, and in other manuscripts as well.[8] However, the listeners present in parallel examples have not been included in the Sinai codex. With the exception of Paul, who holds a Gospel on fols. 139r and 279v, all the apostle portraits are derived from the iconographic types used for the prophets rather than those of the standing evangelists, for they carry scrolls instead of books.

The accompanying figures, from the second group of miniatures, are confined mainly to representations of Paul. He is found with Timothy alone (fols. 261v, 309r: figs. 370, 382), or with Timothy, Lukios, Jason, and Sosipatros (fol. 139r, fig. 358, colorplate xviii:b) or with Timothy and Silvanos (fols. 270v and 279v: figs. 372, 374). These figures appear either as Paul's collaborators or as kinsmen and friends, always mentioned in the salutation verses, either at the opening or the close of a particular letter.[9]

Once more we are dealing with a widespread system of illustration applied first to the evangelist and his accompanying figure, and taken over into the Acts and Epistles. In the case of the Gospels, the source of the additional figures is mainly to be found in the prefaces; but here they are contained in the text of the Epistles. Parallels can be found in eleventh- and twelfth-century codices such as Baltimore, Walters Art Gallery W. 533, Athos, Pantocrator 234, and Dumbarton Oaks 3.[10] But the association of Paul with Lukios, Jason, and Sosipatros is not known from other extant examples.

Furthermore, the presence of more than one accompanying figure in two of the Epistles—Romans and Thessalonians—emphasizes those two texts and their salutation figures, particularly since further additional figures could have been used in other Epistles, but were not. The models used for the compositions in these two instances are of particular interest (figs. 358 [colorplate xviii:b], 372, 374). The

[2] *Greek Mss. Amèr. Coll.*, nos. 20, 21 with bibliography.

[3] Marava-Chatzinicolaou, Toufexi-Paschou, no. 26, figs. 230, 231; also the following codices: Athens, Nat. Lib. 2645, ibid., no. 34, fig. 314; Oxford, E. D. Clarke 10, Hutter, *Oxford*, 1, no. 38, figs. 209, 215, 217; Athos, Panteleimon 6 (cf. fols. 30r, 39v, 89v with Sinai fols. 254v, 256v), Galavaris, *Liturgical Homilies*, pls. XXVI,139, XXVIII,143, XXIX, 148; for color reproductions see *Treasures*, 2, figs. 298, 301, 305.

[4] Cf. cod. Athos, Lavra A 4, fol. 16r, in *Treasures*, 3, fig. 9; also cod. Sinai 339, no. 56 below.

[5] *Treasures*, 3, figs. 259, 261, 263, 264, 266–68.

[6] Spatharakis, *Dated Mss.*, no. 116, figs. 221, 223.

[7] See, for example, cod. Athos, Lavra A 21, in *Treasures*, 3, figs. 20–23.

[8] Another codex with a similar system is Moscow gr. 2280 from the year 1072. See Weitzmann, "Illustrated New Testament," pp. 19–38, esp. p. 25 with references to other examples; Lazarev, *Storia*, p. 189, figs. 213–

17; S. Der Nersessian, "The Praxapostolos of the Walters Art Gallery," *Gatherings in Honor of D. E. Miner*, U. E. McCracken et al., eds., Baltimore 1974, pp. 39–50; cf. also cods. Oxford, Canon gr. 110 with the authors of the Epistles, and Oxford, Auct. T. inf. 1.10 (Ebnerianus) with authors and teachers; see Hutter, *Oxford*, 1, no. 3, figs. 11, 12, 15, 18–20; no. 39, figs. 240, 242–46; C. Meredith, "The Illustrations of the Codex Ebnerianus," *Journal of the Warburg and Courtauld Institutes* 29 (1956) pp. 419ff.

[9] Phil. 1:1, 2:19–22; I. Thes. 1:1, 3:2; II. Thes. 1:1; I. Cor. 16:10, 19; Ro. 16:21; Col. 1:1; Philem. 1:1.

[10] Weitzmann, "Illustrated New Testament," p. 25 with bibliographical references; S. Der Nersessian, "A Psalter and New Testament Manuscript at Dumbarton Oaks," *DOP* 19 (1965) pp. 155–83, esp. pp. 161–63, 177–79, 181–82, figs. 47–50, 54, 62 (repr. in eadem, *Études*, pp. 145–47, 161–63, 165–66, figs. 121–24, 128); eadem, "Praxapostolos" (cited above, note 8) pp. 39–50.

illustration of the Epistle to the Romans is probably modelled on a scene depicting Christ and the four evangelists or Christ and the four evangelist symbols, all set in medallions. Such compositions are common in Gospel books, particularly as illustrations of Gospel prologues.[11] The mandorla used for Paul in the Epistle to the Thessalonians once more points to a Christ composition as its model. Above all, it recalls depictions of the Transfiguration, such as the Metamorphosis icon miniature in Sinai.[12]

The possibility that the miniatures of the second group reflect influences of the illustrated Gospel prologues is strengthened by the illustrations of Christ and the apostles (fol. 1r, fig. 341, colorplate XVIII:a) and Paul with the Ancient of Days (fol. 314r, fig. 384). Strictly speaking, one is a teaching scene while the other belongs to the second group of miniatures. Yet the particular choice of figures in each case is of special interest. In the opening of the Acts (1:1–9) is a general reference to Christ's teaching which may have prompted the choice of a teaching scene. The same theme appears, for example, in the Praxapostolos of the Walters Art Gallery (fol. 1r), and Paris suppl. gr. 1262 from the year 1101 (fol. 35r), in which, however, Christ is enthroned between the apostles.[13] The essence of Acts 1:2–3 is the Mission of the Apostles, and this is the real subject of our miniature, most appropriate to open the book which relates the acts of the apostles. The scene originally invented for the Gospel of Matthew was adopted, for good reasons, for the illustrations of the Gospel prologues.[14] It is very likely that the Sinai illuminator borrowed this introductory miniature from such a Gospel prologue.

The representation of the Ancient of Days relates to the opening verse of the Epistle to the Hebrews, which refers to God's speaking to the Fathers through the prophets (Heb. 1:1). In this case the illustrator has changed his system: instead of representing the teacher alone or in the company of salutation figures, he introduces a reference to the introduction of the Epistle. This miniature is not a new invention, however; it appears in Theophanic representations used as illustrations of prefatory notices in Gospels,[15] whose influence may account for the change in the system of illustration. Also important is the emphasis placed on the text of the hypotheses in the codex by the elegant and elaborate ornamental headbands and by the use of gold for some of their

texts, an emphasis which in New Testament codices has a long tradition in Byzantine book illumination.[16]

Bibliography

Gardthausen, *Catalogus*, p. 56.
Gregory, *Textkritik*, pp. 291 no. 395, 1136 no. 1245.
Von Soden, p. 221, a 158.
Hatch, *Sinai*, pl. XLVI.
Lazarev 1947, p. 320 n. 53.
S. Der Nersessian, "A Psalter and New Testament Manuscript at Dumbarton Oaks," *DOP* 19 (1965) pp. 178, 182; repr. in eadem, *Études*, pp. 162, 166.
Lazarev, *Storia*, p. 254 n. 51.
Kamil, p. 72 no. 299.
S. Der Nersessian, "The Praxapostolos of the Walters Art Gallery," *Gatherings in Honor of D. E. Miner*, U. E. McCracken et al., eds., Baltimore 1974, pp. 39–50, figs. 14, 15.
A. Weyl Carr, "Chicago 2400 and the Byzantine Acts Cycle," *Byzantine Studies/Études byzantines* 3 (1976) pp. 1–29, esp. 1.
Weitzmann, *Sacra Parallela*, p. 201.
Voicu, D'Alisera, p. 559.

42. COD. 207. LECTIONARY
EARLY TWELFTH CENTURY. FIGS. 386–397, COLORPLATE XIX:a

Vellum. 339 folios, 29.3 x 22.4 cm. Two columns of twenty-one lines. Minuscule script for text, clear and regular; titles and calendar indications in *Auszeichnungs-Majuskel*. Gathering numbers at upper right corner of first recto with a horizontal line and stroke only above the letter in red. Parchment fine and white. Ink strong black for the text; titles, calendar indications, captions in the miniatures, and ekphonetic signs in red and carmine. Large initials in carminé and fretsaw styles. Small solid initials in the text in red.

Jo. hebd. Mt. Lk. hebd., Passion pericopes and Hours, Eothina, Menologion, varia.

Fols. 1r–43r, John weeks; 43v–116v, Matthew weeks; 117r–209r, Luke weeks; 209v, blank; 210r–245v, Mark readings; 245v–266v, Passion pericopes; 266v–279r, Hours readings; 279v–284v, Eothina; 285r–337r, Menologion; 337r–338v, varia.

[11] For examples, see cods. Oxford, E. D. Clarke 10; Chicago, Univ. Lib. 131; London, Egerton 2163; and Ann Arbor, Michigan, Univ. 171; in Galavaris, *Prefaces*, pp. 76ff., figs. 53, 56, 59, 60.

[12] See no. 58 below.

[13] Der Nersessian, "A Psalter at Dumbarton Oaks," (cited above, note 10), p. 178 (*Études*, p. 162); eadem, "Praxapostolos," *loc. cit.* (note 8 above); Spatharakis, *Dated Mss.*, no. 116, fig. 220.

[14] See, for example, cod. Venice, Marc. gr. Z 540 (eleventh–twelfth century) and a fourteenth-century codex, Vat. gr. 1210: Galavaris, *Prefaces*, pp. 100–109, figs. 80, 81. For the iconography see N. Gioles, "Πορευθέντες . . . ," Δίπτυχα 1 (1979) pp. 104–42.

[15] Galavaris, *Prefaces*, pp. 93–100, fig. 75, 78.

[16] See, for example, the headpiece marking the hypotheses in cod. Oxford, Canon gr. 110: Hutter, *Oxford*, 1, no. 3, figs. 13, 25.

Condition good. Upper two-thirds of fol. 339 cut out.

Binding: silver-gilt front and back covers attached to a silver spine (fig. 389), and three lateral flaps, a long one along the side and two short ones on the top and bottom (figs. 386–391). Each part is made of one piece. Front and back covers are attached to wooden boards by very fine pins, their heads arranged so as to form an integral part of a floral ornament found on both covers. Traces of wooden boards on the top and side flaps, all of which are fixed to the back cover by hinges and can be attached to the front cover by three long, thin metal pins, each with a ring at one end, which fit tightly through fine cylindrical joints. Hinges and joints of the bottom flap are not as fine and regular as those of the other flaps. The spine consists of narrow metal bands ornamented with a floral rinceau motif which reappears on the covers, joined to the covers by long, thin pins fitting through fine cylindrical joints (fig. 389). All pieces are hammered on a mold; details of their representations and inscriptions are engraved.

The front cover represents the Anastasis in its traditional iconography (fig. 386). A frame, defined on its inner side by a filigree, rope-like fillet, is decorated with quite naturalistic brocade-like flowers in a rinceau pattern that also fills the background of the representation. Trampling on the gates of Hell, Christ lifts Adam, represented on the right. Behind Adam stands Eve and further back Abel, one of the Just. The nimbed John the Baptist and David and Solomon are on the opposite side. The scene takes place over the cave of Hell, where Hades, on a much smaller scale, is shown falling. In the foreground are two tower-like structures, probably representing cities, and above are two mountain crags, set asunder. In the background the inscription "Anastasis," in Georgian.

With a frame and background similar to that of the front cover, the back cover represents the Crucifixion (fig. 387). The crucified Christ is flanked by Mary and the beloved disciple John on the hill of Golgotha over Adam's skull. Two mourning angels fly out of the clouds in the corners. Behind the figures is a low wall with four arched openings, each filled with a flower, and a series of blind arches above. The customary inscription on the tabula atop the cross, and IC XC at either side of Christ, both in Georgian. The top flap represents the Virgin Blachernitissa as the Burning Bush before an aureole on the upper part of which is the following Georgian inscription: "mose ixila maqvalad seuçwelad" (Moses saw the burning but not consumed

blackberry bush; cf. Gen. 3:2–3) (fig. 388).[1] Appearing in the midst of the flames, Mary extends her arms in an attitude of prayer or receiving, stretching out her mantle on which Christ rests in bust form. He holds a scroll in his left hand and blesses with his right. On the left, a half-figure of Moses, his name inscribed in Georgian, nimbed and holding a shepherd's staff, receives the blessing of a half-figure angel who leans over from behind Mary's aureole. At the right is a frontal, three-quarters representation of St. Catherine in imperial costume with nimbus and crown, her name inscribed in Georgian. She is shown holding the wheel of her martyrdom. The background is filled with the same floral motif found on the front and back covers.

The lateral flap contains four medallions set against the same floral background, with the four evangelists, all seated, their names inscribed in Georgian (fig. 390). Matthew is represented writing, Mark is pensive, Luke touches a book on a lectern, and John turns his head to receive inspiration from heaven, represented by a segment of sky and rays. They are all seated on flat benches before writing desks with lecterns supporting open books.

The bottom flap, instead of having a floral background, is filled with irregular dots produced by hammering and carries the following Greek inscription (fig. 391):

ΤῸ ΘΕῖΟΝ ΚΑῚ ἹΕΡῸΝ ἍΓΙΟΝ
ΕὐΑΓΓΈΛΪΟΝ ὙΠΆΡΧ(ει) / ΕΜΟῪ
ἸΩΑΚΕῚΜ· ἹΕΡΌ(μον)ΑΧΟῪ ΤΟῪ ΚΡῊ(τό)C
ΟῪ ΤῸ ἐΠΊΚΛΙ / CΚΟΡΔΊΛΗC: ΚΑῚ
ἈΦΪΕΡΟΝΟ ΑὐΤῸ ὙΠΕΡ ΨΥΧΪΚῆC ΜΟΥ /
CΩΤΗΡΊ(as) ΕῚC ΤῸ ἍΓΙΟΝ ΚΑῚ
ΘΕΟΒΆΔΪCΤ(ον) ὍΡ(ο)C ΤΟῪ CΪΝᾶ. /
ἐΠῚΜΕΛΕΊΑC Τ(ε) ΚΑῚ ὙΜΕΤΈΡΑC
ἐΞΌΔΟΥ ͵ΖΡΙΒ' ῙΝΔ(ικτιῶνος) Β̄:

The divine and sacred holy Gospel belongs to me, Joachim, the hieromonk from Crete whose surname is Skordiles; and I dedicate it for the salvation of my soul to the Holy and God-trodden Mount of Sinai through my own care and expense in the second indiction of the year 7112 (1604).

Workmanship and such technical details as the thickness of the metal indicate that all parts of this cover are contemporary. They were made by a Georgian artist but not necessarily in Georgia. The possibility remains that they may have been produced in Crete, the donor's home.

[1] For the translation of the inscription we are indebted to Professor Heinz Fähnrich of Jena and the kindness of Professor Werner Seibt, Vienna.

Regardless of the cover's origin, the representation on the top flap proves that the cover was made specifically for Sinai.

The date of the donation is the same as that of the covers. The spiritualized, elongated figures with triangular faces and pointed beards, the drapery stressing an elegant stance, and to a certain extent the articulation of the body with a spiral motif around the knees find parallels in several Georgian silver icons from the sixteenth century.[2] In these icons one finds the same floral motif filling the background and frame, as well as the arched wall in the background, which, for example, is seen in an icon of the year 1589.[3] The whereabouts of the book before it came into the possession of Skordiles, a member of a well-known old Cretan family, is unknown.

Illustration

1r Π-shaped headpiece, the vertical bars of which flank a bust of St. John the Theologian, ὁ ἅ(γιος) ἰω(άννης) ὁ θεόλ(ο)γ(ος), over both columns (ca. 12.8 x 21.4 cm. including the palmettes at the corners) (fig. 392). On the horizontal bar, five framed medallions form an interlace in green and yellow set against a fretsaw ornament consisting of stylized pearl-studded stems, green and red alternating, with palmettes. The four outer medallions have birds and griffins heraldically flanking the central one, which contains four heart shapes enclosing palmettes, forming a rosette in red, olive green, and yellow. On each of the vertical bars is a large green and yellow framed medallion, having large palmettes set within an octagon framed by fretsaw ornament. On top, two birds and two lion-like beasts are arranged heraldically around a stylized plant. The entire fretsaw headpiece is rendered in crude colors, the red particularly strong, set against a pale yellow background. John, clothed in pale yellow colors with dark brown-black folds and some red, is represented blessing and holding a green-red book. His head is painted against a green nimbus, outlined in black against the parchment. Initial Є with blessing hand in fretsaw style and colors as above. Jn. 1:1–17.

43v Π-shaped headpiece, left column, with palmettes in zigzag patterns in carminé. Initial Є. First Monday after Pentecost. Mt. 18:10–20.

116v Luke, at the bottom of the column (9.9 x 6.1 cm.) (fig. 393). Luke, ὁ ἅ(γιος) λουκᾶς +, is represented as a vignette, writing. Clad in a colorless tunic with dirty grey clavi and yellow himation, supporting a codex with a red cut on his knee, and holding a pen, he sits on a high, lyre-backed chair resting his feet on a footstool, its top rendered in dirty yellow. A desk with a lectern holding a codex is in front of him. The heavily ornamented chair and the desk are painted dirty green, dirty yellow, and red. Luke's head is depicted against a red nimbus. Seventeenth Sunday, Matthew weeks. Mt. 15:21–28.

117r Rectangular headpiece, over both columns (fig. 394). Eighteen medallions, joined to one another by two pearl-studded, fretsaw red stems with palmettes, as on fol. 1r, form a frame adorned with four palmettes at the corners in muddy olive green and pale yellow. The upper two corner medallions contain yellow and white lions against green and red, while in the lower two there are griffins. The remaining medallions enclose rosettes and palmettes partly in fretsaw and partly in geometric style. Initial T in carminé. Monday, first of Luke weeks. Lk. 3:19–22.

210r Frameless headband consisting of a red Arabic inscription in kufic script, top of left column, reading in translation, "There is no God but God and Muhammad is his prophet."[4] Initial T in carminé (fig. 395). First Saturday of Lent. Mk. 2:23ff.

245v Band-shaped headpiece in red rinceau against the parchment, right column. Initial Є with blessing hand in carminé (fig. 396). Beginning of Passion pericopes.

279v Simple line with crosslets and vertical strokes in red, left column. Initial T in carminé. Beginning of the Eothina.

285r Π-shaped headpiece with palmettes and rosettes in simple red pen drawing, left column (fig. 397). Menologion, September 1.

All other months and varia, fol. 337r, are marked only by wavy red lines and have simple red, outlined knotted initials.

Iconography and Style

Clearly the scribe provided no space for miniatures, but the person who made the ornament squeezed John's bust into a headpiece and painted Luke as a vignette at the bottom of a column (figs. 392 [colorplate xix:a], 393). The

[2] See, for example, a triptych from Alaverdi in W. Seibt and T. Sanikidze, *Schatzkammer Georgien*, exhibition catalogue, Vienna 1981, no. 80, fig. 100.

[3] Ibid., no. 77, fig. 52.

[4] For the translation of the Arabic inscription we are indebted to Mrs. Salwa Ferahian of the Institute of Islamic Studies, McGill University.

consistent color scheme leaves no doubt that the miniatures, ornament, and initials were made by the same hand. Iconographically the bust derives from the portrait of a standing evangelist, while Luke represents the author-writer common in Byzantine book illumination. The lyre-back chair and the type of furniture are also common in evangelist portraits.[5]

Stylistically, the rough execution and color scheme suggest a provincial milieu. The faces, particularly that of John with his skull-shaped head, recall manuscripts produced in the area of Palestine.[6] Furthermore, the heavy ornamentation of the furniture is also characteristic of provincial manuscripts of diverse origins.[7] More important for the localization of the manuscript, however, is the ornament on fols. 1r and 117r and the Arabic inscription that takes the place of an ornamental band on fol. 210r (fig. 395). Typical are the medallions with floral motifs, and the stylized palmettes crowned by an almond-shaped leaf and rosettes, all in fretsaw style rendered in strong, unharmoniously combined colors.[8] They present points of comparison to the ornament found in the cod. London, Brit. Lib. Add. 28.816 from the year 1111, to which the Sinai codex also relates paleographically.[9] In certain details of its ornamental repertory, however, particularly the griffin, the codex reflects in a corrupt state the tradition represented by two earlier Lectionaries in Sinai, the cods. 213 from 967, and 214.[10] The survival of the old tradition can best be seen if one compares the "dissected" birds on fol. 164v of the Horeb Lectionary (fig. 73) with the birds on fol. 1r of the present codex (fig. 392, colorplate XIX:a), and if one also considers the interlace on fol. 1r of cod. 214 (fig. 85). These were most likely produced in Sinai, where the present manuscript must also be assigned.

This conclusion is further strengthened by the Arabic inscription, which appears in the opening part of every Koran. The calligrapher must have been an Arabic-speaking Christian who had no difficulty in copying an Arabic sentence and who was probably familiar with the Koran. Whether he was attracted by the decorative possibilities of the script or there were other reasons prompting the use of this sentence as a headband for Mark's pericope we cannot know. The erection of a mosque in Sinai itself before the year 1100 would have given the Arab-Christian scribes a special chance to become familiar with the Koran and to incorporate it among their sources of ornament.[11]

The codex has another striking peculiarity. The star-like and four-petalled rosettes on fol. 117r (fig. 394) appear in partly carved, partly painted wooden panels in ceilings or window frames in chapels at Sinai. In addition to the rosettes, these panels also have stylized birds, horses, and ducks in an imaginative arrangement.[12] If these panels were securely dated, one might suggest that they served as a direct source of inspiration for the motifs in this codex. Since there are at Sinai other codices with comparable motifs, and at least one from the same period (see cod. 259, no. 47 below),[13] the possibility that the manuscript provided the inspiration for the panels is a strong one.

Bibliography

Gardthausen, *Catalogus*, p. 41.
Gregory, *Textkritik*, p. 447 no. 841.
Kamil, p. 70 no. 232.
Galavaris, "Sinaitic Mss.," pp. 130ff., figs. 14 and 15.

43. COD. 508. MENOLOGION, DECEMBER 16–31 EARLY TWELFTH CENTURY. FIGS. 398–404, COLORPLATE XIX:b

Vellum. 285 folios, 32 x 24 cm. Two columns of thirty lines. Minuscule script for text, regular and clear with some *Keulenstil* elements; titles and month indications in *Auszeichnungs-Majuskel*. Gathering numbers with a horizontal line above and below and a stroke, at lower left corner of first recto and lower right corner of last verso, beginning with gathering γ', fol. 11v. Parchment mixed but mostly thick and hard, white. Ink brown for text; titles, month indications, and small solid initials in text in carmine. A number of figural, ornithomorphic initials at the beginning of Lives.

The codex contains twelve saints' lives and fifteen relevant texts and homilies by John Chrysostom, Gregory of Nazianzus, and Basil the Great.

[5] Cf., for example, the portrait of Mark in cod. Vienna, suppl. gr. 164, fol. 34v, from the year 1109: Spatharakis, *Dated Mss.*, no. 125, figs. 237, 239.

[6] Cf. the cod. Jerusalem, Megale Panagia 1, from 1061: Spatharakis, *Dated Mss.*, no. 72, fig. 128.

[7] See notes 5 and 6 above.

[8] Weitzmann, *Buchmalerei*, figs. 427, 430.

[9] Lake, *Dated Mss.*, 2, no. 77, pl. 135.

[10] See cods. no. 14 and 16 above.

[11] For a discussion see Galavaris, "Sinaitic Mss.," pp. 130ff., figs. 14 and 15.

[12] Cf. the chapel of St. Marina in G. H. Forsyth and K. Weitzmann, *The Monastery of Saint Catherine at Mount Sinai. The Church and Fortress of Justinian*, Plates, Ann Arbor n.d., pl. XCII,A; also Galey 1979, figs. 142–47.

[13] See also Galavaris, "Sinaitic Mss.," pp. 127ff.

The beginning is missing. The first five folios have been rearranged. Fol. 1r, end of the Life of Anatolios, bishop of Constantinople, December 16; 2r, hypomnema on Daniel, December 17; 16r–285r, Lives, relevant homilies, December 18–31; 285v, text of Life of Melane the Roman breaks off.

On fol. 1r, top margin, is the following (thirteenth-century?) Latin inscription: *nostrae in nomini Domini qui fecit coelum et terram*. Occasional Latin texts on various margins.

Condition good. Folio 81 is cut in center and sewn; fol. 165 is cut in half lengthwise; two folios missing between fols. 5 and 6.

The front cover is missing, and the codex is held together by a crude wooden board. The back cover, brown leather on wooden board, has the following pressed ornament. A double frame separated by triple lines contains a palmette motif and a scroll-like ornament inhabited by birds and quadrupeds with rosettes in between. On the corners and center of each side of the frame lines is the "classical" fleur-de-lis. The field is marked by a half-diamond pattern, lyre-shaped palmettes at the four corners, and small arabesque motifs. A late sixteenth-century date for this cover seems most probable.

The cover has four circular marks of Spanish wax with traces of white paper apparently glued on them, in the shape of an envelope. This feature is found in other codices also, and may well mean that the books were sent to the monastery from elsewhere, with the forwarding letter glued to the cover. A later sketch of a head is drawn in ink on the wood of the inner side of this cover (fig. 404).

Illustration

2r Band-shaped headpiece with crenellation in blue and green, outlined in red, left column. Initial A in flower petal style. November 17, hypomnema on Daniel. Feast day of Daniel and the Three Children.

16r Band-shaped headpiece in flower petal style, palmettes in a zigzag pattern, in blue and green on thick red ground, right column. Initial Є with peacock in blue, green, and red, holding a branch with red fruit. December 18, hypomnema of John Chrysostom, First Homily on Matthew.

26v Band-shaped headpiece in flower petal style, green flowers in rosette forms within blue circles outlined in red with palmettes between, against violet ground, left column (fig. 398). Initial K formed by a peacock in blue-green and red leaning against a leafy stem. December 19, Life of St. Boniface.

35r Band-shaped headpiece in flower petal style, open green flowers with red centers against thick blue ground and within squares outlined in red, left column. Initial A with bird (ibis?) pecking at a leafy stem. December 19, John Chrysostom, Second Homily on Matthew.

44r Band-shaped headpiece in flower petal style, green and blue palmettes against carmine ground, left column. Initial Π formed by two blue snakes biting at a leaf on top. December 19, Martyrdom of St. Sebastian.[1]

57v Band-shaped headpiece in flower petal style, palmettes in blue heart shapes against red, right column. Initial Є with a blue blessing hand forming the crossbar. December 20, John Chrysostom, Homily to Philogonios.

66v Band-shaped headpiece in flower petal style, pairs of petals attached to a stem sideways, in dark blue and green against carmine-violet, left column (fig. 399). Initial A formed by a standing figure of the emperor Trajan, ο τραιανός, inscribed in carmine. Wearing a blue crown and clad in blue and green ceremonial costume outlined in red, with the loros, he holds a green serpent in his right hand. December 20, Martyrdom of Ignatios Theophoros.

75v Band-shaped headpiece in very rough flower petal style, left column. Initial I in similar style. December 21, John Chrysostom, Third Homily on Matthew.

83r Band-shaped headpiece, variant of that on fol. 57v, right column. Initial K with three blue snakes balancing on their tails. December 21, Martyrdom of Juliana of Nicomedia.

90r Band-shaped headpiece in flower petal style, palmettes in roundels against red, right column. Initial Є with a blessing hand on the crossbar. December 22, John Chrysostom, Fourth Homily on Matthew.

106r Band-shaped headpiece in flower petal style, left column. December 22, Martyrdom of St. Anastasia.

124r Band-shaped headpiece in flower petal style; three roundels, the central one with a composite palmette and those at the sides with birds, left column. Initial Π. December 23, John Chrysostom, Fifth Homily on Matthew.

[1] In the Constantinopolitan Synaxarion, Sebastian's feast day is December 18: H. Delehaye, ed., *Synaxarium ecclesiae Constantinopolitanae* (Propylaeum ad Acta Sanctorum, vol. 63), Brussels 1902, cols. 321–22.

131r Band-shaped headpiece, Sassanian palmettes in continuous oval forms against thick carmine, left column. December 23, Martyrdom of the Ten Cretan Martyrs.

134v Band-shaped headpiece in flower petal style, palmettes sideways in lyre forms, right column. Initial T supported by a bird (fig. 400). December 24, Gregory of Nazianzus, Homily to Julian the Tax Collector.

142r Band-shaped headpiece in flower petal style, composite palmettes in roundels, right column. Initial K with peacock (fig. 401). December 24, Martyrdom of St. Eugenia.

163r Band-shaped headpiece with green and blue flowers in diamonds and half diamonds, right column. Initial X. December 25, Gregory of Nazianzus, Homily on the Nativity.

171v Band-shaped headpiece and initial X in flower petal style, left column. December 25, Basil the Great, Homily on the Nativity.

178v Band-shaped headpiece in flower petal style, inverted palmettes, right column. Initial Π. December 26, John Chrysostom, Sixth Homily on Matthew.

190r Band-shaped headpiece in flower petal style, coarse leaves in triangles, right column (fig. 402). Initial T formed by the emperor Leo, ὁ λέων. Clad in blue and red ceremonial costume with a stylized loros and blue-green crown, very crude, he is surrounded by two serpents whose dark brown heads form the hasta of the letter. December 26, Martyrdom of Theodore and Theophanes Graptoi.[2]

201v Band-shaped headpiece and initial Є in flower petal style, open flowers within squares, right column. Initial Є. December 27, John Chrysostom, Seventh Homily on Matthew.

210v Band-shaped headpiece in flower petal style, rough red and green rosettes within squares, right column. Initial C. December 27, Martyrdom of Stephen, the first martyr (hypomnema on Stephen).

227r Band-shaped headpiece in flower petal style, rough palmettes in a zigzag pattern, right column. Initial Π. December 28, John Chrysostom, Eighth Homily on Matthew.

234v Band-shaped headpiece in flower petal style, very crude palmettes with red rectangles, right column

(fig. 403). Initial A formed by the figure of the emperor Maximian and a serpent. Clad in a muddy red and blue costume, crude and rubbed, and wearing a blue cap decorated with dots to resemble a crown, Maximian holds a red vessel in the form of a scepter, at which bends the head of a blue serpent whose body—the scales are indicated by a series of dots—forms the left part of the letter. December 28, Martyrdom of Inde and Domna.

256v Band-shaped headpiece in flower petal style, inverted palmettes in a zigzag pattern, left column. Initial K formed by a blue serpent. December 29, John Chrysostom, Ninth Homily on Matthew.

265r Band-shaped headpiece in flower petal style, small inverted palmettes in two rows, right column. Initial Є. December 29, Life of Markellos of the Monastery of the Sleepless.

285r Band-shaped headpiece in flower petal style, palmettes heraldically arranged within circle segments, right column. Initial H. December 31, Life of Melane the Roman.

Iconography and Style

Both the figurative initials and the ornament in the headbands are executed in a crude and sketchy manner and have the same gaudy colors. Nevertheless, the figures of the emperors are not decorative. They represent the particular reigns during which the saints mentioned in the opening lines of the relevant text suffered martyrdom. This sort of pictorialization is not unknown in Byzantine book illumination.[3] However, since these figures have a direct relation to the text, we can assume that they are creations of this particular illustrator, who may have been aware of an existing tradition of the period in which the event took place. In fact, the same system of figurative initials, representing Trajan himself and another emperor, appears in the Menologion in Oxford, cod. Cromwell 26.[4]

Both iconographically and stylistically the Sinai and Oxford manuscripts have striking similarities. The images are sketchy; the emperors wear the same types of crowns; their costumes are decorated with dots or strokes; the figures are combined with snakes; and there are initials formed by peacocks. The flower petal style ornament has similarities in color and execution; the same carmine-red and green have

[2] In the Constantinopolitan Synaxarion, the feast day of the Graptoi is December 28 and in some selected Synaxaria December 27; see Delehaye, *op. cit.* (note 1), cols. 339, 350, 352.

[3] For example, see cod. Parma, Pal. 5, fol. 5r, where Trajan is associated with John the Evangelist; Galavaris, *Prefaces*, p. 90, fig. 50 with fur-

ther references.

[4] Hutter, *Oxford*, 1, no. 23, figs. 127–30 (Trajan is in fig. 128); the other emperor is Licinius, p. 162, fig. 127. Cf. also Moscow, Hist. Mus. 8, initial with Julian the Apostate, in V. Lichačeva, *Byzantine Miniatures*, Moscow 1977, pl. 12.

been used in both. The similarities extend to the paleography, with the same color of ink for text, titles, and inscriptions, and the same measurements as well: the Oxford Menologion, written in two columns, measures 32 x 23 cm. The difference in number of lines—the Oxford codex has twenty-five instead of the Sinai manuscript's thirty—does not alter the obvious conclusion that the codices most likely belong to the same set of a Metaphrastian edition of Lives, the Oxford codex being volume 1 (September) and the Sinai being volume 6 (second half of December).

Hutter has proposed an eleventh-century date for the Oxford Menologion and a tentative assignment to Cappadocia. This date seems too early. In spite of the crudeness, the stylization and patterns of ornament point to the early twelfth century. The contours of the petals or palmettes are stressed in a very linear manner, creating an almost flickering effect which is characteristic of manuscripts dating from the early part of the century, such as the cod. Paris, suppl. gr. 1262 from 1101, or Moscow gr. 8 from 1110.[5]

Neither the ornament nor the initials points specifically to a Cappadocian origin,[6] but rather to an eastern province in general. The imperial figures suggest that this provincial scriptorium was acquainted with works of the capital.

Bibliography

Gardthausen, *Catalogus*, p. 124.
Ehrhard, *Überlieferung*, 2, pp. 496–98.
Restle, *Wandmalerei*, 1, n. 164.
Kamil, p. 91 no. 731.

44. COD. 219. LECTIONARY
EARLY TWELFTH CENTURY. FIGS. 405–407

Vellum. 270 folios, 30.5 x 23.5 cm. Two columns of twenty-five lines. Minuscule script for text, written under and across the line, clear but unsteady; titles in *Epigraphische Auszeichnungs-Majuskel* and *Auszeichnungs-Majuskel*. Gathering numbers lacking. Parchment thick and rough. Ink dark brown for text; title of opening page in gold, all other titles, calendar indications, and ekphonetic signs in carmine. Except for fol. 1r, simple initials in flower petal style outlined only in carmine; solid initials in text in carmine.

Jo. hebd. Mt. Lk. hebd., Passion pericopes and Hours, Menologion, varia, Eothina.

Fols. 1r–36r, John weeks; 36r–94r, Matthew weeks; 94v–136r, Luke weeks; 136r–195v, Mark readings; 195v–216v, Passion pericopes and Hours; 217r–264v, Menologion; 264v–267r, varia; 267v–270v, Eothina.

First and last folios in bad condition, blackened at corners, indicating much handling. Text ends on fol. 270v in right column, part of which contained text (colophon?), now obliterated. Fol. 94v, left column, space left empty for headpiece which was not executed.

At present the codex is bound in crimson velvet over wooden boards which were first covered by linen. To this velvet binding, whose spine is worn, were formerly fastened metal covers—the nail holes are still to be seen—perhaps worked *à jour*, which have left very clear traces of their composition. The front cover bears an impression of an Anastasis scene (fig. 406). Christ was in the center with Adam to his right and Eve to his left. He appears in a mandorla with rays of light, trampling on the broken doors of Hell. Other figures were standing behind Adam and Eve, presumably David and Solomon and John the Baptist at left and the Just at right, extending their hands toward Christ. The cover included floral motifs which framed the composition and filled part of the background. The back cover contained a rectangular plaque fastened on the center, representing the Koimesis (fig. 407). Christ holding Mary's soul was flanked by angels. Below remain traces of the bier and two apostles. Four smaller rectangular metal pieces were nailed on the corners. The two on the left above and below contained busts of the evangelists, nimbed, turned to the right, and holding Gospels, while evangelist symbols (?) may have been in the other two. Two metal pins and corresponding red cotton straps for fastening have survived.

This type of binding, with the boards covered with velvet, one plaque in the center of each cover—the Anastasis on one side and occasionally the Dormition on the other—and separate plaques on the four corners, became common for Gospel books from the middle of the eighteenth century on.[1]

Illustration

1r Π-shaped headpiece and initial Є in flower petal style in thick colors set in gold, mostly gone; the flower petals are enclosed in roundels and alternate with palmettes, left column (fig. 405). Jn. 1:1–17.

36r Band-shaped headpiece with simple interlace in carminé, right column. Initial Є. First Monday after Pentecost, Mt. 18:10–20.

[5] Spatharakis, *Dated Mss.*, no. 116, fig. 221; no. 129, fig. 244.
[6] Cf. Weitzmann, *Buchmalerei*, pp. 65ff.

[1] See Oikonomaki-Papadopoulou, *Argyra*, pp. 8–9, cf. fig. 4.

94v Space left for title and band-shaped headpiece which were not executed, left column. Monday, first of Luke weeks, Lk. 3:19–22.

136r Band-shaped headpiece as on fol. 36r, and initial T, right column. Monday, thirteenth week, Mk. 8:11–21.

217r Band-shaped headpiece with colorless flower petals against red in roundels with colorless half palmettes between them, in carminé, left column. September 1, feast day of Simeon the Stylite and of the Virgin in Chalkoprateia.

All other months are marked by a simple broken red line, with the exception of:

240r Band-shaped headpiece with rosettes in carminé, and initial T, left column. February 1.

267v Band-shaped headpiece with interlace in carminé, and initial T, left column. Beginning of the Eothina.

Style

The ornamentation of the codex can best be described as austere and sparse. In its pattern the ornament of the principal headpiece, fol. 1r (fig. 405), follows that of the cod. Oxford, Christ Church gr. 6, fol. 1r, from the year 1081.[2] Its execution, however, is different. Its sketchy, summary manner—the leaves are flat and outlined by a continuous, nervous line—points to early twelfth-century codices such as Oxford, Barocci 15 from 1105, with which it also shares paleographic features.[3] Despite the ill effects of humidity and handling, the headpiece and the initials on fol. 1r indicate a skillful illuminator and a scriptorium familiar with Constantinopolitan elegance, but not the capital itself.

Bibliography

Gardthausen, *Catalogus*, p. 44.
Gregory, *Textkritik*, pp. 447, 1246 no. 853.
Kamil, p. 70 no. 244.

45. COD. 218. LECTIONARY
EARLY TWELFTH CENTURY. FIGS. 408, 409

Vellum. 336 folios, 28.6 x 22.6 cm. Two columns of twenty-two lines. Minuscule script for text, written with a thick pen under the line, clear but dense; title on fol. 1r in *Epigraphische Auszeichnungs-Majuskel*, all other headings

including typikon in *Auszeichnungs-Majuskel*. Gathering numbers on upper right of first recto and upper left of last verso. Parchment thick, white. Ink dark brown for text, but fol. 1r entirely in gold; titles in gold; ekphonetic signs and typikon in carmine. Large initials in flower petal style, several outlined in gold; small solid initials in gold but in Menologion section in carmine.

Jo. hebd. Mt. Lk. hebd., Passion pericopes, Menologion, varia.

Fols. 1r–46v, John weeks; 46v–115v, Matthew weeks; 116r–209v, Luke weeks; 209v–241r, Mark readings; 241v–276r, Passion pericopes; 276v, blank; 277r–329r, Menologion; 329r–336v, varia; occasional Arabic words in margins.

Fols. 271r, 280r, and several others are cut on the lower right margin; 176v and 177r have been joined together on their inner margins with a piece of parchment containing fragments of text written in upright, round uncial script (*biblica rotonda*), probably from a Lectionary of ninth-century date.[1]

Binding: blue silk over wooden boards without ornamentation.

Illustration

1r Rectangular headpiece, in the center of which a four-lobed frame encloses the title, over both columns (fig. 408). The outer frame consists of a series of rosettes or multi-petalled flowers; in between are inverted flower petals. An inner frame is formed by a narrow band with tiny rosettes in an enamel-like pattern. The title frame in the center is composed of a series of flower petal-triangles. The ground is covered with flower petals in an overall pattern of tiny lozenges. On top, two blue peacocks flank a stylized purple fountain with a pinecone jetting blue water. Palmettes on all four corners. Entire ornament in blue, green, and red-pink against gold. Initial Є. Jn. 1:1–17.

46v Π-shaped headpiece and initial Є in rough flower petal style in roundels with palmettes between, left column. First Monday after Pentecost. Mt. 18:10–20.

116r Π-shaped headpiece and initial T in rough flower petal style, right column.

209v Π-shaped headpiece and initial T in flower petal style as on fols. 46v and 116r, left column (fig. 409). First Saturday of Lent. Mk. 2:23–3:2.

241v Simple interlace outlined only in gold and initial Є, left column. Beginning of Passion pericopes.

[2] Spatharakis, *Dated Mss.*, no. 99, fig. 186.
[3] Cf. fol. 195r of the Oxford codex, ibid., no. 120, fig. 230.

[1] See K. Junak, *op. cit.* in bibliography.

277r Π-shaped headpiece and initial T in flower petal style, left column. Menologion, September 1.

All following months are marked by a band in flower petal or interlace designs in carminé, left or right columns: 283v, October 1; 288r, November 1; 292v, December 1; 301v, January 1; 309v, February 1; 312r, March 1; 313v, April 1; 314v, May 1; 317r, June 1; 321v, July 1; 323v, August 1; 329r, a wavy line with dots, varia.

Style

The elaborate foliate decoration of the headpiece, fol. 1r (fig. 408), executed in vivid blue, green, and pink on gold ground, recalls tapestry or enamel work. Specifically, the rendering of the lozenge pattern, the rosettes, and the inner title frame finds parallels in twelfth-century manuscripts and is comparable to that in the headpieces of the cod. Athens, Nat. Lib. 163, attributed to either Jerusalem or Cyprus, with which the Sinai codex also compares well paleographically.[2] The design is rough and many similarities may be found in the headpieces of the cod. Princeton, Univ. Lib. Garrett 2, fol. 123v, datable in the early part of the twelfth century, whose Canon tables' ornamental repertory is also comparable to that in the Sinai codex.[3] Notwithstanding the richness of patterns and the use of burnished gold, the ornament is of low technical quality and the manuscript must hence be considered the product of a non-Constantinopolitan scriptorium.

Bibliography

Kondakov 1882, p. 104.
Gardthausen, *Catalogus*, p. 44.
Gregory, *Textkritik*, pp. 447, 1246 no. 852.
Kamil, p. 70 no. 243.
K. Junak, "Zu einem neuentdeckten Unzialfragment des Matthäus-Evangeliums," *New Testament Studies* 16 (1969–70) pp. 284–88.

46. COD. 237. LECTIONARY
FIRST HALF OF TWELFTH CENTURY.
FIGS. 410–420

Vellum. 204 folios, 22.8 x 16.6 cm. Two columns of twenty-four lines, but fols. 180r–183r in one column of twenty-eight lines. Minuscule script for text, small, clear letters, written under the line by different hands; titles in

Auszeichnungs-Majuskel, some in minuscule. Gathering numbers at lower right corner of first recto and last verso. Parchment very thick, hard and rough, yellowed brown. Ink black for text; titles and ekphonetic signs in vermillion and carmine. Initials either in simple carminé or in flower petal style outlined and tinted; small solid initials in text in vermillion.

Jo. hebd. Mt. Lk. Sab-Kyr., Passion pericopes and Hours, Menologion, Eothina, varia.

Fols. 2r–39r, John weeks; 39v–59v, Matthew weeks; 60r–92r, Luke weeks; 92r–116r, Holy week lections; 116r–177v, Menologion; 177v–181r, Eothina; 181r–183r, varia; 183v, blank; 184r–198v, Passion pericopes; 198v–202v, Hours and Holy Saturday readings; 204r, a late curse against book thieves and a monokondylon signature.

Fol. 1r and v, discarded beginning of John 1:1; text breaks off on fol. 1v and begins over on fol. 2r; 16r–22r, different script, very thick pen; 22v, earlier type of script returns; 59r, lower right column and 59v by another hand in brown ink; 60r, the old script and black ink return; 180r, text changes into one column of twenty-eight lines; 184r–202v, two columns of twenty-four lines as originally; 202v, text breaks off; 203, paper leaf from a different, later Gospel manuscript. The codex has suffered from handling and humidity.

Binding: wine red leather on wooden boards. The front cover is plain, back has pressed ornamentation (fig. 420). Two borders on the outside—the outer one with an arabesque ornament, the inner one with rosettes—frame a panel whose central part is marked by diagonal, crossing lines forming diamonds and half diamonds decorated with rosettes and small concentric circles. Above and below this pattern are two bands on each side; the inner one has medallions with quadrupeds (lions?), the outer one has a heart-shaped ornament with ivy leaves. The decorative scheme and ornamental motifs indicate a fifteenth-century date.[1]

Illustration

1r Rectangular headpiece, over both columns (fig. 410). Two vertical borders with squares enclosing large flower petals flank a rectangle with a four-lobed panel containing the title. The ground is filled with flower petals within heart shapes in rinceau pattern. Palmettes are on the corners. The entire headpiece is executed in pale carminé. Jn. 1:1ff.

[2] Marava-Chatzinicolaou, Toufexi-Paschou, no. 46, figs. 482, 486.
[3] *Greek Mss. Amer. Coll.*, no. 50, figs. 91, 92; *Byzantium at Princeton*, pp. 157–58, no. 180, color pl. J.

[1] Cf. van Regemorter, "Reliure," pp. 11–13.

2r Rectangular headpiece over both columns, framing the title (fig. 411). Roundels framed in blue and yellow, containing lions and griffins outlined in red, tinted in muddy blue and yellow and painted against the parchment, are on the four corners, and birds are in between separated by palmettes. Initial Є with a blessing hand and a griffin or lion below in muddy blue and light yellow. Jn. 1:1–17.

40r Π-shaped headpiece, right column, formed by a rough interlace and roundels with cross motifs in yellow, muddy blue, and white. An interlaced cross on top. Knotted initial Є (fig. 412). First Monday after Pentecost. Mt. 18:10–20.

60r Π-shaped headpiece, left column, with palmettes in yellow and muddy blue in a heart-shaped pattern against terracotta-red. Knotted initial T. Monday, first of Luke weeks, Lk. 3:19–22.

92r Band-shaped headpiece, right column, with flower petals in carminé. Holy week lections, Monday. Mt. 21:18–43.

116r Π-shaped headpiece, right column, with roundels each enclosing a yellow or blue cross with trilobate ends, in a rough design. The palmettes on the lower extended line take the form of anthemia (fig. 413). Knotted initial T. Menologion, September 1.

118v Band-shaped headpiece, left column, with palmettes in heart forms in red, yellow and blue. Initial Є with hand. September 5, feast day of the prophet Zachariah.

120v Band-shaped headpiece, left column, with an indented pattern. Initial Є with hand. September 8, Feast of the Birth of the Virgin.

121v Initial Є with a snake and a cross in the hasta. September 9, feast day of Joachim and Anna.

122v Band-shaped headpiece, right column, with a simple interlace in black, red and yellow and initial T. September 14, Feast of the Exaltation of the Cross.

124r Initial Є with cross and snake. September 15, Feast of St. Niketas.

125r Band-shaped headpiece, left column, with an interlace in black, blue, yellow, red, and colorless, and knotted initial T. September 16, Feast of St. Euthemia.

126r Band-shaped headpiece, right column, with an interlace. Knotted initial Є with a cross formed by the horizontal bar and an added vertical line. September 20, Feast of St. Eustathios.

126v Band-shaped headpiece, right column, with interlace in red, yellow, and colorless, and a leafy initial T. September 21, Feast of the prophet Jonah.

127v Band-shaped headpiece, right column, with simple interlace and initial Є with a cross in center as on fol. 126r. September 30, Feast of St. Gregory of Armenia.

128r Band-shaped headpiece, left column, with rosettes in roundels, a griffin on the left margin and a bird on top; also on top a "rosette" cross. Initial Є with a blessing hand on the crossbar and a coiling snake on the bow. October 1 (fig. 414).

131r Initial Є with a blessing hand and a bird perched on the upper bow.

132r Band-shaped headpiece, right column, with a palmette motif in heart forms against terracotta-red. October 18, Feast of the evangelist Luke.

133v Band-shaped headpiece with an interlace formed of intertwined snakes, with the snakes' heads at its opposite ends. October 25, Feast of Marcian.

134v Band-shaped headpiece, left column, with a diamond pattern. October 26, Feast of Demetrios.

135r Band-shaped headpiece, right column, with interlaced yellow medallions enclosing birds; birds of different kinds on top and bottom bars. On top of the headpiece a plaited cross in yellow and green outlined in red (fig. 415). November 1.

136v Band-shaped headpiece, left column, with a diamond pattern. Initial Є with a coiling snake. November 13, Feast of John Chrysostom.

137v Band-shaped headpiece, right column, with an interlace and a jumping quadruped. December 1.

142r Band-shaped headpiece, left column, with roundels enclosing crosses. Knotted initial B with a coiling snake. Sunday before Christmas.

143v Band-shaped headpiece, right column, with fretsaw ornament. Christmas eve.

149r Band-shaped headpiece, right column, with one lion and one griffin in medallions. January 1 (fig. 416).

153r Band-shaped headpiece, right column, with an interlace in yellow and red and a plaited cross on top forming a rosette. January 6, Feast of the Epiphany.

157v Band-shaped headpiece, right column, with intersecting circles enclosing the name of the month and two birds outside the frame on the extended line. February 1 (fig. 417).

162r Band-shaped headpiece with palmettes in a fretsaw design. Initial Є with hand. March 1.

164v Band-shaped headpiece, left column, with an interlace as on fol. 153r. April 1.

165v Band-shaped headpiece, left column, with an interlace and two different birds on the margin. May 1 (fig. 418).

166v Band-shaped headpiece, left column, with palmettes in fretsaw. June 1.

170r Band-shaped headpiece, left column, with an interlace. June 30, Feast of Peter and Paul.

171r Band-shaped headpiece, right column, with a wicker pattern. July 1.

173v Band-shaped headpiece, left column, with intersecting circles with flower petals in a cross motif and a huge bird at the right side of the frame. Another interlace on the right column with animal heads. August 1.

177v Π-shaped headpiece with wicker pattern on the side bars in red, yellow, and colorless against light blue, and three medallions with busts of the three evangelists of the Eothina Gospels on the horizontal bar, outlined in red and set against pale blue (fig. 419). A large medallion on top of the headpiece, framed in yellow, contains a bust of Christ, clad in a muddy blue garment, holding a colorless book and blessing, designed in red against the parchment with his head painted against a yellow, cruciform nimbus, the cross marked in blue. Initial T with knots and leaves outlined and tinted in similar colors. Beginning of the Eothina.

181r A simple, unframed interlace ending in two snake heads. Varia.

184r Band-shaped headpiece, left column, with a simple rinceau. Knotted initial Є with a cross. Beginning of Passion pericopes.

198v Band-shaped headpiece, right column, with colorless palmettes against red, in half diamonds. Beginning of the Hours readings.

202r Initial O with a red fish, outlined. Holy Saturday pericope. Mt. 28:1ff.

In addition, the codex has several initials T and Є, not listed here, with hands, birds, snakes, and crosses.

Iconography and Style

The different scripts and inks are all contemporary. Paleographically the script is related to provincial products dated or datable in the first half of the twelfth century.[2] The provincial character of this Lectionary is attested by its illustrations as well. Both figure style and ornament are characterized by a crude design in carminé, or outlined in red and/or yellow and tinted with blue or yellow. Gold is absent. The large initials are either knotted or leafy and include blessing hands; in one case, fol. 202r, a fish forms the initial O. More specifically, the predominant motifs in the repertory of the headpieces are the interlace, sometimes forming crosses, and animals—griffins, lions, snakes. Repertory and style recall the Horeb Lectionary, cod. 213 (see no. 14 above). The similarities are striking; in addition to the griffin, we should point to the persistent use of interlace ending in snake or dragon heads (cf. cod. 213, fols. 196v [fig. 74, colorplate II:c], 247v [fig. 76], 264v, with fols. 133v, 173v, 181r of the present codex). The crosses in medallions on fol. 40r may be compared with the ornament on fol. 3r of the Horeb codex (figs. 412, 60). Similarities extend also to the figurative representations. The medallion with Christ, fol. 177v (fig. 419), is a crude version of the one found in the Horeb Lectionary, fol. 196v (cf. fig. 74, colorplate II:c).

There can be no doubt that the present codex depends on the Horeb Lectionary, whose richness and sophistication it lacks, and that it was produced in Sinai itself.

Bibliography

Gardthausen, *Catalogus*, p. 50.
Gregory, *Textkritik*, pp. 448, 1247 no. 871.
Lazarev 1947, p. 370 n. 78.
Kamil, p. 71 no. 262.
Galavaris, "Sinaitic Mss.," p. 131, figs. 17, 18.

47. COD. 259. PSALTER, NEW TESTAMENT FIRST HALF OF TWELFTH CENTURY.
FIGS. 421–426

Vellum. 277 folios, 20.5 x 15.7 cm. One column of thirty-four lines. Minuscule script for text, minute and very dense, written with a thick pen through the line; titles in *Auszeichnungs-Majuskel*. Gathering numbers at bottom of first recto, in faded red. Parchment mixed, rough and fine. Ink brown for text; titles in brown to terracotta brown. Very small, insignificant solid initials in brown.

Fols. 1–2, flyleaves; 3r–58v, Psalms and Odes; 59r, blank; 59v–60r, Matthew chapters; 60v, blank; 61r–62v, hypothesis of the Acts; 62v–90r, Acts; 90r and v, John Chrysostom's Prologue to the Epistles; 90v–168v, Epistles with hypotheses; 168v, text in cross form; 169r–196v, Matthew (196v, text in form of double cross); 197r, Mark chapters;

Hatch, *Jerusalem*, pl. XLVIII.

[2] See cods. Vienna, suppl. gr. 164, fol. 35r, from 1109, and Jerusalem, Taphou 47, fol. 153: Spatharakis, *Dated Mss.*, no. 125, fig. 239; and

197v, blank; 198r–216r, Mark; 216v, blank; 217r–247v, Luke; 248r, John chapters; 248v, blank; 249r–270v, John; 271r–275r, tables of lections for movable and fixed feasts; 275v–276v, Akolouthia of Confession.

On fol. 276r, an entry in black ink reads: ἔτους ͵ζοε' ἀπριλίῳ ῑ (10th of April in the year 7075 [1567]). Further below, there is a monokondylon signature, difficult to decipher, perhaps of Cyril II, the Cretan, archbishop of Sinai (1759–1798).[1] On fol. 216v, another (perhaps late fifteenth-century) entry reads: τὸ παρ(ὸν) βιβλίον ὑπάρχει κυ(ροῦ) μακαρίου καθηγουμένου τῆς ἐν τῇ μονῇ τῆς συλ(υ)βρίας ἁγίας μαρίνης ἐπονομαζομένης. (This book belongs to Makarios prior of the so-called St. Marina monastery in Selyvria).

Fols. 105r–116v are not part of the original manuscript but later substitutes for Epistles text; in this section, concluding text on fol. 116r and v takes the form of a lozenge. On the whole condition is fair to good. Manuscript has suffered from humidity.

Binding in brown leather on wooden boards with tooled decoration. On the front cover a floral rinceau frames a rectangle, in the center of which a diamond encloses two pressed medallions with fleurs-de-lis above and below a metal rosette. Outside the diamond on the corners are four pressed medallions with rosettes and segments of four metal rosettes. Small metal attachments for fastening the book along the long side (fig. 425). The back cover is similar, except that the central panel is marked by two diagonally crossed lines and the metal rosette is at the center on the crossing with two pressed leaves on either side (fig. 426). A piece of parchment from a twelfth- to thirteenth-century Sticherarion has been glued on the inner side of the front cover. This binding has features in common with that of cod. 3 (no. 37 above, figs. 296, 297); in general, it resembles fifteenth- or sixteenth-century bindings, some of which originated in Thessaly.[2]

Illustration

3r Rectangular headpiece in crude flower petal style (fig. 421). Flowers, a rosette, and crosses with heart-shaped leaves are enclosed in interlaced medallions with rosettes placed between them, all painted in dirty steel blue and cinnabar red colors set against a dirty yellow background. Palmettes are on the corners and one on top. Ps. 1.

29r Band-shaped headpiece with a crude, black or dark brown rinceau against brown. Ps. 77.

54v A band with a simple outlined meander in brown and colorless. Exodus Ode, Ex. 5:1–19.

61r Band-shaped headpiece of intersecting segments of circles with flowers in crude, pale carminé (fig. 422). Hypothesis of the Acts.

62v Band-shaped headpiece of a colorless rinceau against brown. Acts 1:1ff.

169r Band-shaped headpiece of interlaced medallions with crude flower petals and rosettes between in carminé. Mt. 1:1ff.

198r A band of wicker ornament with an animal head attached to it at the right, in carminé (fig. 423). Mk. 1:1ff.

217r Π-shaped headpiece with wicker ornament in carminé and a cross on top with the letters IC XC NI KA. Initial Є in carmine. Lk. 1:1ff.

249r Band-shaped headpiece with stylized upright and inverted colorless calyxes against pale brown (fig. 424). Jn. 1:1ff.

Iconography and Style

The script of the codex has paleographic features found in codices of the early twelfth century, as is shown by comparison, for example, with cods. Venice, Marc. gr. 64, fol. 1r, from the year 1112 or Athos, Lavra A 58, fol. 1r, A.D. 1118 (both of provincial origin).[3]

The choice of decorative motifs, their rendering, and the color treatment also indicate a provincial origin. The principal stylistic features of the ornament are: 1) preference for the pale carminé style, and 2) cinnabar red, steel blue, and dirty yellow colors. Both the color scheme and the motifs are found in other manuscripts which, as we have suggested, originated in Sinai, the best representative being cod. 213, the Horeb Lectionary (no. 14 above). A close study of the repertory of motifs on fol. 1r shows that the illustrator of the manuscript under discussion was most likely familiar with the tenth-century cod. 214 (no. 16 above). The interlaced medallions present in both codices (cf. figs. 421, 85) contain comparable motifs such as the cross with the heart-shaped ornament between the arms, although their stylistic rendering is different. The motif of the almond rosettes set between medallions, known from Constantinopolitan manuscripts, was also, since the ninth and tenth centuries, a

[1] For Cyril see Rabino, p. 90 with earlier bibliography.

[2] Cf. cover of cod. Athens, Nat. Lib. 68, in Van Regemorter, "Reliure," p. 14, pl. 12a, and Marava-Chatzinicolaou, Toufexi-Paschou, p. 180, no. 45; also Athens, Nat. Lib. cod. 190, ibid., p. 154, no. 36.

[3] Spatharakis, *Dated Mss.*, nos. 127, 131, figs. 242, 246.

characteristic of manuscripts associated with western Asia Minor.[4] In this case, although rendered with greater stylization in dull and lusterless colors, their particular style and color scheme relate them to Sinaitic codices, especially cod. 213 (fig. 60). Further comparison can also be made with cod. 207 (no. 42 above), fols. 1r, 117r (figs. 392, 394), most likely produced in Sinai as well. Obviously the present codex represents a tradition which is centered around the Horeb Lectionary.

Bibliography

Gardthausen, *Catalogus*, p. 54.
Gregory, *Textkritik*, pp. 248, 1136 no. 1240.
Rahlfs, p. 292 no. 259, 370 no. 1882.
Hatch, *Sinai*, pl. XLIV.
Kamil, p. 71 no. 284.
Voicu, D'Alisera, p. 558.

48. COD. 179. FOUR GOSPELS

EARLY TWELFTH CENTURY. FIGS. 427–439, COLORPLATE XX:a–b

Vellum. 288 folios, 18.3 x 14.2 cm. One column of twenty lines. Minuscule script for text, minute in size, regularly spaced, *Keulenstil*; titles in *Auszeichnungs-Majuskel*. Gathering numbers absent. Wide outer margins. Parchment fine and white. Ink brown for text, titles in gold, later calendar indications in red. Small solid initials in text throughout in gold. Folios with chapters preceding each Gospel written entirely in gold.

Fols. 1v–2r, later text; 2v–7r, Canon tables; 7v, blank; 8r–9r, Eusebius' letter; 9v–11r, Matthew chapters; 11v–12r, blank; 12v, miniature; 13r–82v, Matthew; 82v–83v, Mark chapters; 84r, blank; 84v, miniature; 85r–128v, Mark; 129r, blank; 129v–131v, Luke chapters; 132r–133r, blank; 133v, miniature; 134r–207v, Luke; 208r and v, John chapters; 209r, blank; 209v, miniature; 210r–265r, John; 265v, blank; 266r–279r, list of lections for movable and fixed feasts; 279v–280v, late entries; 281r, Latin entries beginning with the year 1367; 281v–282r, late Greek text and entries; 282v, Latin entries with the year 1376.

Fols. 2–7 form one loose gathering sewn to the codex; other gatherings are also loose; evangelist portraits are painted on separate bifolios but are part of the original co-

dex. Their color scheme is similar to that of the Canon tables and the headpieces; the broken blue and the light olive green colors are common in all. Condition very good.

Binding in crimson velvet on wooden boards for both covers. On the front cover an embossed silver Crucifix is nailed onto the velvet (fig. 439). The cross, with a tablet reading $\overline{\text{IC}}$ $\overline{\text{XC}}$ and a slanted suppedaneum, stands on a rosette-like hillock enclosing Adam's skull. On the four corners are thin embossed silver medallions with the busts of the four evangelists. Their inscriptions are barely legible, but fragments establish the following sequence: on top, John, ο α(γιος) ιωα(ννης) and Matthew, ο α(γιος ματ)-θεο(ς); below, Luke, ο α(γιος) λουκας and Mark ο α(γιος) μαρκος. The cover is further decorated with a set of sixteen stones, seven of which have fallen out of their cabochons. Under Christ's left arm is a rosette consisting of seven garnets and a golden star in the center. The back cover has only five buckles upon the velvet. Two velvet-covered leather straps, one with a silver hook, have survived on the back cover and two silver pins on the front cover for fastening. The long cut edge of the book is gilt.

This was not the original cover decoration. The earliest, which may go back to the fifteenth century, was probably simply the velvet over the boards. At some later time a metal Crucifix of slightly different form was added; the upper part of the cross terminated in a trilobed form, and the lower was larger than the present. The cross was flanked by Mary and John. Four medallions with the symbols of the evangelists, larger than the present medallions, were attached on the corners. Traces of the nails, the figures and the medallions remain on the velvet. The medallion at the upper right corner preserves traces of an eagle. In a third phase, all these metal pieces, having been lost or removed, were replaced by the present ones. This practice of re-decorating older covers with small metal "icons" was common at the end of the sixteenth and the beginning of the seventeenth century, as is shown by many such covers that have survived.[1] At Sinai itself this practice is to be seen in two other examples, cods. 180 (no. 69 below, fig. 716) and 199 (from about 1400). The present cover should most likely be assigned to the seventeenth century.

Illustration

2v–7r Ten Canon tables (ca. 15.6 x 11.6 cm.) (figs. 427–30). In each of these, the concordance (titles and tables in gold) is contained within a structure consisting of

[4] Weitzmann, *Buchmalerei*, pp. 39ff.

[1] See Oikonomaki-Papadopoulou, *Argyra*, p. 8; cf. the 1568 binding of cod. Istanbul, Patr. 1, in G. Sotiriou, Κειμήλια τοῦ Οἰκουμενικοῦ Πατριαρχείου, Athens 1937, p. 66, fig. 21.

two small arches in blue, light green, or vermillion red, spanned by a large arch supported by two columns and a slender central support sufficiently distinguished only on fols. 2v, 3r (fig. 427), and 3v. Design and colors of a verso folio correspond to those on the following recto. The outer columns, painted in carmine, light blue, or green with white or yellow ornament, or having spiral stripes of red, olive green, and broken blue (fols. 6v [fig. 430], 7r) rise from high-stepped bases rendered in blue or green or carmine. They terminate in capitals of acanthus leaves or palmettes. Two large acanthus leaves with light green plants bearing flowers or fruit spring from the bases of the large arch (fols. 2v, 3r). The acanthus leaves have been omitted in all other Canon tables. In each case the tympanon of the large arch is filled with a rich blue rinceau in fretsaw style set against gold. In a few instances (fols. 4r, 6v, 7r) one or more central palmettes are painted in white against gold. On top of the arch is a pair of birds flanking a fountain which can be rectangular or in the form of a chalice in brown or in *verde antico* colors. Among the birds, which are not always proportionally related to the arch and which are painted in green combined with red or in different tones of blue, purple, and brown, one can distinguish peacocks, fols. 3v, 4r (fig. 428); parrots, fols. 4v, 5r, 6r (fig. 429); and partridges, fols. 6v (fig. 430), 7r.

8r Band-shaped headpiece with petalled flowers framed by a rope-like border, against gold. Eusebius' letter.

12v Matthew (10.5 x 9.5 cm.) (fig. 431). Seated to the left on a red, cushioned faldstool and resting his feet on a brown footstool, he is writing on a codex in his lap. He is dressed in a blue tunic with black clavus and a brown himation highlighted in blue, has grey hair and bluish beard, warm brown flesh tones, and a nimbus delineated in red. To the right is a circular brown writing table, partly flaked, with a lectern on it and an open cupboard below. Behind the author towers a tall, narrow building with two blue gables, a doorway filled in black, and window slits on the side. The background is gold and the composition is framed by a band decorated with flowers in rose, blue, and olive green.

13r Π-shaped headpiece with a foliated rinceau stemming from two cornucopias in the center, all in blue and light olive green against gold (fig. 435). The scroll is inhabited by two birds and two quadrupeds in brown with red bands around their necks. On top are two brown leopards with red bands on their necks, flank-

ing a porphyry fountain. Initial B with a green griffin. Mt. 1:1ff.

84v Mark (10.5 x 8 cm.) (fig. 432). Seated to the left on a brown stool with a black cushion and resting his feet on a footstool, Mark writes in a codex on his lap. His nimbus is delineated in black, he has black hair, and is clad in grey-green tunic with brown clavus and cinnabar himation. On the brown table with a quatrefoil top lie an open codex and implements of writing; the ink bottle hangs at the side. Figure and table are set on a strip of grey ground and against a background of tarnished gold. The frame consists of a band with small, delicate rosettes in vermillion and green against dark blue.

85r Band-shaped headpiece in flower petal style with three roundels and free floral motifs between (fig. 436). On top, two yellow-brown lynxes flanking a porphyry fountain in the form of a vase with handles. Initial A with a bird of prey holding another bird in purple and blue. Mk. 1:1ff.

133v Luke (11 x 8.7 cm.) (fig. 433). Clad in a blue-green tunic with yellow clavus and green-brown himation, he is seated to the left on a high-backed, rectangular, red-cushioned brown chair with his feet on a footstool, its top painted black. With his right hand he writes in an open codex held on his lap; with his extended left hand he touches another open codex resting on a lectern set on a brown writing table with the writing implements on it. Ground and background are as on fol. 84r, while the border of the miniature consists of flowers within chevrons.

134r Band-shaped headpiece in flower petal style in the form of a rinceau stemming from a central vase, on either side of which within the foliage are two quails (fig. 437). On top, two foxes (?) flank a fountain. Initial Є with a quadruped jumping against a bird of prey. Lk. 1:1ff.

209v John (10.7 x 10 cm.). (fig. 434). Clad in a blue tunic and a violet-rose himation, with grey hair and warm, dark brown flesh with red tones, he is seated to the left on a high-backed brown chair. Resting his feet on a footstool whose top is painted very dark blue, John holds a pen with his right hand over an open codex held on his lap. He is not writing but thinking. Before him on a dark brown cabinet are the writing implements and a lectern with a hanging oil lamp and an open codex. The ground is olive green and the background gold. The border is a variant of fol. 133v.

210r Band-shaped headpiece with heart-shaped flowers on interlaced stems (fig. 438). On top are two quails flanking a fountain. Initial Є with a griffin, its body blue, head purple, and paws olive green. Jn. 1:1ff.

266r A simple interlace. Beginning of list of lections.

Iconography and Style

Although the structure of the Canon tables mirrors a good tenth-century tradition[2] also seen in the square format of the miniatures, many elements in the rendering of the evangelists reflect later transformations. All of them, including the contemplative John, have been changed into writers. The portrait of Matthew is like that in cod. Leningrad 21; here one also finds the corresponding types of Mark and Luke.[3] The codex held on Luke's lap, however, is not found in tenth-century examples depicting the evangelist touching the lectern.[4] Instead, it appears in the late eleventh and twelfth centuries.[5] Furthermore, although John is represented in a contemplative attitude, there is ambiguity in his attempt to write, another element which appears in eleventh- and twelfth-century examples, e.g., in the portrait of Matthew in cod. Venice, Marc. gr. Z 540, datable to the end of the eleventh or early twelfth century.[6]

The form of the writing table also betrays a later period. In late eleventh-century depictions, the table is occasionally polygonal instead of rectangular.[7] The quatrefoil form is uncommon and not known before the twelfth century, an early example being the cod. Oxford, E. D. Clarke 10.[8] Another iconographic feature are the birds and animals flanking fountains, which are not limited to the Canon tables but have been employed in the headpieces as well, reflecting a later development in this mode.[9] In addition to birds and animals at fountains, a "hunting" theme develops involving a bird of prey attacking another bird or animal.[10] In the Sinai codex, this particular theme is represented in some decorated initials. The combination of birds and quadrupeds in a hunting theme is also found in twelfth-century codices such as Oxford, Laud. gr. 37.[11]

The figure style also indicates the early twelfth century. Although the figures are elegant and of high quality, their style is hard. The rendering of drapery and faces is achieved largely by highlighting in broken blue. The faces themselves have acquired an angularity which one finds in early twelfth-century codices such as Oxford, Auct. T. inf. 2.7 and others.[12]

In the ornament, the inhabited scroll emerging from cornucopias or central vases found in the headpieces has become patternized; other ornamental motifs are mannered in their repetition, recalling headpieces found, for instance, in the twelfth-century cod. Athos, Dionysiou 65..[13] The degree of ornamentation in the rendering of the various birds, and the stylized plants on either side of the large arch in the Canon tables recall those in the headpieces of cod. Harvard gr. 3 from 1105,[14] or those in cod. Athos, Lavra Δ 46, fol. 174r, which is the closest parallel and datable to the same period,[15] and point to the early twelfth century. The paleography supports the proposed date, a good parallel being provided by the cod. Vat. gr. 2048 from the year 1126.[16]

Despite its high quality, the codex may not be associated with the capital. Two of the evangelists, Matthew and Mark (figs. 431, 432 [colorplate xx:a]), show a stylistic peculiarity, a fold in the forehead following the ridge of the nose, which also appears in a full-page title miniature in cod. Sinai 208 (no. 60 below, fig. 646) and in a group of Sinai icons which are related to the frescoes in Asinou (1105–1106), and have been attributed to Cyprus.[17]

Bibliography

Gardthausen, *Catalogus*, p. 35.
Gregory, *Textkritik*, pp. 247, 1135 no. 1216.
Hatch, *Sinai*, pl. XI.
Colwell, Willoughby, *Karahissar*, pp. 171–75, 177, 184, 204, 211; 2, p. 29.
Lazarev 1947, p. 316 n. 36.
Idem, *Storia*, p. 251 n. 35.
Kamil, p. 69 no. 204.

[2] Cf. cod. Paris gr. 70, A.D. 964, Weitzmann, *Buchmalerei*, pl. XVII, 87, 88.

[3] Friend, "Evangelists," pl. XI,108, 109.

[4] Ibid., pls. VIII,89, X,103, XI,109, XIII,118, XIV,135.

[5] Ibid., pls. XII,125, XIV,142.

[6] Ibid., pl. XIV,144; for more recent bibliography on the codex, see Galavaris, *Prefaces*, p. 101 n. 87.

[7] Friend, "Evangelists," pl. XIV,139.

[8] Hutter, *Oxford*, 1, no. 38, fig. 216; for later examples see *Greek Mss. Amer. Coll.*, no. 44.

[9] The examples are several; see cod. Athens, Nat. Lib. 57, Marava-Chatzinicolaou, Toufexi-Paschou, no. 26, figs. 222–27.

[10] See ibid., nos. 34, 35, figs. 319–22, 328.

[11] Hutter, *Oxford*, 1, no. 40, figs. 258, 260.

[12] Ibid., no. 42, figs. 275–78; cf. also the evangelists in cod. Athos, Lavra A 4, in *Treasures*, 3, figs. 10–12, and the Luke of the Sinai codex to the portrait of Matthew in cod. Athos, Koutloumousi 60 in Spatharakis, *Dated Mss.*, no. 314, fig. 550; for color reproductions see *Treasures*, 1, figs. 295–99.

[13] See *Treasures*, 1, figs. 126, 127; the correct date of this manuscript is given by Spatharakis, *Portrait*, pp. 49–50. Cf. also cod. Athos, Lavra A 4, fol. 16r, unpublished.

[14] Spatharakis, *Dated Mss.*, no. 119, fig. 225.

[15] See *Treasures*, 3, fig. 113; cf. also cod. Athens, Nat. Lib. 2645, fol. 167r, in Marava-Chatzinicolaou, Toufexi-Paschou, no. 34, fig. 322.

[16] Lake, *Dated Mss.*, 8, no. 312, pl. 571.

[17] Weitzmann, "Cyprus."

R. S. Nelson, "The Later Impact of a Group of Twelfth-Century Manuscripts," *Third Annual Byzantine Studies Conference, Abstracts of Papers*, New York, 3–5 December 1977, p. 60.

Voicu, D'Alisera, p. 555.

49. COD. 2090. LECTIONARY
EARLY TWELFTH CENTURY. FIG. 440,
COLORPLATE XX:c

Vellum. 326 folios, 27.2 x 22 cm. Two columns of twenty-four lines. Minuscule script for text, large, round, widely spaced letters with *Keulenstil* elements; titles and calendar indications in *Epigraphische Auszeichnungs-Majuskel* and *Auszeichnungs-Majuskel*. Gathering numbers on left corner, bottom margin of first recto, and right corner of last verso, with a horizontal line and a stroke above and below the letter. Parchment fine and white. Ink light brown for text; titles and calendar indications on opening pages in gold, elsewhere in gold or carmine. Ekphonetic signs in carmine. Initials in flower petal style and carminé; small solid initials in carmine or in gold.

Jo. Mt. Lk. hebd., Passion pericopes and Hours, Eothina, Menologion.

Fols. 1r–39r, John weeks; 39v, blank; 40r–83r, Matthew weeks; 83r–105r, Mark readings; 105v–185v, Luke weeks; 186r–220v, pannychides; 220v–251v, Passion pericopes and Hours; 252r–257r, Eothina; 257r–259v, varia; 259v–323r, Menologion; 323r–326r, varia.

Fol. 1, right and left margins repaired; several folios have been repaired at lower margin. On fol. 83r, space left for headpiece which was not executed. Codex has suffered from humidity but on the whole is in excellent condition, showing no traces of use.

The binding is simple, dark brown, modern leather on wooden boards.

Illustration

1r Rectangular headpiece over left column in flower petal style. At the four corners are roundels, each enclosing four heart-shaped leaves forming a rosette and between them palmettes in a scroll pattern—all in blue, red, and green against gold. Initial Є with hand in similar style. Jn. 1:1–17.

40r Rectangular headpiece, left column, in flower petal style (fig. 440). Roundels and divided ovals formed by dark blue stems contain flower petal motifs in blue, green, deep red, and vermillion, and half palmettes fill the spaces in between—all against gold. An acanthus motif in vermillion, rose, and different tones of blue and green frames the title, on the inner side of the rectangle. On top, two quails in grey and brown and two peacocks flank a trilobate red and green marble fountain filled with dark blue water. A stylized green plant with cool green leaves and red buds and flowers stands ambiguously at the fountain's center. Floral motifs on the upper corners of the frame and palmettes on an extended groundline. Initial Є in flower petal style. Monday after Pentecost, Mt. 18:10–20.

83r Empty space over the right column for an unexecuted headpiece.

105v Band-shaped headpiece, left column, in flower petal style in roundels and initial T in similar style. Monday, first of Luke weeks, Lk. 3:19–22.

186r Band-shaped headpiece, left column, in flower petal style with petals in a chevron pattern and crenellations. Initial Є in similar style. Monday, first week of Lent, Lk. 21:8–26.

187r Band-shaped headpiece, right column, in flower petal style arranged in a scroll pattern, and initial T in similar style. Saturday, first week of Lent, Mk. 2:23–3:2.

221v Band-shaped headpiece, right column, with gold crenellations flanking flower petals in a chevron-like pattern. Initial Є in flower petal style. Passion pericopes.

241r Simple carminé band, left column, with a wavy line adorned with T-crosslets. Initial T in simple carminé. Hours readings.

252r Band-shaped headpiece, left column, in flower petal style; rosettes in a lozenge pattern and initial T in similar style. Eothina.

259v Band-shaped headpiece, right column, in flower petal style, with rosettes in two rows. September 1, Menologion.

260r Initial T in flower petal style. September 1, Lk. 4:16–22.

All other months are marked by simple carminé bars of wavy or broken lines with or without the T-crosslets.

Iconography and Style

The iconographic motif of a fountain flanked by two pairs of different birds and a stylized plant is a common element in headpieces in manuscripts datable to the late eleventh and early twelfth century.[1] Ornament and initials are delicately executed but formalized in their patterns and flat

[1] See, for example, cod. Sinai 179 (no. 48 above).

in their rendering. They are comparable to those of cods. Athos, Panteleimon 2, fol. 84r, and Oxford, Auct. T. inf. 1.10, fol. 18r, assigned to the early twelfth century.[2] An early twelfth-century date is supported by the paleography, which finds parallels in such dated manuscripts as Paris, suppl. gr. 1262 from 1101.[3]

The shimmering gold, the delicacy of the ornament and its brilliant colors point to a Constantinopolitan area as the manuscript's center of production.

Bibliography

Beneševič, p. 320.
Kamil, p. 74 no. 348.
Galey 1979, fig. 157.

50. COD. 234. LECTIONARY
LENINGRAD, STATE PUBLIC LIBRARY COD. GR. 297: ONE LEAF
A.D. 1118/1119. FIGS. 441–446

Vellum. 172 folios, 24.7 x 20.1 cm. *Leningrad*: one leaf, 24.8 x 19.8 cm. Two columns of twenty-five lines. Minuscule script for text, *Perlschrift*, small round letters elegantly written under the line; titles and calendar indications in *Epigraphische Auszeichnungs-Majuskel* and a mixed script, *Auszeichnungs-Majuskel* combined with minuscule. No gathering numbers. Parchment hard, thick, yellowed, of average quality. Ink pale brown to brown for text; opening titles of Gospels in gold, all other titles, chapters, calendar indications, and ekphonetic signs mostly in carmine. Large, decorated initials and small solid initials in text, in carmine.

Jo. hebd. Mat. Lk. Sab-Kyr., Passion pericopes and Hours, Eothina, Menologion.

Fols. 1r–33r, John weeks (*Leningrad*: Jn. 3:27–33, 20:19–21); 33v–51r, Matthew weeks; 51v–72r, Luke weeks and pannychides; 72v–101v, Mark weeks; 102r–124v, Passion pericopes; 125r–129r, Eothina; 129v–171v, Menologion, lections September–August; 171v–172r, list of various lections.

On fol. 172r, left column, the following colophon, contemporary with the manuscript, is written in carmine (fig. 446):

Νόμοις σοῖς καὶ δόγμασι: / καὶ ὑποθήκαις:– / ταῖς
ἐνθάδε κειμέναις· / ἄναξ ἀνάκτων:– /

παρασκεύασον συνι/έναι καὶ εἴκειν:– / διατηρεῖν τε
ἄχρι τέρ/ματος ζωῆς:– / χθαμαλὸς λεόντιος /
δεῖται σοι ταῦτα:– / ὁ καὶ τῆς ἧδε κτήτωρ / σεπτῆς
πτυκτίδος:– / ἥτις κ(αὶ) ἐγράφη ἐν τῷ ,ϛχκζ' / ἔτει·
εἰς δόξαν τῆς μακάριας / κ(αὶ) πανυμνήτ(ου)
τριάδ(ος)· π(ατ)ρ(ὸ)ς, ὑ(ιο)ῦ· κ(αὶ) ἁγ(ίου) /
πν(εύματο)ς:–

Thy laws and doctrines and promises which are laid down in this, King of kings, were prepared to be understood and to be obeyed and to be preserved to the end of life. The humble Leontios offers these to Thee; he who is also the owner of this venerable book which was written in the year 6627 (1118/19) for the glory of the blessed and exceedingly lauded-with-hymns Trinity of the Father, the Son, and the Holy Ghost.

In addition to the Leningrad leaf, two others are missing: fol. 173 is a flyleaf from a Latin codex; and 174r is a second flyleaf, with two doodles. Some gatherings are loose but otherwise condition is very good.

Binding of crimson silk brocade faded to light brown in exposed areas, on wooden boards previously covered with chamois leather. On the front cover, the shapes of the silk areas that retain the original color show that originally (sixteenth-century?) metal pieces were attached to it: a Crucifixion in the center flanked by two oblong panels, and four medallions on the corners. This cover was probably similar to that of cod. 179 (no. 48 above). The back cover has plain silk and traces of five studs.

Illustration

Sinai

1r Rectangular headpiece framing the title over both columns, in rough flower petal style (fig. 441). Stems in a vine-scroll pattern form roundels containing flower petals and rosettes in red, blue, and green on gold ground. There are palmettes on the corners and a tree-like palmette at the lower right. Circular initial Є formed of plaited leafy stems and a floral motif in the center, in a rinceau pattern. Jn. 1:1–17.

1v Initial Θ of braided stems resembling wickerwork. From the horizontal bar hang two leaves (fig. 442). Easter Monday, Jn. 1:18–28.

2v Initial T of braided stems in similar colors. Tuesday of Diakainisimou, Lk. 24:12–35. Several additional similar initials throughout the codex not listed here.

[2] *Treasures*, 2, fig. 272; Hutter, *Oxford*, 1, no. 39, fig. 227.

[3] Spatharakis, *Dated Mss.*, no. 116, figs. 220, 223.

3v Initial T of braided stems springing from a star of David, some points of which are marked by leaves, in a wickerwork style in red, blue, grey-blue, and white (fig. 443). Wednesday after Easter, Jn. 1:35–52.

Leningrad

1r Initial O formed by a braided interlace woven around the circle in polygonal forms. Thomas Sunday, Jn. 20:19.

Sinai

33v Band-shaped headpiece over both columns, in flower petal style in blue, red, and grey-green on gold ground, flower petals alternating with rosettes; very large palmettes at top corners (fig. 444). Initial Є with a sleeved hand, blessing in the Latin manner, emerging from a segment of a mantle. The letter branches out in knotted stems, tendrils, and leaves. Saturday after Pentecost, Mt. 5:42–48.

34r Initial Є of stems and tendrils in an interlace drawn in red and then redrawn in brown ink. Sunday of All Saints, Mt. 10:32–33, 37–38; 19:27–30.

51v Π-shaped headpiece, left column, in flower petal style: circles alternating with inverted half palmettes enclose flowers marked with radiating crosses in colors as on fol. 33v. Initial T with pendant leaves in wickerwork style. Monday, first of Luke weeks, Lk. 4:31–36. Another initial T, a variant of the first, with clearly depicted knots. First Sunday, Lk. 5:1–11.

71v Band-shaped headpiece, left column, with an interlace in flower petal style and typical colors. Pericopes for the pannychides.

72v Band-shaped headpiece, right column, with flower petals in a rinceau and initial T, both in the wickerwork style. Saturday, first week of Lent, Mk. 2:23–3:2.

102r Band-shaped headpiece, left column, and knotted, plaited initial Є in flower petal style. Passion pericopes.

129v Band-shaped headpiece over both columns, in flower petal style arranged in a zigzag pattern, against gold. Initial T somewhat similar to those on fol. 51v (fig. 445). September 1, Menologion. All other months are marked by a simple carminé line.

Style

The flower petal style in the headpieces is provincial and mannered in its patterns. The lack of balance of the headpiece on fol. 1r (fig. 441), an anticlassical element in itself, produced by the addition of the tree-like palmette at one side instead of the usual, symmetrical two, is a feature found in provincial manuscripts such as the cod. Athos, Esphigmenou 25, fol. 77r, from 1129.[1] The style of the initials is the manuscript's most distinctive characteristic (figs. 441–445). The leafy stems of the initials are not simply interlaced or knotted but braided, giving the impression of wickerwork, a motif recalling rinceau patterns in such Western manuscripts as the exultet rolls of South Italy, but without their zoomorphic components.[2] The hand making a Latin blessing gesture in the initial Є, fol. 33v (fig. 444), also indicates a Western tradition evident in Greek codices produced in South Italy, such as the cods. Vat. gr. 2138, fol. 37r, from 991 and Vat. Ottob. gr. 250/251, fol. 138r.[3] More particularly, the initials of the Sinai codex recall those in the cod. Vat. gr. 1646, fol. 1r, produced in Reggio, Calabria, in 1118.[4] The relationship to codices of this area is further supported by the paleography, a study of which has also shown that two more codices, Cambridge, Univ. Lib. MS no. 2.36 and Vat. Barb. gr. 482, were written by the same scribe who wrote the Sinai manuscript.[5] All of this evidence points to a South Italian scriptorium for the Sinai codex.

Bibliography

Kondakov 1882, p. 106, pl. 92,5.
Gardthausen, *Catalogus*, pp. 48–49.
Gregory, *Textkritik*, pp. 448, 1247 no. 868.
Vogel, Gardthausen, p. 260.
Gardthausen, *Palaeographie*, 1, p. 208 n. 1.
Beneševič, pp. 115–16 no. 109.
Lake, *Dated Mss.*, Indices, p. 179.
Devreesse, *Introduction*, p. 304.
Granstrem, *VV* 23 (1963) pp. 170–71.
Kamil, p. 71 no. 259.
Husmann, p. 150.
Spatharakis, *Dated Mss.*, p. 40, no. 132, fig. 247; p. 78 (no. 321).
Voicu, D'Alisera, p. 558.
Harlfinger et al., pp. 41–42, 63 no. 21, pls. 95–98.

Leningrad leaf:
Cereteli 1904, pp. 17, 76, 97, 187.
Gregory, *Textkritik*, p. 1280 no. 1405.

[1] Spatharakis, *Dated Mss.*, no. 136, fig. 256. There are several other examples, but we mention only cod. Sinai 180, fol. 187r, from 1186, see no. 69 below (fig. 714).

[2] For examples see Grabar, *Manuscrits grecs*, figs. 84, 341, 344.

[3] Ibid., nos. 16, 22, figs. 111–13; Weitzmann, *Buchmalerei*, pp. 85ff.,

pl. XCII,582, 593.

[4] Grabar, *Manuscrits grecs*, no. 27, fig. 165; Spatharakis, *Dated Mss.*, no. 130, fig. 245.

[5] Harlfinger et al., p. 41, with further references.

Cereteli, Sobolevski, p. 11, pl. 24.
Beneševič, pp. 115–16, 615 no. 109.
Idem, *Mon. Sinaitica*, 2, pl. 55.
Franz, "Ornament," pl. 5,1.
Lake, *Dated Mss.*, Indices, p. 179.
Devreesse, *Introduction*, p. 304.
Granstrem, *VV* 23 (1963) pp. 170–71 no. 313.
Spatharakis, *Dated Mss.*, no. 132.
Voicu, D'Alisera, p. 354.
Harlfinger et al., pp. 41–42.

51. COD. 44. PSALTER
LENINGRAD, STATE PUBLIC LIBRARY COD. GR. 268: ONE LEAF
A.D. 1121/1122 AND LATE THIRTEENTH CENTURY. FIGS. 447–450

Vellum. 215 folios, 20.1 x 15.8 cm. *Leningrad*: one leaf, 20.2 x 15.4 cm. One column of twenty lines. Minuscule script for text, written under the line, calligraphic round letters with *Perlschrift* elements; title on fol. 1r in *Epigraphische Auszeichnungs-Majuskel*, other titles in a mixed type of *Auszeichnungs-Majuskel* and minuscule. Gathering number at the lower left corner of first recto and lower right corner of last verso, also numbers by a later hand. Parchment hard, rough, and yellowish. Ink brown for text; large titles and initials in flower petal or geometric forms, and small solid ones in text, in carmine; a few titles and some initials in brown. Doxa and kathismata in carmine.

Fols. 12–181v (Leningrad leaf between fols. 79 and 80), Psalms; 182r–197r, Odes; 197r–214r, varia; 214v–215v, fourteen Easter tables beginning with the year ‚Ϛχλ′ (1121/22) and ending with the year ‚Ϛχμγ′ (1134/35) (figs. 449, 450).

Condition poor. Manuscript shows heavy use. Some leaves are missing. First gathering is loose and some folios have been repaired. Some later commemorations of readers' names, and marginal notes in Arabic on some folios. Ornamental headpieces are much flaked and miniature on fol. 95v is not contemporary with the manuscript.

Plain binding of wood covered with linen, perhaps contemporary with the manuscript. Only the back cover is still attached to the codex.

Illustration

1r Rectangular headpiece framing the title, in rough, flaked, flower petal style against gold ground. Initial

M in similar style (fig. 447). Ps. 1.

95v Moses receiving the tablets of the law (12.5 x 11.6 cm.) (fig. 448). Moses is depicted wearing a blue tunic and a blue-green mantle decorated in a linear black pattern, with a much flaked brown turban like a crown on his head (the flesh tones are dark ochre). Holding the tablets, outlined in brown in his covered hands, he turns to the right and looks toward the hand of God emerging from a segment of muddy blue sky. The caption reads: δέχεται μωσ(ῆ)s τὰs πλάκαs οὐ(ρα)νόθεν. Minus the last word, it is repeated as a *boustrophedon* on the tablets. Painted against the bare parchment, the composition is framed on three sides (the fourth is cut off) by a wine red and dark blue band with a crude half-diamond pattern and an interrupted fillet in blood red. End of Ps. 76.

96r Band-shaped headpiece in very rough flower petal style against gold. Initial Π.

182r Band-shaped headpiece in poor flower petal style against gold. Initial A, Exodus Ode, Ex. 15:1–19.

Iconography and Style

The three ornamental bands in rudimentary flower petal style constitute the original decoration of the provincial codex, whose scribe emphasized decorative detail in the form of certain initials, such as the Φ, which is drawn as a liturgical cross (fols. 93v, 113v).

The date 1121/22 does not apply to the miniature, painted in an empty space between the end of Psalm 76 and the beginning of Psalm 77, which was written on a new page. Reduced to its bare essentials, the scene represents the iconographic tradition of the Aristocratic Psalter recension. In fact, its actual place in the manuscript reflects an early phase of this tradition. It is related to Psalm 77, the text of which justifies the theme.

Stylistically, the composition is flat and crude. The facial type, the Mongolian eyes, the oriental-looking blue-green garments, and the turban point to an Islamic source comparable to the miniatures of the Maqamat of Al-Hariri of the thirteenth century.[1] The scene was most likely added by a monk at Sinai, where in the late thirteenth century the Islamic tradition was strong both in Arab-Christian and Islamic art.

Bibliography

Gardthausen, *Catalogus*, p. 12.
Beneševič, pp. 19–20 no. 5.

[1] See cods. Paris, Bibl. Nat. Ms. Arabe 3929 and Ms. Arabe 6094, reproduced in D. Talbot Rice, *Islamic Art*, London 1965, figs. 105, 106; and

O. Grabar, *The Illustrations of the Maqamat*, Chicago and London 1984, pp. 8, 9 (in this publication illustrations are on microfiche).

Rahlfs, pp. 288 no. 44, 360 no. 1197.
Devreesse, *Introduction*, p. 304.
Kamil, p. 64 no. 44.
Husmann, pp. 149ff.
Cutler, "Aristocratic," p. 257.
Spatharakis, *Dated Mss.*, pp. 40–41, no. 133, fig. 248.
Voicu, D'Alisera, p. 553.
Harlfinger et al., pp. 43–44, 64 no. 23.
Cutler, *Psalters*, no. 47.
Galavaris, "Sinaitic Mss.," p. 140, fig. 26.

Leningrad leaf:
Cereteli 1904, pp. 7, 17, 83, 90, 100, 187, pls. 1, 2, 7, 8.
Beneševič, p. 609 no. 5.
Idem, *Mon. Sinaitica*, 2, pl. 56.
Rahlfs, pp. 229 no. 268, 360 no. 1197.
Lake, *Dated Mss.*, 6, no. 256, pl. 451.
Devreesse, *Introduction*, p. 304.
Granstrem, *VV* 23 (1963) p. 171 no. 315.
Voicu, D'Alisera, p. 353.
Harlfinger et al., pp. 43, 44.

52. COD. 39. PSALTER
EARLY TWELFTH CENTURY. FIGS. 451–453

Vellum. 331 folios, 19.8 x 14.8 cm. One column of seventeen lines. Minuscule script for text, calligraphic, exquisitely written in round, upright, carefully spaced letters under the line, with elements of *Perlschrift*; title for Psalm 1, fol. 9r, in *Epigraphische Auszeichnungs-Majuskel*, other titles, hypothesis, and table of contents in *Auszeichnungs-Majuskel*. There are no gathering numbers. Parchment fine and white. Ink brown for text; titles in gold. Three initials in flower petal style and small solid initials in text. Doxa, alleluia, and kathismata indicated in gold.

Fols. 1r–8r, hypothesis and table of contents; 8v, blank; 9r–302v, Psalms; 303r–328r, Odes; 328v–329v, late entries.

Condition fair. Parchment is blackened on edges. Some gatherings are loose and have suffered from humidity. Fols. 89, 90, and 101, containing Psalms 51, 53, and 58, were sewn into the codex later, probably in the sixteenth or seventeenth century. The original text continues on fols. 91r and 102r. Fols. 330 and 331, with text of a psalm, are from another manuscript.

Old, dark brown leather binding on wooden boards stamped with parallel bands with a zigzag pattern and an interlace and a field containing rosettes in rectangles. Both covers are similar (fig. 453).

[1] Spatharakis, *Dated Mss.*, no. 104, fig. 200.
[2] Hutter, *Oxford*, 1, nos. 37, 41, figs. 201, 268; Spatharakis, *Dated Mss.*, no. 120, fig. 230.

Illustration

2r Band-shaped palmette border in gold marking the titles, table of contents.

9r Rectangular headpiece framing the title; flower petals within roundels, with heart-shaped palmettes on stems between, set in gold (fig. 451). Initial M in similar style. Ps. 1.

158r Band-shaped headpiece in flower petal style in roundels. Initial Π in similar style. Ps. 77 (78).

303r Band-shaped headpiece and initial A in flower petal style—roundels joined by diagonal lines. The Exodus Ode, Ex. 15:1–19.

329v David fighting Goliath, drawing in light red ink, lower part of the page (13.6 x 10 cm.) (fig. 452). Wearing a chlamys and leaning on his right foot, David is about to cast the stone (only the sling is represented, drawn diagonally), and is prepared to defend himself, with his raised left arm wrapped in his billowing mantle. Outlined forms on the lower left side may indicate plants. Parts of the figure (face, head, right shoulder, and top of the mantle across the chest) are redrawn in brown ink.

Iconography and Style

Comparison of the flower petal ornament and initials with dated manuscripts such as Vat. gr. 342 from 1087 show that the Sinai ornament is more patternized and drier.[1] The ornament is closer to that in cod. Oxford, Barocci 15 (Psalter) from the year 1105, to which it is also related paleographically, and to that in the cod. Oxford, Cromwell 19, assigned to the early part of the twelfth century.[2] The good quality of the ornament, the use of gold, and the exquisite script may indicate a center of production related to Constantinople.

The representation of David about to fight Goliath (fig. 452), a later addition to the original manuscript, most likely post-Byzantine, is a faithful copy of a complete scene in a good aristocratic Psalter, as shown by comparisons with the cods. Paris gr. 139 and Oxford, Barocci 15.[3]

Bibliography

Gardthausen, *Catalogus*, p. 11.
Beneševič, pp. 28–29 no. 33.
Rahlfs, pp. 288 no. 39, 360 no. 1195.
Kamil, p. 63 no. 39.

[3] K. Weitzmann, "Prologomena to a Study of the Cyprus Plates," *Metropolitan Museum Journal* 3 (1970) pp. 97–111, figs. 2, 8; repr. in *Psalters and Gospels*, no. V.

53. COD. 158. FOUR GOSPELS
FIRST HALF OF TWELFTH CENTURY.
FIGS. 454–458

Vellum. 308 folios, 22.5 x 16.7 cm. Two columns of twenty-two lines. Minuscule script for text, small letters, irregular in direction with *Hakenschrift* elements; titles in prefatory matter in large minuscule, in Gospels in *Epigraphische Auszeichnungs-Majuskel* and *Auszeichnungs-Majuskel*. Gathering numbers at lower right corner of first recto. Parchment fine. Ink dark brown for text; titles and solid initials in carmine.

Fols. 1r–v, Eusebius' letter; 1v–8v, Canon tables; 9r–10r, Matthew chapters; 10v, cross page, miniature; 11r–95r, Matthew; 95v–96r, Mark chapters; 96v, blank; 97r–125r, Mark; 125v–126v, Luke chapters; 127r–240r, Luke; 240v, originally blank, now very late entries; 241r, John chapters; 241v, blank; 242r–307v, John; 308r–v, originally blank, now very late entries.

On fol. 307v is the following note written by a later hand:

+ Τὸ παρὸν τετραβάγγελον ἀφιέρωσεν / ὁ κυρίτζη κανκτακουζηνὸς τοῦ δοῦκαμ(?) / ἐκκ νίσου μυτιλήνης, ἐν χώρα μολύβου· / καὶ ἀφιέρρωσε αὐτὸν εἰς τὸ ἅγιον ὄρος / τοῦ σινᾶ· καὶ ἔγραψεν, καὶ δύο ὀνόματα· / γϊανάκει· καὶ κουβασιλενα εἰς τὴν / ἁγίαν πρόθεσιν· ἐπὶ καὶ αὐτὸς γρα/μένος ἦν· ἐπὶ ἔτους· ͵ζρκγ΄ / ἐν μη(νὶ) μαρτί(ω) ā. μάξιμος ἱερομόναχος.

+ The present Gospel was dedicated by Kyritzes Kantakouzenos Doukas (?) from the island of Mytilene and the village Molyvos; and he dedicated it to the holy mount Sinai; and he wrote two names at the holy prothesis, Yanakis and Kouvasilena because he himself was also inscribed (at the prothesis); in the year 7123 (1615) on March 1st. Maximos hieromonk.[1]

Condition good. Parchment slightly blackened on edges. Simple light brown leather covers with pressed ornamentation: a frame with a rinceau with small heart-shaped leaves. Front cover is burned at sides. One braided leather strap for locking on the back cover (fig. 458).

Illustration

1r–v The letter of Eusebius is set within arches, with spandrels supported by two slender double colonnettes. Standing on a ground strip with crenellation and two plant-like palmettes on the sides, these colonnettes are broken at midpoint by a foliate capital and terminate in acanthus capitals. At left and right of the arch are palmettes terminating in fleurs-de-lis; on fol. 1v, oil lamps with hanging crosslets suspended from chains. Arch and spandrels are decorated in flower petal style in strong but muddy colors, blue-green and purple-red being the most predominant. The structure is crowned by a cross springing from a leafy, lyre-shaped scroll.

2r–v, 3r–v, 4r–v, 5r (fig. 454), 5v (fig. 455), 6v, 7r–v, 8r–v Ten Canon tables (ca. 17.3 x 15.3 cm.). These occupy a structure with two small arches spanned by a larger one set on an extended beam with palmettes at the corners and suspended oil lamps as on fol. 1v in every case except fol. 4r (Canons III and IV). The arches, spandrels, and tympana are rendered in flower petal style. On fols. 5v and 6r (Canons V and VI), a gable is substituted for the arch. A cross, a variant of those on fols. 1r and v, stands atop each structure, and palmettes are on the corners. The arches are supported by double colonnettes at each side as on fols. 1r and v, and by a single central column. The colors are muddy, the blue extremely strong, and the most predominant ornament is set on a deep carmine ground.

10v Cross page (fig. 456). A cross with a stepped base from either side of which rises a leafy scroll, is set under an arch supported by two variegated columns with bases and capitals. The cross, with the letters \overline{IC} \overline{XC} / NÌ KÁ in deep carmine between the arms, is decorated with crenellations and a roundel in the center. Arch and spandrels are in flower petal style in wavy or heart-shaped patterns and with a florid cross on top, a variant of those on the Canon tables. Palmettes are at the upper corners and on the extended bar of the arch. The color scheme of the entire page is extremely strong and is comprised of blue, red, grey, and dirty yellow.

[1] The translation is literal. In essence the text refers to the early rite of the Proskomide (Prothesis) and the commemoration of names, living and dead, related to it. It was customary in the early Church to accept eucharistic gifts only from persons worthy of offering gifts for the altar. Their names were written down and included in the commemoration of the rite of Proskomide. Although in later centuries and today no attention is paid to the worthiness of those who offer bread and wine for the Eucharistic sacrifice, the custom continues and names are written down and commemorated at the Proskomide. In general, see M. M. Solovey, O.S.B.M., *The Byzantine Liturgy*, Washington 1970, pp. 121ff.; R. Taft, *The Great Entrance, A History of the Transfer of Gifts and Other Pre-Anaphoral Rites of the Liturgy of St. John Chrysostom*, Rome 1975.

11r Band-shaped headpiece with flower petals in simple carminé, left column, and initial B (fig. 457). Mt. 1:1ff.

97r Band-shaped headpiece with interlace in simple carminé, left column, and initial A. Mk. 1:1ff.

127r Band-shaped headpiece with Sassanian palmettes in carminé, left column, and initial Є. Lk. 1:1ff.

242r Band-shaped headpiece with flower petals in carminé, left column, and initial Є. Jn. 1:1ff.

Iconography and Style

Cross pages with inscriptions are found often in eleventh- and twelfth-century codices such as Sinai 500 from 1063 (no. 28 above) and Esphigmenou 25 from 1129.[2]

More significant are the arches applied to the cross page, the letter of Eusebius, and the Canon tables. In their structure they follow forms traditional since the tenth century.[3] Special formal features, however, are the suspended oil lamps and the double colonnettes interrupted at midpoint by foliate capitals. The latter element is known as early as eleventh-century manuscripts associated with the Constantinopolitan area.[4] But the lamps represent a later motif. They parallel the devotional crowns hanging from Canon tables in early twelfth-century manuscripts such as Princeton, Scheide Lib. cod. M 70, ca. 1100.[5] The combination of lamps, however, with supports of the arches in the form of double, interrupted colonnettes is found in later codices, the cod. Princeton, Garrett 2, for example, datable by its ornament to the first half of the twelfth century.[6] All this evidence points to a date in the first half of the twelfth century (paleographers attribute the codex to the eleventh century) and to Constantinopolitan models, though the manuscript does not seem to be a product of the capital. The leafy scroll at the sides of the cross, for instance, and the palmettes on the top corners (fig. 456) look rather provincial (Athos?). Above all, it is the strong muddy coloring, and especially the reds, a common characteristic of all its illuminations, that sets the manuscript apart and remains without exact parallel. These may be reflections of the coloristic tradition found in earlier codices such as Athos, Karakallou 11, or Paris, suppl. gr. 1081,[7] a tradition that seems to continue into the twelfth century, as the cod. Athos, Dionysiou 82 demonstrates.[8] None of these codices has a sure provenance.

Bibliography

Gardthausen, *Catalogus*, p. 30.
Gregory, *Textkritik*, pp. 246, 1134 no. 1195.
Hatch, *Sinai*, pl. XXIII.
Colwell, Willoughby, *Karahissar*, 1, p. 232.
Kamil, p. 68 no. 183.
Husmann, p. 150.
Voicu, D'Alisera, p. 554.
Harlfinger et al., pp. 60–61, 65 no. 38.

54. COD. 193. FOUR GOSPELS WITH COMMENTARY
A.D. 1124. FIGS. 459–465

Vellum. 328 folios, 20.5 x 15.5 cm. Two columns of thirty-nine lines (fol. 6v, one column). Different types of script: minuscule and *Auszeichnungs-Majuskel* for text, including a minuscule in minute handwriting with elements of *Perlschrift*;[1] titles in *Epigraphische Auszeichnungs-Majuskel* and *Auszeichnungs-Majuskel*. Gathering numbers are not preserved; that on fol. 94r is later; later numbers following a non-Greek system at upper left and a cross in mid-upper margin of each last verso. Parchment hard, white, average quality. Ink dark brown to black for text; titles and small solid initials in strong crimson-red and blue.

Fols. 1r, Eusebius' letter and Canon I; 1v–4v, Canon tables; 5r, empty arches for Canon; 5v, blank; 6r–97v, Matthew; 97v–149r (148v blank), Mark; 149r–242v, Luke; 242v–322v, John; there is a commentary and hypothesis for each Gospel, as well as verses to Luke, fol. 149r, to John, fol. 242v, and to the evangelists, fol. 322v; 322v, colophon; 323r–327v, a text (*epilysis*) on the Descent into Hell; 327v–328v, Hypothesis to the Acts and some of the Epistles.

On fol. 322v, lower part of left column, is the following colophon in brown ink, contemporary with the text (fig. 463):

'Εγράφη ἡ θεία αὕτη τῶν ἱερῶν εὐαγγελίων /
βίβλος διὰ χειρὸς τοῦ εὐτελοῦς καὶ ἀναξίου

[2] Spatharakis, *Dated Mss.*, no. 136, fig. 255.
[3] See cod. Athens, Nat. Lib. 56, fol. 2v, in Marava-Chatzinicolaou, Toufexi-Paschou, no. 1, fig. 2.
[4] See cod. Athens, Nat. Lib. 57, ibid., no. 26, figs. 222–27.
[5] *Greek Mss. Amer. Coll.*, no. 33, fig. 57; *Byzantium at Princeton*, pp. 148–49, no. 174.
[6] *Greek Mss. Amer. Coll.*, no. 50, fig. 91; *Byzantium at Princeton*,

pp. 157–58, no. 180, color pl. J.
[7] Weitzmann, *Buchmalerei*, p. 69, pl. LXXVI,464, 468, 469, LXXVIII,484.
[8] *Treasures*, 1, fig. 148.

[1] For a detailed analysis of the script see Harlfinger et al., p. 44.

ἱερέως / καλοῦ σπουδῇ καὶ προθυμία τοῦ
ὁσιωτ(ά)τ(ου) ἐν μο/ναχοῖς μοναχοῦ κοσμᾶ πόθω
πολλῷ καὶ κόπω / ἀγωνισαμένου κτῆσαι τὴν
παροῦσαν δέλτον. / οἱ καὶ ἀναγινώσκοντες
εὔχεσθ(ε) δ(ιὰ) τὸν κ(ύριο)ν. εὔχεσθε ὑπερ τε /
αὐτοῦ καὶ ἐμοῦ τοῦ ταπεινοῦ καλοῦ ἱερέ(ως)·
τελειωθεῖσα / μη(νὶ) ἰουλίω κγ, ἔτ(ους) ,Ϛχλβ'·
δόξα τῷ θ(ε)ῷ πάντων / ἔνεκα ἀμήν. +

This book of the holy Gospels was written by the
hand of the humble and unworthy priest Kalos with
the care and eagerness of the most holy among
monks the monk Cosmas who strove with great de-
sire and effort to acquire this book. They who read it
pray to the Lord; pray for him and for me the hum-
ble Kalos, the priest. It was completed on July 23 in
the year 6632 (1124). Glory be to God for every-
thing. Amen. + [It is followed by several τέλος
monograms.]

The first name of the scribe, the priest Kalos, not given
in the colophon, is Ἰωάννης. It was discovered by Harlfin-
ger hidden in the verses to Luke on fol. 149r, verse 4, and to
the evangelists, fol. 322v, verses 6 and 16, and once more,
including his family name, in the verses to John, fol. 242v,
verses 4–5. In his discussion Harlfinger has shown that the
priest John Kalos used twelve-syllable verses, known from
other examples, and replaced the names found in them by
his own.[2]

Condition poor. Parchment has suffered from humid-
ity and is torn and cut at edges. Gatherings are loose and
leaves are missing.

Old red leather binding on boards with pressed orna-
ment, with identical patterns on both covers, poorly pre-
served. The covers are detached from the codex. Both covers
have four parallel frames and a central panel with the fol-
lowing decoration, beginning at the outer border (figs. 464,
465): guilloche, rich rinceau, floral motifs inscribed in small
rectangles, and palmettes in an interlaced heart-shaped ar-
rangement. The central panel or field contains three loz-
enges, one above the other, each with a double-headed eagle.
A round boss in the center and a stud in the form of a leaf,
upper left corner, both of copper, are on the back cover. In
addition to the corner studs, there was originally one on each
side between the corners. This cover, recalling that of cod.
Athens, Nat. Lib. 629, can be assigned to the fourteenth or
fifteenth century and possibly to Sinai itself.[3]

[2] Ibid., *loc. cit.*
[3] Van Regemorter, "Reliure," p. 22, pl. 12b.

Illustration

1r A small crude arch for a Canon table on lower right
column.

1v, 2r–v (fig. 459), 3r–v, 4r–v (fig. 460) Seven Canon ta-
bles (ca. 16.9 x 14.2 cm.) (Canons I–X).

5r Two empty arches for Canon tables. All Canon tables
are almost identical in form and ornament and are
very crude. Two arches, drawn and tinted in muddy
red and blue, rest on three flimsy supports marked by
a series of rings and knots, a diamond ornament, and a
rinceau pattern. On fol. 2v the two arches are joined
in the center by a drawn anthemion, which on fol. 3r
takes an expanded form. On fol. 4r, the tympana
along the inner part of the arch are marked with sim-
ple or crude plaited crosses in red and blue.

6r Unframed Π-shaped headpiece (fig. 461). A series of
interlaced circles divided into four segments contains
palmettes in the form of classical anthemia. Similar
inverted palmettes between the circles. On three cor-
ners a crest-like scroll sprouts from the anthemion.
The colors are muddy red, steel blue, and lemon yel-
low against very dark brown, almost black back-
ground. Initial B formed by two spires. Mt. 1:1ff.

97v Π-shaped headpiece framed by a fillet forming two
knots on the sides and terminating in half palmettes
on the outer corners. Rough interlaced roundels en-
close palmettes imitating fretsaw style in colors as on
fol. 6r, right column. Mk. 1:1ff.

149r Π-shaped headpiece framed by a fillet as on fol. 97v
and a crest-like ornament in black and red at top cen-
ter encloses a crude rinceau with strong spiral motifs
recalling the anthemia of fol. 6r (fig. 462). Florid ini-
tial Є for the Gospel text, with a volute, leaves, and
knots, right column. Lk. 1:1ff.

243r Π-shaped headpiece with a rinceau and initial Є for
the Gospel text, both similar in style to those on
fol. 149r, left column. Jn. 1:1ff.

Style

The colophon gives us the name of the scribe, the priest
Kalos, the owner of the book, the monk Cosmas, and the
date of its completion, but not the place of its production. On
paleographic grounds the codex has been assigned to
Otranto in south Italy.[4] The characteristic features of this
definitely provincial manuscript are the flimsy ringed and
knotted supports in the Canon tables, the knotted fillets and

[4] See Harlfinger et al., p. 44 with references to discussions of paleog-
raphy.

crests on the frames, and the initials with their spiral forms, knots, and bars. These initials, small and florid, are found in manuscripts of various areas from Greece to Jerusalem in the eleventh and twelfth centuries.[5] The knotted columns may reflect a tradition found in the earlier cod. Athos, Dionysiou 2, which has been seen as related to Cyprus.[6] The knotted fillets of the frames and the crest-like ornament on top and sides recall headpieces in the cod. Athens, Nat. Lib. 74, assigned to an Italian circle with strong Coptic and Egyptian influences and connected with Cyprus.[7] However, the palmettes within segments of interlaced circles (fol. 6r, fig. 461) and the overall effect of the ornament bring to mind a headpiece in cod. Vat. gr. 1646, produced in Reggio, Calabria in the year 1118.[8] The evidence for an Italian origin is therefore strengthened.

Bibliography

Kondakov 1882, pp. 103, 159 no. 91.4.
Gardthausen, *Catalogus*, p. 38.
Vogel, Gardthausen, p. 227.
Gregory, *Textkritik*, pp. 247, 1135 no. 1230.
Hatch, *Sinai*, pl. XXIV.
Colwell, Willoughby, *Karahissar*, 1, p. 232.
Lake, *Dated Mss.*, Indices, p. 180.
Devreesse, *Introduction*, pp. 169 n. 10, 304.
Kamil, p. 69 no. 218.
Husmann, p. 150.
A. Jacob, "Les écritures de Terre d'Otrante," in *Paléographie grecque*, pp. 270, 277.
Spatharakis, *Dated Mss.*, p. 41, no. 134, figs. 249, 250.
Voicu, D'Alisera, p. 556.
Harlfinger et al., pp. 44–45, 64 no. 24, pls. 108–11.

**55. COD. 174. FOUR GOSPELS
FIRST HALF OF TWELFTH CENTURY.
FIGS. 466–467**

Vellum. 291 folios, 10.6 x 9.5 cm. One column of nineteen lines. Minuscule script for text, very minute in size, written through and under the line with *Hakenschrift* elements; titles in *Auszeichnungs-Majuskel*. Later gathering numbers at bottom margin of first recto and last verso.

Parchment fine and white. Ink brown for text; titles and opening Gospel headings in gold; all other titles in carmine. Initials in flower petal style and small solid initials in faded carmine, but in gold on opening pages of Gospels.

Fols. 1v–2v, hypothesis and Matthew chapters; 3r–5v, Canon tables; 6r–88r, Matthew; 88v, Mark hypothesis; 89r–140v, Mark; 141r–230v, Luke; 231r–291v, John.

The codex is incomplete at beginning and end. Parchment has suffered a great deal from exposure to heat. Last folios totally worn.

Red leather binding, faded into brown, on wooden boards ornamented on both covers with simple crossing, diagonal lines.

Illustration

3r–v, 4r–v, 5r–v Six Canon tables (ca. 7.7 x 5.5 cm.); that on fol. 3v has no text. Two knotted columns with lyre-shaped capitals support two arches spanned by a larger one within a square drawn in blue and filled with gold. Ornament applied to tympana is mostly gone, except that on fol. 4r where the arch, tympanon, and spandrels are decorated with palmettes in heart forms (fig. 466).

6r Π-shaped headpiece in ordinary flower petal style, flower petals in roundels and large palmettes between, all against gold. Initial B (fig. 467). Mt. 1:1ff.

89r Π-shaped headpiece with blue rosettes in two rows against gold. Initial A. Mk. 1:1ff.

141r Π-shaped headpiece in flower petal style, very rough blue palmettes in roundels. Initial Є. Lk. 1:1ff.

231r Π-shaped headpiece in flower petal style in a zigzag pattern, almost totally flaked. Initial Є in gold only. Jn. 1:1ff.

Style

The flat forms of the flower petals and the stereotyped patterns suggest a twelfth-century date, while the heavy, muddy colors and the meagre quality of the ornament point to a provincial origin for this pocket-sized book.[1]

Bibliography

Kondakov 1882, p. 103.
Gardthausen, *Catalogus*, p. 33.

[5] For examples, see Athens, Nat. Lib. cods. 179 and 166, in Marava-Chatzinicolaou, Toufexi-Paschou, nos. 18 and 40, figs. 144, 145, 404; cod. Jerusalem, Taphou 47, in Hatch, *Jerusalem*, pls. XLVIII and L.

[6] Weitzmann, *Buchmalerei*, pp. 64–65, pl. LXX,414, 415; Canart, "Chypriotes," pp. 39, 71; also *Treasures*, 1, figs. 12, 13.

[7] For a discussion of the various views and bibliographical references see Marava-Chatzinicolaou, Toufexi-Paschou, pp. 76–79, no. 9; cf. also Sinai cod. 401, no. 31 above.

[8] Grabar, *Manuscrits grecs*, no. 27; Spatharakis, *Dated Mss.*, no. 130, fig. 245.

[1] Ornament and initials find parallels in cod. Princeton, Garrett 3 produced in Jerusalem in 1136; see *Greek Mss. Amer. Coll.*, no. 37, fig. 65; Spatharakis, *Dated Mss.*, no. 141, fig. 266; *Byzantium at Princeton*, pp. 154–55, no. 178. Cf. also Athos, Lavra A 58: Spatharakis, *Dated Mss.*, no. 131, fig. 246.

Gregory, *Textkritik*, pp. 246, 1134 no. 1211.

Hatch, *Sinai*, pl. VIII.

H. Buchthal, *Miniature Painting in the Latin Kingdom of Jerusalem*, Oxford 1957, p. 29 n. 4.

Kamil, p. 68 no. 199.

A. Weyl Carr, "Diminutive Byzantine Manuscripts," *Codices manuscripti* 6 (1980) p. 157.

Voicu, D'Alisera, p. 555.

56. COD. 339. GREGORY OF NAZIANZUS, 16 LITURGICAL HOMILIES
CA. A.D. 1136–1155. FIGS. 468–586, COLORPLATES XXI–XXV

Vellum. 437 folios, 32.3 x 25.4 cm. Two columns of twenty-two lines. Minuscule script for text, written under and through the line, carefully spaced letters, calligraphic; titles and dedication, fol. 3r, in *Epigraphische Auszeichnungs-Majuskel*; titles in table of contents and colophon, fols. 2r–v, 437v, in *Auszeichnungs-Majuskel*. Gathering numbers at lower inside corner of first recto and/or lower right of last verso. Parchment white and fine, good quality. Ink black, some folios in dark brown, for text; titles, dedication, colophon, opening lines of first homily, and solid initials in text in gold. The concluding text of four homilies, fols. 73r, 90r, 197r, 396v (figs. 583–586), written in cross form.

Fols. 1r and v, blank; 2r–v, table of contents; 3r, dedication; 3v, blank; 4r, late entry; 4v–437v, Gregory of Nazianzus, sixteen liturgical homilies.

On fol. 3r is the following dedication, written in huge letters (20 mm. high each) in five lines (fig. 470):

+ ἈΦΙΕΡΏΘ(η) Ἡ ΠΑΡΟῦCΑ / ΒΊΒΛΟ(s) Τῇ ΜΟΝῇ ΤῆC ΠΑΝΤΑΝΆCCΗC / ἉΓΊΑC Θ(εοτό)ΚΟΥ Τῇ ᾿ΕΝ Τῇ ΝΉCῳ ΤῆC ἉΓ(ίαs) ΓΛΥΚΕΡΊΑC ΠΑΡᾺ ΤΟῦ / ΚΑΘΗΓΟΥΜ(έ)Ν(ου) ΤῆC ΒΑCΙΛΙΚῆC ΜΟΝῆC ΤΟῦ ΠΑΝΤΟΚΡΆΤΟΡΟC / ΤΟῦ ΜΟΝΑΧΟῦ ΚΥΡΟῦ ἸωCΉΦ ΤΟῦ ἉΪΟΓΛΥΚΕΡΊΤΟΥ:

+ The present book was dedicated to the monastery of the Holy Theotokos Pantanassa on the island of St. Glykeria by the abbot of the imperial monastery of Pantocrator, the monk Joseph Hagioglykerites.

The colophon on fol. 437v, at the lower part of the right column (fig. 471), in a twelve-syllable metric entry, seven verses, reads:

+ τὴν χρυσοτευκτόστικον / ἀργυφῆ βίβλον· / ἥν ἐκρότησε τοῦ θ(εο)ῦ τελ(ῶν) στόμα· / τῶν ποιμεναρχῶν γρη(γό)ρ(ιος) ἀκρότης, / τεύξας μοναστὴς ἰωσὴφ ἀρχηγέτης / μο(νῆς) μοναστ(ῶν) παντοκράτ(ο)ρ(os) λόγ(ου)· / τῆς παντανάσσης τῇ μο(νῇ) δῶρον νέμει· / εἰς λύτρον εἰς κάθαρσιν ἀγνοημάτων +[1]

+ The monk Joseph, leader of the monastery of the Pantocrator-Logos, who made this book glittering with silver-whiteness, dappled with gold, which Gregory the highest of the people-shepherds, being the mouthpiece of God, composed, presents it as a present to the Monastery of the Pantanassa for the cleansing of his sins. +

On fol. 4r, a later entry reads:

+ ἔτους· ˏζυη´· μηνὶ· ἰουλίῳ· α͞η· ἐπροσίλω/σα ἐγὼ γερμανὸς· (μον)αχ(ὸs)· καὶ οἰκονόμος / τῆς κρίτης· τὸ παρὸν βιβλίον ἤγουν / θεολόγος· εἰς τὴν θείαν καὶ ἱερὰ βασιλει/κὴν μονὴν· τῆς μεγάλης ἐκκλησίας· / τοῦ ἁγίου καὶ θεοβαδίστου ὄρους σινὰ.

+ On July 1st of the year 7058 (1550), I, Germanos, monk and oeconomos of Crete, brought this book, that is the Theologos, to the divine and holy royal monastery of the Great Church of the holy and God-trodden Mt. Sinai.

This is followed by the usual curse against book thieves. Under this entry is a monokondylon of bishop Eugenios of Sinai (d. 1538).[2]

Fols. 270, 278, 311–313, and 415 are fifteenth-century parchment replacements for original folios, probably with miniatures, which were cut out. On the verso sides of these folios space has been left empty, perhaps for illustrations which were never produced.

The condition of the codex is good, though first and last gatherings are loose with some leaves missing. The covers are completely detached from the codex.

Old binding of brown leather on wooden boards with pressed ornament similar on both covers (figs. 468, 469). Three frames have the following motifs, pressed with rectangular stamps: a heart-shaped guilloche, almond rosettes

[1] On the vocabulary of this colophon see remarks by Noret, *Byzantion* 1978, p. 157 n. 9.

[2] On the significance of this entry and another, later entry on the later

back flyleaf, see Noret, *Byzantion* 1978, p. 158 n. 15, and Harlfinger et al., p. 47.

in diamonds and half diamonds, and a regular rinceau in scroll-like forms. These frames are separated by triple lines forming rectangles with small rosettes on each corner. In the central field, lines form an irregular Maltese cross marked with lilies in medallions, two large triangles with a mask encircled with leaves and flanked by a rinceau, two smaller triangles with basiliscs (?) and rosettes. Five round metal studs are on the front cover, three on the back. Two straps for closing are on the front cover. Three red circles in a guilloche-like pattern are depicted on all edges of the book cut. These motifs and forms appear on covers considered Byzantine and attributed to the fourteenth or fifteenth century, such as Athens, Nat. Lib. 629.³ The masks on the Sinai cover, however, indicate a later date, in the early part of the sixteenth century. The binding was done in Crete.

Illustration

Apart from the author portrait, each homily is illustrated with a large rectangular title miniature and a historiated initial referring to the text; several homilies contain additional illustrations in the margins. In addition, there are throughout the text 214 figural initials, zoomorphic genre scenes which do not illustrate the text, most of them delineated in gold; there are also hundreds of solid gold initials, very delicate, with small crosses or floral motifs. The title miniatures have frames with flower petal ornament defined by delicate fillets or bands and palmettes on the two upper corners and on the extended lines of the lower frame. The rendering of the palmettes varies considerably. The representations take the form—rectangular or centralized—of insets in these often multiple frames ornamented in brilliant colors set against gold. All scenes in these insets are against a gold background.

4v The author portrait (22.7 x 17.6 cm., including the crosses and lower half palmettes) (fig. 472). Gregory, clad in brown and black-green monks' vestments, sits on a chair facing to the right, beneath a tripartite arch decorated with flower petals and supported by knotted porphyry colonnettes with red bases, blue capitals, and spandrels in *verde antico* adorned with two porphyry discs. In his left hand he holds a piece of parchment on which he is about to write, receiving inspiration from a bust of Christ (I̅C̅ X̅C̅) above. Christ, clad in blue and carmine with gold highlights, appears from a sky of three different tones of blue and extends his hand in blessing. Gregory's expressive face, in red-brown tones, is framed by grey hair and

beard and a nimbus with a crenellation pattern imitating enamel work. His high-backed brown chair is decorated in gold, while the top of the footstool has a gold hatched pattern. A violet lectern with gold highlights holding an open codex stands on a red-brown table before the author. The ground takes the appearance of an inlaid marble floor. The scene is set within a grandiose architectural complex copying real church architecture. At the roof line are juxtaposed a number of architectural forms: five domes (the one in the left foreground with a conical form), two conical steeples, blue gabled roofs, and walls in red and *verde antico*. Domes and steeples are crowned by delicate gold and white crosses. Through the drum of the large central dome one can see the apse of the church with the seated Virgin (M̅P̅ Θ̅Y̅) in blue and carmine, holding the Christ Child clad in yellow and brown. The garments have gold striations and the background is gold. The small side domes with latticed windows rest on walls with speckled panels of polychrome marble revetment which have a window on the right decorated with geometric patterns, counterbalanced by a door on the left adorned with double crosses, behind a chancel slab in blue and white. Both window and door have moldings. Below and at either side are archways with doors made of chancel slabs, affording twin garden vistas with trees and flowers against a glittering gold background. In the center foreground a white-pink wall supports the arch that encloses Gregory with two black niches containing fountains of different design. A red and gold fillet, imitating filigree work, defines the lower part of the composition with two palmettes at its ends.

5r Anastasis (15 x 15 cm. without palmettes); the same scene in initial A (fig. 473). Multiple frames defined by filigree fillets are decorated with open flower petals, rosettes bordered above and below with flower petals and stems, and a rich flower rinceau with small leaves stemming from a central vase resting on acanthus leaves. The inset enclosing the scene has the form of a quatrefoil with a crenellated frame, enamel-like in blue, red, white, and green. Christ, in light purple and blue garments with gold highlights, holding the patriarchal cross, is depicted striding from left to right across the brown rocks of the cave and the broken gates of Hell. He approaches and seizes Adam with his outstretched right arm (on the palm of the hand is

³ Van Regemorter, "Reliure," pl. 12a; and cods. Oxford, Auct. T. inf. 1.3, and Laud. gr. 90: Hutter, *Oxford*, 1, nos. 43, 60, figs. 288, 381.

visible the stigma) and raises him from a sarcophagus. Behind Adam, dressed in light blue and carmine, are Eve in red and Abel in the lightest pink-grey holding a red staff. The prophet kings David and Solomon, in red and blue, and John the Baptist stand in a sarcophagus on the left. Under Christ's right foot and within the black interior of Hell one recognizes Hades by his white hair (his flesh is very dark brown) and a loincloth. The palmettes on the extended filigree fillet are plant- and tree-like. The initial A is formed by a larger figure of Christ on the right, raising Adam and Eve from a sarcophagus on the opposite side. First Homily on Easter (*PG* 35, 396).

The following figural initials appear in the same homily:

6r X with two birds in yellow, blue, and white.

7r Φ with two blue, red, and dotted partridges perched on a stem (the hasta of the letter) and pecking at leaves (fig. 487).

8v Υ with two dogs, with red bands on their necks. Standing on a foliate base in the form of an inverted capital, their tails entwined, the dogs attempt to jump in opposite directions (fig. 488). This form of the base, with variations, is found in several of these initials.

9v 1) The so-called vision of Habakkuk (13 x 15 cm. without palmettes) (fig. 474); 2) the same scene but reduced, and Gregory teaching in initial Є; 3) the Vision of Habakkuk with Christos-Angelos on the left margin (10 x 4.5 cm.).

1) A wide frame, defined by a filigree fillet, filled with a flower petal ornament in scroll patterns in a variety of designs, creating a tile-like effect: joined heart forms, rosettes, ovals with pink flowers and light green calyxes. The youthful Christ-Emmanuel, in carmine and blue garments with gold highlights, seated on a light blue, double arc of heaven, is depicted in the inner square. He rests his feet on another rainbow-strip within a three-colored blue aureole which is carried by the four zodia—the Angel, Lion, Calf, and Eagle—in grey and yellow-brown colors. Christ holds a golden book in his left hand and extends his right toward Gregory, who is represented as a bishop, below on the left, counterbalanced by the youthful Habakkuk. Both the author of the homily and the prophet, in blue and purple-carmine garments, gaze at the vision. Gregory seems to address Christ, while Habakkuk points to the scroll that he holds in his left hand.

2) The initial Є, decorated in flower petal style, contains Gregory on the left, in vestments as above, seated on the leafy stem of the letter and extending his right hand in a teaching gesture. Habakkuk, standing opposite on a smaller scale, extends his right hand toward Gregory. Both figures are set on a foliate base in the form of an inverted capital. Above, a bust of Christ leaning out of a segment of sky has replaced the complete vision found in the title miniature.

3) Next to the initial, in the left margin, are Gregory and Habakkuk, similar in garments, colors, and general stance to those in the title miniature, except that Gregory's left hand is raised in a more expressive and vivid gesture. Both are gazing at the Theophany, now rendered differently. A mandorla in three tones of blue encloses a standing, gold-nimbed angel who appears out of a series of red rays. Clad in light brown and light olive garments with wide open black wings with carmine tips, the angel extends his right hand in blessing. On the evidence of other related codices with inscriptions, the angel can be identified as Christos-Angelos, ἄγγελος μεγάλης βουλῆς, i.e., the Messenger of Great Counsel.[4] Archangels in dark pink and gold garments, all carrying scepters, stand behind the mandorla. Second Homily on Easter (*PG* 36, 624). The homily also contains the following ten figural initials:

10r K with a long-legged falcon in enamel-like green, blue, and pink perched on a pink sphere (fig. 489).

12r M with two yellow birds with red bands on their necks.

13v T with two entwined serpents, flower petals suspended from their mouths.

16r Є with a green and white-pink bird on the crossbar.

17v Δ with a bird of prey perching on a red and blue flower.

23r T rendered in flower petal style, held in the mouth of a fox (fig. 490).

26v O with a fox biting its tail.

28r Є in flower petal style with a parrot at the lower bow and a jumping hare at the cross-stroke (fig. 491).

30r Π with a heraldic blue, red-dotted eagle on top of two flower-petal stems (fig. 492).

39v Π with two birds perched on flower stems and joining beaks.

42v 1) Gregory teaching, Mamas as shepherd (9.3 x 14.3 cm.) (fig. 475); 2) Gregory teaching on the "Encaenia" in initial Є; 3) the consecration of a church; and

[4] Galavaris, *Liturgical Homilies*, pp. 120ff.

142

4) the incredulity of Thomas, the latter two on the left margin (ca. 4.7 x 4.7 cm.).

1) A wide frame, defined by an outer border with delicate clusters of flowers alternating with heart-shaped leaves, contains a rich, regular rinceau ornament: stems with large acanthus leaves, joined by rings with flower petals above and below the ring and rolling out into circular forms, terminate in open calyxes. Smaller circles, medallion-like within the rich rinceau, contain flowers and a large rose-like blossoming calyx in the center. An inner square with a cyma border encloses the scene. Gregory standing on the left in purple and blue bishops' vestments, nimbed and holding a golden book, addresses Mamas, who is represented as a shepherd. Clad in a short blue tunic and *anaxyrides*, nimbed, and holding a red staff, Mamas sits on top of a mountain in the form of two hills in green, brown, and carmine colors. He turns his head and gazes at Gregory. Two light brown deer, looking in different directions, are on the hill at the right. The stylized palmettes on the top corners recall tiles or engraved metal discs. The composite palmette at the lower left resembles a flourished tree, while the one on the right is more delicate and curled as if blown by the wind.

2) The initial Є is formed by the teaching Gregory in bishops' vestments (his face, expressing determination, is set against a gold nimbus) and a small bust of Christ above. Opposite Gregory, on the lower bow of the letter, on a foliate pedestal in the form of a canister, stand three worshippers before the open red doors of a blue-domed church; in its black interior is a lighted red candle on a gold candlestick. The scene portrays a specific part of the ceremony of the encaenia, the lighting of the candle on the altar.[5]

3) In the lower left margin, Gregory, identified by his physiognomy, with blue-grey hair, in light olive garments and with a gold nimbus, kneels in front of an altar set under a ciborium with light pink and green columns, and touches its dark porphyry column. A young deacon with black hair, his arms crossed in devotion on his chest, stands behind Gregory looking outside the picture, as if at an invisible congregation. This scene represents the "anointing of the altar," the central rite of the Feast of the Encaenia of a church.[6]

4) A hieratic figure of Christ, in brown and blue garments, flanked by the disciples, grasps Thomas' hand to apply it to the scar of his wound. Thomas stands in the group at the left, which is headed by John (here the apostles are clad in blue and light brown garments); he is dressed in blue and carmine robes and depicted in profile, leaning forcefully forward with his head upward in eagerness. The group at the right is headed by Peter in blue and olive colors, while the apostles behind him are in blue and carmine and display vivid, expressive faces. The scene takes place against a large, closed, light brown door with a frame in a lighter brown and on a variegated marble floor. Homily on New Sunday (*PG* 36, 608).

The following initials belong to the same homily:

43r Є with two falcons in blue and green on the upper and lower bows, chasing a hare at the crossbar (fig. 493).

47r, 49r O formed by a fish designed in gold (fig. 494).

51v A with the head of a dog designed in gold only.

53r Mamas milking, right margin (4.8 x 6.4 cm.) (fig. 476). Nimbed and clad in tunic and chlamys in light blue and carmine colors, Mamas is milking a black-grey doe, pouring the milk into a brown vessel. The doe, with a naturalistically rendered curiosity, turns its head back and looks at Mamas. A second, brown doe gazing straight ahead, outside the picture, stands beside the first. A brown mountain with a black cave and blue-grey plant is behind Mamas. Same homily.

54r Pentecost (13.3 x 14.4 cm.) (fig. 477). A frame, bordered on all sides by a simple fillet marked at intervals by pairs of dots, is carpeted with a *millefiori* pattern. A second, wide frame encloses a circle with a cyma pattern, the "inset" within the scene. The space between the circular and rectangular frames is filled with flower petals in an intricate rinceau pattern. Stems with leaves in small scale, petals, calyxes, and flowers sprout from a cluster of rich acanthus leaves at the lower center, arranged in a scrolled, cartouche-like form flanked by two deer. The one at the left seems to search through the leaves; that at the right turns his head suddenly back, as if hearing an unexpected sound. The inner circle encloses the Pentecost scene. The apostles, in blue, light brown, and carmine garments, with Peter and Paul prominently represented on top, are seated on a brown bench in a

[5] For the ceremony see G. Galavaris, "Some Aspects of Symbolic Use of Lights in the Eastern Church: Candles, Lamps, and Ostrich Eggs," in *Essays Presented to Sir Steven Runciman = Byzantine and Modern Greek Studies* 4 (1978) pp. 69–78, esp. 72f.

[6] For a discussion see Galavaris, *Liturgical Homilies*, pp. 38ff.; and for the proposal of a different but untenable interpretation see Walter, *Art*, pp. 158ff.

semicircular arrangement heightened to the proportions of an arched doorway. Red tongues of fire emanate from a segment of sky. In the black opening underneath the bench are placed the representations of the peoples and tongues: two old men in blue and carmine (one has dishevelled blue-grey hair) stand on the left; two young men in red and blue are on the right. Of the four palmettes, the one on the lower right, with a ringed trunk and rich curled leaves, bears two pomegranates heraldically arranged. The same scene, but without the representations of peoples and tongues, forms the initial Π. The tongues of fire are here depicted below the extended line of the fillet of the title miniature. Homily on Pentecost (*PG* 36, 428).

The following figural initials are found in the same homily:

54v Є with two birds of prey above on the upper bow and the crossbar, and a proud peacock standing on a foliate pedestal forming the lower bow (fig. 495).

62r O with a fish designed in gold only.

73r Cross page with gold petals at the corners and Φ(ῶς) Χ(ριστοῦ) Φ(αίνει) Π(ᾶσιν) in gold (fig. 583).

73v 1) Gregory as author and Julian the Tax Collector (12.1 x 14.3 cm.) (fig. 478); 2) Gregory and the scribes, in initial T and lower left margin (3 x 2 cm.); 3) Julian as moneychanger, in the upper left margin (5.5 x 5.7 cm.).

1) A wide frame, bordered on the outer side by a narrow gold-defined band decorated with flower petals, calyxes with buds, and a simple filigree fillet on the inner side, contains a lush flower petal ornament. In the lower center, a large palmette with curly leaves springs forth from a series of rich acanthus leaves; from the stems of the palmettes at either side sprout calyxes forming a cornucopia pattern, stems and flowers like garlands in an overall candelabra pattern. As in all other cases, a contrast between the palmettes on the lower ends appears here also: a strong, erect palmette is contrasted to a smaller, more bending one. In the inner square on the left, Gregory, dressed in a brown monastic habit with a black megaloschema, sits on a large, high-backed chair and writes in a codex held in his left hand. He is balanced by Julian the Tax Collector seated on a brown faldstool. Clad in a long carmine robe and wearing a tall white cap, Julian is represented as a bearded old man writing on a piece of parchment. A group of officials, the scribes, stands between the two writers. Three of them, in

long black garments with gold striations and tall white caps, differentiated by age, are grouped together. The two who are fully shown hold scrolls and inkwells. A fourth scribe in similar garments but in different colors (white-blue and light steel blue), also holding a scroll and an inkwell, turns slightly toward Julian. Minor changes in the position of their heads convey their listening and attentiveness.

2) The hasta of the initial T is formed by Gregory represented as a bishop holding a book and standing frontally on a foliate pedestal. Two scribes, depicted as in the title miniature but in light green, blue, red, and carmine colors with gold striations, stand frontally beside Gregory in the margin.

3) In the upper left margin, Julian, dressed in his official costume with gold brocade, sits on a brown chair with red cushion in front of a black table with coins on it. He holds a piece of parchment in his right hand and extends his left in a gesture of demanding or receiving the money tribute. A scribe stands behind him and before a tall pink building with a saddled roof flanked by two blue cupolas. In the center, behind the table, another official is shown in grey-green robes and white cap holding a pair of gold scales with one hand while extending the other toward a group of three people of various ages, at the right side. One of them, a beardless young man, delivers his coin onto the table. In the background to the right, a man leads three others with a rope fastened around their necks down a brown mountain. They are all clad in carmine, yellow-brown, and red. Homily to Julian the Tax Collector (*PG* 35, 1044).

The following initials appear in the same homily:

74r Є formed by a peacock holding a flower petal in its beak and perched on a foliate pedestal (fig. 496).

79v O with fish outlined in gold only.

81r M with two hares facing one another with their legs joined and leaning against two foliate stems (fig. 497).

81v Φ with two birds (canaries?) pecking at the leaves of a flower-petalled stem (fig. 498).

86v Δ with a fox jumping across two stems and catching one of them in its mouth (fig. 499).

90r Cross page with gold floral motifs at the corners and ’ΙϹ̅ Χ̅Ϲ̅ ΝΙ ΚΆ in gold (fig. 584).

91r The Nativity (13.1 x 14.6 cm.) (fig. 479). A band-like outer frame, defined by filigree fillets, is decorated with delicate petalled flowers in a chevron-like pattern. Another frame, enclosing the four-lobed panel-inset with the scene (the latter bordered by a cyma), is

filled with flower petal ornament. A rinceau, running from lower center to upper center, develops into four large corner roundels with smaller scrolls between, all symmetrically arranged. Each of the corner roundels, their borders carpeted with open flowers in tile-like patterns, encloses one extremely rich whirling palmette.

The Nativity is represented as a liturgical feast picture rendered conventionally. The Virgin in blue and carmine with a gold nimbus lies on a red mattress in front of the cave. The Christ Child in light blue swaddling clothes lies in a light brown manger with the ass and the ox beside him in light blue and brown respectively. At the lower left, the pensive Joseph in blue and carmine is seated on a rock amidst bushes, with his back turned to infant and mother. Below, in the foreground, is the Bathing of the Child. The naked, nimbed infant, supported by a midwife seated on the left in red and with a white headdress, is seated in a golden chalice-like basin. The midwife at the right, clad in blue, holding a golden vessel and a white napkin, bends slightly toward the child. The composition includes the Annunciation to the Shepherds who, depicted on the right in black, blue, and red garments, receive the message brought to them by an angel appearing from behind a mountain. Opposite, on the left side, the three Magi, in red, carmine, and blue, all with red tiaras, approach the mother and child in adoration. The Virgin, resting her head on her hand, turns slightly toward them. Five angels singing the Doxology are on top of the mountain.

The essential features of the title miniature have been used to form the initial X: the reclining Virgin and the child in the manger are in the center; the pensive Joseph in expressive profile and a midwife bathing the child are below, with two flying angels above. Homily on the Nativity (*PG* 36, 312).

91v In the left margin (3 x 2.2 cm.) (fig. 480), is a group of five women—the one in the foreground is prostrating herself—all wearing tunics in brown, grey-blue, and carmine, and mantles in olive green, carmine, and red, worshipping the Virgin Blachernitissa enclosed in a quatrefoil with gold background, forming the center of the initial X. This scene is found in the same homily and serves as text illustration (*PG* 36, 313).

The following figural initials belong to the same homily but do not relate to its text:

92v T with a leopard with a red collar standing on a foli-

ate pedestal, its jaws on a fox which attempts to flee (fig. 500).

95r A with bird outlined in gold only.

97r Θ with two large birds joining beaks, wings, and tails (fig. 501).

101v Π with two partridges (?), the backs of their heads joined on top of two flower-petalled stems (fig. 502).

103v X with two leopards with red collars (fig. 503).

105r M with two blue cranes in the middle, each pecking at a foliate stem on the sides (fig. 504).

105v C with a long, coiling blue and green serpent (fig. 505).

106v N with a bird of prey between two flower-petalled stems (fig. 506).

107r M with two birds between two foliate stems, at a fountain with a gold pinecone.

108r C with a peacock perched on a pedestal (fig. 507).

109r The Koimesis of Basil the Great (11.5 x 14.6 cm.) (fig. 481). A filigree fillet defines the outer sides of the frame which is decorated in flower petal style in an intricate design of large diamonds and half diamonds, creating a tile-like effect. A cyma band borders the inset with the funeral scene. The central part is occupied by the body of Basil, in white bishops' vestments, resting on a blue mattress arranged in a sweeping curve and set on a bier covered with a carmine, gold-ornamented drape. Gregory Nazianzenus, nimbed and, like Basil, in bishops' vestments (white omophorion with black crosses and a phelonion with red crosses, polystavrion), holds a gold book in his left hand and extends his right as if addressing his dead friend. Two groups of mourners, all bishops in blue and carmine vestments, flank the bier. The leader of the group to the right has a gold codex in his hands, while his counterpart in the lefthand group holds a pyxis and swings a censer, both in gold. A figure of Gregory teaching, in purple bishops' vestments and with a golden book, stands behind the foliate stem of the initial Є. Funeral Oration on Basil the Great (*PG* 36, 493).

The following initials appear in the same homily:

109v M with two birds at a fountain; Є in flower petal style with a blessing hand at the crossbar.

110v Π with a quadruped sitting on two vertical stems (fig. 508).

111v T with a heraldic eagle on a vertical stem (fig. 509).

112r Є with a fox lying on the crossbar and gazing at its tail, which forms the upper bow of the letter (fig. 510).

113r Δ with a long, coiling serpent of green, blue, and white with a green head, swallowing a small gold bird on top (fig. 511). A with two birds perching on a sphere and joining their beaks at a flower stem with a palmette (fig. 512).

114v Є with a rampant pink griffin with yellow wings turning its head back (fig. 513).

116r T with two blue-yellow serpents emerging from a flower stem.

118r Є with a bird of prey about to fly from a foliate stem (fig. 514).

120r T with two small birds pecking in opposite directions at a flower stem.

122r H with two small birds perched on separate red spheres; their raised wings form the crossbar.

122v Є with a grey-blue circus cat (or monkey?) playing a gold-framed, yellow harp on the upper bow (fig. 515). Є with a grey cat or a monkey, standing on a pedestal and blowing a gold trumpet (forming the crossbar of the letter) to the delight of a dog (lower bow), who looks on attentively. Two small flying birds (upper bow) join their beaks and one leg (fig. 516).

123r Γ with a standing leopard grabbing the legs of a flee-ing rabbit above (fig. 517).

124r Π with a quadruped on top.

125v O with a gold-defined blue frame decorated with acanthus-leaves enclosing a bird against a gold ground (fig. 518).

126v Є with a jumping fox eating a flower, its tail forming the upper bow of the letter (fig. 519).

129r Δ with two blue and yellow birds joining their beaks at a gold stem with a blue flower (fig. 520), a variant of the initial Φ on fol. 7r (fig. 487).

129v K with a quadruped leaning against a flower stem.

130v T with coiling snakes.

131v Δ with two butting light brown goats on a floral ground (fig. 521).

133r B with a serpent coiling around a floral stem on top of which are two birds pecking at a leaf (fig. 522).

134v Γ with a stem from which emerges the green head of a quadruped snatching a running green lizard (fig. 523).

135v N with coiling serpent.

137r A with a peacock perching on a leaf and pecking at a foliate stem (fig. 524).

138r T with two small pink birds at a fountain atop a foli-ate stem.

138v O with a fish delineated in gold only.

139r Π with two standing foxes joining muzzles and paws at a round red object, probably food (fig. 525).

140r I with the head of a rose; canine rising from a foliate stem.

141v O with two peacocks joining beaks and tails (fig. 526).

143r M with two standing stags drinking at a gold pine-cone fountain set on top of a flower-petalled stem (fig. 527).

144v Δ with a lamb supporting two flower stems.

145v O with two peacocks as on fol. 141v.

147r X with two hares jumping downward from a central ring and gazing at two small birds heraldically ar-ranged (fig. 528).

148v T, two lions with one head carrying the foliate letter (fig. 529).

151r H with a coiling serpent on two vertical stems.

152v K with two birds at a floral stem, one standing below and the other flying from above (fig. 530).

154r O with two serpents.

156v Γ with a small serpent emerging from a foliate stem.

159r Є with a lion standing on the crossbar, its tail forming the upper bow of the letter.

162r T with two small yellow birds in the mouths of two blue serpents coming out of a foliate stem.

162v Є with two birds of prey; the one below has caught a small partridge; the one above is chasing a fleeing hare at the crossbar (fig. 531).

164v Λ with a fox attacking a bird (fig. 532).

166v Γ with a small bird on top of a foliate stem.

167r O with a blue-white snake, its green head biting its tail.

168v T with two serpents coming out of a foliate stem.

169v X with two birds.

172v A with a yellow-blue serpent biting a stem.

175r C with a blue serpent.

179v T with a blue heron swallowing two blue and yellow serpents (fig. 533).

185v Φ with two parrots pecking at a leafy stem (fig. 534).

189r Δ with a white stork on a floral ground (fig. 535).

191v T in the mouth of a dog, a variant of that on fol. 23r.

192v O with a bird in a disc against gold.

193r Γ with an upright bird, a fish at its beak.

194r A with a coiling blue-green serpent biting a stem as on fol. 172v.

195r K with a small flying bird.

195v Δ with a pink griffin biting its carmine wing, on a leafy stem (fig. 536).

197r Cross page with gold leaves at corners and letters $\overline{\Phi}\,\overline{X}$ $\overline{\Phi}\,\overline{\Pi}$ (Φῶς Χριστοῦ Φαίνει Πᾶσιν) (fig. 585).

197v The Baptism of Christ (10.3 x 14.4 cm.) (fig. 482). Filigree fillets, as on fol. 9v, define a wide frame filled with a foliate rinceau pattern. Stems sprouting from a central palmette like a candelabrum form medallions with palmettes, flower petals and calyxes between, which enclose either a single lush palmette with curled leaves or smaller ones in a rosette pattern; on the whole this is a variant of the ornament on fol. 91v. The baptism scene is depicted as a feast picture. Christ, his flesh tones light brown, is immersed in the light blue waters of the Jordan, which he blesses. The personified Jordan (the illustration at this point is mostly flaked) reclines with a gold urn in his hand. One person swims on the opposite side. John, in dark brown *tunica exomis*, standing on the yellow-brown bank, bends slightly and places his right hand on Christ's head. At the opposite bank are three adoring angels in carmine, light blue, and green. Behind the lefthand river bank two disciples, identifiable by their physiognomies, bear testimony to Christ's baptism: Andrew in brown garments and with dishevelled white hair, and John in carmine (cf. Jn. 1:35). A segment of blue sky above, fragments of an inscription in red on the gold background. John and Christ with a segment of the river form the initial Π. Homily on Epiphany (*PG* 36, 336).

The homily also contains the following eleven figural initials:

197v A with a fox jumping at a foliate stem.

198r K with a yellow-blue serpent coiling around a stem.

198v O with two birds, tails and beaks joined, perched on a red sphere.

199r M with two yellow-green parrots forming the hasta of the letter.

203v Φ with two serpents at a foliate stem.

207r C with a parrot forming the lower bow of a floral stem.

209v A with a blue heron pecking at a flower stem.

211v I with a bird perched on a red sphere.

213v K with two birds flying toward a stem.

215r O with a peacock.

216v N with a serpent coiling around two stems.

217r Teaching scene (9.4 x 14.5 cm.) (fig. 483). Filigree fillets define and divide a wide frame into oblongs and squares, enclosing tile-like rosettes at their four corners. The oblongs are decorated with composite palmettes in roundels, joined by sprouting leaves and flower petals. In the inner rectangle, Gregory in bishops' vestments of blue and carmine, seated on a

brown, backless chair with a red cushion, and with a gold book in his hand, faces the spectator. He is flanked by two groups of attentive bishops of different ages holding golden books. The baptism of Christ forms the initial X. John, clad in a yellow-brown chlamys and a dark olive tunic, places his hand on the head of Christ, who is immersed in the very light blue water of the Jordan. Two angels dressed in carmine garments fly down from above. Homily on Baptism (*PG* 36, 360).

The following figural initials also belong to the same homily:

217v C with a fox standing on a foliate pedestal and, as if performing, turning around to look at its upright tail (fig. 537).

219r C with a curled fox biting a piece of food (fig. 538). Γ with a fox jumping from above and catching a rooster with muzzle and claws (fig. 539).

221r Φ with two grey foxes with intertwined tails holding a palmette at their muzzles.

223r Δ with a bird of prey attacking another (fig. 540).

224v A with a white stork biting a long, coiling yellow-green serpent (fig. 541).

226v Є with a blessing hand.

232r A with a flute-playing grey-blue monkey and a tiny brown rabbit hidden between its tail and legs (fig. 542).

234v Γ with a crane biting a leaf; P with a griffin biting its wings.

237r Δ with a stork biting a coiling serpent.

238v T with the head of a caterpillar emerging out of a stem.

240v ω with two peacocks joining tails.

243r B with a fox raising its tail and grabbing a flower stem, a variant of that on fol. 217v.

245r O with a circus elephant (fig. 543).

245v K with a griffin.

249r C with a bird perched on a red sphere, a variant of that on fol. 10r.

251v Є with a heron biting a serpent; Z with a serpent.

253r M with a small heron on a red sphere between two stems.

255v K with a peacock perched on a red sphere.

258v O with two blue cranes.

261r K with two coiling snakes.

262v Γ with two jugglers. One, in a circus costume, supports on his head a spiral pole which takes the form of the letter; another performer, a child (?) also in circus

costume, attempts to balance himself on this pole at the extreme right (fig. 544).

266v Є with caterpillar at the crossbar.

269r Є with two foxes on the upper and lower bows, intertwining their tails at the crossbar (fig. 545).

The following figural initials belong to the Homily addressed to Gregory of Nyssa (*PG* 35, 832), whose original opening text is missing; it surely contained a title miniature and a historiated initial:

271r Є with a blue crane with upturned tail and outspread wing; its neck and beak form the crossbar of the letter (fig. 546).

272r X with a bird perched on a sphere.

272v Φ with a dancing bear (fig. 547); ω with two birds at a pinecone fountain (fig. 548).

276r Λ with a lion leaping at the throat of a bull (fig. 549).

The following initials belong to the Homily on Athanasios the Great (*PG* 35, 1081), whose original opening text with its title miniature and historiated initial is now missing:

279r Γ with a seated dog holding a hare.

280r Δ with a doe on a floral stem.

282v K with a long, coiling serpent (fig. 550).

285r P with a bear holding a bunch of grapes over a bowl in order to squeeze them (fig. 551).

286v Δ with a falcon on a foliate ground (fig. 552).

287v K with a bird of prey.

289v K with a grey circus cat or monkey as juggler, with a red cap on its head, holding a red racket in his right paw and a red ball in his raised left paw (fig. 553).

290v Y with two serpents.

293r M with two circus monkeys with red-brown feathers (caps?) on their heads, eating from a bowl placed on top of a foliate stem (fig. 554).

294r Є with a rose-colored griffin perched on the crossbar and licking his paw forming the upper bow, and a blue serpent coiling around the stem of the lower bow (fig. 555).

296r O with a brown bird of prey holding a small hare.

298r B with a coiling snake.

300v N with two birds perched on small spheres, facing one another. The raised wing of the bird at the left forms the diagonal of the letter.

301v T with a lion seated frontally on a high pedestal (resembling the pose of the god Bes?), with a leafy scroll-like stem at his neck (fig. 556).

304v T with a blue heron.

305v Θ with two birds facing one another, perched on a sphere.

307v T with two quadrupeds jumping out of a foliate stem.

310r N with a leopard.

The following initials belong to the Farewell Oration delivered before 150 Bishops (*PG* 36, 1081), of which the original, opening text with its title miniature and historiated initial is now missing:

314r C with two canines, one leaping and catching the tail and legs of the other (fig. 557).

315v T with a bird of prey perched on a sphere.

317v O with a quail seated on a nest with eggs; the blue ring is decorated with a cyma pattern (fig. 558).

318v Γ with a bird on top of a stem.

320r Є with a griffin perched on the edge of a foliate base, looking back at two intertwined snakes forming the upper bow and the crossbar of the letter (fig. 559).

322r M with a bird looking like a sphinx, perched on a vase-like pedestal between two flower-petalled stems (fig. 560).

322v A with a parrot biting a leafy stem.

325r Є with a circus cat wearing a decorated red girdle around its waist, holding a gold bowl; a dark brown bird over it. The cat is stepping on a coiling blue snake which raises its head (fig. 561).

327r M with two birds on spheres and a stem between them, a variant of that on fol. 105r.

328v Δ with a pink griffin seated on its long tail and biting its yellow-brown wing (fig. 562).

330v Є with two birds of prey, the upper and lower bows, attacking another bird (pheasant?) forming the crossbar (fig. 563).

332r Y with a long-horned, relaxing antelope, depicted in profile (fig. 564).

333r Δ with a bird of prey and a serpent.

334v T with a circus cat (or a monkey?) wearing a decorated girdle as on fol. 325r and a striped cap; standing on a pedestal, it plays the violin (fig. 565).

337r O with a quadruped.

338v Θ with a fox which, looking at its tail, hides under a blossomed stem on which perch two quails joining their beaks (fig. 566).

340v X with two long-tailed birds flying in opposite directions but turning their heads toward one another (fig. 567).

341r X with two serpents (fig. 568).

341v 1) Gregory addressing the poor (10.9 x 14.5 cm.) (fig. 484); 2) Gregory giving alms (3 x 2.2 cm.), in the initial and left margin.

1) Filigree fillets, as on fol. 197v, define a frame decorated with a rinceau. Stems with palmettes form roundels, each enclosing a wind-blown palmette except the four medallions on the corners, which have rayed, pink rosettes. Between the roundels are stems with rich, sprouting acanthus leaves in a garland-like arrangement flanked by palmettes. The palmettes on the upper corners are in the form of curled, three-petalled flowers. The inner rectangle encloses the nimbed Gregory, at the left, dressed in bishops' vestments in the usual colors (carmine, dark brown, white), with a gold book in his hand. He stands before a tall building with a blue archway, a carmine wall with a window, and a red tiled roof. He is addressing the poor and the disabled, led by a young man, an amputee, who has managed to reach Gregory with the aid of his crutches. Behind him is a bearded old man, a hunchback holding a stick in his left hand, his age weighing on his legs. The following figure, another young man, is blind. All three extend their left hands toward Gregory as if beseeching him or demanding alms. The remaining figures among these "poor and wretched ones," differentiated in age, stance, and gestures, express restrained sorrow in their faces.

2) The initial A is formed by an imposing figure of Gregory as bishop at the right, giving alms to one of three poor people, represented on a smaller scale opposite him. A second figure extends his hand, while a third one, partially visible, waits his turn. They are followed at a certain distance by the amputee and the blind man, both raising their left hands in beseeching gestures. Homily on the Love of the Poor (*PG* 35, 857).

The following initials belong to the same homily:

342v Π with two partridges on spheres holding a leaf.

344v H with a winged centaur musing over the music he makes on his lute (fig. 569).

347r Ѡ with two serpents.

349r O with a partridge and a dog-headed snake biting each other (fig. 570).

350v K with a peacock leaning against a stem.

353r K with a bird perched on a sphere.

354v Δ with a long-legged bird on flower petals (fig. 571).

357r A with a partridge pecking at a stem.

357v H with a seated quadruped.

359v M with a heraldic eagle perched on a sphere (fig. 572).

361v M with a long, coiling serpent.

365r K with a bird on a sphere.

366v A with a griffin turning back and biting its wing.

368v P with a seated leopard licking at its paw (fig. 573).

370v Γ with a snake.

375r O with two long-tailed birds joining their beaks and tails.

377r Λ with a golden bird of prey carrying a serpent upward (fig. 574).

378v Є with a camel, turning its head back and raising its tail, and stepping on an enormous coiling serpent (fig. 575).

381v The martyrdom of the seven Maccabees and Eleazar in six scenes (10.4 x 14.3 cm.) (fig. 485). The band-like frame, bordered by a filigree fillet, is decorated with pearl-studded rosettes with inverted three-petalled flowers between them. The large Sassanian palmette on the extended left end of the fillet is depicted as if blown by the wind. In the inset, the six scenes in two rows, each bordered by a simple fillet marked at intervals with pairs of rings, represent from upper left to lower right:

1) Before a brown mountain, a soldier with a pointed beard and brown armor with gold striations, pushes the old and bent Eleazar, with blue-white garments and hair, into a raging fire.

2) Two of the Maccabees, each on a separate wheel, are tortured by two men, one old and balding with a white beard, and the other young, who operate the wheels with great force. Various instruments of torture are on top of the yellow wall in the background.

3) Before a mountain segment, a young torturer, clad in green, holds in his hands one of the Maccabees, nimbed and partly naked, and is about to throw him into a cauldron where another youth is clearly visible (the miniature is slightly flaked at this point). A second torturer stands with arms raised behind the cauldron, in front of a rugged mountain on whose lower slope flowers grow.

4) At the left, before a rocky landscape, Solomone, in blue and green garments and nimbed, bends forward and urgently admonishes one of her sons who is dying in the fire.

5) One of the Maccabees, half nude as in all scenes and with bound hands, but gazing upward as if communicating with God, is being led away by a young executioner, a soldier clad in a red chiton, blue leggings, a purple chlamys, and a Phrygian cap. The landscape is mountainous as in previous scenes.

6) A grey-bearded and shaggy-haired executioner in carmine garments breaks the legs of another youth, nimbed and in a loincloth, who lies on the ground. Landscape forms the background.

The initial T is formed of the busts of Eleazar and Solomone on top and their seven sons, one behind the other, comprising the hasta of the letter. The son who is fully represented is dressed in pink and red and holds a martyr's cross. Homily on the Maccabees (*PG* 35, 912).

The following figural initials also belong to the same homily:

382r Γ with an upright goat munching a leaf (fig. 576).

384r N with a dog turning back, not to look at its raised tail but upward as if to bark (fig. 577). Ψ with a heraldic griffin perched on a foliate pedestal and crowned with calyxes and flowers (fig. 578).

386v A with a bear turned to the left and tapping its raised left leg, as if dancing (fig. 579).

389r T with two birds flying over a stem forming the hasta of the letter.

390v M with a bird (eagle?) with outspread wings perched on a sphere.

391v Є with a blessing hand.

394r OY with two butting goats (fig. 580).

395v A with quadruped seated on a floral motif.

396v Cross page with Є̄ Є̄ Є̄ Є̄ ([Σταυρὸς] Ἑλένης Εὕρημα Ἐλπὶς Ἐλπίδων?) (fig. 586).

397r 1) Gregory addressing Cyprian and Justina (11.9 x 14.1 cm.) (fig. 486). The wide frame, bordered by a cyma pattern and a filigree fillet, is decorated in flower petal style. Roundels formed by stems enclose palmettes with curled leaves. Between them are inverted flower petals on the vertical sides, and blossoming, sprouting palmettes on the horizontal sides—all in a compact arrangement. Another variant of the wind-blown palmette is on the extended lower right band. In the central square, on the left, Gregory, clad as a bishop and standing before a tall building with a saddled roof and a doorway, turns slightly to the right and addresses Cyprian. Cyprian, an old man with grey hair, also nimbed and holding a gold book, and in light blue and pink bishops' vestments, extends his right hand toward Gregory. Justina stands next, unrelated to the other figures. She is in a frontal position, nimbed, wearing a light blue maphorion with gold striations, and holding a white cross, the cross of martyrs, before her breast.

The same three figures form an initial M: the two bishops, standing on the sides, place their hands on Justina's nimbus; she is represented frontally and on a smaller scale.

2) The martyrdom of Cyprian (4.4 x 4.4 cm.), on the right lower margin. On the left, an executioner, in a brown *tunica exomis* and red leggings, raises a sword forcefully and is about to decapitate the old Cyprian, represented as a bishop to the right. The nimbed martyr, his hands under his vestments, bends to receive the sword's stroke and gazes upward with an expression of trust. A brown, mountainous landscape with grey rocks, trees, and bushes forms the setting. Homily on the Saint and Holy Martyr Cyprian (*PG* 35, 1169).

The following figural initials belong to the same homily:

397v A with a bird on a stem.

399v Π with a camel on a foliate base facing to the right (fig. 581).

401v T with two serpents being swallowed by a third.

402v O with a grey fox fiercely devouring a small, brown, bleeding lamb (fig. 582).

405r C with a fox-like, brown canine.

406v T with two serpents emerging from a foliate stem.

408v Є with two serpents, their canine heads forming the crossbar.

410r O with intertwined serpents.

413r K with two birds at a stem, partly flaked.

The following figural initials belong to the Homily to his Father who Kept Silent about the Plague of Hail (*PG* 35, 933), of which the original opening text, its title miniature, and historiated initials are missing:

417v Φ with a heraldic eagle (?).

419v A with a rampant griffin on a red sphere.

421r O with a bird attacking a serpent.

422v Γ with a snake coming out of a foliate stem.

425v Є with a snake around a leafy stem.

429r A with a griffin biting its wing.

431v Φ with an upright griffin.

434v Λ with a fox looking upward and seated on a floral ground.

Iconography and Style

The two scribal entries leave no doubt that this codex, one of the richest surviving copies of the Liturgical Edition of the Homilies of Gregory Nazianzenus, is a Constantinopolitan product. The abbot of the imperial monastery of Pantocrator "made it" and presented it to the Monastery of

Theotokos Pantanassa on the island of St. Glykeria not far from Constantinople on the Asiatic side of the Sea of Marmora.[7] The ambiguity of the word τεύξας, which may mean that the codex was made through the care of the abbot, does not prove that it was produced in the Pantocrator monastery itself; but it does not argue against this possibility, either. The donor, the abbot Joseph, must have been a monk in the Pantanassa monastery before his appointment to the Pantocrator religious establishment. The epithet Glykerites does not mean that Joseph was born on the island or that he spent his childhood there, as has been proposed.[8] Noret has correctly pointed out that the island is very small (ca. 100 x 40 meters) and that it should have been occupied entirely by the monastery, leaving no space for a secular settlement.[9] The adjective Glykerites, therefore, must refer to an earlier association of Joseph with the monastery.

The typikon of the Pantocrator monastery was granted in the year 1136, a date that must be considered the *terminus post quem* for the abbot himself and the Gregory codex. The donor, however, is mentioned as abbot of Pantocrator in a document of the year 1149, and there is evidence indicating that he died about the year 1155.[10] Thus the manuscript can be dated between 1136 and 1155.

Following the tradition of the portraits of the evangelists or saints, the portrait of Gregory as author with an inspiration motif, in this case Christ himself, has been placed at the beginning of the codex. The complex edifice of this composition is similar to those of the frontispieces of the twelfth-century Kokkinobaphos manuscripts, the cods. Paris gr. 1208 and Vat. gr. 1162. It has been suggested that this may reflect the now lost Constantinopolitan church of the Holy Apostles.[11]

Only a small number of the miniatures connected with the homilies illustrate the text directly. Most of these have been taken from other cycles. The choice and iconography of its scenes relate the codex to earlier Gregory manuscripts belonging to the same recension, the eleventh-century codices Moscow, Hist. Mus. 146, Turin, Univ. Lib. C.I.6, and Athos, Dionysiou 61.[12] In most cases having more than one scene for each homily, the Sinai codex and its relatives bear

testimony to a richly illustrated archetype, now lost, which was made for liturgical use sometime in the tenth century. The codex adduces strong evidence for the liturgical character of this edition with miniatures whose theological meaning relates directly to the liturgy, the two Visions of Habakkuk, for example (fig. 474, colorplate XXI), or illustrations describing liturgical rites such as the Encaenia scene (fig. 475) or the worship of the Virgin Blachernitissa (fig. 480). Further, it contributes to our knowledge of illustrated Lives of Saints, the extensive cycle of the Martyrdom of the Maccabees being a case in point (fig. 485, colorplate XXIV).

The figure style displays certain distinctive characteristics: the faces are soft, the plasticity of the hair is emphasized by shadow lines. To a large extent this style continues that of late eleventh-century codices, and lacks the sharp contrasts found in twelfth-century manuscripts such as Vat. Urb. gr. 2.[13] The garments are painted in brilliant colors and chrysography is used to articulate drapery patterns or to define a plane, with the body acquiring a non-corporeal quality. Anderson has attempted to explain the "duality" between the bodies' plasticity and the highlights by the use of different models.[14] Very striking are the headpieces with their rich and infinitely varied ornament, to which several parallels have been pointed out, such as the cods. Vat. gr. 1162, Paris gr. 71, and others said to be part of the conjectural Kokkinobaphos workshop.[15] But the reference to pattern parallels in other Constantinopolitan manuscripts cannot minimize the inventiveness and originality of the artist of the Sinai codex.

In its decorative figural initials the codex provides a vast repertory of subjects, ranging from falconry and animal life to circus scenes. Such initials are not unknown in the tradition of the illustrated Liturgical Homilies of Gregory at an earlier time, as the cod. Turin, Univ. Lib. C.I.6 shows.[16] But the extent of the Sinai artist's inventiveness in this area is without parallel. The ultimate sources of these initials, their introduction into the repertory of the various homilies and their uneven distribution therein are problems still to be investigated.[17]

[7] For the island of Glykeria, see Noret, *Byzantion* 1978, *loc. cit.* (supra note 2), with further references.

[8] See J. C. Anderson, "The Illustration of cod. Sinai gr. 339," *The Art Bulletin* 61 (1979) pp. 169ff.

[9] Noret, *Byzantion* 1978, *loc. cit* (supra note 2).

[10] P. Gautier, "Le Typikon du Christ Sauveur Pantocrator," *REB* 32 (1974) p. 22; Anderson, *op. cit.* (supra note 8), p. 169.

[11] See A. Xyngopoulos, "Ἡ μικρογραφία ἐν ἀρχῇ τοῦ Σιναϊτικοῦ κώδικος 339," *EEBS* 16 (1940) pp. 128–37.

[12] Galavaris, *Liturgical Homilies*, pp. 179ff.

[13] C. Stornajolo, *Miniature della omilie di Giacomo Monaco (cod. Vat. gr. 1162) e del evangeliario greco Urbinate (cod. Vat. Urbin. gr. 2)* (Codices e Vaticanis selecti, Series minor, 1), Vatican 1910, pls. 83–91.

[14] Anderson, *op. cit.* (supra note 8), pp. 176ff.

[15] Ibid., pp. 170–71.

[16] Galavaris, *Liturgical Homilies*, pp. 126, 164ff., 259–60, with illustrations; for a stylistic analysis of these initials see Anderson, *op. cit.* (supra note 8), pp. 171ff.

[17] Cf. Galavaris, *Liturgical Homilies*, pp. 165ff.

These initials add to the effect of sumptuousness, as do the gold striations, the gold titles, and the gold lines in the text. Whether the codex was made in the same center that produced the Moscow and Turin codices, as Anderson proposes, or in another scriptorium, possibly the Pantocrator monastery itself, remains an open question.[18] The manuscript was presented to Sinai only on July 1, 1550.

Bibliography

Kondakov 1882, pp. 107, 128, 143–52, pls. 60–75, 93,5.
Gardthausen, *Catalogus*, pp. 72–73.
Kondakov, *Histoire*, pp. 97ff.
Pokrovskij 1892, pl. XLVIII.
Kondakov, *Initiales*, pl. I.
Idem, *Izobraženija russkoj knjažeskoj semi v miniatjurach XI věka*, St. Petersburg 1906, pp. 18–20, pl. 1.
H. L. Kehrer, *Die heiligen drei Könige in Literatur und Kunst*, 2, Leipzig 1909, repr. Hildesheim 1976, p. 90, fig. 79.
Vogel, Gardthausen, p. 220.
Beneševič, pp. 199–200 no. 319.
O. M. Dalton, *Byzantine Art and Archaeology*, Oxford 1911, repr. New York 1961, pp. 435, 478 n. 1, 494, figs. 257, 296, 407.
Gardthausen, *Palaeographie*, 1, p. 217.
N. P. Kondakov, *Ikonografija Bogomateri*, 2, St. Petersburg 1915, p. 338, fig. 188.
Millet, *Recherches*, pp. 103 n. 5, 154, 176 n. 8, 178 n. 4, 183, 190, 207 n. 7.
H. Glück, *Die christliche Kunst des Ostens*, Berlin 1923, p. 4, fig. 3.
Beneševič, *Mon. Sinaitica*, 1, col. 48, pls. 31, 32.
Ebersolt, *Miniature*, pp. 38 n. 3, 43 n. 4, 47 n. 7, 50 n. 3, 63 n. 3.
M. Alpatov, "La Trinité dans l'art byzantin et l'icone de Roublev," *Echos d'Orient* 26 (1927) p. 162, fig. 19.
S. Der Nersessian, "Two Slavonic Parallels of the Greek Tetraevangelion Paris 74," *The Art Bulletin* 9 (1927) pp. 1–52, repr. in *Études*, 1, pp. 231–63, esp. p. 256 n. 83.
A. Grabar, "La schéma iconographique de la Pentecôte," *Seminarium Kondakovianum* 2 (1928) p. 228; repr. in *Fin de l'Antiquité*, 1, p. 619.
M. Nekrasov, "Les frontispieces architecturaux dans les manuscrits russes . . . ," *L'art byzantin chez les Slaves*, Recueil T. Uspenskij, 2, Paris 1932, pp. 253–54, pl. XXXVIII.
H. Stern, "Les représentations des Conciles dans l'église de la Nativité à Bethléem," *Byzantion* 11 (1936) p. 150, pl. 15, fig. 42.
A. Xyngopoulos, "Ἡ μικρογραφία ἐν ἀρχῇ τοῦ Σιναϊτικοῦ κώδικος 339," *EEBS* 16 (1940) pp. 128–37, pl. 1.
G. Millet, *La dalmatique du Vatican*, Paris 1945, pl. VIII,1.
Lazarev 1947, p. 115.
H. Stern, "Nouvelles recherches sur les images des conciles dans l'église de la Nativité à Bethléem," *CA* 3 (1948) p. 104.
A. Grabar, "Un rouleau liturgique constantinopolitain et ses peintures," *DOP* 8 (1954) pp. 179 n. 21, 196 n. 47; repr. in idem, *Fin de l'Antiquité*, 1, pp. 482 n. 1, 494 n. 1.
Sotiriou, *Icônes*, 2, p. 120.
Weitzmann, "Einflüsse," p. 314 n. 34.
Grabar, "Pyxide," pp. 143ff., fig. 34; repr. in idem, *Fin de l'Antiquité*, 1, pp. 246ff., 3, pl. 53.
S. Der Nersessian, "Notes sur quelques images se rattachant au thème du Christ-Ange," *CA* 13 (1962) pp. 212, 214, fig. 3, repr. in *Études*, 1, pp. 44ff., fig. 25.

Eadem, "The Illustrations of the Homilies of Gregory of Nazianzus, Paris gr. 510," *DOP* 16 (1962) p. 202 n. 22; repr. in *Études*, 1, p. 82 n. 22.
Byzantine Art. An European Art, Ninth Exhibition of the Council of Europe, 2nd ed., Athens 1964, p. 333.
K. Weitzmann, "Mount Sinai's Holy Treasures," *The National Geographic Magazine*, January 1964, pp. 124, 125.
A. Frolow, "Un bijou byzantin inédit," *Mélanges R. Crozet*, 1, Poitiers 1966, pp. 628, 630.
C. Franc-Sgourdéou, "Les initiales historiées dans les manuscrits byzantins aux XIᵉ–XIIᵉ siècle," *BSl* 28 (1967) pp. 340–46, 353, pl. III.
Lazarev, *Storia*, pp. 193, 252 n. 48, fig. 264.
Velmans, "Fontaine de vie," p. 134, fig. 12.
Galavaris, *Liturgical Homilies*, see index.
Ch. Walter, "Lazarus a Bishop," *REB* 27 (1969) pp. 199, 206–209, repr. in idem, *Studies in Byzantine Iconography*, London 1977, no. IV.
Kamil, p. 76 no. 401.
Grabar, *Manuscrits grecs*, p. 98, figs. 358–60.
Ch. Walter, "Un commentaire enluminé des homélies de Grégoire de Nazianze," *CA* 22 (1972) p. 118 n. 13.
G. Alibegašvili, *Chudožestvennyi princip illjustrirovanija gruzinskoj rukopiskoj, knigi XI–nacala XIII vekov* (with French résumé) (Academie de Sciences de la RSS de Géorgie), Tbilissi 1973, pp. 127, 142.
Galavaris, "Homilienillustration," cols. 260–64.
Weitzmann, *Sinai Mss.*, p. 22, figs. 28, 29.
A. Cutler, "The Spencer Psalter: A Thirteenth Century Byzantine Manuscript in the New York Public Library," *CA* 23 (1974) p. 139.
P. Gautier, "Le Typikon du Christ Sauveur Pantocrator," *REB* 32 (1974) p. 22.
J. C. Anderson, "An Examination of Two Twelfth-Century Centers of Byzantine Manuscript Production," Ph.D. dissertation, Princeton University, 1975, pp. 12ff., 201–42 and passim.
V. P. Darkevich, *Svetskoe iskusstvo vizantii*, Moscow 1975, pp. 181, 184–85, figs. 278, 282, 283a–b.
R. Janin, *Les églises et les monastères des grands centres byzantins*, Paris 1975, p. 57.
L. Nees, "An Illuminated Byzantine Psalter at Harvard University," *DOP* 29 (1975) p. 220 n. 74.
A. Grabar, "Une source d'inspiration de l'iconographie byzantine tardive: les cérémonies du culte de la Vierge," *CA* 25 (1976) p. 161, repr. in idem, *L'Art paléochrétien et l'art byzantin*, London 1979, no. X.
Weyl Carr, *McCormick New Testament*, pp. 117 n. 26, 126, 180.
R. S. Nelson, "The Later Impact of a Group of Twelfth-Century Manuscripts," *Third Annual Byzantine Studies Conference, Abstracts of Papers*, New York, 3–5 December 1977, p. 60.
S. Dufrenne and R. Stichel, "Inhalt und Ikonographie der Bilder," in *Der Serbische Psalter*, H. Belting, ed., Wiesbaden 1978, p. 197 n. 51.
I. Furlan, *Codici greci illustrati della biblioteca Marciana*, 1, Milan 1978, pp. 59, 60.
Marava-Chatzinicolaou, Toufexi-Paschou, p. 58.
Noret, *Byzantion* 1978, pp. 156–61.
J. C. Anderson, "The Illustration of cod. Sinai gr. 339," *The Art Bulletin* 61 (1979) pp. 179, 184–85.
Galey 1979, figs. 148, 154, 158, 163.
A. Grabar, *Les voies de la création en iconographie chrétienne, Antiquité et moyen-âge*, Paris 1979, fig. 109.
P. Huber, *Heilige Berge*, Zurich, Einsiedeln and Cologne 1980, p. 15, figs. 4, 88.
P. Magdalino and R. S. Nelson, "The Emperor in Byzantine Art of the Twelfth Century," *Byzantinische Forschungen* 8 (1981) p. 150.
Spatharakis, *Dated Mss.*, p. 43, no. 146, figs. 272–79.
Voicu, D'Alisera, p. 560.

[18] Anderson, *op. cit.* (supra note 8), p. 184. For problems of Byzantine ateliers see the excellent study by Dufrenne, "Ateliers."

D. H. Wright, "A Luxuriously Decorated Russian Psalter of the Twelfth Century," *Actes du XV^e Congrès International d'Études Byzantines (Athens, 1976)*, 2, Athens 1981, pp. 924, 926.

A. Grabar, "L'iconographie du Ciel dans l'art chrétien de l'Antiquité et du haut Moyen Age," *CA* 30 (1982) p. 19 n. 33.

Weyl Carr, "A Group," pp. 48, 50.

Eadem, "Gospel Frontispieces," pp. 7, 18 n. 51.

Walter, *Art*, pp. 16, 24 n. 111, 88 n. 16, 158ff.

Harlfinger et al., pp. 46–48, 64 no. 26, pls. 114–18.

O. Demus, *The Mosaics of San Marco in Venice*, Chicago and London 1984, 1, p. 253.

57. COD. 418. JOHN CLIMACUS, THE HEAVENLY LADDER
TWELFTH CENTURY. FIGS. 587–632, COLORPLATE XXVI

Vellum. 313 folios, 17 x 13.5 cm. One column of twenty-two lines. Minuscule script for text written under the line, regular, widely spaced; titles in *Epigraphische Auszeichnungs-Majuskel* and *Auszeichnungs-Majuskel*. Gathering numbers lacking. Parchment fine, yellowish-white. Ink light brown for text, occasionally in carmine for emphasis; titles in gold. Initials in floral motifs against gold, some of them drawn only; small solid initials throughout the text in gold.

Parchment flyleaf; fols. 1r–v, blank; 2r–v, frontispiece and dedication page; 3r–4v, letter of John of Raithou to John Climacus (*PG* 88, 624–25); 5r–15r, preface, chapters in gold (5v, 6r), Life of John Climacus by Daniel of Raithou (7v–12v) and the author's reply to John of Raithou (13r–15r) (*PG* 88, 596–608, 625–28); 15v, miniature; 16r–289v, Homilies 1–30 (*PG* 88, 632–1161); 290r–313r, Homily to the Pastor (*PG* 88, 1165–1208).

The condition of the codex is excellent. Some miniatures have suffered minor flaking.

Deep red leather binding on wooden boards with pressed motifs, similar on both covers (fig. 632). There are two parallel frames, the outer one decorated with Sassanian palmettes enclosed within acanthus leaves, between which are pairs of joined palmettes. The inner frame contains pairs of Sassanian palmettes placed sideways in a lyre-shaped pattern. The frames are separated by quadruple fillets, on the joining corners of which are star-like rosettes. Rosettes also appear in the center of each side of the outer frame. The central panel encloses two medallions with a floral motif surrounded by star-like rosettes. The configurations are

joined by a large round silver stud flanked by two stamped lozenges with floral motifs in the form of a cross. Four more similar studs are on the corners of the outer frame. There are two original leather straps with silver rings on the back cover, and two silver pins for fastening on the front cover. The motifs of the cover derive from ornamental bands in Byzantine illuminated manuscripts; most likely the cover is Byzantine, from the second half of the fourteenth century.[1]

Illustration

Apart from the prefatory matter, whose illustration takes various forms, the miniatures applied to the homilies beginning with fol. 16r follow a consistent pattern. They are set within rectangular, decorated headpieces consisting of one or more frames, and take the form of a rectangle, quatrefoil, or circle. In every case the scene is set against a gold background. The frames are defined by simple, thin fillets mostly in blue, occasionally ornamented with simple wavy lines. There are four palmettes on the corners; in most cases the lower ones stand on the extended line of the fillet. All ornament is set in gold, which in several of the palmettes and initials provides only a shapeless background. Most initials are in flower petal style but several show the influence of the fretsaw, and this is true also of the palmettes.

2r Frontispiece (12.1 x 9.1 cm.) (fig. 587). Beneath a cusped, blue arch with brown bases, capitals, and grey-green variegated columns, stands a cross ornamented with rosettes outlined in blue on a stepped base; at the crossing of the arms is a blue medallion containing a yellow heraldic eagle. The cross is flanked above by two white-blue doves and below by two heraldically opposed seated lions, that on the left rendered in grey and that on the right in brown. The spandrels of the arch are decorated with a flower petal pattern also appearing in a band below including the base of the cross in its center. The background is gold.

2v John Climacus offering his book to Christ (12.3 x 9.4 cm.) (fig. 588). The author, inscribed ὁ ἅ(γιος) ἰω(άννης) ὁ τῆς κλίμακος in red, with dark brown hair, brown flesh tones, and a nimbus outlined in blue, is clad in a brown and olive black monastic habit and stands at the right. Slightly inclining his head, John offers to Christ his book rendered in red with a blue edge. Christ, I̅C̅ X̅C̅, nimbed and with hair and flesh tones in green-brown, is clad in carmine tunic and blue himation; holding a scroll in his left hand and standing almost frontally, he receives the book, gazing at the spectator. Both figures are depicted against a

[1] Van Regemorter, "Reliure," pp. 12ff.

gold background. The composition is framed by a band of interjoined circles with palmettes in meager flower petal style.

3r The Exchange of Letters (5.3 x 8.9 cm.) (fig. 589). At the left, the abbot of Raithou, represented as an old man with white-grey hair, in violet tunic and dark brown mantle, and seated on a brown chair, hands the letter, in the form of a scroll, to a boy messenger clad in a short red tunic. The boy in turn, represented a second time, delivers the letter to John Climacus, who is depicted in carmine and dark brown monastic habits, with brown hair, reddish brown flesh tones and white highlights, seated on a chair similar to that of the abbot. The composition is flanked by a band in flower petal style—roundels with flower petals and palmettes on stems between. Initial T in flower petal style. Letter of John of Raithou.

4v Two crosses (7.7 x 10.3 cm.) (fig. 590). Under a carmine double arch, joined at the bottom by a blue band, are two double gold crosses outlined in blue and red, each on a stepped blue base, painted against the parchment. Conclusion of John of Raithou's letter.

5r A rectangular frame enclosing the title is decorated with flower petals contained within intersecting segments of circles (fig. 591). Initial T in similar style. Preface.

5v Band-shaped headpiece ornamented in ordinary flower petal style containing flower petals in medallions with palmettes on stems between them in green, blue, and carmine, on gold ground. Preface and table of contents in gold.

6v Band-shaped headpiece in a chevron pattern. Initial Є. Preface.

7r Headpiece enclosing the title, decorated in flower petal style (fig. 592). Roundels with flower petals are joined by diagonal stems, between which are palmettes. The palmettes on the upper corners and on the extended lower line of the frame show the influence of fretsaw style, seen also in the initial T. Life of John Climacus.

13r Ornamental headpiece over the column (6.9 x 9.1 cm.) and the Exchange of Letters in the margin (fig. 593). A narrow band decorated with flower petals in a chevron pattern encloses another large frame containing the title within a small quadrilobe. This large frame is ornamented with flower petals forming rosettes in a tile-like pattern. The rosette motif and the tile effect, orientalizing in character, also appear on the corner palmettes. Initial A in flower petal style.

Two rectangular vignettes in the right margin represent: 1) Next to the text (3.3 x 2.5 cm.), John Climacus at the left, depicted as a young man with dark brown hair in grey and dark brown habit, seated on a chair, about to hand a letter to a messenger standing opposite who is clad in blue and holds a staff in his left hand. 2) Next to the headpiece (2.9 x 2.9 cm.), John of Raithou, depicted as an old man with grey hair in light and dark brown monastic garments, seated on a yellow-brown chair with gold grisaille and a footstool, receives a scroll, John's replying letter, from the messenger, represented as above. In both scenes the background is gold. The author's reply.

15v The Heavenly Ladder (13.9 x 9.4 cm, including Christ's medallion) (fig. 594). A full-page miniature framed by a narrow band with crenellation represents the Heavenly Ladder in blue against a gold background. The figures are somewhat flaked. Four monks in light and dark brown are seen ascending, while small black demons assail them; one of the climbers is caught by the hair, another by the foot. The uppermost is aided by Christ, who reaches out to grasp the monk's hand. Christ, placed within a gold medallion which breaks the border of the picture, is clad in carmine tunic and light blue himation and holds a gold book. At the bottom, to the right side of the ladder, three officials stand stiffly, wearing tall, domical, white caps and dark brown and red-brown garments (the robes of the first and third are patterned), pointing to the ladder. They represent those intending to abandon the world for a monastic life.

16r John Climacus writing (9.1 x 9.1 cm.) (fig. 595). A thin fillet decorated with a wavy line defines on both sides a rectangular frame, its ornament partly flaked. On the four corners, stems branch out into two roundels with palmettes at an angle. The same pattern but on smaller scale covers the space between. The central quadrilobe, bordered by a blue cyma pattern, shows John, his hair and beard dark, in light carmine and dark brown garments, seated before a desk with a lectern. He is writing in a book supported by his hand. All furniture is brown. The initial T is outlined only. Homily 1, On Renunciation of Life.

27r Man giving his belongings to the poor (7.7 x 9.1 cm.) (fig. 596). The outer frame of this headpiece is divided into rectangles with large, rough stylized Sassanian palmettes enclosing a smaller one. The second frame, also with branched-out palmettes, surrounds a quatrefoil with the scene. The palmettes on the upper two

corners of the headpiece are rendered in fretsaw style, while those on the extended line below take the form of stylized flowers or plants. At the left, a white-haired and -bearded man, clad in brown with his face upturned, implying that he hears a voice from heaven, holds out his hand to two other figures. One, a youth in a long, light steel blue tunic with long sleeves and a red turban, stands before him; the second, clad in red, is crouching at his feet. Both youths hold red garments which they have received. Initial O. Homily 2, On Dispassionateness.

31v A novice approaches a hermit in a cave (6.8 x 9.1 cm.) (fig. 597). The outer frame is decorated with four ellipses superimposed by segments of arches ending on the outer sides of the rectangle. They enclose flower petals in heart-shaped forms flanking inverted palmettes in the center. The scene in the inner square represents a wandering novice, bearded and with long brown hair, clad in a yellow-brown, knee-length tunic. Carrying over his shoulder a staff from which hangs a red basket, he makes his way through the desert and approaches a small black cave in a steel grey mountain in which is visible the head of an anchorite with blue-black hair. Initial Ξ. Homily 3.1, On Pilgrimage.

37r A sleeping monk tempted by demons (8.4 x 9.1 cm.) (fig. 598). The frame is decorated in flower petal style with palmettes contained in a heart-shaped pattern. The enclosed scene, partly flaked, depicts a monk in brown and black garments asleep on a white and steel blue colored couch with a violet hanging. Two winged black demons hover over him to tempt him in his dreams. Initial O. Homily 3.2, On Dreams.

39r An abbot addresses six monks (8.7 x 8.9 cm.) (fig. 599). The frame is decorated with four large roundels at the corners, each divided horizontally and containing inverted flower petals which sprout from stems. Between the roundels, on the horizontal sides, are intersecting circles divided horizontally and containing small inverted palmettes; on the vertical sides, diamond forms alternate with circles, all divided and with similar floral motifs. The central square represents six monks on the right in brown, pink, and black habits with long grey-blue and brown beards, listening attentively to an abbot. Clad in pink and brown, nimbed, holding a black staff in his left hand, and seated on a light brown chair with a gold-topped footstool, the abbot is John Climacus, his facial features effaced. Initial Π. Homily 4, On Obedience.

79r Monks praying to Christ, in the headpiece (8.5 x 9 cm.); three monks praying before the Virgin, in the margin (5.4 x 3.4 cm.) (fig. 600). An outer frame encloses a square in which a medallion-like circle containing the scene is inscribed. The frame is decorated with roundels with rough flower petals and inverted palmettes between them. A somewhat similar motif is on the spandrels. The scene represents two groups of monks clad in light brown, black-brown, light blue, violet, and brown garments, standing on either side and lifting their hands up to a bust of Christ. Wearing brown and blue garments and a cruciform nimbus, Christ extends his hands toward the monks. Two other monks kneel below; the one on the left wears brown and black-brown garments, and the one on the right light brown and violet; both raise their arms to Christ. Attached to this, a rectangular miniature in the right margin contains three penitent brethren, in colors as above; two of them are kneeling and praying to the Virgin Mary, clad in blue, who stands on a gold footstool. She is represented on a larger scale as an orant, interceding for the penitent. Initial M. Homily 5, On Penitence.

94v A monk contemplating before a sarcophagus with four mummies (8.4 x 9.1 cm.) (fig. 601). The frame is decorated in rough flower petal style: roundels with heraldic palmettes on the vertical sides and palmettes between, flanking a roundel on the horizontal sides. The spandrels are filled with small-scale flower petal motifs. On top of the headpiece are two green parrots holding a stem with a red fruit in their beaks, and flanking a light brown fountain. The inner quatrefoil shows a monk, largely flaked, in brown and black-brown garments, seated on a pink rock and contemplating a pink marble sarcophagus containing four mummies wrapped in steel grey shrouds. Initial Π with a crosslet on top. Homily 6, On Remembrance of Death.

99v A monk sitting in a cell (8.6 x 9.1 cm.) (fig. 602). The outer frame is ornamented with a broad blue half-diamond pattern with palmettes on gold, and contains an inner frame enclosing a quatrefoil with the scene. The miniature shows a monk, perhaps John Climacus, in light and very dark brown garments with a blue-grey beard and a gold nimbus; supporting his head on his hand, he is seated on a light brown chair within a shelter that has a tent-like, grey-blue roof and a brown interior. A white basket, probably containing a loaf of bread (the object is flaked) appears at

the right. Initial Π. Homily 7, On Sorrow.

113v A monk instructs youths (9.1 x 9 cm.) (fig. 603). Square panels with flower petals in a tile-like pattern form a frame enclosing a rectangle with the scene. A monk in a light brown and black-brown habit, and with blue-grey hair, is seated on a brown chair with a footstool, before a lectern supported by a spiral column that stands on a desk. Reading from a book, the monk instructs a youth in pink and with black leggings who stands gesturing to him. A white book rests on the lectern, and a tiny white lamp is suspended above it. Below are seen two other youths, clad like the first in short tunics, the one at the left in red with black leggings, the one at the right in blue with red leggings. The one on the right guides his companion by the hand and at the same time points to a tall brown chest with open doors, a bookcase which, however, contains no books. Initial Ѡ. Homily 8, On Placidity and Meekness.

121r A man enthroned and two servants stepping over two prostrate figures (8.5 x 9 cm.) (fig. 604). The outer frame is decorated with a zigzag pattern vertically divided into small triangles, each with a palmette. It encloses a quatrefoil with palmettes in large heart forms at the corners. In the center of the scene, a youthful man with brown hair, clad in a rich purple, patterned tunic, is seated on a yellow throne with a red cushion, a white hanging on its back, and a gold footstool. He is flanked by two attendants whom he seems to address. The one at the left, clad in red, steps upon and beats with a black stick a prostrated man dressed in carmine. The second attendant, on the right, in blue garments, tramples another prostrated man dressed in red. Initial A. Homily 9, On Malice.

124r A man whispering into the ear of a seated brother who addresses a third one before him (7.3 x 9 cm.) (fig. 605). The rectangular frame is decorated with spreading flower petals on a stem forming a wavy pattern. Palmettes in the upper corners take the form of floral motifs in diamond form, orientalizing in character. The scene depicts an aged monk with grey hair, in light brown and olive garments, seated on a brown stool and resting his feet on a footstool. He addresses a younger brother with brown hair and monastic dress in similar but reversed colors who stands before him. A third young monk with brown hair, wearing olive and reddish brown garments, stands behind the seated monk and whispers in his ear, obviously slanderously

accusing the meek brother on the right. Initial O. Homily 10, On Slander.

127v A monk speaks to another one who is seated and keeps silence (8 x 9.1 cm.) (fig. 606). The rectangular frame is divided into square panels with large flower petals on stems arranged in cross forms against gold. This is a simplified version of the frame on fol. 113v. The miniature shows at the left a bearded monk with blue-grey hair, in steel blue and dark brown habit, standing with both hands thrust out. He addresses a second monk with violet-grey hair and wearing dark brown and steel blue garments, who sits opposite on a brown chair and presses his hands to the former's mouth to quell the outburst. Initial Є. Homily 11, On Talkativeness and Silence.

129v A man extends his hands toward a demon(?) while an angel beckons to him (8.1 x 9.1 cm.) (fig. 607). The frame consists of two parallel bands. The outer band is decorated with flower petals in a chevron-like pattern with cross-form rosettes on the four corners; the inner one contains joined roundels and heart-shaped forms at the four corners, all containing stylized palmettes. A young man with brown hair, in a long blue tunic, his right arm extended and his left placed across his breast, stands facing to the right. The representation at the upper right corner is completely flaked; it was probably the figure of a demon. An angel with brown hair, clad in pink, partly effaced, is seen at the left, as if speaking to the man and seeking to dissuade him from conversing with the demons. Initial Γ. Homily 12, On Falsehood.

132r A monk sleeping at a lectern (8.7 x 8.9 cm.) (fig. 608). The outer frame, a variant of that on fol. 31v, contains a huge circle intersected by segments forming four ellipses. The inner square encloses a quatrefoil with the scene. The various sections of the outer frame contain flower petals on stems, either freestanding or heraldically arranged. The corners of the inner frame are decorated with stems in fretsaw style. A monk with very dark brown hair and steel grey and darkest brown garments is seated on a brown chair before a lectern with an open book. With his eyes closed and his head resting on the book, the monk appears to have fallen asleep while reading. Initial Є. Homily 13, On Sloth.

135r A symposium (8.1 x 9.1 cm.) (fig. 609). The frame is decorated with large triangles filled with flower petals in an inverted arrangement. The inner square depicts

a white-bearded old monk in light and dark brown garments. Seated before a green-white building with a blue, saddled roof, he presides over a symposium, holding a cup into which he pours wine from a small vessel. A bowl of wine and a goblet, both outlined in yellow, and two square objects rest on a table, behind which a younger monk in pink, likewise raising a cup, shares the enjoyment of the wine. A third figure at the right in blue garments, holding an unidentified object, possibly a vessel, bends over a flame issuing from a completely flaked vessel below. In the right margin, a reddish brown cock perches on an olive grey column, reminiscent of representations of Peter's denial. Initial M. Homily 14, On Gluttony.

142v A standing figure holding a staff (8.1 x 9.2 cm.) (fig. 610). A broad frame with large heart forms on the four corners, each with a palmette, and flower petals in roundels between them, encloses a rectangle also decorated with heart-shaped palmettes and flower petals. In the center is a quatrefoil with the scene that is almost completely rubbed away, perhaps intentionally. One can still see a single figure in an olive grey robe with a vertical gold border standing in the center and holding a staff; traces of other figures can be seen at left, right, and below. Initial A. Homily 15, On Chastity and Temperance.

162v A rich monk and his servants driving away two beggars (10.6 x 9.1 cm.) (fig. 611). An outer frame divided into rectangles with tile-like patterns, a variant of that on fol. 113v, encloses a rectangle at whose corners are stems with calyxes and flowers in fretsaw style, an expanded variant of the inner frame on fol. 132r. In the center is a quatrefoil containing the scene. A man with black hair and beard, wearing a long blue garment and a large white cap, sits on a red-cushioned gold throne with a white hanging on its back, resting his feet on a red-cushioned footstool. He contemplates his wealth, represented by a tall, gold-ornamented chest at his right and a high cupboard at his left. Beneath him, two servants with upraised sticks attempt to drive away a pair of beggars; one beggar, clad in violet and kneeling, is pleading for help with his right arm upraised; the other, in red, perhaps a blind man, supports himself with a cane. Initial Π. Homily 16, On Avarice.

163r A second miniature belonging to the same homily in the lower margin (2.4 x 4.7 cm.) (fig. 612) represents the two beggars from the previous illustration receiv-

ing alms from a man clad in green. Another man in a long blue tunic with a red border carries two bundles, a green one over his shoulder and a smaller one in his right hand, evidence of his prosperity, and looks back at the beggars.

164r A seated figure attended by two angels (8.1 x 9.1 cm.) (fig. 613). The outer frame is divided into rectangles with lower petals arranged in a tile-like pattern and a central crosslet, a variant of the frame on fol. 127v. The miniature represents a seated, bearded and bare-foot man, with blue-black hair, wearing a loose garment resembling a *tunica exomis*. He is attended by two angels, both with tunics and wings in shades of yellow. The one on the right in a blue mantle holds a staff and places a white wreath with a double red cross on the man's head. The other, standing behind the seated figure and wearing a carmine mantle, reaches forward and places a scepter in the form of a cross-staff in the man's left hand. Initial A. Homily 17, On Poverty.

166v A monk stands at a table covered with food, looking at features from a Last Judgment scene (9.8 x 9.1 cm.) (fig. 614). The outer frame is divided into squares with flower petals forming rosettes, a variant of the frame on fol. 164r. The illustration depicts at the right a brown table laden with food and vessels, as if set for a meal; a blue kettle stands on a tripod at its feet. Nearby is a man in blue-green and very dark blue garments with brown hair and beard, reaching out with one hand for food while holding the other to his cheek. He turns his head and looks at four rectangular vignettes at the left. At the top and extending over the gold ground to the right is a cluster of trees and plants set against a yellow-green background, partly against gold; beneath this, four heads swim in a red sea of fire and five skulls float over a black-olive ground; finally, five more heads are eaten by white worms in a black background. Initial A. Homily 18, On Insensibility.

170r Sleep, prayer, and psalm-singing (8 x 9.1 cm.) (fig. 615). The rectangular frame is decorated with flower petals forming rosettes in a diamond pattern. The stems of the palmettes on the extended lower line of the frame are in cross form. In the inner square, an elder brother with white-violet hair and dark brown habit lies at the left, asleep under a violet blanket upon a green mattress on a bed with a dark brown hanging. A winged black demon with a yellow staff

hovers over him, touching his eyes. At the right, another monk, clad as the first one, is seated on the ground before a reading stand on which rests a book that he touches with his right hand. Evidently he is singing psalms. Behind him is a half-length angel in blue and yellow, placing a white wreath on his head. A third monk is seen above in three-quarter view, his legs concealed by a groundline. Dressed in light and dark brown garments, he strikes the semantron which he holds with his left hand, calling the brethren to prayer. Initial Υ. Homily 19, On Sleep, Prayer, and Psalm-Singing.

172r Monks praying before Christ (8.1 x 9.3 cm.) (fig. 616). The outer frame is decorated in a zigzag pattern with palmettes, a variant of the frame as on fol. 135r. On each of the corners of the inner rectangle is a roundel with stems shooting forth with flower petals. The center is formed by a quatrefoil containing the scene. Six monks, differentiated in age and arranged into groups, in brown, violet, and black garments, make obeisance to Christ. Clad in a brown tunic and blue himation and holding a Gospel book, Christ stands on a red footstool blessing them. Some of the monks lift up their arms; one at the right reads or sings from a book placed on a brown lectern; another kneels at Christ's feet. Initial Τ. Homily 20, On Wakefulness.

175r Two seated monks conversing (8.1 x 9.3 cm.) (fig. 617). The frame is adorned in flower petal style in roundels and with palmettes and inverted petals between. All four corner palmettes are in fretsaw style. At the left, an aged monk in brown and black-brown habit sits on a yellow, blue-cushioned bench, resting his feet on a footstool. Tormented by a small flying demon, now mostly erased, he raises his arms. A second monk, elevated above his fellow, with violet-white hair and wearing violet and brown garments, sits on a slender blue chair. He addresses the tormented monk and offers him encouragement. Initial Δ. Homily 21, On Timidity.

177r Funeral procession (7.6 x 8.9 cm.) (fig. 618). The frame, a variant of that on fol. 172r, is decorated with palmettes in a zigzag pattern. On a bed with a white mattress and a brown hanging, carried on the shoulders of two boys in blue and red, lies a dead youth clad in blue. Three mourning women in blue, red, and violet, their hands placed under their mantles, follow at its foot. The procession is headed by a group of men in

similar colors, carrying tall lighted candles, and a bearded white-robed priest holding a censer and a tall candle. Another censer is borne by the foremost marcher. Initial Τ. Homily 22, On Vainglory.

184v Two men, one praying to Christ (7.2 x 9.3 cm.) (fig. 619). The outer frame is a variant of that on fol. 175r, but on the horizontal sides, long diagonal stems join the central roundel to those on the corners. The inner frame contains flower petals in inverted heart-shaped forms, and a quatrefoil enclosing the representation as on fol. 142v. At the right, a bearded man in blue, standing near a building rendered in yellow-brown grisaille and with a red roof, thrusts his arms out horizontally, personifying pride. At the left, another young, beardless man clad in red and personifying humility, bows slightly and looks up in prayer to the bust of Christ in gold garments, above. Initial Χ. Homily 23.1, On Pride.

189v Blasphemy against the Host and repentance (8.4 x 9.4 cm.) (fig. 620). The frame is decorated with a diamond pattern of large palmettes and flower petals. At the left of the composition, holding the Host in his hand, a white-robed priest with gold *epitrachelion* stands before a red-draped altar behind which rises a blue-white ciborium. A dark-bearded man clad in a simple long blue tunic approaches from the right and motions with his hand toward the Host. In a second episode, the man in the blue tunic kneels and embraces the feet of an aged monk with white-grey beard, seated at the right, who places his hand on his shoulder and comforts him. A later inscription above the monk identifies him erroneously as the author: ἰω-(άννης) ὁ τ(ῆ)ς κλήμακο(ς). Initial Χ. Homily 23.2, On Blasphemy.

193v The space within the headpiece, usually reserved for an illustration, is here occupied by the title (fig. 621). The frame (8.6 x 9.6 cm.), decorated with flower petals in roundels and palmettes between them, geometrically arranged, is a variant of the frame on fol. 127v. The palmettes at the upper corners take the form of an orientalizing flower, recalling the ornamented bars heading the *suras* in a Koran. The illustration appears in the left margin, next to the frame (5.8 x 2.7 cm.). An aged monk, in light brown and black-brown garments, sits on a black-brown chair in front of a white-violet house with a blue roof. Holding a staff on which he rests his chin, he appears not to see three agitated youths below. One of them, at the lower left,

in a short, light violet tunic, carries a red mantle on a staff over his shoulder and seems to run away. Behind him, another youth, clad in blue, with outstretched arms, strides in the opposite direction. A third, in a dark brown tunic, holds up a blue garment or cloak before the monk. Initial Π. Homily 24, On Meekness, Simplicity, Guilelessness, and Wickedness.

197v As on fol. 193v, the space within the headpiece reserved for the illustration has been given to the title (fig. 622). The frame (8.6 x 9.6 cm.) is decorated in rough flower petal style—flower petals alternating with palmettes in roundels and irregular diamond forms, mostly flaked. The illustration is in the left margin (4.1 x 2.1 cm.), next to the headpiece. A bearded monk, at the left, with blue-grey hair and wearing brown and dark brown garments, holds a stick in his upraised hand, and administers a beating to a brother in violet and light brown garments, who meekly receives the blows, standing with folded arms. Both wear the black megaloschema. Initial O with a crosslet with flaring arms in center. Homily 25, On Humility.

211r A monk lying on a bed, another standing, and a third praying to Christ (8.8 x 9.7 cm.) (fig. 623). The frame is decorated in a rough flower petal style in a pattern of roundels. At the left, a monk with white-violet hair and clad in violet and dark olive robes reclines in a half-sitting posture on a brown bed with a blue mattress. At the foot of the bed another aged monk with white-violet hair and brown garments stands motionless, his hands folded on his chest. A third aged monk, with white-violet hair and long beard, in brown and darkest brown garments, lifts his arms to the half-length figure of Christ who appears above clad in gold, holding his hand over the praying monk's head. The miniature, which bears some resemblance to the Prayer of Hezekiah in the Paris Psalter, cod. 139, fol. 446v,[2] has been interpreted as follows: the monk on the left lies sick, in the center he is cured of his illness, and on the right he gives thanks to Christ. Initial Δ. Homily 26.1, On Discretion.

231v David and five monks in prayer (8.1 x 9.6 cm.) (fig. 624). Two parallel band-like frames enclose the scene. The outer one is decorated in flower petal style in a chevron pattern; the inner one has a simple scroll pattern with flower petals. In the scene at the left, David, in a red tunic and a blue chlamys adorned with a

gold tablion, and wearing a jewelled crown, is represented praying to a blue arc of heaven. Five monks are gathered in front of him; clad in garments ranging from violet and brown to olive in color, in various attitudes of entreaty, they are "yearning for the precepts of the divine and blessed" (*PG* 88, 1056). At the extreme right, one of them is seated on a brown grisaille stool. Initial O. Homily 26.2, On Discretion.

248r John Climacus teaching (7.4 x 9.5 cm.) (fig. 625). The frame is ornamented in flower petal style in roundels and at the four corners in heart forms. At the left, John Climacus, in brown and dark olive monastic habit, a hood drawn over his head, sits and reads from his work; with his right hand he touches an open book on a lectern with a tall support set on a low desk. His attentive audience consists of densely grouped brethren, all aged, bearded, and with expressive faces. Initial Π. Homily 26, conclusion.

254r Various types of anchorites (7.4 x 9.7 cm.) (fig. 626). Palmettes in heart forms, arranged in a variant of the pattern found in the oval sections of fol. 31v, decorate the frame. At the left, an old, white-bearded hermit peers from the black opening of his dark olive cell. Next is a stylite in dark olive habit, on a blue column with a pink capital and a protective railing, recalling Simeon the Stylite. A slender tree grows near the base of the column. A seated anchorite to the right, wearing a garment of woven straw, raises his left hand as if in speech. Another, blue tree in grisaille grows behind him. Initial H. Homily 27.1, On Solitude.

259r Monks paying homage to a stylite (7.7 x 9.5 cm.) (fig. 627). The frame is decorated with four roundels with composite wind-blown palmettes at the corners and in the center of each horizontal side. Between the roundels is a variant of the motif found in the same place on fol. 193v. All four palmettes on the outer corners of the headpiece are in fretsaw style. At the left, a stylite appears within a dark little hut with two yellow shutters and a pointed white roof. At the foot of the pink-veined marble column—the base and capital are blue—three monks bow and address themselves to the column-dweller. At the right, another monk in a brown and dark brown habit sits weaving a basket. A completed basket is seen above. Initial H. Homily 27.2, On Solitude.

269r Monks praying (7.7 x 9.4 cm.) (fig. 628). The ornament of the frame is a slight variant of that appearing

[2] Martin, *Heavenly Ladder*, p. 99.

on the outer frame of fol. 121r. Part of the interior of a church is in the center of the scene. A blue ciborium with a carmine baldachin on top is flanked by two icons, that of the Virgin Mary on the left and of Christ on the right, their faces painted against the gold and framed in carmine. These are meant to be the despotic icons of an iconostasis. A monk in violet and brown garments stands under the ciborium reading from a book placed on a red lectern. Around him, six other monks pray in various attitudes: two young ones kneel at the left, one with long hair and beard stands with uplifted arms and prays to the icon of Mary, and a dark-bearded monk at the extreme right prays to the icon of Christ. Two more monks, one of them hooded, are seated in meditation. Initial Π. Homily 28, On Prayer.

279r The exaltation of the "poor man" (7.6 x 9.5 cm.) (fig. 629). The frame is decorated with flower petals; at the top and bottom, roundels and diamonds, divided horizontally, are similar to those on fol. 39r; but the vertical sides, containing roundels, with diagonal stems joined to the corner roundels, recall the horizontal sides of fol. 184v. On top of the headpiece, two olive grey birds holding a leafy branch in their beaks flank a gold fountain filled with blue water as on fol. 94v. In the illustration, at the left, a monk with a long, pointed, grey-blue beard and blue-white hair, in a brown and black-brown habit, stands with his hands in prayer. An angel in blue and carmine with brown wings, holding a scroll, stands to his left; a second angel, in half figure, wearing brown and blue and flying above, places a white diadem on the monk's head. A group of people in secular garments is at the right: two young men, the one at the left wearing a long red garment with black borders, and the one on the right clad in pink and blue; next to them are two women in rich apparel, the first in white and deep red robes, the second in a red, rinceau-patterned robe and a blue mantle; both wear large white headdresses. Two diminutive black demons which seem to have been added later by a reader to whom female figures could signify evil, and are now almost completely effaced, are shown near the two women. The luxurious dress of all these figures and their pious gestures—three of them hold their hands in prayer like the monk—would identify them as "the princes of the people of the Lord." Initial I. Homily 29, On Tranquility.

283r Hope, Faith, and Charity personified (7.5 x 9.3 cm.)

(fig. 630). The frame is decorated in ordinary flower petal style in roundels with palmettes or inverted flower petals between them. The illustration contains the three virtues personified. Charity, depicted as an empress, is in the center. She wears a crown and imperial blue robes with a gold loros, and holds in her left hand a white orb with a double cross. She sits upon an ornate, red-cushioned, yellow grisaille throne with a lyre-back, over which she spreads her yellow wings. The bust of Christ in gold and blue, his hands extended to the sides, appears above her head. Both figures are enclosed within a large, circular, crenellated aureole in blue, red, and dark green. Faith and Hope, also with yellow wings, stand on either side; each wears a belted tunic with short sleeves, a skirt reaching to the ankles, in blue and red for the figure at the right and red and pink for the figure at the left, and a fillet about the hair. On the right, three white rays are directed from the red sun toward the head of Faith, whose arms are crossed over her breast. Hope, on the opposite side, holds up her hands in prayer. Every figure wears a nimbus. Initial N. Homily 30, On Faith, Hope, and Charity.

288v Band-shaped headpiece with palmettes in roundels with flower petals between. Table of contents in reversed order written in gold.

290r John Climacus teaching (8.3 x 9.3 cm.) and a Deesis on top (1.6 x 4.9 cm.) (fig. 631). The flower petal ornament of the frame is similar to that on the horizontal sides of the frame on fol. 279r. John Climacus, with a long, pointed, brown-white beard, nimbed and in brown and dark brown monastic garments, sits on a brown throne with a carmine back and a blue cushion in the midst of six monks of different ages, teaching from an open scroll held in his left hand. Two of the monks, one on each side, in violet and very dark brown garments, seated on tall carmine chairs and resting their feet on footstools, extend their arms addressing John. In striving for the celestial world, the intercession of the Mother of God and of John the Baptist is necessary, and this is shown by the Deesis on top of the headpiece. Mary on the left, clad in blue, and John the Baptist in brown at the right, intercede with Christ who, clad in gold tunic and blue himation, holds a gold book in his left hand and blesses with his right. All three are nimbed and shown as half figures. The scene refers to the celestial world, in contrast to the title miniature, which represents the earthly world. Initial Є. Homily to the Pastor.

Iconography and Style

This book, one of the most richly illustrated codices of John Climacus' work, has forty-three miniatures which generally can be divided into those illustrating the prefatory material, and those applied to the thirty chapters or homilies on spiritual exercises of the monks. Of the first group, the author portrait and the Ladder (figs. 588, 594) are common among Climax manuscripts.[3] Of special interest is the first miniature, fol. 2r (fig. 588), serving as the frontispiece. Its strongly orientalizing character, the heraldically arranged lions, the form of the arch, and the ornament have been related by J. R. Martin to the Norman mosaics of the Royal Palace at Palermo, and to the cod. Paris gr. 550 (Homilies of Gregory Nazianzenus), both from the twelfth century.[4]

The impressive picture of the dedication is unique among surviving Climax codices. Although it may ultimately derive from Gospel or Lectionary dedication pages with the evangelists and Christ,[5] in its concept the composition relates to scenes found in late eleventh- and twelfth-century codices which depict Christ or the Virgin Mary, among others, as recipients, such as the cod. Athos, Dionysiou 61 and Melbourne, Nat. Gall. Victoria 710/5.[6]

Related to the dedication page is a miniature, fol. 79r, depicting the Virgin Orans adored by monks (fig. 600, colorplate xxvi:a). This is similar to dedication pages with donors in proskynesis before the interceding Mother of God depicted in various iconographic types,[7] as, e.g., in Athos, Lavra A 103, fol. 3v, and the Martorana mosaic from 1148 showing the founder of the church and Mary.[8]

All other illustrations in single or multiple frames, a practice common in Constantinopolitan manuscripts of the twelfth century,[9] illustrate the requirements of a religious life; the painter endeavors to present a concrete enactment of the virtues and vices discussed in the various chapters or sermons of the treatise. Of special iconographic interest are the personifications of Faith and Hope, on fol. 283r (fig. 630), whose rendering has been related to that in another Climax manuscript, cod. Vat. gr. 394,[10] probably dating from the

early twelfth century, in which the elements of the Last Judgment scene, fol. 166v (fig. 614) are also found.

Martin's study of the iconography of this and all other illustrated Climax manuscripts has shown that the program of the illustration does not follow an old tradition but is compiled from a variety of sources.[11] In all Climax codices the hermitic life has a special place, its scenes having been borrowed from an unknown, earlier cycle with the lives of anchorites (fols. 31v, 254r, 259r: figs. 597, 626, 627).

In terms of style and method of decoration, Martin has related the Sinai codex to the Gregory manuscript cod. Paris gr. 550;[12] the figures in both manuscripts are slim and wiry, the folds of the garments are indicated by dark, fine lines and certain mannerisms. The Gregory codex is certainly Constantinopolitan, and the question arises whether the Sinai Climax manuscript should also be assigned to the capital. On the whole the drawing is delicate and the figures are elegant. The faces are expressive and individualized; their modelling indicates an artist trained in or familiar with Constantinopolitan workshops. The color is subtle and the use of gold abundant. Darker colors are consistently used for the monks more resplendent ones for Christ and his angels.

The same intricacy and skill are seen in the decoration of the furniture, where the use of grisaille is to be noticed. The compositions against their gold backgrounds—landscape is seldom represented—are somber and at times seem to be frozen in their arrangement. However, the ornament makes a Constantinopolitan origin questionable. The design is meager and the execution is rough. The large heart forms enclosing single palmettes, for example, are found in provincial manuscripts such as the cods. Jerusalem, Taphou 47 and Princeton, Garrett 3.[13] Among the colors applied to the headpieces, the blue in particular is paler than that used in Constantinopolitan products. But there is another peculiarity which indicates a provincial origin. The corner palmettes in flower petal or fretsaw style (the latter appears in some of the headpieces as well) have a shapeless gold background. The palmette at times resembles a jewelled flower recalling

[3] Ibid., pp. 10ff.

[4] Ibid., pp. 87, 189.

[5] Ibid., p. 88.

[6] Galavaris, *Liturgical Homilies*, p. 25, pl. LXVII,355; Spatharakis, *Portrait*, pp. 76–78, fig. 43. Buchthal, who first published the Melbourne codex and proposed a date ca. 1100, is recently inclined to date it later, but still within the twelfth century; see "A Greek New Testament Manuscript in the Escorial Library: Its Miniatures and its Bindings," in *Byzanz und der Westen. Studien zur Kunst des europäischen Mittelalters*, ed. I. Hutter, Vienna 1984, p. 87 n. 7. Another example from the second half of the twelfth century is in cod. Moscow, Hist. Mus. gr. 387; see Spatharakis, *Portrait*, pp. 128–29, fig. 85.

[7] Cf. S. Der Nersessian, "Two Images of the Virgin in the Dumbarton Oaks Collection," *DOP* 14 (1960) pp. 69–86; repr. in eadem, *Études*, pp. 61–76.

[8] See Spatharakis, *Portrait*, pp. 78–79, fig. 45, and Demus, *Norman Sicily*, pp. 73, 83 n. 103, fig. 58b.

[9] Cf. cod. Sinai 339, no. 56 above.

[10] Martin, *Heavenly Ladder*, pl. XXIX,99.

[11] Ibid., pp. 121ff.

[12] Ibid., p. 189.

[13] Hatch, *Jerusalem*, pl. XLV, cf. fol. 142v (fig. 610) of cod. Sinai 418; Spatharakis, *Dated Mss.*, no. 141, fig. 266.

the gold discs marking the *sura* of a Koran or ornament found in headpieces of Christian-Arabic manuscripts.[14] This particular feature may point to a locale where Islamic influences were common, such as Palestine or possibly Sinai itself.

Bibliography

Kondakov 1882, pp. 153ff., pls. 77, 78.

Gardthausen, *Catalogus*, pp. 100–101.

Kondakov, *Histoire*, pp. 134ff.

G. Millet, "L'art byzantin," in A. Michel, *Histoire de l'art*, 1, Paris 1905, p. 250.

A. Reuter, *Beiträge zur einer Ikonographie des Todes*, Leipzig 1913, pp. 49ff.

C. R. Morey, "East Christian Paintings in the Freer Collection," in W. Dennison and C. R. Morey, *Studies in East Christian and Roman Art*, New York and London 1918, pp. 3, 12ff.

O. Wulff, *Altchristliche und byzantinische Kunst*, Berlin 1924, 2, p. 536.

Ebersolt, *Miniature*, p. 39.

Lazarev 1947, p. 320.

A. Grabar, "Un rouleau liturgique constantinopolitain et ses peintures," *DOP* 8 (1954) pp. 179 n. 21, 196 n. 47; repr. in *Fin de l'Antiquité*, 1, pp. 482 n. 1, 494 n. 1.

Martin, *Heavenly Ladder*, passim, pp. 187–89, pls. LVII,174–LXVII, 216.

H. Buchthal, "The Beginnings of Manuscript Illumination in Norman Sicily," *Papers of the British School at Rome*, 24 (New Series, 11) (1956) p. 79, pl. XIa.

A. Grabar, "Iconographie de la sagesse divine et de la Vierge," *CA* 8 (1956) pp. 255–57; fig. 2, repr. in *Fin de l'Antiquité*, 1, pp. 556–57, 3, pl. 140c.

J. Meyendorff, "L'iconographie de la sagesse divine dans la tradition byzantine," *CA* 10 (1959) p. 269, fig. 6.

S. Der Nersessian, "Two Images of the Virgin in the Dumbarton Oaks Collection," *DOP* 14 (1960) p. 80; repr. in eadem, *Études*, p. 70.

A. Grabar, "Deux notes sur l'histoire de l'iconostase d'après des monuments de Yougoslavie," *Zbornik radova vizantološkog instituta* 7 (1961) p. 20, fig. 7; repr. in *Fin de l'Antiquité*, 1, p. 409, 3, pl. 106d.

M. Harisiades, "Les miniatures du tétraévangile du métropolite Jacob de Serrès," *Actes du XIIᵉ Congrès International d'Études Byzantines (Ochrid, 1961)*, 3, Belgrade 1964, p. 128.

Lazarev, *Storia*, p. 254 n. 51.

Idem, *Theophanes der Grieche und seine Schule*, Vienna and Munich 1968, p. 261 n. 227.

Galavaris, *Liturgical Homilies*, pp. 26, 94 n. 235, 213, 228, 244.

Kamil, p. 87 no. 642.

Ch. Walter, *Iconographie des conciles dans la tradition byzantine*, Paris 1970, p. 195, fig. 89.

Idem, "Further Notes on the Deësis," *REB* 28 (1970) p. 163, fig. 6, repr. in *Studies*, no. II.

R. Stichel, *Studien zum Verhältnis von Text und Bild spät- und nachbyzantinischer Vergänglichkeitsdarstellungen* (Byzantina Vindobonensia, 5), Vienna 1971, p. 65.

Ch. Walter, "The Origins of the Iconostasis," *Eastern Churches Review* 3 (1971) pp. 261, pl. 5, repr. in *Studies*, no. III.

Weitzmann, *Sinai Mss.*, pp. 18–19, fig. 23.

M. E. Frazer, "Church Doors and the Gates of Paradise," *DOP* 27 (1973) p. 150, fig. 7.

[14] Cf. *suras* in a Koran and ornament in a bohairic-Arabic biblical manuscript from the early thirteenth century in M. Cramer, *Koptische*

Weitzmann, "Cyclic Illustration," p. 87, fig. 27.

Marava-Chatzinicolaou, Toufexi-Paschou, pp. 108, 195.

Weitzmann, *The Icon*, p. 8, fig. II.

Galey 1979, figs. 155, 156, 159, 160.

S. Dufrenne, "L'insensé dans l'illustration des psautiers byzantins et slaves," in *Byzance et les slaves. Mélanges Ivan Dujčev*, Paris 1979, pp. 129ff., fig. 9.

T. Velmans, "Rayonnement de l'icon au XIIᵉ et au début du XIIIᵉ siècle," *Actes du XVᵉ Congrès International d'Études Byzantines (Athens, 1976)*, 3, Athens 1981, pp. 197ff.

Voicu, D'Alisera, p. 561.

Weyl Carr, "A Group," p. 50.

D. Barbu, *Manuscrise bizantine în colectii di România*, Bucharest 1984, pp. 22, 24, 25.

58. OLD LIBRARY, ROOM I, SOUTH WALL, ROW VI, NO. 3
MINIATURE ICON. METAMORPHOSIS
FIRST HALF OF TWELFTH CENTURY.
FIG. 633

Parchment on wood. Parchment 34.8 x 25 cm. (39 x 29.5 cm. with wooden frame).

The parchment with the miniature is glued firmly onto a wooden panel. Originally the sheet had a simple, red border line that was overpainted in dark steel blue, the same color applied to the frame. Large areas of the surface have flaked badly; most of the gold ground is gone, revealing the reddish brown underpaint. The pigment of Christ's white garments is almost completely lost. Some parts, especially the hands of Christ, have been redrawn, apparently in recent times.

Christ floats above the ground in the center, standing in a narrow mandorla in three shades of blue repeated in the beams of light emanating from it. Clad in white and with a beam of light descending upon him from a segment of sky above, which may have included a hand of God, he is flanked to his left by the youthful Moses and to his right by the grey-haired Elijah, their feet only touching the mountain. Moses, wearing light blue and light green garments, holds the tablets like a codex. Elijah is clad in a dark brown cloak with steel-colored highlights, somber colors befitting a hermit. At the foot of the mountain range full of flowers and bushes and topped by trees which flank Moses and Elijah, one sees the three disciples in various positions: on the left, Peter, in blue and light brown garments, in his usual physiognomic type, kneels, but, as if ready to rise from the

Buchmalerei, Recklinghausen 1964, figs. 19, 20.

ground, he throws back his head and raises his arm, gazing at Christ; in the center, the youthful John in the same light blue and green as Moses, facing to the left, is in proskynesis; at the right, the bearded, dark-haired James, wrapped in a cloak of subtle pink, turning his head around toward Christ, is trying to steady himself with his left hand while he holds his right motionless in the sling of his mantle.

Christ and the prophets wear nimbi which in pattern and color imitate cloisonné enamels. The nimbi of the disciples are gold. Above the heads of the prophets is an inscription in *Epigraphische Auszeichnungs-Majuskel* in gold set into a tabula with a white background also imitating enamel technique: + H ΜΕΤΑ/ΜΟΡΦΩCIC.

A detailed study of the iconography of the icon has shown that it is related to tenth- and eleventh-century works such as the cods. Paris gr. 510, Athos, Iviron 1, and Paris gr. 74, presumably reflecting a common archetype—the lost mosaic in the northern cupola of the Church of the Holy Apostles in Constantinople.[1] At the same time, the miniature shows changes, such as new variants in the depictions of Peter and James and the use of an oval aureole for Christ, the latter feature going back to an Early Christian tradition represented by the mosaic in Sinai.

The miniature is possibly a Constantinopolitan product. The figure style is elegant and graceful. The modelling of the faces is achieved by strong highlights on the noses, cheeks, chins, and between the eyebrows. But apart from the distinctive portrait of Peter, the faces lack expressive power. The drapery is linear and displays specific features: a regular patternized, zigzag motif at the hem, best seen on Moses' mantle and the distinct, central loop in Peter's and James' himations, the relation of the drapery to the thigh, and the form taken by the knee. These characteristics are comparable to those found in manuscripts datable in the first half or the middle of the twelfth century. In particular the drapery compares well with that in cod. Athos, Koutloumousi 60.[2] Furthermore, the pattern of the nimbi of Christ and the prophets is found in the figure of Matthew in cod. Vienna, suppl. gr. 52,[3] and in the portrait of Gregory Nazianzenus in cod. Sinai 339,[4] both from the first half to the middle of the twelfth century.

It is most likely that the miniature was cut from a sumptuous Lectionary with full-page feast pictures and turned into an icon at a later time. The transformation of a Lectionary miniature into an icon would not have been objected to, since full-page representations in Lectionaries were understood as icons.[5]

Bibliography

K. Weitzmann, "A Metamorphosis Icon or Miniature on Mt. Sinai," in *Mélanges Djurdje Bošković*, *Starinar*, N.S. 20 (1969) pp. 415–21, repr. in *Psalters and Gospels*, no. XIII.
Idem, *Sinai Mss.*, p. 23, fig. 30.

59. COD. 157. FOUR GOSPELS
CA. A.D. 1127–1157/58. FIGS. 634–644

Vellum. 269 folios, 22.2 x 16.1 cm. Two columns of twenty-four lines. Minuscule script for text, small round, pendant letters, carefully written with *Keulenstil* elements; titles in *Epigraphische Auszeichnungs-Majuskel* and *Auszeichnungs-Majuskel*. Gathering numbers at the lower left of last verso with two horizontal lines and two strokes. Parchment fine and white. Ink black for text; titles and initials outlined or solid in vermillion.

Fols. 1r–4v, Synaxarion; 5r–6r, preface to the Gospels; 6r–7r, Matthew chapters; 7v, miniature; 8r–78r, Matthew; 78v–79r, Mark chapters; 79v, miniature; 80r–125r, Mark; 125v–127r, Luke chapters; 127v, miniature; 128r–206v, Luke; 207r, John chapters; 207v, miniature; 208r–265r, John; 265v–269r, Menologion (September–August, only list of readings for fixed feasts); 269r, colophon.

The colophon, on fol. 269r at the lower part of the left column in red ink, is contemporary with the text and reads (fig. 643):

ἐγράφη ἡ παροῦσα ἱερὰ / βίβλος ἐν πάτμω / τῆ νήσω ἐν τῶ σπηλ(αίω) / ἔνθα εἶδεν ὁ ἅγ(ιος) ἰω(άννης) ὁ / θεολό(γος) τὴν ἀποκάλυ(ψιν), / διὰ χειρὸς ἰωά(ννου) (μον)αχ(οῦ) πρὸς / τὸν καθ' ἡγούμ(ε)ν(ον) (μον)αχ(ὸν) κῦ(ρ) θεό/κτιστ(ον)· καὶ ἐτελειώθ(η) μην(ὶ) / κ̄· ἰνδ(ικτιῶνος)

This holy book was written in Patmos in the cave where St. John the Theologian saw the Apocalypse by the hand of the monk John at the request of the abbot, monk Theoktistos, and it was completed in the month . . . , 20, indiction.

[1] For a full discussion see K. Weitzmann, *op. cit.* in bibliography.
[2] See *Treasures*, 1, fig. 299.
[3] Gerstinger, *Griech. Buchmalerei*, p. 34, pl. XIX; P. Buberl and H. Gerstinger, *Die byzantinischen Handschriften* (Beschreibendes Verzeichnis der illuminierten Handschriften in Österreich, N.F.: Die illuminierten Handschriften der Nationalbibliothek in Wien, IV, 1–2), Leipzig 1937–38, pp. 50ff., pl. XXV no. 2.
[4] See no. 56 above, fol. 4v, fig. 472.
[5] Cf. cod. Sinai 204, no. 18 above.

The month and the number of the indiction and the year are missing.

On fols. 7r and 269v, later entries, commemorations of names.

The codex is in good condition, but the illustrations, which belong to the mansucript and are part of the gatherings, have suffered considerable flaking.

Old, very dark brown leather binding on wooden boards with pressed ornament, in poor condition (fig. 642). From the front cover a large, central piece has been cut out; from the back cover two pieces are missing. Possibly the missing parts contained metal attachments (small icons?); metal studs must have existed on the four corners. The ornamentation, best seen on the front cover, consists of parallel frames (bands and thin fillets) with a rinceau motif in different patterns, and medallions enclosing lions which are also found in the central field. Two metal pins for fastening are on the front cover. Its condition makes an attempt to date the cover difficult; possibly it is not earlier than the fifteenth century. On the inside of the back cover on a glued paper page are later drawings of a figure in a short tunic in blue-grey wash, and a head drawn in black ink (fig. 644).

Illustration

1r Π-shaped headpiece with a rough crenellation in blue and gold with red dots in center and a red fillet defining the frame, left column. List of daily readings (Synaxarion).

7v Matthew, inscribed in red ὁ ἅγιος [μα]τθαῖος, writing (13 x 8.8 cm.) (fig. 634). Clad in a violet chiton with a red clavus and a steel blue mantle, with brown flesh tones and grey-olive hair and beard, the evangelist sits turned to the right on a red-cushioned stool with a red footstool. He is writing in a codex held by his left hand on his lap. His large nimbus, imitating cloisonné enamel, has red and blue crosslets. In front of him is a desk with a tall lectern on which rests an open book containing the opening words of his Gospel. All furniture, completely flaked, has traces of brown pigment and gold. The ground strip is black-blue and the background gold. The frame of the miniature is decorated with a crenellation in blue with red dots and black on gold ground. On top there is a delicate stylized palmette in fretsaw style flanked by two half palmettes, all in red.

8r Rectangular headpiece with a quatrefoil in the center, enclosing the title decorated in flower petal style (fig. 635). Tendrils with small flower petals attached

to them form complete blue roundels, the four largest in the corners. Enclosing composite flower petals, these four roundels are framed with an enamel-like pattern. Between the corner roundels are pairs of smaller, simpler roundels. Although the ornament is not very delicate, the color scheme—blue, red, and black against gold—is very effective. The stylized palmettes in the corners and the extended lower line of the frame are simply outlined, as is the initial B. Mt. 1:1ff.

79v Mark pensive, ὁ ἅγιος μάρκος (13.7 x 9.3 cm.) (fig. 636). The evangelist, clad in a red chiton and with an olive green mantle draped over his left shoulder, sits contemplatively on a cushioned stool with a footstool as Matthew on fol. 7v. His right hand is on a codex in his lap, and he rests his chin on his left hand. His face, completely flaked, has traces of brown and his hair is violet-black. His large gold nimbus is ornamented with a rinceau in green and red. An inspiration motif, a white dove, flies from the left toward the writer's ear. The desk, and the lectern on a dolphin stand with an open codex on it, are completely flaked. A grey-green strip serves as ground; the background is gold. The composition is set within an arch supported by dark brown marble columns with grey capitals. The arch itself is decorated with a crenellation motif in dark blue, grey-white, and red, and the area above with connected flower petal-roundels. A stylized palmette at top center is flanked by two half palmettes; two small palmettes are on the corners.

80r Rectangular headpiece enclosing the title in an inner square (fig. 637). The frame is decorated in flower petal style. The overall linear pattern is that of a quatrefoil intersected by segments of arches and filled with flower petals heraldically arranged. On the four corners are roundels containing bent, composite, wind-blown palmettes. The spaces between the ovals and the roundels are filled with more flower petal motifs. The colors are blue, red, and black with yellow set on gold ground. Initial A in carminé. Mk. 1:1ff.

127v Luke writing, ὁ ἅγ(ιος) λου[κᾶς] (13.8 x 9.7 cm.) (fig. 638). The composition, almost completely flaked, depicts the evangelist seated and writing on a codex held on his lap. He is clad in a light blue chiton with a red clavus and a light grey-green mantle, and has a gold nimbus, possibly with ornament now lost. The furniture is brown and the cushion on his chair red. The lectern on the desk reaches the height of his head

and rests on a tall thin support. An open codex on it contains fragments of the opening words of his Gospel. The ground strip is black and the background gold. The figure is set against an architectural structure. Two black marble columns with red acanthus capitals support a pediment with crenellation in circle segments, set in a rectangle ornamented with flowers roughly designed in a pattern imitating enamel work. A small, dark blue cross with flaring arms and rays and two small leafy tendrils springs from its base, flanked by two palmettes on top.

128r Rectangular headpiece enclosing the title in an inner square (fig. 639). Roundels with flower petal motifs fill the four corners and are connected by long diagonal tendrils on either side of which are very mannered composite palmettes. All are rendered in colors as previously, on gold ground. Initial Є in carminé. Lk. 1:1ff.

207v John and Prochoros, ὁ ἄγιο(s) ιω(άννηs) ὁ θεολόγοs, ὁ a(γιοs) προχορος (15.1 x 9.7 cm.) (fig. 640). John, standing to the right clad in a steel blue chiton with a gold clavus and deep red mantle, turns his head back toward the hand of God emerging from a gold segment of sky; at the same time, leaning slightly to one side as if taken by surprise, he extends his right hand in blessing over the head of Prochoros at the left who, seated on a gold, red-cushioned stool, busily records the words of his master. John's face is completely flaked but his large gold nimbus is decorated with red and blue crosses in an enamel-like pattern similar to Matthew's nimbus on fol. 7v. Prochoros wears a grey-blue mantle (his tunic is flaked), has brown flesh tones modelled with green, brown hair, and a gold nimbus decorated with a rinceau in blue and red similar to Mark's nimbus on fol. 79v. A very dark color, almost black, has been applied to the ground. The background is gold. The scene is set under an arch supported by grey-green columns, mostly flaked, decorated with crenellation. The space above the arch is filled in rough flower petal ornament. Circular tendrils form heart-shaped patterns at the spandrels and circular forms between them enclosing flower petals.

Palmettes are at the center, the two top corners, and the extended line at the base of the composition.

208r Rectangular headpiece enclosing the title in an inner square (fig. 641). The frame is decorated with a tile pattern. Square tiles are divided diagonally into four sections, each with one palmette on a tendril, all four sections forming a rosette. Initial Є in carminé. Jn. 1:1ff.

Iconography and Style

In their iconography the portraits of the evangelists follow types common in Middle Byzantine book illumination (cf. Sinai cods. 172 and 179, nos. 29 and 48 above).

According to its colophon this book was produced in Patmos for the monk Theoktistos, the abbot of the monastery. There have survived two documents related directly to him: his testament, written on September 23, 1157/58, the day he died, during the reign of Manuel Comnenos, and a petition to the same emperor dated March 1145.[1] In the testament, Theoktistos says that he had spent some time in Palestine and Cyprus before settling in Patmos. At first he assisted the abbot Joseph Iasites, a collector of books, and then he succeeded him to the rank of prior about the year 1127, according to Eva Vranousis, who has studied the relevant documents.[2] The Sinai Gospels, therefore, must have been produced between ca. 1127 and 1157/58.

Figure style, compositions, and ornament support an approximate date within this period, especially about the mid-twelfth century. All figures are elegant and at least Mark shows considerable plasticity. They are, however, over-articulated and subjected to an overall linear treatment through the strongly highlighted drapery, the folds of which are multiplied and stylized in a mannered, yet forceful fashion, as is shown, for example, by the wavy hemline of the garments of Matthew. The faces are carefully modelled with green shades; in their original state they must have been expressive and full of energy, as can be deduced from the rendering of the hair in sculpturesque, distinct locks with dynamic upward strokes (see especially Matthew, fol. 7v, fig. 634).

Facial types, drapery, poses, and furnishings find parallels among several twelfth-century manuscripts.[3] A very close parallel to the treatment of the drapery, pointed out by

[1] See F. Miklosich and J. Müller, *Acta et diplomata monasteriorum et ecclesiarum orientis*, 6, Vienna 1890, repr. Aalen 1968, pp. 106–110; M. Nystazopoulou-Pelekidou, Βυζαντινὰ ἔγγραφα τῆς Μονῆς Πάτμου 2. Δημοσίων λειτουργῶν, Athens 1980, p. 113.

[2] E. L. Vranousis, Τὰ ἁγιολογικὰ κείμεα τοῦ Ὁσίου Χριστοδούλου ἱδρυτοῦ τῆς ἐν Πάτμῳ μονῆς, Athens 1966, p. 188; eadem, "Πατμιακὰ Γ. Ὁ καθηγούμενος τῆς μονῆς Πάτμου Ἰωσὴφ Ἰασίτης καὶ ἡ

ἀρχαιότερη ἀναγραφή χειρογράφων τῆς μονῆς," *DChAE* 4 (1964) (Τιμητικὸς Γ. Σωτηρίου) pp. 345–51.

[3] See cods. Oxford, Auct. T. inf. 2.7, fols. 44v, 116v, in Hutter, *Oxford*, 1, no. 42, figs. 276, 277; Athos, Koutloumousi 60, fols. 56v and 115v: *Treasures*, 1, figs. 297, 299 (in this publication the headpieces of the codex have not been reproduced); Princeton, Univ. Lib. Garrett 5: *Greek Mss. Amer. Coll.*, no. 34, fig. 59; *Byzantium at Princeton*, pp. 152–53, no. 177.

R. Nelson, is found in the apostles in the apse of the cathedral of Cefalù from 1148.[4]

In their designs the ornamental headpieces recall the ornament of cod. Sinai 339 (see no. 56 above). But in their execution and color scheme they are quite removed from Constantinopolitan products, as may be demonstrated by comparing the provincial-looking headpiece on fol. 8r (fig. 635) with that on fol. 91r of cod. Sinai 339 (fig. 479). Nevertheless, the Patmos ornament has a unique, expressive quality because of the distinct color scheme which combines colors for contrast; for example, the black ground is employed against the gold of the background, as are black and yellow, red and green against the gold in the headpieces and in the nimbi. The quality is very high, but whether the manuscript demonstrates the influence of a model from the capital or was executed by an illustrator trained in a scriptorium related to the capital, we cannot know. Furthermore, whether its features should be considered characteristic of products of Patmos or of the Aegean islands in general during this period must remain at present an open question.

Bibliography

Gardthausen, *Catalogus*, p. 30.
Gregory, *Textkritik*, pp. 246, 1134 no. 1194.
Vogel, Gardthausen, p. 205.
Hatch, *Sinai*, pl. XXXII.
Colwell, Willoughby, *Karahissar*, 1, pp. 210–11.
Lazarev 1947, p. 370 n. 78 (here the codex is dated to the fourteenth century).
Devreesse, *Introduction*, p. 57.
Kamil, p. 68 no. 182.
R. S. Nelson, "Text and Image in a Byzantine Gospel Book in Istanbul (Ecumenical Patriarchate cod. 3)", unpublished Ph.D. dissertation, New York University, 1978, pp. 43ff., 45, 48ff., 61ff., 65, 82, figs. 48, 50.
Voicu, D'Alisera, p. 554.
Weyl Carr, "A Group," pp. 48, 51.

60. COD. 208. LECTIONARY
MIDDLE TO SECOND HALF OF TWELFTH
CENTURY. FIGS. 645–651,
COLORPLATE XXVII

Vellum. 254 folios, 38.3 x 28.2 cm. Two columns of twenty-two lines. Minuscule script for text, very hieratic and of monumental character (letters 45 mm. high), almost rectangular, thick, and consciously archaic in style, with

[4] See bibliography below and Demus, *Norman Sicily*, fig. 4B.

titles in *Epigraphische Auszeichnungs-Majuskel* and *Auszeichnungs-Majuskel*, also used for calendar indications. Gathering numbers at lower right corner of recto. Parchment very fine and white; very wide outer margins. Ink strong black for text; titles in gold, some in deep red; ekphonetic signs in red. Very simple but elegant initials in flower petal style, and solid initials in gold.

Jo. hebd. Mat. Lk. Sab-Kyr., Passion pericopes, Eothina, Menologion, varia.

Fol. 1r, blank; 1v, miniature; 2r–53r, John weeks; 53v, blank; 54r–78v, Matthew weeks; 79r–v, blank; 80r–107r, Luke weeks; 107r–108v, pannychides, first week of Lent; 109v, blank; 110r–147v, Mark readings; 147v–176r, Passion pericopes; 176v–181r, Eothina; 181v, blank; 182r–251r, Menologion, September–August; 251r–254v, varia, readings for various occasions. A folio cut out at the end may have contained a colophon.

Condition excellent. In the monastery the codex is known as Prince Alexander's Gospel, and it is considered to have been a gift to the monastery, possibly to the metochion of Sinai in Roumania, by the prince of Wallachia in the second half of the sixteenth century. This is confirmed by the metal covers.

Silver-gilt covers, partly hammered, worked on a mold and engraved, with representations in excellent state of preservation. Each cover consists of one piece nailed onto a wooden board first covered with leather. The spine consists of a wire chain with similar locks; the upper lock has been preserved, but only a fragment of the lower. Both covers follow the same layout (figs. 648, 650).

On the front cover, in the center, is the Crucifixion, РАСПЄТНЄХВО͞. The crucified, dead Christ, I͞C X͞C, is depicted on the hill of Golgotha containing Adam's skull, his arms in a completely horizontal position and his head with flowing hair resting on his right shoulder. Mary, M͞P Θ͞Y, and the other two Maries stand at the left, John, I͞Ѡ, and the centurion, looking upward with raised arm, at the right. The sun and moon and two mourning angels are above on either side of the cross. The city of Jerusalem is represented in the lower background as a series of parallel walls, each with two towers, and floral motifs between, perhaps indicating gardens. Floral motifs are in the upper background. The half-figure portraits in the small panels, most of them in three-quarter view and oriented toward the central scene, represent saints. The four evangelists are on the corners. On top, Matthew, MAT͞Є, and John, I͞Ѡ; at bottom, Mark, С͞T MAPKO, and Luke, Λ͞OYKA; between

them are saints and prophets. On top, Cosmas of Maiuma, the poet, ΚΟϹ / M̄Ā / ΠΟΙΗΤΥ; Moses, ΜΟΗϹΙ; and Aaron, ΑΡΟΝ. On the sides, left and right, David, ΔΑΒΗ̂ ΠΡΚ; Solomon, ϹΟΛΟΜΟΝ; Isaiah, ΗϹΑΗΑ ΠΡΚ; Zachariah, ΖΑΧΑΡΗ; Jeremiah, ϵΡϵΜΗΑ ΠΡΟΚ; Jonah, ΙѠΝΑ; Ezekiel, ΗϵΖϵΚϵΗΛ; Micah(?), ΜΗ(?) ΚΟ(?). At the bottom, Daniel, ΔΑΝΗΗΛ; Habakkuk, ΑΒΑΚΟΥΜ; John Kalybites, ῙѠΗ ΚΑΛΥΒΥΤΥ. The evangelists and the two saints are represented holding open Gospel books, and the prophets open scrolls, except Jeremiah who is represented frontally beside a building, perhaps uttering his lamentations. In every other panel the background is decorated with small rosettes.

The back cover contains in the center the Transfiguration in its standard iconography. Christ is flanked by the old Elijah at his right, ΗΛΙΑϹ, and the younger Moses at his left, Ο ΜΟΗϹΙ. They stand on three mountain peaks with the three disciples below, Peter looking up, John in proskynesis, and James falling down while he attempts to shade his eyes. Rosettes are between Christ and the Prophets, with the following inscription above their heads within the panel: η αγια μεταμορφωσις του χ(ριστο)υ. Below the scene, separated from it by a slanting line, are the portraits of the three donors, all kneeling in adoration and gazing at the event. They wear ceremonial robes and crowns and have long flowing hair; all except the figure at the left are bearded.[1] The portraits are identified by inscriptions: ιω(ανν)υ μ(ι)χ(αηλ) βοεβο(ντα) [–]υτ[–](?) ιω(αννυ) αλεξ(α)νδρυ βοεβο(ντα) η τομνα αικατερινια (John Alexander Voevode, his wife Catherine and [their son] John Michael Voevode.)

Around the central composition is another inscription: + ἐγγοσμημα κ(αι) δεξιότητι τοῦ εὐσεβεστάτου αὐθεντος, ιω(αν)υ(ου) · ἀλεξανδρου βοεβοντα πασης ουγροβ(λ)α-χί(α)ς συν της τομυ(ας) αικατεριν(ης) εἰς σινα ορους. (+ Decoration and skill [or, loosely translated, "a precious offering"] of the most pious prince John Alexander of the entire "Ugroblachia" with his wife Catherine to Mt. Sinai.) This prince is probably Alexander II of Moldavia and Wallachia (1568–1575), a member of the ruling family that after the fall of Constantinople assumed protectorship of the Orthodox world and dispensed gifts to most important monasteries.[2]

The portraits around the border represent mostly ascetics and martyrs. The evangelist symbols, nimbed and winged, are on the four corners: the eagle, ΙѠ; the angel,

MATϵH; the lion, ΜΑΡΚΟ; and the calf, ΛΟΥΚΑ. Except for the calf, which turns its head back, the other three zodia are oriented toward the scene. Between the symbols are, on top: Euthymios the Great, ϵΦΤΗΜΗ ΒϵΛΗΚϵΗ; Athanasios, ΑΘΑΝΑϹΙΟϹ; Anthony the Great, ΑΝΤΝΗϵ ΒϵΛΗΚΗ; at the left and right sides (read horizontally): Maximos the Confessor, ΜΑΞΗΜ ΗϹΠΟΒϵ; Theodosios the Coenobiarch, ΤϵѠΔΟϹΗϵ ѠbΨϵŽΙΤϵΛΟ; Paul the Great, clad in a sleeveless goatskin, ΠΑΒϵΛΗ ΒϵΛΗϹΚ; Onouphrios, represented naked, ѠΝΟΦΡΗϵ; Makarios the Great, ΜΑΚΑΡΗϵ ΒϵΛΙΚΗ; Onouphrios once more (?), Η ѠΝΟΦΡΟϵ; "Saint" Makarios clad in priestly vestments, ΜΑΚΑΡΗϵ ΒϵΛΗΚΗ; Mark (?), ΜΑΡΚ [–]ΡΟΥϵϹΚΗ; and at the bottom: St. George, ϹΤ̄Η ΓϵΟΡΓΗϵ; St. Demetrios, ϹΤ̄Η ΔΗΜΗΤΡΗϵ; and the prophet Daniel, ΔΑΝϵΗΛb.

The iconographic program of the cover is of special interest. While the representation of the Crucifixion is standard on book covers, the Transfiguration relates specifically to the destination of the cover, Mt. Sinai. The inclusion of prophets, evangelists, and symbols around the main themes follows an old tradition, but the choice of certain saints deserves special attention.

In the front cover, the inclusion of Cosmas of Maiuma and John Kalybites is uncommon. The first can be easily explained. He was one of the leading ecclesiastic poets and a monk who spent most of his life in the monastery of St. Sabas glorifying God in his poetry. But there is no convincing explanation for the inclusion of John Kalybites. In the account of his life it is reported that a gold-wrought Gospel book was given to him by his mother while he was a small child, and he kept it to the end of his life, during which the Gospel played a great role.[3] The Gospel book became his attribute, as it appears in his depiction on the cover. Perhaps the importance of this attribute prompted his inclusion on a Gospel cover.

For the back cover the donor has chosen for the most part ascetics of the desert, a choice surely justified by the purpose of the gift. Among them, Hosios Paul is Paul the Hermit of Latros, identified by the sleeveless goatskin; the nakedness of the first figure of Onouphrios identifies him as the hermit who spent his life in the Thebaid. The second figure of Onouphrios, however, may well be related to Sinai. Perhaps he may be identified with Onouphrios, one of the first hermits to occupy a grotto in Ouadi Leyan south of the Djebel Mousa at the beginning of the fourth century and to

[1] For the costume see C. Nicolescu, *Le costume de cour dans les pays roumains (XIVᵉ–XVIIIᵉ siècles)*, Bucharest 1970.

[2] N. Iorga, *Byzance après Byzance*, Bucharest 1935, pp. 126ff., 155ff.
[3] See *PG* 114, 568–80.

whom a chapel was dedicated.[4] There are also two figures of Makarios. The first, wearing a simple monastic habit, is surely Makarios the Egyptian Anchorite. The second, however, is clad in priestly vestments: the omophorion with a cross is clearly distinguishable. The inscription gives him the title Great, which should not be overemphasized since captions do not always correspond to actual sainthood. Among the several saints under the name of Makarios in the Synaxarion, one can single out two as possibilities: Makarios the abbot of the monastery of Peleketes in Triglia, Hosios and Confessor, who died in the ninth century fighting for the icons; and the Hosiomartyr Makarios, a disciple of the patriarch Nephon in the Holy Mount Athos, who suffered martyrdom at the hands of the Turks in 1527, a few decades prior to the production of this cover.[5] If he was proclaimed martyr soon after his execution, which seems most likely, he may be a likely candidate. Nevertheless, the question remains open. If we were to propose Makarios the martyr, then his presence on this cover destined for Sinai may have political implications, referring to the protectorship of the Orthodox world undertaken by the Voevodes. The inclusion of the prophet Daniel twice (costume, attributes, and captions leave no doubt of this), once in his proper place among the prophets and once among the military saints, may also be of significance. Daniel foretold the fall of Babylon (5:5ff.). Can he be seen here as the symbol of the expected fall of the Ottoman Empire?

In its form the cover follows patterns found in covers dating from the second half of the sixteenth century. A similar Gospel cover, but in different style, a gift of Prince Jeremiah Mogilas in 1598, is also at Sinai (cod. 247).[6] This is another example of the many gifts presented by the Roumanian princes to Greek monasteries, especially to Athos, Sinai, and Jerusalem.[7]

Illustration

1v Deesis, full-page (30.5 x 23.5 cm.) (figs. 645–647). The entire page is divided into nine compartments in three registers, all framed with a wide band with rough crenellation in dark blue, red, and light yellow against gold. The central compartment, the largest, contains Christ enthroned. Clad in a purple tunic and dark blue mantle, he holds a gold book with a red edge in his left hand and blesses with his right. The elabo-

rately decorated throne, its legs taking the form of shafted columns with Corinthian capitals, is gold and the cushion bright red. The right leg of the throne is incoherently overlapped by a red footstool with blue and black pearl-studded edges. The inscription \overline{IC} \overline{XC} and all other captions are in black ink. All figures are set against a brilliant gold ground. Left and right, in separate compartments, stand Mary and John the Baptist in three-quarter view extending their hands in prayer toward Christ. The Mother of God, \overline{MP} $\overline{ΘY}$, is clad in blue and purple garments, while John, Ὁ ἍΓΙΟϹ \overline{IW}(άννης) Ὁ ΠΡ(όδρομ)ΟϹ, is clad in a light brown tunic and darkest brown mantle, with yellowish brown highlights, and his hair and beard have similar colors.

The four evangelists, all with stern, vivid expressions achieved by the slight contraction of their eyebrows, are represented in the corner compartments as half figures turned toward the center. On the upper left, John, Ὁ Ἅ(γιος) \overline{IW}(άννης) Ὁ ΘΕΟΛΌΓΟϹ, with receding white hair and wearing a blue tunic and a brown mantle lightening to white-grey forcefully wrapped over his right arm and shoulder, holds in both hands his half-opened gold book. Facing him is Matthew, Ὁ Ἅ(γιος) ΜΑΤΘΑῖΟϹ, wearing a blue tunic and dark brown mantle lightening to grey, with rich grey hair and holding a closed book with red edges in his left, raising his right in a gesture of blessing. At the lower left is Luke, Ὁ ἍΓΙΟϹ ΛΟῦΚΑϹ, clad in blue tunic and brown mantle lightening to light brown, with rich black-brown hair with yellowish touches, and a sparse short beard divided into two locks. He holds a gold book with red edge in his left hand as if displaying it, and raises his right hand in a gesture of blessing. He looks at Mark at the right, Ὁ ἍΓΙΟϹ ΜΆΡΚΟϹ, who is clad in a blue tunic and pink mantle shading to brown, and has dark brown hair with blue touches and a short full beard. He holds with both hands a gold book with red edge which is tilted forward.

2r Π-shaped headpiece, left column, in delicate but ordinary flower petal style. Two diamond-shaped flower petals on the top bar between three roundels set in gold. Initial Є in similar style (fig. 649). Jn. 1:1–17.

[4] Rabino, pp. 1, 37.

[5] Eustratiades, *Hagiologion*, pp. 283–84.

[6] See M. Beza, *Byzantine Art in Roumania*, London 1940, pp. 7, 65, fig. 36; cf. also a metal cover from the year 1519, with the Anastasis in a somewhat similar technique, in the Museum of Religious Art in Bucha-

rest, and the cover of cod. Athos, Dionysiou 587; see N. Iorga, *Histoire des Roumains*, 4, Bucharest 1937, figs. 37, 65; and Weitzmann, "Lectionary Dionysiou," pp. 248ff., figs. 6, 7.

[7] In general see Beza, *op. cit.* (supra note 6), passim.

54r Π-shaped headpiece over the left column, in rough flower petal style. Between roundels are stylized carmine calyxes with pink flowers set against gold. Initial Є in similar style. First Saturday after Pentecost. Mt. 5:42–48.

80r Π-shaped headpiece, left column, in rough flower petal style (fig. 651). The tendrils form roundels containing petals with heraldically arranged palmettes between them on the top bar and inverted flower petals on the sides. Initial T in similar style. First Saturday of Luke weeks, Lk. 4:31–36.

110r Π-shaped headpiece, left column, in rough flower petal style, a variant of that on fol. 2r. Initial T in delicate fretsaw style with a cross on the hasta. First Saturday of Lent, Mk. 2:23–3:2.

147v Band-shaped headpiece, left column, a variant of that on fol. 80r. Initial T in flower petal style. Menologion, September 1.

Thereafter the beginning of each month is marked by a small band-shaped headpiece and initial T or Є drawn in gold only and with very simple patterns, such as ordinary palmettes, zigzag, wavy, or horizontal lines, meanders and rinceau on the following folios:

193v Zigzag ornament, left column. October 1.

200r Starry ornament, right column. November 1.

203v Zigzag ornament, left column. December 1.

214r Simple rinceau, left column. January 1.

224v Outlined crenellation, right column. February 1.

227v Meander, right column. March 1.

231r Squares with crossed diagonal, right column. April 1.

232v Horizontal lines, right column. May 1.

237r Wavy lines, left column. June 1.

243r Hatched pattern, right column. July 1.

246v Cross-meander pattern, right column. August 1.

Iconography and Style

In introducing this Lectionary with a Deesis scene, the illustrator follows a well-established tradition. The composition, which includes portraits of the evangelists deriving ultimately from scenes representing them offering their Gospels to Christ, is known in Lectionaries since the tenth century, as shown by the cod. Athos, Lavra A 92.[8] In some Lectionaries or Gospel books there is prefatory textual material including a Deesis scene. In the Sinai Lectionary, however, there are no prefatory texts which would require the Deesis illustration.[9] In this case, therefore, we must reckon with the strong liturgical tradition of the Deesis theme. Its actual source may well have been an iconostasis beam, the center of which was formed by the Trimorphon, followed by other figures, including the evangelists, forming a so-called extended Deesis.[10] However, the formal arrangement of the illustration, and particularly the setting of the figures within framed compartments, points to a different antecedent, related to representations of the evangelists dedicating their books to Christ, as seen in cod. Vat. gr. 756,[11] while the crenellated borders suggest a possible direct imitation of enamelled book covers or reliquaries, as a comparison with the staurotheke of Limburg an der Lahn from 964–965 shows.[12]

The figure style has a decorative character. The organic structure of the bodies is weak, and any impression of corporeality is limited by the linear quality of the drapery: straight or parallel lines and folds, and metallic hems, best seen in the garments of the Trimorphon. In the drapery of the apostles the fabric is stiff, hanging rigidly about the arms. The faces have stern expressions conveyed by a stylistic peculiarity, a groove between the eyebrows dividing the forehead in half. The intention of the artist may have been to convey the impression of contracted brows and hence to endow his figures with an emotional quality. This peculiarity, as well as the head types, expression, and drapery can be found in the miniatures of a Lectionary in Athos, cod. Koutloumousi 61, which also must be assigned to the twelfth century.[13] The comparison of these two manuscripts should focus on the figure style and not the ornament.

[8] Galavaris, *Prefaces*, fig. 88, pp. 115ff. with other examples; for a color reproduction of the Lavra miniature see *Treasures*, 3, fig. 48.

[9] Galavaris, *Prefaces*, *loc. cit.*

[10] Such beams have been preserved in Sinai; see Sotiriou, *Icônes*, 1, figs. 95, 96, 103, 106, 111, 113, 115; Weitzmann, *Sinai Mss.*, p. 23; idem, "Icon Programs of the 12th and 13th Centuries at Sinai," *DChAE*, per. 4, vol. 12 (1986) pp. 64ff.

[11] Friend, "Evangelists," p. 133, pl. VII,84, 85; R. Devreesse, *Codices Vaticani Graeci*, 3, Vatican 1950, pp. 272–74; Galavaris, *Prefaces*, pp. 106–107, figs. 83, 84.

[12] For a reproduction see D. Talbot Rice, *The Art of Byzantium*, London 1959, pls. 125, 126; for bibliography see H. Schnitzler, *Rheinische Schatzkammer*, Düsseldorf 1958, p. 24 no. 12, pls. 38–47; and for the most recent discussion of the inscriptions see J. Koder, "Zu den Versinschriften der Limburger Staurothek," *Archiv für mittelrheinische Kirchengeschichte* 37 (1985) pp. 11–31.

[13] The Koutloumousi codex has been variously dated from ca. 1065/70 to the thirteenth century. The early date and attribution to Antioch proposed by G. Mercati ("Origine Antiochene di due codici greci del secolo XI," *Analecta Bollandiana* 68 [1950], pp. 210–22, esp. 216–17) and accepted by Spatharakis (*Dated Mss.*, p. 28, no. 88) may be applicable to the text of this incomplete codex but not to its miniatures, which in our opinion are inserted and do not belong to the original codex. For a reproduction see *Treasures*, 1, pp. 452–53, figs. 300–304; on the iconography of its miniatures see Weitzmann-Fiedler, "Begleitfiguren," pp. 32ff.; Galavaris, *Prefaces*, pp. 57–58, figs. 26, 27 and passim.

The Sinai Lectionary has been connected to a group of icons now in Sinai which are related to the frescoes of the church of Panagia Phorbiotissa at Asinou in Cyprus from 1105–1106, and which have been attributed to Cyprus.[14]

The codex may be the work of a Cypriot illustrator. Paleographically it belongs to a milieu comprising Cyprus, Palestine, Syria, and Egypt.[15] Artistically it goes beyond the chronological limits of the Asinou frescoes, as is shown by the growing isolation of different parts of the body and by the predominance of the colors blue and brown. Both of these traits are common in late twelfth-century manuscripts such as London, Brit. Lib. Burney 19,[16] attributed to the third quarter of the century. The metallic drapery, however, lacks the exaggerated movement seen in the Lagoudera frescoes in Cyprus from 1192.[17] Therefore a date for the Sinai codex in the middle or third quarter of the twelfth century (i.e., before Lagoudera) is plausible.

Bibliography

Gardthausen, *Catalogus*, p. 41.

Gregory, *Textkritik*, p. 447 no. 842.

M. Beza, *Byzantine Art in Roumania*, London 1940, pp. 61–62, no. 35.

Sotiriou, *Icônes*, 2, p. 105.

Kamil, p. 70 no. 233.

Weitzmann, *Sinai Mss.*, pp. 23–24, figs. 31, 32.

Greek Mss. Amer. Coll., p. 157 n. 3.

Weitzmann, "Cyprus," pp. 59–60, pl. 25.

P. Drossoyanni, "Some Observations on the Asinou Frescoes," Κληρονο-μία 10 (1978) p. 76.

Marava-Chatzinicolaou, Toufexi-Paschou, p. 147.

Galavaris, *Prefaces*, p. 118.

P. L. Vokotopoulos, "Τά ἐπίτιτλα ἑνός τετραευαγγελίου τῆς ὁμάδος τῆς Νικαίας," *DChAE*, per. 4, vol. 9 (1977–79) p. 137 n. 18.

Voicu, D'Alisera, p. 557.

R. S. Nelson, *The Iconography of Preface and Miniature in the Byzantine Gospel Book*, New York 1982, p. 113.

Weyl Carr, "A Group," p. 52.

Eadem, "Gospel Frontispieces," pp. 4, 6.

61. COD. 216. LECTIONARY
SECOND HALF OF TWELFTH AND FIFTEENTH CENTURIES. FIGS. 652–658

Vellum. 261 folios, 30.2 x 22.2 cm. Two columns of twenty-seven lines. Minuscule script for text, written under the line, even, clear and well-spaced letters; titles and calendar indications in *Epigraphische Auszeichnungs-Majuskel* and *Auszeichnungs-Majuskel*. Gathering numbers on bottom margin of recto folios. Parchment mostly thin but yellowish, average quality. Ink light brown for text; titles and calendar indications in gold; entire pages fols. 1r, 34r, 89r written in gold, partly flaked and showing the red underneath. Ekphonetic signs in carmine. Initials in flower petal style outlined in gold alternating with solid initials in gold.

Jo. hebd. Mt. Lk. hebd., Passion pericopes and Hours, Menologion, varia, Eothina.

Fols. 1r–33r, John weeks; 33v, miniature; 34r–88v, Matthew weeks; 89r–157v, Luke weeks; 158r–188r, Mark readings; 188v, miniature; 188v–205r, Passion pericopes; 205r–211v, Hours readings; 212r–256r, Menologion, September–August; 256r–257r, varia; 257v–261r, Eothina; 261v, blank.

At present the manuscript is incomplete. Parchment is torn at edges and last folios are in bad condition. The miniatures are not contemporary with the codex, but were added later in empty spaces.

Dark brown leather binding on wooden boards stamped on both covers with small lozenges containing rosettes formed of four heart-shaped leaves; freestanding fleurs-de-lis are attached to the corners of some lozenges (figs. 656, 658). In addition, on the back cover there are small star-like rosettes and "classical" fleurs-de-lis (two inverted flowers). Furthermore, the back cover is marked by thin triple converging diagonal lines mostly covered now by metal pieces (discussed below). On the front cover, below the metal plaque, is the following stamped inscription contained within a rectangle: ΚΛΗΜΗC ΙЄΡΟ(μου)ΑΧ(ος). Two metal pins for closing have been preserved on the front cover.

The hieromonk Clemens was most likely the binder; his dates at Sinai and therefore the date of this leather binding can be confirmed by another text, an entry on fol. 340v of cod. Sinai 448 of the year 1004 by Ioasaph, the archbishop and abbot of Sinai (1617–1660), with the date 1637. The translation of the Greek text runs as follows:[1]

[14] For a detailed discussion see Weitzmann, "Cyprus."

[15] See Canart, "Chypriotes," pp. 23ff.

[16] See Beckwith, *Constantinople*, p. 128.

[17] See A. H. Megaw and A. Stylianou, *Cyprus: Byzantine Mosaics and Frescoes*, UNESCO, Paris 1963, pls. XIV–XVIII; A. Papageorgiou, *Masterpieces of the Byzantine Art of Cyprus*, Nicosia 1965, pls. XXIII–

XXVII; C. D. Winfield and C. Mango, "The Church of the Panagia tou Arakos, Lagoudera," *DOP* 23/24 (1969/70) pp. 377ff.

[1] For the original text see Beneševič, p. 234; and Harlfinger et al., p. 19, no. 5.

"The present Paterikon was brought by the hieromonk Klemens the Cretan from Raithou; and he rebound it because it was much damaged in the year 1637. The binding was completed in the month of January. And whenever the monastery closes and they wish to take it (to Raithou?) so that they can read it they can do so."

The leather binding bearing the stamped "signature" of Clemens must have been made at about the same time, probably in the first quarter of the seventeenth century.

Thin, repoussé, silver-gilt metal pieces are nailed upon the leather cover. In the center of the front cover is the Crucifixion with Mary, \overline{MP}, John, $\overline{I\omega}$, and two mourning angels before a small segment of a Gothic arch (fig. 656). The scene is set under a scalloped Gothic arch supported by two thin spiral columns. The four evangelists are at the corners. Read horizontally, they correspond to the sequence of the Gospel readings in the Lectionary. John, on the upper left, seated within a cave and attentive to the inspiration of the hand of God above, dictates to the writing Prochoros, IΩ-ANN, ΠPOXOP. On the opposite corner is Matthew, MATΘA, seated facing to the left on a chair with spiral legs, writing on a book in his hand. The peaks of two rocky mountains are on either side of the background. At lower left, Luke, ΛOYKA, seated on a wide, cushioned bench facing to the right and resting his feet on a footstool, is writing in a codex. A low table with a large inkstand and an unrolled scroll, presumably on a lectern which is not represented, are before him. Two tall domed buildings with doorways and loggias form the background. On the opposite side Mark, MAPKO, facing to the left, seated on a wide bench with two cushions and a footstool, is reading from a codex. A low table with a large inkstand in the form of a vase and a lectern, barely visible, with an open codex stand before him. Two tall gabled buildings with window or door openings and a loggia joined above by a piece of drapery form the background.

Between these corner pieces are narrow bands with a floral motif. On the leather, between the Crucifixion plaque and the border, are four large studs in a cross arrangement.

The back cover has an ornamental border similar to that on the front, four metal discs each stamped with a seraph, CEPAΦHM, and four round studs at the corners (fig. 658). A flat gilt plaque in the form of a cusped arch containing an incised, extremely animated Transfiguration is affixed with eight nails in the center. Christ, inscribed \overline{IC} \overline{XC}, with O ω N on his nimbus, stands within a mandorla floating on a cloud, flanked by the bearded Elijah at his right and the youthful Moses holding the tablets at his left. Both, in three-quarter view and inclining their heads toward Christ, stand on rugged mountain peaks. The disciples are below in their usual positions. Peter on the left tries to raise himself while pointing to Christ with his right hand. John is in proskynesis in the center, and James is falling down violently with his head turned up. They are inscribed in Slavonic: ΠЄTPЬ, IωAN, ЇAKOBУ.

The scene is complemented by two narrative episodes at the sides. Christ leads the three disciples, headed by Peter, up the mountain at the left and blesses them while they descend at the right. First in the latter group is the youthful John, who turns slightly toward Christ; the imposing figure of Peter rises from behind. In both episodes Christ is inscribed \overline{IC} \overline{XC} as usual, with O ω N on his nimbus. Two more, unidentifiable scenes are on the upper part of the composition. At the left, a bearded saint kneeling on a cloud and extending his hands in supplication is led to Christ by the archangel Michael, MHXAHΛ. On the opposite side Gabriel, APX ΓABPHΛ, raises a bearded saint out of a sarcophagus while pointing with his right hand to Christ. There was on the sarcophagus an inscription probably identifying the saint, of which only the following traces are left: I / IOΛAH. On the top appears the bearded figure of God the Father with a rayed nimbus holding an orb in his left hand and blessing with his right. On the top border of the arch there was an engraved inscription, now lost except for the following, damaged letters: A CΔI / Θb(?).

The Slavonic inscriptions point to a Slavic country as the binding's place of origin. The iconography and style indicate Russia.

The Crucifixion depicts the dead Christ with his body arched in a strong curve and his left leg clearly displayed above his right. These are Western iconographic elements known in Italian Crucifixes since the thirteenth century.[2] However, the form of the arch, mostly framing figures, is found in Greek and Russian icons after the sixteenth century and becomes common in the following two centuries.[3] It can also be seen in sixteenth-century metal book covers, like that on the cod. Athos, Dionysiou 587.[4]

In the representations of the evangelists, the lecterns are distinguished by their size and the large vase-like

[2] See, for example, the Crucifixion of the Master of St. Francis in the National Gallery, London: J. Taylor, *Icon Painting*, London 1979, fig. on p. 38.

[3] See two examples in *Ikonen*, Munich 1970, nos. 119, 121.

[4] Weitzmann, "Lectionary Dionysiou," pp. 248ff., fig. 6.

inkstands in the center. These iconographic features appeared in Byzantium in the fourteenth century, and spread into the Russian world, where they continued to the eighteenth century.[5] Normally only John and Prochoros are represented against a landscape, presumably Patmos. The representation of Matthew against a mountain occurs in Russia and the Slavic lands in the seventeenth and early eighteenth centuries.[6]

But the principal scene of the Transfiguration goes back to an earlier thirteenth- or fourteenth-century model. Most indicative of this is the position of James, who falls on his back while attempting to cover his face. An early example of this pose occurs in the cod. Paris gr. 54, from the last quarter of the thirteenth century.[7] Furthermore, the style of the Paleologan model has left its imprint on the plaque in the fullness of the bodies and the fluttering garments. The immediate source must have been a Russian icon, where the inclusion of the supplementary narrative scene as well as additional iconographic elements were quite popular.[8] But the key to the date of the plaque is given by the figure of God the Father. Wearing a rayed nimbus and holding a globe, he appears in Russian icons at the end of the seventeenth and early eighteenth century.[9] This particular type of nimbus is first associated with the representation of the Holy Trinity in the mid-seventeenth century, and with the development of mystic subjects around the Son of God.[10]

The form of the plaque, a cusped arch, is found variously in Russian icons,[11] but since the end of the seventeenth and throughout the eighteenth century the production of small triptychs in this particular form became common.[12] The plaque follows this tradition and should be dated ca. 1700. A similar date is applicable to the ornamental frame, its motif found on silver repoussé frames in Russian icons of the period.[13]

The metal front cover is a routine, "ready-made" work, but the central plaque of the back cover is of high quality. Its subject suggests that it was made specifically for Sinai and that the unknown saint may have had particular importance

to the donor. The discrepancy in quality raises the question whether the Transfiguration plaque and the rest of the metalwork could be contemporary. In this case the ready-made pieces were combined with the "commissioned" Transfiguration plaque.[14]

Illustration

1r Π-shaped headpiece, left column, in somewhat rough flower petal style in conventional patterns (fig. 652). On top of the headpiece, long, bending stems with flowers are flanked by two quails. Another bird perches on the central, largest flower and two more long-tailed blue birds are flying toward the cluster of flowers. The stylized palmettes on the top corners show the influence of the fretsaw style. Below, the extended line of the frame terminates in three blossoming calyxes with a small bird on top. Initial Є in flower petal style outlined in gold. Jn. 1:1–17.

33v Matthew touching the Gospel on the lectern (17.4 x 15 cm.) (fig. 653). The evangelist, seated facing to the right on a cushioned, decorated bench with his feet on a footstool, touches with his left hand an open codex on a lectern set on a table. He is clad in blue tunic and light yellow-brown himation, and has pink flesh tones, white-grey hair, and a large gold nimbus. The furniture is rendered in brown except the top of the footstool, which is gold, and the red cushion of the seat. There is a strip of ground in pale olive color and an architectural setting consisting of a tall, pale yellow tower with four turrets with red roofs and a sketchy brown dome; at the right is a building in similar color, with a gold doorway framed in blue and a light blue gable, a red roof, yellow, red, and blue towers, and a cornice on the wall decorated with a brown meander. The background is gold. There is a broad, watery red frame and the inscription ὁ ἄ(γιος) ματθ(αῖος) ὁ ἀπό(στολος). The miniature was painted later in an empty space following the conclusion of John's pericope on fol. 33r.

[5] *Ikonen*, Munich 1970, no. 304.

[6] Galavaris, *Icons-Wisconsin*, pp. 26ff. with further bibliography.

[7] Lazarev, *Storia*, fig. 393. Cf. also the mosaics of the Church of the Holy Apostles in Thessalonike, 1312–1315; ibid., fig. 560, and A. Xyngopoulos, Ἡ ψηφιδωτὴ διακόσμηση τοῦ ναοῦ τῶν Ἁγίων Ἀποστόλων Θεσσαλονίκης, Thessalonike 1953.

[8] Cf. a seventeenth-century icon of the Moscow school in Autenried, *Katalog des Ikonenmuseums Schloss Autenried*, Munich and Autenried 1974, p. 80, III,6; cf. also an icon of the Transfiguration with archangels floating on a cloud by Theophanes the Greek from 1403, in Moscow, Tretjakov Gallery: B. N. Antonova and H. E. Mneva, *Katalog drevnepycckoij*

zivopisi, 1, Moscow 1963, no. 217, fig. 177.

[9] Recklinghausen, *Ikonen-Museum*, 5th ed., Recklinghausen 1976, nos. 16, 81, 203, figs. 108, 111, 141.

[10] Ibid., nos. 55, 74.

[11] *Ikonen*, Munich 1970, no. 213; also V. Elbern, *Das Ikonenkabinett*, Staatliche Museen Preussischer Kulturbesitz, Berlin 1970, no. 22; Galavaris, *The Icon in the Church*, pl. XXXII.

[12] See K. Sommer, *Ikonen*, Munich 1979, pl. 15.

[13] Cf. D. Talbot Rice, *Russian Icons*, New York 1963, pl. XXXVIII.

[14] See the metal cover of cod. Sinai 275, no. 41 above, fig. 375.

34r Π-shaped headpiece, left column, in flower petal style in subdued colors. First Monday after Pentecost, Mt. 18:10–20.

69v Mark pensive (14.8 x 9 cm.) (fig. 654). The evangelist, clad in blue tunic and very light yellow-brown mantle, with pink flesh tones and reddish brown hair, is seated facing to the right on a red-cushioned brown bench. With his left hand he pensively supports his chin, resting the other on his right knee. He rests his feet on a blue footstool awith a gold top. Before him on the lectern is a drawn, unrolled scroll. In the background are two tall buildings with red roofs, their marble walls in lightest yellow-brown with doorways and gables filled in blue. The background is gold. A broad blue band interrupted on the right side by the drawn scroll frames the illustration, which is accompanied by the following inscription: ὁ ἅ(γιος) μάρκος ὁ ἀπό(στολος). The miniature was painted in an empty space on the right column and is not contemporary with the codex. The left column contains the concluding text of Mt. 18:23–35.

70r Π-shaped headpiece in flower petal style, with ordinary half-diamond patterns in rectangles. Monday of the twelfth week, Mk. 1:9–15.

89r Rectangular headpiece framing the entire left column containing calendar indications of lections (fig. 655). Leafy blue tendrils with large flowers in carmine and white with red tips form spirals terminating in flower petals or open flowers painted in light steel blue, light green, and red on gold ground. Initial T in flower petal style supported by a bird. Monday, first of Luke weeks, Lk. 3:19–22.

158r Π-shaped headpiece in flower petal style, petals in roundels, left column. First Saturday of Lent, Mk. 2:23–3:2.

188v Band-shaped headpiece and the Crucifixion above (ca. 13.5 x 11.4 cm.) over both columns: τα ἅγια παθ(η) τοῦ κ(υρίο)υ κ(α)ὶ θ(εο)ῦ ημ[ῶν] (fig. 657). The narrow band set over the title belongs to the original decoration of the codex and is ornamented in a simple flower petal style in a scroll pattern. The dead crucified Christ is depicted with his grey-pink body nailed on the heavy brown cross, wearing a white loincloth and a gold nimbus. Blood gushes from the wounds of his hands and side. The skull of Adam under the suppedaneum extends into the ornamental band. Mary, John, and the centurion are at the sides

of the cross. The Mother of God, M̅P̅ Θ̅Y̅, is clad in garments in the watery colors used in all miniatures in the codex, blue for the tunic and pale carmine for the mantle; John's garments are rendered in blue and yellow-brown. Both wear gold nimbi. The centurion, his nimbus only outlined, wears yellow-brown armor and a blue mantle, holds a long spear in his left hand, and points to Christ with his right. At the foot of the cross, at the side of Mary and John, are two soldiers in olive grey garments, dividing Christ's blue cloak. All figures have reddish brown hair. Two flanking walled cities with turrets are joined in the background by a high wall with a cornice decorated with a meander like that on fol. 33v. The sun and moon complete the composition. They are painted in grey-pink colors against the parchment, but the disc of the sun contains the head of Helios in red. This scene was added later, apparently in a space reserved for it, because the title above is in gold and in the same script as the title below the ornamental band. Beginning of Passion pericopes, Jn. 13:31–38.

212r Π-shaped headpiece, left column, in flower petal style in ordinary roundels. On the extended lower line are two olive green cypresses around which is tied a vermillion stem terminating at both ends in a trefoil flower. Menologion, September 1.

All other months are marked by a simple band in flower petal style of various patterns on the left or right columns as follows: 218r, October; 222v, November; 225v, December; 232r, January; 234v, February; 242r, March; 243r, April; 243v, May; 245r, June; 249r, July; 251v, August.

256r Band-shaped headpiece with a scroll pattern, right column, varia.

257v Band-shaped headpiece with palmettes in half diamonds, left column. Eothina.

Iconography and Style

The original decoration of the codex was limited to the ornament. The miniatures were added later, and except for the Crucifixion, for which space had been provided, were painted in whatever empty spaces were available.

The ornament is distinguished by the use of calyxes with flowers, open flowers, and birds perched on calyxes or fruit which terminate the lower, extended lines of the headpieces. Calyxes on the lower, outer corners of headpieces had already appeared at the end of the eleventh and the beginning of the twelfth century.[15] But in the case of this codex, the calyxes invade the ornamental band; they are

[15] See cod. 179, no. 48 above, fols. 3r, 4r, 6r (figs. 427–29), and cod. Oxford, Canon gr. 92, fol. 1r, in Hutter, *Oxford*, 3, 1.2, no. 68, fig. 257.

chalice-like and grouped in threes, resembling candelabra. The form is foreshadowed by the ornament of the cod. Vat. Urb. gr. 2 from ca. 1125,[16] but this clustering in threes points to a later date.[17] However, the meander motif on fol. 188v is somewhat similar to that on fol. 231v of the cod. Sinai 418 (see no. 57 above; fig. 624) and the open flowers with large folded leaves, fol. 89r, appear in cod. Paris gr. 21, assigned to the twelfth century.[18]

A date in the second half of the twelfth century is also supported by the paleography. The alpha with the high, raised loop, and the spread-out omega, to single out two features, find parallels in codices of the second half of the century, for example, the cod. Neapolit. II A 18 from the year 1175.[19] Despite the use of gold and the careful script, the codex is not of very fine quality, and is mostly likely a provincial product.

The later evangelist portraits and Crucifixion present some distinct iconographic features. The types used for the evangelists, Matthew touching the Gospel and the pensive Luke, are well-known and interchangeable (cf. cods. 172, 205, 179, 157: nos. 29, 33, 48, 59 above). Their actual rendering, however, has certain peculiarities. Allowing for the roughness of style, the legs give the impression of being crossed—cf. especially Mark, fol. 69v (fig. 654)—and the feet are very small. These features and the overcrowded buildings in the background point to a late twelfth-century model, like the cod. Athos, Dionysiou 12.[20] At the same time, the long unrolled scroll on the lectern, fluttering over the frame, as it were, occurs in such fourteenth-century codices as Athos, Dionysiou 80.[21] Other iconographic features and the style show changes from the postulated model and betray still a later date. The rectangular turrets on the city walls in the portrait of Matthew (fol. 33v) and in the Crucifixion scene (figs. 653, 657), alternating with gable-roofs illogically arranged, are common in post-Byzantine manuscripts such as the cod. Athos, Koutloumousi 100, from the sixteenth century.[22] The Virgin's tunic, folded under and giving the impression that she is wearing an apron under her mantle, is a fifteenth-century element also seen in cod. Athos, Dionysiou 471.[23] The round, rather fat faces of the soldiers in that scene point to the same century. Considering all these elements, it can be concluded that the illustrations were added sometime in the fifteenth century, and most likely in its second half.

Bibliography

Kondakov 1882, p. 104.
Gardthausen, *Catalogus*, p. 43.
Gregory, *Textkritik*, pp. 447, 1246 no. 850.
Lazarev 1947, p. 370 n. 78.
Idem, *Storia*, p. 423 n. 113.
Kamil, p. 70 no. 241.
Voicu, D'Alisera, p. 558.

62. COD. 220. LECTIONARY
A.D. 1167. FIGS. 659, 660

Vellum. 355 folios, 29.8 x 21.3 cm. Two columns of twenty-two–twenty-five lines. A second hand with a smaller script appears on fols. 4r–16v, 56r–127v; the first hand with wider lines returns on fol. 128r. Minuscule script for text, written under the line with a broad pen, rough and inelegant, of the "Cypro-Palestinian" type, Canart's *epsilon arrondi*.[1] Titles on fols. 1r and 276r in *Epigraphische Auszeichnungs-Majuskel*; all others in *Auszeichnungs-Majuskel*. Gathering numbers on upper right corner of first recto. Parchment thick, rough but white. Ink black for text but four opening lines in left column, fol. 1r, are in gold over carmine; titles and few opening lines of text, rubrics, and ekphonetic signs in dull wine red and red-brown. Simple solid initials in similar colors, some with a blessing hand.

Jo. hebd. Mt. Lk. hebd., Passion pericopes and Hours, Menologion, Eothina.

Fols. 1r–55v, John weeks; 56r–116r, Matthew weeks; 116v–199v, Luke weeks; 199v–201v, pannychides, 201v–241v, Mark readings; 242r–258v, Passion pericopes; 258v–273v, Hours and Holy Saturday readings; 273v–274r, Eothinon A (Mt. 28:16–20); 274v–275v, blank; 276r–348r, Menologion; 348r–352v, Eothina; 352v, colophon.

The colophon reads:

ἐπληρώθη τὸ παρὸν ἅγ(ιον) εὐἀγγέλ'(ιον)· διὰ
χει/ρὸς βασιλείου ἀμαρτ(ω)λ(οῦ)· νοταρίου τοῦ
σκηνού(ρη) / καὶ ἥ τις τῷ ἀναγινώσκη εὔχεσθαί

[16] Spatharakis, *Dated Mss.*, no. 135, fig. 253.
[17] Cf. the thirteenth-century cod. Athos, Dionysiou 4 in *Treasures*, 1, figs. 18–21, 26, 27.
[18] Ebersolt, *Miniature*, pl. LIV,1; Bibliothèque Nationale, *Byzance et la France médiévale*, Paris 1958, no. 34.
[19] Spatharakis, *Dated Mss.*, no. 163, fig. 310.
[20] *Treasures*, 1, figs. 32–35.

[21] Ibid., fig. 145.
[22] Ibid., figs. 336, 337.
[23] Cf. the figure of St. Theodore the Sanctified; ibid., fig. 172.

[1] See Canart, "Chypriotes," pp. 53–67.

μοι / ψυχικόν σας αἰμοὶ τῷ ἁμαρτωλῷ· ἵνα εὕρω /
ἔλαιως ἐν τη ἡμέ(ρα) τῆς κρίσεως· ὁμοίως καὶ οἱ
ἀ/ναγινώσκωντ(ες) αὐτῶ· σὺν τῷ αὐθέντη του τὸ
τη/μιωτάτω κἀθήγουμένω τῆς ἐν τῇ ἀγ(ία)
βιθλεὲμ, / ἐν τῇ σεβασμία μονῇ τῶν ἀγ(ίων)
κελλίων· μη(νὶ) φευροα/ρίω ἰνδικτιῶνος ιε' τοῦ
,Ϛχοε' ἔτους +

This holy Gospel was completed by the hand of Basil Skenouris, the sinner *notarios*, and if one reads it may he pray, as a charity, for me the sinner that I may find mercy on the day of judgment and likewise the readers of this book together with its owner the most honorable prior (who is) in Bethlehem in the venerable monastery of the Holy Cells; in the month of February on the 15th indiction of the year 6675 (1167). +

The scribe is the same one who produced a Gospel without illustrations now in Sinai, cod. 232, in March 1174.[2] The family name, Skenouris, is known from other Byzantine documents.[3] An Arabic entry on fol. 354v reads in translation: "Masūd dedicates the volume on the 5th Muharram 689 A.H. (18 January 1290) to the Sinai monastery."[4]

Fol. 2v is blank, although it is part of a regular quaternion (gathering α', fols. 1–8); between fols. 55 and 56, the beginning of the Matthew weeks is missing; text on fols. 241r–v (which is loose) is written in cross form (end of pericopes for the liturgy in Maundy Thursday and Passion); 274v and 275r are blank; 353–355 are later, paper gathering. The codex shows heavy use but condition on the whole is good.

Plain red-brown faded to light brown leather binding on reused wooden boards. The front cover once had a silver border with a rinceau pattern, of which a fragment survives at the upper right corner, crudely nailed on the cover. In addition, a metal Greek cross was affixed in the center, its imprint seen on the leather along with traces of nails. A metal pin for closing has survived at the upper right of the front cover. The back cover is badly worn.

Illustration

1r Rectangular headpiece with a bust of Christ (15 × 14.6 cm.) (fig. 660). A thin fillet decorated with color-less beads frames a second, larger frame enclosing a quatrefoil with a bust of Christ in a medallion. The inner frame is filled with leafy tendrils in a rinceau pattern beginning on either side of a small cross on the upper part, and expanding in the four corners into a variety of irregular heart forms, all in a provincial carminé style in brown and brown-red. The medallion framed as the outer fillet contains a bust of Christ, I͞C X͞C, holding a scroll in his left hand and blessing with his right, rendered in preliminary drawing only in a faded or dull wine red and brown red. The lobes of the quatrefoil contain the title. Initial Є with a blessing hand with traces of gold in the outline, and traces of blue within. Jn. 1:1–17.

116v Band-shaped headpiece over both columns with a rinceau in carminé. Huge initial T in similar style. Monday, first of Luke weeks. Lk. 3:19–22.

201v Π-shaped headpiece, left column, with a rinceau pattern in carminé. First Saturday of Lent, Mk. 2:23–3:2.

242r Band-shaped headpiece with crosslets in two rows in carminé, left column. Beginning of Passion pericopes, Jn. 13:31–38.

276r Band-shaped headpiece, over both columns, with rosettes in diamonds and stylized flower petals between in carminé (fig. 659). Menologion, September 1.

Thereafter, each month is marked by a band-shaped headpiece in left or right column, with interlace, rinceau, and flower petal ornaments all in carminé style, as follows: 283r, October 1; 289v, November 1; 293v, December 1; 304r, January 1; 315v, February 1; 320r, March 1; 323r, April 1; 325r, May 1; 328v, June 1; 335v, July 1; 338v, August 1; 348r, Eothina.

Iconography and Style

Portrait busts of Christ Pantocrator in medallions, known from various periods, are common in Gospel or Lectionary headpieces in the twelfth century. Christ is represented in the headpieces either alone, as in cod. London, Brit. Lib. Add. 11836,[5] or with the evangelists, their symbols or other saints.[6] Christ is usually shown holding a Gospel book in his left hand while he blesses with his right. The scroll motif instead of the Gospel is rare in this type of

[2] Vogel, Gardthausen, p. 56.

[3] See Harlfinger et al., p. 50, for references to documents.

[4] Ibid., *loc. cit.*

[5] Galavaris, *Prefaces*, p. 76, fig. 61.

[6] Here are some examples: cods. Jerusalem, Taphou 47, in Hatch, *Jerusalem*, pl. XL; Athens, Nat. Lib. 68 and 93, in Marava-Chatzinicolaou, Toufexi-Paschou, nos. 45, 61, figs. 475, 649; and Vat. Barb. gr. 449, from

the year 1153, in Spatharakis, *Dated Mss.*, no. 149, fig. 285. Cf. also M. Chatzidakis, "An Encaustic Icon of Christ at Sinai," *The Art Bulletin* 49 (1967) pp. 197–208; Weitzmann, *Sinai Icons*, no. B.1, pls. I, II, XXXIX–XLI, no. B.61, pls. XXVIII, CXX–CXXII; A. Cutler, "The Dumbarton Oaks Psalter and New Testament. The Iconography of the Moscow Leaf," *DOP* 37 (1983) pp. 35–45.

portrait bust.[7] It is common especially in Majestas compositions[8] and also in strictly liturgical scenes.[9] Its presence in the Sinai headpiece adds the meaning of Logos-teacher to that of Christ Pantocrator and in general relates the image to Theophanic representations.[10]

Paleographically the codex has been associated with a group of manuscripts related to the cod. Barberini gr. 449 and the "Family 2400," having Cypriot and Palestinian associations. Stylistically the codex represents a style which, although ultimately deriving from Constantinople, had a long tradition in the Palestinian area where the manuscript was produced, although the exact identity of the Monastery of the Holy Cells remains unknown.[11] In an earlier phase the style is exemplified by the cods. Jerusalem, Sabas 25 and 144, and Jerusalem, Patr. Lib. cod. 23, all produced in the monastery of St. Sabas in the early part of the eleventh century;[12] and by manuscripts which have tentatively been assigned to that area, such as the cod. Sinai 188 (see no. 21 above). In these earlier manuscripts the ornament is distributed equally and has a geometric character. This Sinai Lectionary and other codices of the period from the area, such as the cod. Jerusalem, Anastaseos 9 from 1152,[13] show the style at the point when it was developing greater complexity and liveliness. The distribution of the motif is uneven, the pattern is a jumble, and although the older form of the palmettes and half palmettes is recognizable, the overall effect is that of an arabesque.

Bibliography

Kondakov 1882, pp. 104, 105, pl. 92.1.

Gardthausen, *Catalogus*, pp. 44, 48.

A. Ehrhard, "Die griechische Patriarchal-Bibliothek von Jerusalem," *Römische Quartalschrift für christliche Altertumskunde und für Kirchengeschichte* 5 (1891) pp. 257–59.

A. Papadopoulos-Kerameus, Ἱεροσολυμιτικὴ Βιβλιοθήκη, 2, St. Petersburg 1894, repr. Brussels 1963, p. 726 n. 7.

Vailhé, "Repertoire," 4, p. 524 n. 20.

Gregory, *Textkritik*, pp. 447–48, 1246 no. 854.

Vogel, Gardthausen, p. 56.

Beneševič, pp. 116–17 no. 110, 621.

Lake, *Dated Mss.*, Indices, p. 180.

Devreesse, *Introduction*, pp. 47 n. 6, 57.

Kamil, p. 70 no. 245.

Weyl Carr, *McCormick New Testament*, pp. 72, 114, 116, 301, fig. 224.

Husmann, pp. 150, 167.

Spatharakis, *Dated Mss.*, p. 45 no. 156, fig. 299.

Voicu, D'Alisera, p. 558.

Harlfinger et al., pp. 50–51, 64 no. 28, pls. 123–27.

Weyl Carr, "A Group," pp. 45, 51, 53.

[7] It is an early motif which in Middle Byzantine works one can see in the lost mosaics of the narthex of the Church of the Dormition at Nicaea, from 1065–1067; see Lazarev, *Storia*, fig. 271.

[8] See examples in Lazarev, *Storia*, figs. 226, 330; Weitzmann, *Sinai Icons*, no. B.10, pl. LVI; Galavaris, *Prefaces*, figs. 50, 53.

[9] For an example see the mosaics of the Church of St. Sophia in Kiev;

63. COD. 221. LECTIONARY

A.D. 1175. FIGS. 661–665,
COLORPLATE XXVIII:a

Vellum. 281 folios, plus four folios numbered twice (75, 82, 151, 222), 30.8 x 23.2 cm. Two columns of twenty-eight lines. Minuscule script for text, written under the line, broad, round, calligraphic but not elegant, especially angular lambda; titles and calendar indications in *Epigraphische Auszeichnungs-Majuskel* and *Auszeichnungs-Majuskel*. Gathering numbers no longer visible; occasional marks in a non-Greek system by a later hand at lower left corner of first recto. Parchment yellowish white, of average quality. Ink brown for text; titles in red throughout; ekphonetic signs in light terracotta red. Large ornamental initials, some designed in blue and red and filled with gold, others in carmine. Small solid initials in red.

Jo. hebd. Mat. Lk. hebd., pannychides, Passion pericopes and Hours, Menologion, Eothina.

Fol. 1r, miniature; 1v, blank; 2r–38v, John weeks; 39r–v, allelouias for certain feasts; 40r–94r, Matthew weeks; 75[bis]v, colophon; 94v, blank; 95r–167v, Luke weeks; 168r–170v, lections and troparia for the pannychides; 171r–203r, Mark readings; 203r–225r, Passion and Hours pericopes; 225v, blank; 226r–269r, Menologion; 269v–273r, Eothina; 273r–v, colophon; 279r–280v, Eothina (completion); 281r–v, Eusebius' letter written in red.

The colophon, fol. 75[bis]v, written in red, reads:

+ ὁ θ(εὸ)ς ἐλε(ή̓σοι) τὸν κτή/τορα· τὸν καὶ
ταύτ(ην) / τὴν ἱερὰν βίβλον / ἀνάθημα
δωρι/σάμενον προς ἥ̓ν / οὗτος ἐδείματο ἁγίαν / καὶ
γυναικείαν / μονὴν τῆς ὑπεραγ(ίας) θ(εοτό)κου +

+ May God have mercy upon the owner who presented this holy book also as an offering to the holy nunnery of the All-Holy Theotokos which he founded. +

The colophon on fol. 273r–v (figs. 663, 664), also in red ink, reads:

ἀπηρτήθ(η) και ἀνετέθ(η) ἀνά/θημα ἡ παροῦ(σα)
ἱερὰ καὶ / θεία τοῦ εὐα(γγελίου) βίβλος τῆ κ(α)τ(ὰ)
κρήτ(ην) ἔ̓ξωθ(εν) τοῦ κ(άσ)τρ(ου) ἐκ νέ(ου)
δομηθείση εἰς / ὄνομ(α) τῆς ὑπ(ερα)γ(ίας)
δεσποί(νης) ἡμῶ(ν) καὶ θ(εοτό)κου γυναικεία

Lazarev, *Storia*, fig. 180.

[10] Cf. Galavaris, *Prefaces*, pp. 74ff.

[11] See A. Weyl Carr, "A Group", and Harlfinger et al., p. 50.

[12] Weitzmann, *Buchmalerei*, pp. 72ff., 75, pl. LXXXI,504–506.

[13] Spatharakis, *Dated Mss.*, no. 148, fig. 282.

μο(νῆ) τῆς ἐλεούσης· κατ(ὰ) / μῆ(να)
φε(βρουάριον) ἰνδικτ(ιῶ)ν(ος) ὀγδόης· τοῦ ‚ςχπγ′
ἔτους· τὸν γοῦν βουληθ(έν)τ(α) και
ἐγχει/ρισάμενον ἐξᾶραι αὐτὴν καὶ ἐξελεῖν τῆς
τοιαύτ(ης) μο(νῆς) εὐλόγω ἤ παρα/λόγ(ω)
ἀφορμ(ῆ)· ὅπερ χ(ριστ)έ μου μὴ γένοιτο· ἤ
τετράδ(ιον)· ἤ φύλλον· ἤ μετ(ώ)π(ιον) / ἐκκόψαι
καὶ ἐξᾶραι ἐξ αὐτῆς· ὁποῖος ἄν και εἴη, τῆς τῶν
χρι/στιανῶν με(ρί)δ(ος) ἐκπεσεῖται ὡς ὁ ἰούδ(ας)
τῆς δωδεκάδ(ος)· τὸ τῆς / τριάδ(ος) φέγγος ὁρᾶν μὴ
ἀξιωθείς· ἕξει δε καὶ ταῖς ἀραῖς τῶν / ἀπ᾽ αἰώνων
προκεκοι(μημένων) ἁγίων ἡμῶ(ν) π(ατέ)ρων· καὶ
τὸ ἀνάθεμα // ἀπὸ κ(υρίο)υ θ(εο)ῦ παντοκράτορος·
αὐτὴν δε τὴν θεομήτορ(α), / πόρρω που τοῦ υἱοῦ
αὐτῆς καὶ θ(εο)ῦ ἡμῶν διάκουσαν / ἐν ἡμ(έ)ρ(α)
δικαιοκρισίας αὐτοῦ καὶ ἀποκαλύψεως· τὸν δ᾽ ἐκ
πόνων αὐτοῦ καὶ ἰδρώτων κτη/σάμενον ταύτην καὶ
ἀναθή/σαντι ὡς εἴρηται ἦι ἐρρέ/θη γυναικεία τῆς /
ὑπεραγίας θε/οτόκου / ἁγία / μονῇ, / εὔχεσθε οἱ
τυχόντες αὐτῆς +.

This holy and divine book of the Gospels was com-
pleted and presented as an offering to the nunnery
known by the name of Our All Holy Lady Theoto-
kos Eleousa, which was built anew outside the Kas-
tro (Heraklion) in Crete, in the month of February,
8th indiction of the year 6683 (1175). He who would
attempt to take it away from this monastery by per-
suasion or by force (may this not happen, my Christ)
or to cut and take away a quaternium, a leaf or a
headpiece, whosoever, may he be cast away from the
Christians just as Judas was from the group of the
twelve; may he not be deemed worthy to gaze at the
light of the Holy Trinity. He will also have the
curses of our holy Fathers who have slept for centu-
ries and the anathema of the Lord, God Pantocrator
and in the day of judgment and revelation may he
not receive help from the Mother of God. But those
who by chance come across the book may pray for
him who acquired this book with his toil and sweat
and dedicated it as said to the nunnery of the All
Holy Theotokos, which urged for it +.

On fol. 1v is the following, possibly thirteenth-century
entry:

+ βιβλίω εὐαγγέλ(ιον) τοῦ ἀρχιητροῦ (μον)αχ(οῦ)
θεοφίλου· και ἐδώθ(η) παρα φίλαξιν / εἰς τ(ὸ)
μετόχι τοῦ σινὰ· εἰς τ(ὸν) ἁγ(ιον) γιώρ(γιον) τὴν
παλαιὰ γιστέρναν εἰς τ(ὸν) χάνδακ(α) +

+ This Gospel belongs to the chief physician, monk
Theophilos and it was given for care-taking to the
metochion of Sinai at St. George's old cistern in
Chandax (Herakleion). +

Above the entry of Theophilos another hand (of the
same period?) has written the following entry, cited here be-
cause it contains terms relating to bookbinding: ἔχει καρφία
θ′, ἀμυγδάλια / β′ και λοφωτὰ ζ′.[1] The colophon suggests
that the book was completed in Crete by an unnamed scribe
who, it seems, was also the donor and who dedicated it
in 1175 to the nunnery of Theotokos Eleousa, founded by
him outside the Kastro (Heraklion). The words ἔξωθεν τοῦ
Κάστρου imply a certain proximity to the city and the sug-
gestion has been made that this nunnery can perhaps be
identified with a church of the same name in the area, men-
tioned in various documents between 1320 and the seven-
teenth century.[2] By the thirteenth century the Lectionary
was in the hands of a physician monk by the name of
Theophilos, who probably was serving a community; it was
then given "on loan" to the metochion of Sinai in Crete. The
reference to St. George's cistern most likely refers to a
cistern near the Gate of St. George, one of the city gates of
Heraklion at the time, also known as the Gate of the
Lazaretto because it probably led to a hospital. We know
that the Sinaitic metochion was not far from the beginning
of two known streets, the *via dello spedale* and the *strada
larga*, which joined the marketplace (*foro*) with the gate of
the Pantocrator.[3]

The condition of the codex is deplorable. All gatherings
up to fol. 47 are loose and several others are sewn in. The
sequence of folios presented above most likely is not original.
Beneševič reported the colophon now on fols. 273r–v as be-
ing on fols. 9r–v. Eusebius' letter, fols. 281r–v, should nor-
mally have been at the beginning. The codex was carelessly
bound long after its arrival in Sinai and as a result it is se-
verely cut on the margins, particularly in the early gather-
ings, including the full-page miniature, which in the process
lost the evangelist John. The miniature, although painted
on a separate page, belongs to the original manuscript as

[1] Cf. A. Atsalos, "Sur quelques termes relatifs à la reliure des manu-
scrits grecs," *Studia codicologica*, K. Treu, ed. (Texte und Untersuch-
ungen, 124), Berlin 1977, pp. 15–42; Harlfinger et al., p. 53.

[2] Harlfinger et al., *loc. cit.*, note 1, with documentation.

[3] See St. Alexiou, "Τὸ Κάστρο τῆς Κρήτης καὶ ἡ ζωὴ του στὸν ΙΣΤ′
καὶ ΙΖ′ αἰώνα," *Kritika Chronika* 19 (1965) pp. 146, 169; A. G. Frangouli,

Ἡ Σιναία Σχολή τῆς Ἁγ. Αἰκατερίνης στό Χάνδακα, Athens 1981,
pp. 17, 19 and passim; for the Sinai metochion in Crete, P. Gregoriades,
Ἡ ἱερὰ Μονὴ τοῦ Σινᾶ κατὰ τὴν τοπογραφικήν, ἱστορικήν καὶ διοικη-
τικὴν αὐτῆς ἔποψιν, Jerusalem 1875, repr. Athens 1978, ed. Holy Mon-
astery of St. Catherine, Sinai, pp. 90–93.

demonstrated above all by the color scheme, which is that found in the headpieces. Miniature and headpieces have suffered considerable flaking. Small strips of parchment written in the so-called *maiuscola biblica*, from earlier codices of the fifth or sixth century, have been used for repairs (e.g., fols. 170v, 211r, 218v); some of these pieces apparently have relatives among the newly discovered Sinai manuscripts.[4]

Plain leather binding on wooden boards with only small studs arranged in the form of a cross remaining on the front cover. Only the back cover is still attached to the codex.

Illustration

1r Christ and three evangelists (27 x 19.6 cm.) (fig. 665). The imposing Christ, $\overline{\text{IC}}$ $\overline{\text{XC}}$ (all inscriptions are rendered in red), standing frontally on a jewelled brown dais with red top, clad in a purple brown chiton with a red clavus and a steel blue mantle (himation), holds an open book with red edge and blesses with his right hand. His head, in flesh tones of brown with red and green shadows and with dark brown hair, is encircled by a cruciform nimbus, the arms of the cross being marked with dots. He is flanked by three of the evangelists. John has been cut off; a small segment of his nimbus is still visible on the right edge along with the words Ὁ ΑΓΙΟϹ. The three remaining evangelists proceed with reverence toward Christ to deliver to him their Gospels. At the left is Mark, Ὁ ΑΓΙΟϹ ΜΑΡΚΟϹ, clad in a blue chiton with red clavus and grey-green mantle. Bearded, with dark purple hair with blue strands, and with his face rendered in brown with red tones, he holds a closed book with a gold cover and proceeds slowly to Christ. Matthew, Ὁ ΑΓΙΟϹ ΜΑΤΘΑΙΟϹ, in a pink-red tunic and a violet mantle, with dark olive hair with light blue strands and a half-open book with a gold cover, is depicted walking. At the right side is Luke, Ὁ ΑΓΙΟϹ ΛΟΥΚΑϹ. Wearing a blue tunic and a violet mantle and holding a gold book with a red and white edge, he seems to show a stance similar to that of Mark. His face, part of his garments, and his feet are gone. All three evangelists stand on a deep green ground against a gold background. The composition is framed by a red fillet and on top of the miniature is a border in the form of a band with dark green crosslets on gold in an enamel-like pattern.

2r Band-shaped headpiece, over both columns, in a rough and meager flower petal style, with partly flaked lyre-shaped, steel-colored rinceau painted against gold. Initial Є with a hand in steel blue and carmine against gold (fig. 661).

21r Band-shaped headpiece, over both columns, in a rough and meager flower petal style, with partly flaked heart-shaped, steel-colored rinceau painted against gold. Initial Є with a hand designed in steel and carmine against solid gold.

40r Π-shaped headpiece, left column, with a much damaged rinceau of wide leaves framed with a crenellation pattern against gold (fig. 662). At top center is a small, solid double cross flanked by two half palmettes showing influences of fretsaw style and inscribed $\overline{\text{IC}}$ $\overline{\text{XC}}$. Three palmettes in different designs, only outlined, are on the top corners and on the extended line of the frame. Initial Є with hand holding a red scroll; the lower bow of the letter is formed by a rooster and the upper by a zoomorphic head, possibly of a quadruped. The sleeve is decorated with a gold palmette in fretsaw style, the hasta itself with enamel-like crosslets. First Monday after Pentecost, Mt. 18:10–20.

76r Band-shaped headpiece, left column, with a diamond pattern in plain carminé and a huge initial Є. Monday, twelfth week, Mk. 1:9–15.

95r Band-shaped headpiece, left column, with a stylized rinceau in plain carminé. Monday, first of Luke weeks, Lk. 3:19–22.

168r Band-shaped headpiece, left column, with a rinceau pattern in carminé. Lections for the pannychides, Lk. 21:8–26.

171r Π-shaped headpiece, left column, with rough palmettes in large, joined, heart-formed tendrils in green, red, and dark steel blue on gold ground. Initial T designed in blue and filled with solid gold. First Saturday of Lent, Mark readings, Mk. 2:23–3:2.

203r Band-shaped headpiece, right column, in a meager carminé diamond pattern. Beginning of Passion pericopes, Jn. 13:31–38; 14:1ff.

226r Π-shaped headpiece with a blue-green crenellation on gold ground, left column, with three small stylized

[4] See Harlfinger et al., p. 54. The use of parchment folios from older manuscripts for repairs has been noticed in other instances: see cod. 218, no. 45 above. Among the recent Sinai discoveries, i.e., the fragments of manuscripts found walled-up, was included a considerable number of very small pieces of parchment. According to Dr. Panayotis Nikolopoulos, who presently is preparing the publication of this material, these pieces were to be used for repairs of manuscripts, and they were not cut from complete codices. The ramifications of this, in our opinion correct, interpretation, are discussed by Dr. Nikolopoulos in his forthcoming book. We thank him especially for this piece of information.

palmettes on top. Large initial Є in carminé. Menologion, September 1.

232v Band-shaped headpiece, right column, outlined only and without ornament, October 1.

236v Band-shaped headpiece, left column, crosslets in diamonds in simple carminé. November 1.

All following months are marked by an outlined band with no ornament, in left or right column: 239r, December 1; 246r, January 1; 252r, February 1, 254v, March 1; 256r, April 1; 257, May 1; 258v, June 1; 263v, July 1; and 266r, only a wavy line with dots in the loops, August 1.

269v A wavy line, similar to that on fol. 266r, left column. Eothina.

Iconography and Style

The colors of the illustrations and of the ornament in the large band on top of the miniature, as well as the decorative pattern in the band, correspond to those in the headpieces throughout the codex. There can be no doubt that the full-page miniature is part of the original decoration of the codex. Its iconography, which must date before the tenth century, has left its reflection in evangelist portraits of the Macedonian Renaissance and occurs in a rather clumsy picture in the eleventh-century codex Vat. gr. 756,[5] which embodies the concept of the harmony of the Four Gospels, relating to the textual concordances that constituted prefatory material in a Gospel book.[6] Compositionally, however, the miniature may be traced back to compositions depicting the Mission of the Apostles,[7] a theme embodied in the present illumination. A very similar illustration is found in fol. 8r of the Georgian Gospel of Vani, now in Tbilissi, cod. A 1335, dated between 1184–1213,[8] which was commissioned by Queen Thamar and produced in the neighborhood of Constantinople by the Greek artist Michael Koresios. The very close similarities between the two illustrations indicate the existence of a Constantinopolitan model or models.

The figure types are related to other works of the Middle Byzantine period, such as the earlier cod. Venice, Marc.

gr. Z 540[9] or the contemporary cod. Moscow, Hist. Mus. gr. 519.[10] The figures display the mannered style of the second half of the twelfth century. They are tall, elongated, and have a monumental quality; their height is enhanced by the drapery, especially the linear folds which are formed by dark lines and highlighted by thin white brush strokes that assume the color against which they are painted. This linearity, aided by the light colors which avoid strong contrasts, diminishes the volume of the bodies.

The faces are painted with great care and the details are rendered by a series of thin white, black, red, and green lines on brown ground. Some distinctions have been attempted by the artist. Christ is distinguished by his size and the use of stronger colors; much more red has been applied to his face. The irises of the eyes have an oval shape, giving the faces empty stares. This characteristic is found in several twelfth-century icons, many of them in Sinai,[11] though for the time being no further conclusion can be drawn from that observation. There is something archaic in the heaviness and design of the large initials. Although their patterns are different, they remind us of a few initials and the hand of God in the ninth-century *Sacra Parallela* codex.[12] Another feature shared by the two codices is the use of solid gold.[13] In some of the initials of the Sinai codex, the gold is not confined by the forms of the design but goes beyond it, as in cod. Sinai 418 (see no. 57 above), which we have assigned to a Palestinian center or possibly to Sinai itself.

Paleographically the codex represents certain elements that are present in manuscripts produced in or assigned to what paleographers term the "Palestino-Cypriotic" milieu, such as the cods. Jerusalem, Anastaseos 9, produced in 1152 for the archiepiscopal church of Tiberiade, and Vat. Barb. gr. 449 of 1153 and a Cypriotic provenance[14]: the letters are thick; the beta, mu, and ypsilon, though in minuscule, have a rectangular stylization and an angularity. Here one also finds the pseudo-ligatures typical of that group, which has been admirably discussed by Canart.[15] This indicates that the Sinai codex is another example of the mutual influence

[5] For examples and discussions see Friend, "Evangelists," esp. p. 133, pl. VII,84, 85.

[6] For a discussion see Galavaris, *Prefaces*, pp. 104ff.

[7] Cf., for example, cod. Athos, Dionysiou 587, fol. 32v, in *Treasures*, 1, fig. 206.

[8] See E. Takaichivili, "Antiquités géorgiennes; l'évangile de Vani," *Byzantion* 10 (1935) pp. 655–63, esp. 658–59; Lazarev, *Storia*, p. 221 with further bibliography; and Galavaris, *Prefaces*, p. 105.

[9] Cf. fol. 12v of the cod. Marc. gr. Z 540; for recent bibliography see *Venezia e Bisanzio* (exhibition catalogue), Venice 1974, no. 47; H. L. Kessler, *The Illustrated Bibles from Tours*, Princeton 1977, p. 39, fig. 58; Galavaris, *Prefaces*, pp. 101ff.

[10] Lazarev, *Storia*, fig. 265.

[11] Weitzmann et al., *Die Ikonen*, pp. 24, 27, figs. 50, 52.

[12] Weitzmann, *Sacra Parallela*, figs. 26, 29, 66, 181, 229.

[13] Ibid., pp. 14ff.

[14] Canart, "Chypriotes," p. 33; Spatharakis, *Dated Mss.*, no. 149, fig. 285.

[15] Canart, "Chypriotes," pp. 33ff. See also paleographic connections of the Sinai codex with the cod. Vat. Pal. gr. 13, written in Crete in 1167: H. Follieri, ed., *Codices graeci Bibliothecae Vaticanae selecti* (Exempla scripturarum 4), Vatican 1969, pl. 28; and Harlfinger et al., p. 53 with further references and other comparisons.

apparent in the Eastern Mediterranean in the second half of the twelfth century.

Bibliography

Gardthausen, *Catalogus*, p. 45.
Gregory, *Textkritik*, pp. 448, 1246 no. 855.
Beneševič, pp. 119, 120 no. 114.
Lazarev 1947, p. 342 n. 43.
Sotiriou, *Icônes*, 2, p. 209.
Lazarev, *Storia*, p. 336 n. 35.
Kamil, p. 70 no. 246.
Husmann, pp. 150, 167.
Weyl Carr, *McCormick New Testament*, p. 117 n. 20.
I. Spatharakis, "Ἕνα εἰκονογραφημένο χειρόγραφο τοῦ 1175 ἀπο την Κρήτη," *Thesavrismata* 14 (1977) pp. 71–75, figs. 1–3.
Galavaris, *Prefaces*, pp. 104–105.
P. L. Vokotopoulos, "Τὰ ἐπίτιτλα ἐνὸς τετραευαγγελίου τῆς ὁμάδος τῆς Νικαίας," *DChAE*, per. 4, vol. 9 (1977–79) p. 137 n. 18.
Spatharakis, *Dated Mss.*, p. 46 no. 162, figs. 308, 309.
Voicu, D'Alisera, p. 558.
Harlfinger et al., pp. 52–54, 64, no. 30, pls. 132–35.
Weyl Carr, "Gospel Frontispieces," p. 4.
Byzantium at Princeton, p. 153.

64. **COD. 153**. FOUR GOSPELS
SECOND HALF OF TWELFTH CENTURY.
FIGS. 666–677, COLORPLATE XXVIII:b–c

Vellum. 421 folios, 21.5 x 16.4 cm. One column of eighteen lines. Minuscule script for text, broad, round letters written under the line, mostly separated from one another without clear spacing between words; Gospel titles in *Epigraphische Auszeichnungs-Majuskel* and calendar indications in *Auszeichnungs-Majuskel*. Gathering numbers at lower left on recto folio, beginning with fol. 10r, with one horizontal stroke above and below and an additional vertical stroke below. Parchment fine and white. Ink light brown for text; titles, Gospel headings, chapters and numbers of chapters, and calendar indications in gold; rubrics in carmine. Initials in flower petal style; small solid initials in text in gold.

Fols. 1r–2v, Eusebius' letter; 3r–6v, Canon tables; 7r–8v, Matthew chapters; 8v–9v, Hypothesis to Matthew; 10r–121r, Matthew; 121r–122r, hypothesis to Mark; 122r–123r, Mark chapters; 123v–124r, blank; 124v, miniature; 125r–190r, Mark; 190r–v, hypothesis to Luke; 191r–192v, Luke chapters; 193r, blank; 193v, miniature; 194r–312r, Luke; 312r–313r, hypothesis to John; 313v, John chapters; 314r, blank; 314v, miniature; 315r–384r, John; 395r, hy-pothesis to John; 395v, blank; 396r–411r, Menologion (movable feasts from Easter to Pentecost); 411v–412v, blank; 413r–420r, later folios with Menologion.

The codex is in good condition. Matthew's portrait is missing. The remaining portraits belong to the original codex, being part of gatherings.

Brocaded Venetian red velvet binding on wooden boards previously covered with white linen, sixteenth-century (figs. 666, 667). Silver-gilt metal pieces were originally affixed to the cover, comprising a narrow, dotted fillet along the edges of both covers (a small segment of this on the upper edge is still *in situ*) and a Crucifixion in the center, now missing. One of the flying angels that flanked the cross is still present on the lefthand side. In addition, there were symbols of the four evangelists in discs on the corners of the front cover; their imprints clearly remain on the velvet. The back cover has only four large round studs at the corners (cf. covers of cod. 180, no. 69 below, fig. 716).

Illustration

3r Canon table, Canon I (ca. 14.2 x 11.4 cm.), in carmine (fig. 668). Two elegantly drawn, undecorated columns with bases and lyre-shaped acanthus capitals, standing on a simple horizontal bar, support an entablature with a large arch spanning two smaller arches set in a rectangle. The large central arch is decorated with a leafy tendril springing from a central vase and branching out into two scrolls, each terminating in a large calyx with a flower, thus forming a candelabra pattern. The spandrels on either side are filled with small square "tiles" with a variety of rosettes and floral motifs. A small, elegant, solid cross between two scrolls is on top and two outlined palmettes on the two corners. On the extended line of the epistyle are scroll-like floral motifs.

3v, 4r Canon tables, Canons II–V, similar in form to those for Canon I (fol. 3r) except that the columns are interrupted in the middle by dotted discs. But the motifs here are different: the central arch contains a palmette in a circle on fol. 3v and within an elliptical form on 4r, on either side of which unfolds a scroll pattern. Scroll motifs also fill the spandrels. A double crosslet is at the top of 4r and palmettes are on the corners and the ends of the epistyle.

4v Canon tables, Canons V–VII, similar in form and style but with different ornament. The columns have geometric bases and are interrupted in the middle by spherical shafts. The large arch contains in its center

a heart-shaped ornament with a large composite palmette, palmettes and half palmettes at the sides. On the spandrels there is a delicate design of oval and heart-shaped forms with palmettes interrupted on the left side by rosettes. A small solid floral motif and stylized palmettes are at the top and the ends of the epistyle.

5r Canon tables, Canons VIII and IX, in form and style as above with minor variations (fig. 669). There is an added *taenia* between the capitals, supported in the center by a pillar ornamented with a rinceau motif. The large arch is filled with small palmettes and on each spandrel is a roundel with flower petals. A chevron motif frames the three sides of the rectangle with a graceful flower on top and three palmettes.

5v Canon tables, Canon X, similar in form to that on fol. 3r except that here the colonettes are double and the bases and capitals are richer in foliage. In the central arch, a thin tendril forms a large heart-shaped design with a grape-like palmette in the center and half palmettes on either side. A variant of this pattern fills the spandrels. A delicate floral motif on top and the usual palmettes are on the corners and the sides.

6r, 6v Canon tables, Canon X, similar in form to that on fol. 3r, in carminé style. The columns are knotted and the flower petal ornament on the entablature is arranged in heart-shaped designs and candelabra patterns (fig. 670).

10r Headpiece, its lower side cut out by a trefoil for the title (fig. 671). Long leafy blue tendrils unfold in a lively scroll pattern in red, blue, and green all set in gold on either side of an inverted palmette flanked by rich acanthus leaves. A thin fillet of deep green and blue in a cyma pattern frames the headpiece. There are stylized floral motifs on the upper corners and different types of Sassanian palmettes on the extended lines of the frame. Initial B in flower petal style. Mt. 1:1ff.

124v Mark pensive (14 x 10 cm. without the floral motifs) (fig. 672). The evangelist is seated facing to the right on a high-backed, red-cushioned, dark brown chair. Holding a pen with his right hand and lightly touching his thick beard with his left hand, he is absorbed in thought. He is clad in a blue chiton and a dull violet himation, both with white highlights, which contrast with the brownish tones of his face brightened by red touches on brow, cheeks, and nose, and his brown hair; he rests his feet on a footstool. His head is encir-

cled by a large, rotating gold nimbus. A carefully designed dark brown table holds the implements of writing and a lectern supported by a dolphin, with an empty unrolled scroll thrown upon it. The background is gold and the evangelist is inscribed in brown ink, ὁ ἅγιος μάρκος. A thin red fillet in a filigree borders the miniature with the usual palmettes in the four corners.

125r Headpiece similar in form to that on fol. 10r in very rough flower petal style (fig. 673). Small squares with open flowers, trefoils, or simple tendrils in green, white, and pink set against gold fill the spandrels in a tile-like pattern. A very sketchy cyma border in pink and blue and stylized floral motifs are on the corners and sides. Initial A in a lively flower petal style. Mk. 1:1ff.

193v Luke dipping his pen (14 x 10 cm.) (fig. 674). The evangelist, facing to the right, sits on a high-backed, gold chair with brown details and a red cushion. He leans forward, about to dip his pen into an inkwell on the dark brown table, while he moves his feet wide apart on the gold footstool. With his left hand he supports an open book with the opening words of his text on his knee. Clad in a blue tunic and a dull violet himation, both with white highlights, he has a determined expression on his face, rendered in dark brown with a few red brush strokes harmonizing with his strong dark brown hair. The gold of his nimbus appears to be reflecting. The gold background has suffered some flaking. The inscription is once more in brown, ὁ ἅγιος λουκᾶς. The composition is framed by a thin red fillet and four stylized palmettes on the corners.

194r Headpiece enclosing a medallion with the title (fig. 675). It is filled with palmettes and trefoils on gold ground in a tile pattern. Red flowers in a blue calyx are on the extended lower line of the frame, the left one merged with the initial Є. Lk. 1:1ff.

314v John pensive (14 x 9.6 cm.) (fig. 676). The aged, balding evangelist with grey-blue hair and beard, and brown face, somewhat flaked, is seated facing to the right on a heavy dark brown chair, holding a pen in his right hand. With his other hand, which emerges from his grey-green himation over a violet tunic, he touches his beard, while turning his eyes with an expression of concentration to the hand of God, the source of his inspiration: [?] ἐν ἀρχή ην ὁ λόγος. He rests his feet close together on a gold footstool; beside

him is a dark brown desk; there are writing implements on it and in an open cupboard. On the desk a spiral column supports a dark brown lectern with an unrolled scroll on it. The inscription is in brown, ὁ ἅγιος ἰω(άννης) ὁ θεολόγος. A rope-like fillet in blue with four floral motifs on the corners frames the miniature.

315r Headpiece in the form of an arch, its spandrels filled with a gold clover-leaf pattern encircled in blue on grey-green ground (fig. 677). One large, chalice-like flower in blue-green with red tips is on the right extended lower line of the frame. The initial Є in flower petal style merges with the ornament on the lower line of the headpiece. Jn. 1:1ff.

Iconography and Style

The evangelist portraits belong to a stereotyped iconography found in codices throughout the twelfth century: the pensive evangelist and the evangelist dipping his pen are common. Iconographically and stylistically they are related to the evangelist portraits in Princeton, Univ. Lib. cod. Garrett 5, datable on stylistic grounds to the second half of the twelfth century. The correspondence of the portraits in both codices goes beyond pose, facial types, and furniture to include a characteristic double fold of drapery hanging from the edge of the chair: cf. fol. 124v of the Sinai codex (fig. 672, colorplate XXVIII:c) to Princeton, Garrett 5, fol. 13r.[1] Although they relate to the depictions in the Princeton manuscript and Sinai cod. 221 from 1175 (see no. 63 above), the drapery highlights in the present Sinai codex are stronger, concentrating on larger areas, and have a flickering effect foreshadowing the drapery style found in codices of the end of the twelfth century, such as Athens, Nat. Lib. cod. 93.[2]

Another stylistic peculiarity is found in the nimbi of the three evangelists, which show a reflecting effect produced by the same rotation technique characteristic of Constantinopolitan icons.[3]

The ornamental Canon tables and the headpieces, although different in style, share a common repertory of motifs and they are contemporary. Such discrepancies between headpieces in a variety of colors and monochrome Canon tables are not unusual (cf. cod. 188, no. 21 above).

In the Canon tables the focal point of the design is the

inclusion of the arches in a rectangle.[4] Their motifs, tile-like patterns with rosettes or floral motifs, and vivid scroll patterns are simplified versions of those found in the headpieces. The tile-like patterns of both Canon tables and headpieces are comparable to those in cod. London, Brit. Lib. Add. 5111, completed shortly before 1189,[5] although the Sinai codex is of higher quality. What is unusual about these headpieces is the form taken by a trefoil or an arch, which foreshadows later developments in Byzantine and post-Byzantine book illumination.[6]

Although the ornament is at times rough and uneven in quality and the colors in the miniatures are not brilliant, the high technical accomplishment and a vividness in the patterns indicate that the artist must have been well acquainted with Constantinopolitan works.

Bibliography

Gardthausen, *Catalogus*, p. 29.
Gregory, *Textkritik*, pp. 245, 1134 no. 1190.
Hatch, *Sinai*, pl. XXIX.
Lazarev 1947, p. 320 n. 53.
Idem, *Storia*, p. 254 n. 51.
Kamil, p. 68 no. 178.
Voicu, D'Alisera, p. 554.

65. COD. 163. FOUR GOSPELS
END OF TWELFTH CENTURY.
FIGS. 678–680, COLORPLATE XXVIII:d

Vellum. 279 folios, 19.4 x 13.3 cm. One column of twenty-one lines. Minuscule script for text, written under the line without any particular direction, testifying to the decline of the minuscule canon. The script is related to Cypriotic scriptoria, Canart's style ε.[1] Titles in *Epigraphische Auszeichnungs-Majuskel* and *Auszeichnungs-Majuskel*. Gathering numbers (not always present) at upper right corner of first recto, beginning with gathering β′, fol. 9r, with a horizontal stroke above. Parchment fine and white. Ink strong black for text; titles in gold throughout but much flaked, showing the red underpainting. Larger initials outlined in gold over red; small solid initials in gold.

[1] *Greek Mss. Amer. Coll.*, no. 34, fig. 59; *Byzantium at Princeton*, pp. 152–53, no. 177, with bibliography.
[2] Marava-Chatzinicolaou, Toufexi-Paschou, no. 61, fig. 639.
[3] Weitzmann, "The Icons of Constantinople," figs. 48–50, 62, passim.
[4] Cf. cods. Sinai 158, 188 (nos. 53, 21 above); Princeton, Scheide Lib. cod. M 70: *Greek Mss. Amer. Coll.*, no. 33, fig. 57; *Byzantium at Princeton*, pp. 148–49, no. 174.

[5] Spatharakis, *Dated Mss.*, no. 168, fig. 316.
[6] Cf. cod. Athos, Iviron 1384, from the fourteenth century, in *Treasures*, 2, fig. 147.

[1] Canart, "Chypriotes," pp. 46, 51; also Hunger, "Auszeichnungsschriften," p. 209 n. 33.

Fols. 1r–83v, Matthew; 84r–v, blank; 85r, miniature; 85r–137r, Mark; 137v–138v, blank; 139r, miniature; 139r–218v, Luke; 219r, miniature; 219r–279r, John.

Fols. 1r–8v and 266r–279v are of paper and constitute a recent restoration of lost parts of the text, which must have contained the now-lost portrait of Matthew. The original text begins on fol. 9r in the middle of Mt. 5:3ff., and concludes on fol. 265v, Jn. 17:13. Since in each case the Gospel text begins beneath the illustration and continues on the verso, the empty pages before these folios may have been designated for a list of chapters or hypotheses. In general the condition of the codex is good, but the illustrations are partly flaked.

Old binding of crimson red silk brocaded with floral motifs and small square patterns placed over leather; much damaged and worn.

Illustration

85r Mark dipping his pen (9.4 x 9.1 cm.) (fig. 678). The evangelist in profile sits on a gold faldstool with a red seat, pulling his right foot back at the edge of a gold footstool with a red top, and leans forward, about to dip his pen into an inkwell on a purple table with a double top. In his left hand he holds a piece of parchment with the opening words of his Gospel. He is clad in a light blue tunic and a violet mantle. His flesh is rendered in brown, his curly hair and thick beard are dark brown, his massive head is encircled by a nimbus outlined in red. The ground is dark green, the background gold, and there are two buildings with openings on either side. The building on the left is painted yellow-brown, while that on the right is rendered in violet. The miniature has two side borders with a crenellation, mostly flaked, in steel blue. Initial A in flower petal style outlined in gold. Above the miniature is a red inscription, ὁ ἅ(γιος) μάρκος. Mk. 1:1ff.

139r Luke writing (9.1 x 8.9 cm.) (fig. 679). Facing to the right, seated on an ornamental chair and resting his feet on a footstool, Luke writes on a huge open codex with a red edge and the opening word of his Gospel, which he holds on his lap. He wears a light blue tunic and a richly folded violet mantle. His curly hair is brown, as are the flesh tones of his face, combined with touches of red. His nimbus is outlined in red

while his chair and footstool are red with gold frames. As on fol. 85r there is a dark green ground, a gold background, and two tall, tower-like buildings, the one on the left light yellow-brown, and the one on the right light violet. There are two side borders with a crenellation in steel blue, mostly flaked. Initial Є with very decorative floral motifs in gold over red. Lk. 1:1ff.

219r John about to read (9.1 x 8.8 cm.) (fig. 680). The evangelist, in three-quarters profile, clad in a light blue tunic and dark olive green mantle, is seated on a decorated gold backless chair with a red cushion, his crossed feet resting on a red footstool. He holds with both hands a large, slightly opened book with a gold cover and a red edge. His bearded face with a meditating expression shows only traces of brown color. The building on the left is light violet and the one on the right light yellow-brown; behind the evangelist there must have been an olive green building with a cornice and two arches, the forms of which are confused with those of the table. There is a steel-colored crenellation border left and right, and the evangelist's name is inscribed in red on top, ὁ ἅ(γιος) ἰω(άννης) ὁ θεολό-γ(ος). A simple initial Є, delicately drawn in gold. Jn. 1:1ff.

Iconography and Style

While Mark and Luke belong to a stereotyped iconography, John returns to a type known in codices from the Macedonian Renaissance, such as Athens, Nat. Lib. 56, which is a variant of the pensive type.[2] This type continues in the following centuries with minor variations,[3] but occurs less often in the twelfth century; its popularity increases thereafter.

Iconographically and stylistically the portraits have close similarities with the original decoration of the Kraus Gospels (New York, Coll. H. P. Kraus, olim Philipps, cod. 3887)[4] first published by Buchthal, who associated it with a large number of manuscripts grouped around the Rockefeller McCormick New Testament, the "Family 2400,"[5] and even more closely with another codex of the same family, Athos, Dionysiou 23.[6] The miniatures of Mark and Luke are almost identical in both the Sinai and Athos codices, including the unusual high-backed chair-throne on which

[2] Friend, "Evangelists," pl. XIII; Marava-Chatzinicolaou, Toufexi-Paschou, no. 1, fig. 6.

[3] For example, the book is interchanged with a scroll; see cod. New Haven, Yale Univ. Lib. 150, vol. II, from the early eleventh century, in *Greek Mss. Amer. Coll.*, no. 9, fig. 14.

[4] Ibid., no. 51, fig. 93.

[5] H. Buchthal, "An Unknown Byzantine Manuscript of the Thirteenth Century," *Connoisseur* 155 (1964) pp. 217ff.

[6] *Treasures*, 1, figs. 57–60.

Luke sits (figs. 678 [colorplate xxviii:d], 679). John is also of similar iconography in both manuscripts (fig. 680). The types of seats of the evangelists are exchanged and there are minor variations in the architectural backgrounds, which, however, share common features: the tall forms, the vertical openings, the "beam-ends" indicated on top of the buildings, and the colors of violet and yellow-brown. The color similarities extend to all elements of the composition, light blue, violet, olive green, and red being the most predominant tones. The miniatures in both codices also share the characteristic crenellated borders in similar colors, although in the Dionysiou codex they occur along three sides of the composition instead of two as in the Sinai manuscript. Both the Kraus and the Dionysiou codices have been assigned to the early thirteenth century. Recently the entire "Family 2400" has been studied by A. Weyl Carr and A. Cutler, who are of the opinion that the family should be placed in the second half of the twelfth century.[7] Following this proposed date, which is not beyond doubt, the Sinai codex may be dated in the last quarter of the century. Weyl Carr, the principal student of this group of manuscripts in recent years, has assigned a very large number of these codices to Cyprus.[8] A Cypriotic origin for this and other relatives has also been proposed on the basis of their paleography by Canart, who relates the codex to what he terms the "rectangular style."[9]

Bibliography

Gardthausen, *Catalogus*, p. 31.
Gregory, *Textkritik*, pp. 246, 1134 no. 1200.
Hatch, *Sinai*, pl. XXXVI.
Colwell, Willoughby, *Karahissar*, 1, pp. 204, 206; 2, p. 40.
Kamil, p. 68 no. 188.
Hunger, "Auszeichnungsschriften," p. 209 n. 33, fig. 19.
Weyl Carr, *McCormick New Testament*, pp. 28, 66 n. 5.
Voicu, D'Alisera, p. 554.
Canart, "Chypriotes," pp. 46, 52, 72.
Weyl Carr, "A Group," p. 40 n. 16.

66. COD. 149. FOUR GOSPELS
END OF TWELFTH CENTURY. FIGS. 681–693

Vellum. 300 folios, 17.4 x 13 cm. One column of twenty-two lines. Minuscule script for text, letters lacking any specific direction, dense, an example of the decline of the minuscule canon; it has been related to Cypriot scriptoria, Canart's style ε.[1] Titles i *Epigraphische Auszeichnungs-Majuskel* and *Auszeichnungs-Majuskel*. Later gathering numbers without strokes at lower right corner of first recto beginning with gathering γ' on fol. 6r. Parchment fine and whitish. Good quality. Ink black for text; titles and opening lines of each Gospel in gold. Zoomorphic and small solid initials in gold.

Fols. 1r–3v, Canon tables; 4r, blank; 4v, miniature; 5r, blank; 5v, miniature; 6r–89r, Matthew; 89v, verses to Matthew; 90r–v, 91r, blank; 91v, miniature; 92r–144r, Mark; 144v, verses and hypothesis to Mark; 145r–146r, blank; 146v, miniature; 147r–232r, Luke; 232v, verses and hypothesis to Luke; 233r–235r, blank; 235v, miniature; 236r–300r, John; 300v, verses and hypothesis to John.

The codex in its present state is incomplete, beginning with Canon III on fol. 1r. The Canon tables contain only the frames, without text. The text is written in quaternia throughout. The Canon tables are in binia and the evangelist portraits are painted on the last verso side of a binion to face the text where a new gathering begins. The binion containing Matthew also has the portrait of Moses. This indicates that the miniatures were painted separately; but there can be no doubt, since the color scheme and technique are similar to those in the headpieces at the beginning of the Gospel texts, that the Canon tables and the miniatures are part of the manuscript. The first gathering is loose and the miniatures have suffered considerable flaking.

The binding consists of crimson silk covers over wooden boards with two pins and a small textile strap for closing. Silver pieces with relief representations are nailed on the front cover (fig. 681), a Crucifix in the center and the four evangelists on the corners. The four arms of the Greek cross end in discs with rosettes. The cross and the discs are bordered by a fine rope-like fillet imitating filigree work. Over the nimbus of the crucified Christ is a small Greek cross with the inscription IC XC. Each of the four corner pieces comprises two arms of the cross with two discs containing the rosettes, and is bordered by the same filigree ornament. They represent the evangelists in three-quarters view walking toward the center with closed books in their hands—a variant of an old theme, the evangelists presenting their Gospels to Christ (see cod. 221, no. 63 above, fol. 1r, fig. 665, colorplate xxviii:a).

[7] See Cutler, Weyl Carr, "Benaki Psalter."
[8] Weyl Carr, "A Group," p. 40 n. 16.
[9] Canart, "Chypriotes," pp. 46, 52.

[1] A. Canart, "Chypriotes," pp. 40, 45; Hunger, "Auszeichnúngs-schriften," p. 209 n. 33.

This type of cover, combining textile and metal pieces, would indicate a seventeenth- or eighteenth-century date.[2] In fact the figure style, the cylindrical legs completely wrapped by the drapery, and the elongated faces are very similar to those in a Gospel cover now in the Monastery of the Prophet Elijah in Thera dated by its inscription to the year 1731.[3]

Illustration

1r Canon table, Canon III (each ca. 13.1 x 11.2 cm.) (fig. 682). Three columns in steel blue with sketchy acanthus capitals support a gable structure consisting of three parts: an epistyle with a series of *archetti* containing the abbreviated names of the evangelists in gold. Above, a triangular pediment filled with large flower petals in steel blue against gold in heart shapes, enclosing a horseshoe arch with the number of the Canon in silver against deep red. This triangular pediment pierces an ornamental band with flower petals in a zigzag pattern, on top of which is a spherical decorated terminal with gold crosslets in small squares outlined in blue and filled with deep red. On the extended line of the epistyle are palmettes on which perch two cranes in blue and pink. A red ape climbs on the right side of the pediment, and two small birds flank the terminal. Another crane (?) perches on the palmette at the lower right.

1v Canon table, Canons IV and V (fig. 683). Three columns and epistyle as on fol. 1r support a stepped structure: a larger rectangle with rough rosettes set in gold within blue diamonds in a tile-like pattern encloses two horseshoe arches with the silver numbers of the Canons; above it is a smaller rectangle with flower petal style ornament in heart forms, and finally a third house-like structure with a saddle roof, with ornament similar to that in the larger rectangle. Steel blue, red, and gold are the predominant colors.

2r Canon table, Canons VI and VII. Three silver columns set on an extended, horizontal, steel blue bar support an epistyle with four metopes containing the names of the evangelists in gold. On top are two pediments enclosing horseshoe arches filled with deep red and containing the number of the Canon in silver as in previous cases. Above each arch is a stylized palmette set against gold. The third pediment that rises behind and above is divided horizontally by a blue *taenia*

with a palmette on top and a tile-like design in silver, red, and gold below. Palmettes are on the two projecting lines.

2v Canon table, Canons VIII and IX. The lower structure with columns is similar to that of fol. 2r with minor variations. The spaces between the metopes imitate ancient triglyphs. On top is a horseshoe arch framed by a band of palmettes in inverted silver and red heart forms, and enclosing a tympanon with a checkerboard pattern of squares with rough rosettes against gold. Enclosed are two smaller horseshoe arches with the number of the Canon in silver against gold.

3r Canon table, Canon X. Four columns in blue and silver outlined in red support an epistyle with metopes and triglyphs as on fol. 2v, on top of which is a triangular pediment comprising two horseshoe arches containing the title of the Canon in silver against a red background. The remaining space is filled with leafy stems forming four roundels arranged in a cross form containing flower petals. There is a small palmette on the top and four of different sizes on the projected lines of the epistyle and the base below.

3v Canon table, Canon X (fig. 684). The structure takes the form of a tempietto. Three columns in muddy blue and outlined in red with acanthus capitals standing on a base line with two flanking flowers support an epistyle with flower petals against gold in a zigzag arrangement. It supports a rectangle with flower petals enclosing a horseshoe arch with the title of the Canon in gold. The gold of the background against which the ornament is set is mostly gone, leaving the red underpainting exposed. On top is a horseshoe arch enclosing crosslets against red in a rough tile-like pattern.

4v Moses receiving the tablets of the Law (10.7 x 7.5 cm.) (fig. 685). The composition, which has suffered considerable flaking, represents Moses clad in a steel blue tunic and a carmine mantle with a steel *changeant* tone. He has dark brown hair and a face rendered in grey-brown tones. He moves to the right on Mt. Sinai, painted in carmine, and raises his veiled hands to receive the grey-green tablets of the Law from the hand of God emerging from a segment of blue sky. The mountain in the left background is rendered in brown and grey-green. There is a green stripe of wavy foreground. The sky between the mountains is

[2] Oikonomaki-Papadopoulou, *Argyra*, p. 9.
[3] P. Lazarides, *Santorin. Das Kloster Prophet Elias*, Athens, n.d., no. 50.

rendered in gold. Above the miniature is the inscription in black, ὁ μω(ι)σῆs.

5v Matthew writing (10.7 x 7.5 cm.) (fig. 686). The evangelist, facing to the right, clad in a steel blue tunic with a deep carmine clavus and a mantle of carmine with steel *changeant* colors, is seated on a low gold chair with a vermillion cushion and writing the beginning of his Gospel on a codex held in his left hand. His face, with grey-blue hair and dark brown flesh tones with green shades, conveys the impression of concentration. His nimbus is outlined in red and his feet rest on a vermillion footstool. Before him is a table holding writing implements and a red lectern with an open codex with some writing. Of the two buildings in the background, that at the left is painted in blue, brown, and violet colors and has a blue roof and a red facade. That on the right is violet with a blue cornice. The inscription above the miniature, in deep red, reads: ὁ ἅ(γιοs) ματθαῖοs. The ground is muddy green, and a thin red fillet borders the composition.

6r Square headpiece in rough flower petal style in lozenges forming a tile-like design in brown and steel blue on gold ground (fig. 687), bordered by a filigree-like fillet in steel blue. At top center is a bust with a human head in profile, rendered in brown, wearing a steel blue cloak, and with flowing hair from which sprout two leafy stems, flanked by two large peacocks in blue, brown, and red. Two birds (quails?) in deep brown and red are perched on the palmettes that stand on the lower extended line of the frame. The one on the right takes the form of a Sassanian palmette. The initial B is formed by a brown lion standing upright and biting the tail of a blue snake, which in turn bites the front leg of the lion, while a second snake coiling over the first one attempts to swallow a smaller snake on which the lion steps. Mt. 1:1ff.

91v Mark pensive (10.7 x 7.5 cm.) (fig. 688). The evangelist, seated on a gold chair with a vermillion cushion, facing to the right and resting his feet on a vermillion footstool, leans his head against his left arm in a contemplative pose and holds a piece of parchment with the beginning of his Gospel over his right leg. In his right hand he holds a pen. Clad in a tunic painted in steel blue with a carmine clavus and a carmine-violet mantle with blue *changeant* colors, and having a very dark brown face, still darker thick hair and bushy beard, and a red-outlined nimbus, Mark touches the right edge of the footstool with his right foot. The table before him displays writing implements and sup-

ports a lectern with an open codex on it. There is the usual dark green ground strip and an architectural background consisting of a violet wall with openings, just behind the carmine and grey-green chair, and two tall buildings on either side with a gold sky between. The building at the left is brown and green with a blue roof and a violet doorway, and that at the right is grey-green with a blue cornice; from its top hangs a piece of drapery. The evangelist's name is inscribed above the miniature in red, ὁ ἅ(γιοs) μάρκοs.

92r Square headpiece with a crenellated border (fig. 689), decorated with circle segments, each with a palmette at the four corners and a disc with a composite palmette in the center. The background, similar to that in the Canon tables on fols. 1v and 2v, is filled with diamonds against gold. There are four palmettes on the corners; the fourth one, at the lower right, is a Sassanian palmette. The color scheme is as on fol. 6r but in more subdued tones. Initial A with a deep red-violet fox biting a leafy stem. Mk. 1:1ff.

146v Luke dipping his pen (10.7 x 7.5 cm.) (fig. 690). The evangelist, seated on a gold decorated, bright red-cushioned chair, his crossed feet resting on a bright red, gold-lined footstool, leans forward and dips his pen into a red inkwell on a table before him. He is clad in garments of steel blue and carmine with steel *changeant* colors, has a dark brown face with olive shades and very dark brown, curly hair. The red lectern with a grey-green stand on the table displays an open codex. Behind the chair is a carmine wall with narrow openings and two buildings at the sides with gold ground between. The building on the left, divided into three stories with narrow openings, is painted blue, brown, and carmine and that on the right, rendered in carmine and also of three stories, is crowned by a blue drape. The evangelist's name is inscribed above the miniature in red, + ὁ ἅ(γιοs) λουκάs.

147r Square headpiece with crenellated frame, filled with nine interlaced roundels in three rows enclosing a flower petal on gold ground (fig. 691). Between the roundels are small, four-petalled rosettes in pink. Four palmettes are on the corners. Initial Є in flower petal and fretsaw style. Lk. 1:1ff.

235v John and Prochoros (10.7 x 7.5 cm.) (fig. 692). John stands at the right turning his head upward toward the hand of God reaching out from a segment of sky. He thrusts out his left arm wrapped in a heavy garment and extends his right hand over Prochoros. The

latter, depicted on a smaller scale, is seated on a low cushioned stool and writes the beginning of John's Gospel on a piece of parchment. Both figures are clad in garments of steel blue and carmine with steel *changeant* colors and have dark brown flesh tones; the face of John contains green shadows. Prochoros' stool is gold with a light red cushion and his footstool has a bright red top. The scene takes place before a range of mountains set on the left in olive grey, carmine, and steel *changeant* colors. There is a gold background, and the inscription above the miniature is in deep red: + ὁ ἅ(γιος) ἰω(άννης) ὁ θεολ(όγος).

236r Square headpiece with a crenellated violet frame and two diagonally placed rope-like, deep red fillets dividing the inner part into four triangles (fig. 693). Each triangle is filled with intertwined stems with flower petals in a large heart-shaped design in steel blue and pink against gold. Initial Є in flower petal and fretsaw style, which on the crossbar is vine-like.

Iconography and Style

The portraits of the evangelists follow a stereotyped iconography. For Mark the illustrator chose the more common type of evangelist, supporting his head on his hand in a meditative pose. The types used for Matthew and Luke occur in cod. Sinai 163 (see no. 65 above), but the miniature of John follows the iconography of the evangelist with Prochoros known since the eleventh century.[4]

For the miniature of Moses receiving the Law (fig. 685) there is no textual justification in the Gospel text. However, this illustration does appear with the appropriate text-prologues to the Gospels in verse or prose in a number of Lectionaries and Gospels since the tenth century.[5] Among twelfth-century manuscripts the scene occurs in the cods. Florence, Laur. Plut. VI.32, including the appropriate prologue text and its illustration;[6] Athos, Dionysiou 4;[7] Manchester, John Rylands Lib. 17; and several other manuscripts, all belonging to the so-called "Family 2400," of which the present codex is a member.[8]

Stylistically the codex is related to members of the "Family 2400" (see cod. 163, no. 65 above). Its Canon tables, playful and mannered in their construction, forms, and

ornament, including the birds perching on the palmettes or on the roofs of the structures, follow the tradition of its relatives, as is seen by comparison with the Canon tables in cod. Athos, Lavra B 26, for example.[9] In patterns, type of ornament, and style, the headpieces are related to those in cods. Dionysiou 12 and Iviron 55, whose headpiece on fol. 178r is a variant of the headpiece on fol. 92r in the Sinai manuscript.[10] The relationship extends to the initials as well. The A on fol. 92r, for example, is very similar to that in cod. Dionysiou 4,[11] and the initial B on fol. 6r relates to a similar initial in cod. Jerusalem, Taphou 47, another member of the same family.[12]

In its miniatures the codex contains all the ambiguities typical of these manuscripts in the various compositional elements, buildings, furnishings, and figures. Specifically, in terms of its facial types, drapery, settings, and actual coloring—steel blue is the most predominant color and it is shared with a number of manuscripts produced in Jerusalem—the codex is a close relative of cod. Athos, Dionysiou 12.[13] In light of the new proposed date for the "Family 2400" (see cod. 163, no. 65 above), the Sinai Gospel may now be assigned to the end of the twelfth century. In his paleographic studies Canart has related the codex to a Cypriot scriptorium of the style є.[14]

Bibliography

Gardthausen, *Catalogus*, p. 28.
Gregory, *Textkritik*, pp. 245, 1133 no. 1186.
Hatch, *Sinai*, pl. XXVI.
Colwell, Willoughby, *Karahissar*, 1, pp. 27, 188, 190, 194, 197–98, 216; 2, p. 31.
Lazarev 1947, p. 342 n. 43.
Idem, *Storia*, p. 336 n. 57.
Kamil, p. 68 no. 174.
Weyl Carr, *McCormick New Testament*, pp. 24ff., 45, figs. 42, 51–54.
Hunger, "Auszeichnungsschriften," p. 209 n. 33.
R. S. Nelson, "The Later Impact of a Group of Twelfth-Century Manuscripts," *Third Annual Byzantine Studies Conference*, Abstracts of Papers, New York, 3–5 December, 1977, p. 60.
Galavaris, *Prefaces*, p. 126.
Canart, "Chypriotes," pp. 40, 45, 72.
Voicu, D'Alisera, p. 553.
R. S. Nelson, *The Iconography of Preface and Miniature in the Byzantine Gospel Book*, New York 1982, p. 72 n. 71.
Weyl Carr, "A Group," p. 40 n. 16.
Eadem, "Gospel Frontispieces," pp. 4, 19 n. 86.

[4] Weitzmann-Fiedler, "Begleitfiguren," pp. 30–34.
[5] Galavaris, *Prefaces*, pp. 124ff.
[6] Ibid., pp. 125ff., figs. 98, 99.
[7] For a color reproduction see *Treasures*, 1, fig. 14.
[8] Galavaris, *Prefaces*, p. 126 with further examples and bibliography.
[9] See *Treasures*, 3, figs. 69, 70.
[10] Ibid., 1, figs. 36, 37; 2, fig. 48.

[11] Ibid., 1, fig. 21.
[12] See Hatch, *Jerusalem*, pl. XL; cf. also the evangelists in the same codex, ibid., pls. XLI–XLIV. See also Canart, "Chypriotes," pp. 56, 72, who assigns the manuscript to a Cypriotic scriptorium.
[13] See *Treasures*, 1, figs. 32–35; cf. especially the Luke portrait, fig. 34, with the Luke in the Sinai codex, fol. 146v.
[14] See Canart, "Chypriotes," p. 45.

67. COD. 178. FOUR GOSPELS
END OF TWELFTH CENTURY. FIGS. 694–702

Vellum. 200 folios, 18 x 11.1 cm. One column of thirty-one or thirty-two lines. Minuscule script for text, written under the line, tendency to expand lines of letters to the right, wide spaces between sentences, narrow margins, an example of the decline of the minuscule canon; titles in majuscule and minuscule. Gathering numbers at upper right corner of first recto with a simple stroke above. Parchment fine and white. Ink strong black for text; titles in red. Very small solid initials in red.

Fol. 1r–v, Eusebius' letter; 2r–6r, Canon tables; 6v, miniature; 7r–v, preface to the Gospels by St. Epiphanios; 7v–8v, Matthew chapters; 9r, blank; 9v, miniature; 10r–54r, Matthew; 54v–55r, hypothesis and chapters of Mark; 55v, blank; 56r–87r, Mark; 87r–88v, hypothesis and chapters of Luke; 89r–90r, blank; 90v, miniature; 91r–144v, Luke; 145r, John chapters; 145v–146r, blank; 146v, miniature; 147v–183r, John; 183v–195v, eklogadion (list of lections of movable feasts); 195v–200v, Menologion, fixed feasts, September–August.

On fol. 88v, following the chapters of Luke, is the following later note in black ink:

+ ζπγ γεναρίου· / ἔφερα· ἐγὼ νή/φως
ἱερωμ(ο)ναχός· το παρὸ(ν) τε/ταράβαγγελό(ν)
ἐ(κ) τις πολεως τηριπολῆς· καὶ αφιερωσα αὐφὰτο /
εἰς τω σινεων ὄρος·

+ In January of 1575 I, Nephon, hieromonk, brought this Gospel from the city of Tripolis (in the Peloponnese) and dedicated it to Mt. Sinai.

This is followed on fol. 89r by the usual curse against book thieves.

The Canon tables are very crude, having only arches drawn in black ink. All the tables have been squeezed in on fols. 2r–3r; fols. 3v–6v have only two arches drawn on the upper part of the page, without text. Concerning the illustrations, the case is similar to that of cod. 149 (see no. 66 above). The evangelist portraits were painted separately but they are of the same period, forming part of gatherings containing Gospel chapters and the concluding text of Gospels.

Old leather binding in very dark brown, almost black leather, on wooden boards with pressed ornamentation similar on both covers (figs. 701, 702). The outer frame is formed by triple fillets intersecting at the corners; the wider

inner frame is ornamented by an X-shaped scroll design. The central rectangular panel has as its principal motif an oval-shaped design with two fan-like forms at top and bottom connected to the central oval by a cross. Similar crosses fill the ground. Two leather straps with metal rings are attached to the back cover and two corresponding metal pins to the front cover for fastening.

This binding presents a striking affinity to Islamic bindings after the fifteenth century.[1] The impact of Islamic decoration is strong on bindings from Northern Italy, especially Venice, in the fifteenth and sixteenth centuries. Three published Venetian bindings from this time are closely related to the binding of the Sinai codex,[2] whose origin, however, should not be sought in Venice but rather in the Helladic area and most likely in Sinai itself. Because of the schematization of the ornament, the binding may tentatively be assigned to the early seventeenth century.

Illustration

6v Christ and the evangelist symbols (6.8 x 6.8 cm.) (fig. 694). The illustration, almost completely flaked, contains in an inner square a bust of Christ with traces of blue garments, his face rendered in greenish tones and hair in red-brown. His head is encircled by a gold nimbus bearing a blue cross. He holds a gold, jewel-studded codex and is painted against a ground of gold, which has also been applied to the square framing border. At the upper left corner of the border is the bust of an angel holding a codex and on the opposite side is an eagle, also with a codex. The other two symbols of the evangelists, painted on the lower corners, have flaked. Two double arches drawn atop the miniature were probably intended for Canon tables which were never filled in, as on fols. 2r–6r.

9v Matthew pensive (11.8 x 7.7 cm.) (fig. 695). Almost totally flaked, the illustration shows the evangelist seated on a gold stool, facing to the right, and holding his left hand to his mouth in a pensive pose. In his right hand he probably held a piece of parchment. There are traces of grey-brown in his garments and grey-blue in his hair. There is a grey-blue desk, and a lectern holding a codex set against a yellow-brown wall. Two tall houses rise at left and right in dirty violet and brown colors with saddled roofs and cornices painted steel blue. The background is gold. A later inscription with the apostle's name appears above the miniature.

[1] See F. Sarre, *Islamic Bookbindings*, London 1923, p. 6 with pertinent examples.

[2] See E. Ph. Goldschmidt, *Gothic and Renaissance Bookbindings*, London 1928, repr. Amsterdam 1967, p. 87, pls. 49, 94, 130.

10r A frameless, band-shaped headpiece of crude inter-lace outlined in black; initial B outlined in black and tinted in red (fig. 698). Mt. 1:1ff.

56r Band-shaped headpiece with a crude red and colorless rinceau and initial A in red. Mk. 1:1ff.

90v Mark dipping his pen (12.8 x 8.8 cm.) (fig. 696). The gold-nimbed evangelist, like Matthew, is seated on a low, backless, red-cushioned gold chair, with his feet wide apart on a gold footstool. Holding an unusually large book with gold edge over his lap, he leans for-ward and dips his pen into an inkwell on a brown table. He is clad in a light blue tunic and carmine hi-mation; his face is rendered in dark olive and violet-brown tones, while his hair and beard are brown with strong red touches. Behind him is a grey-olive wall with cornices rendered in blue at the center and on top. Two violet-brown houses with blue cornices are at the sides. That on the right has a saddled red roof and a large doorway framed in steel blue; that on the left is taller and has a grey marble baldachin. The background is gold with traces of a gold inscription. There is a later inscription erroneously citing Luke's name above the miniature.

91r Frameless band-shaped headpiece in a crude red chain pattern and initial Є (fig. 699). Lk. 1:1ff.

146v John pensive (11.3 x 8.3 cm.) (fig. 697). Clad in a light blue tunic and light green himation, gold-nimbed, seated on a gold backless chair facing to the right, and with his feet on a gold footstool, the evange-list touches his mouth in a pensive pose. He probably held an open scroll with his right hand. His hair is rendered in grey-green colors and his face in red-brown tones with green shades. The gold lectern is supported by an unusually large gold dolphin. It holds a huge book in steel color bearing traces of the Gospel's text in black. Behind John is a red-brown wall with a steel blue cornice and two houses at the sides. That to the right is grey-green and has a blue roof above which rises a red-brown tower also with a red roof. At the left, the grey-green building has a blue cornice and is crowned by a piece of red drapery. The background is gold with traces of a red inscrip-tion: ὁ ἅγ(ιος) ιω(άννης).

147r Frameless band-shaped headpiece with a crude orna-ment of red, colorless, and steel blue chain pattern; initial Є (fig. 700). Jn. 1:1ff.

Iconography and Style

All three evangelist portraits are common in twelfth-century codices, particularly from the second half of the cen-tury (see cod. 153, no. 64 above). One iconographic element, however, should be singled out: the very large lectern in the John miniature; it is supported by a large dolphin and stands on the ground, the table on which it is normally placed having been eliminated.

The illustration of Christ and the four symbols (fol. 6v, fig. 694) is iconographically most important. It illustrates a prologue version (fol. 7r) which in the codex is attributed to St. Epiphanios and concerns the interpretation of the four zodia and their role in God's glorification.[3] For prefaces of this version the illustrators chose a theophanic composition, a Majestas. The Sinai codex is one of several examples that retain the basic components of such a composition.[4]

In terms of style and architectural elements the manu-script relates to the cod. Athos, Dionysiou 23;[5] both share the differentiation and type of buildings as well as the gen-eral color tones. It is also related to the cod. Athos, Diony-siou 12, which displays the same red-brown flesh tones.[6] Nevertheless, this provincial manuscript does not belong to the same family or share the same place of origin as these Athos codices. The color scheme is, on the whole, more sub-dued and does not conform to that of the codices belonging to the Family 2400; the same is true of the paleography. How-ever, there are some paleographical connections with the cod. Leningrad 298 from 1181(?), said to have come from a codex produced at St. Sabas near Jerusalem.[7] But this possi-ble relationship is not strong enough to assign the man-uscript to a Palestinian milieu. The possibility that the manuscript was produced in Greece remains.

Bibliography

Kondakov 1882, p. 203.
Gardthausen, *Catalogus*, p. 35.
Gregory, *Textkritik*, pp. 247, 1135 no. 1215.
Hatch, *Sinai*, pl. LII.
Kamil, p. 68 no. 203.
Galavaris, *Prefaces*, p. 84.
Voicu, D'Alisera, p. 555.
R. S. Nelson, *The Iconography of Preface and Miniature in the Byzantine Gospel Book*, New York 1982, pp. 62, 70 n. 37, fig. 38.

[3] For the complete text see von Soden, pp. 302–303.
[4] For a discussion of this and related examples, see Galavaris, *Prefaces*, pp. 74ff.

[5] *Treasures*, 1, figs. 57–60.
[6] Ibid., figs. 32–35.
[7] See Lake, *Dated Mss.*, 6, no. 252, pl. 447.

68. COD. 260. NEW TESTAMENT
SECOND HALF OF TWELFTH CENTURY.
FIGS. 703–710

Vellum. 193 folios, 19.7 x 13.6 cm. One column (in the Acts, two columns) of thirty-one to fifty lines. Minuscule script for text, round minute letters, dense, letters often enlarged, especially epsilons at the ends of lines; minutest script for the text of the Acts by a different hand; titles in *Auszeichnungs-Majuskel* and majuscule. Gathering numbers at center bottom margin of first recto with two horizontal lines above and a stroke below. Parchment rough and hard, yellow. Ink black for text; titles in red and light brown. Initials in red or blue and red, filled with a yellow wash; solid initials throughout the text in light red, pale brown, and carmine.

Fol. 1r, blank; 1v, miniature; 2r–32r, Matthew; 32r–32v, Matthew chapters; 32v, miniature; 33r–55v, Mark; 56r–v, Luke chapters; 56v, miniature; 57r–90v, Luke; 91r, John chapters and miniature; 91v–116r, John; 116v, late entry; 117r–137r, Acts; 137r, miniature; 137v–193r, Epistles (fol. 156v, blank).

On fol. 137r, following the conclusion of the Acts, right column, is the following entry written in carmine ink and marked by a wavy line with strokes terminating in floral motifs above and by a knotted line below (fig. 710): πράξεις ζωηραὶ τῶν χ(ριστ)οῦ μυστῶν / πρώτων: / γραφεῖσαι χειρὶ ἀλητρ(ώτ)ου γεωργίου:· (The vivid deeds of the first initiates of Christ are written by the hand of the unredeemed George.) Obviously this statement applies to the section written by this hand, i.e., the complete Acts and the hypothesis of the Epistle to the Corinthians, fols. 117r–138r.

The illustrations fill odd spaces that happened to be empty; they were not planned from the beginning. The text on fol. 55v, Mark's conclusion, is in the form of a triangle and that on fol. 116, John's conclusion, in the form of a chalice. The codex is in poor condition. Lower edges of folios are torn; the bottom of fol. 91r is cut and the illustrations have suffered losses.

The binding displays only poor fragments of dark red textile on a wooden board on front cover, completely torn. The back cover is missing.

Illustration

1v Matthew pensive (12.3 x 9.5 cm.) (fig. 703). The evangelist, seated on a wide, backless yellow chair, facing to the right, holds a large brown book with a red edge under his right arm and leans his head against his left hand in a meditative pose. Clad in a dull blue tunic with a red clavus and a dull carmine himation, both with folds in dark lines, he has olive brown flesh tones with red touches on his cheeks, olive grey hair and beard, and a large yellow nimbus outlined in black. He rests his feet on a yellow footstool decorated like the chair with a black rinceau. Before him is a decorated desk in yellow and red with an outlined lectern on top or behind. The cushion of the chair, the top of the footstool and the frame of the desk are in the same dull blue as the apostle's tunic; the right side of the desk, however, is painted in brown. There is a very late inscription, μαθεὼς. The illustration is oddly painted, touching the bottom edge of the page and leaving almost half of the area above empty.

2r Π-shaped headpiece in a degenerate flower petal style (fig. 704). Six roundels in muddy blue joined by dull grey-blue palmettes contain leaves of the same color set against deep red. The background is a lemon yellow wash. Large Sassanian palmettes are on the corners and the lower extended line of the frame. Initial B is formed by a leafy stem; the loops are filled with a lemon yellow wash. Mt. 1:1ff.

32v Mark writing (13.8 x 9.5 cm.) (fig. 705). Facing to the right, the evangelist is seated on a bench and is writing in a large codex held upright by his left hand. There is a large footstool and a roughly outlined desk. The portrait is rendered in crude pen drawing with some red wash on the cheeks, neck, hand, and feet. There is a much later inscription, μάρκος. The miniature placed at the end of Mark's chapters was probably not completed.

33r Π-shaped headpiece with heart-shaped palmettes in red, dirty yellow, olive grey, and colorless (fig. 706). Initial A with the horizontal bar taking the form of a double crosslet. Mk. 1:1ff.

56v Luke pensive (16.2 x 9.3 cm.) (fig. 707). Executed in pen drawing, the evangelist is seated on a large, backless, cushioned chair and rests his feet on a footstool; he raises his hand to his bearded chin in a pensive pose while holding a codex on his lap. There is a much later inscription, λουκας. The drawing is placed below Luke's chapters.

57r Band-shaped headpiece with palmettes in a zigzag in pale, crude carminé. Initial Є. Lk. 1:1ff.

91r John writing (?) (12.5 x 10 cm.) (fig. 708). The evangelist is depicted in pen drawing, seated facing to the right, writing (?)—the pen is missing—and touching

a lectern with his left hand. His feet and the legs of the chair have been cut off. The later inscription reads ιωαν(ν)ης. The drawing is placed at the end of John's chapters.

91v Band-shaped headpiece with a simple rinceau in a crude carminé. Initial Є. Jn. 1:1ff.

117r Π-shaped headpiece of a sloppily designed rinceau, left column, in very dark blue, red, and yellow (fig. 709). The frame of the headpiece is surrounded by another large rinceau in similar colors spreading all around and into the margins. Large initial T formed of knotted stems and fretsaw ornament. The lower part of the hasta splits into two branches, each terminating in animal heads biting the stems. The entire initial is rendered in red and muddy blue. Acts 1:1ff.

137r The apostle Paul (11.8 x 3.5 cm.) (fig. 710). He stands in three-quarters view, facing to the right and holding a book. The figure in plain pen drawing was not completed and perhaps was meant to hold a codex. It is placed in the right column following the end of the Acts and the scribe's entry.

195r Band-shaped headpiece, left column, with a simple interlace drawn in black with some red. Colossians 1:1ff.

188r Band-shaped headpiece with a simple interlace in black against the parchment. I. Peter 1:1ff.

Iconography and Style

The original decoration of the codex consists of the ornamental headbands and the large initials, whose color—dull grey-blue with red on yellow or simple carmine—and crude designs of medallions and heavy rinceau are decidedly provincial. Similar ornament is found in a large number of twelfth-century codices, mostly of uncertain provenance. The cod. Athens, Nat. Lib. 2525, which most likely originated in Sinope,[1] contains initials that are comparable, especially in the rendering of knots, loops, and large leaves attached to the inner part of the loops. The peculiarity of the Sinai codex is that some of its initials, for example that on fol. 117r, terminate their split ends in heads biting their own stems, and that the frame of the headpieces expands into the

margins. The problem is similar to that encountered in other codices, such as Sinai 193 and 234 (see nos. 54 and 50 above), and ultimately relates to the origin of cod. Athens, Nat. Lib. 74 and its relatives.[2]

The Sinai codex should most likely be assigned to South Italy, and one should see in it reflections of an earlier tradition;[3] however, an attribution to Asia Minor cannot be ruled out.

The portraits, which show stereotyped iconography (cf. cod. 275, no. 41 above), were not planned from the beginning. They were placed in available spaces and, except for the portrait of Matthew, were not executed in color. However, the color scheme in Matthew's portrait indicates that it and possibly the other portraits were added at the time when the ornament was colored. The dull blue and the yellow in Matthew's portrait, for example, are similar to those in the headpiece on fol. 2r, while the olive grey appears again in the headpiece on fol. 33r.

Certain facial peculiarities must be singled out: the beard in Luke's portrait divided in two and painted as if hanging down; the line of the beard between the ear and the mouth taking the form of a tau; the shape of the skull; and the lines suggesting hair. All these compare well to a portrait of Luke in cod. London, Brit. Lib. Add. 5107 from the year 1159.[4]

The overall treatment of the drapery and certain details in particular, such as the loop of the right sleeve of the tunic falling over the mantle, the folds stuck under the seat, and the drooping zigzag folds frozen between the legs, as well as the thrust of the feet on the footstool, are typical features of the second half of the century; a close parallel is provided by the cod. Sinai 157 (see no. 59 above). But the double fold that appears along the right thigh of the figure is a stylistic feature pointing to the thirteenth century.[5] On the basis of all this, a date in the second half of the twelfth century seems most likely.

Bibliography

Gardthausen, *Catalogus*, p. 54.
Gregory, *Textkritik*, pp. 248, 1136 no. 1241.
Hatch, *Sinai*, pl. XLV.
Colwell, Willoughby, *Karahissar*, 1, p. 211.
Kamil, p. 71 no. 285.
Voicu, D'Alisera, p. 558.

[1] Marava-Chatzinicolaou, Toufexi-Paschou, no. 56, figs. 582–96.

[2] See ibid., no. 74, especially pp. 58–61.

[3] Compare, for example, the initial T on fol. 117r of the Sinai codex with a cross and an initial T in cod. Paris gr. 375, fols. 3v and 76v, which was produced in Italy in 1022; also fol. 174r of the cod. Vat. gr. 866 from

the end of the tenth century, from Capua (?); see Grabar, *Manuscrits grecs*, no. 24, figs. 158, 160; and no. 17, fig. 119.

[4] Spatharakis, *Dated Mss.*, no. 152, fig. 293.

[5] Cf., for example, cod. Baltimore, Walters W. 532, in *Greek Mss. Amer. Coll.*, no. 43, fig. 74.

69. COD. 180. FOUR GOSPELS
A.D. 1186. FIGS. 711–716

Vellum. 261 folios, 22.4 x 15.8 cm. One column of twenty-six lines (Menologion, fols. 239r–260v, in two columns, same number of lines). Minuscule script for text written under the line, calligraphic, small, stylized letters, somewhat rectangular, pending lines of letters mostly directed to the right, characteristic of "Palestino-Cypriotic" manuscripts;[1] Gospel headings in *Epigraphische Auszeichnungs-Majuskel*, calendar indications in minuscule. Gathering numbers at upper right corner of each first recto and lower right of each last verso. Parchment mostly thick but occasionally extremely thin and not usable on both sides, white, average quality. Ink very dark brown for text; titles throughout in strong crimson red. Large initials in carminé outlined in strong crimson; small solid initials throughout the text in similar color.

Fols. 1r–5v, John Chrysostom's Commentary to Jn. 19:25 (*PG* 59, 462f.)[2] and a text on the twelve apostles; 6r, blank; 6v–7v, Matthew chapters; 8r–v, blank; 9r–73r, Matthew; 73r–v, Mark chapters; 74r–114r, Mark; 114r–115v, Luke chapters; 116r–186r, Luke; 186v, John chapters; 187r–237r, John; 237v–238v, blank; 239r–252r, lections list for movable feasts, beginning with Easter; 252r–260v, lections list for fixed feast days.

On fol. 260v, right column, is the following colophon (fig. 715):

ἐτελειώθ(η) τὸ παρ(ὸν) τετρα/βάγγελον διὰ χειρος / κἀμοῦ γεωργ(ίου) ἀναγνώστ(ου)/. (There follow seven lines that have been intentionally obliterated. In these only the following words are still decipherable: ἱερομονά[χου], end of line 8 of colophon; της, end of line 9; παπ[ᾶ], end of line 10.) μ(ι)χ(αήλ) ἐπι τῆς βασιλ(εία)s / ἰσαακίου μ(ε)γ(ά)λ(ου) βασιλέως / καὶ αὐτοκράτωρο(s) ῥω/μαίων τοῦ ἀγγέλ(ου)· μη(νὶ) φευ/ρουαρίω ἰν(δικτιῶνος) δ'. ἔτ(ους) / ,ϚΧ Ϛ δ': καὶ οἱ ἀναγὶνώσκοντες / ταύτ(ην) εὔχεσθαί μοι / διὰ τὸν κ(ύριο)ν· ἀμήν.

This Gospel was completed by Georgios Anagnostes ... hieromonk ... of(?) ... priest ... Michael in the reign of the great king and emperor of the Romans Isaac Angelos; in the month of February, 4th indiction, of the year 6694 (1186). May the readers of this book pray for me for the love of the Lord; amen.

The obliterated lines probably contained the names of donors or of those who commissioned the manuscript, a hieromonk and a priest named Michael, and perhaps even the place of production.

Various later entries, including commemorations, appear in the codex. Condition is very good.

Binding in plain red-brown leather on wooden boards. Edge of book has circles in a garland pattern. On the front cover are five thin embossed sheet-metal attachments: four silver (?) pieces on the corners and a copper Crucifix in the center with a double cross (fig. 716). Of the silvery pieces, that at the upper right corner contains a half figure, nimbed and holding a book. Each of the remaining three pieces has the lower part of a standing figure. At the two bottom corners the bodies are oriented toward the center; in that at top left, the body faces the opposite direction. Perhaps these were a set of the four evangelists. Fragments of dotted frames and floral motifs indicate that these attachments were cut from a larger piece, probably a metal icon.[3] Two round metal pins for fastening have been preserved on the front cover.

The practice of cutting metal icons to decorate bindings is known since the middle of the eighteenth century,[4] a most likely date for this cover, which is most probably Sinaitic.

Illustration

1r Framed, braided band in bright crimson red. John Chrysostom's Commentary on Jn. 19:25.

6v Band-shaped headpiece in a simple rinceau in carminé. Matthew chapters.

9r Rectangular headpiece with medallions, each enclosing a developed palmette, crosses, and small hexagonals in between in a tile-like pattern (fig. 711). All ornamental motifs are colorless, set against a red ground. Large initial B in simple carminé. The hasta is formed of knotted double stems and the loops by a single one. Simple palmettes are on the upper corners and on the extended lower line of the frame. Mt. 1:1ff.

73r Frameless, simple red interlace in carminé. Mark chapters.

74r Rectangular headpiece with squares including four crosslets attached to a framed medallion and in between crosses with crosslets attached to a square, all in a tile-like pattern, colorless against red (fig. 712). Large initial A in carminé with knotted double stems. Mk. 1:1ff.

[1] See below, p. 193.

[2] Cf. M. Aubineau, *Codices Chrysostomici graeci*, 1, Paris 1968, p. 191 no. 201.

[3] Cf. a twelfth/thirteenth-century metal icon in Leningrad: *Exhibition Leningrad*, 2, no. 540, p. 79.

[4] Oikonomaki-Papadopoulou, *Argyra*, p. 9.

114r Frameless, simple interlace, colorless and red. End of Mark, Luke chapters.

116r Rectangular headpiece of very small palmettes in heart forms enclosing diagonal crosslets in a delicate tile-like arabesque pattern (fig. 713). Initial Є formed of knotted double stems. Lk. 1:1ff.

187r Rectangular headpiece with interlaced medallions, each of which contains two pairs of colorless ivy leaves in a cross-form design (fig. 714). Between the medallions are composite colorless, stylized palmettes. Large initial Є in carminé formed of a knotted double stem. Jn. 1:1ff.

237r Simple tailpiece of black strokes, red crosslets, and black half palmettes at each end. Conclusion of John's Gospel.

239r Simple strokes with crosslets, left column, in red. Lections list for movable feasts.

252r Simple frameless interlace, colorless and red, left column. Lections list for fixed feasts.

Iconography and Style

The headpieces in elegant and flowing designs all adhere to a tile-like pattern centered around the Sassanian palmette. The greatest variety of such tile patterns is to be seen in the lusterware tiles in the mihrabs of great mosques, for example, at Wayarawān from 862/3.[5] There can be no doubt that these headpieces reveal strong Islamic influences.

The codex should be seen in the context of the tradition of cod. Sinai 237 (no. 46 above), whose headpiece on fol. 1r (fig. 410) is a variant of that on fol. 116r of the present codex (fig. 713). We have assigned this relative to Sinai, a center which we propose for this Gospel also. If the codex was not made in the Monastery of St. Catherine itself, it was probably produced in a nearby center with which Sinai had close connections.

Canart has observed some paleographic similarities with works from Cypriotic scriptoria.[6] Nevertheless, he has hesitated to include it among Palestino-Cypriotic products. A more recent paleographic study, however, has opted for Palestine as the manuscript's place of production,[7] a conclusion that corroborates our own proposal.

Bibliography

Gardthausen, *Catalogus*, p. 35.
Gregory, *Textkritik*, pp. 247, 1135 no. 1217.
Hatch, *Sinai*, pl. XXV.
Colwell, Willoughby, *Karahissar*, 1, p. 233.
Lake, *Dated Mss.*, Indices, p. 181.
Devreesse, *Introduction*, p. 308.
Kamil, p. 69 no. 205.
Treu, "Kaiser," p. 19.
Canart, "Chypriotes," p. 49 n. 101.
Spatharakis, *Dated Mss.*, p. 47 no. 167, fig. 315.
Voicu, D'Alisera, p. 555.
Harlfinger et al., pp. 58–59, 64, 65 no. 34.

[5] See K. A. C. Creswell, "Problems in Islamic Architecture," *The Art Bulletin* 35 (1953) p. 3, fig. 2.

[6] Canart, "Chypriotes," p. 49 n. 101.
[7] Harlfinger et al., p. 59.

Concordance

Sinai Library Ms. Number	Catalogue Number in Present Volume	Sinai Library Ms. Number	Catalogue Number in Present Volume
3	37	221	63
30	1	234 (+ Leningrad 297)	50
32	2	237	46
39	52	259	47
44 (+ Leningrad 268)	51	260	68
48 (+ Leningrad 267)	30	275	41
68	19	283 (+ Leningrad 220)	8
149	66	293 (+ Leningrad 318)	26
150	32	326	40
153	64	339	56
155	22	341	39
157	59	342 (+ Leningrad 330)	25
158	53	346	38
163	65	360	17
166	10	364	24
172 (+ Leningrad 291)	29	368	20
174	55	375 (+ Leningrad 343)	6
178	67	401	31
179	48	417	9
180	69	418	57
183 (+ Leningrad 266)	12	421	15
188	21	423	36
193	54	499	34
204	18	500 (+ Leningrad 373)	28
205	33	503	35
207	42	508	43
208	60	512	27
210 (+ Leningrad 194)	3	734–735	13
211	4	863	5
213 (+ Leningrad 283)	14	956	11
214	16	1112	7
216	61	1186	23
218	45	2090	49
219	44		
220	62	Icon	58

General Index

Numbers in bold face are catalogue numbers. Those in Roman type are page numbers

Acts and Epistles, **8** 6, 24–28, **26** 69–70, **41** 8, 82, 110–116, 191
Africa, 38
Agarenes, **27** 70, 71
Alexander, Prince, Voevode, *see* John
Alexander, ascension of, 36, 38
Alexandria, 63
Akka/Acre, conquest of in 1291, **27** 70, 71
Anastos, M., 63
Anderson, J., 152
Armenia, 45
Asia, Asia Minor, 8, 40, 91, 128, 191
Asinou, 9, 130, 170
Athens, 100
Athos, **32** 91; 137, 168
Attica, 40

Basil Skenouris, notarios, monastery of the Holy Cells, scribe, **62** 174, 175
Basil hypodiakonos, scribe, **26** 69
Basil the Great, Homilies, **40** 7, 109–110, **43** 119
Beneševič, V., 83, 177
Bethlehem, *see* monasteries and churches
bilingual texts, Greek-Arabic, **2** 16, 17
bindings:
 Byzantine, **10** 31, **15** 40, **16**(?) 41, **21** 50, **29**(?) 81, **57** 153
 Cretan and/or Sinaitic, **6** 22, **20** 48, **28** 74, **54** 138, **56** 141, 142, **67** 188, **69** 192
Bithynia, 17, 19, 20, 40
Buchthal, H., 183
Byzantine Empire, Eastern provinces, 7f., 37f., 40f., 49, 69f., 112

Caesarea, 40, 91
Calabria, 8, 10, 89, 133
Canart, P., 14, 179, 182, 184, 187, 193
Candia/Chandax, **63** 177; *see also* Sinai, metochia
Canons, **7** 4, 24–24
Catherine, wife of John Alexander Voevode, **60** 167
Cappadocia, 38, 90, 91, 122
Cavallo, G., 13, 46
Cefalù, 166
Chaldia and Coloneia, **29** 8, 80, 82
Chamaretos, *see* Daniel
Christian Topography, *see* Cosmas Indicopleustes
Clemens, hieromonk, Sinai, bookbinder, **61** 170, 171
Commodilla, Catacomb of, 83
Constantine VII, Porphyrogenitus, emperor, 72
Constantine IX, Monomachos, emperor, **24** 8, 66, 67
Constantine Doukas, emperor, **29** 80
Constantinople:
 city, 6f., 28ff., 31ff., 34ff., 42, 46ff., 51, 63, 67ff., 73, 94f., 96, 98, 104ff., 115, 120, 123 130, 135ff., 180ff.
 churches, St. George of Mangana, **24** 8, 65, 67; Holy Apostles, 151, 163; St. Sophia, 67; *see also* monasteries and churches
Cosmas, monk, ktetor, 12th century, **54** 138
Cosmas Indicopleustes, **23** 7, 52–65
Crete, 4, 7, 9, 22, 67, 74, 97, 117, 141, 176ff.; *see also* monasteries and churches, Sinai
Cynegetica, 105
Cutler, A., 184

Cyril II, Cretan, archbishop of Sinai, **47** 127
Cyprus, Cypriotic, 8ff., 27, 67, 124, 130, 139, 165, 170, 184, 187, 192f.

Dalisandos in Asia Minor, **26** 69, 70; *see also* Basil hypodiakonos
Damascus, 31
Damianos, archbishop of Sinai, 4
Daniel Chamaretos, hieromonk, 16th century, 19, 47
Devreesse, R., 90
Dome of the Rock, Jerusalem, 6, 31
Dmitrievski, A. A., 18

Eirene (Irene) Gabraba, wife of Theodore Gabras, **29** 80f.
Egypt, Egyptian, 22, 38, 41, 49, 51
El-Hakîm, mosque, Cairo, 38
enamel, 94
Euchologion, **11** 33–35
Eugenios, archbishop of Sinai, 16th century, **56** 140
Eustathios, presbyter, scribe, **14** 35
Eustathios, monk, scribe, 73
evangelists, epigrams to, **14** 35

Follieri, E., 21

Gabras, *see* Theodore
Gabraba, *see* Eirene
Gardthausen, V., 46
Georgia, 117
Georgian:
 artists, icons, monks, codices, 4, 9, 118
 inscriptions, 42, 117
George, scribe, **68** 190
George Anagnostes, hieromonk, scribe, **69** 192

Iconographic Index

Makarios, St., **60** fig. 650
Mamas, **38** fig. 324, **56** figs. 475, 476
manna, miracle of, **23** fig. 142
 colorplate ix:b
Marcian, St., **27** fig. 198 colorplate xv
Mariamne, St., *see* Bartholomew,
 apostle
Matrona, St., **28** fig. 207
Maximian, emperor, **43** fig. 508
Maximos the Confessor, **60** fig. 650
Melchisedek, **23** fig. 159
Menas, St., **28** fig. 210
menorah, **23** fig. 148
Michael, archangel, **29** fig. 226; and
 Gabriel, **61** fig. 658
Mission of the Apostles, *see* Apostles
Moses: **23** figs. 141, 142, 152, **60** fig.
 648
 and the burning bush, **23** fig. 163,
 42 fig. 388
 receiving the Law, vision of, **23** figs.
 144 colorplate x:b, 163, **51** fig.
 448, **66** fig. 685
 smiting the rock, **23** fig. 143
 colorplate x:a

Nabuchodonosor, **23** fig. 128
Nativity, **38** fig. 327, **56** fig. 479
Noah, and ark of, **23** figs. 157, 158;
 see also Jordan

ocean, **23** figs. 133–135, 136 colorplate
 ix:a, 137–139
Onouphrios, St., **60** fig. 650

paradise, **23** fig. 136 colorplate ix:a
Paul, apostle, **8** fig. 31 colorplate i:a,
 29 fig. 226, **33** fig. 286, **41** figs.
 360, 363, 367 colorplate xviii:c,
 368, 376, 380, **68** fig. 710
 conversion of, **23** fig. 168 colorplate
 xii:b
 and Ancient of Days, **41** fig. 384
 and John Chrysostom, **28** fig. 212
 and Saints: Timothy, **41** figs. 365,
 370, 382; Timothy and Silvanos,
 41 figs. 372, 374; Timothy,
 Lukios, Jason, and Sosipatros, **41**
 fig. 358 colorplate xviii:b

Paul the Confessor, **28** fig. 205
Paul of Latros, **60** fig. 650
Paul of Thebaid, **27** fig. 198 colorplate
 xv
Pegasios, St., **28** fig. 201
Pentecost, **38** fig. 325, **56** fig. 477
Persia, five saints of, **28** fig. 201
Persian (Median), *see* Daniel
Personifications:
 Hope, Faith and Charity, **57** fig.
 630
 Thanatos, **23** fig. 156
Peter, apostle, **8** fig. 30, **29** fig. 226,
 30 fig. 246, **38** fig. 286, **41** figs. 345,
 347; in prison, **27** fig. 198
 colorplate xv
Peter of Monobata, Hosios, **18** fig. 95
 colorplate vii
Philip, apostle, **28** fig. 213, **33** fig. 286
Polyeuktos of Armenia, **27** fig. 198
 colorplate xv
priest, vestments of, **23** fig. 151; *see
 also* Aaron
Prochoros, *see* evangelists, Mark
Ptolemaic throne, **23** fig. 127

quails, *see* Moses

Raithou, city, **23** fig. 143; Holy
 Fathers martyred at, **27** fig. 198

Samonas, *see* Confessors
Samuel anointing David, **30** fig. 240
Saul, **23** fig. 166, **30** fig. 265
seasons, cycle of, **23** fig. 178
Seraph, **61** fig. 658
Silvanos, St., *see* Paul
Simon, St., **33** fig. 286
Sinai, Mt., representations of, *see*
 Moses
Solomon, **60** fig. 648
Solomone, *see* Maccabees
Sosipatros, *see* Paul
springs, Israelites at the twelve, **23** fig.
 141 colorplate x:a
stars, motion of, **23** fig. 179
Stephen, St., stoning of, **23** figs. 166,
 167

Stratonikos, St., **27** fig. 198 colorplate
 xv
stylites, *see* anchorites

Tabernacle, the, **23** figs. 144
 colorplate x:b, 146, 150, 174
Theodora, empress, *see* Constantine
 IX Monomachos
Theodore Gabras, **29** fig. 224
Theodosios the Coenobiarch, **27** fig.
 198 colorplate xv, **60** fig. 650
Theoktiste of Lesbos, **28** fig. 209
Thomas, apostle, **29** fig. 226, **33** fig.
 286; incredulity of, **56** fig. 475
throne, Ptolemaic, *see* Ptolemaic
Timothy, St., *see* Paul
Trajan, emperor, **43** fig. 399
 colorplate xix:b
Transfiguration, **58** fig. 633, **60** fig.
 650, **61** fig. 658
Tribes, the Twelve of Israel, **23** fig.
 152 colorplate xi:a

universe, *see* cosmos

vestments, *see* priest
Vikentios and Viktor, Sts., **28** fig. 210
Virgin Mary, Theotokos:
 enthroned, **56** fig. 472
 standing, **18** fig. 94 colorplate iv;
 orans, monks praying to, **57** fig.
 600 colorplate xxvi:a
 busts, of the Burning Bush, **42** fig.
 388; Blachernitissa, **56** fig. 480;
 Hodegetria, **28** figs. 216, 217;
 icon of, **57** fig. 628 colorplate
 xxvi:d
 Koimesis of, **44** fig. 407
 with Irene Gabras (Gabraba), **29**
 fig. 225

Zachariah, **60** fig. 648
Zacharias, **23** fig. 149
zodia, four, see Habakkuk, *see also*
 evangelist symbols
zodiac, signs of, **23** fig. 140
Zoe, empress, *see* Constantine
 Monomachos

Index of Manuscripts

Abbâ Garimâ
gospels, 90 n. 8

Ann Arbor, Michigan
University of Michigan Library,
cod. 171, 116 n. 11

Athens
National Library: cod. 56, 34, 50 n.
1, 82, 137 n. 3, 183; cod. 57, 27 n.
9, 79 n. 21, 94, 96, 107, 115, 130
n. 9, 137 n. 4; cod. 68, 100 n. 4,
127 n. 8, 175 n. 6; cod. 69, 82;
cod. 74, 82 n. 8, 88, 90 n. 3, 139,
191; cod. 76, 78 n. 12; cod. 93,
175 n. 6, 182; cod. 149, 33 n. 8;
cod. 163, 27, 124; cod. 166, 139 n.
5; cod. 179, 91, 139 n. 5; cod.
190, 107, 127 n. 2; cod. 204, 24;
cod. 629, 138, 141; cod. 2251, 27
n. 16; cod. 2254, 108 n. 8;
cod. 2363, 109, n. 7; cod. 2364,
48; cod. 2525 191; cod. 2551, 69
n. 2; cod. 2639, 100 n. 4;
cod. 2645, 96, 115 n. 3, 130 n. 5;
cod. 2804, 96, 97; cod. suppl. 535,
78 n. 5

Athos
Dionysiou, cod. 1, 40; cod. 2, 139;
cod. 4, 174 n. 16, 187; cod. 12,
174, 187, 189; cod. 18, 38; cod.
20, 27; cod. 23, 27 n. 8, 183, 184,
189; cod. 61, 151, 161; cod. 65,
130; cod. 70, 42; cod. 80, 174;
cod. 82, 137; cod. 471, 174; cod.
587, 99 n. 1, 168 n. 6, 171, 179 n.
7

Dochiariou, cod. 5, 115; cod. 22, 33
n. 7

Esphigmenou, cod. 14, 72 n. 6; cod.
25, 79 n. 18, 133, 137

Iviron, cod. 1, 163; cod. 2, 96 n. 9;
cod. 5, 82; cod. 55, 187; cod.
1384, 182; unnumbered cod., 98

Karakallou, cod. 11, 38, 49 n. 4, 137

Koutloumousiou, cod. 60, 130 n. 12,
163, 165 n. 3; cod. 61, 169; cod.
100, 174; cod. 412, 78

Lavra, cod. A 4, 115 n. 4, 130 n. 12,
n. 13; cod. A 19, 32 n. 2; cod. A
21, 115 n. 7; cod. A 23, 16 n. 5;
cod. A 42, 82 n. 8; cod. A 44, 27 n.
17; cod. A 58, 127, 139 n. 1; cod.
A 86, 38; cod. A 92, 169; cod. A
103, 161; cod. A 106, 33 n. 7;
cod. B 26, 187; cod. Δ 46, 130;
cod. Δ 82, 73

Panteleimonos, cod. 2, 78, 132; cod.
6, 109, 115 n. 3; cod. 25, 27 n.
17; cod. 100, 78 n. 5

Pantocrator, cod. 10, 32 n. 3; cod.
olim 49, see Washington,
Dumbarton Oaks cod. 3; cod.
234, 115

Philotheou, cod. 33, 27

Stavronikita, cod. 43, 94

Vatopedi, cod. 456, 34; cod. 761,
109; cod. 918, 32 n. 3; cod. 949,
78 n. 12

Baltimore
Walters Art Gallery, cod. W. 524,
27, 115; cod. W. 532, 191; cod.
W. 533, 27 n. 16, 115, 116

Bologna
Biblioteca Università, cod. 70, 16 n.
4

Cambridge
University Library, cod. MS 2.36,
133

Cambridge, Mass.
Harvard College Library, cod. 3,
130

Chicago
University of Chicago Library, MS
131, 116 n. 11; MS 965
(Rockefeller McCormick New
Testament), 10, 176, 183, 184,
187, 189

Dublin
Trinity College, cod. 55, 16 n. 4

Erivan (Etschmiadzin), cod. 2374, 90

Escorial, cod. gr. 328, 89

Florence
Biblioteca Medicea Laurenziana,
cod. Plut. IV.29, 27; Plut. VI.32,
187; Plut. IX.15, 38; Plut.
IX.28, 63; Plut. XI.9, 16 n. 5;
Plut. XI.10, 97 n. 12; Plut.
XXVIII.26, 16 n. 9

Grottaferrata, cod. B.a.XX, 49 n. 4

Jerusalem
Greek Patriarchate Library, cod. 23,
176; cod. Anastaseos 9, 176, 179
Megale Panagia, cod. 1, 119 n. 6
Sabas, cod. 25, 38, 176; cod. 82, 22
n. 6; cod. 107, 49 n. 3; cod. 144,
176
Stavrou, cod. 55, 32 n. 2, 33; cod. 74,
51
Taphou, cod. 5, 105 n. 10; cod. 13,
51; cod. 42, 51; cod. 47, 126 n. 2,
139 n. 5, 161, 175 n. 6, 187

Leningrad
State Public Library, cod. gr. 21,
130; cod. gr. 33, 49; cod. gr. 36,
35 n. 1; cod. gr. 216 (Uspenskij
Psalter), 16, 18, 19; cod. gr. 219,
21; cod. gr. 298, 189; cod. gr.
B.I.5, 90 n. 5

London
British Library:
Add., cod. 5107, 191; cod. 5111,

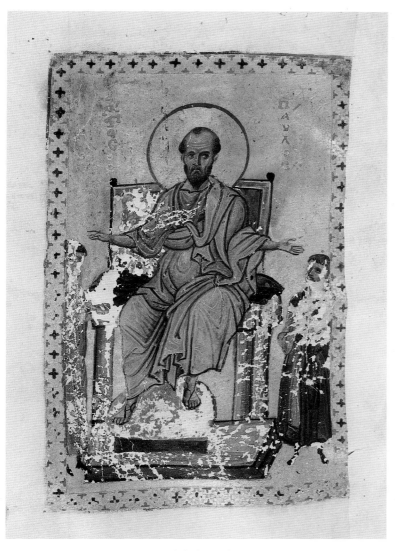

a. Cod. 283, fol. 107v. Paul (cf. fig. 31)

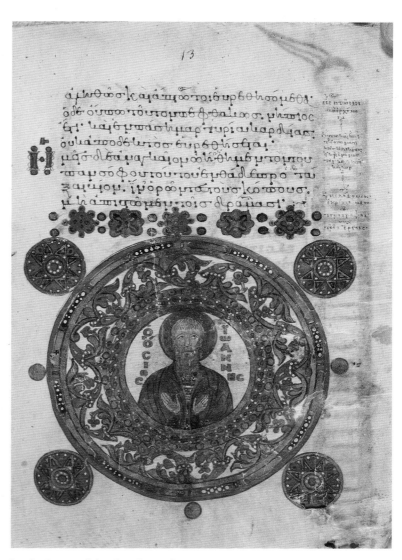

b. Cod. 417, fol. 13r. John Climacus (cf. fig. 32)

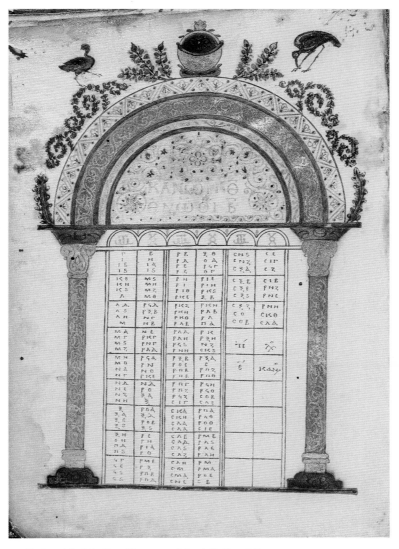

c. Cod. 166, fol. 3v. Canon table (cf. fig. 46)

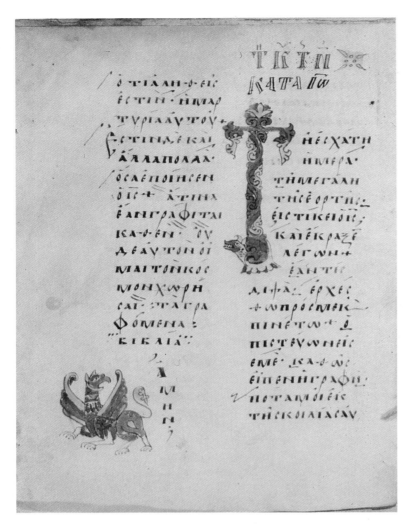

a. Cod. 213, fol. 73v. Initial T (cf. fig. 69)

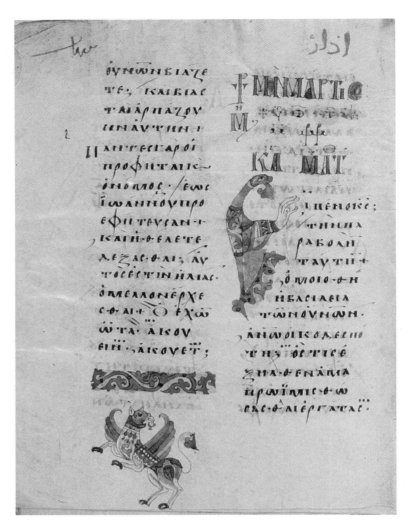

b. Cod. 213, fol. 312v. Tailpiece and initial Є (cf. fig. 79)

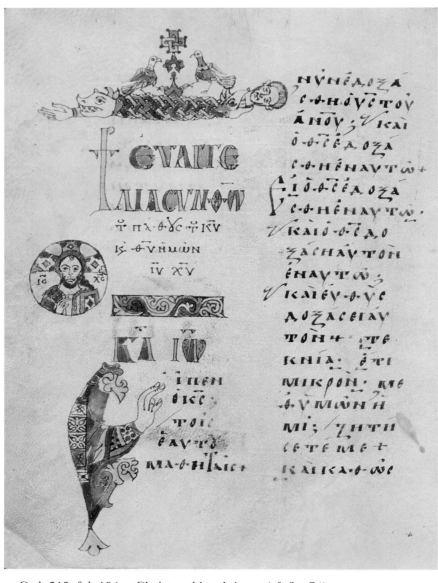

c. Cod. 213, fol. 196v. Christ and headpieces (cf. fig. 74)

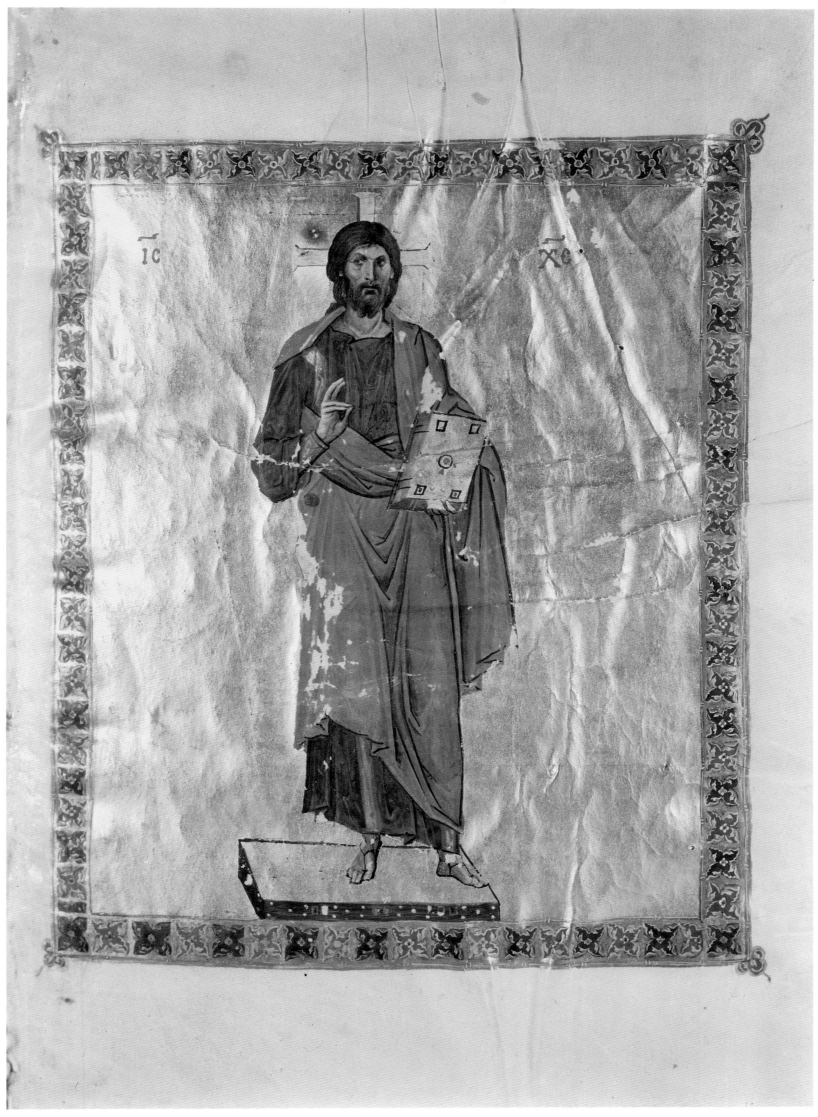

Cod. 204, p. 1. Christ (cf. fig. 93)

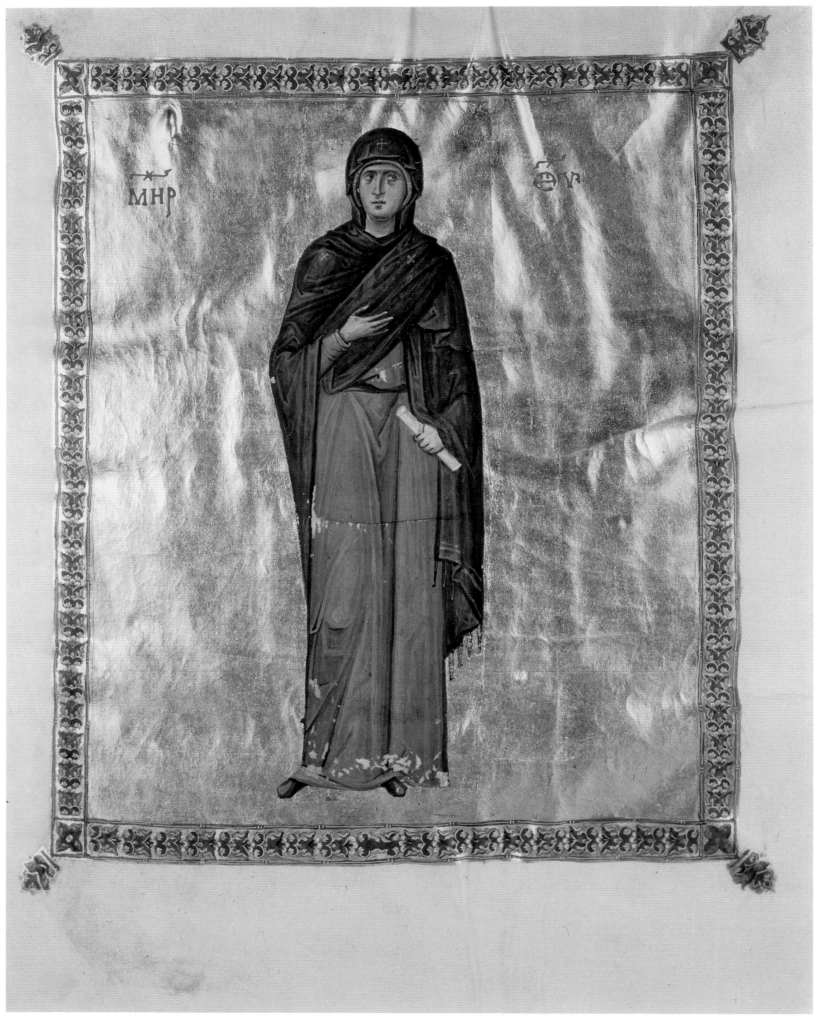

Cod. 204, p. 3. The Mother of God (cf. fig. 94)

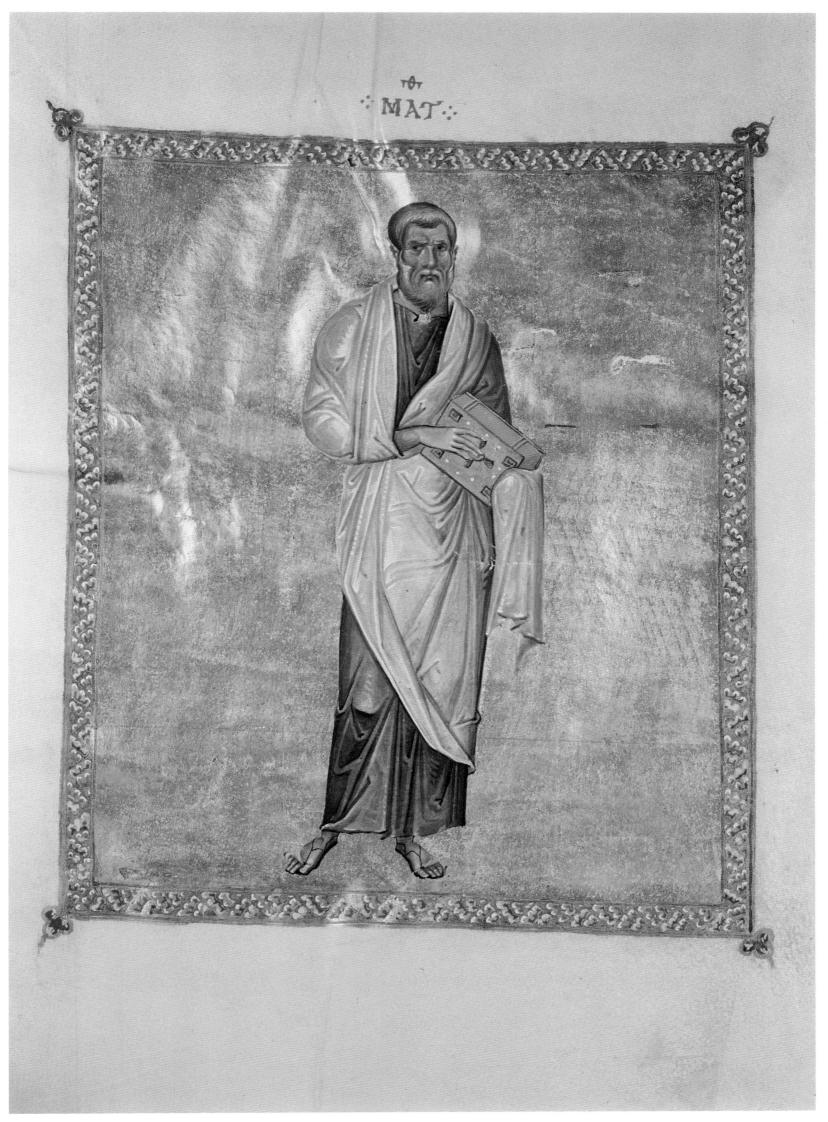

Cod. 204, p. 8. Matthew (cf. fig. 96)

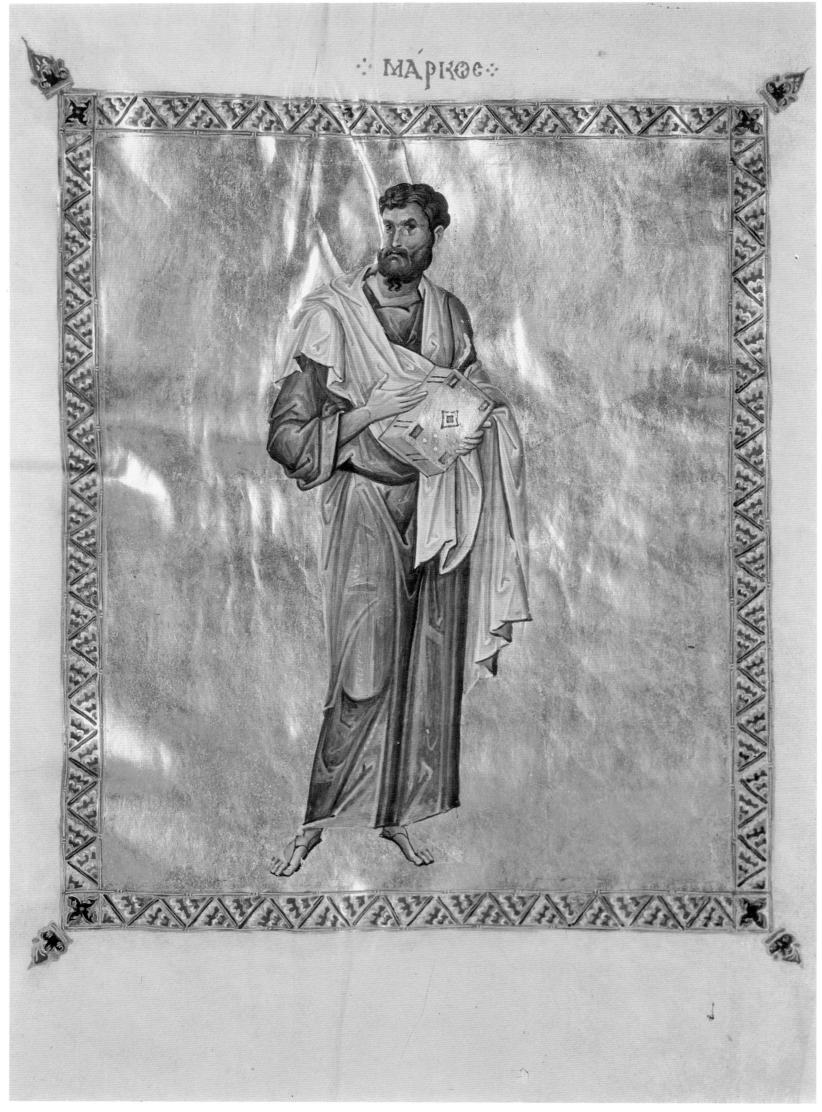

∴ΜΆΡΚΟϹ∴

Cod. 204, p. 10. Mark (cf. fig. 97)

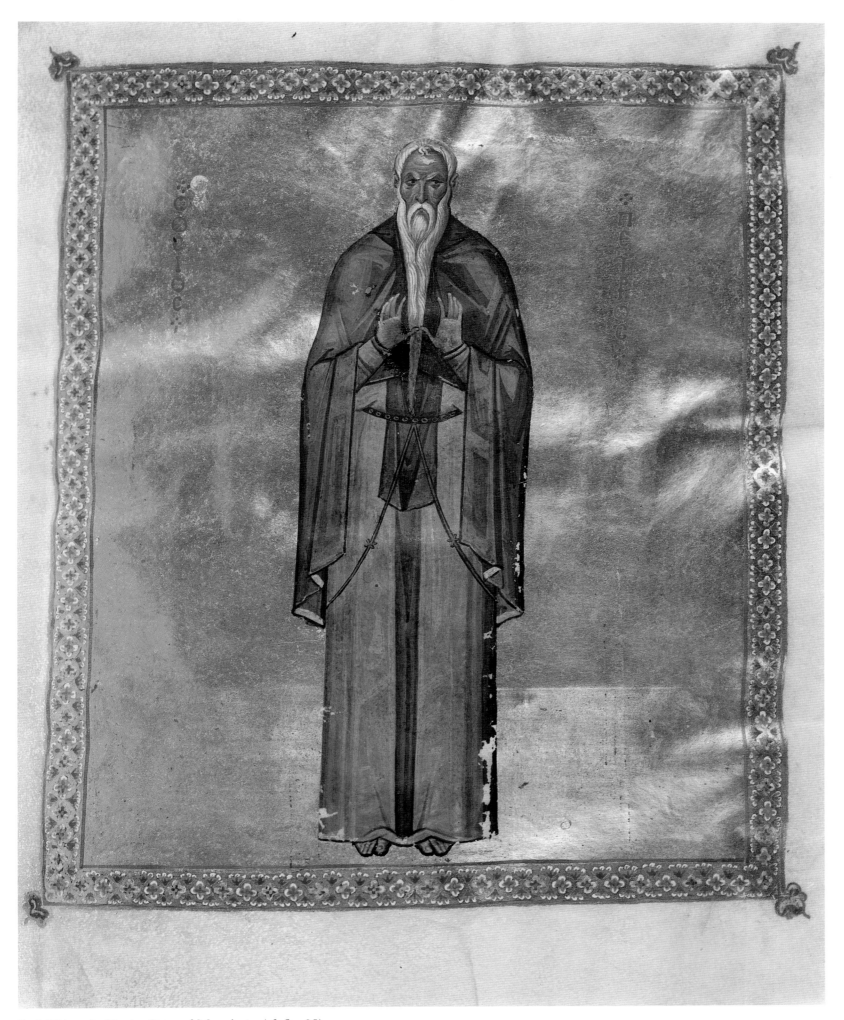

Cod. 204, p. 5. Hosios Peter of Monobata (cf. fig. 95)

Cod. 204, p. 15. Headpiece (cf. fig. 100)

a. Cod. 1186, fol. 66v. The world and Paradise (cf. fig. 136)

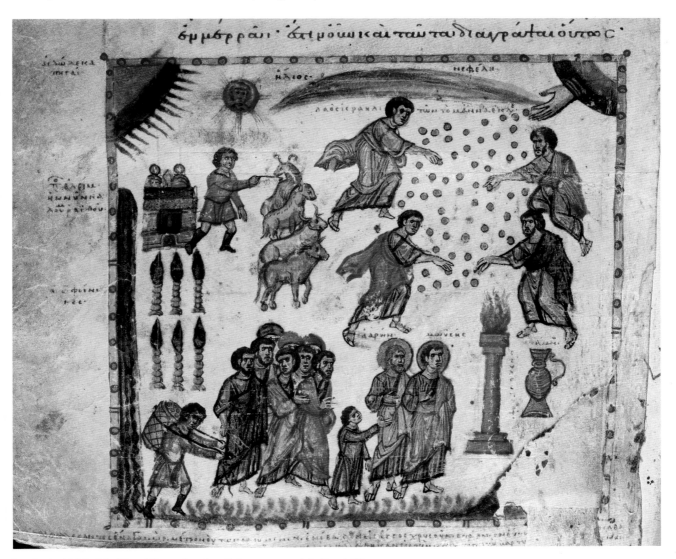

b. Cod. 1186, fol. 73v. The miracle of the manna (cf. fig. 142)

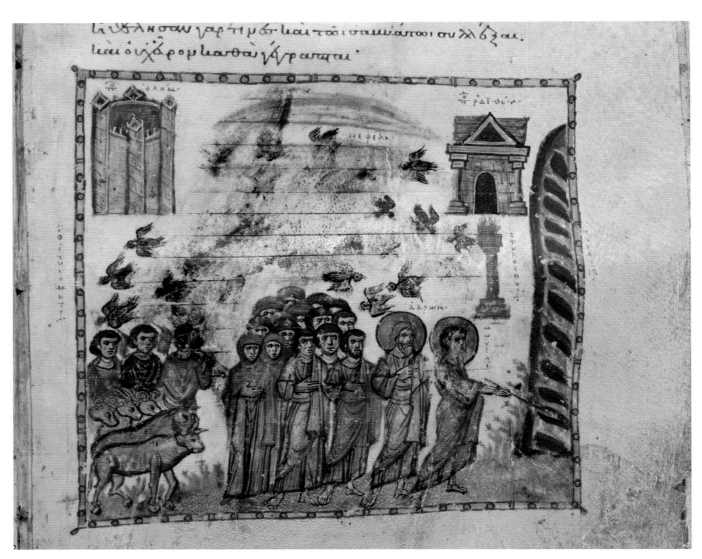

a. Cod. 1186, fol. 74r. The smiting of the rock (cf. fig. 143)

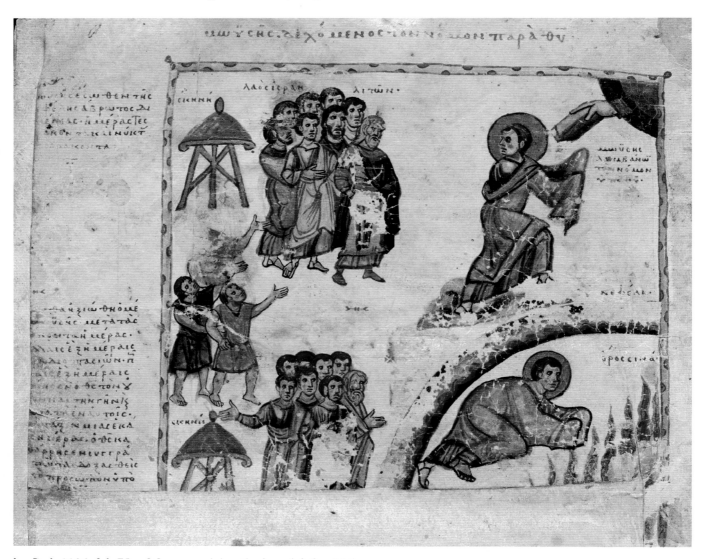

b. Cod. 1186, fol. 75v. Moses receiving the law (cf. fig. 144)

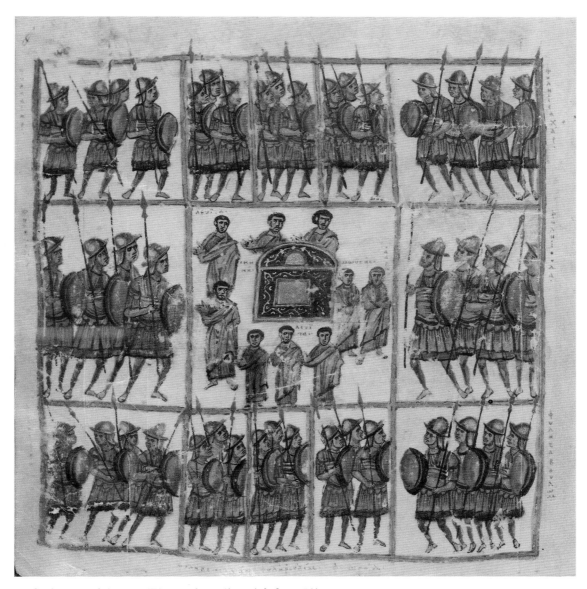

a. Cod. 1186, fol. 86v. The twelve tribes (cf. fig. 152)

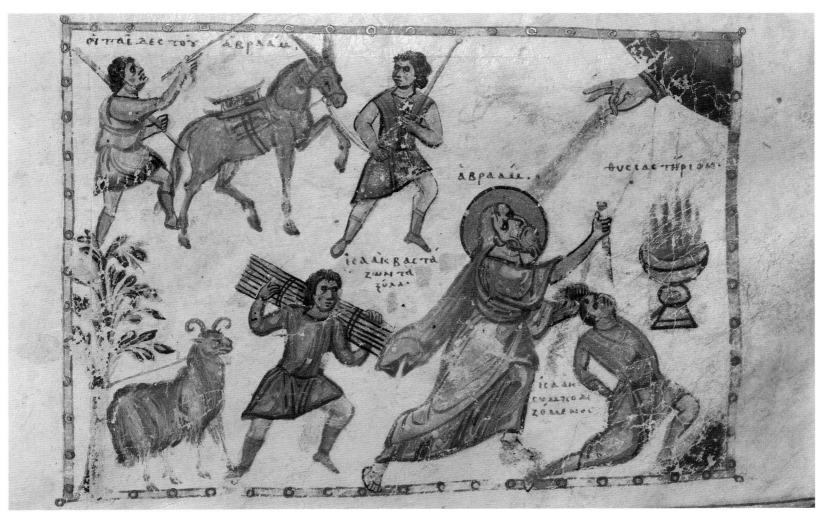

b. Cod. 1186, fol. 98r. The sacrifice of Isaac (cf. fig. 160)

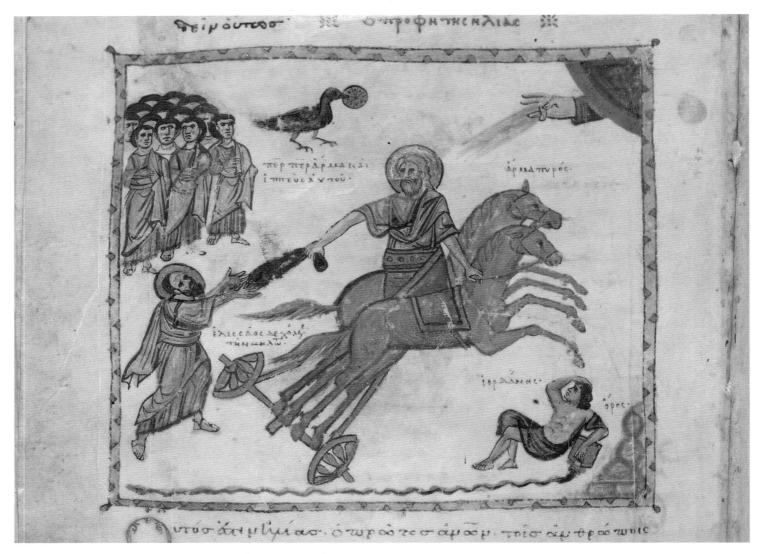

a. Cod. 1186, fol. 107v. Elijah's ascension (cf. fig. 164)

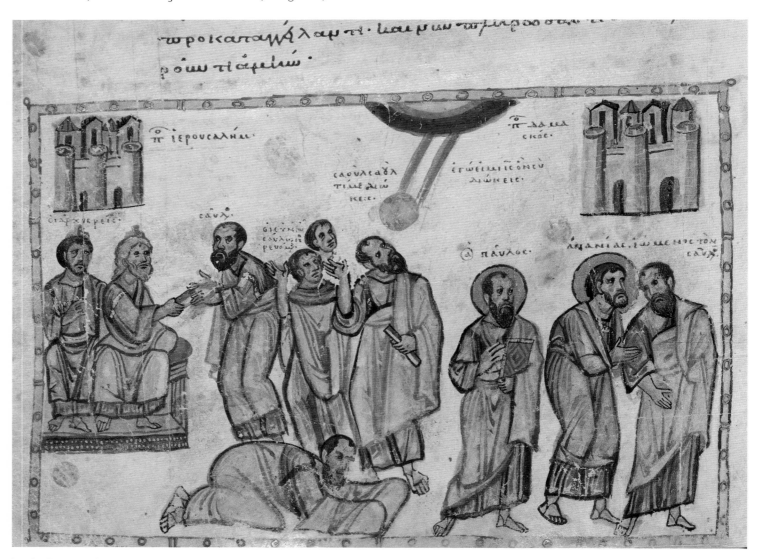

b. Cod. 1186, fol. 126v. The conversion of Paul (cf. fig. 168)

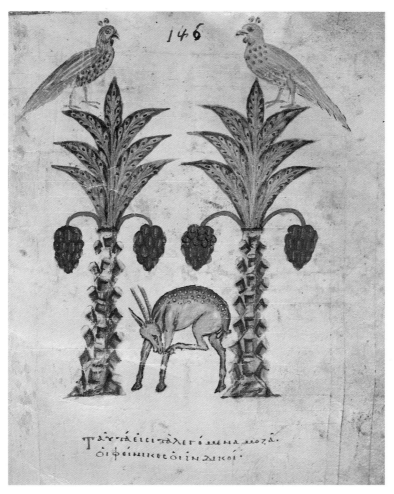

a. Cod. 1186, fol. 146r. Gazelle and palm trees (cf. fig. 172)

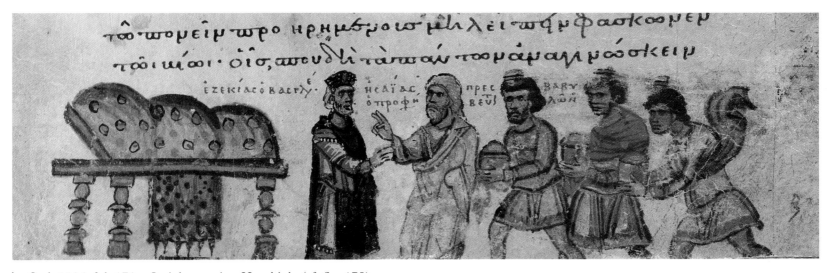

b. Cod. 1186, fol. 171r. Isaiah warning Hezekiah (cf. fig. 175)

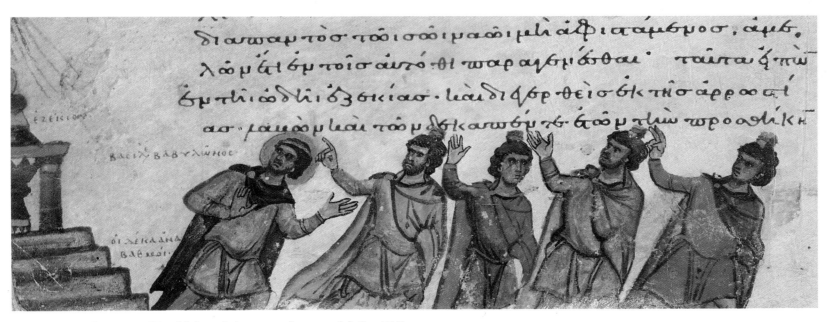

c. Cod. 1186, fol. 174v. Hezekiah and the retreating sun (cf. fig. 176)

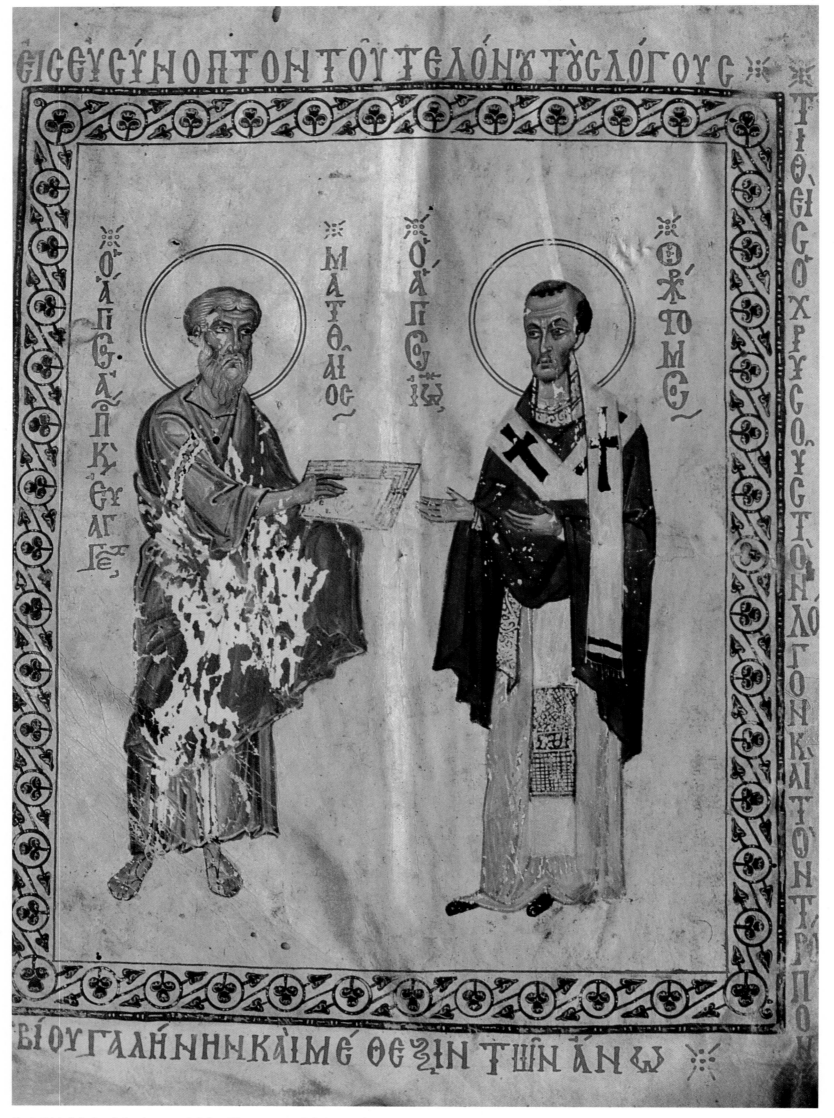

Cod. 364, fol. 2v. Matthew and John Chrysostom (cf. fig. 184)

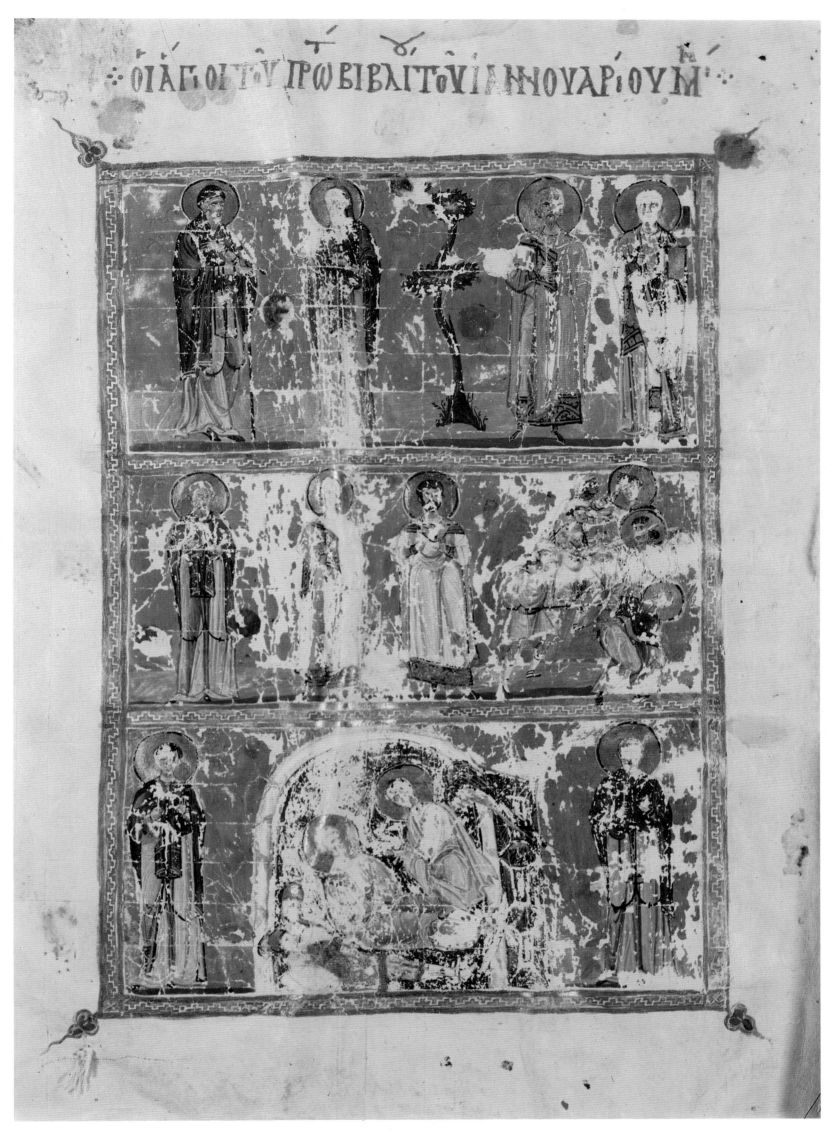

Cod. 512, fol. 2v. Saints of the first half of January (cf. fig. 198)

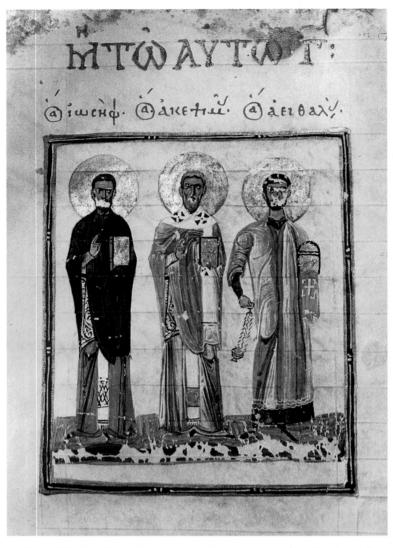

a. Cod. 500, fol. 25v. Sts. Joseph, Akepsimas, and Aeithalas (cf. fig. 202)

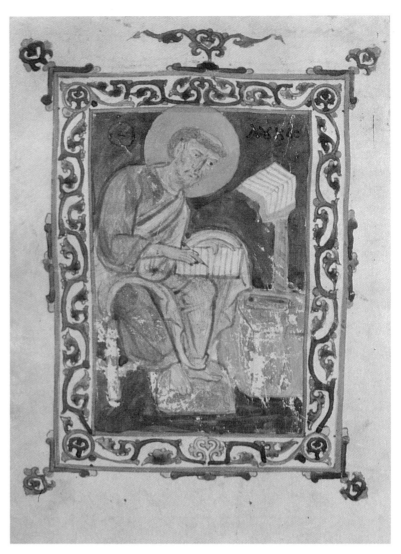

b. Cod. 172, fol. 104v. Luke (cf. fig. 229)

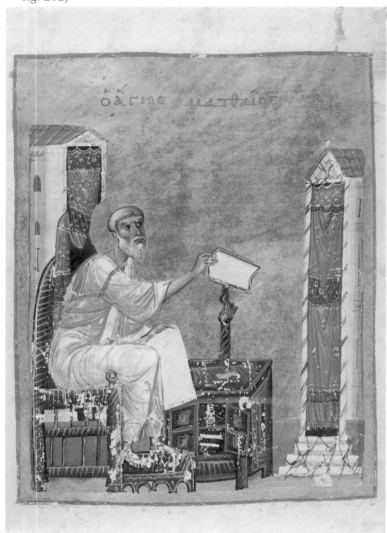

c. Cod. 205, fol. 45v. Matthew (cf. fig. 279)

d. Cod. 205, fol. 114r. Headpiece (cf. fig. 282)

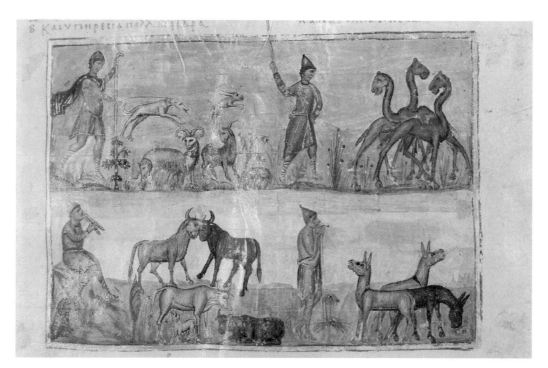

a. Cod. 3, fol. 8r. Job's herds (cf. fig. 300)

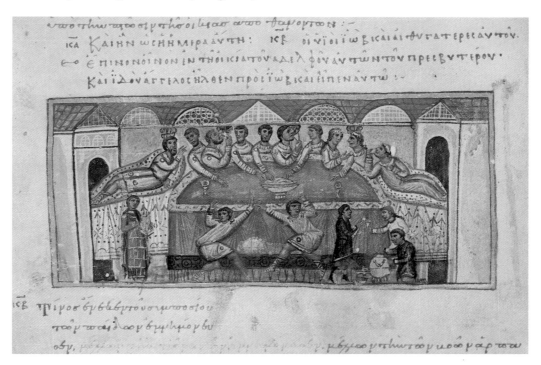

b. Cod. 3, fol. 17v. Job's children at the banquet (cf. fig. 307)

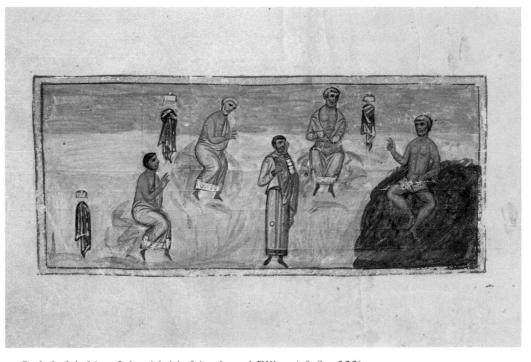

c. Cod. 3, fol. 30v. Job with his friends and Elihu (cf. fig. 322)

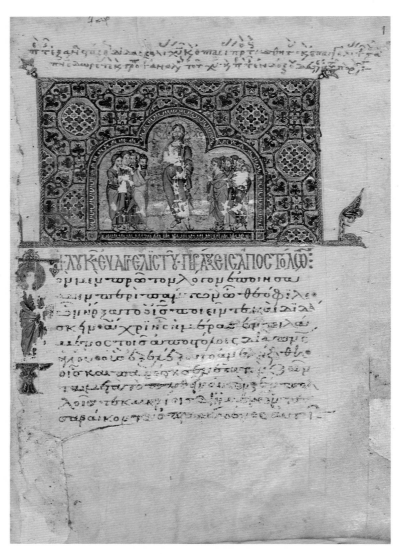

a. Cod. 275, fol. 1r. The Mission of the Apostles (cf. fig. 341)

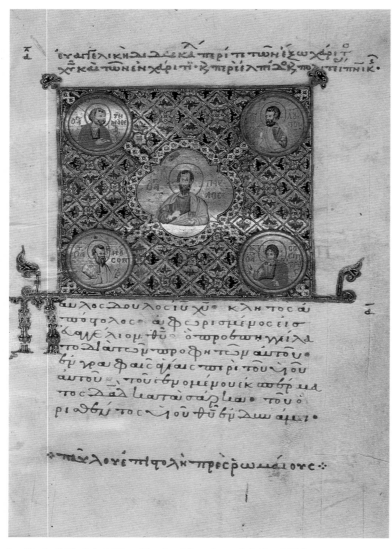

b. Cod. 275, fol. 139r. Paul with saints (cf. fig. 358)

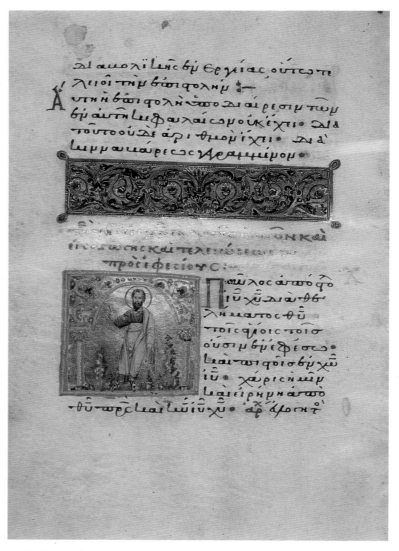

c. Cod. 275, fol. 254v. Paul (cf. fig. 367)

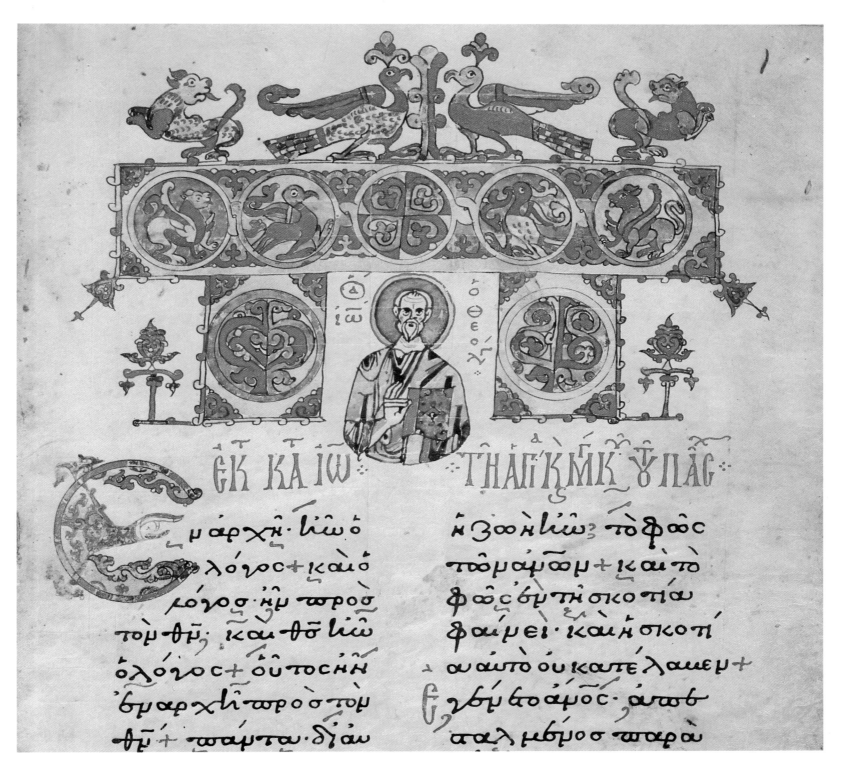

a. Cod. 207, fol. 1r. John (cf. fig. 392)

b. Cod. 508, fol. 66v. Headpiece, initial A with
emperor Trajan (cf. fig. 399)

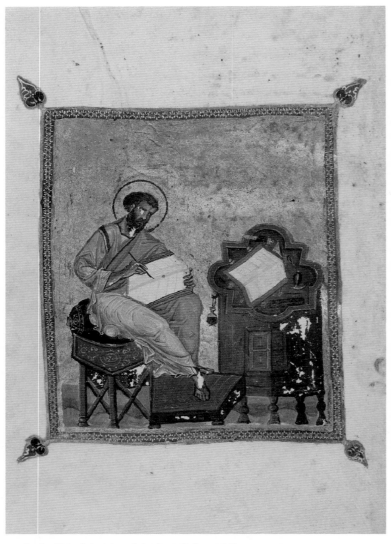

a. Cod. 179, fol. 84v. Mark (cf. fig. 432)

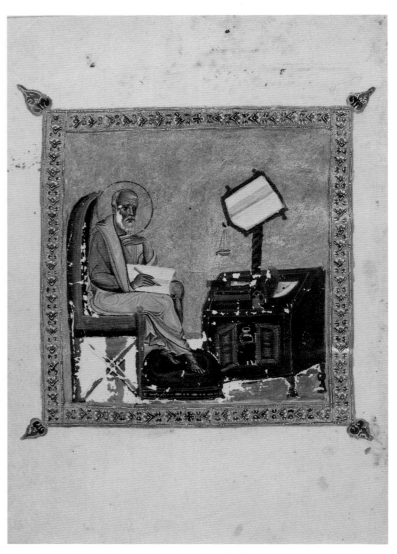

b. Cod. 179, fol. 209v. John (cf. fig.434)

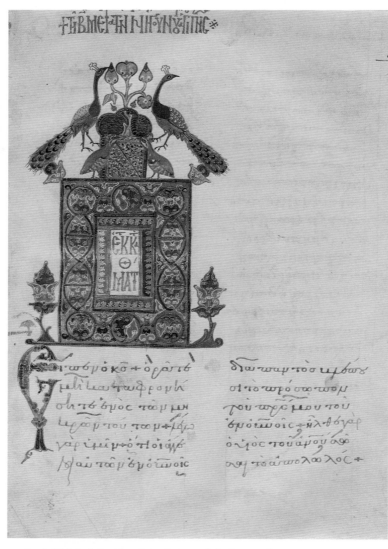

c. Cod. 2090, fol. 40r. Headpiece (cf. fig. 440)

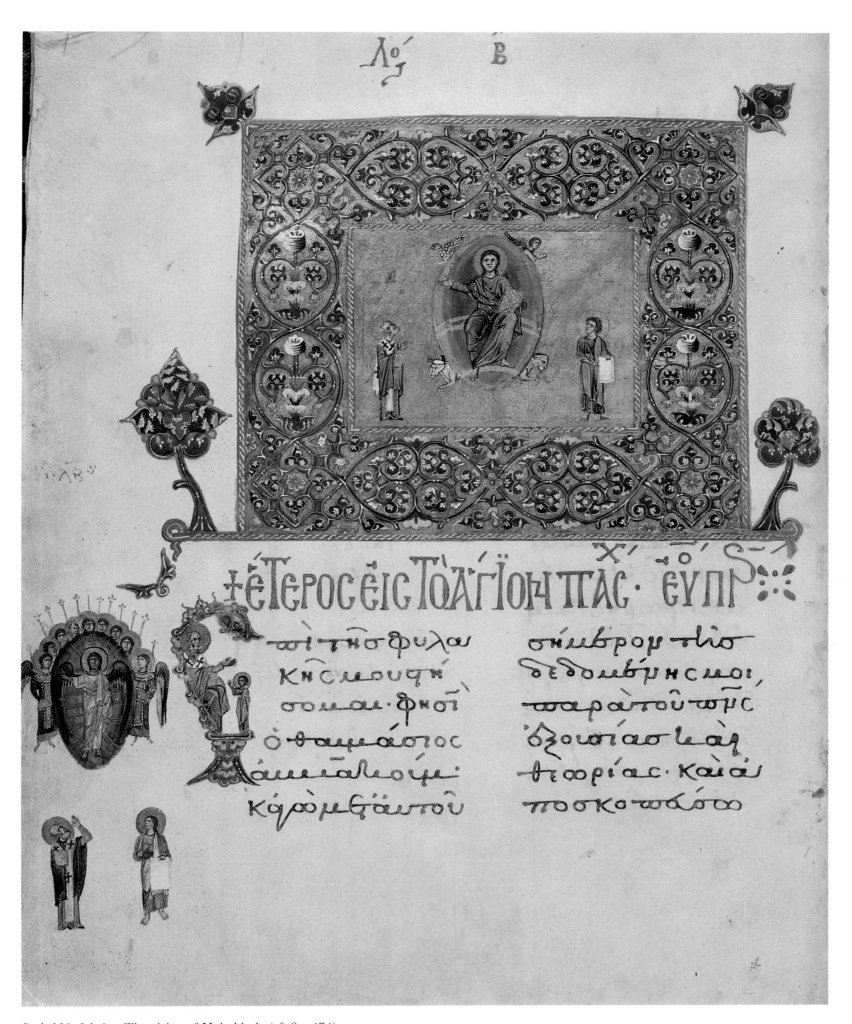

Cod. 339, fol. 9v. The vision of Habakkuk (cf. fig. 474)

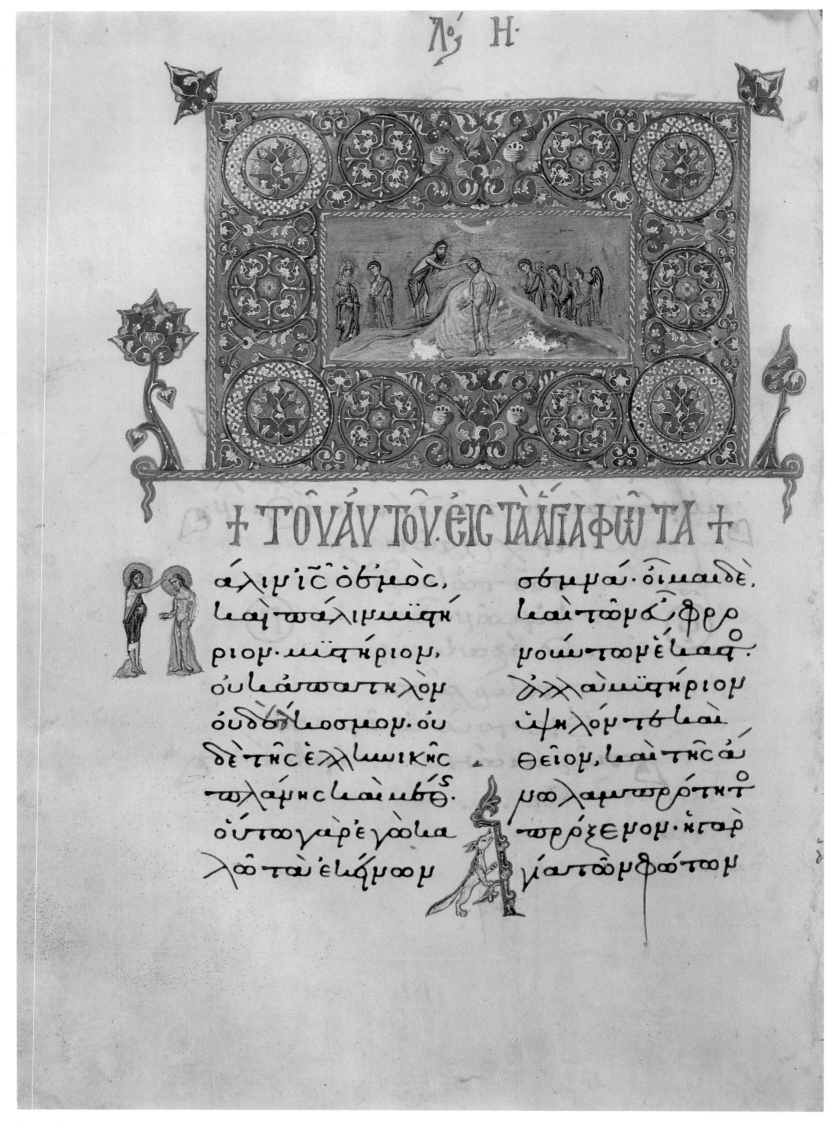

Cod. 339, fol. 197v. Baptism of Christ (cf. fig. 482)

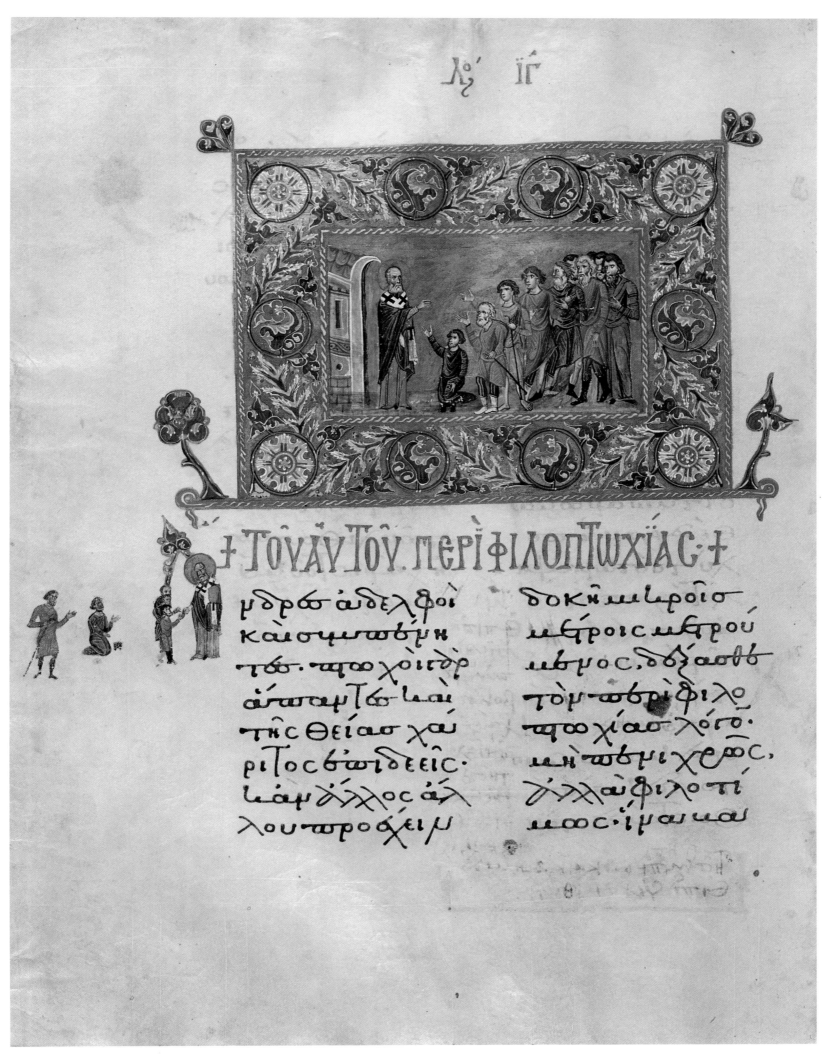

Λό ΙΓ

† ΤΟΥ ΑΥΤΟΥ ΠΕΡΙ ΦΙΛΟΠΤΩΧΙΑΣ †

Cod. 339, fol. 341v. Gregory and the poor (cf. fig. 484)

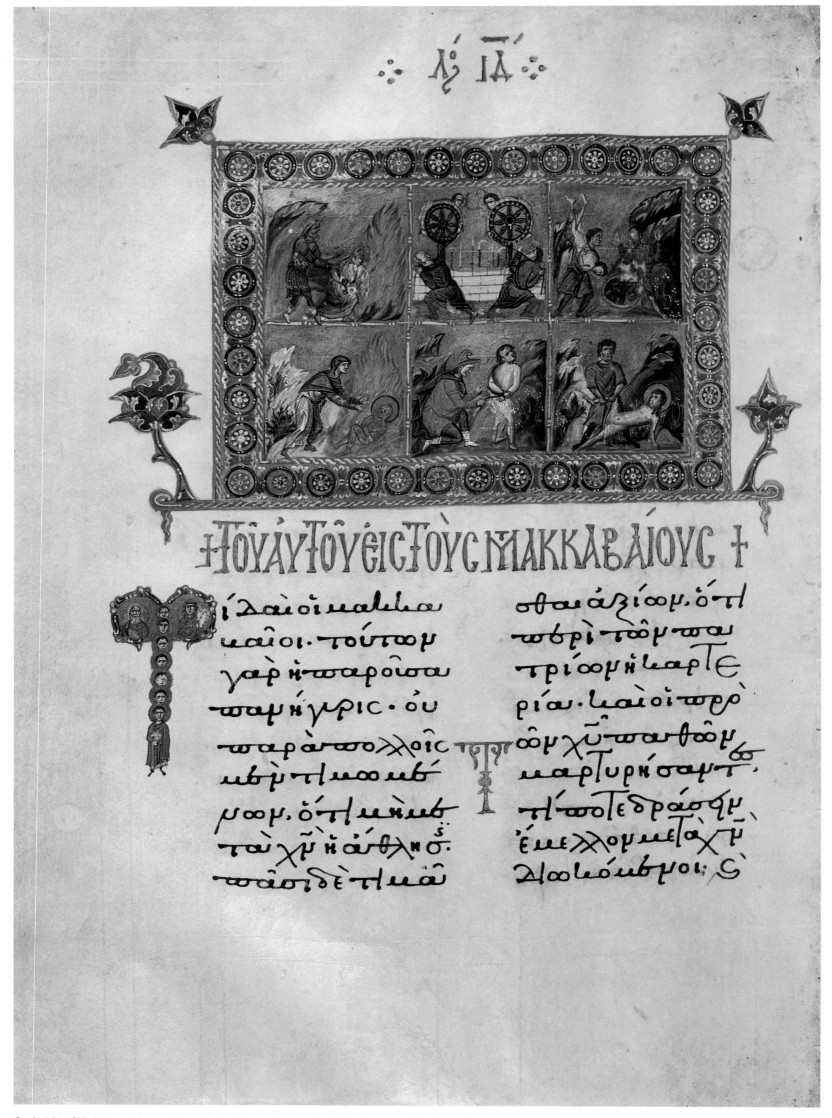

Cod. 339, fol. 381v. Martyrdom of the Maccabees, initial T, Eleazar (cf. fig. 485)

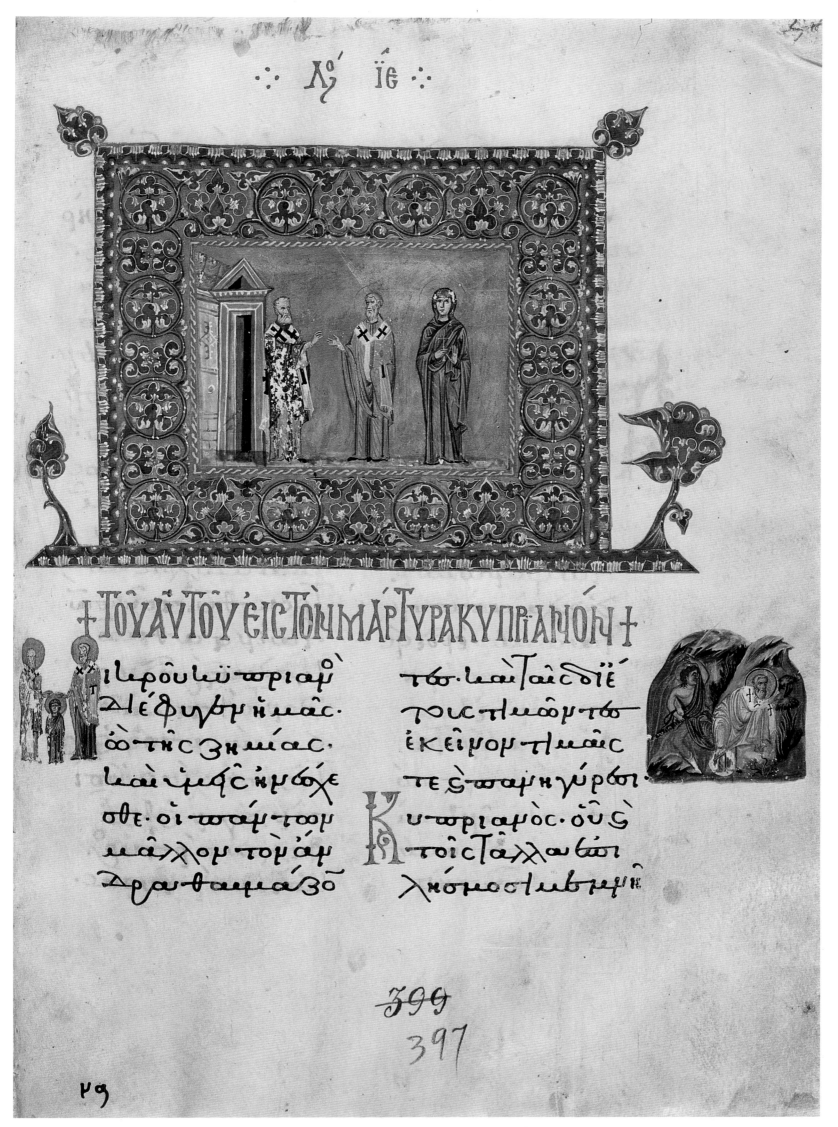

† ΤΟΥ ΑΥΤΟΥ ΕΙС ΤΟΝ ΜΑΡΤΥΡΑ ΚΥΠΡΙΑΝΟΝ †

ἱεροῦ κωπορίαυ
Δ͂ ἐ φυΓη ἡμᾶс.
ὡ τῆс 3ημίαс.
ἰ ὰ ι ἡμᾶс ἐμβόχε
οθε. οἱ πάντομ
μᾶλλον τὸν ἄμ
Δρα θαυμαζ̓ο

τῶ. ιὰι Ταῖс διε
τοιс πμ ῶρ τῶ
ἐκ ε̂ιμορ ἡμᾶс
τε ὡ παμη γύρ ω
Κυπριαμὸс. οὐ ὅ
τοῖс Ταλλω ωι
λ ημω σ πομρηκ̂

399
397

ـ

Cod. 339, fol. 397r. Gregory with Cyprian and Justina, Cyprian's martyrdom (cf. fig. 486)

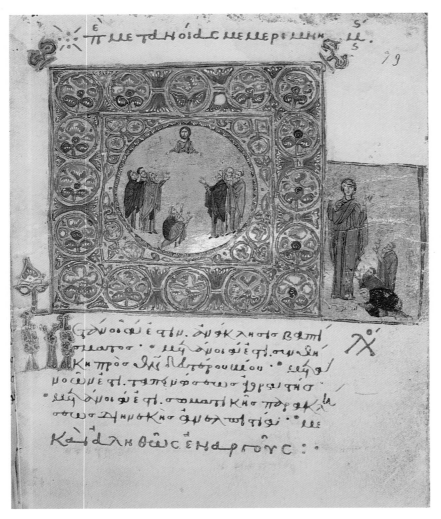

a. Cod. 418, fol. 79r. Monks praying to Christ and the Virgin (cf. fig. 600)

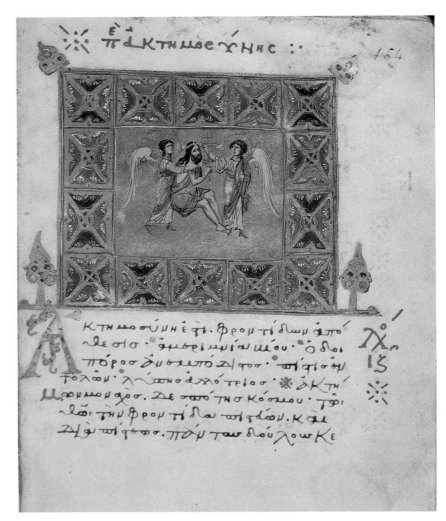

b. Cod. 418, fol. 164r. Poor man attended by angels (cf. fig. 613)

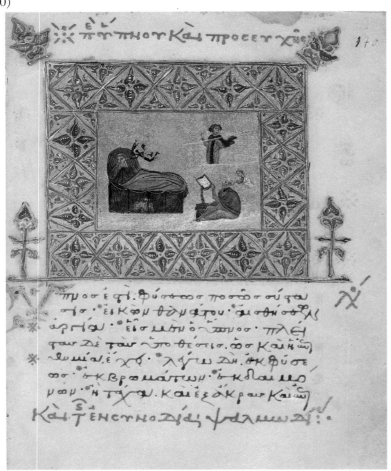

c. Cod. 418, fol. 170r. Sleeping, praying, and singing monks (cf. fig. 615)

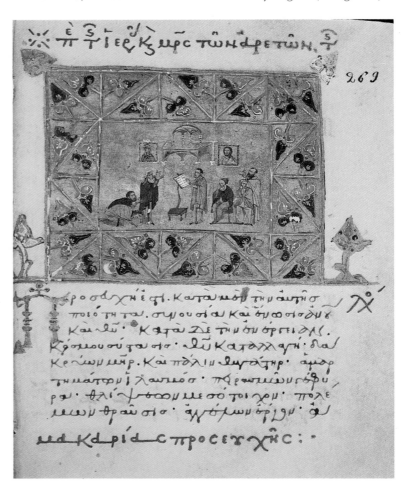

d. Cod. 418, fol. 269r. Monks praying (cf. fig. 628)

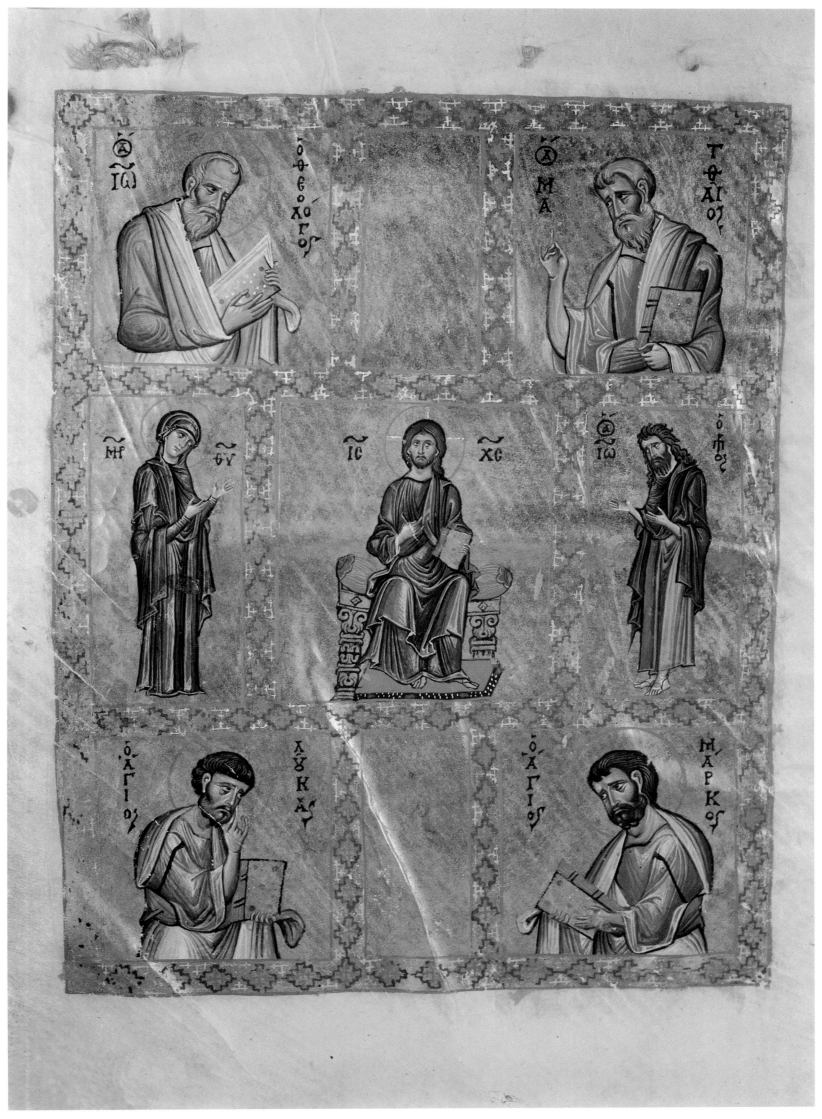

Cod. 208, fol. 1v. Deesis with evangelists (cf. fig. 647)

a. Cod. 221, fol. 1r. Christ and evangelists (cf. fig. 665)

b. Cod. 153, fol. 10r. Headpiece (cf. fig. 671)

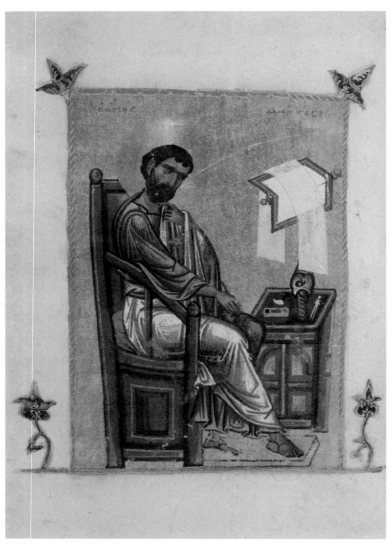

c. Cod. 153, fol. 124v. Mark (cf. fig. 672)

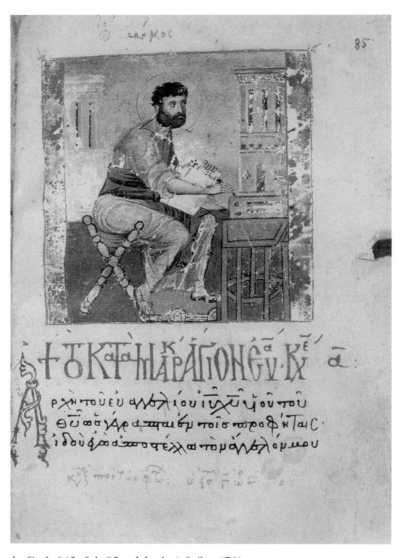

d. Cod. 163, fol. 85r. Mark (cf. fig. 678)

PLATE XXIX

1. Cod. 30, fol. 56r

3. Cod. 30, fol. 403v. Tailpiece

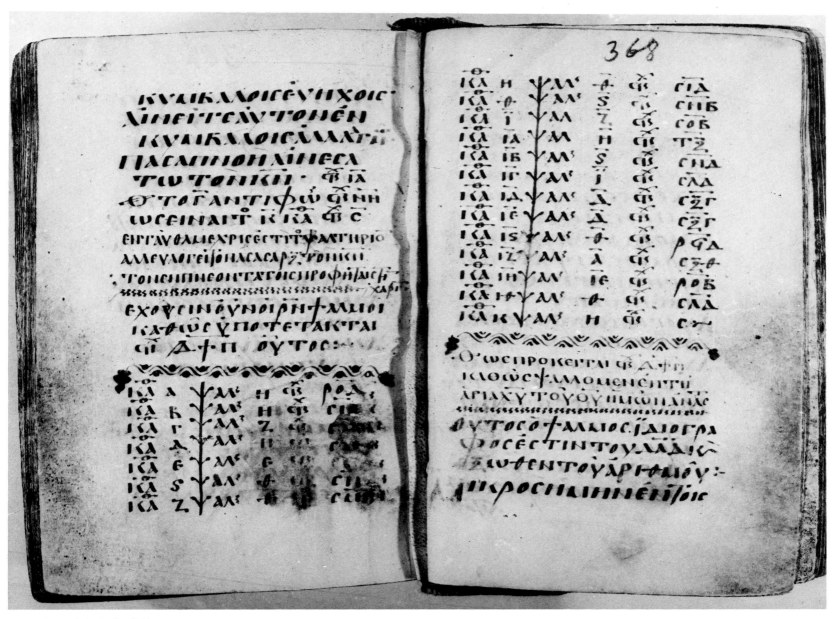

2. Cod. 30, fols. 367v–368r

PLATE XXX

4. Cod. 32, fol. 3r. Headpiece

5. Cod. 32, fol. 374v

6. Cod. 32, fol. 408v. Tailpiece

7. Cod. 210, fol. 2r

8. Cod. 210, fol. 9r

9. Cod. 210, fol. 64r. Headpiece

10. Cod. 210, fol. 95r

PLATE XXXI

11. Cod. (210) NE MΓ 12. Colophon

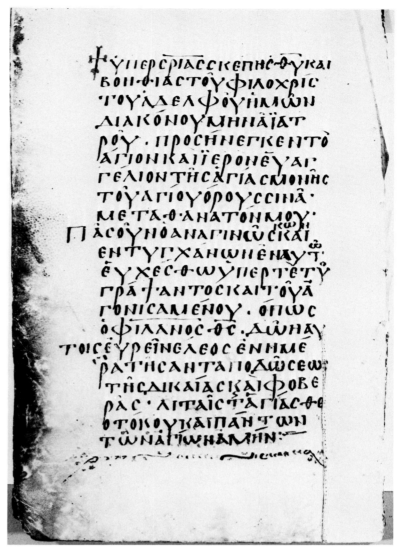

12. Cod. 210, fol. 63v

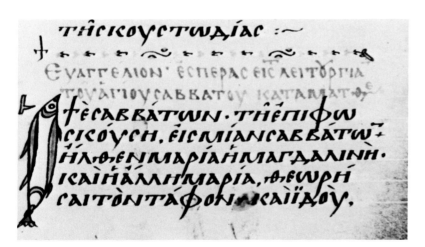

13. Cod. 211, fol. 189r. Initial O

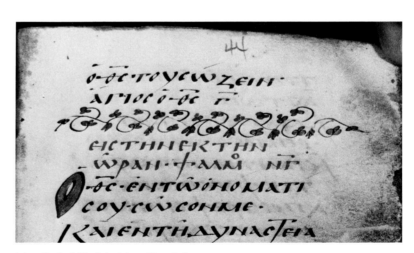

14. Cod. 863, fol. 44r. Headpiece

PLATE XXXII

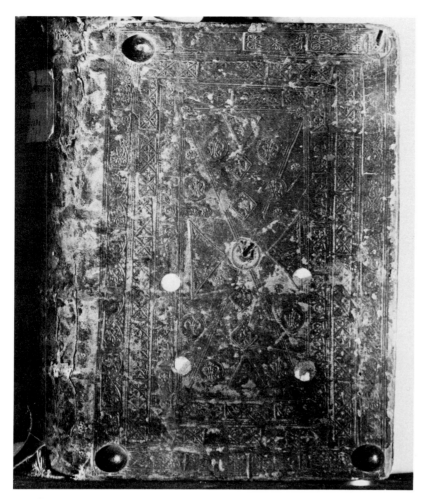

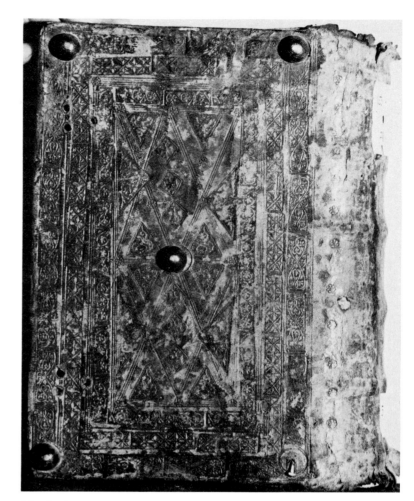

15. Cod. 375, front cover

16. Cod. 375, back cover

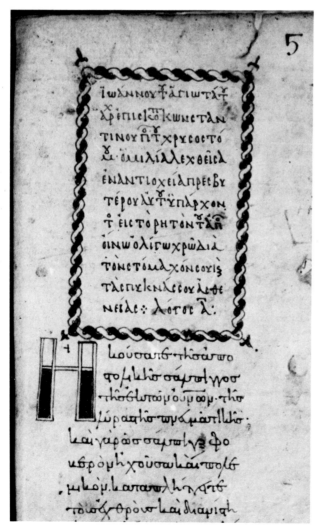

17. Cod. 375, fol. 5r. Headpiece

18. Cod. 1112, fol. 4v. Cross page

PLATE XXXIII

19. Cod. 1112, fol. 5r. Headpiece

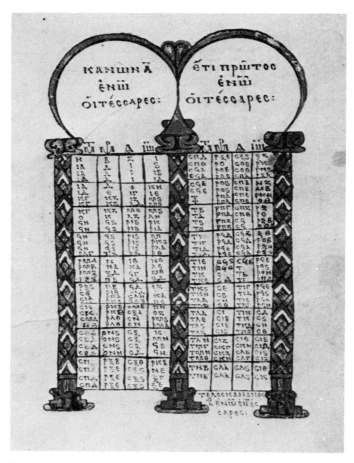

21. Cod. Leningrad 220, fol. 3r. Canon table

20. Cod. 1112, fol. 173v. Headpiece

22. Cod. Leningrad 220, fol. 10r. Headpiece

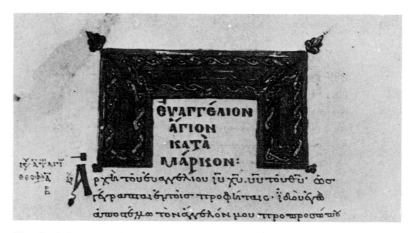

23. Cod. Leningrad 220, fol. 68r. Headpiece

24. Cod. 283, fol. 5r. Headpiece

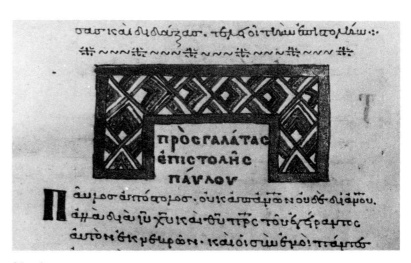

25. Cod. 283, fol. 169r. Headpiece

PLATE XXXIV

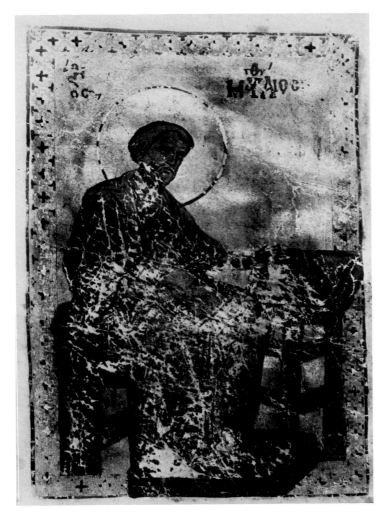

26. Cod. Leningrad 220, fol. 9v. Matthew

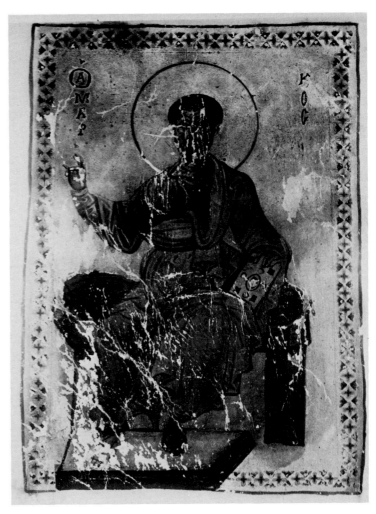

27. Cod. Leningrad 220, fol. 67v. Mark

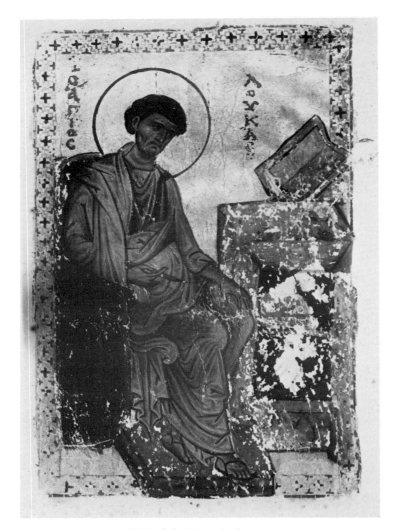

28. Cod. Leningrad 220, fol. 106v. Luke

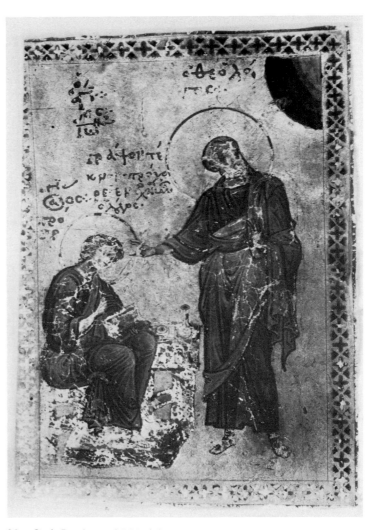

29. Cod. Leningrad 220, fol. 168v. John and Prochoros

PLATE XXXV

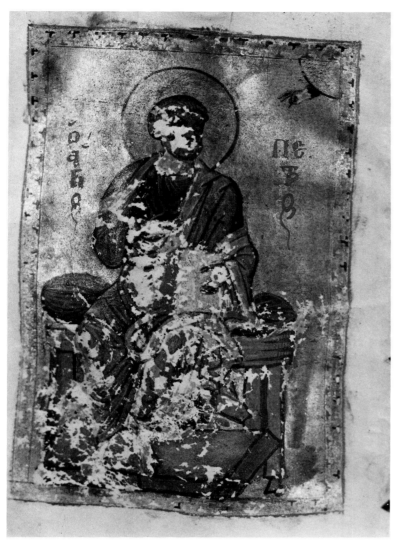

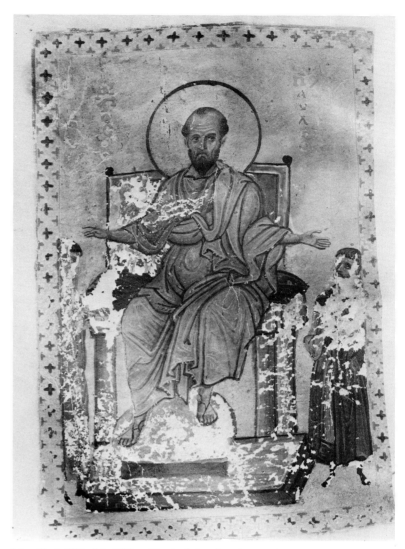

30. Cod. 283, fol. 72v. Peter

31. Cod. 283, fol. 107v. Paul (cf. colorplate ı:a)

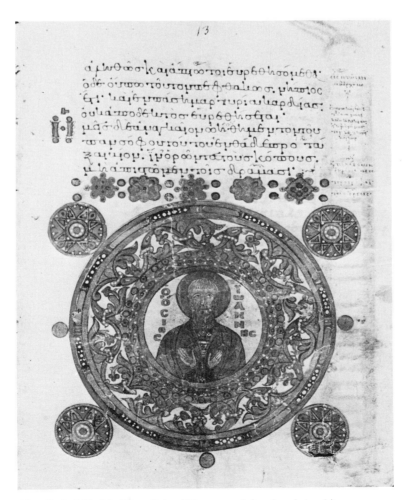

32. Cod. 417, fol. 13r. John Climacus (cf. colorplate ı:b)

PLATE XXXVI

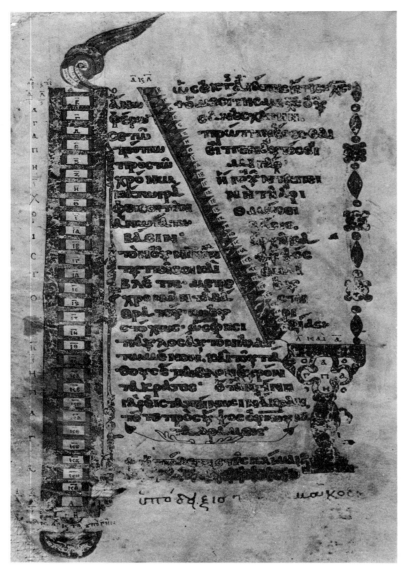

33. Cod. 417, fol. 13v. The heavenly ladder

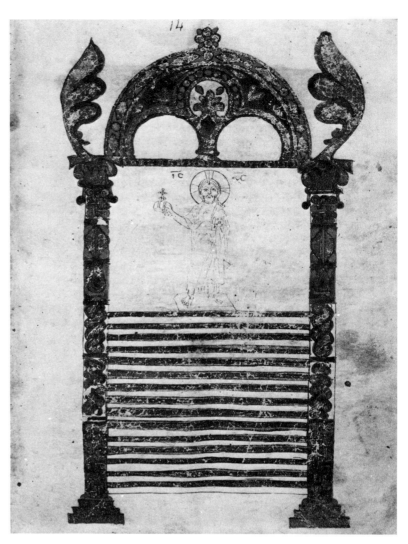

34. Cod. 417, fol. 14r. Christ

35. Cod. 417, fol. 4r. Headpieces

36. Cod. 417, fol. 11r. Tailpiece

37. Cod. 417, fol. 19v. Headpieces

38. Cod. 417, fol. 27r. Headpiece

PLATE XXXVII

39. Cod. 417, fol. 89v. Headpieces

40. Cod. 417, fol. 148r. Headpieces

41. Cod. 417, fol. 209r. Headpiece

42. Cod. 417, fol. 229v. Headpiece

43. Cod. 417, fol. 235r. Headpieces

44. Cod. 417, fol. 254v. Tailpiece

PLATE XXXVIII

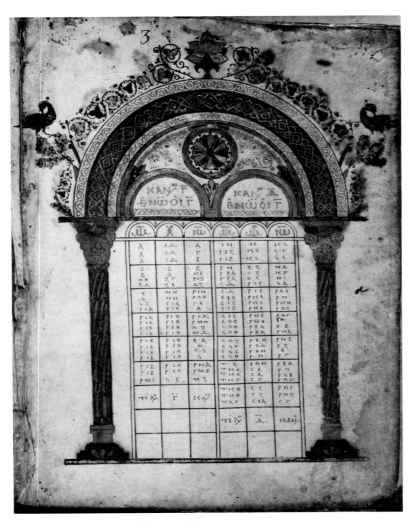

45. Cod. 166, fol. 3r. Canon table

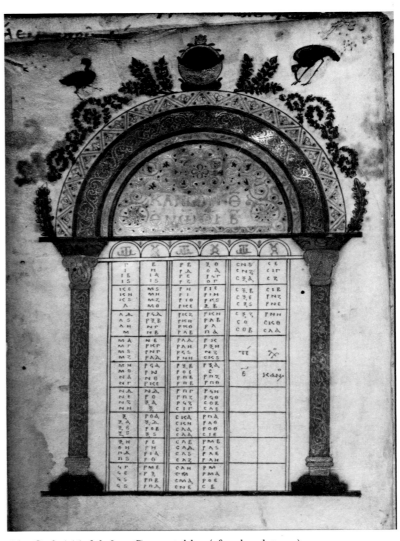

46. Cod. 166, fol. 3v. Canon table (cf. colorplate I:c)

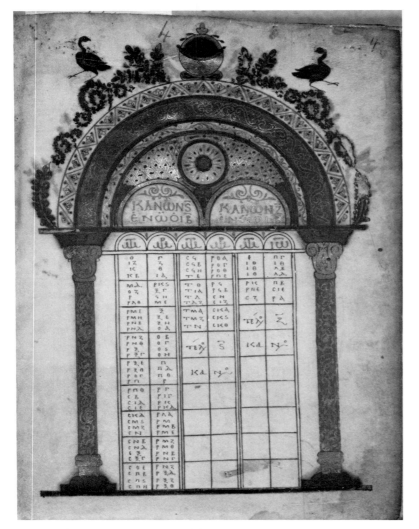

47. Cod. 166, fol. 4r. Canon table

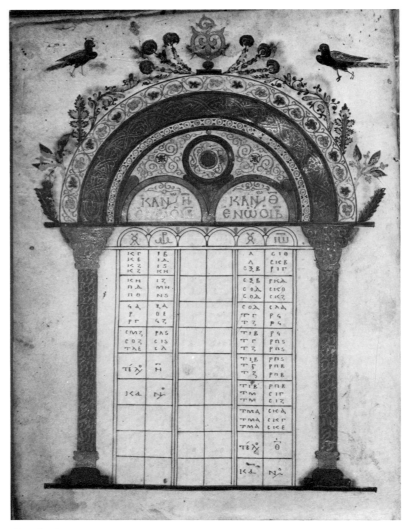

48. Cod. 166, fol. 4v. Canon table

PLATE XXXIX

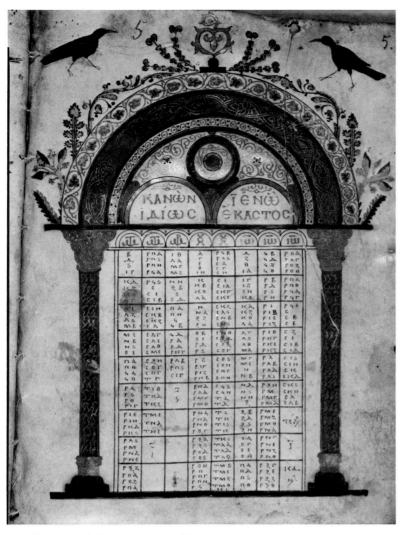

49. Cod. 166, fol. 5r. Canon table

50. Cod. 166, fol. 6v. Matthew

51. Cod. 166, fol. 96v. Luke

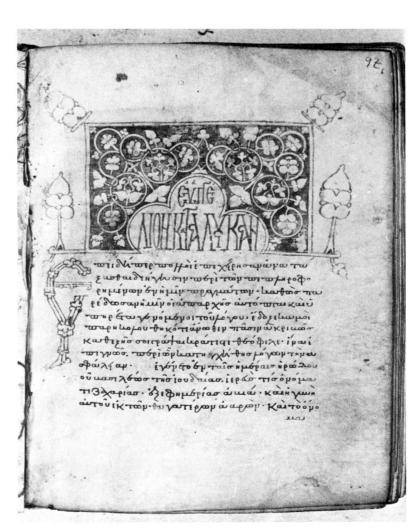

52. Cod. 166, fol. 97r. Headpiece

PLATE XL

53. Cod. 166, front cover

54. Cod. 166, back cover

55. No. 956, section I

56. No. 956, section II

57. Cod. 183, fol. 28r. Headpiece

58. Cod. 183, fol. 84r. Headpiece

59. Cod. 734, fol. 3r. Headpiece

PLATE XLI

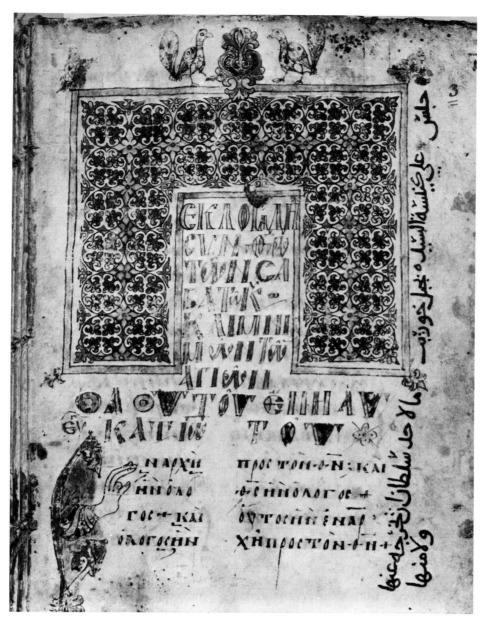

60. Cod. 213, fol. 3r. Headpiece

61. Cod. 213, fol. 8v. Initial T

62. Cod. 213, fol. 14r.
Initial O

63. Cod. 213, fol. 19v. Initial Є

PLATE XLII

64. Cod. 213, fol. 21v.
Initial T

65. Cod. 213, fol. 27r.
Initial Є

66. Cod. 213, fol. 28v.
Initial Є

70. Cod. 213, fol. 75v. Initial Є

67. Cod. 213, fol. 58v.
Initial Є

68. Cod. 213, fol. 68r.
Initial Є

69. Cod. 213, fol. 73v. Initial T (cf. colorplate II:a)

71. Cod. 213, fol. 77r. Headpiece

PLATE XLIII

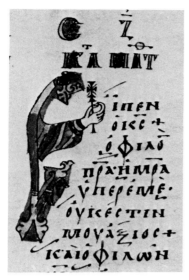

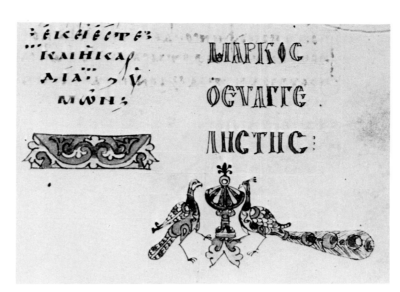

72. Cod. 213, fol. 90r. Initial Є 73. Cod. 213, fol. 164r. Tailpiece

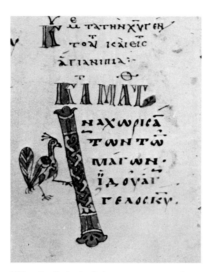

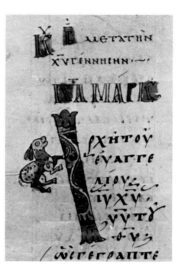

75. Cod. 213, fol. 244r. Initial O 77. Cod. 213, fol. 293v. Initial A 78. Cod. 213, fol. 299v.
Initial A

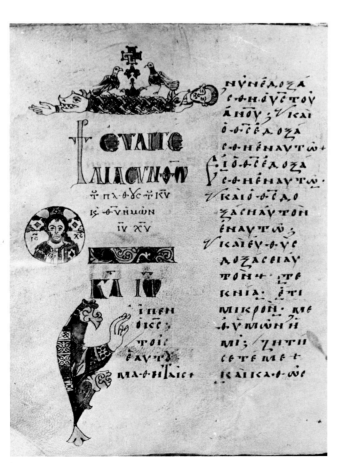

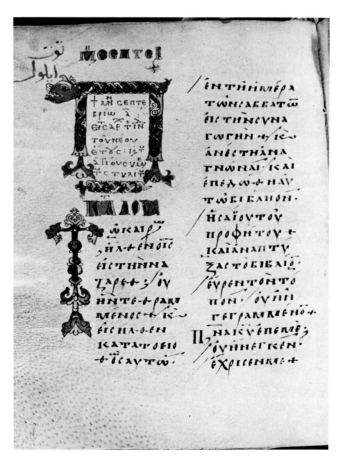

74. Cod. 213, fol. 196v. Christ and headpieces 76. Cod. 213, fol. 247v. Headpiece
(cf. colorplate II:c)

PLATE XLIV

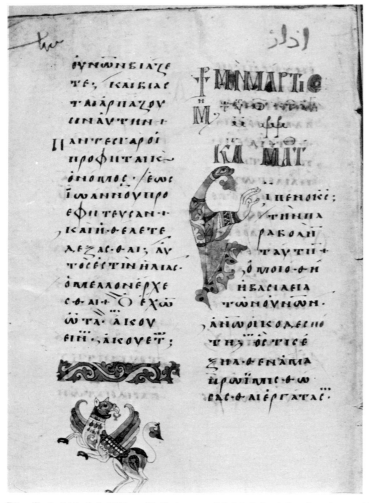

79. Cod. 213, fol. 312v. Tailpiece and initial Є (cf. colorplate II:b)

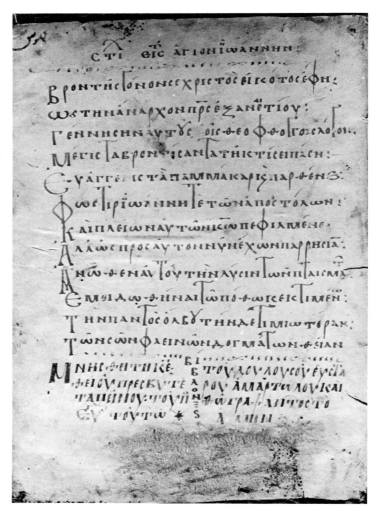

80. Cod. 213, fol. 1v. Colophon

81. Cod. 213, fol. 340v. Colophon

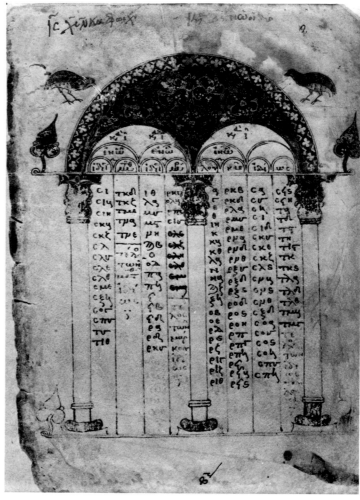

82. Cod. 213, fol. 2r. Canon table

PLATE XLV

83. Cod. 421, fol. 3v. Headpiece

87. Cod. 214, fol. 48r. Headpiece

84. Cod. 421, back cover

85. Cod. 214, fol. 1r. Headpiece

86. Cod. 214, fol. 26v. Headpiece

PLATE XLVI

88. Cod. 360, fol. 25r. Headpiece

90. Cod. 360, fol. 86v. Headpiece

91. Cod. 360, fol. 150r. Headpiece

89. Cod. 360, fol. 78r. Headpiece

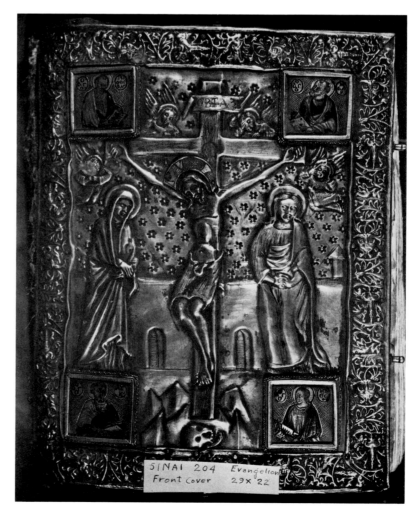

92. Cod. 204, front cover

PLATE XLVII

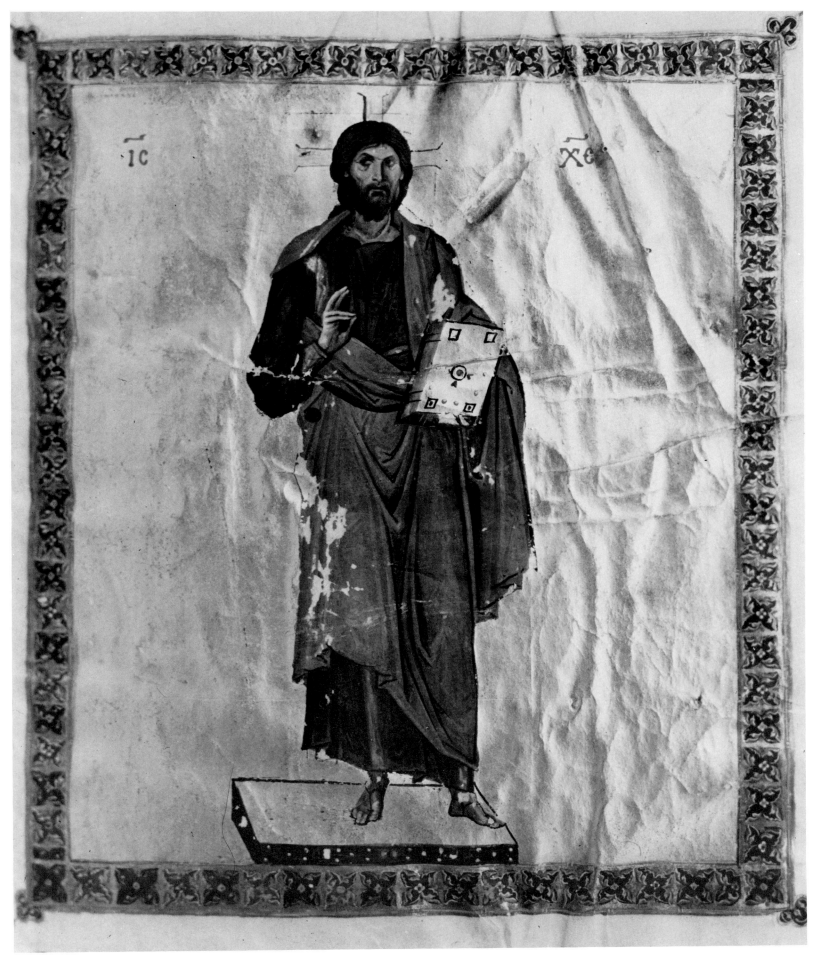

93. Cod. 204, p. 1. Christ (cf. colorplate III)

PLATE XLVIII

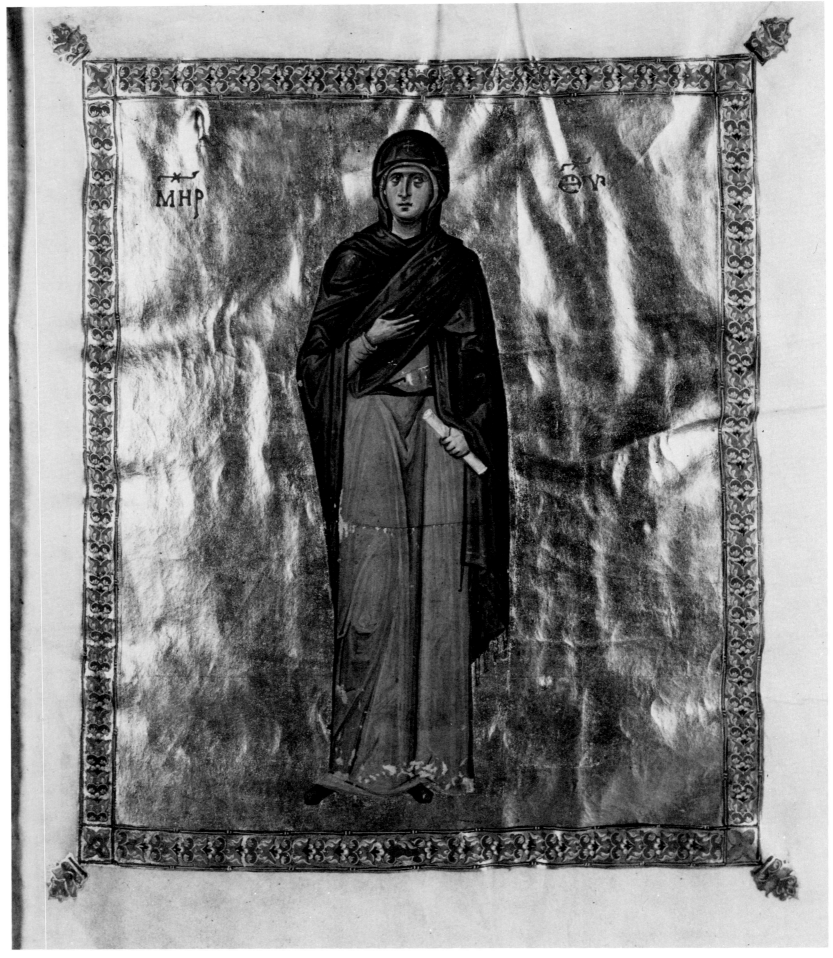

94. Cod. 204, p. 3. The Mother of God (cf. colorplate IV)

PLATE XLIX

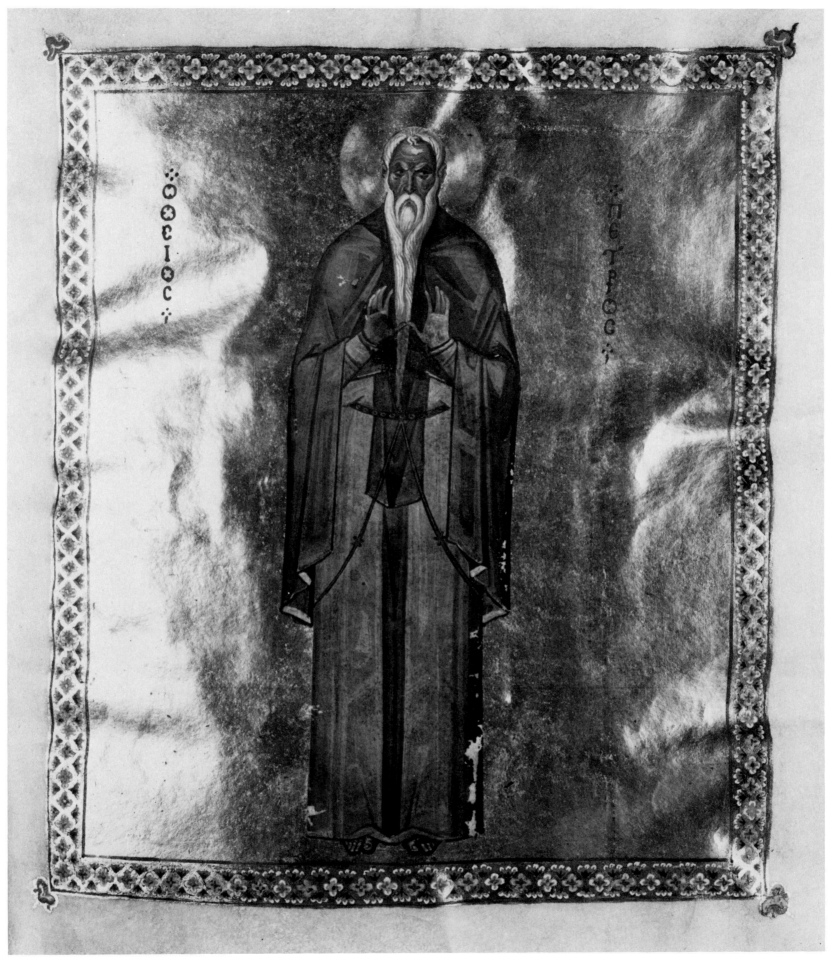

95. Cod. 204, p. 5. Hosios Peter of Monobata (cf. colorplate VII)

PLATE L

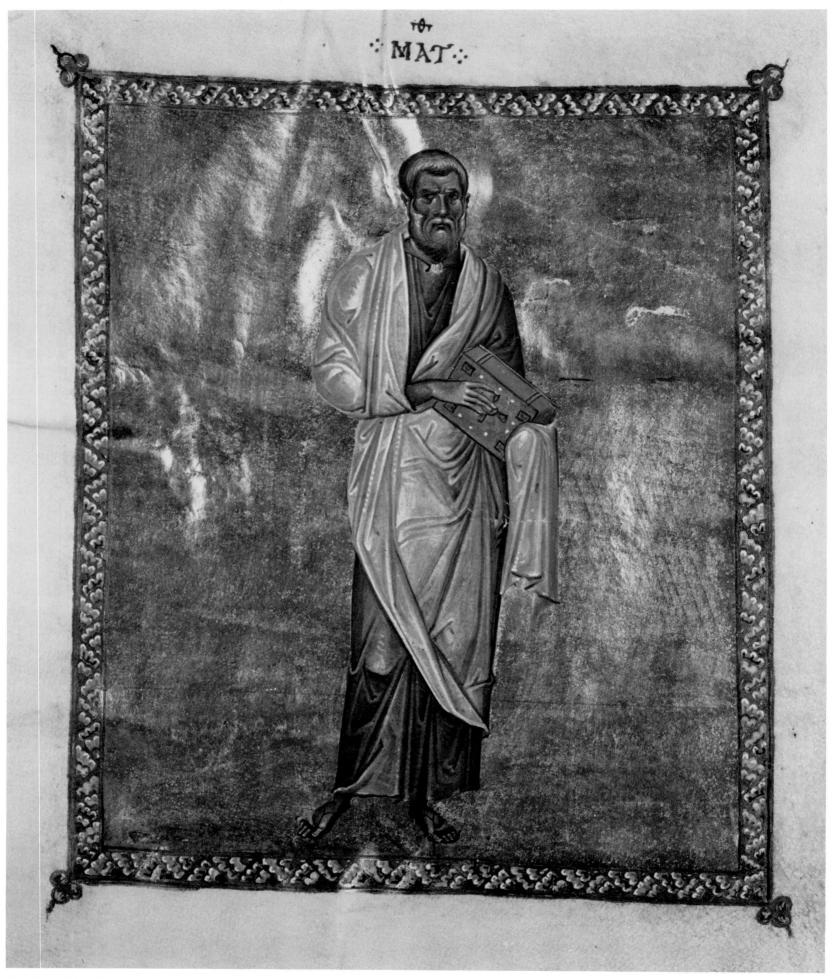

96. Cod. 204, p. 8. Matthew (cf. colorplate v)

PLATE LI

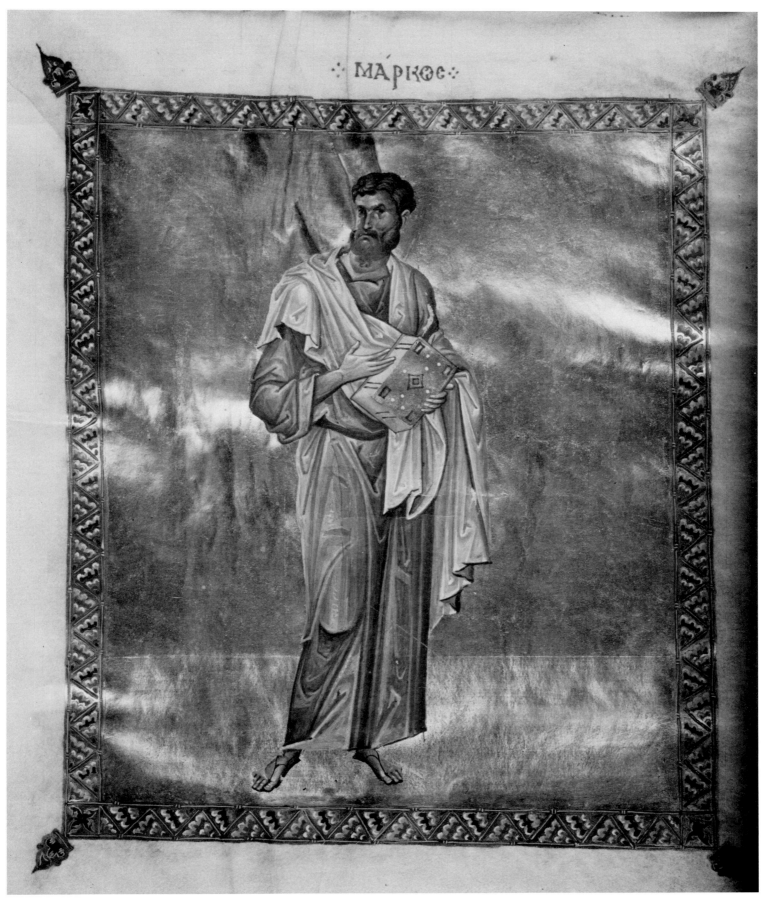

97. Cod. 204, p. 10. Mark (cf. colorplate VI)

PLATE LII

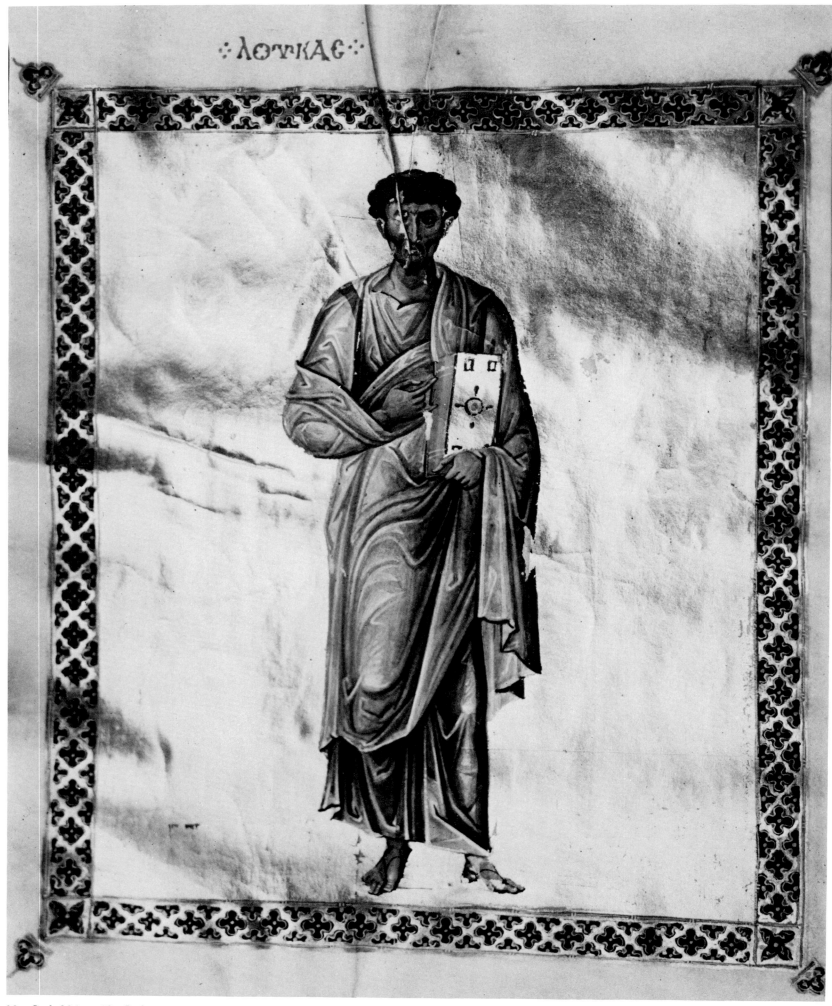

98. Cod. 204, p. 12. Luke

PLATE LIII

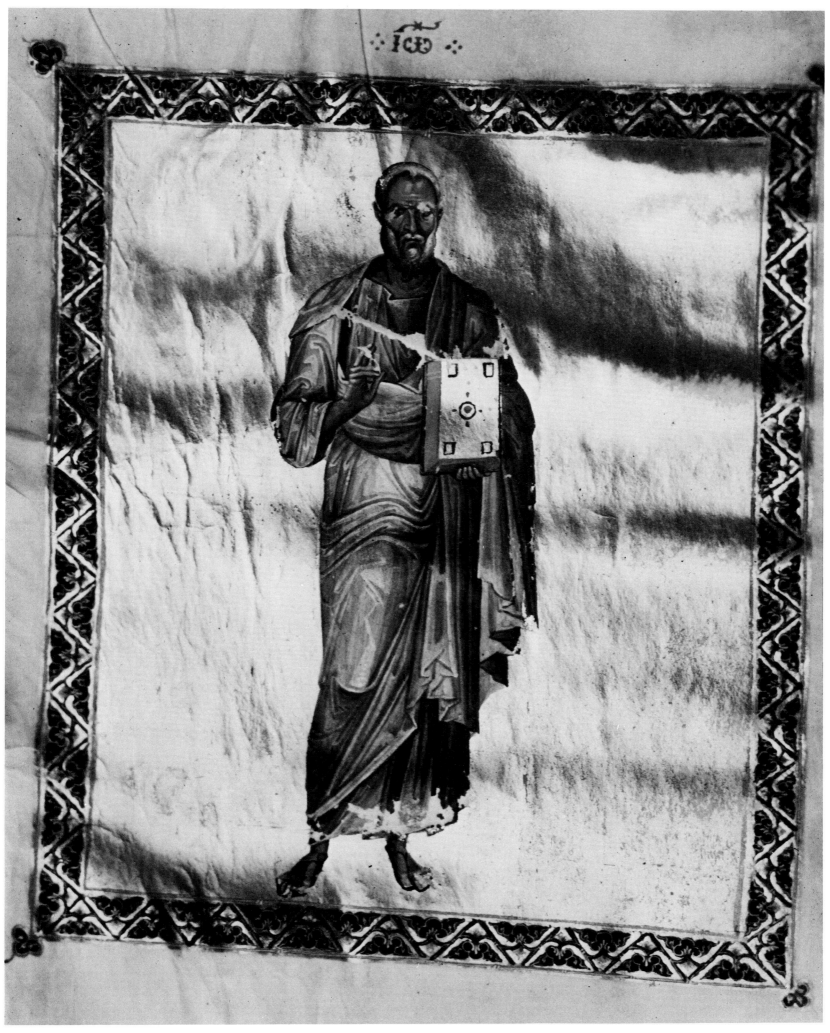

99. Cod. 204, p. 14. John

PLATE LIV

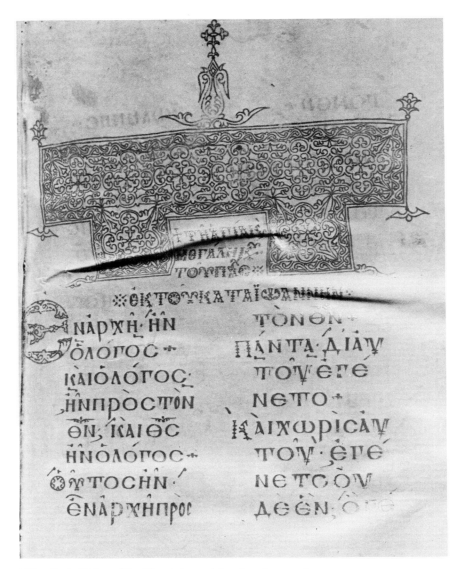

100. Cod. 204, p. 15. Headpiece (cf. colorplate VIII)

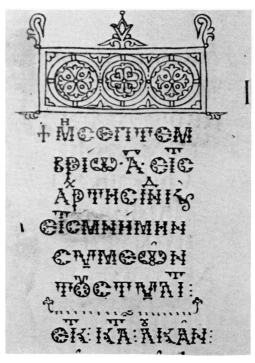

101. Cod. 204, p. 22. Initial T 102. Cod. 204, p. 30. Initial T 103. Cod. 204, p. 287. Headpiece

PLATE LV

104. Cod. 204, p. 161. Headpiece

105. Cod. 204, p. 323. Headpiece

106. Cod. 204, p. 340. Tailpiece

107. Cod. 204, p. 341. Headpiece

PLATE LVI

108. Cod. 204, inside of front cover

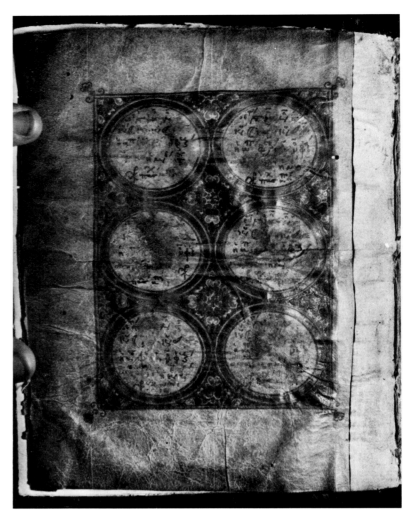

109. Cod. 68, fol. 6v. Easter tables

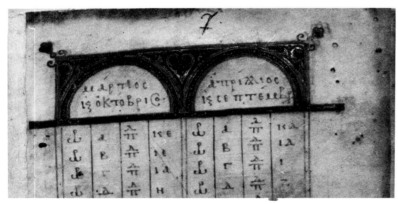

110. Cod. 68, fol. 7r. Horologion table

111. Cod. 68, fol. 10r. Headpiece

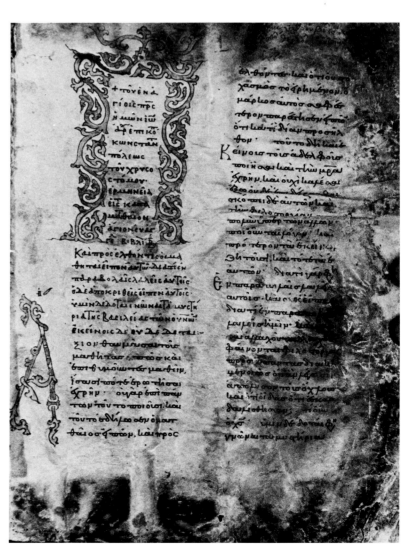

112. Cod. 368, fol. 1r. Headpiece

PLATE LVII

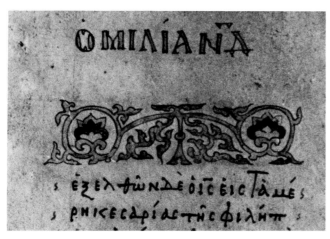

113. Cod. 368, fol. 75r. Headpiece

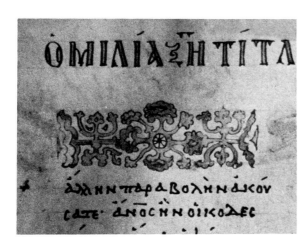

114. Cod. 368, fol. 199r. Headpiece

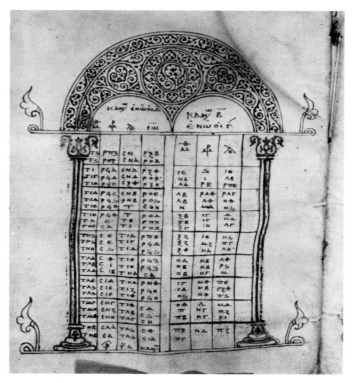

116. Cod. 188, fol. 12v. Canon table

117. Cod. 188, fol. 18r. Headpiece

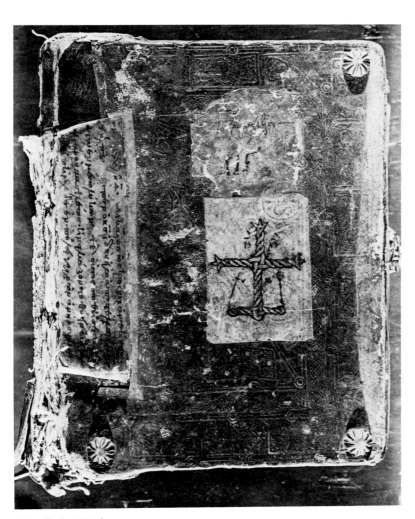

115. Cod. 188, front cover

118. Cod. 188, fol. 198r. Headpiece

PLATE LVIII

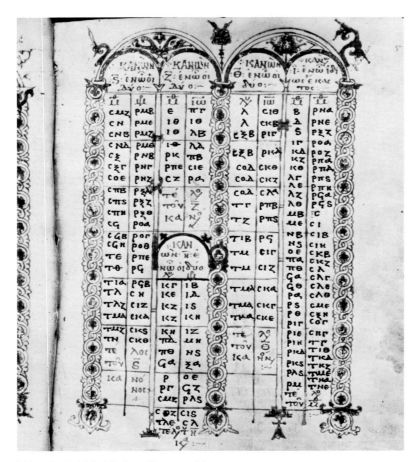

119. Cod. 155, fol. 5r. Canon table

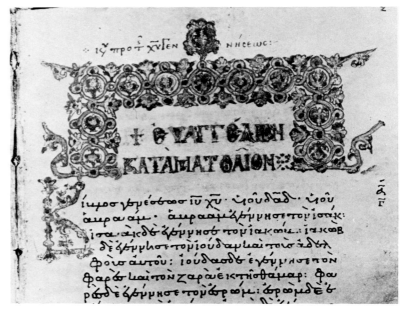

120. Cod. 155, fol. 29r. Headpiece

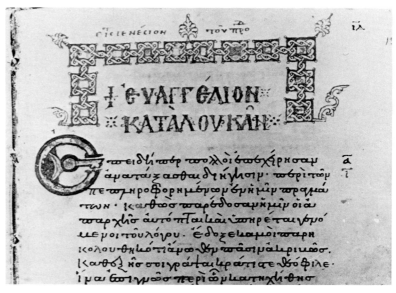

121. Cod. 155, fol. 131r. Headpiece

123. Cod. 1186, front cover

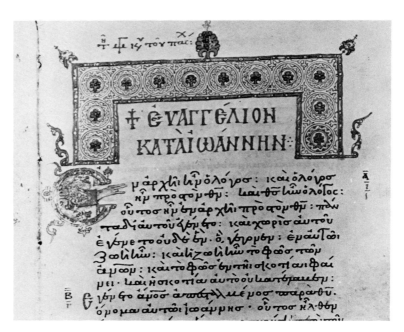

122. Cod. 155, fol. 196r. Headpiece

PLATE LIX

124. Cod. 1186, fol. 3r. Headpiece

125. Cod. 1186, fol. 3v. Tailpiece

126. Cod. 1186, fol. 6r. Headpiece

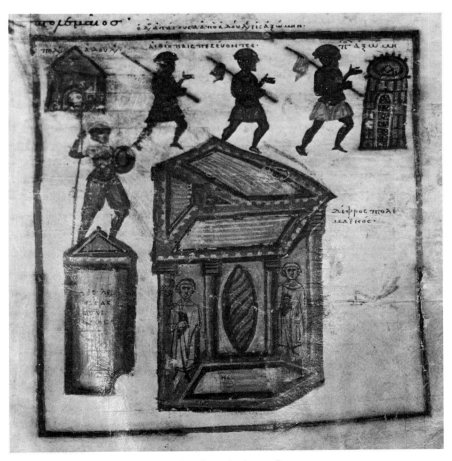

127. Cod. 1186, fol. 28r. The "Ptolemaic throne"

PLATE LX

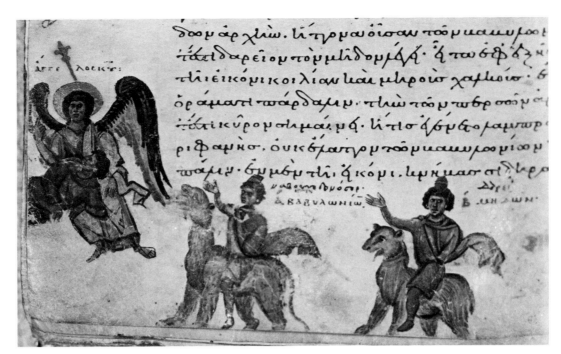

128. Cod. 1186, fol. 30v. Vision of Daniel

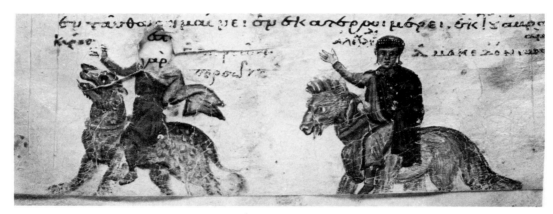

129. Cod. 1186, fol. 31r. Vision of Daniel

130. Cod. 1186, fol. 33v. The earth of Ephoros

131. Cod. 1186, fol. 34r. The earth and its inhabitants

PLATE LXI

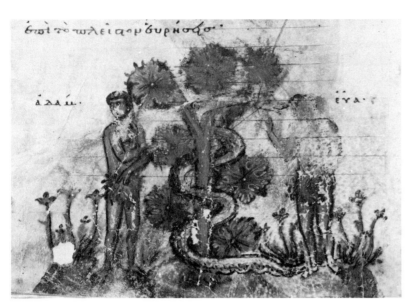

132. Cod. 1186, fol. 59v. Temptation and fall of Adam and Eve

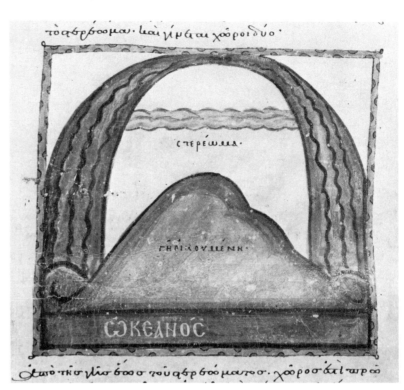

133. Cod. 1186, fol. 65r. The firmament

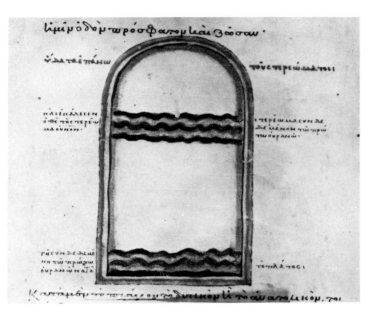

134. Cod. 1186, fol. 65v. Side view of cosmos

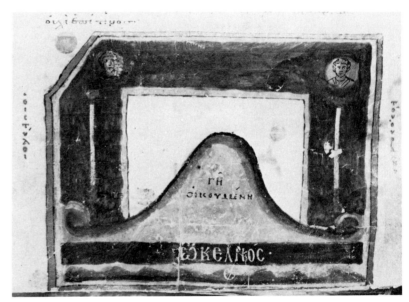

135. Cod. 1186, fol. 66r. The world and the pillars of heaven

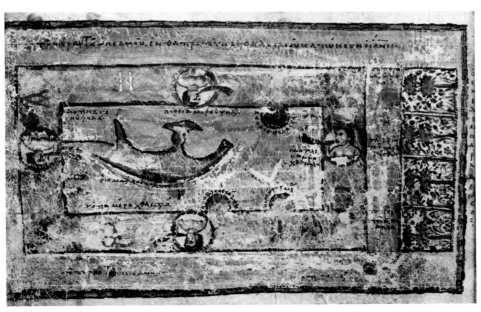

136. Cod. 1186, fol. 66v. The world and Paradise (cf. colorplate ix:a)

PLATE LXII

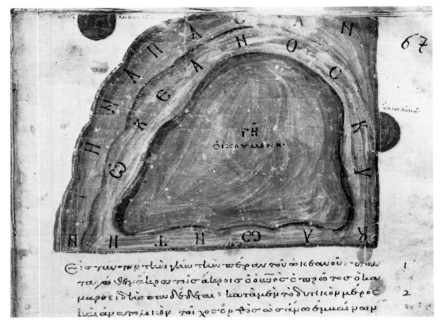

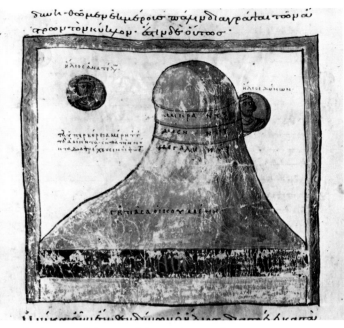

137. Cod. 1186, fol. 67r. The world and the ocean

138. Cod. 1186, fol. 68v. The earth seen from the northwest

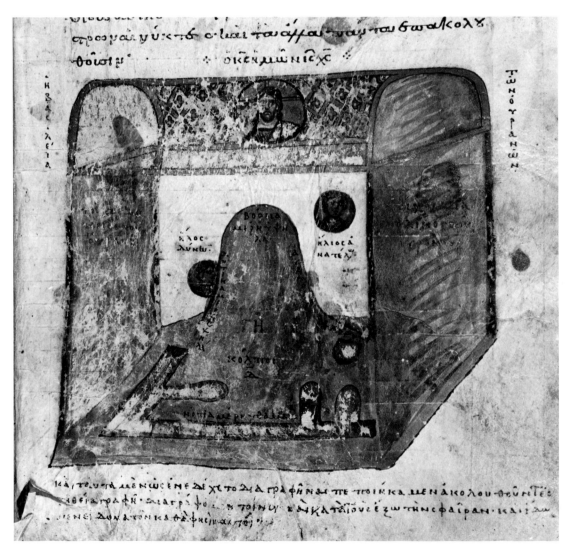

139. Cod. 1186, fol. 69r. The universe

PLATE LXIII

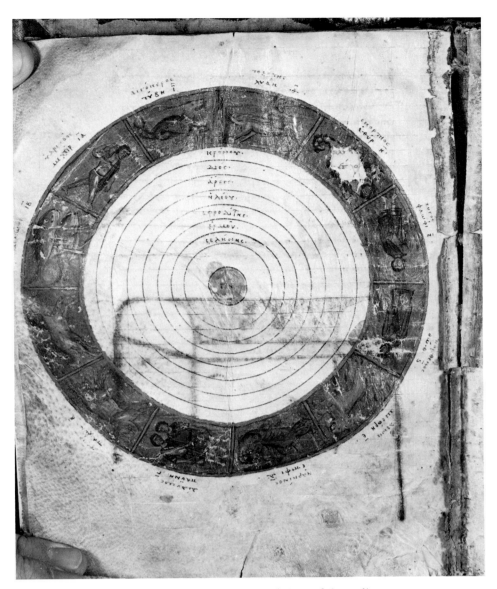

140. Cod. 1186, fol. 69v. The nine heavens and signs of the zodiac

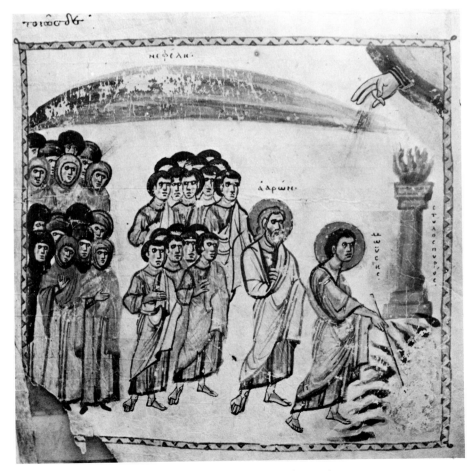

141. Cod. 1186, fol. 73r. The Israelites at the twelve springs

PLATE LXIV

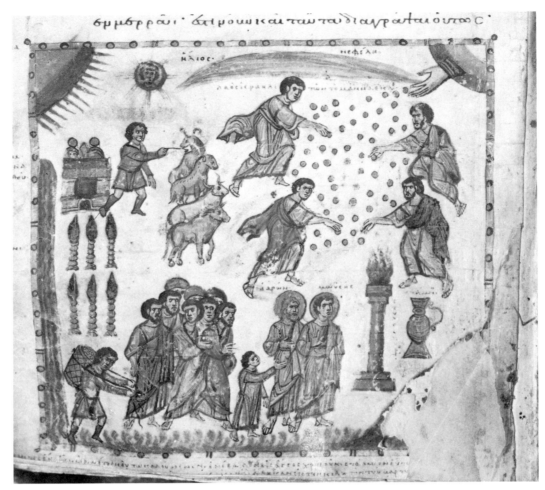

142. Cod. 1186, fol. 73v. The miracle of the manna (cf. colorplate IX:b)

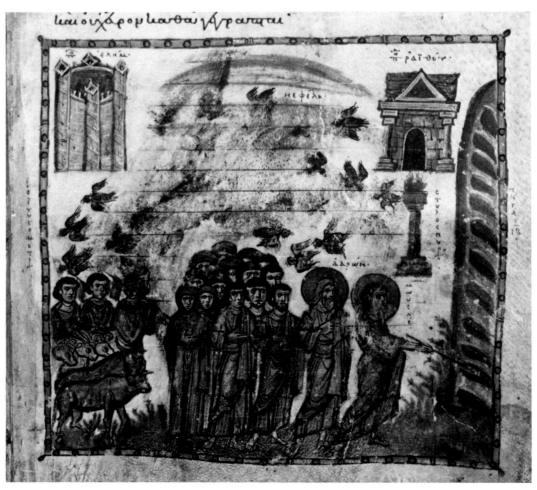

143. Cod. 1186, fol. 74r. The smiting of the rock (cf. colorplate X:a)

PLATE LXV

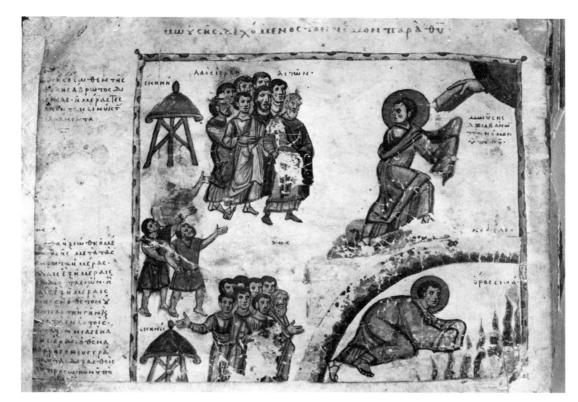

144. Cod. 1186, fol. 75v. Moses receiving the law (cf. colorplate x:b)

145. Cod. 1186, fol. 77r. Two Attic rhetoricians

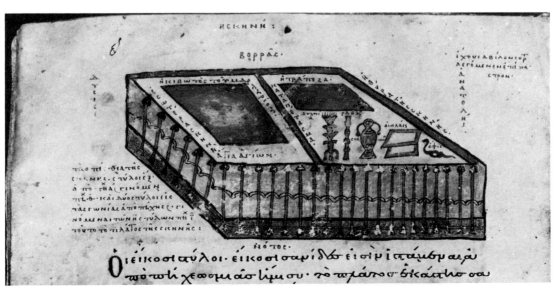

146. Cod. 1186, fol. 77v. The tabernacle

PLATE LXVI

147. Cod. 1186, fol. 79r. The coverings of the tabernacle

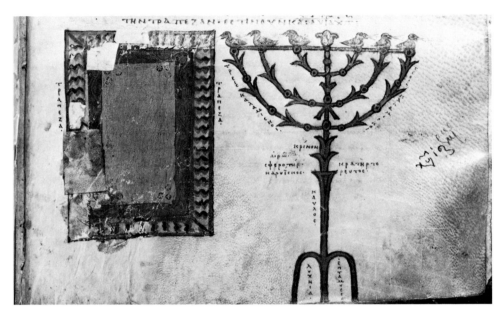

148. Cod. 1186, fol. 81r. The table and the menorah

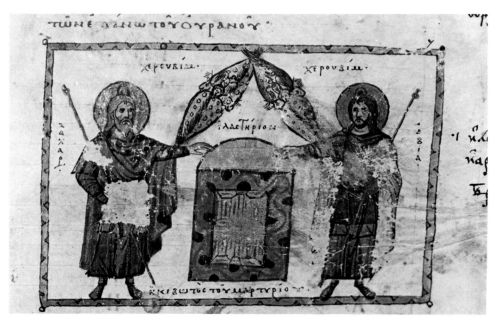

149. Cod. 1186, fol. 82r. The Ark of the Covenant

PLATE LXVII

150. Cod. 1186, fol. 82v. The tabernacle and its court

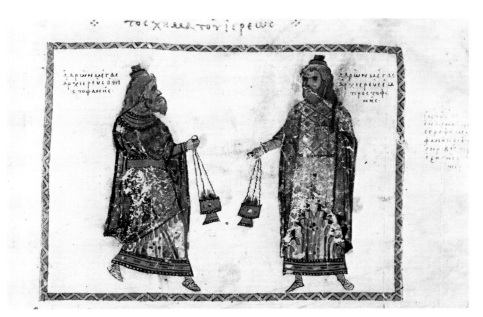

151. Cod. 1186, fol. 84r. The vestments of the priest

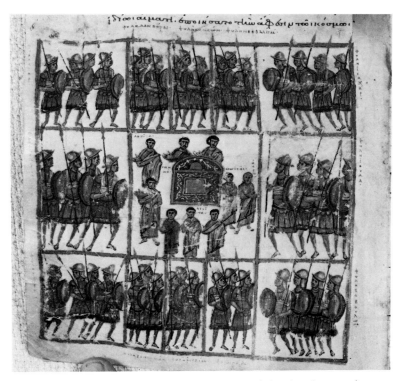

152. Cod. 1186, fol. 86v. The twelve tribes (cf. colorplate XI:a)

PLATE LXVIII

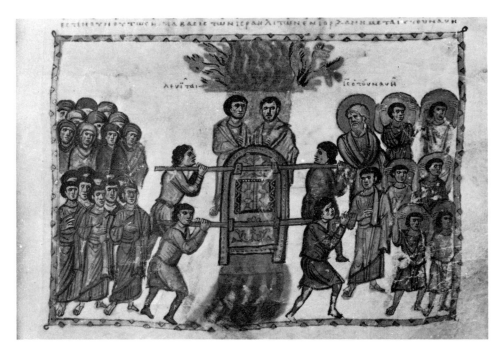

153. Cod. 1186, fol. 89r. The crossing of the Jordan

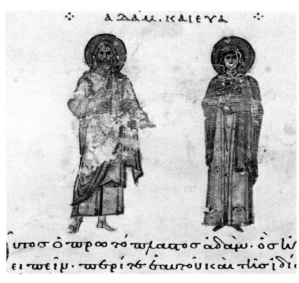

154. Cod. 1186, fol. 89v. Adam and Eve

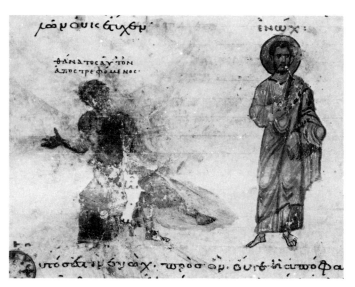

156. Cod. 1186, fol. 93v. Enoch and Thanatos

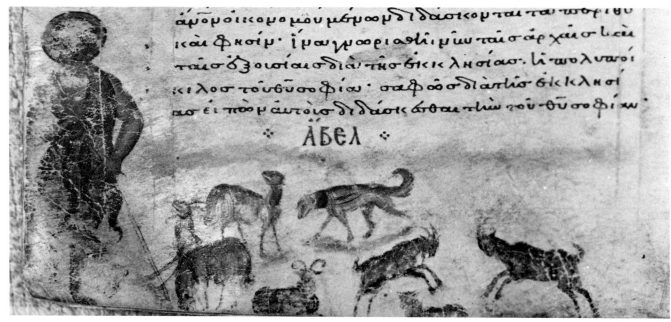

155. Cod. 1186, fol. 91v. Abel

PLATE LXIX

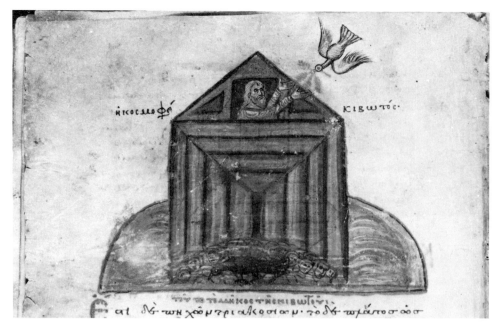

157. Cod. 1186, fol. 94v. Noah and the ark

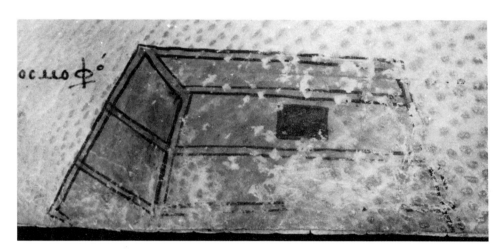

158. Cod. 1186, fol. 94v. The ark

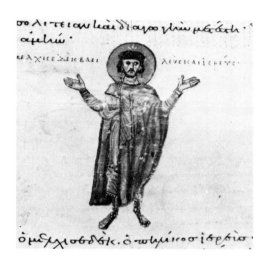

159. Cod. 1186, fol. 97r. Melchisedek

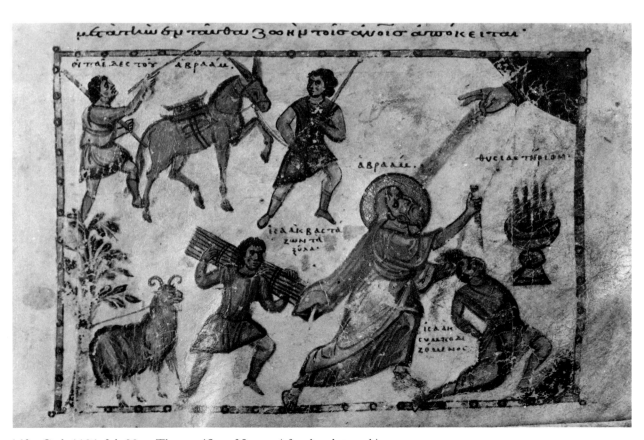

160. Cod. 1186, fol. 98r. The sacrifice of Isaac (cf. colorplate XI:b)

PLATE LXX

161. Cod. 1186, fol. 99v. 162. Cod. 1186, fol. 100v. Jacob and Judas
Isaac

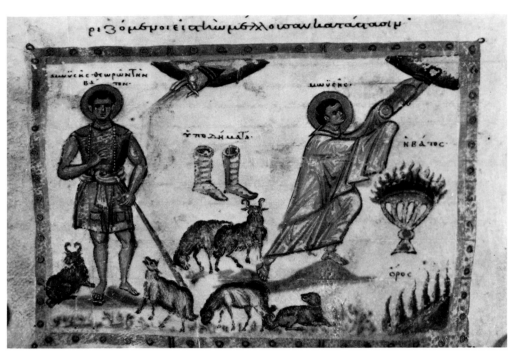

163. Cod. 1186, fol. 101v. Moses and the burning bush, Moses receiving the Law

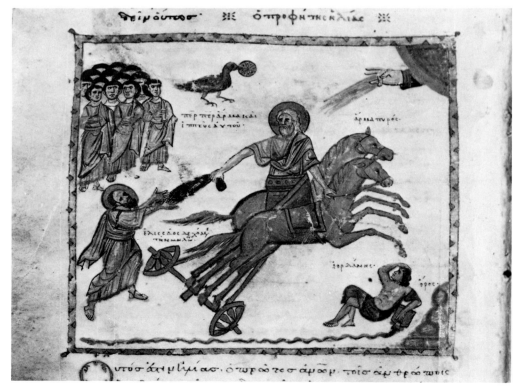

164. Cod. 1186, fol. 107v. Elijah's ascension (cf. colorplate XII:a)

PLATE LXXI

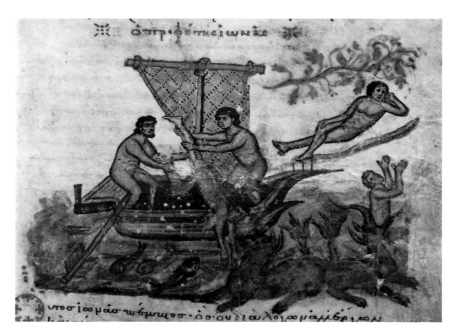

165. Cod. 1186, fol. 110r. Jonah

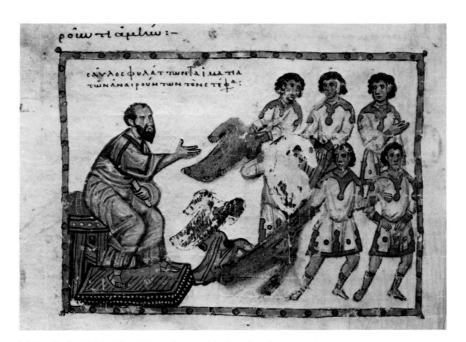

166. Cod. 1186, fol. 125v. Saul with Stephen's executioners

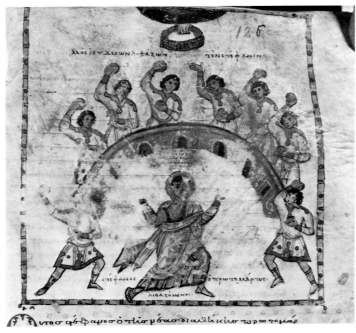

167. Cod. 1186, fol. 126r. The stoning of Stephen

PLATE LXXII

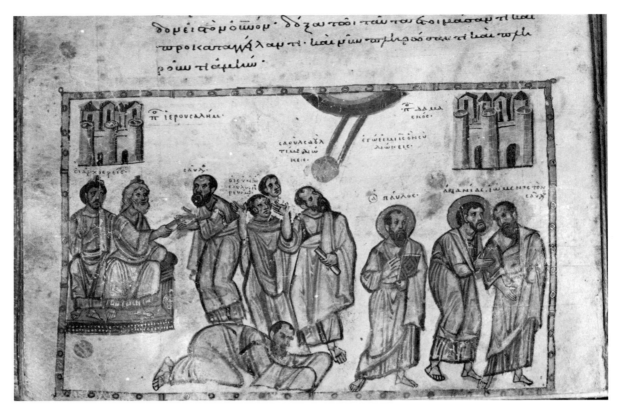

168. Cod. 1186, fol. 126v. The conversion of Paul (cf. colorplate XII:b)

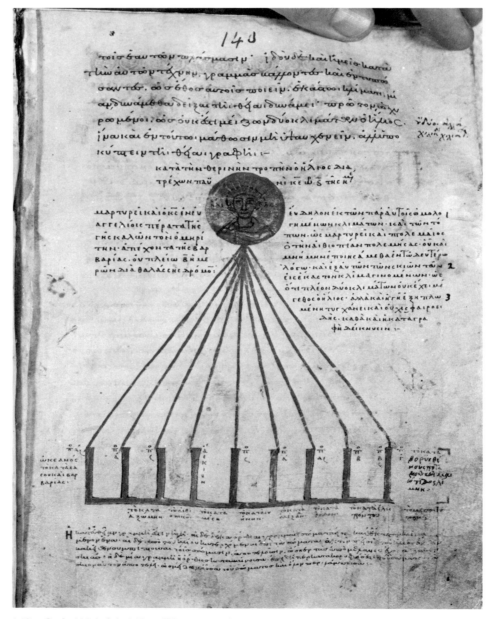

169. Cod. 1186, fol. 140r. The sun and the climes

PLATE LXXIII

170. Cod. 1186, fol. 145r. The two strata of the universe

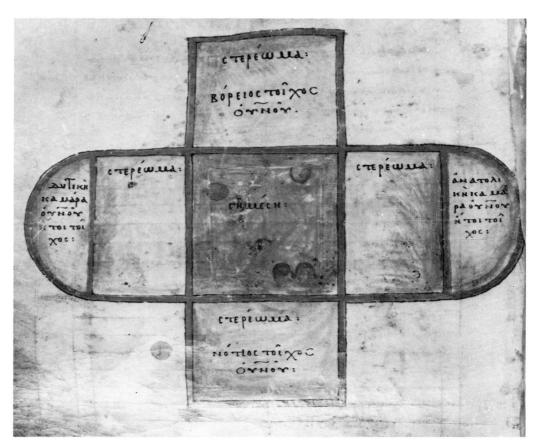

171. Cod. 1186, fol. 145v. The universe

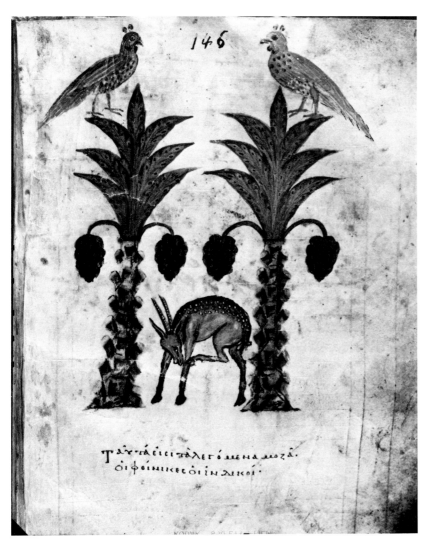

172. Cod. 1186, fol. 146r. Gazelle and palm trees (cf. colorplate XIII:a)

173. Cod. 1186, fol. 146v. Sun and earth with climes

PLATE LXXIV

174. Cod. 1186, fol. 168r. The tabernacle

175. Cod. 1186, fol. 171r. Isaiah warning Hezekiah (cf. colorplate XIII:b)

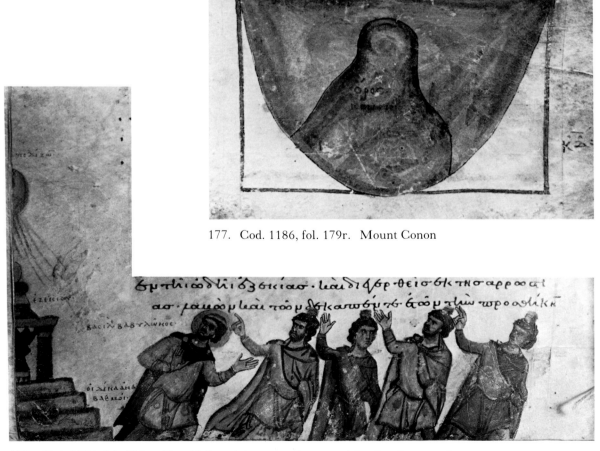

177. Cod. 1186, fol. 179r. Mount Conon

176. Cod. 1186, fol. 174v. Hezekiah and the retreating sun (cf. colorplate XIII:c)

PLATE LXXV

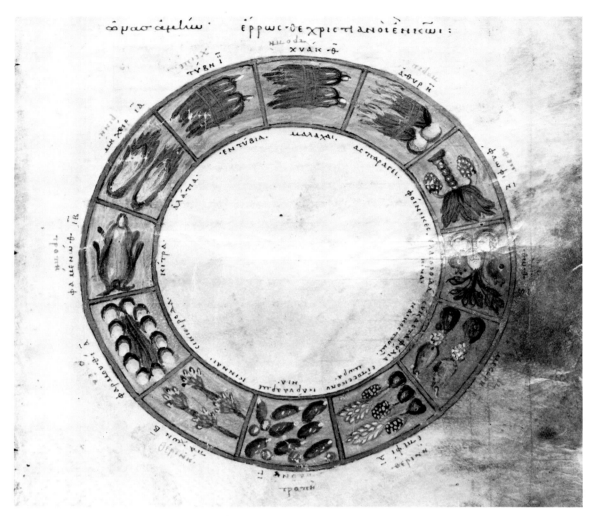

178. Cod. 1186, fol. 180r. The cycle of the seasons

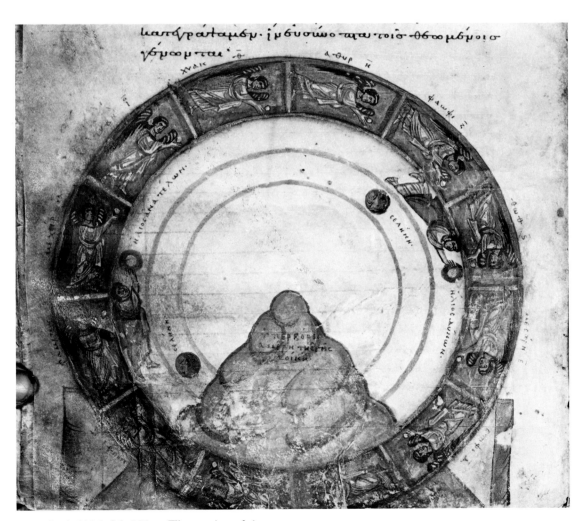

179. Cod. 1186, fol. 181v. The motion of the stars

PLATE LXXVI

180. Cod. 1186, fol. 202r. Hunter and animals

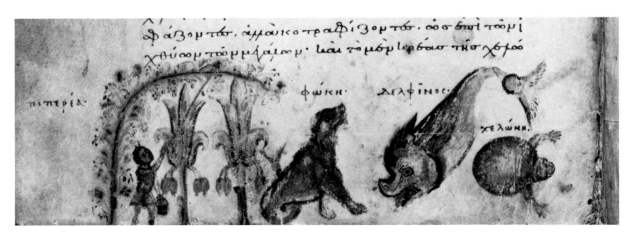

181. Cod. 1186, fol. 202v. Pepper tree and sea creatures

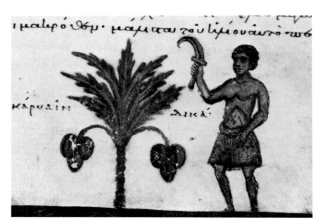

182. Cod. 1186, fol. 203r. Coconut tree

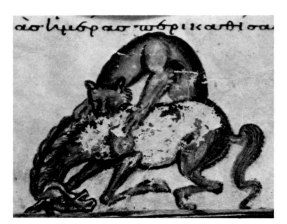

183. Cod. 1186, fol. 204v. Lion and horse

PLATE LXXVII

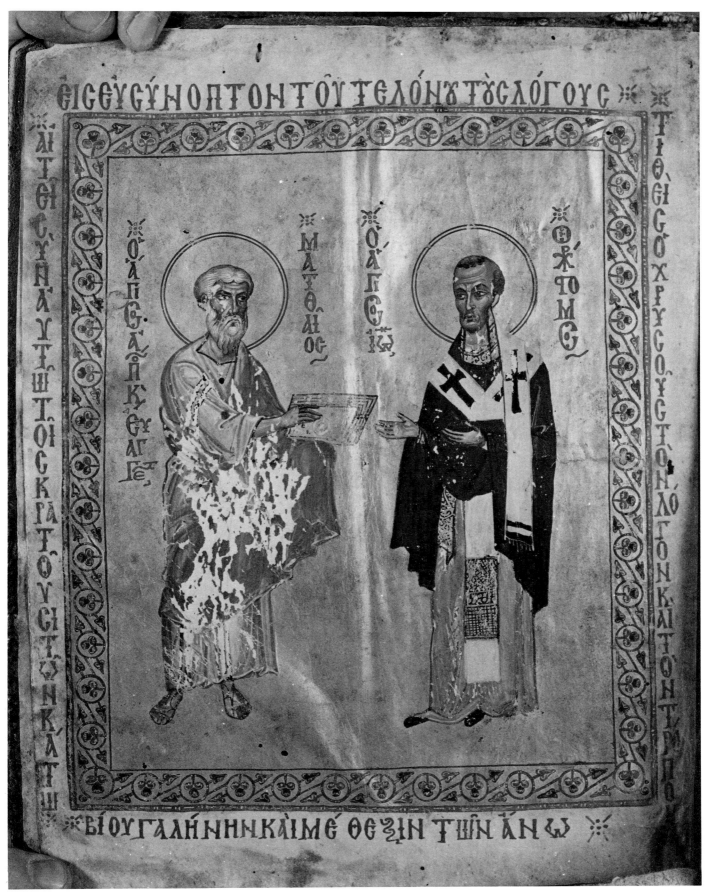

184. Cod. 364, fol. 2v. Matthew and John Chrysostom (cf. colorplate XIV)

PLATE LXXVIII

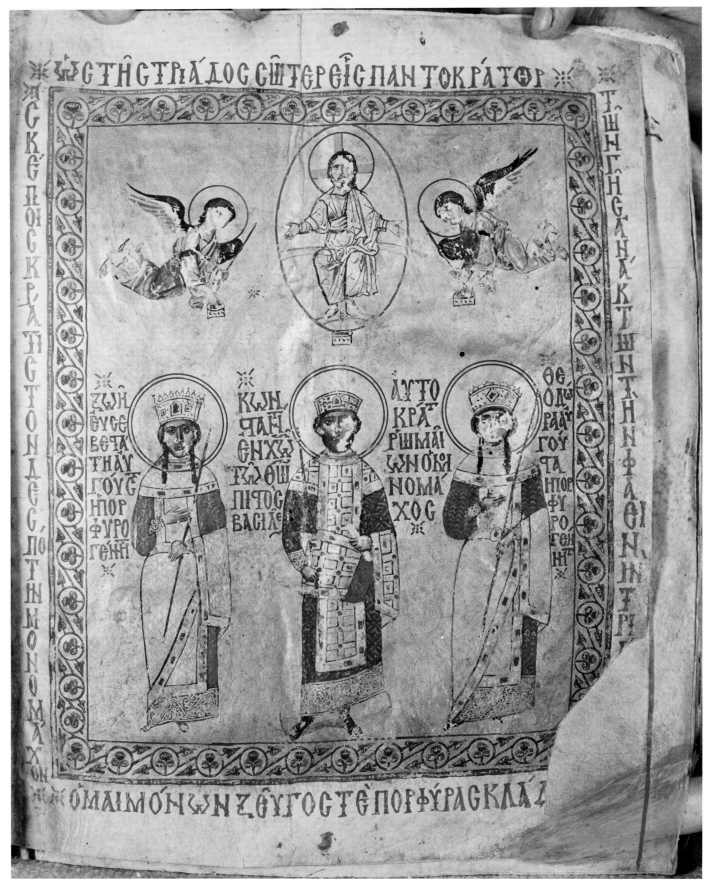

185. Cod. 364, fol. 3r. Constantine IX Monomachos, Zoe, and Theodora

PLATE LXXIX

186. Cod. 364, fol. 4r. Headpiece

187. Cod. 342, fol. 1r. Headpiece

189. Cod. 342, fol. 239r. Colophon

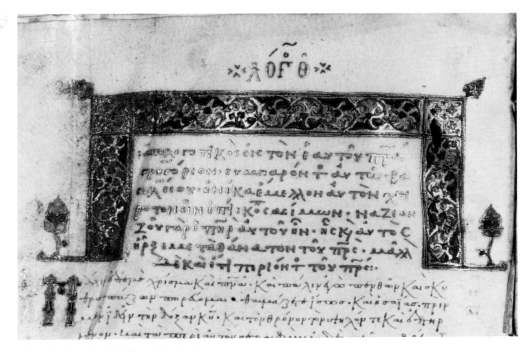

188. Cod. 342, fol. 73r. Headpiece

190. Cod. 342, flyleaf. Gregory

PLATE LXXX

191. Cod. 293, fol. 59v. Initial A

192. Cod. 293, fol. 90v. Initial A

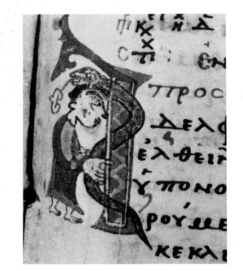

193. Cod. 293, fol. 104r. Initial A

194. Cod. 293, fol. 108v. Initial A

195. Cod. 293, fol. 145v. Colophon

196. Cod. 512, fol. 1r. Headpiece

197. Cod. 512, fol. 3r. Headpiece

PLATE LXXXI

198. Cod. 512, fol. 2v. Saints of the first half of January (cf. colorplate xv)

PLATE LXXXII

199. Cod. 500, fol. 4v. Cross

PLATE LXXXIII

200. Cod. 500, fol. 5r. Miracles of Sts. Cosmas and Damian

PLATE LXXXIV

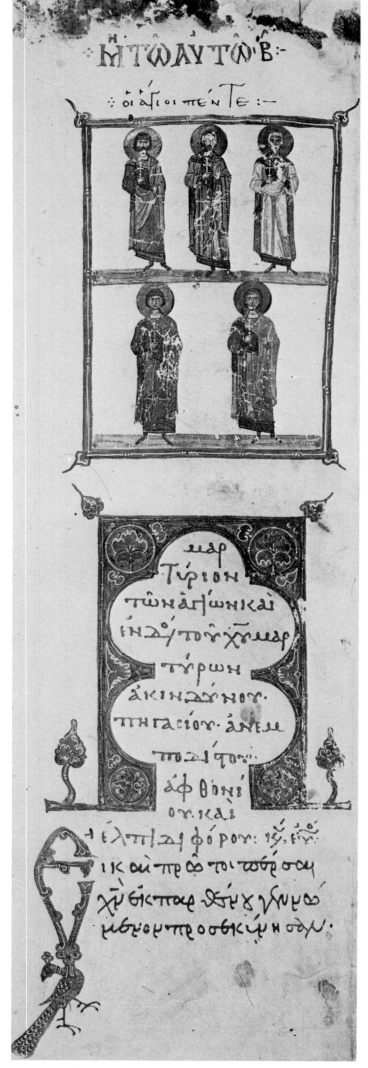

201. Cod. Leningrad 373, fol. 1v. Five Saints martyred in Persia

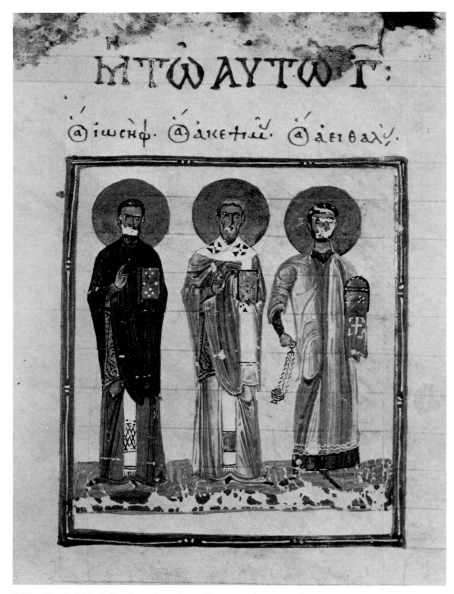

202. Cod. 500, fol. 25v. Sts. Joseph, Akepsimas, and Aeithalas (cf. colorplate XVI:a)

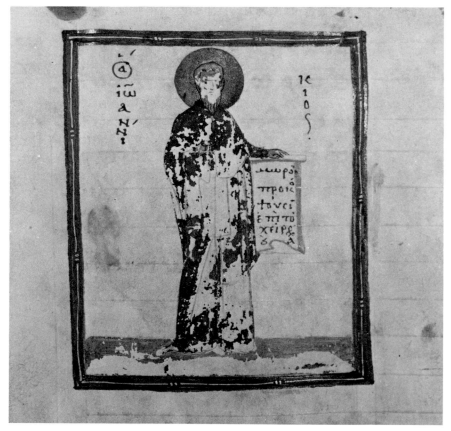

203. Cod. 500, fol. 43v. St. Ioannikios

PLATE LXXXV

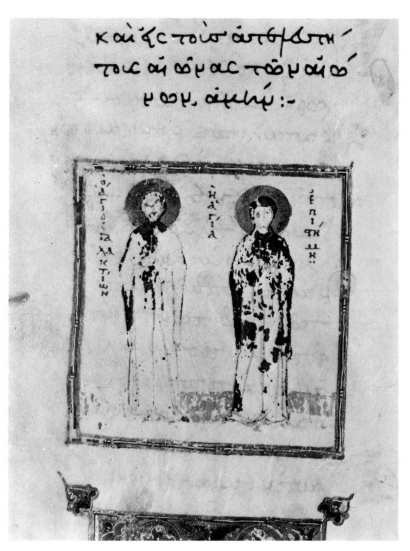

204. Cod. 500, fol. 77r. Sts. Galaktion and Episteme

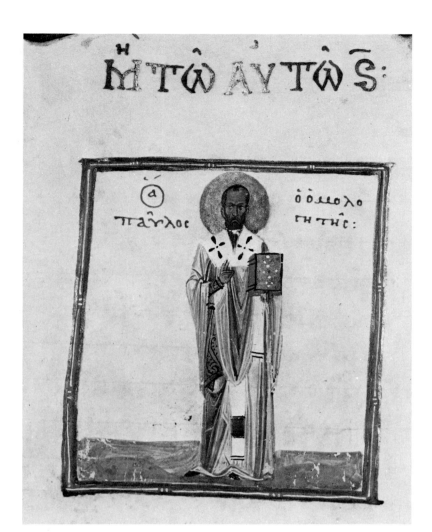

205. Cod. 500, fol. 86r. Paul the Confessor

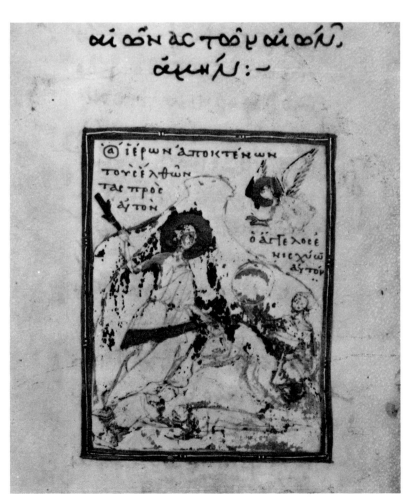

206. Cod. 500, fol. 92v. St. Hieron killing his pursuers

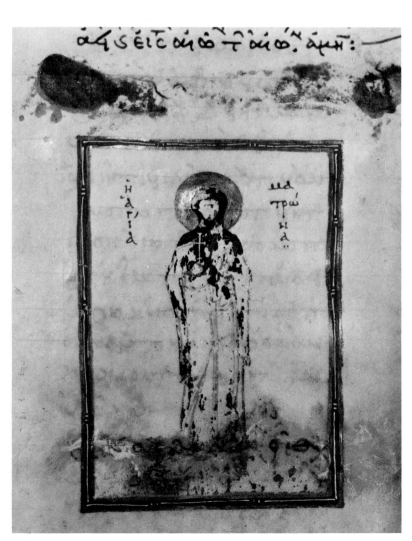

207. Cod. 500, fol. 98v. St. Matrona

PLATE LXXXVI

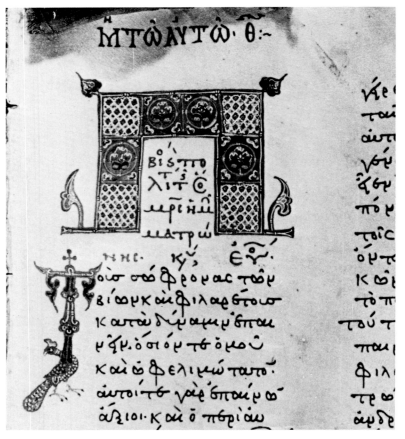

208. Cod. 500, fol. 99r. Headpiece

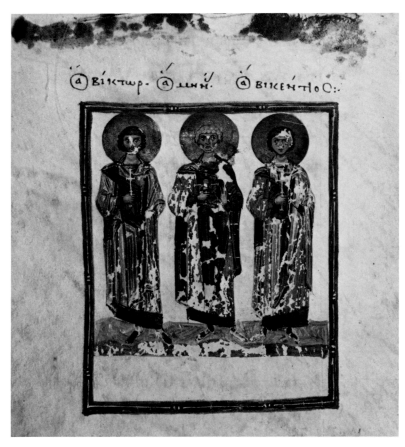

210. Cod. 500, fol. 129v. Sts. Viktor, Menas, and Vikentios

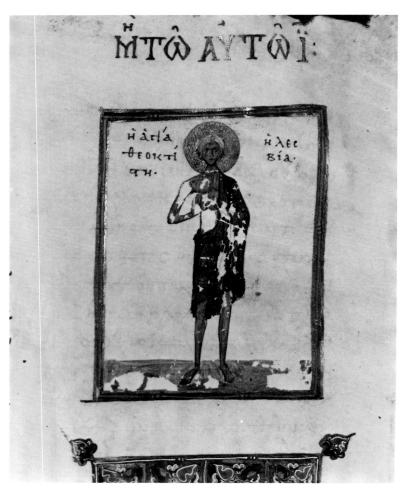

209. Cod. 500, fol. 118v. St. Theoktiste

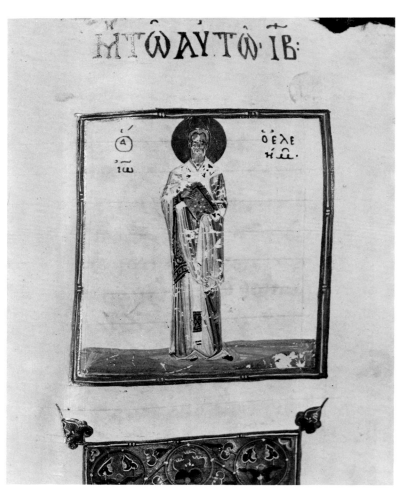

211. Cod. 500, fol. 136r. St. John the Almoner

PLATE LXXXVII

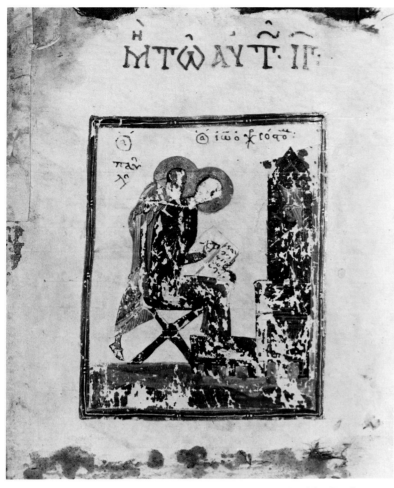

212. Cod. 500, fol. 175r. St. John Chrysostom inspired by Paul

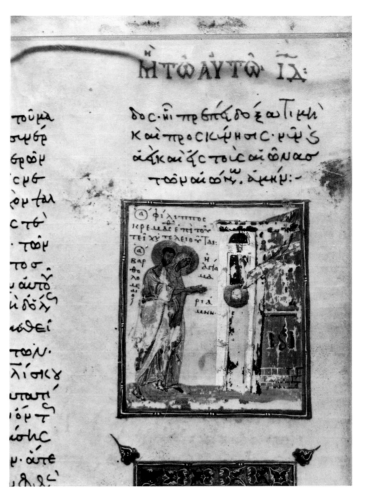

213. Cod. 500, fol. 275v. Sts. Bartholomew, Philip, and Mariamne

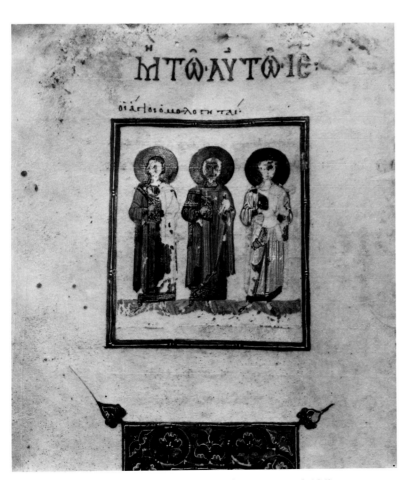

214. Cod. 500, fol. 281v. Sts. Gourias, Samonas, and Abibos

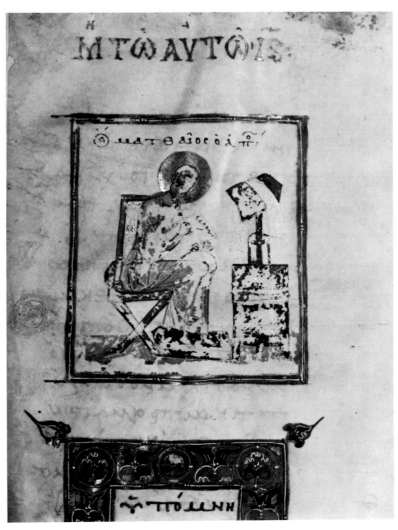

215. Cod. 500, fol. 302r. Matthew

PLATE LXXXVIII

216. Cod. 500, front cover (detail)

217. Cod. 500, back cover

218. Cod. 172, front cover

219. Cod. 172, back cover

PLATE LXXXIX

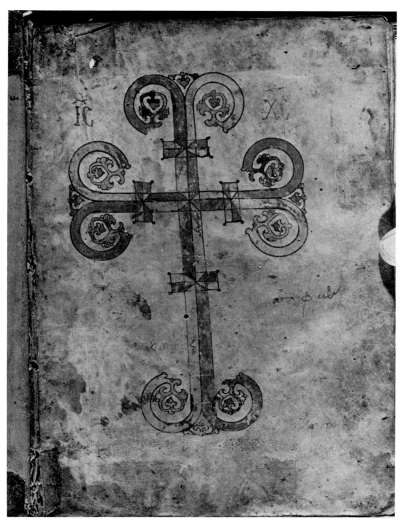

220. Cod. 172, fol. 1r Cross

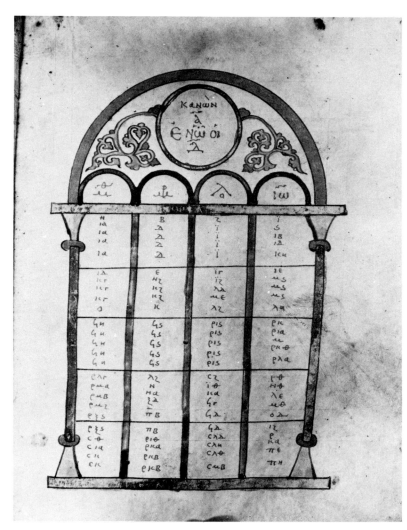

221. Cod. 172, fol. 3r. Canon table

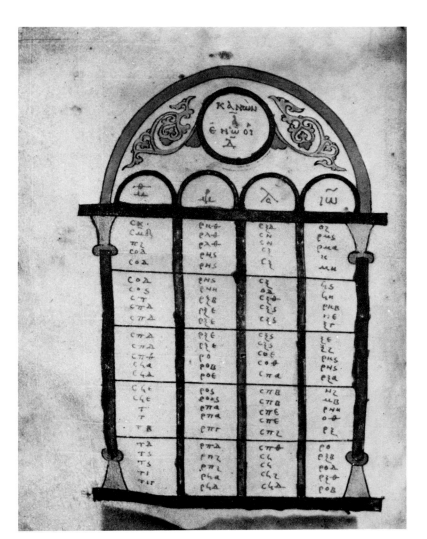

222. Cod. 172, fol. 3v. Canon table

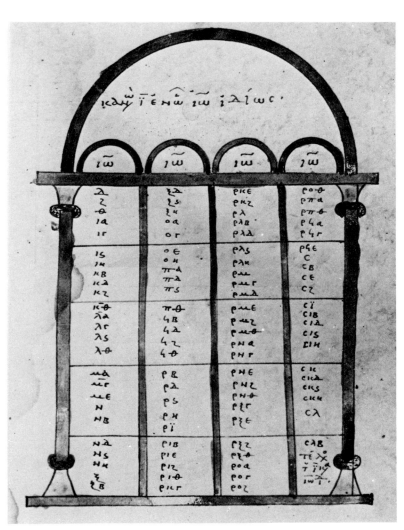

223. Cod. Leningrad 291, fol. 2r. Canon table

PLATE XC

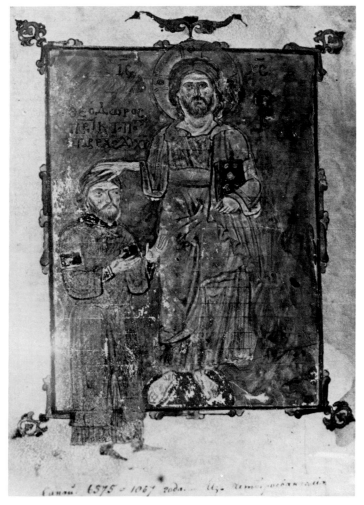

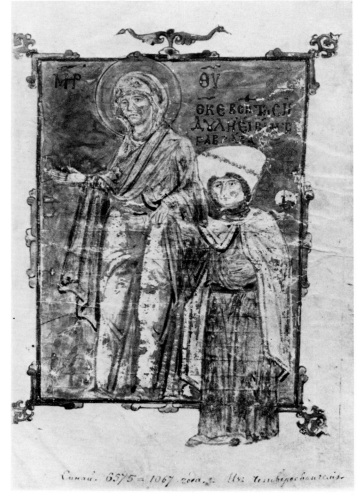

224. Cod. Leningrad 291, fol. 2v. Christ and Theodore Gabras

225. Cod. Leningrad 291, fol. 3r. Mary and Irene Gabras

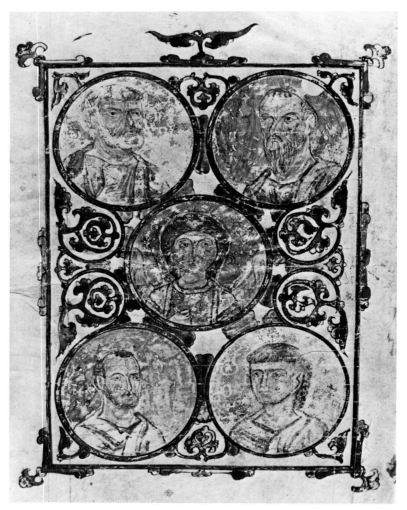

226. Cod. Leningrad 291, fol. 3v. Medallions with portrait busts

227. Cod. 172, fol. 11r. Headpiece

PLATE XCI

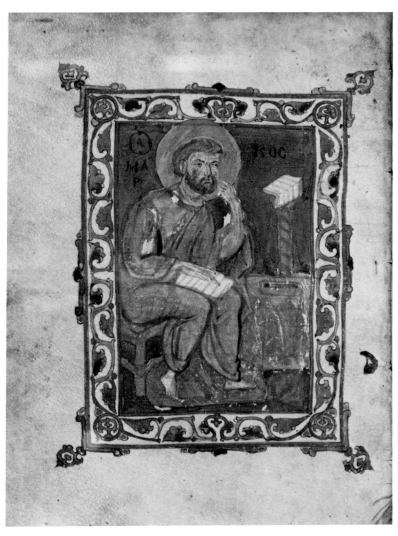

228. Cod. 172, fol. 66v. Mark

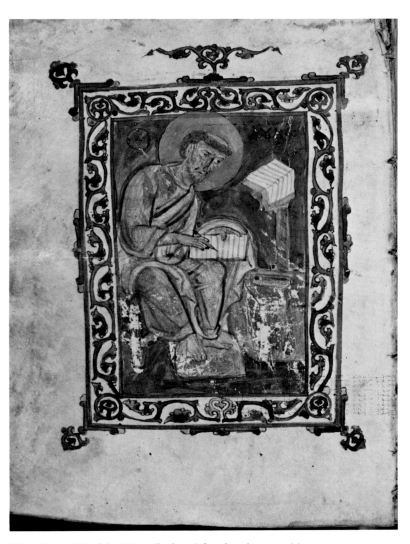

229. Cod. 172, fol. 104v. Luke (cf. colorplate XVI:b)

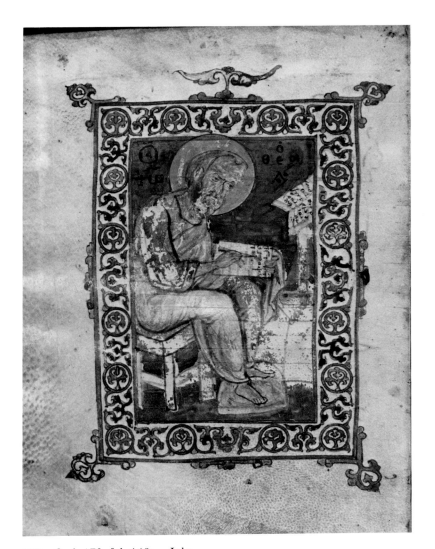

230. Cod. 172, fol. 168v. John

231. Cod. 172, fol. 197r. Colophon

PLATE XCII

232. Cod. 48, fol. 15v. David

233. Cod. 48, fol. 21v. Lot and his daughters

234. Cod. 48, fol. 22r. The Crucifixion

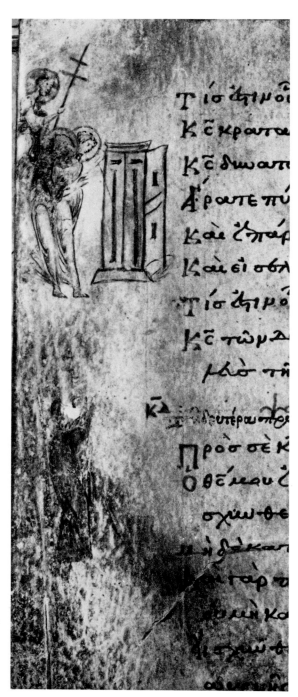

235. Cod. 48, fol. 23r.
The Crucifixion

236. Cod. 48, fol. 24r. The "worship-
pers of the Lord"

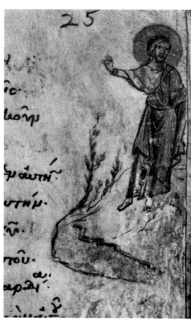

237. Cod. 48, fol. 25r. Christ

239. Cod. 48, fol. 27r. Christ blessing
David

238. Cod. 48, fol. 25v. Christ and angels

PLATE XCIII

240. Cod. 48, fol. 28r. Samuel anointing David

241. Cod. 48, fol. 29r. Christ before Caiaphas

242. Cod. 48, fol. 30v. Baptism of Christ

243. Cod. 48, fol. 32r. David

244. Cod. 48, fol. 34r. Man holding staff

245. Cod. 48, fol. 34v. Man pulling thorn from foot

246. Cod. 48, fol. 38r. Peter admonishing man

247. Cod. 48, fol. 39r. Christ confronting adversaries

248. Cod. 48, fol. 39v. Figure with scroll (Christ?)

PLATE XCIV

249. Cod. 48, fol. 41v. Warrior

250. Cod. Leningrad 267, fol. 1r.
Christ addressing the "wicked" man

251. Cod. 48, fol. 44v. John
Chrysostom

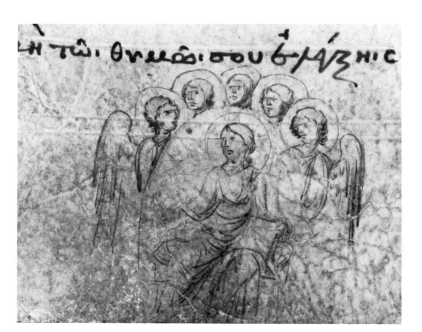

252. Cod. 48, fol. 45r.
Joseph enthroned

253. Cod. 48, fol. 45v. Christ and angels

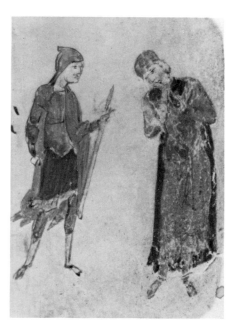

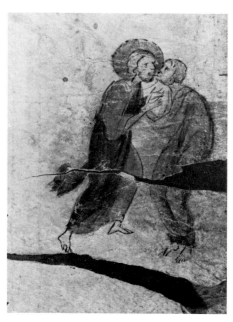

254. Cod. Leningrad 267, fol. 2r.
David and soldier

255. Cod. 48, fol. 50r.
Youth receiving alms

256. Cod. 48, fol. 51r. Kiss of Judas

PLATE XCV

257. Cod. 48, fol. 51v. David

258. Cod. 48, fol. 53v.
The Patriarchs

259. Cod. 48, fol. 56r. David
and Christ

260. Cod. 48, fol. 57v. Group imploring Christ

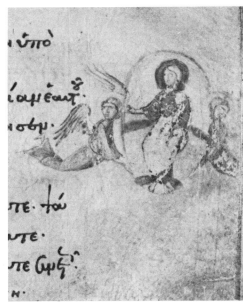

261. Cod. 48, fol. 59r. Christ in majesty

262. Cod. 48, fol. 60v. John
Chrysostom

263. Cod. 48, fol. 61r. Man
bending

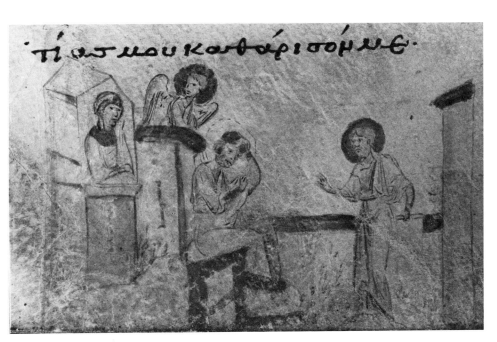

264. Cod. 48, fol. 64r. Penitence of David

PLATE XCVI

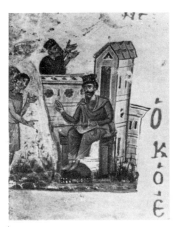

265. Cod. Leningrad 267,
fol. 3v. Saul and Siphites

266. Cod. 48, fol. 69r.
David arrested by the
Philistines

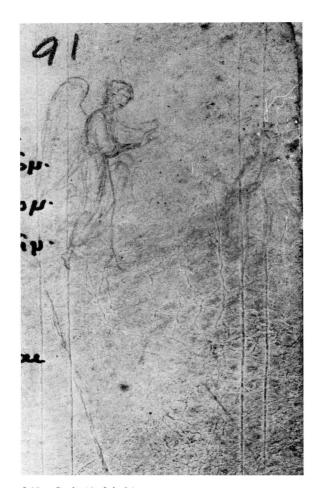

268. Cod. 48, fol. 91r.
The Annunciation

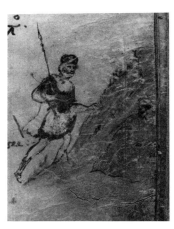

267. Cod. 48, fol. 70r. David
fleeing Saul

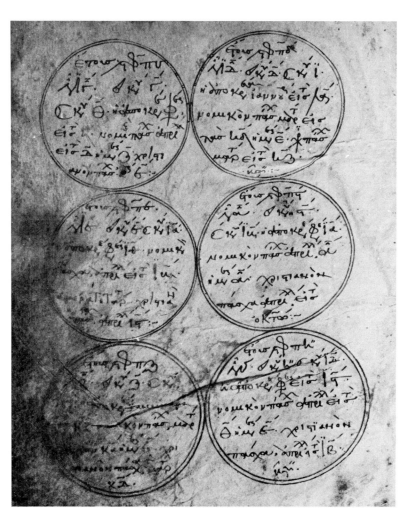

269. Cod. 48, fol. 219v. Easter tables

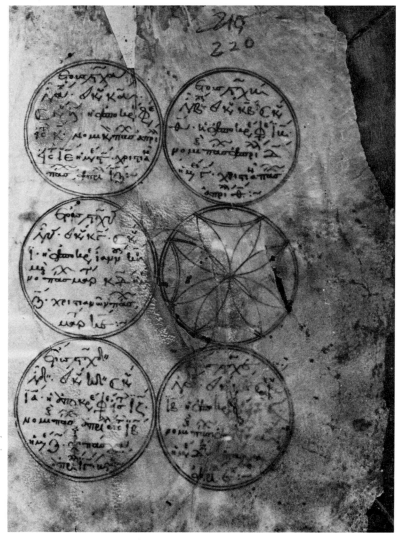

270. Cod. 48, fol. 220r. Easter tables

PLATE XCVII

271. Cod. 401, fol. 3r. Initial T

272. Cod. 401, fol. 19v. Headpiece

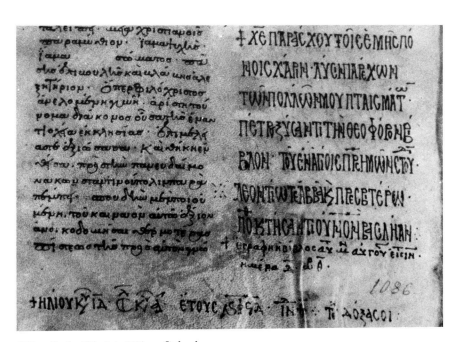

273. Cod. 401, fol. 205v. Colophon

274. Cod. 150, fol. 51r. Canon table

275. Cod. 150, fol. 54r. Canon table

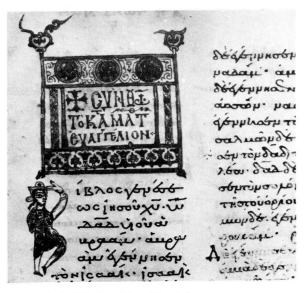

276. Cod. 150, fol. 55r. Headpiece

PLATE XCVIII

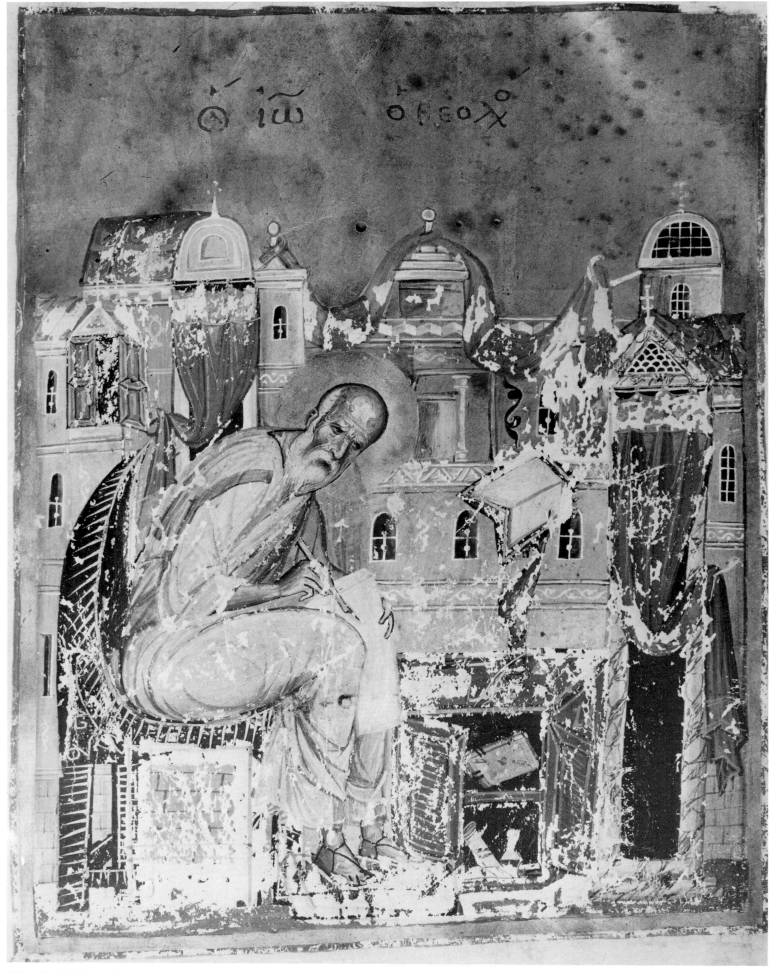

277. Cod. 205, fol. 2v. John

PLATE XCIX

278. Cod. 205, fol. 3r. Headpiece

PLATE C

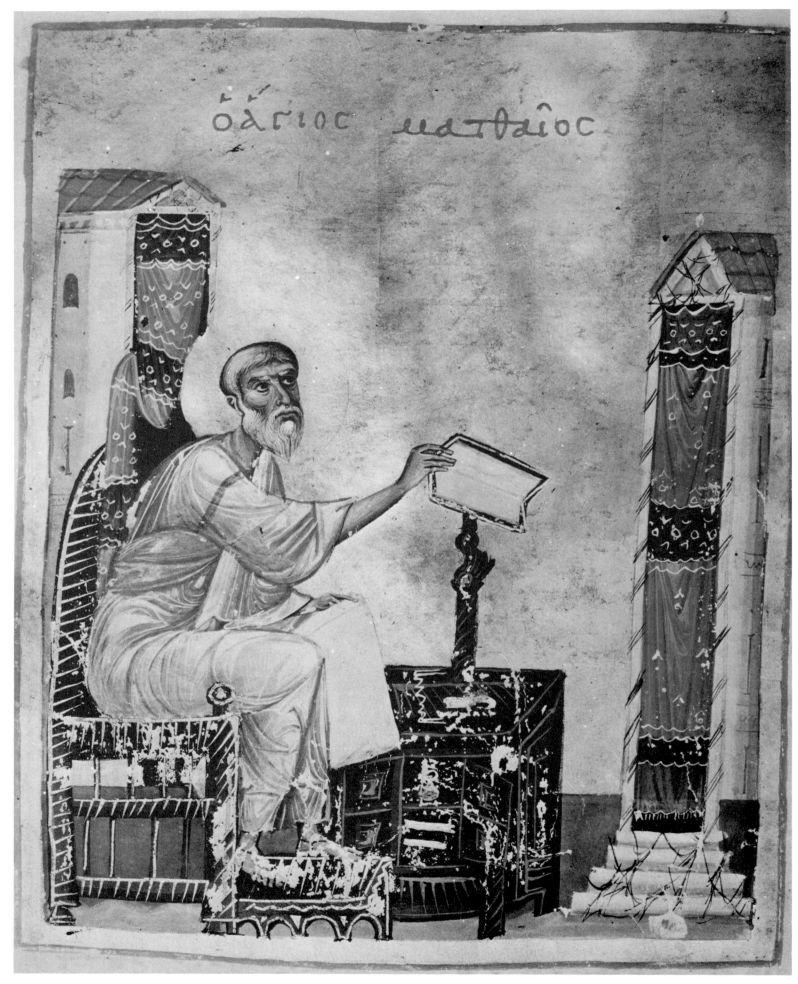

279. Cod. 205, fol. 45v. Matthew (cf. colorplate XVI:c)

PLATE CI

280. Cod. 205, fol. 46r. Headpiece

PLATE CII

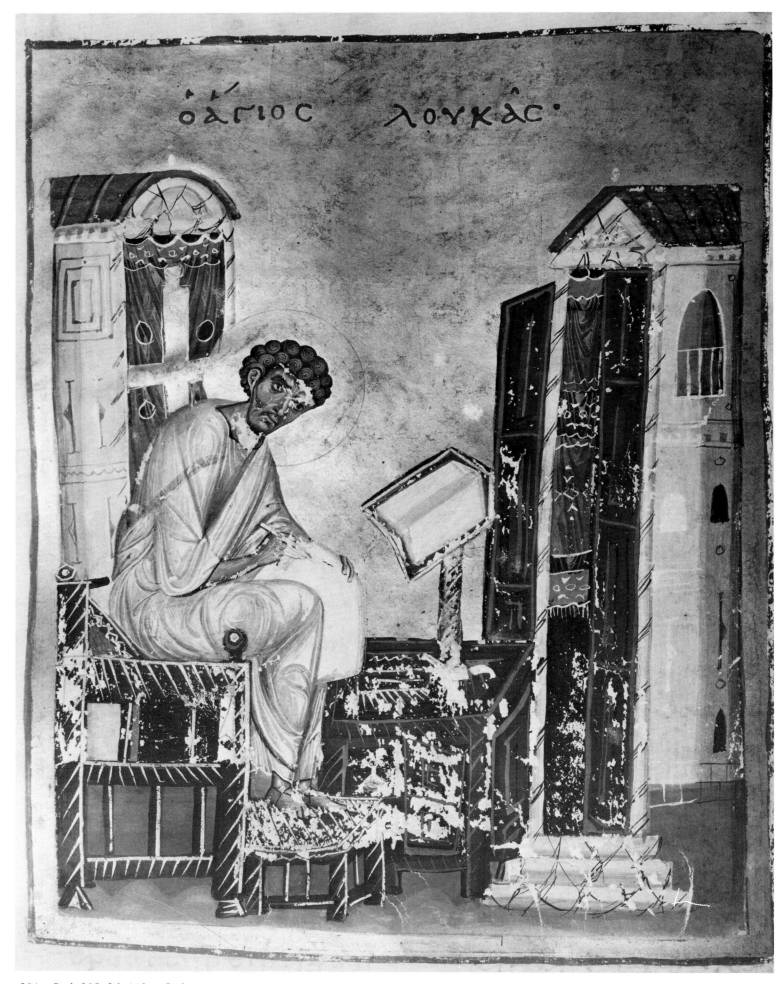

281. Cod. 205, fol. 113v. Luke

PLATE CIII

282. Cod. 205, fol. 114r. Headpiece (cf. colorplate xvɪ:d)

PLATE CIV

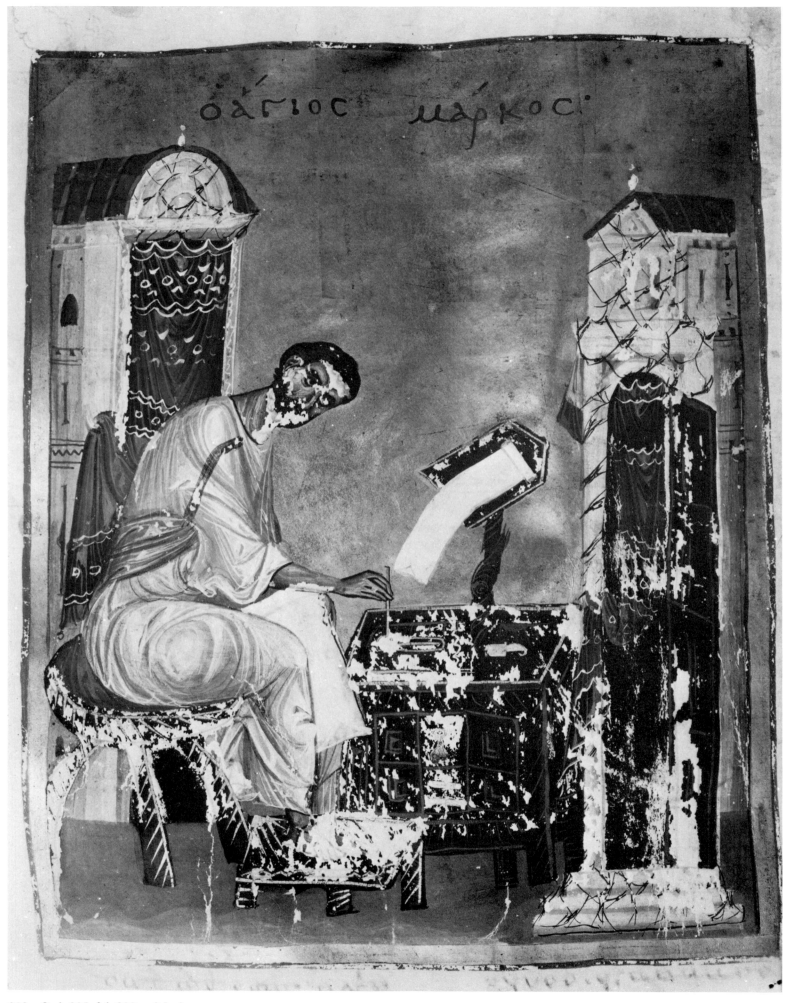

283. Cod. 205, fol. 200v. Mark

PLATE CV

:CΑΒΒΑΤΟΝΑ͞ΤΩ͞ΝΗ͞ΝΤΕΙΩ͞Ν:

ΚΑΙ Μ͞ΝΗΜΗΤ͞ΑΝΠ͞ΠΙΟΒΟ͞
ΕΚΟ͞Υ ΚΑΤΑ ΜΑΡΚΟΝ

284. Cod. 205, fol. 201r. Headpiece

PLATE CVI

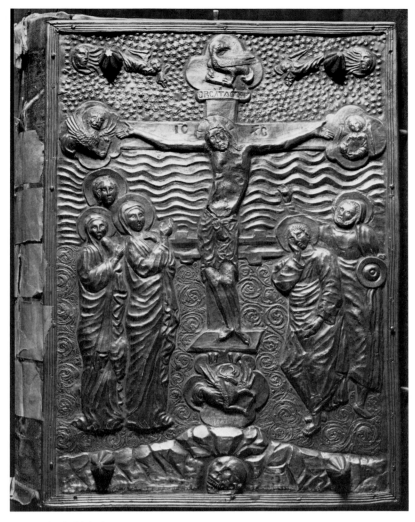

285. Cod. 205, front cover

286. Cod. 205, back cover

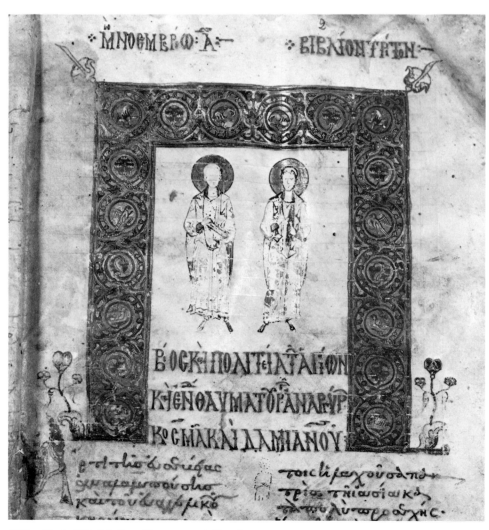

287. Cod. 499, fol. 2r. Cosmas and Damian

PLATE CVII

288. Cod. 499, fol. 26v. Headpiece

289. Cod. 499, fol. 142v. Headpiece

290. Cod. 499, fol. 164r. Headpiece

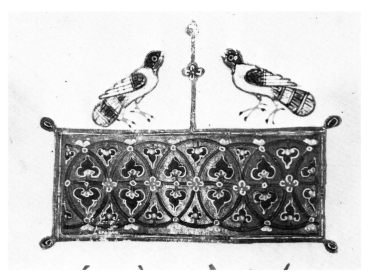

291. Cod. 499, fol. 213v. Headpiece

292. Cod. 503, fol. 1r. Headpiece

293. Cod. 503, fol. 40r. Headpiece

294. Cod. 503, fol. 201v. Headpiece

PLATE CVIII

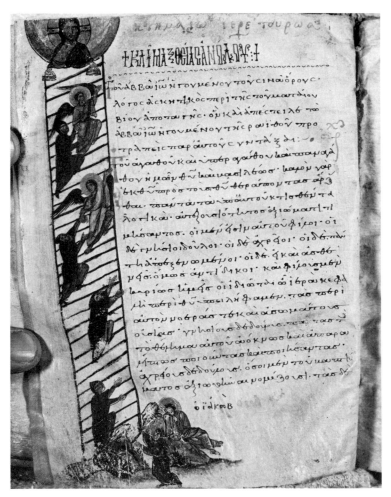

295. Cod. 423, fol. 10v. The heavenly ladder

296. Cod. 3, front cover

297. Cod. 3, back cover

PLATE CIX

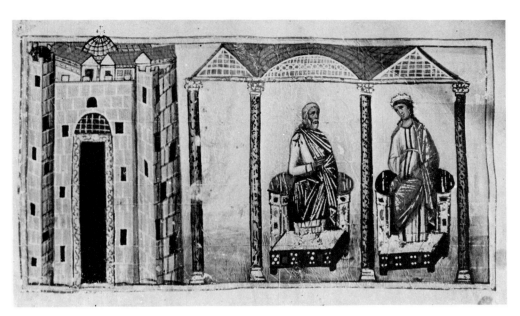

298. Cod. 3, fol. 7r. Job and his wife

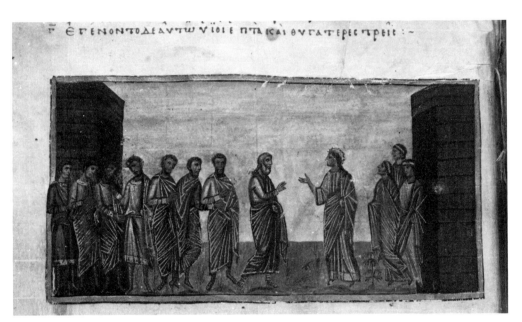

299. Cod. 3, fol. 7v. Job and his family

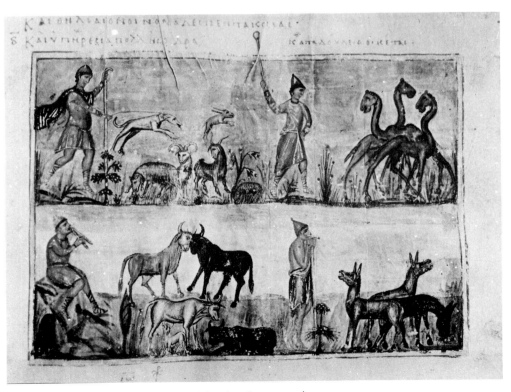

300. Cod. 3, fol. 8r. Job's herds (cf. colorplate XVII:a)

PLATE CX

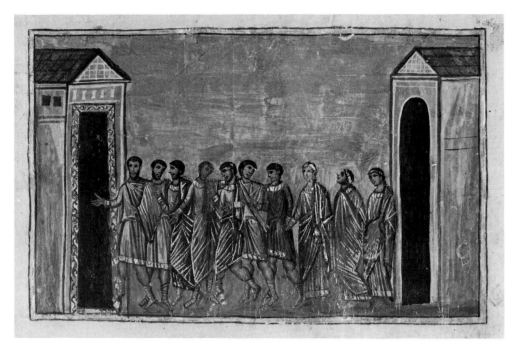

301. Cod. 3, fol. 8v. Job's children

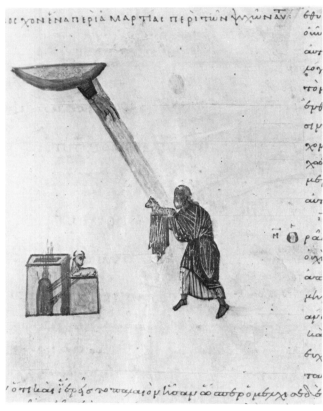

302. Cod. 3, fol. 9r. Job sacrificing

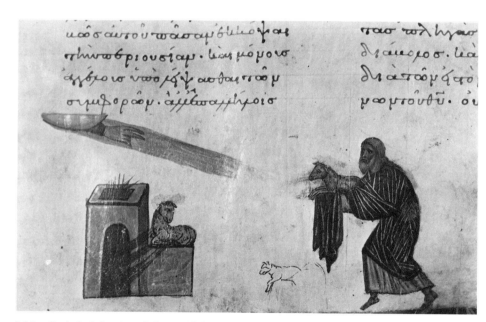

303. Cod. 3, fol. 10r. Job sacrificing

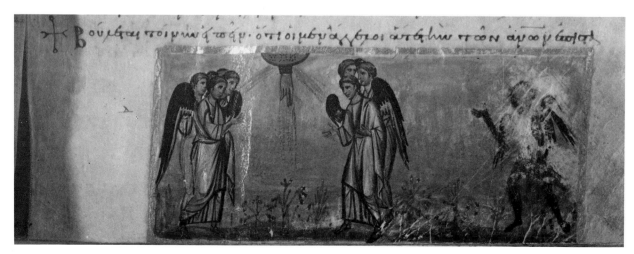

304. Cod. 3, fol. 13r. The Devil and the angels

PLATE CXI

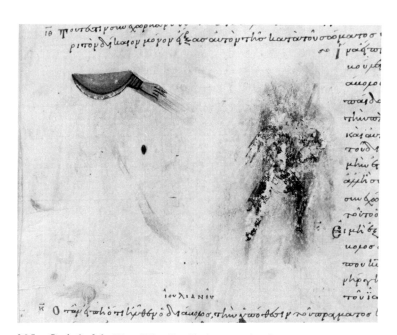

305. Cod. 3, fol. 17r. The Devil given authority

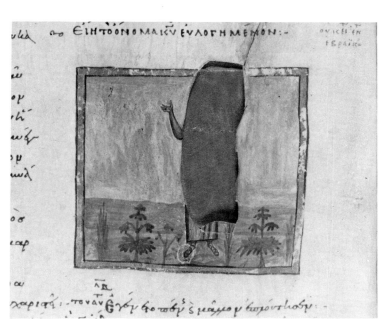

306. Cod. 3, fol. 21v. Job praying

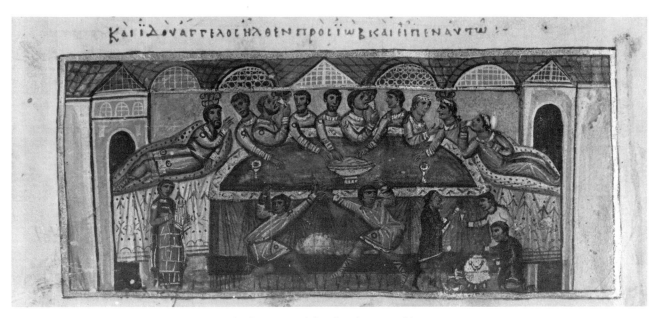

307. Cod. 3, fol. 17v. Job's children at the banquet (cf. colorplate XVII:b)

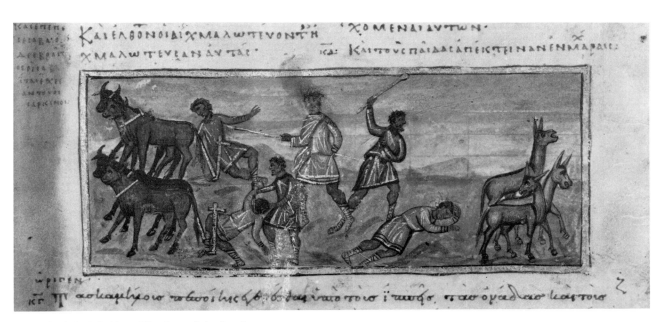

308. Cod. 3, fol. 18r. The loss of the herds

PLATE CXII

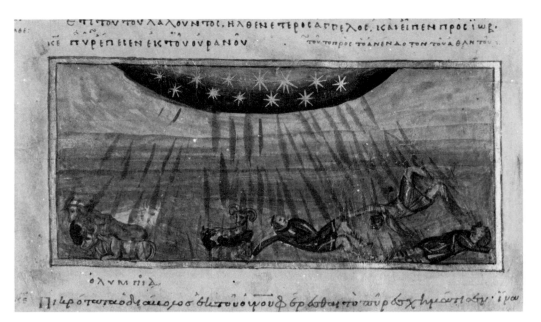

309. Cod. 3, fol. 18v. Fire falling upon the herds

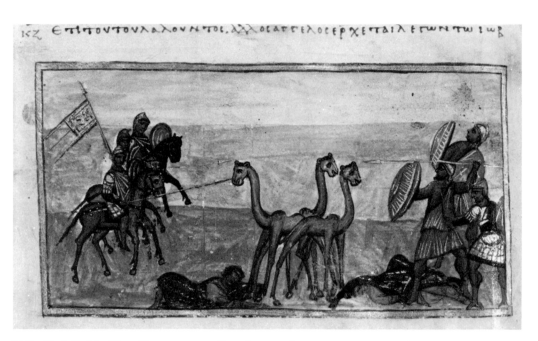

310. Cod. 3, fol. 19v. Horsemen stealing the camels

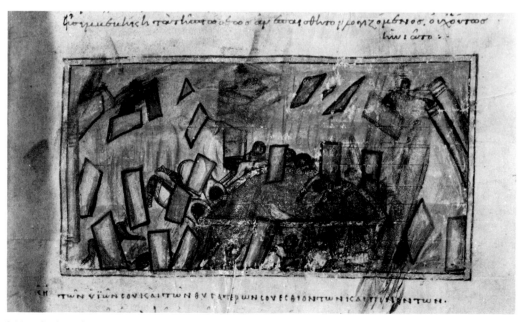

311. Cod. 3, fol. 20r. The collapse of the house

PLATE CXIII

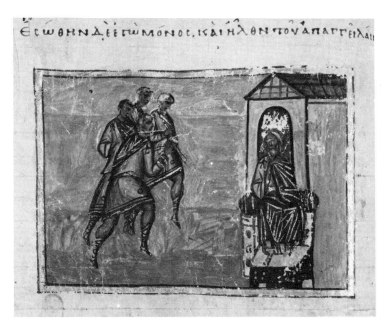

ЄⲤⲰⲐⲎⲚ·ⲆⲈⲈⲅⲰⲘⲞⲚⲞⲤ·ΚΑΙΗΛⲐⲞⲚⲦⲞⲨⲀⲠⲀⲄⲄⲈⲓⲖⲀⲓ

312. Cod. 3, fol. 20v. The disaster announced to Job

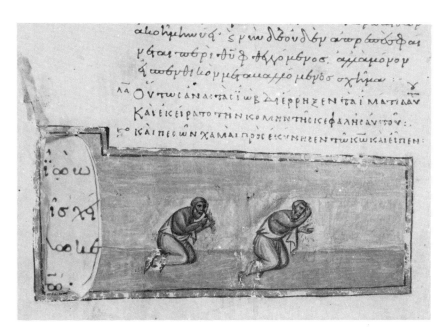

313. Cod. 3, fol. 21r. Job shaving his head and falling

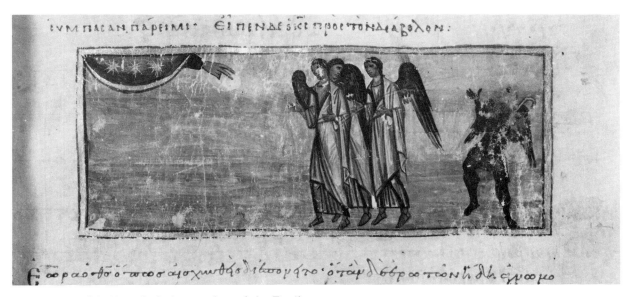

ⲤⲨⲘⲠⲀⲤⲀⲚ·ⲠⲀⲢⲈⲓⲘⲓ· ⲈⲓⲠⲈⲚⲆⲈ·ΚⳞⲠⲢⲞⲤⲦⲞⲚⲆⲓⲀⲂⲞⲖⲞⲚ:

314. Cod. 3, fol. 23r. God, the angels, and the Devil

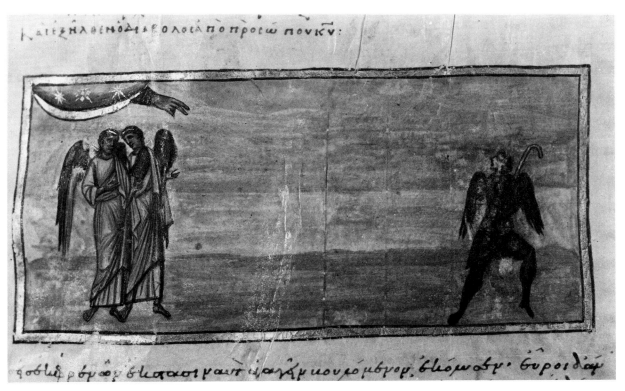

ΚⲀⲓⲈⳞⲎⲖⲐⲈⲚⲞⲆⲓⲀⲂⲞⲖⲞⲤⲀⲠⲞ·ⲠⲢⲞⲤⲰ·ⲠⲞⲨΚⳙ:

315. Cod. 3, fol. 25r. The Devil going out from the Lord

PLATE CXIV

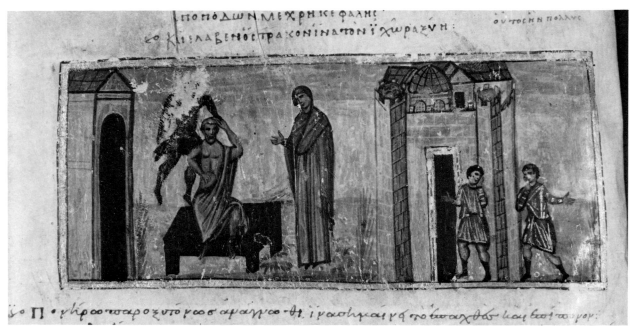

316. Cod. 3, fol. 25v. The Devil smiting Job with boils

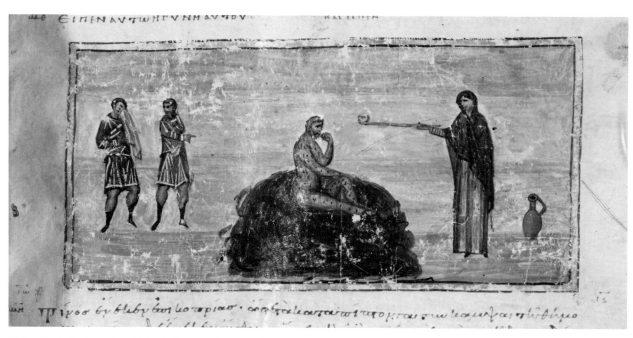

317. Cod. 3, fol. 26r. Job sitting on the dung heap

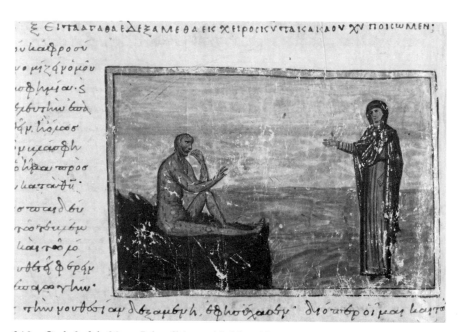

318. Cod. 3, fol. 28v. Job talking with his wife

PLATE CXV

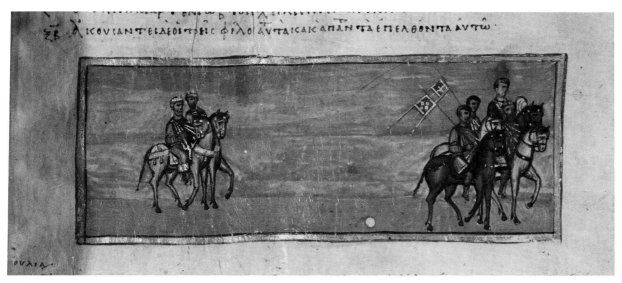

319. Cod. 3, fol. 29r. Two of Job's friends on the march

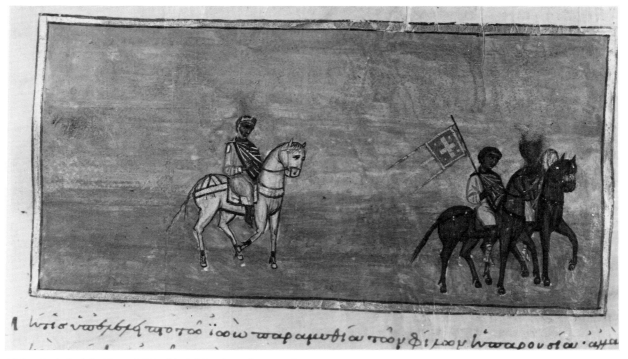

320. Cod. 3, fol. 29v. Job's third friend on the march

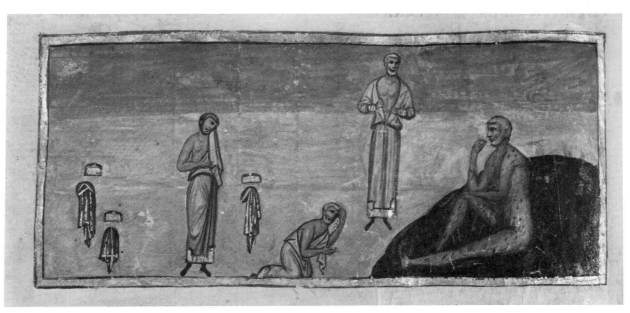

321. Cod. 3, fol. 30v. Arrival of Job's friends

PLATE CXVI

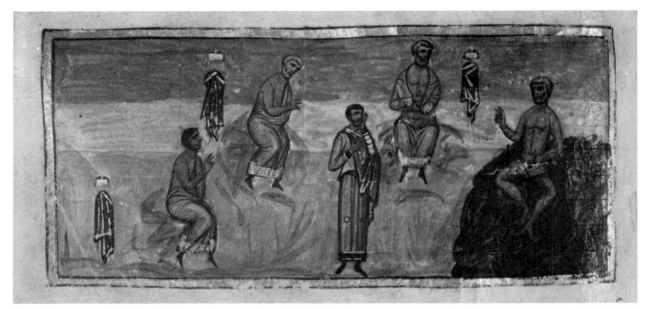

322. Cod. 3, fol. 30v. Job with his friends and Elihu (cf. colorplate XVII:c)

323. Cod. 3, fol. 169r

PLATE CXVII

324. Cod. 346, fol. 27r.
Initial Є, Gregory teaching
and St. Mamas

325. Cod. 346, fol. 32r.
Initial Π, Pentecost

326. Cod. 346, fol. 42v. Initial T, Gregory and Julian the
tax collector

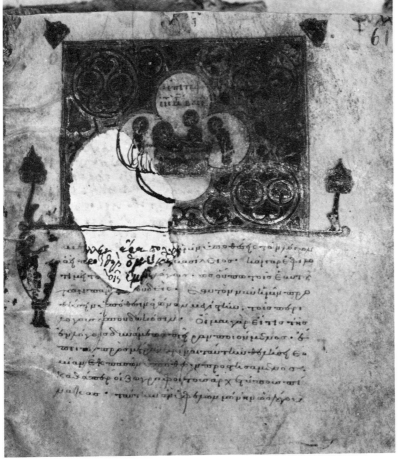

327. Cod. 346, fol. 51r.
Initial X, Nativity

329. Cod. 346, fol. 112v. Initial Π,
Baptism of Christ

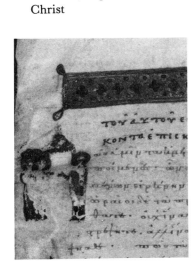

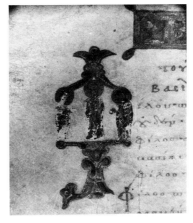

330. Cod. 346, fol. 123r.
Initial X, Baptism of
Christ

328. Cod. 346, fol. 61r. Koimesis of Basil and initial Є, Gregory

331. Cod. 346, fol. 152v.
Initial Φ, Gregory, Basil, and
Gregory of Nyssa

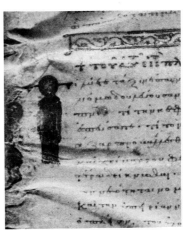

332. Cod. 346, fol. 180r.
Initial Π, Gregory and the
bishops

333. Cod. 346, fol. 194v.
Initial A, Gregory
giving alms

334. Cod. 346, fol. 227r. Initial
M, Gregory and St. Cyprian

335. Cod. 346, fol. 237r.
Initial T, Gregory and his
father

PLATE CXVIII

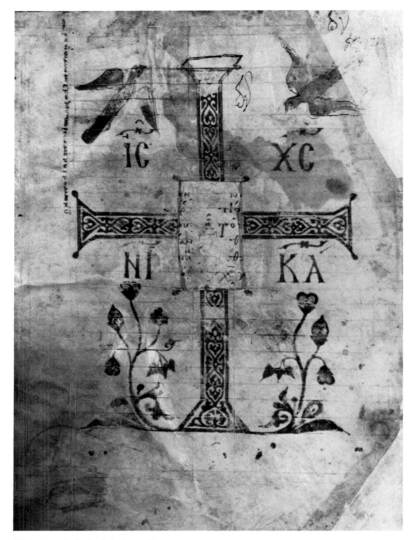

336. Cod. 341, fol. 2v. Cross

337. Cod. 341, fol. 49r. Headpiece

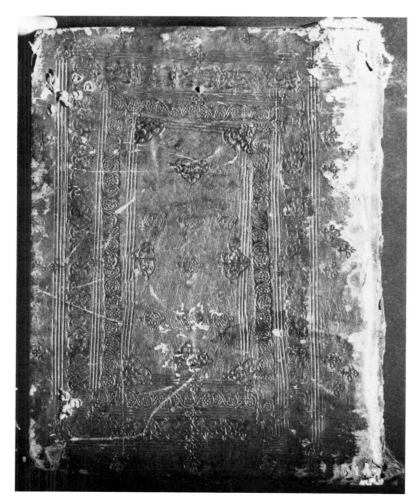

338. Cod. 341, front cover

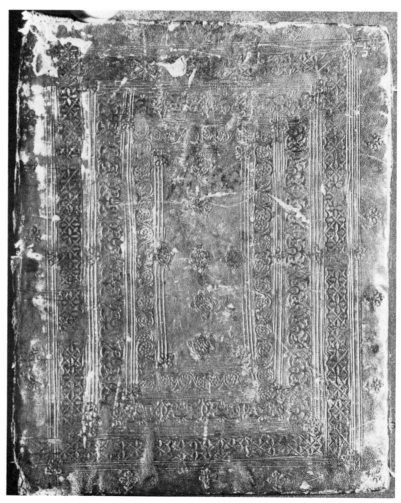

339. Cod. 341, back cover

PLATE CXIX

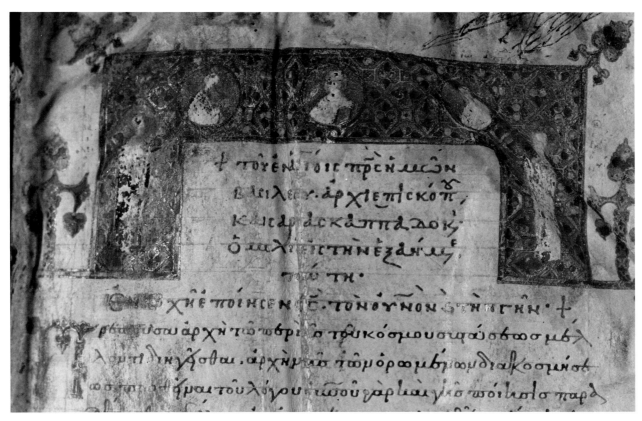

340. Cod. 326, fol. 3r. Headpiece with Deesis

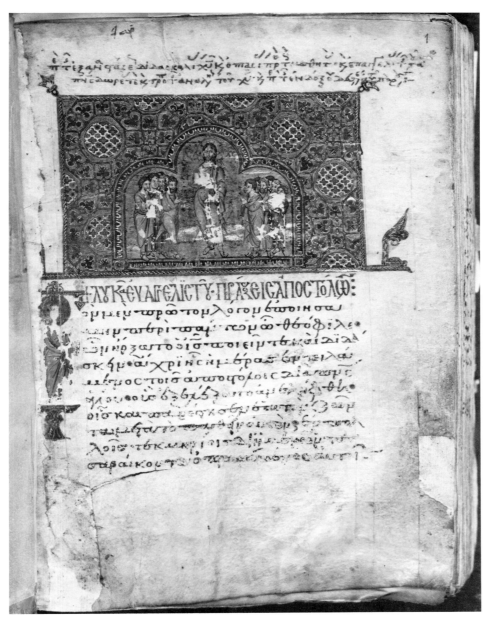

341. Cod. 275, fol. 1r. The Mission of the Apostles (cf. colorplate XVIII:a)

PLATE CXX

342. Cod. 275, fol. 90v. Headpiece

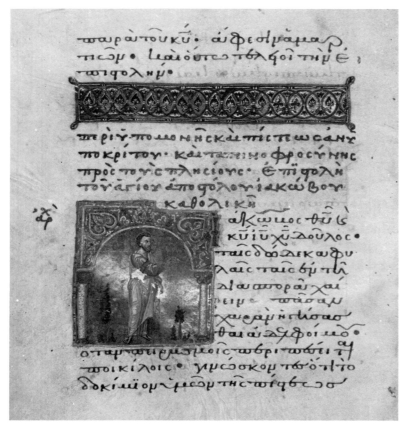

343. Cod. 275, fol. 91v. James

344. Cod. 275, fol. 100r. Headpiece

345. Cod. 275, fol. 101r. Peter

346. Cod. 275, fol. 110v. Headpiece

347. Cod. 275, fol. 111v. Peter

PLATE CXXI

348. Cod. 275, fol. 117v. Headpiece

349. Cod. 275, fol. 119r. Headpiece

350. Cod. 275, fol. 119v. John

351. Cod. 275, fol. 128r. Headpiece

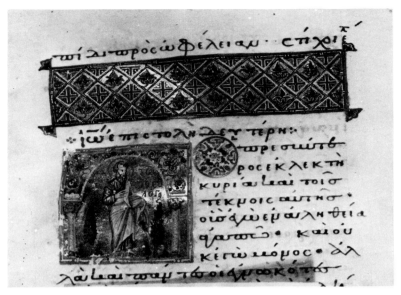

352. Cod. 275, fol. 129r. John

353. Cod. 275, fol. 130r. Headpiece

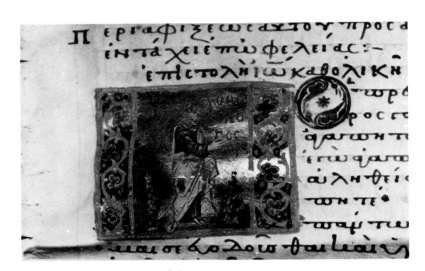

354. Cod. 275, fol. 131r. John

355. Cod. 275, fol. 132r. Headpiece

PLATE CXXII

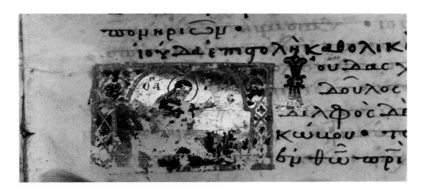

356. Cod. 275, fol. 133r. Judas

357. Cod. 275, fol. 135v. Headpiece

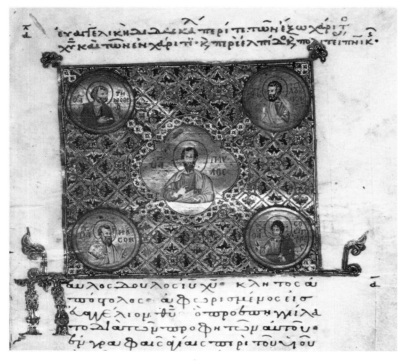

358. Cod. 275, fol. 139r. Paul with saints (cf. colorplate XVIII:b)

359. Cod. 275, fol. 172r. Headpiece

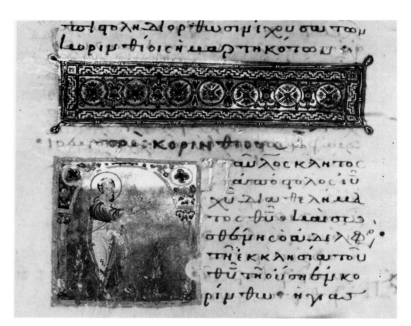

360. Cod. 275, fol. 173v. Paul

361. Cod. 275, fol. 205r. Headpiece

362. Cod. 275, fol. 226r. Headpiece

PLATE CXXIII

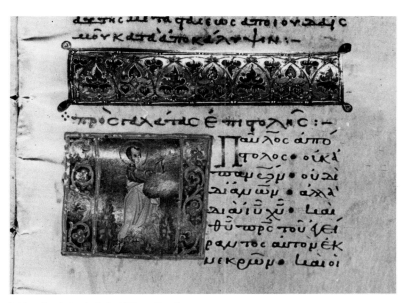

363. Cod. 275, fol. 227r. Paul

364. Cod. 275, fol. 244r. Headpiece

365. Cod. 275, fol. 245r. Paul and Timothy

366. Cod. 275, fol. 253v. Headpiece

367. Cod. 275, fol. 254v. Paul (cf. colorplate XVIII:c)

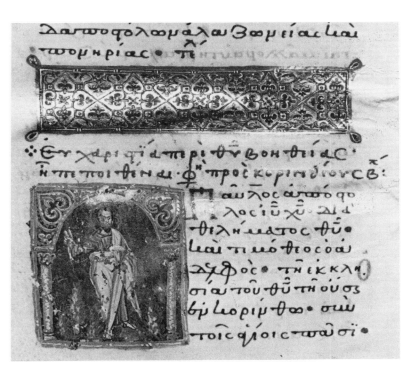

368. Cod. 275, fol. 256v. Paul

PLATE CXXIV

369. Cod. 275, fol. 260r. Headpiece

373. Cod. 275, fol. 278r. Headpiece

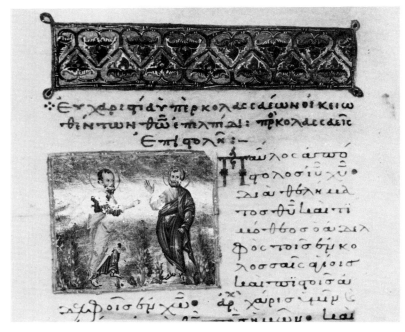

370. Cod. 275, fol. 261v. Paul and Timothy

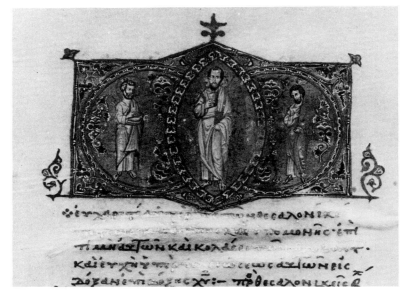

374. Cod. 275, fol. 279v. Paul, Timothy, and Silvanus

371. Cod. 275, fol. 269r. Headpiece

375. Cod. 275, fol. 283v. Headpiece

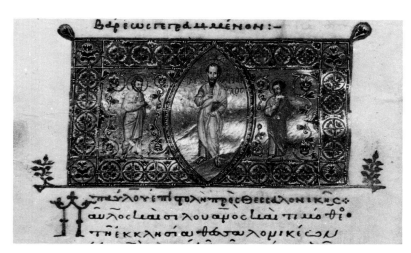

372. Cod. 275, fol. 270v. Paul, Timothy, and Silvanus

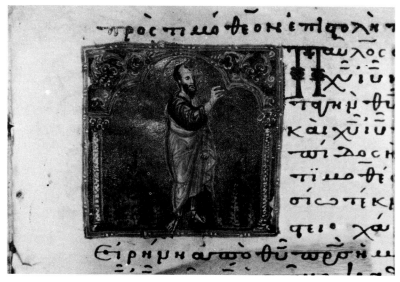

376. Cod. 275, fol. 286r. Paul

PLATE CXXV

377. Cod. 275, fol. 294v. Headpiece

381. Cod. 275, fol. 308v. Headpiece

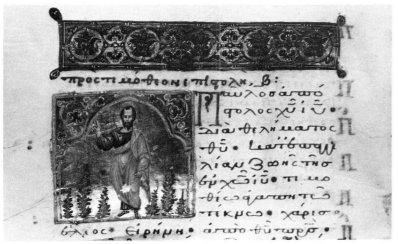

378. Cod. 275, fol. 296v. Paul

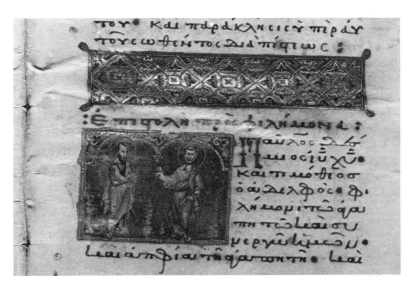

382. Cod. 275, fol. 309r. Paul and Timothy

379. Cod. 275, fol. 303r. Headpiece

383. Cod. 275, fol. 311r. Headpiece

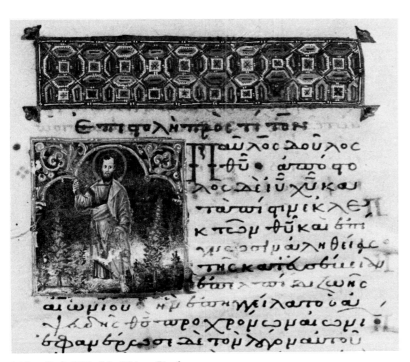

380. Cod. 275, fol. 304r. Paul

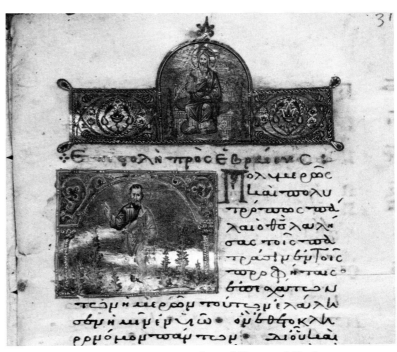

384. Cod. 275, fol. 314r. The Ancient of Days and Paul

PLATE CXXVI

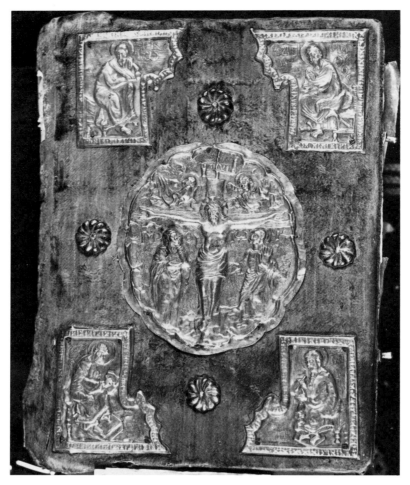

385. Cod. 275, front cover

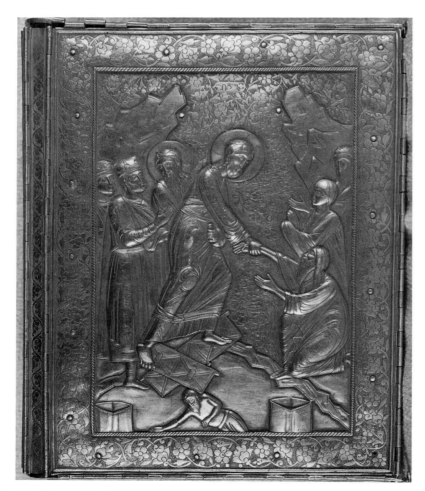

386. Cod. 207, front cover

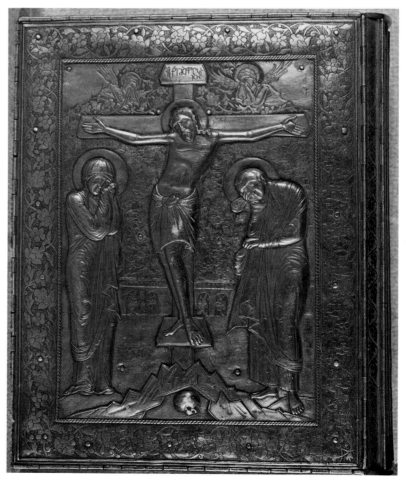

387. Cod. 207, back cover

PLATE CXXVII

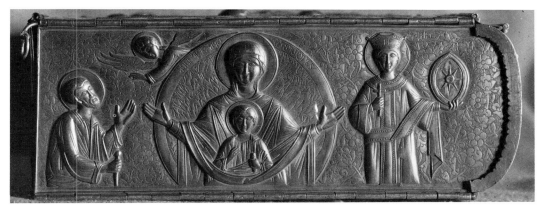

388. Cod. 207, top of cover

389. Cod. 207, spine

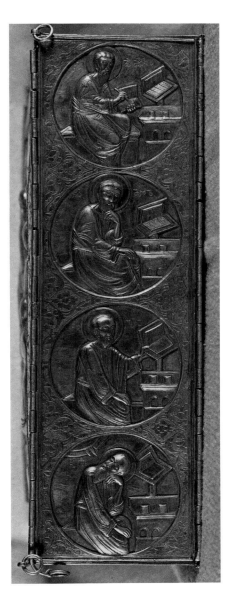

390. Cod. 207, side of cover

391. Cod. 207, bottom of cover

PLATE CXXVIII

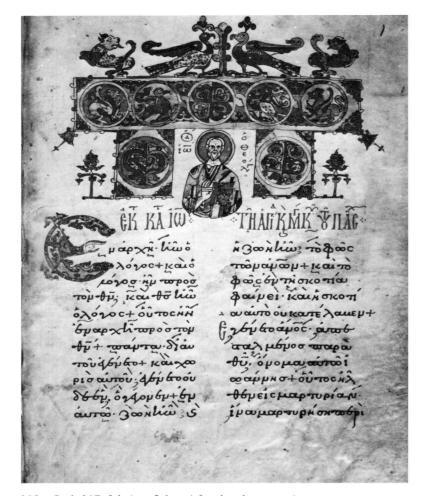

392. Cod. 207, fol. 1r. John (cf. colorplate XIX:a)

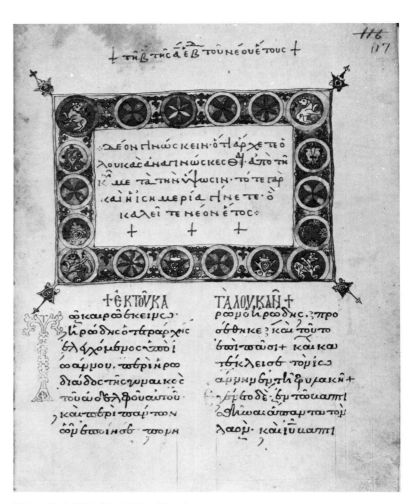

394. Cod. 207, fol. 117r. Headpiece

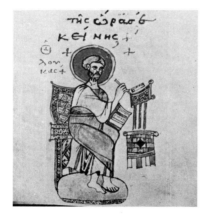

393. Cod. 207, fol. 116v. Luke

395. Cod. 207, fol. 210r. Headpiece

396. Cod. 207, fol. 245v. Headpiece

397. Cod. 207, fol. 285r. Headpiece

PLATE CXXIX

398. Cod. 508, fol. 26v. Headpiece

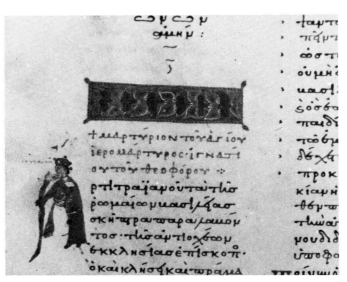

399. Cod. 508, fol. 66v. Headpiece, initial A, emperor
Trajan (cf. colorplate XIX:b)

400. Cod. 508, fol. 134v. Headpiece

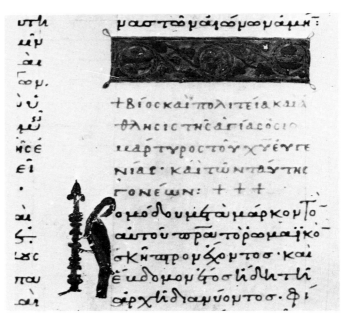

401. Cod. 508, fol. 142r. Headpiece

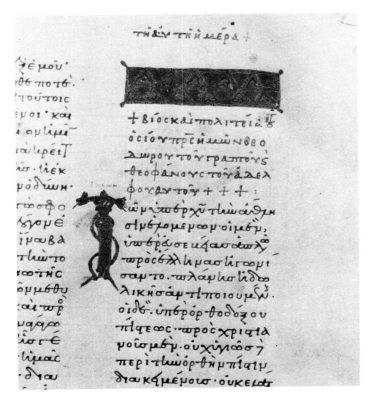

402. Cod. 508, fol. 190r. Headpiece, initial T,
emperor Leo

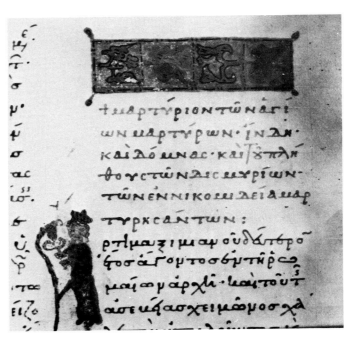

403. Cod. 508, fol. 234v. Headpiece, initial A,
emperor Maximian

PLATE CXXX

404. Cod. 508, inside of back cover

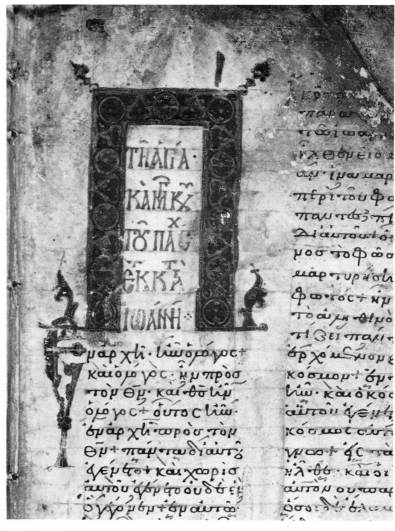

405. Cod. 219, fol. 1r. Headpiece

406. Cod. 219, front cover

407. Cod. 219, back cover

PLATE CXXXI

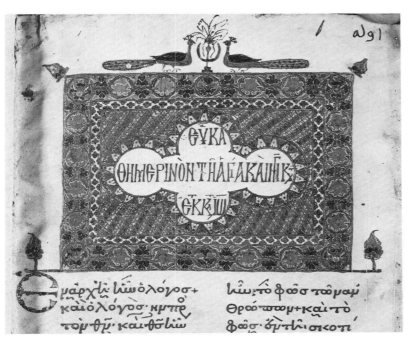

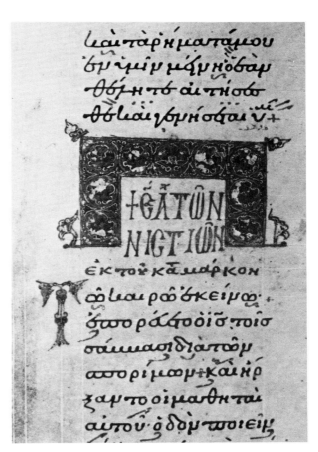

408. Cod. 218, fol. 1r. Headpiece

409. Cod. 218, fol. 209v. Headpiece

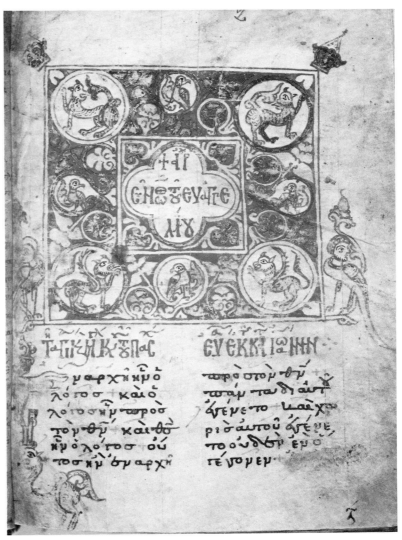

410. Cod. 237, fol. 1r. Headpiece

411. Cod. 237, fol. 2r. Headpiece

PLATE CXXXII

412. Cod. 237, fol. 40r. Headpiece

413. Cod. 237, fol. 116r. Headpiece

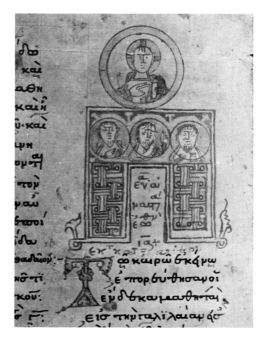

419. Cod. 237, fol. 177v. Headpiece,
Christ and evangelists

414. Cod. 237, fol. 128r.
Headpiece

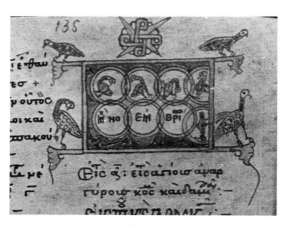

415. Cod. 237, fol. 135r. Headpiece

416. Cod. 237, fol. 149r.
Headpiece

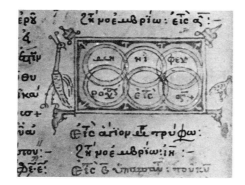

417. Cod. 237, fol. 157v. Headpiece

418. Cod. 237, fol. 165v. Headpiece

420. Cod. 237, back cover

PLATE CXXXIII

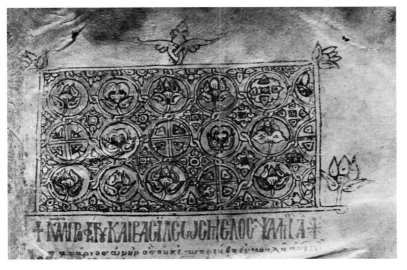

421. Cod. 259, fol. 3r. Headpiece

422. Cod. 259, fol. 61r. Headpiece

423. Cod. 259, fol. 198r. Headpiece

424. Cod. 259, fol. 249r. Headpiece

425. Cod. 259, front cover

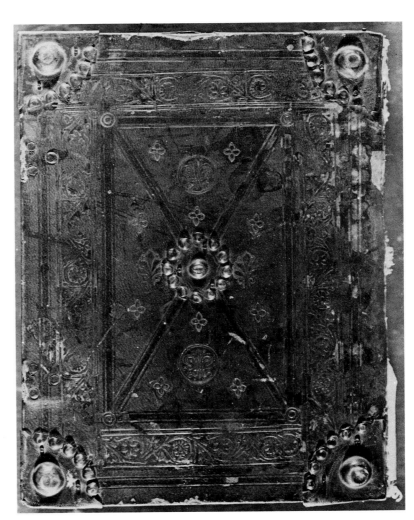

426. Cod. 259, back cover

PLATE CXXXIV

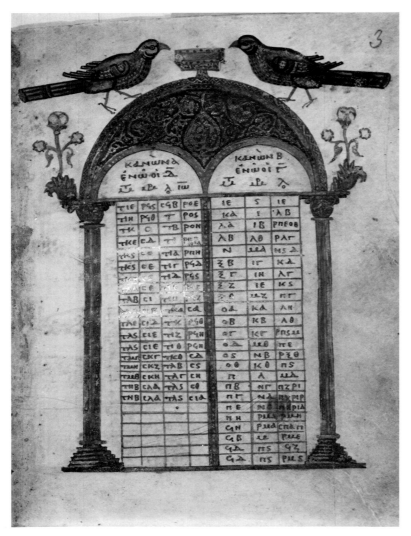

427. Cod. 179, fol. 3r. Canon table

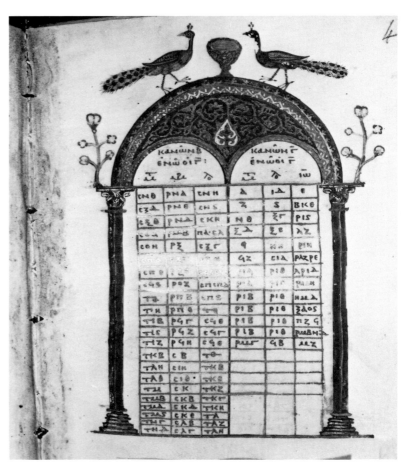

428. Cod. 179, fol. 4r. Canon table

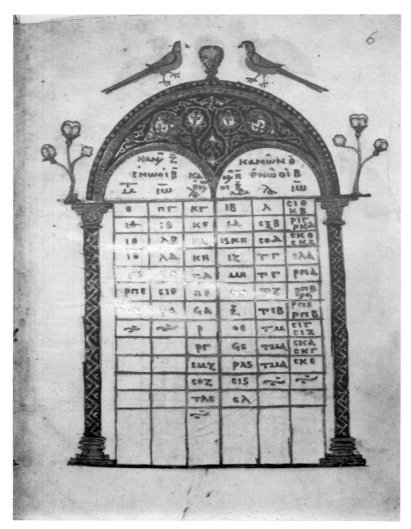

429. Cod. 179, fol. 6r. Canon table

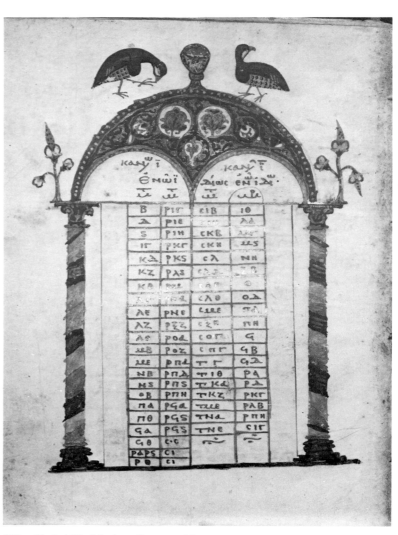

430. Cod. 179, fol. 6v. Canon table

PLATE CXXXV

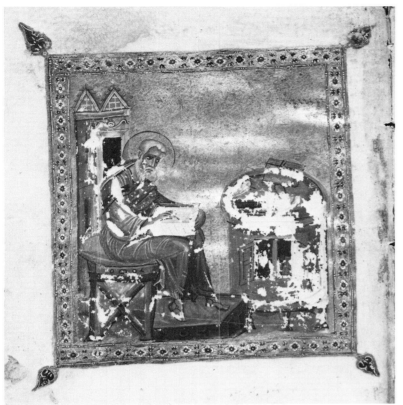

431. Cod. 179, fol. 12v. Matthew

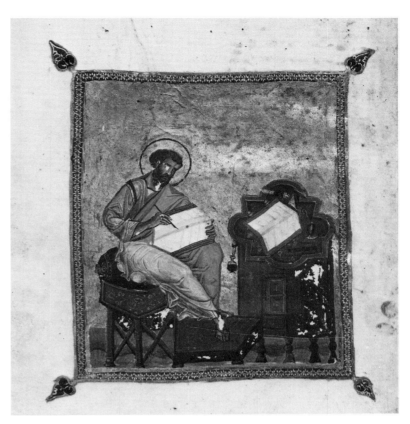

432. Cod. 179, fol. 84v. Mark (cf. colorplate xx:a)

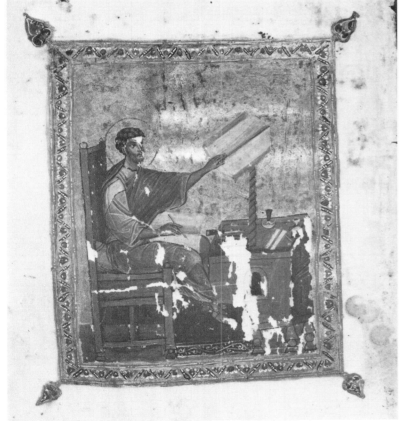

433. Cod. 179, fol. 133v. Luke

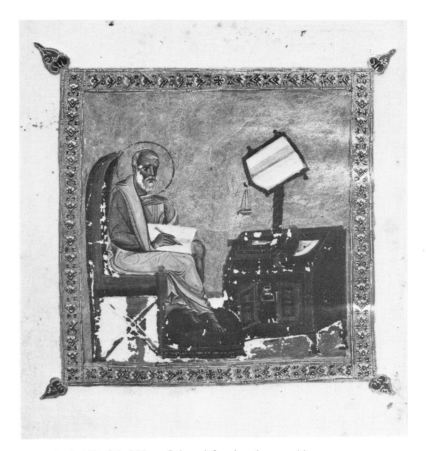

434. Cod. 179, fol. 209v. John (cf. colorplate xx:b)

PLATE CXXXVI

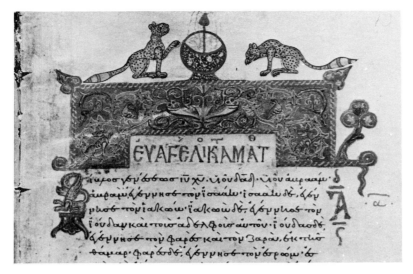

435. Cod. 179, fol. 13r. Headpiece

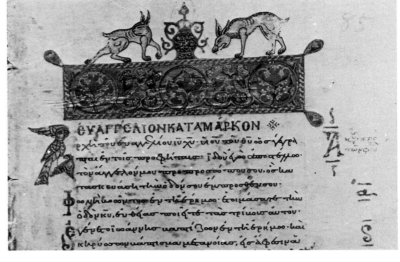

436. Cod. 179, fol. 85r. Headpiece

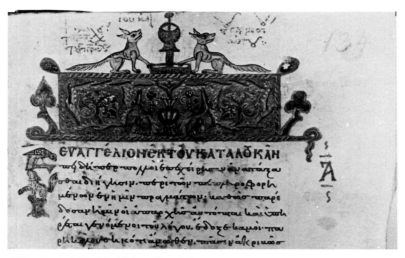

437. Cod. 179, fol. 134r. Headpiece

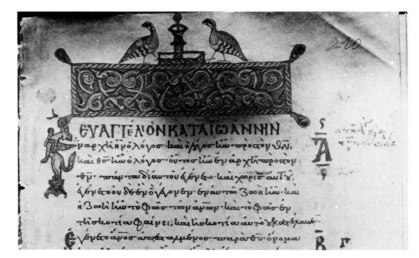

438. Cod. 179, fol. 210r. Headpiece

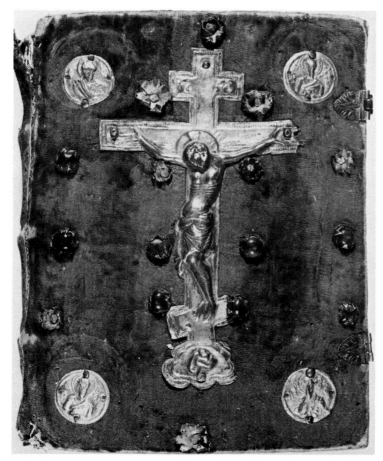

439. Cod. 179, front cover

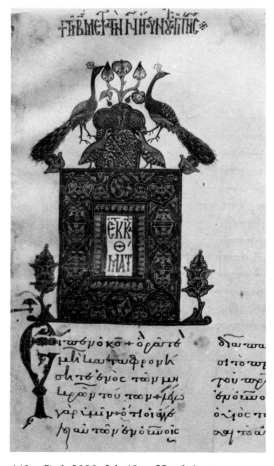

440. Cod. 2090, fol. 40r. Headpiece
(cf. colorplate xx:c)

PLATE CXXXVII

441. Cod. 234, fol. 1r. Headpiece

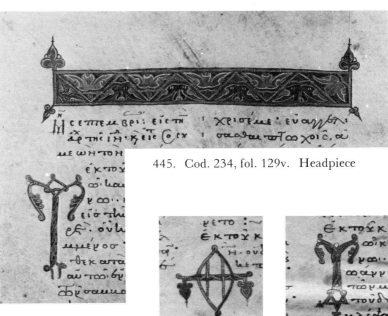

445. Cod. 234, fol. 129v. Headpiece

442. Cod. 234, fol.
1v. Initial Θ

443. Cod. 234, fol.
3v. Initial T

444. Cod. 234, fol. 33v. Headpiece

447. Cod. 44, fol. 1r. Headpiece

446. Cod. 234, fol. 172r. Colophon

448. Cod. 44, fol. 95v. Moses

PLATE CXXXVIII

449. Cod. 44, fol. 214v. Easter tables

450. Cod. 44, fol. 215v. Easter tables

451. Cod. 39, fol. 9r. Headpiece

452. Cod. 39, fol. 329v. David

453. Cod. 39, front cover

PLATE CXXXIX

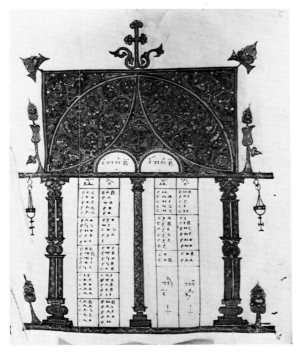

454. Cod. 158, fol. 5r. Canon table

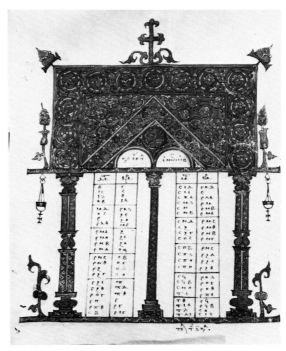

455. Cod. 158, fol. 5v. Canon table

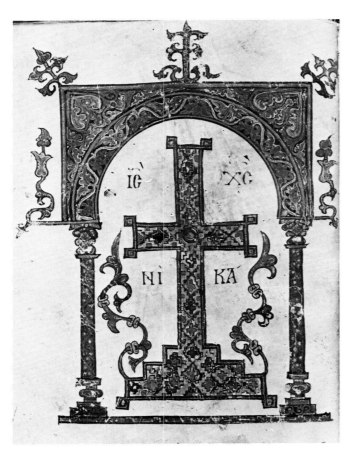

456. Cod. 158, fol. 10v. Cross

458. Cod. 158, back cover

457. Cod. 158, fol. 11r. Headpiece

PLATE CXL

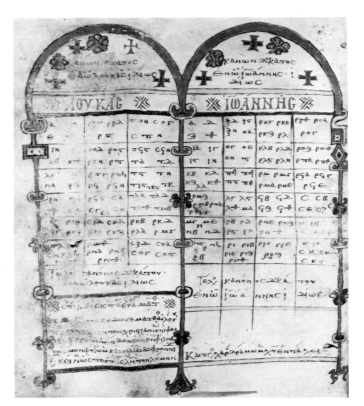

459. Cod. 193, fol. 2v. Canon table

460. Cod. 193, fol. 4v. Canon table

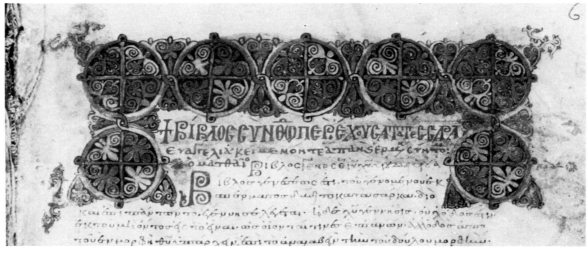

461. Cod. 193, fol. 6r. Headpiece

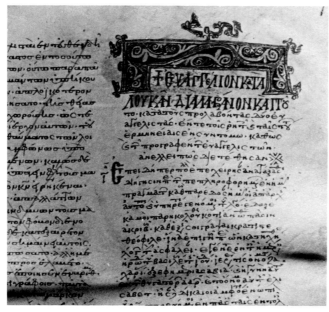

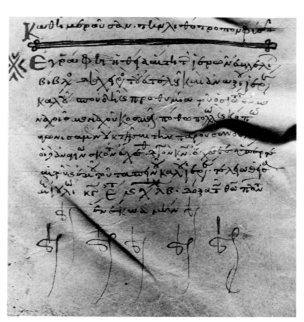

462. Cod. 193, fol. 149r. Headpiece

463. Cod. 193, fol. 322v. Colophon

PLATE CXLI

464. Cod. 193, front cover

465. Cod. 193, back cover

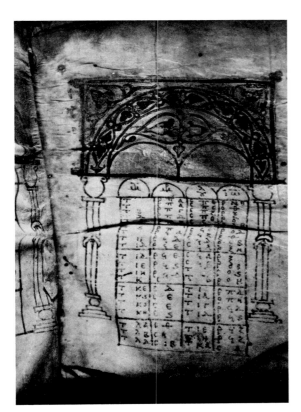

466. Cod. 174, fol. 4r. Canon table

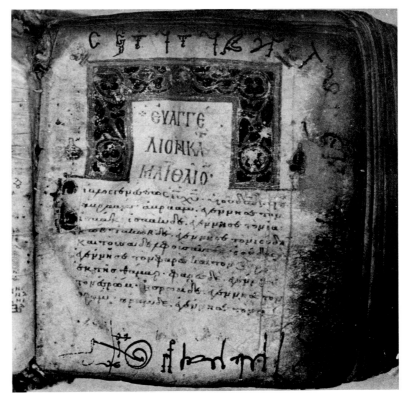

467. Cod. 174, fol. 6r. Headpiece

PLATE CXLII

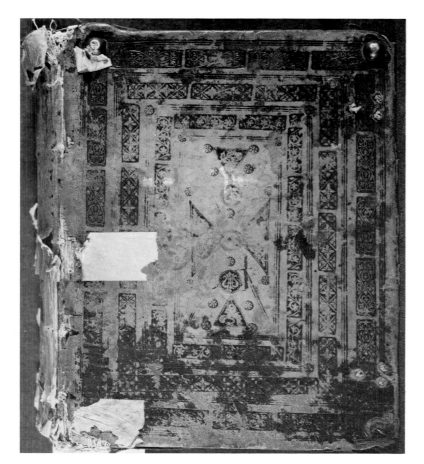

468. Cod. 339, front cover

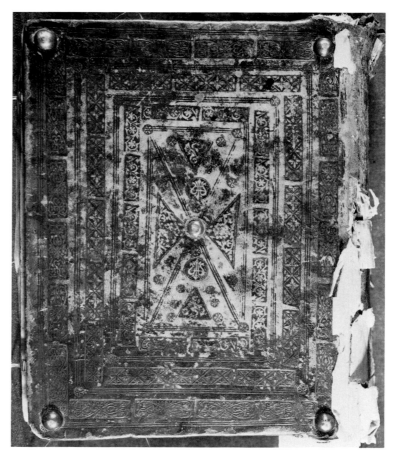

469. Cod. 339, back cover

470. Cod. 339, fol. 3r. Dedication

471. Cod. 339, fol. 437v. Colophon

PLATE CXLIII

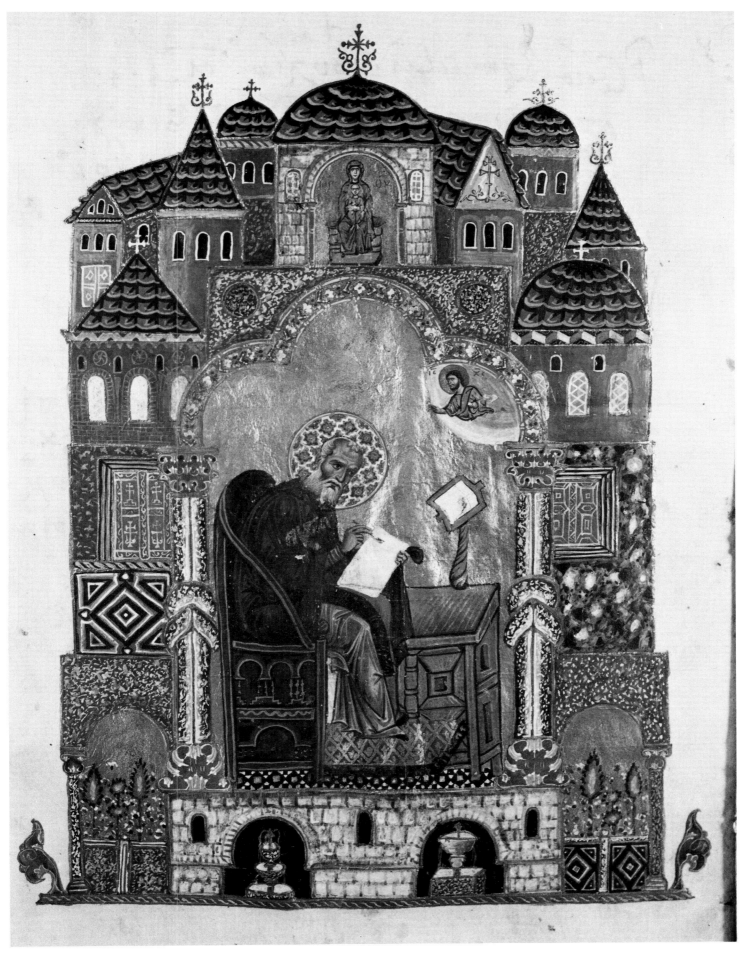

472. Cod. 339, fol. 4v. Gregory of Nazianzus

PLATE CXLIV

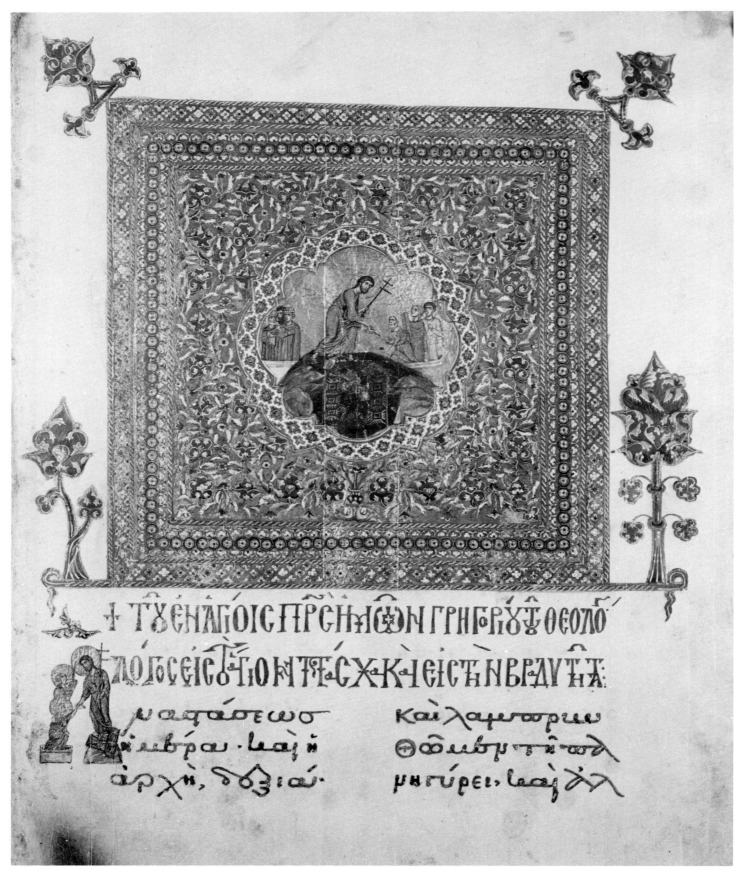

473. Cod. 339, fol. 5r. Anastasis

PLATE CXLV

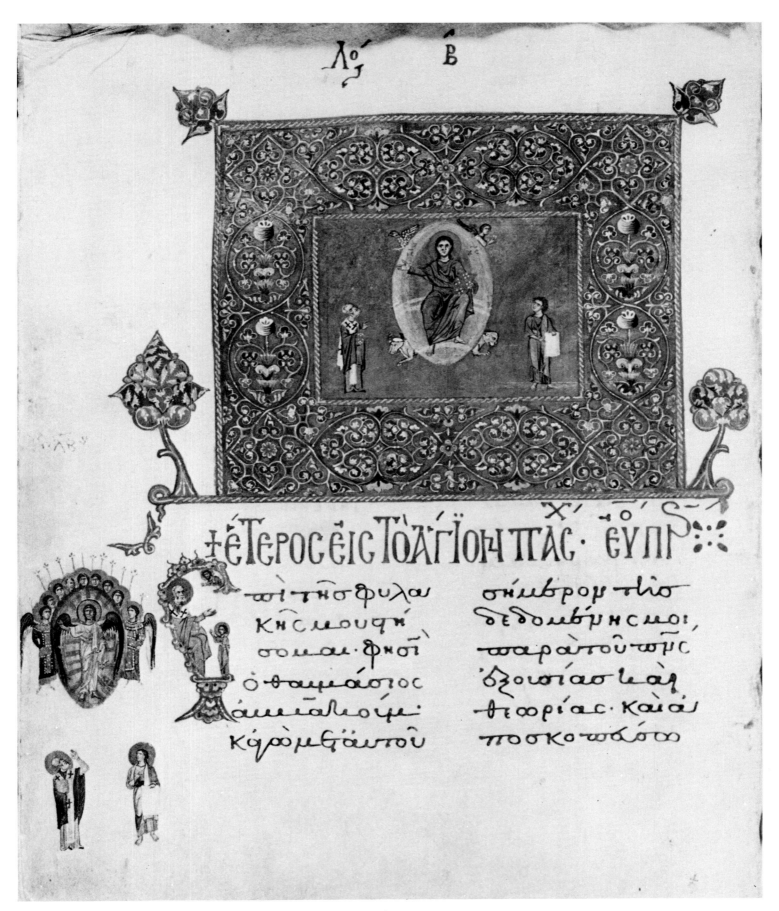

474. Cod. 339, fol. 9v. The vision of Habakkuk (cf. colorplate XXI)

PLATE CXLVI

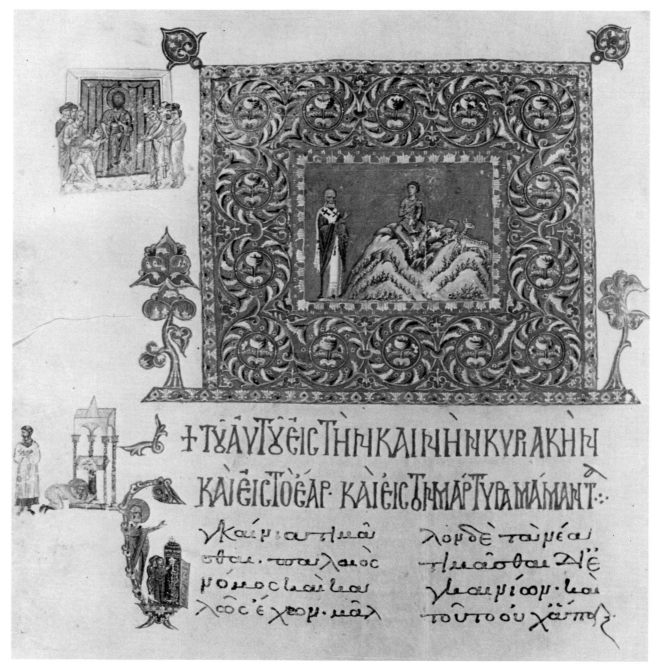

† ΤΥ ΑΥΤΥ ЄΙС ΤΗΝ ΚΑΙΝΗΝ ΚΥΡΑΚΗΝ
ΚΑΙ ЄΙС ΤΟ ЄΑΡ ΚΑΙ ЄΙС ΤΗΝ ΜΑΡΤΥΡΑ ΜΑΜΑΝΤ :

475. Cod. 339, fol. 42v. Gregory and Mamas, encaenia, incredulity of Thomas

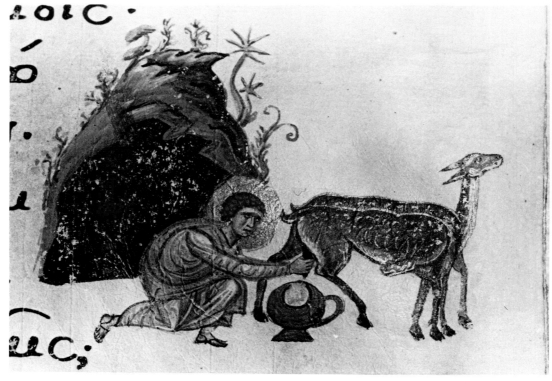

476. Cod. 339, fol. 53r. Mamas milking

PLATE CXLVII

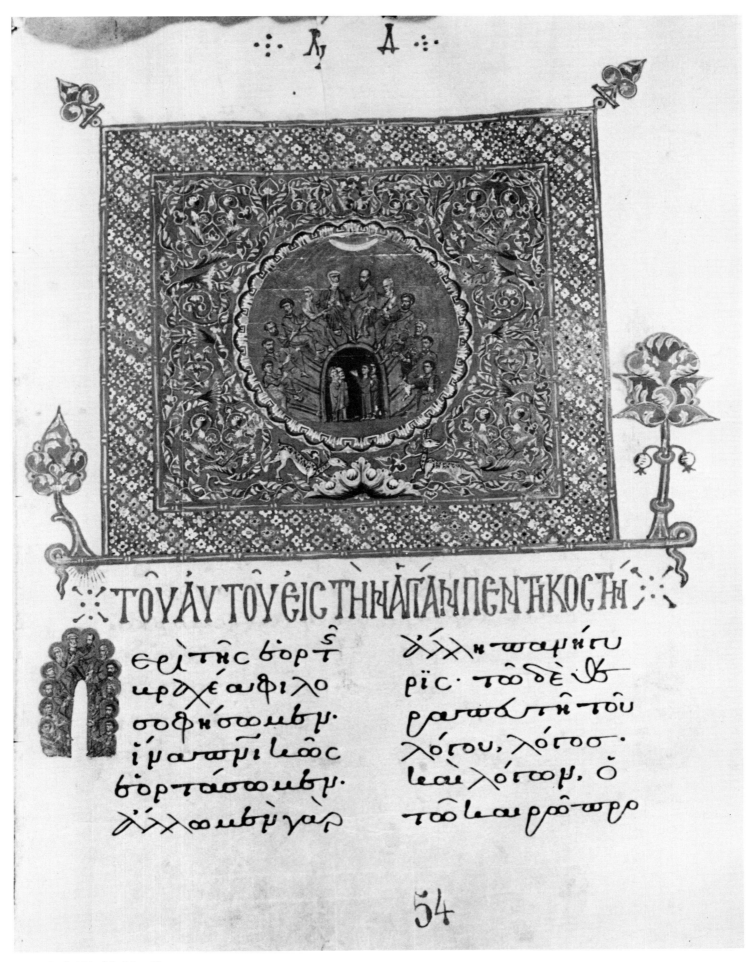

477. Cod. 339, fol. 54r. Pentecost

PLATE CXLVIII

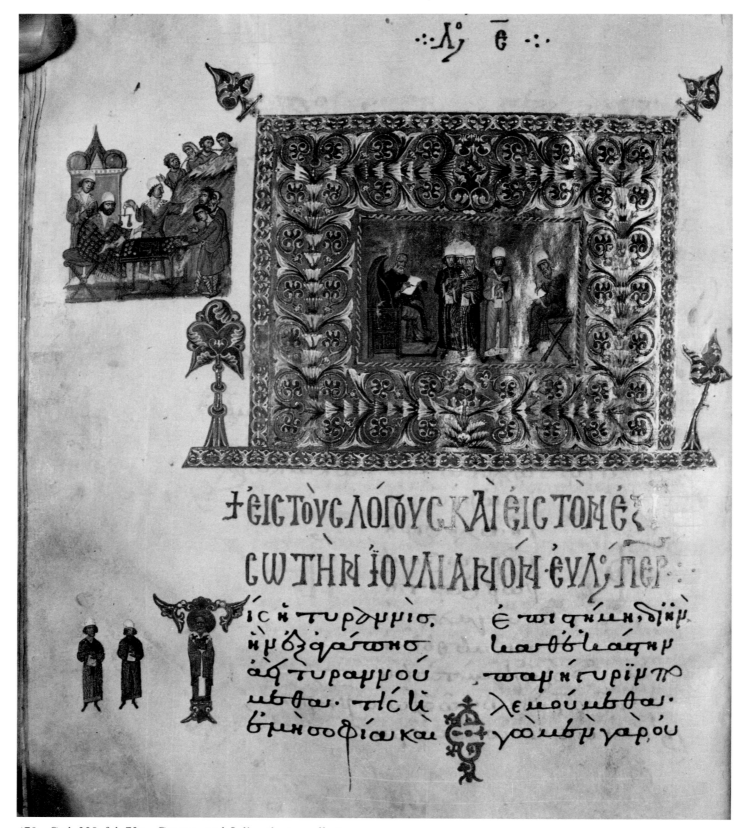

478. Cod. 339, fol. 73v. Gregory and Julian the tax collector

PLATE CXLIX

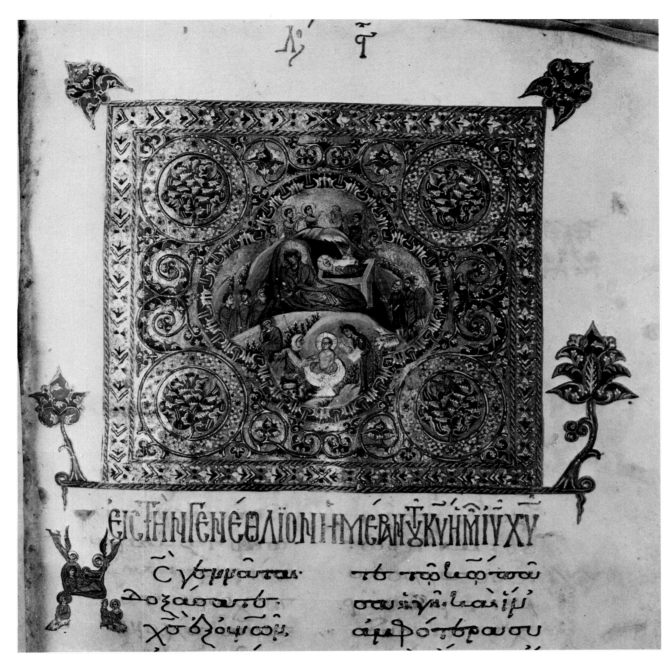

479. Cod. 339, fol. 91r. The Nativity

480. Cod. 339, fol. 91v. Women adoring the Virgin

PLATE CL

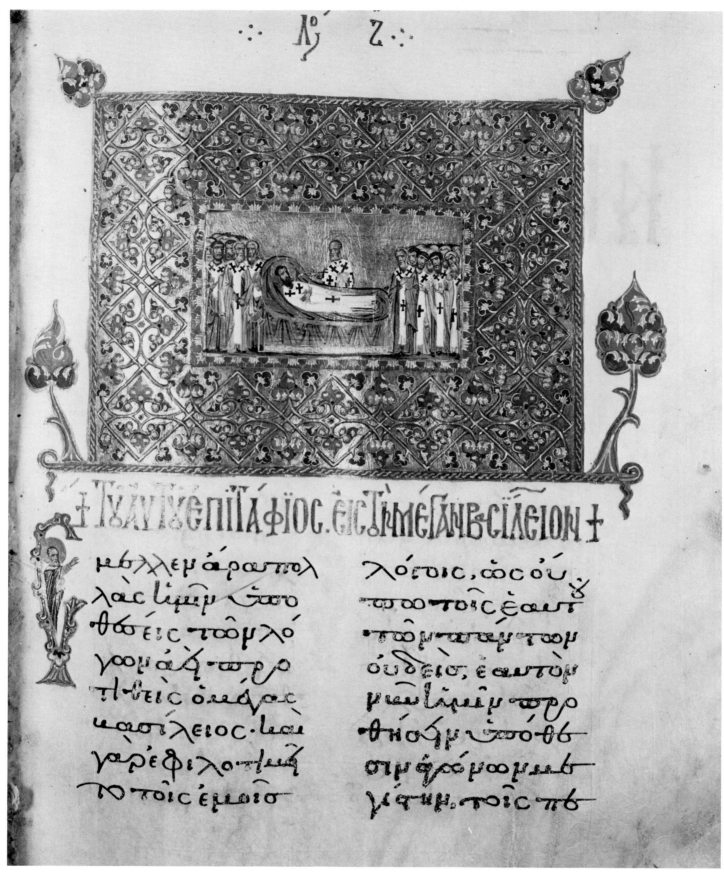

481. Cod. 339, fol. 109r. Koimesis of Basil

PLATE CLI

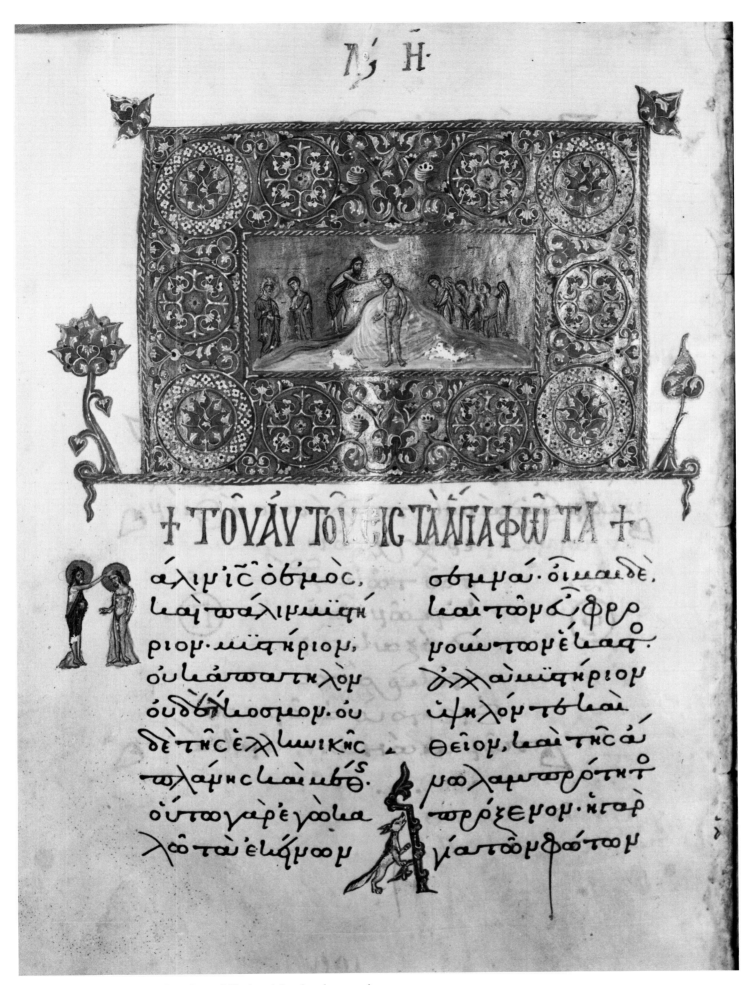

† ΤΟΥ ΑΥΤΟΥ ΕΙΣ ΤΑ ΑΓΙΑ ΦΩΤΑ †

ἀλιμισ΄ ὁ θμὸς,
καὶ τὸ ἀλιμιᾶρι-
ριον· μυστήριον,
οὐ καταωστικλὸν
οὐδ τλεσσμοῦ. οὐ
δὲ τῆς ελλιωικῆς
πλαμισ καὶ μβ̅ς.
οὕτω γὰρ ἐγούκα
λοται ελιᾶμοον

σθμμαῖ οἱ ιαιδε.
καὶ τὸ μᾶ φρο
μοῶτω μέ καῆ.
ἀλλὰ μυστήριον
ιφηλόν τὸ καὶ
θεῖον, καὶ τῆς ά
μολαμπορτηῖ
ωρόχεμον· καὶ
γίατωρβο ὅτοορ

482. Cod. 339, fol. 197v. Baptism of Christ (cf. colorplate XXII)

PLATE CLII

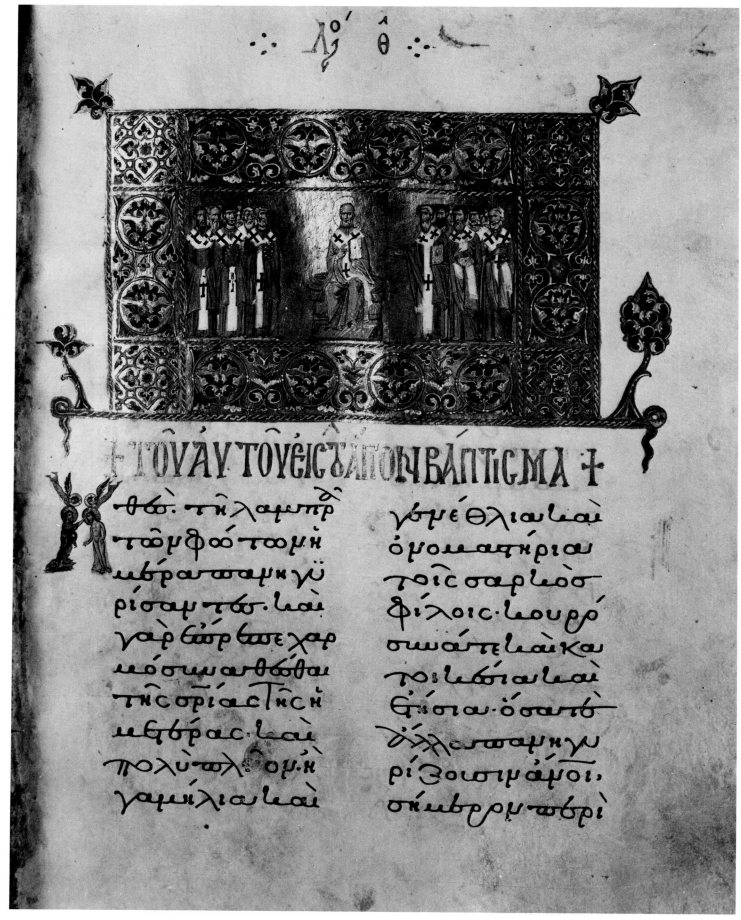

483. Cod. 339, fol. 217r. Gregory teaching bishops, initial X, Baptism

PLATE CLIII

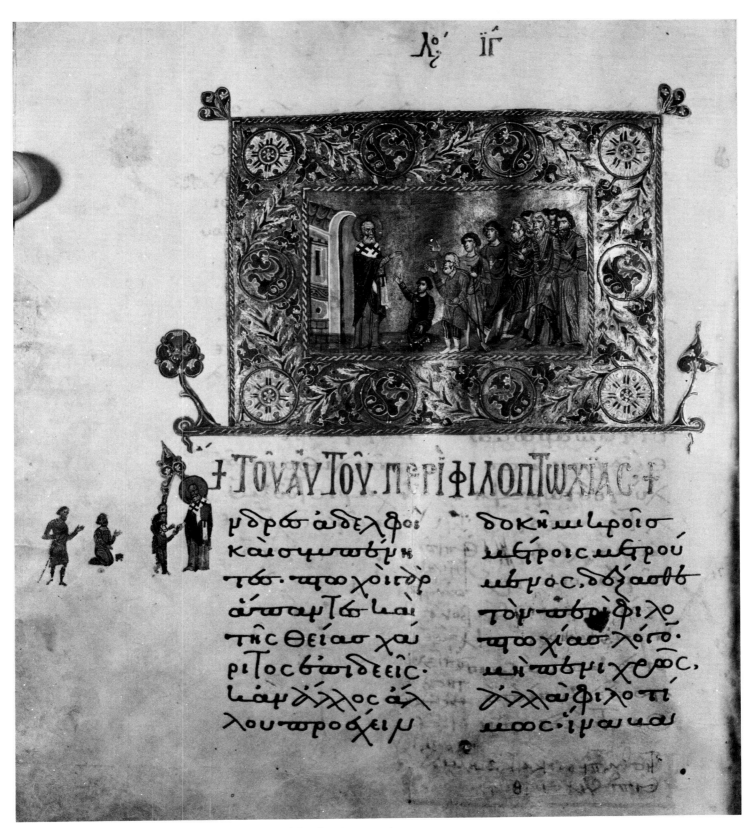

484. Cod. 339, fol. 341v. Gregory and the poor (cf. colorplate XXIII)

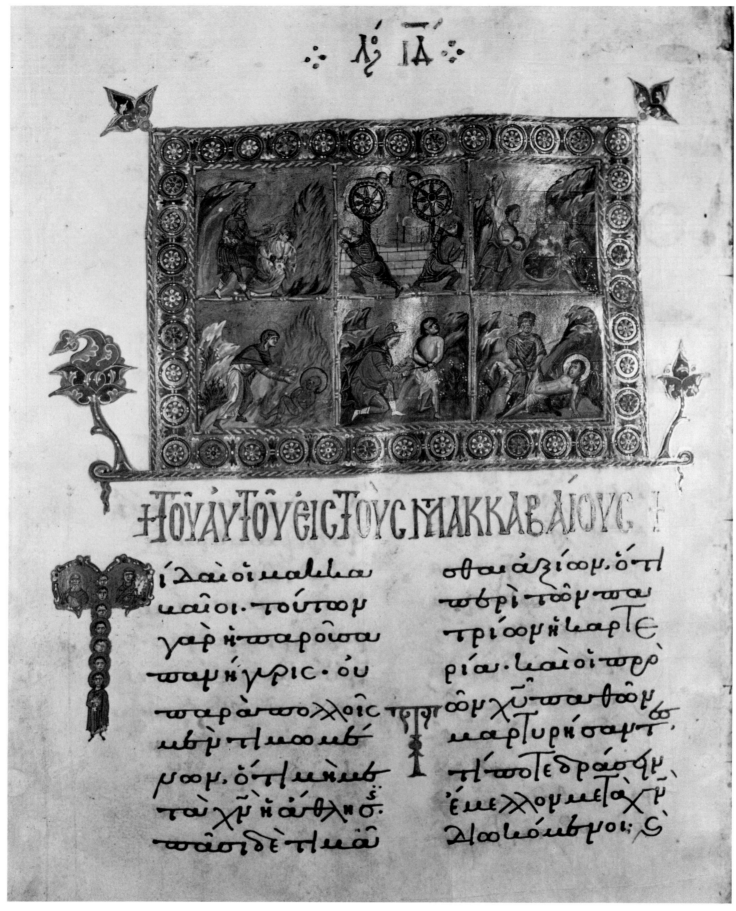

485. Cod. 339, fol. 381v. Martyrdom of the Maccabees, initial T, Eleazar (cf. colorplate XXIV)

PLATE CLV

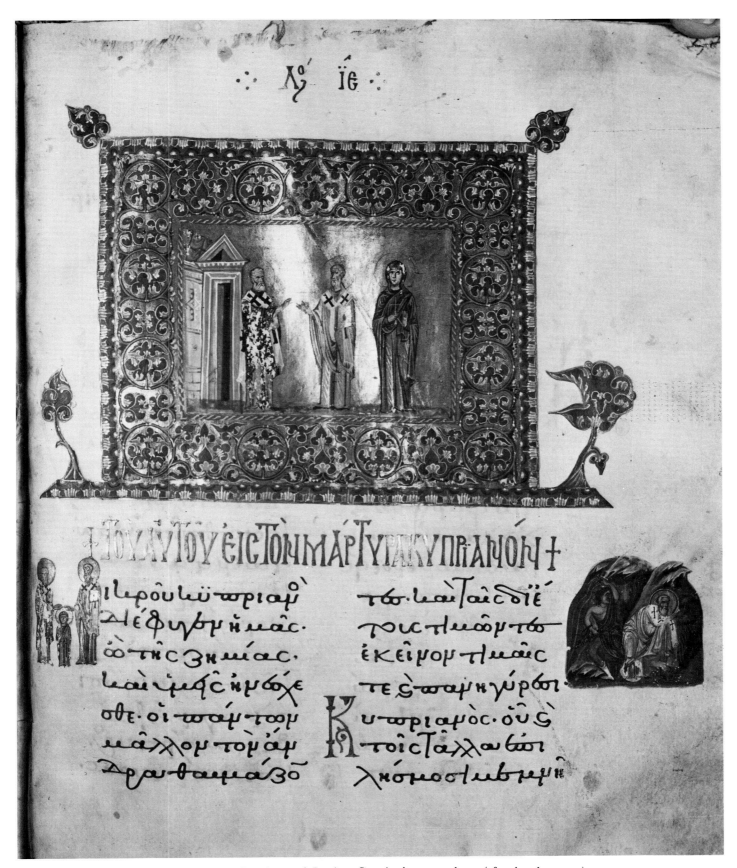

486. Cod. 339, fol. 397r. Gregory with Cyprian and Justina, Cyprian's martyrdom (cf. colorplate xxv)

PLATE CLVI

487. Cod. 339, fol. 7r.
Initial Φ

488. Cod. 339, fol. 8v.
Initial Υ

489. Cod. 339, fol. 10r.
Initial Κ

490. Cod. 339, fol. 23r.
Initial Τ

491. Cod. 339, fol. 28r.
Initial Є

492. Cod. 339, fol. 30r.
Initial Π

493. Cod. 339, fol. 43r.
Initial Є

494. Cod. 339, fol. 49r.
Initial Ο

495. Cod. 339, fol. 54v.
Initial Є

496. Cod. 339, fol. 74r.
Initial Є

497. Cod. 339, fol. 81r.
Initial Μ

498. Cod. 339, fol. 81v.
Initial Φ

499. Cod. 339, fol. 86v.
Initial Δ

500. Cod. 339, fol. 92v.
Initial Τ

501. Cod. 339, fol. 97r.
Initial Θ

502. Cod. 339, fol. 101v.
Initial Π

PLATE CLVII

503. Cod. 339, fol. 103v.
Initial X

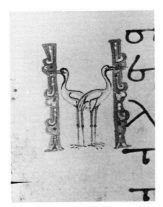

504. Cod. 339, fol. 105r.
Initial M

505. Cod. 339, fol. 105v.
Initial C

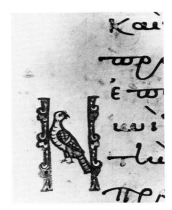

506. Cod. 339, fol. 106v.
Initial N

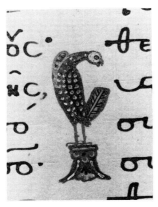

507. Cod. 339, fol. 108r.
Initial C

508. Cod. 339, fol. 110v.
Initial Π

509. Cod. 339, fol. 111v.
Initial T

510. Cod. 339, fol. 112r.
Initial Є

511. Cod. 339, fol. 113r.
Initial Δ

512. Cod. 339, fol. 113r.
Initial A

513. Cod. 339, fol. 114v.
Initial Є

514. Cod. 339, fol. 118r.
Initial Є

515. Cod. 339, fol. 122v.
Initial Є

516. Cod. 339, fol. 122v.
Initial Є

517. Cod. 339, fol. 123r.
Initial Γ

518. Cod. 339, fol. 125v.
Initial O

PLATE CLVIII

519. Cod. 339, fol. 126v.
Initial Є

520. Cod. 339, fol. 129r.
Initial Δ

521. Cod. 339, fol. 131v.
Initial Δ

522. Cod. 339, fol. 133r.
Initial B

523. Cod. 339, fol. 134v.
Initial Γ

524. Cod. 339, fol. 137r.
Initial A

525. Cod. 339, fol. 139r.
Initial Π

526. Cod. 339, fol. 141v.
Initial O

527. Cod. 339, fol. 143r.
Initial M

528. Cod. 339, fol. 147r.
Initial X

529. Cod. 339, fol. 148v.
Initial T

530. Cod. 339, fol. 152v.
Initial K

531. Cod. 339, fol. 162v.
Initial Є

532. Cod. 339, fol. 164v.
Initial Λ

533. Cod. 339, fol. 179v.
Initial T

534. Cod. 339, fol. 185v.
Initial Φ

PLATE CLIX

535. Cod. 339, fol. 189r.
Initial Δ

536. Cod. 339, fol. 195v.
Initial Δ

537. Cod. 339, fol. 217v.
Initial C

538. Cod. 339, fol. 219r.
Initial C

539. Cod. 339, fol. 219r.
Initial Γ

540. Cod. 339, fol. 223r.
Initial Δ

541. Cod. 339, fol. 224v.
Initial A

542. Cod. 339, fol. 232r.
Initial A

543. Cod. 339, fol. 245r.
Initial O

544. Cod. 339, fol. 262v.
Initial Γ

545. Cod. 339, fol. 269r.
Initial Є

546. Cod. 339, fol. 271r.
Initial Є

547. Cod. 339, fol. 272v.
Initial Φ

548. Cod. 339, fol. 272v.
Initial ω

549. Cod. 339, fol. 276r.
Initial Λ

550. Cod. 339, fol. 282v.
Initial K

PLATE CLX

551. Cod. 339, fol. 285r.
Initial P

552. Cod. 339, fol. 286v.
Initial Δ

553. Cod. 339, fol. 289v.
Initial K

554. Cod. 339, fol. 293r.
Initial M

555. Cod. 339, fol. 294r.
Initial Є

556. Cod. 339, fol. 301v.
Initial T

557. Cod. 339, fol. 314r.
Initial C

558. Cod. 339, fol. 317v.
Initial O

559. Cod. 339, fol. 320r.
Initial Є

560. Cod. 339, fol. 322r.
Initial M

561. Cod. 339, fol. 325r.
Initial Є

562. Cod. 339, fol. 328v.
Initial Δ

563. Cod. 339, fol. 330v.
Initial Є

564. Cod. 339, fol. 332r.
Initial Υ

565. Cod. 339, fol. 334v.
Initial T

566. Cod. 339, fol. 338v.
Initial Θ

PLATE CLXI

567. Cod. 339, fol. 340v.
Initial X

568. Cod. 339, fol. 341r.
Initial X

569. Cod. 339, fol. 344v.
Initial H

570. Cod. 339, fol. 349r.
Initial O

571. Cod. 339, fol. 354v.
Initial Δ

572. Cod. 339, fol. 359v.
Initial M

573. Cod. 339, fol. 368v.
Initial P

574. Cod. 339, fol. 377r.
Initial Λ

575. Cod. 339, fol. 378v.
Initial Є

576. Cod. 339, fol. 382r.
Initial Γ

577. Cod. 339, fol. 384r.
Initial N

578. Cod. 339, fol. 384r.
Initial Ψ

579. Cod. 339, fol. 386v.
Initial A

580. Cod. 339, fol. 394r.
Initial OY

581. Cod. 339, fol. 399v.
Initial Π

582. Cod. 339, fol. 402v.
Initial O

PLATE CLXII

583. Cod. 339, fol. 73r. Cross page

584. Cod. 339, fol. 90r. Cross page

585. Cod. 339, fol. 197r. Cross page

586. Cod. 339, fol. 396v. Cross page

PLATE CLXIII

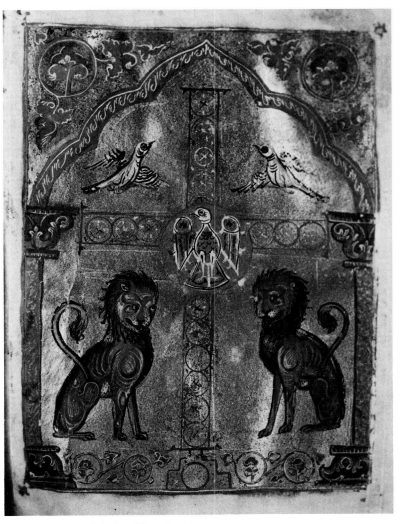

587. Cod. 418, fol. 2r. Frontispiece

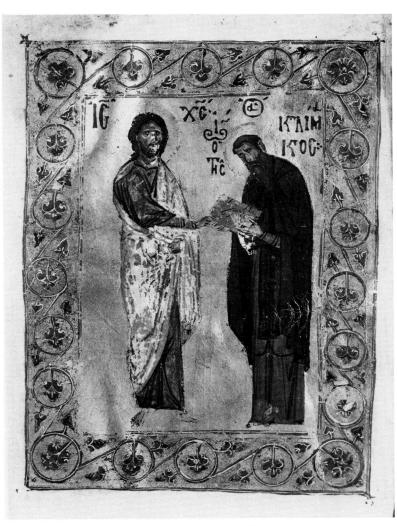

588. Cod. 418, fol. 2v. John Climacus and Christ

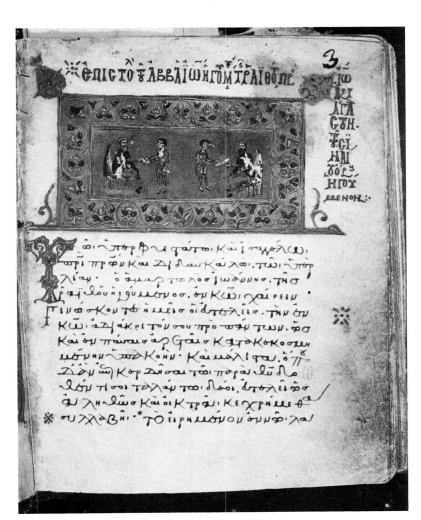

589. Cod. 418, fol. 3r. The exchange of letters

590. Cod. 418, fol. 4v. Two crosses

PLATE CLXIV

591. Cod. 418, fol. 5r. Headpiece

592. Cod. 418, fol. 7r. Headpiece

594. Cod. 418, fol. 15v. The heavenly ladder

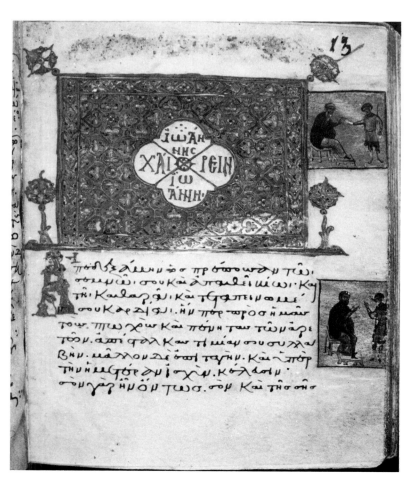

593. Cod. 418, fol. 13r. Headpiece, exchange of letters

595. Cod. 418, fol. 16r. John Climacus

PLATE CLXV

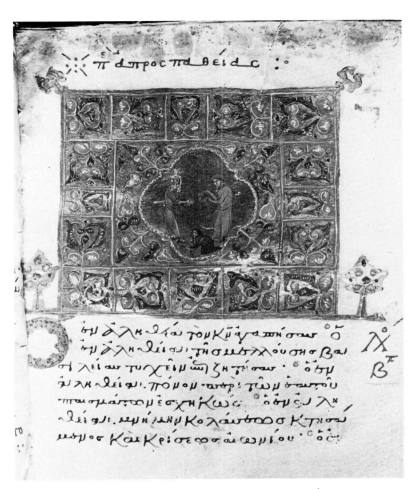

596. Cod. 418, fol. 27r. Man giving his belongings to the poor

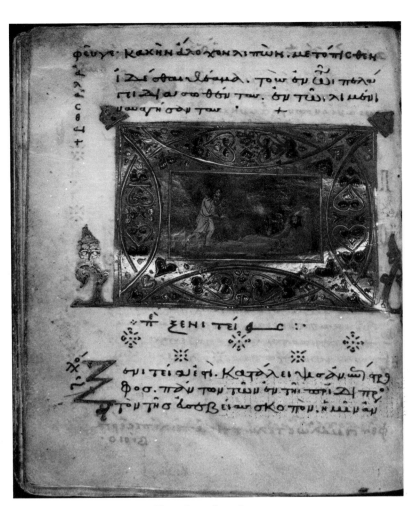

597. Cod. 418, fol. 31v. Hermit and novice

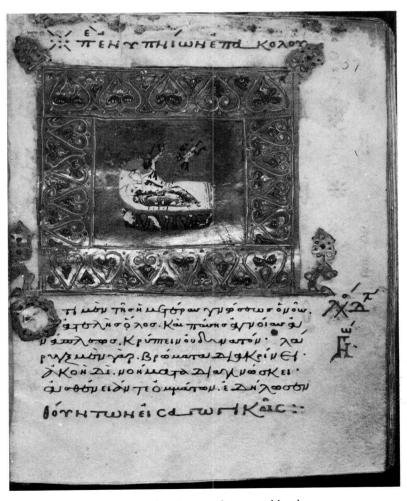

598. Cod. 418, fol. 37r. Sleeping monk tempted by demons

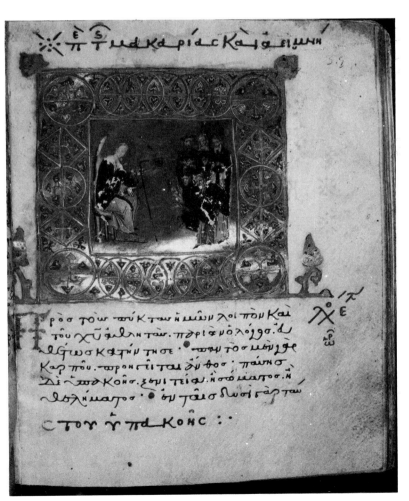

599. Cod. 418, fol. 39r. Abbot and monks

PLATE CLXVI

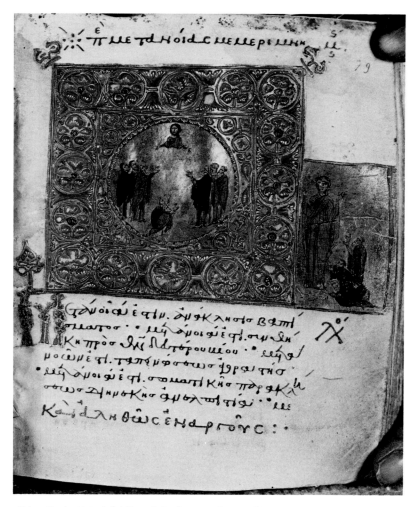

600. Cod. 418, fol. 79r. Monks praying to Christ and the Virgin
(cf. colorplate XXVI:a)

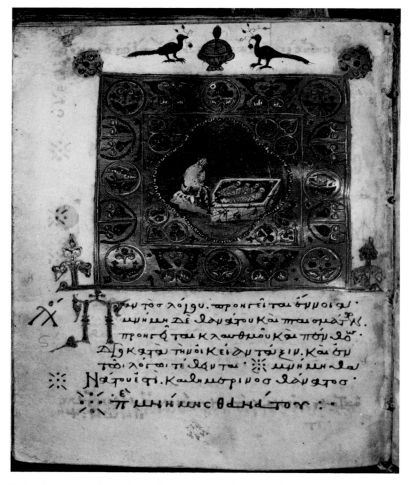

601. Cod. 418, fol. 94v. Monk contemplating before a sarcophagus

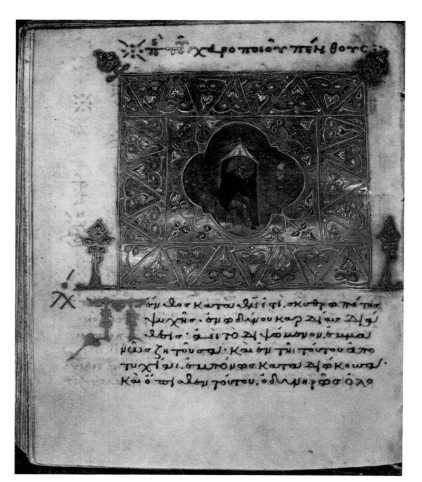

602. Cod. 418, fol. 99v. Monk in his cell

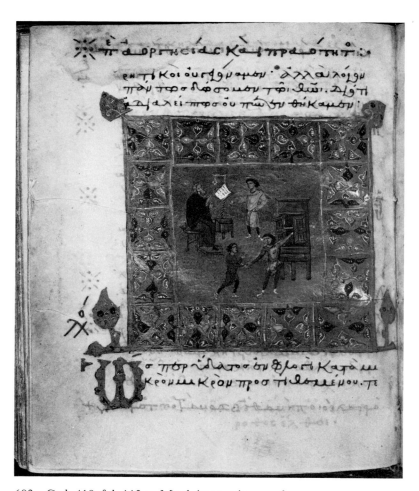

603. Cod. 418, fol. 113v. Monk instructing youths

PLATE CLXVII

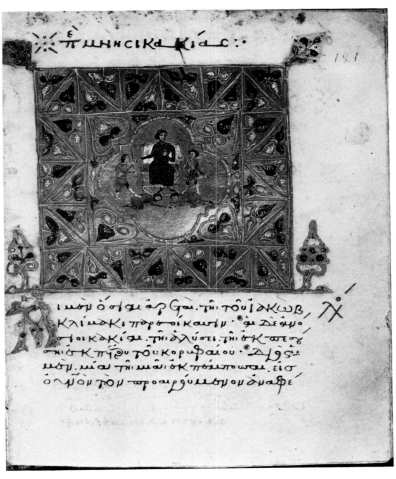

604. Cod. 418, fol. 121r. Man and two servants

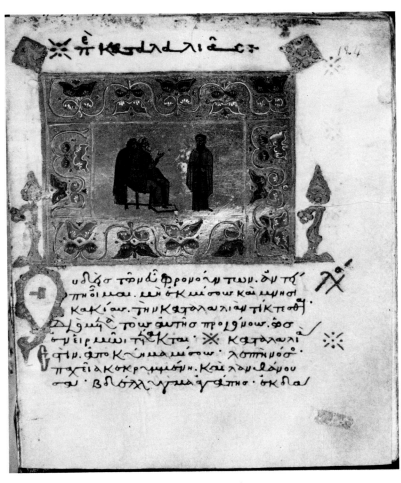

605. Cod. 418, fol. 124r. Slanderous monks

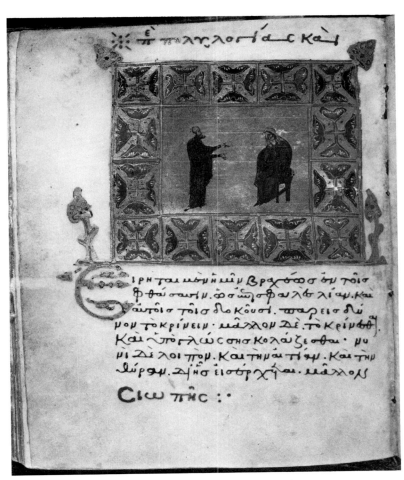

606. Cod. 418, fol. 127v. Talkative and silent monk

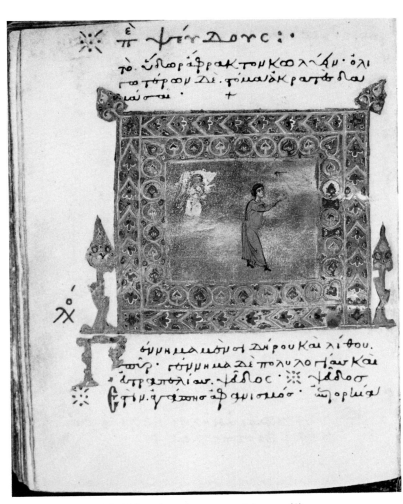

607. Cod. 418, fol. 129v. Angel, man, and demon (?)

PLATE CLXVIII

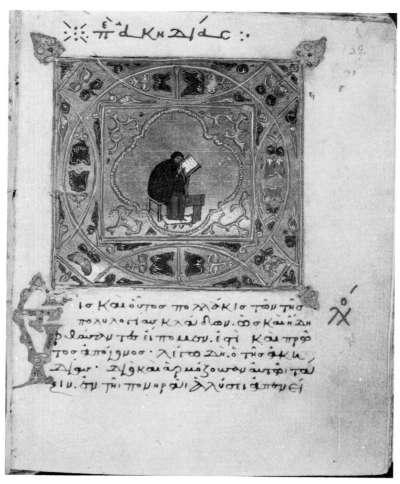

608. Cod. 418, fol. 132r. Sleeping monk

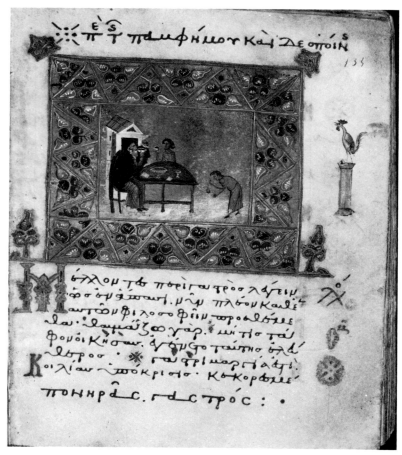

609. Cod. 418, fol. 135r. Symposium

610. Cod. 418, fol. 142v. Figure with staff

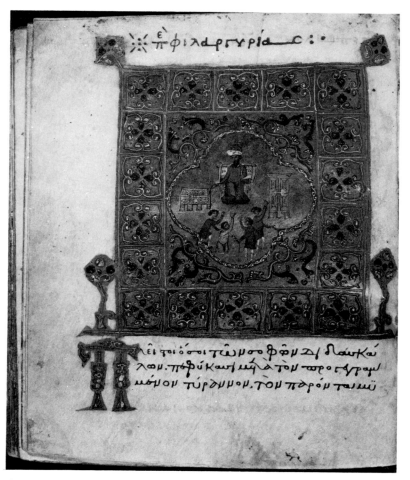

611. Cod. 418, fol. 162v. Rich monk, servants, and beggars

PLATE CLXIX

612. Cod. 418, fol. 163r. Beggars and rich men

613. Cod. 418, fol. 164r. Poor man attended by angels
(cf. colorplate XXVI:b)

614. Cod. 418, fol. 166v. Insensible monk

615. Cod. 418, fol. 170r. Sleeping, praying, and singing monks
(cf. colorplate XXVI:c)

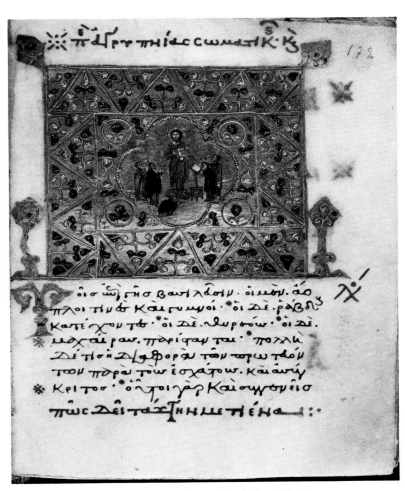

616. Cod. 418, fol. 172r. Monks praying before Christ

PLATE CLXX

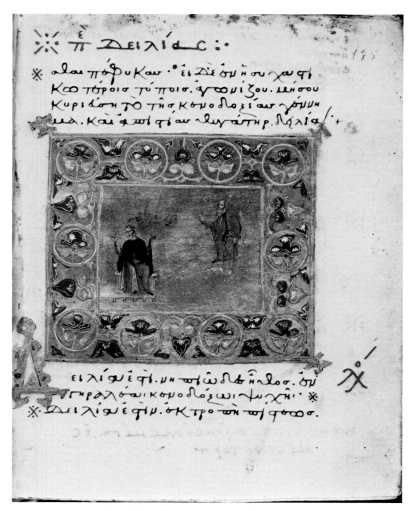

617. Cod. 418, fol. 175r. Conversing monks

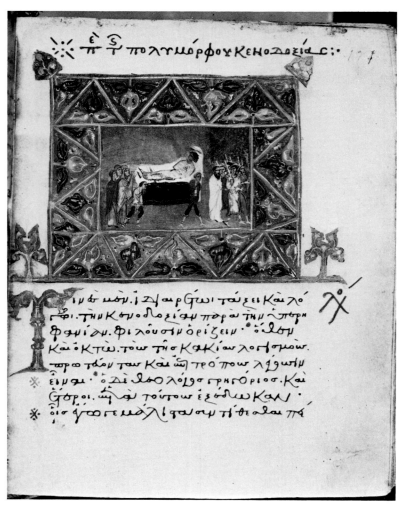

618. Cod. 418, fol. 177r. Funeral procession

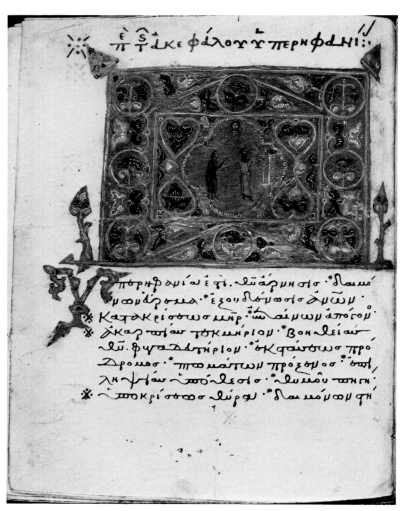

619. Cod. 418, fol. 184v. Proud and humble men

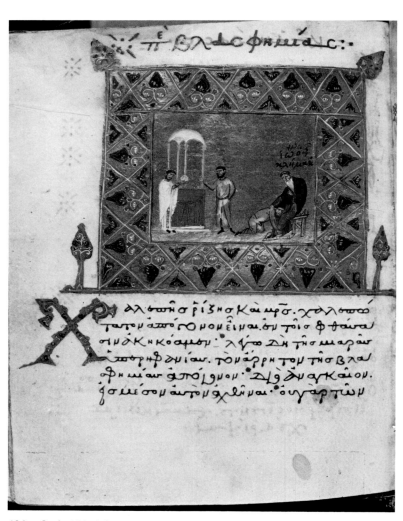

620. Cod. 418, fol. 189v. Blaspheming and repentent men

PLATE CLXXI

621. Cod. 418, fol. 193v. Aged monk and youths

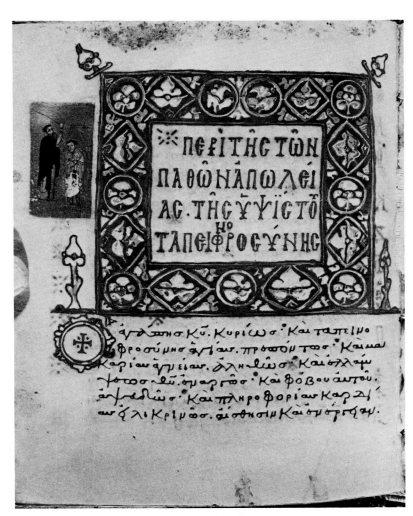

622. Cod. 418, fol. 197v. Monk beating brother

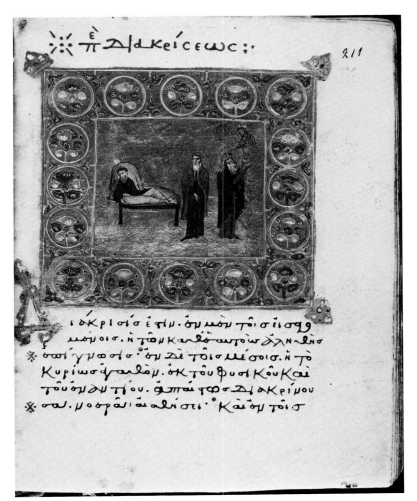

623. Cod. 418, fol. 211r. Sick monk healed, giving thanks to Christ

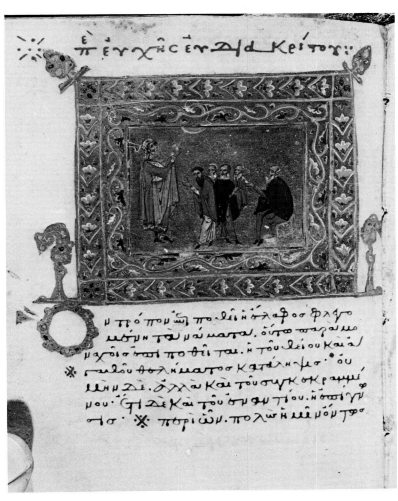

624. Cod. 418, fol. 231v. David with monks

PLATE CLXXII

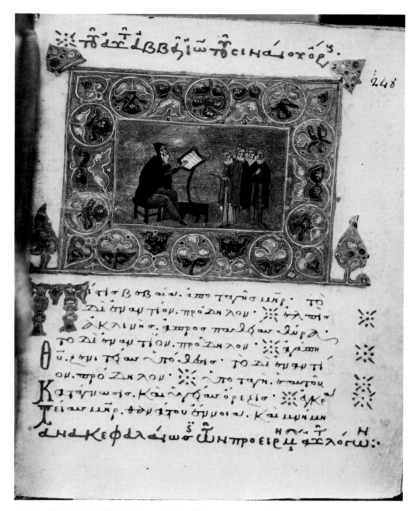

625. Cod. 418, fol. 248r. John Climacus teaching

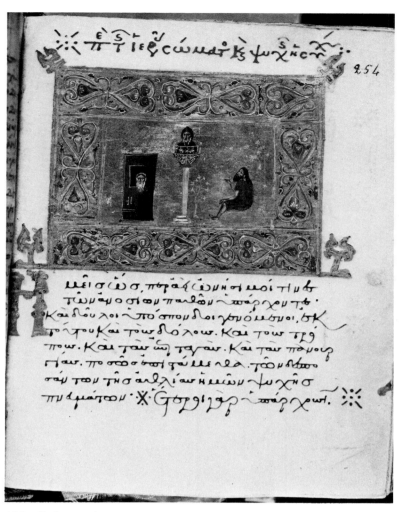

626. Cod. 418, fol. 254r. Anchorites

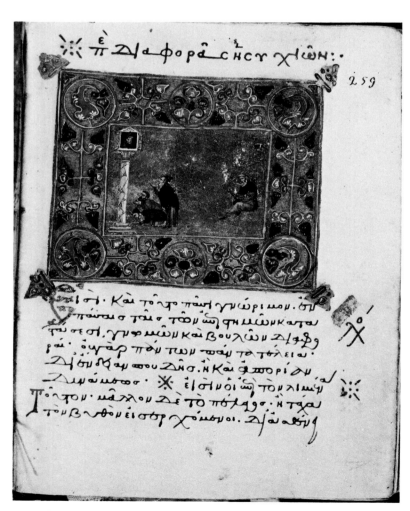

627. Cod. 418, fol. 259r. Monks paying homage to stylite

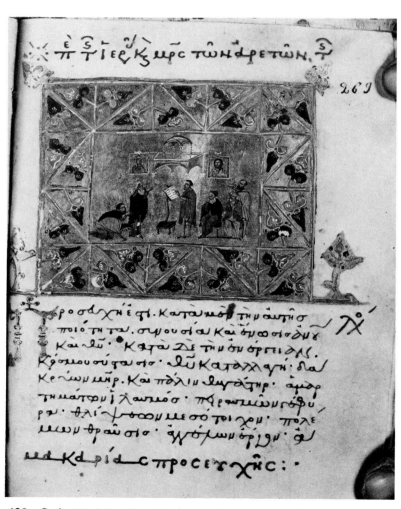

628. Cod. 418, fol. 269r. Monks praying (cf. colorplate XXVI:d)

PLATE CLXXIII

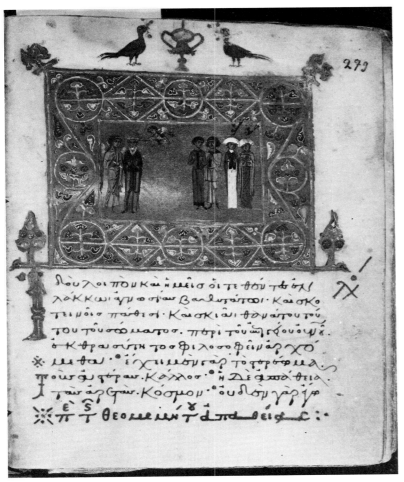

629. Cod. 418, fol. 279r. The exaltation of the poor man

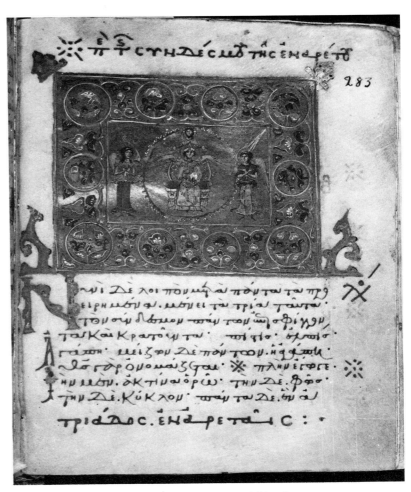

630. Cod. 418, fol. 283r. Faith, Hope, and Charity

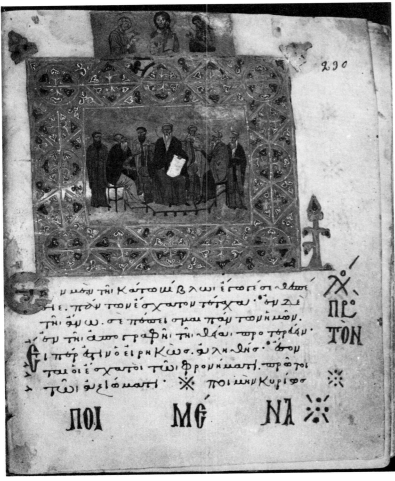

631. Cod. 418, fol. 290r. John Climacus teaching

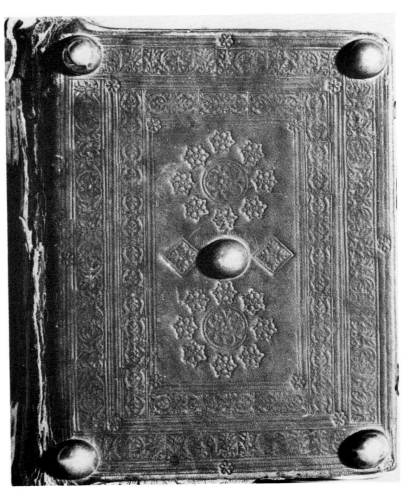

632. Cod. 418, front cover

PLATE CLXXIV

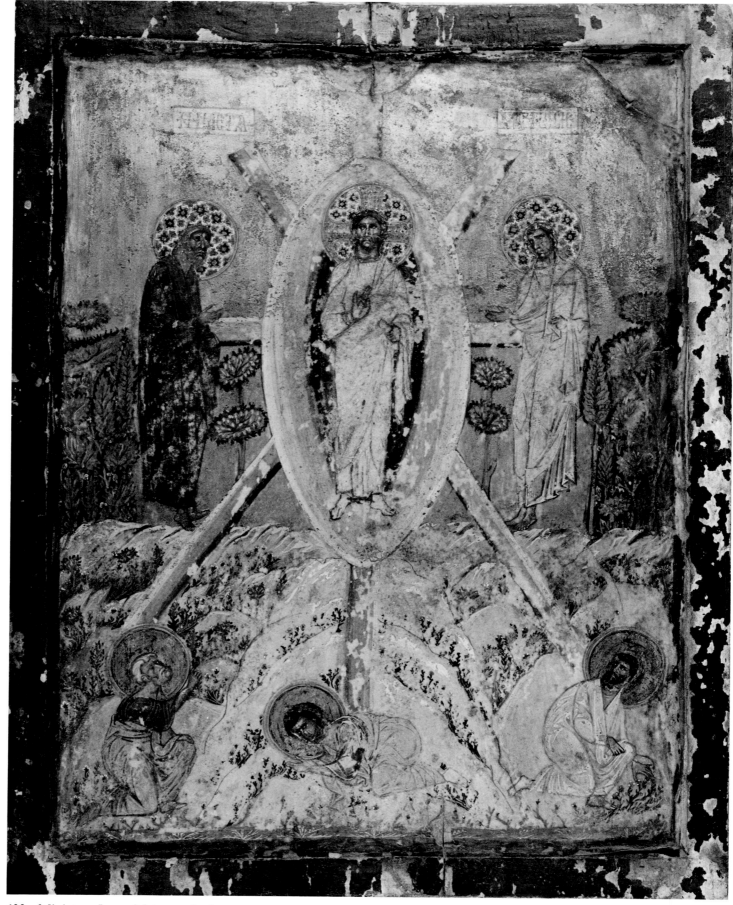

633. Miniature Icon. Metamorphosis

PLATE CLXXV

634. Cod. 157, fol. 7v. Matthew

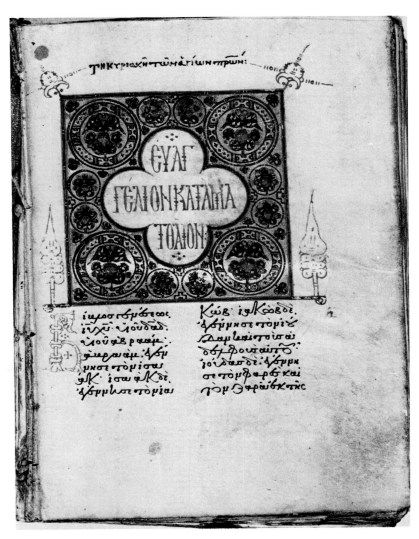

635. Cod. 157, fol. 8r. Headpiece

636. Cod. 157, fol. 79v. Mark

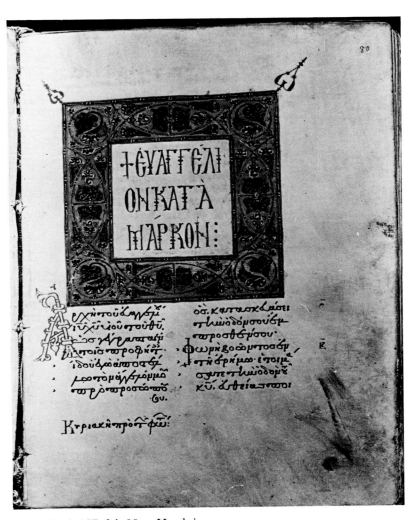

637. Cod. 157, fol. 80r. Headpiece

PLATE CLXXVI

638. Cod. 157, fol. 127v. Luke

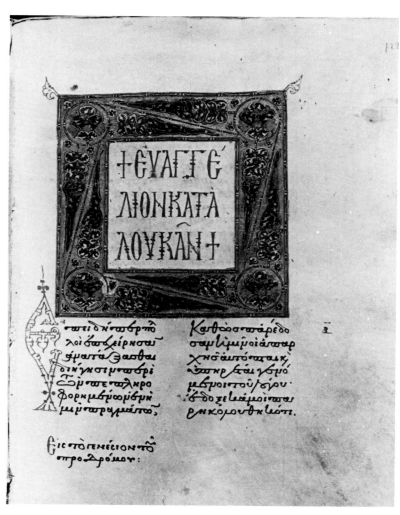

639. Cod. 157, fol. 128r. Headpiece

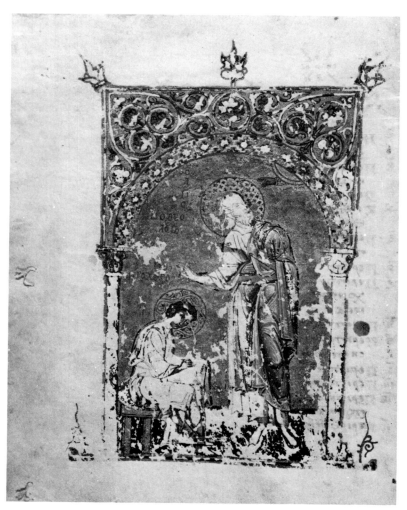

640. Cod. 157, fol. 207v. John and Prochoros

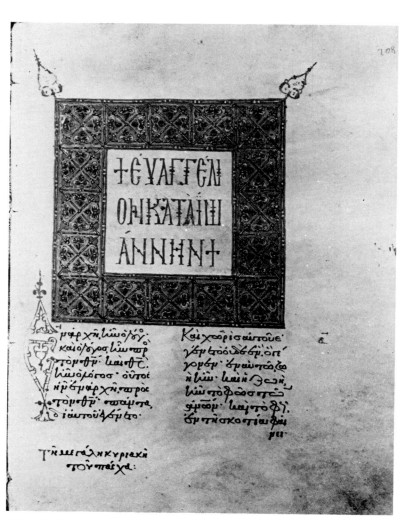

641. Cod. 157, fol. 208r. Headpiece

PLATE CLXXVII

642. Cod. 157, front cover

643. Cod. 157, fol. 269r. Colophon

644. Cod. 157, paper page on inside of back cover

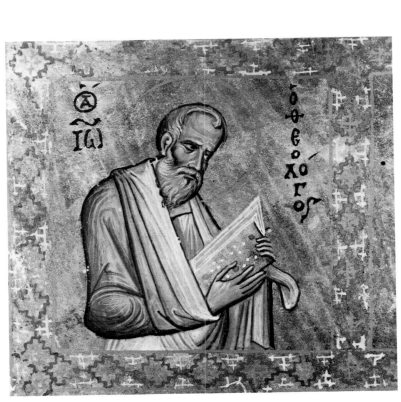

645. Cod. 208, fol. 1v (detail). John

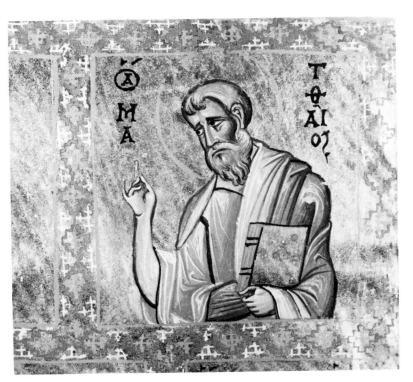

646. Cod. 208, fol. 1v (detail). Matthew

PLATE CLXXVIII

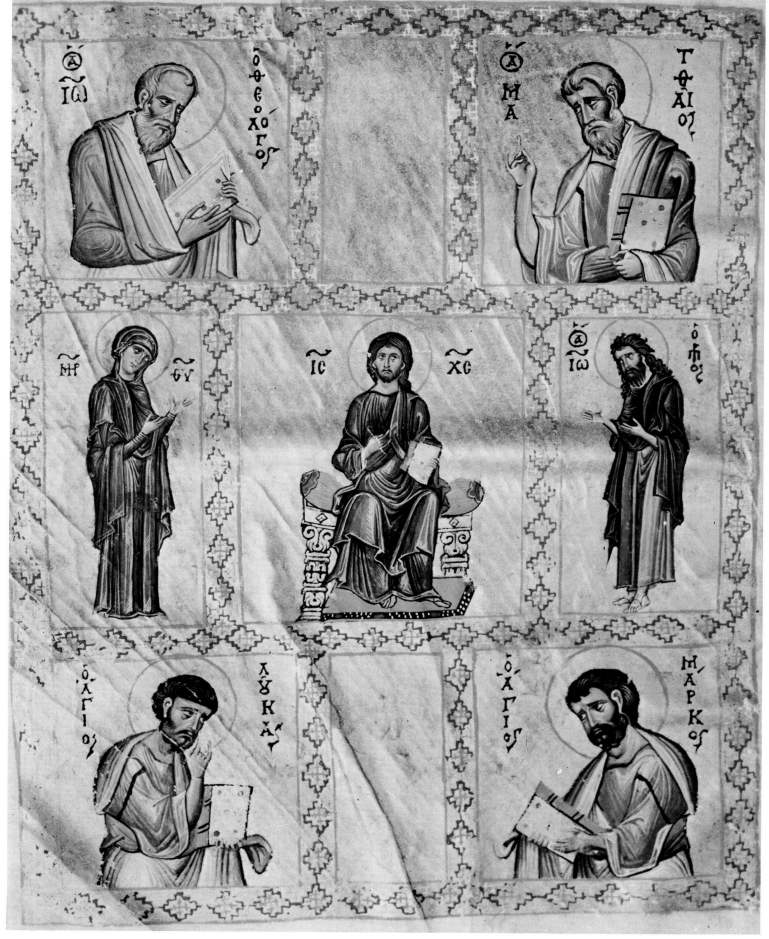

647. Cod. 208, fol. 1v. Deesis with evangelists (cf. colorplate XXVII)

PLATE CLXXIX

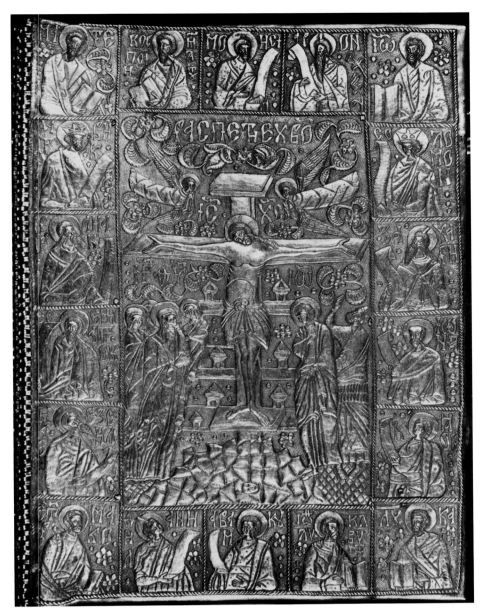

648. Cod. 208, front cover. Crucifixion and saints

649. Cod. 208, fol. 2r. Headpiece

PLATE CLXXX

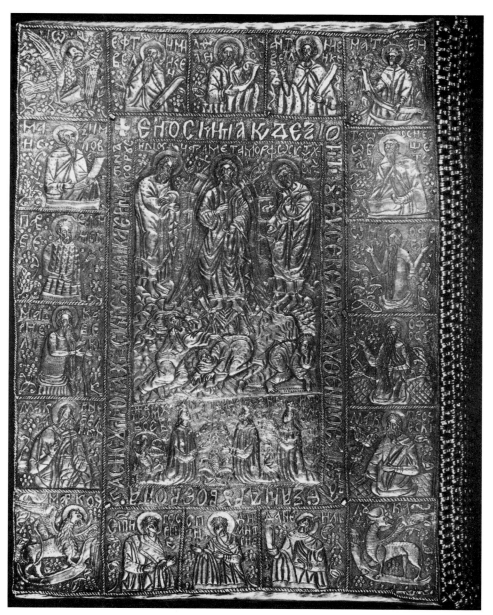

650. Cod. 208, back cover. Transfiguration and saints

651. Cod. 208, fol. 80r. Headpiece

PLATE CLXXXI

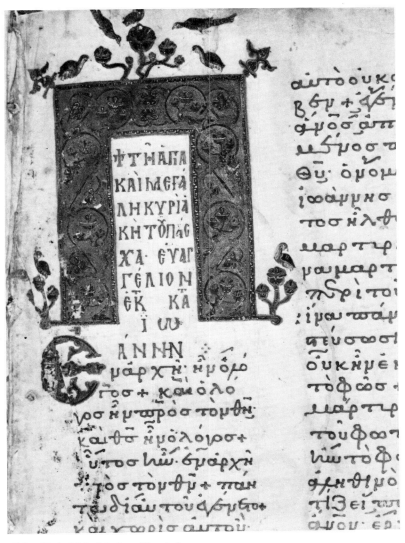

652. Cod. 216, fol. 1r. Headpiece

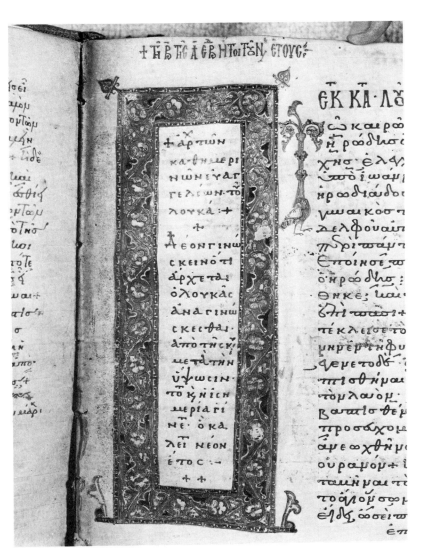

655. Cod. 216, fol. 89r. Headpiece

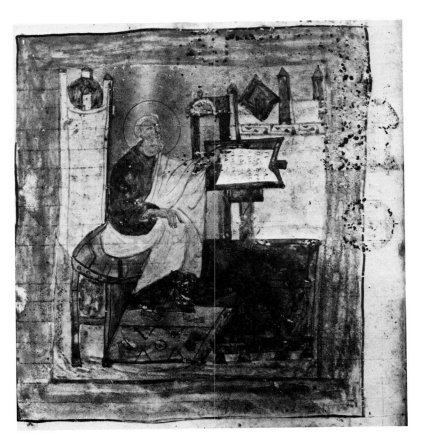

653. Cod. 216, fol. 33v. Matthew

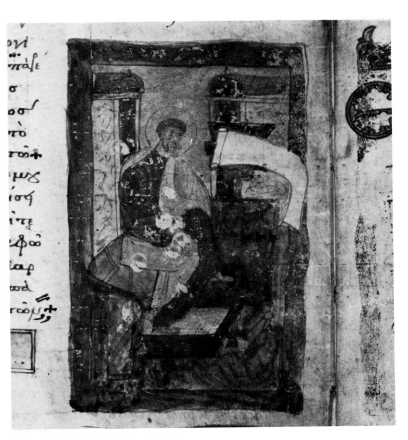

654. Cod. 216, fol. 69v. Mark

PLATE CLXXXII

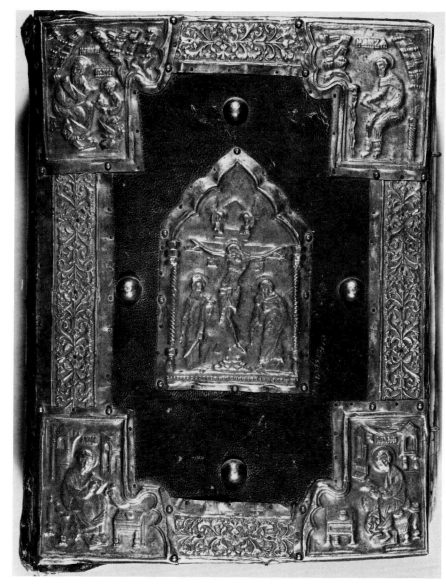

656. Cod. 216, front cover. Crucifixion and evangelists

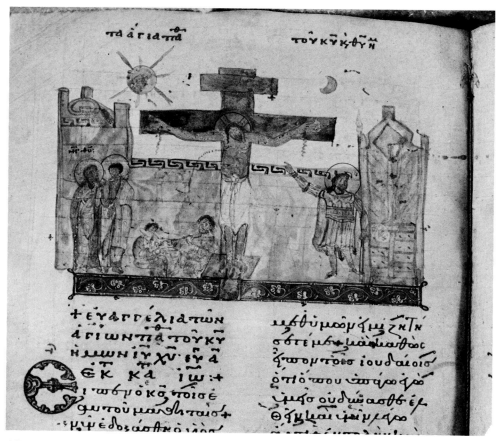

657. Cod. 216, fol. 188v. Crucifixion

PLATE CLXXXIII

658. Cod. 216, back cover (detail). Transfiguration

659. Cod. 220, fol. 276r. Headpiece

PLATE CLXXXIV

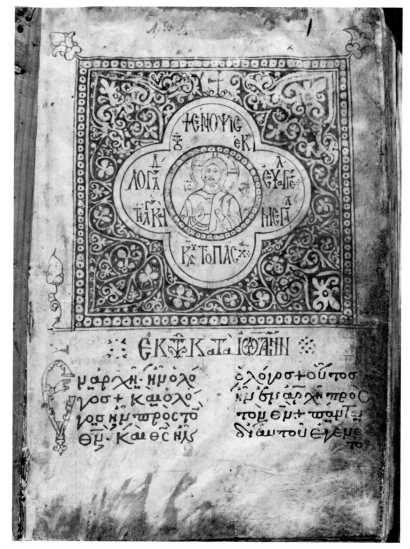

660. Cod. 220, fol. 1r. Christ

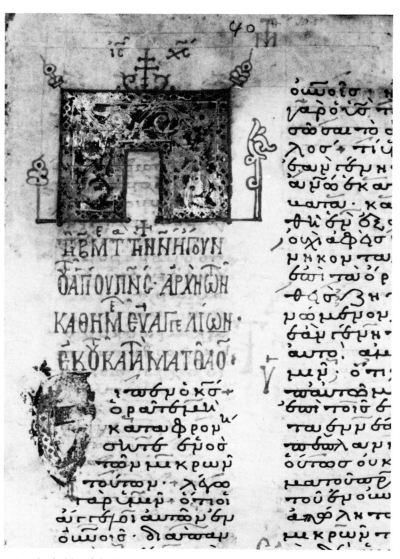

662. Cod. 221, fol. 40r. Headpiece

661. Cod. 221, fol. 2r. Headpiece

663. Cod. 221, fol. 273r. Colophon

664. Cod. 221, fol. 273v. Colophon

PLATE CLXXXV

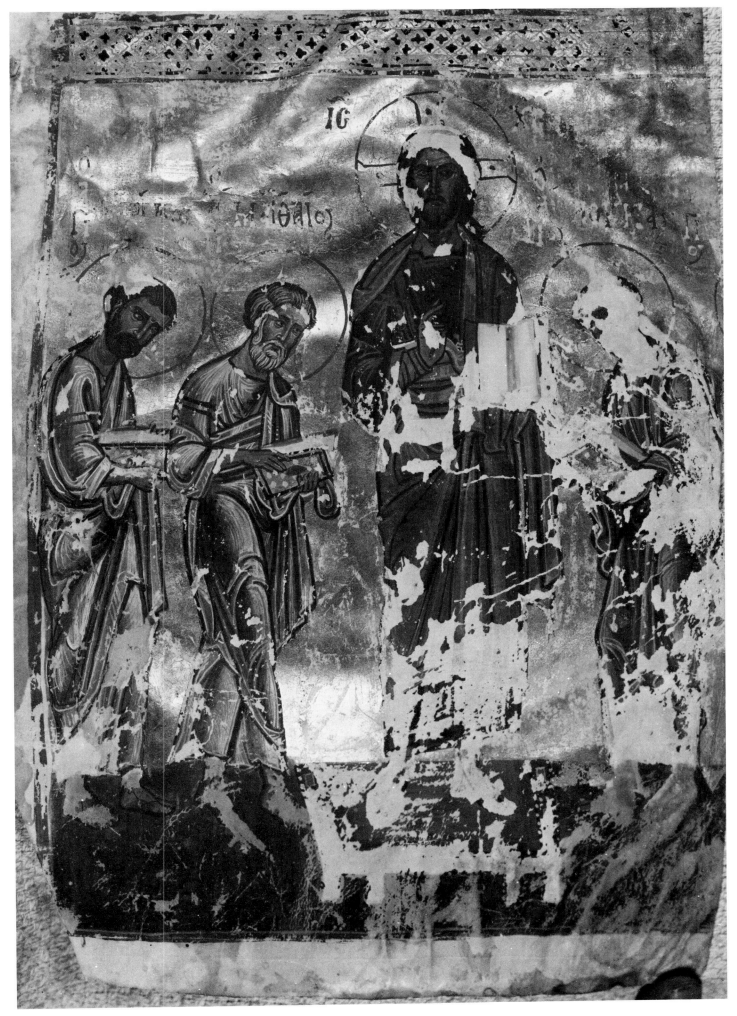

665. Cod. 221, fol. 1r. Christ and evangelists (cf. colorplate XXVIII:a)

PLATE CLXXXVI

666. Cod. 153, front cover

667. Cod. 153, back cover

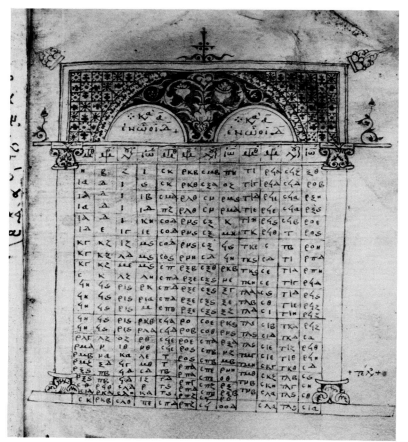

668. Cod. 153, fol. 3r. Canon table

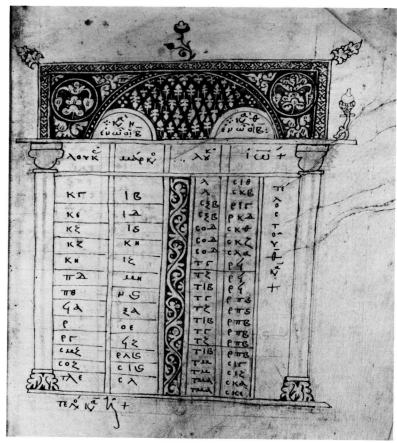

669. Cod. 153, fol. 5r. Canon table

PLATE CLXXXVII

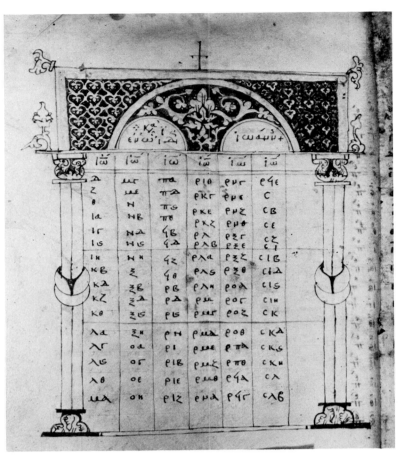

670. Cod. 153, fol. 6v. Canon table

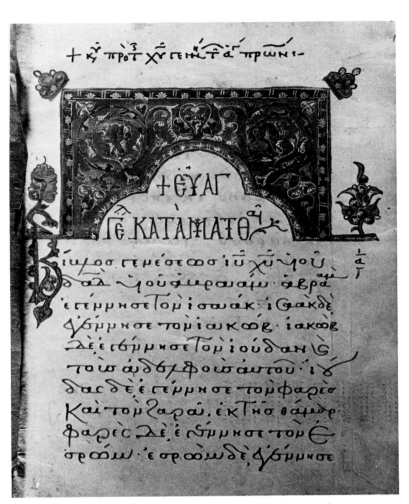

671. Cod. 153, fol. 10r. Headpiece (cf. colorplate XXVIII:b)

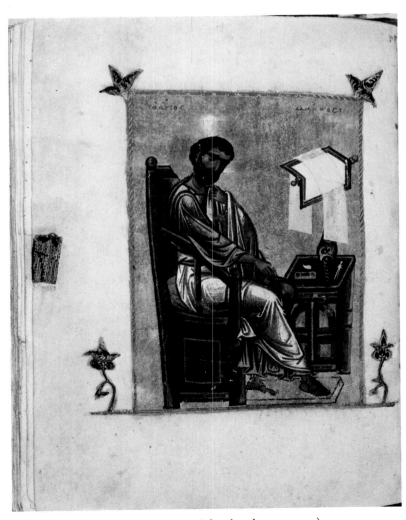

672. Cod. 153, fol. 124v. Mark (cf. colorplate XXVIII:c)

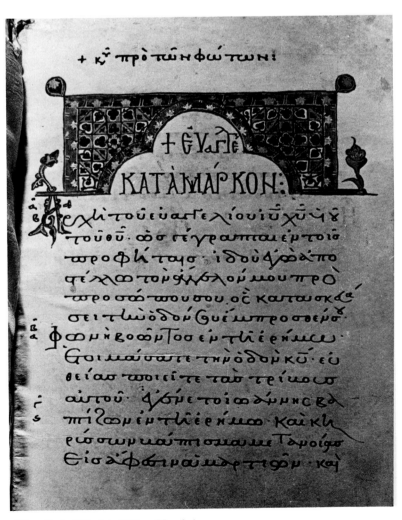

673. Cod. 153, fol. 125r. Headpiece

PLATE CLXXXVIII

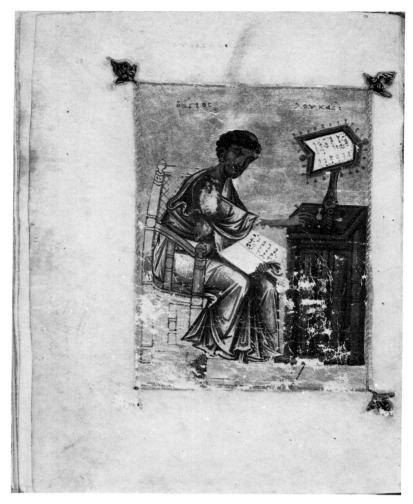

674. Cod. 153, fol. 193v. Luke

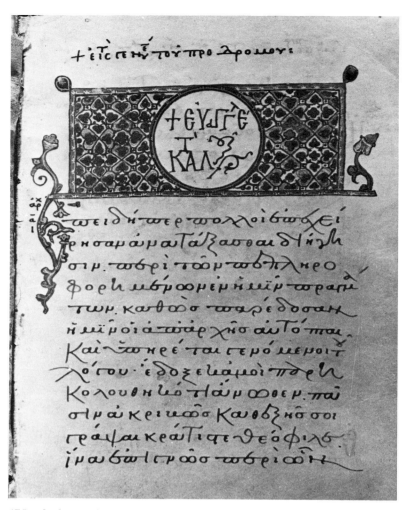

675. Cod. 153, fol. 194r. Headpiece

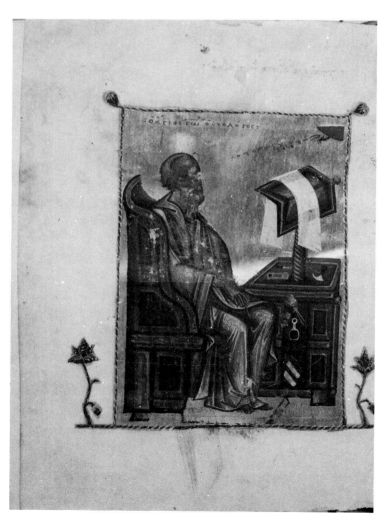

676. Cod. 153, fol. 314v. John

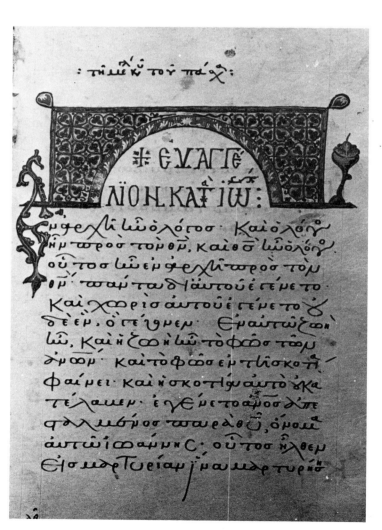

677. Cod. 153, fol. 315r. Headpiece

PLATE CLXXXIX

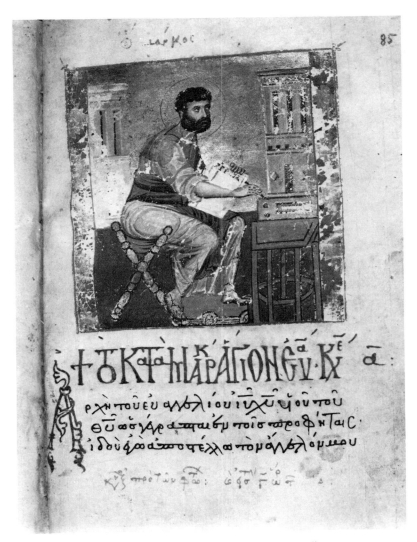

678. Cod. 163, fol. 85r. Mark (cf. colorplate XXVIII:d)

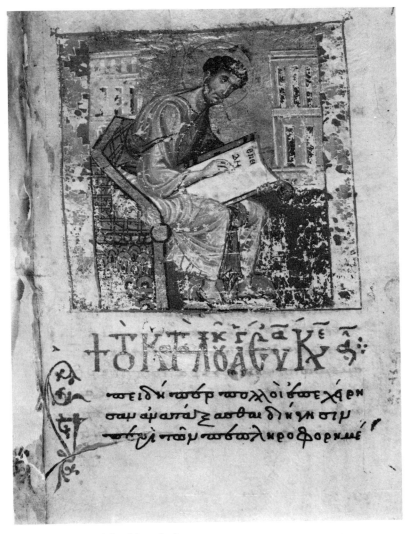

679. Cod. 163, fol. 139r. Luke

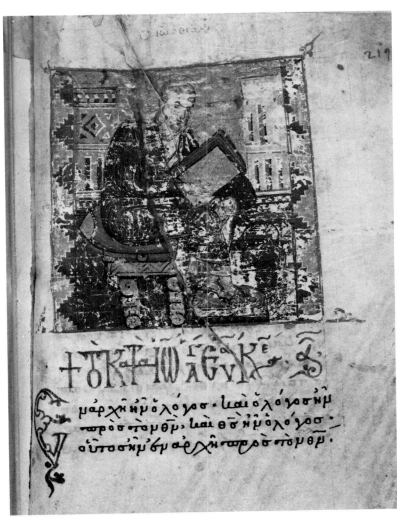

680. Cod. 163, fol. 219r. John

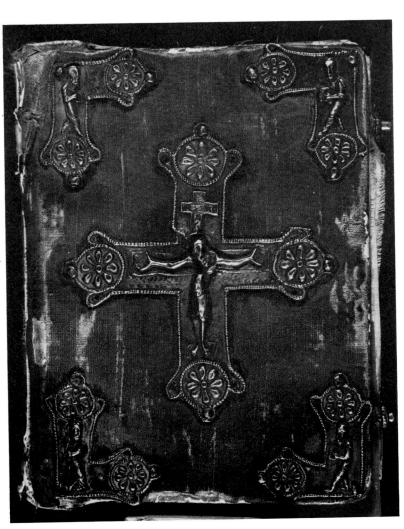

681. Cod. 149, front cover. Crucifixion and evangelists

PLATE CXC

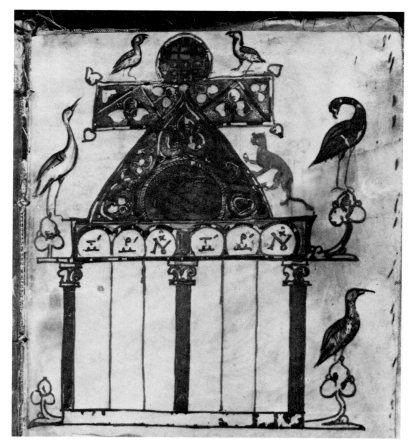

682. Cod. 149, fol. 1r. Canon table

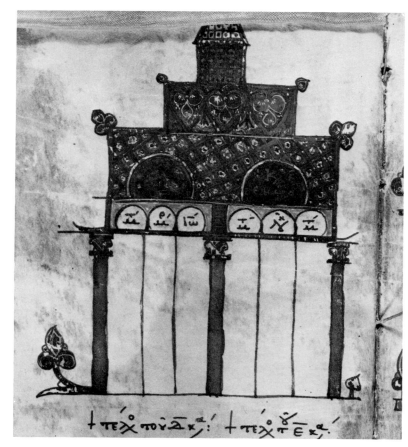

683. Cod. 149, fol. 1v. Canon table

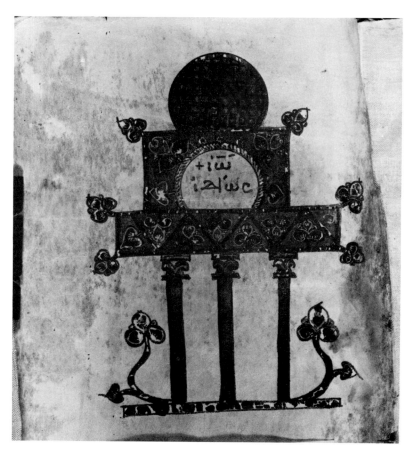

684. Cod. 149, fol. 3v. Canon table

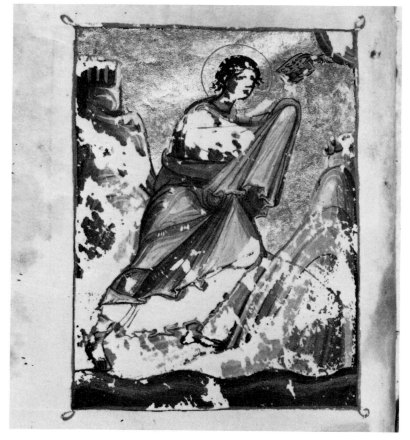

685. Cod. 149, fol. 4v. Moses receiving the law

PLATE CXCI

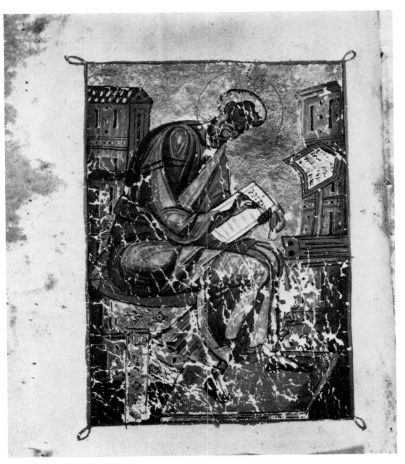

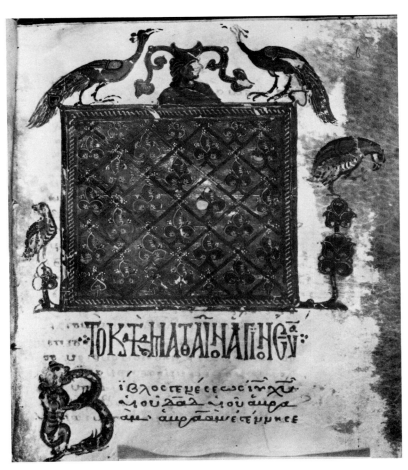

686. Cod. 149, fol. 5v. Matthew

687. Cod. 149, fol. 6r. Headpiece

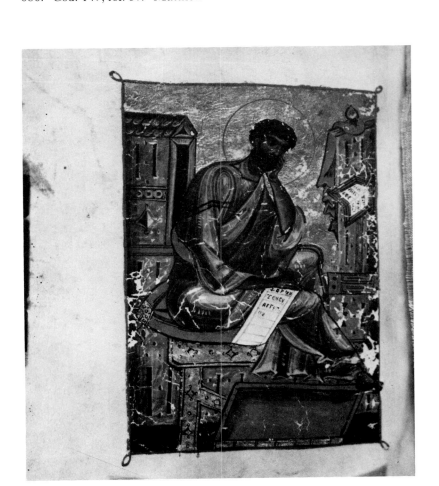

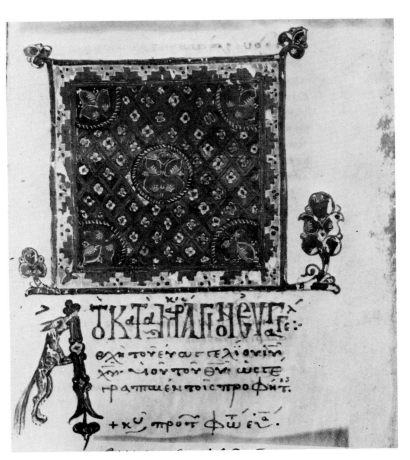

688. Cod. 149, fol. 91v. Mark

689. Cod. 149, fol. 92r. Headpiece

PLATE CXCII

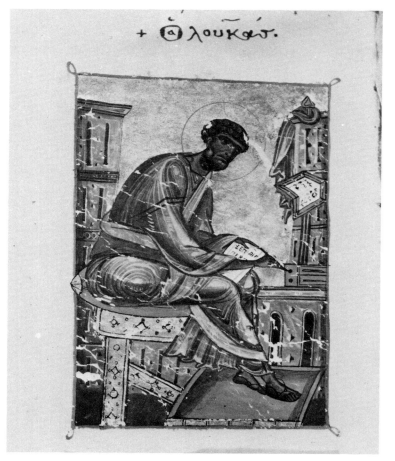

690. Cod. 149, fol. 146v. Luke

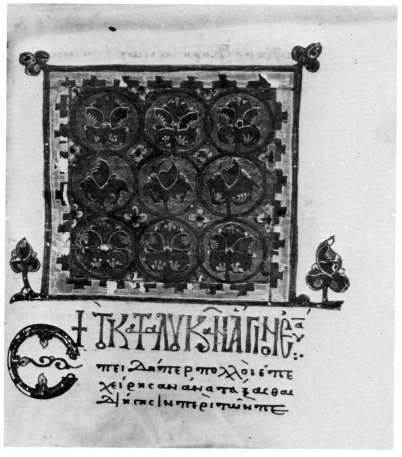

691. Cod. 149, fol. 147r. Headpiece

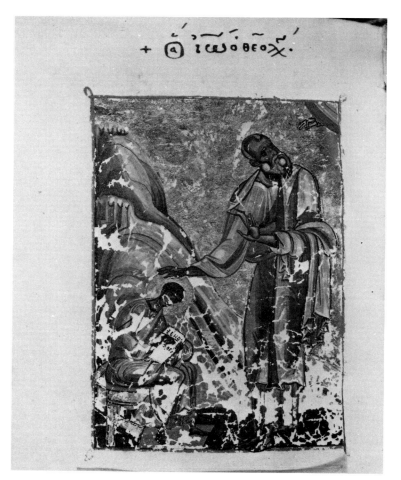

692. Cod. 149, fol. 235v. John and Prochoros

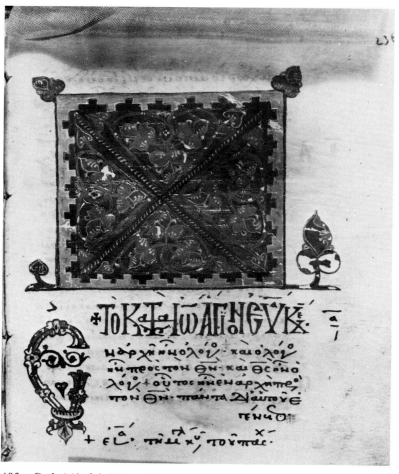

693. Cod. 149, fol. 236r. Headpiece

PLATE CXCIII

694. Cod. 178, fol. 6v. Christ and evangelist symbols

695. Cod. 178, fol. 9v. Matthew

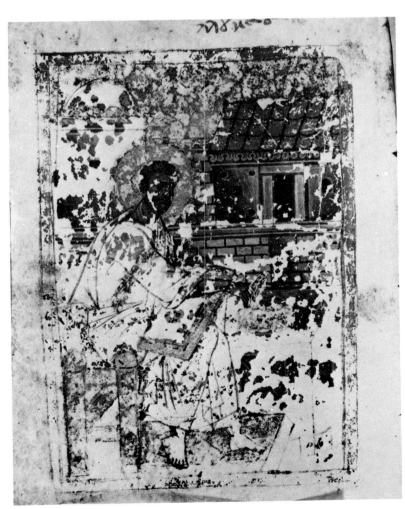

696. Cod. 178, fol. 90v. Mark

697. Cod. 178, fol. 146v. John

PLATE CXCIV

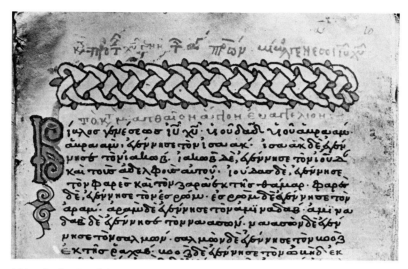

698. Cod. 178, fol. 10r. Headpiece

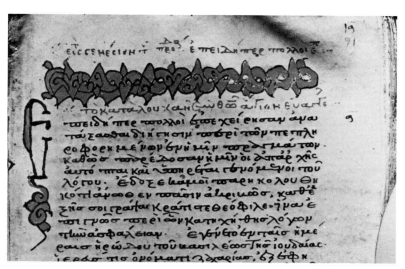

699. Cod. 178, fol. 91r. Headpiece

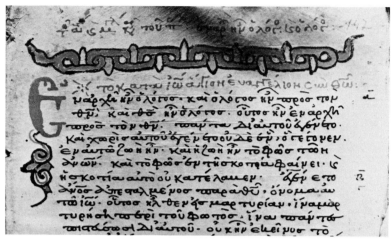

700. Cod. 178, fol. 147r. Headpiece

701. Cod. 178, front cover

702. Cod. 178, back cover

PLATE CXCV

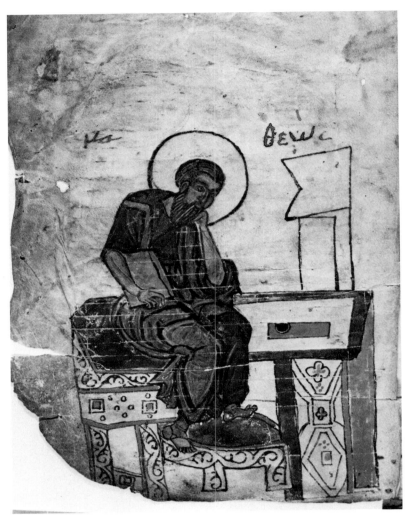

703. Cod. 260, fol. 1v. Matthew

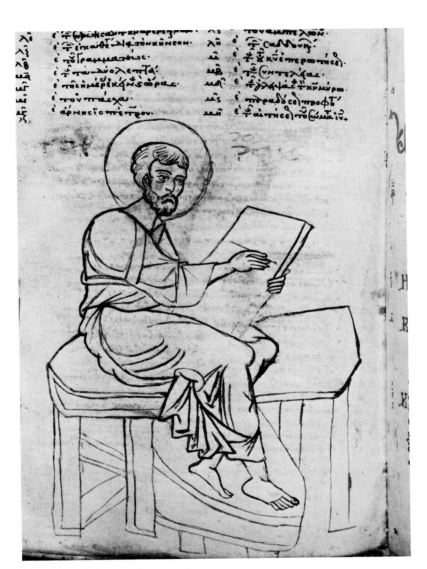

705. Cod. 260, fol. 32v. Mark

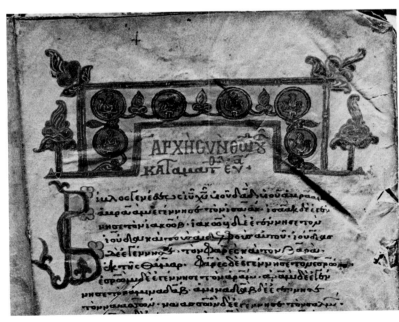

704. Cod. 260, fol. 2r. Headpiece

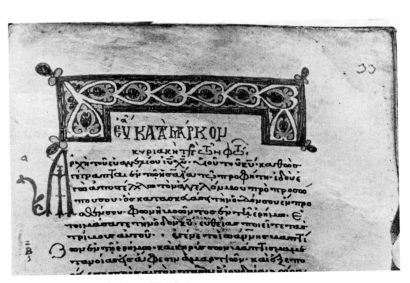

706. Cod. 260, fol. 33r. Headpiece

PLATE CXCVI

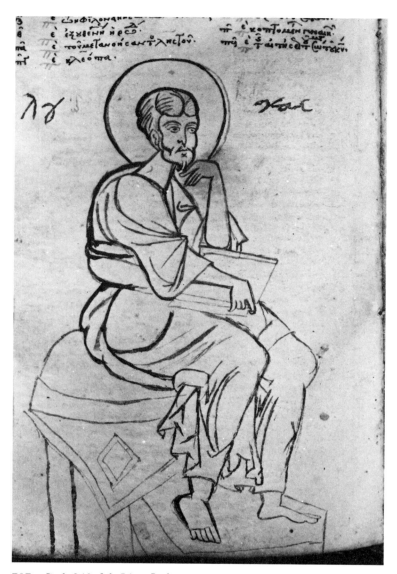

707. Cod. 260, fol. 56v. Luke

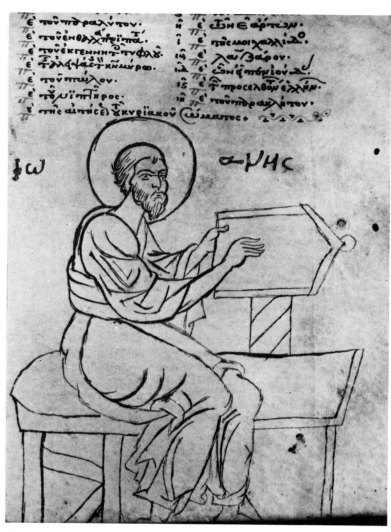

708. Cod. 260, fol. 91r. John

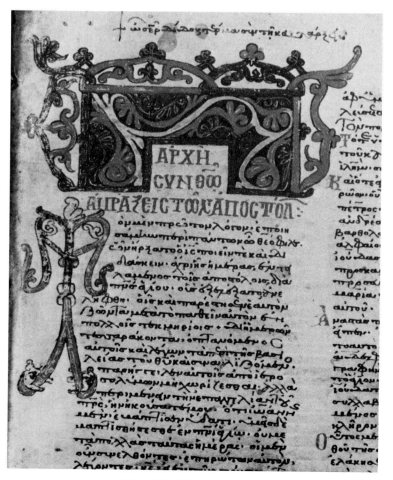

709. Cod. 260, fol. 117r. Headpiece

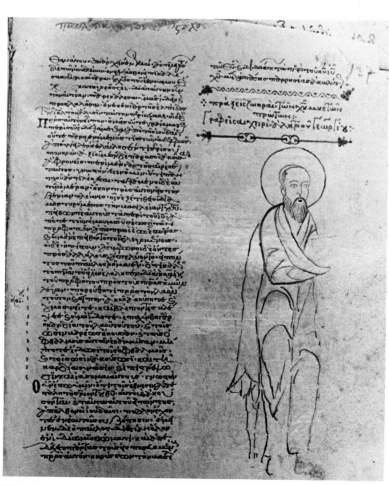

710. Cod. 260, fol. 137r. Paul

PLATE CXCVII

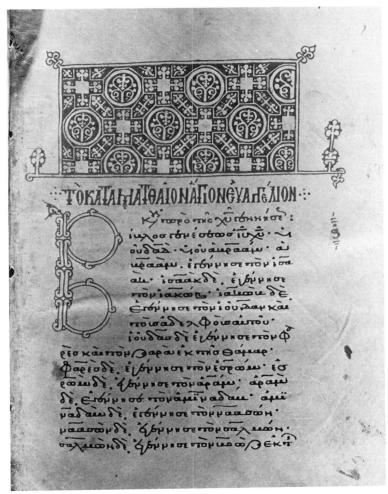

711. Cod. 180, fol. 9r. Headpiece

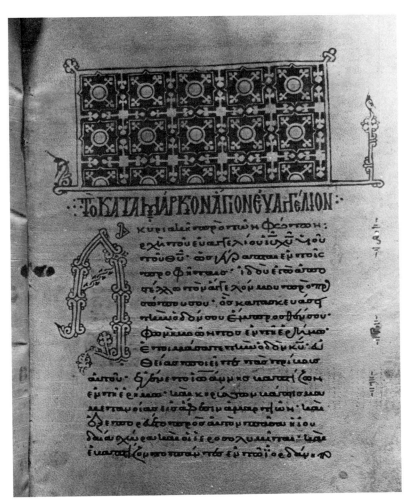

712. Cod. 180, fol. 74r. Headpiece

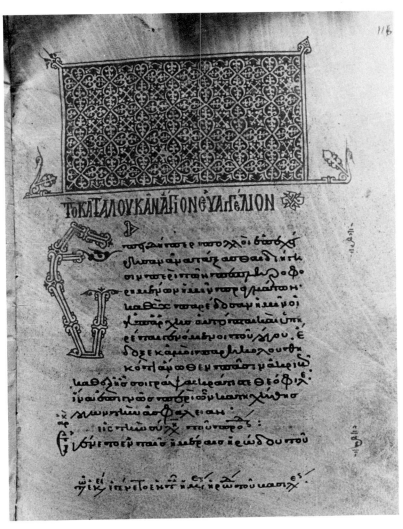

713. Cod. 180, fol. 116r. Headpiece

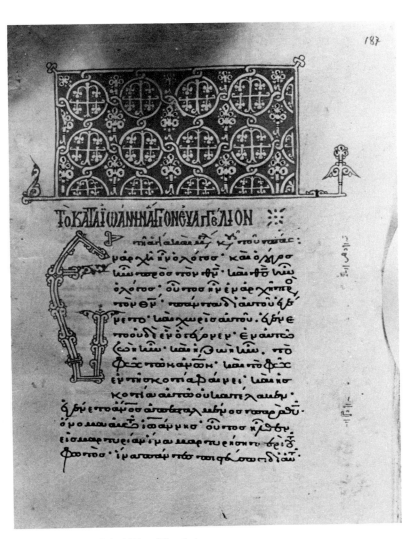

714. Cod. 180, fol. 187r. Headpiece

PLATE CXCVIII

715. Cod. 180, fol. 260v. Colophon

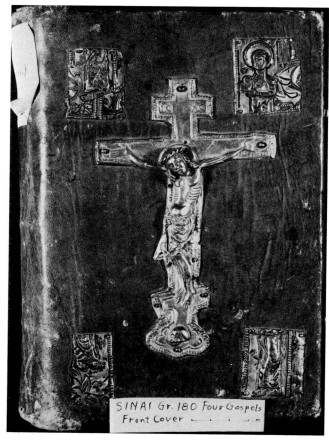

716. Cod. 180, front cover